Creating Black Americans

Nell Irvin Painter

Creating Black Americans

African-American History and its Meanings, 1619 to the Present

OXFORD
UNIVERSITY PRESS
2006

Also by Nell Irvin Painter

Southern History across the Color Line

Sojourner Truth, a Life, a Symbol

Standing at Armageddon: The United States, 1877–1919

*The Narrative of Hosea Hudson: His Life as a Negro
Communist in the South*

Exodusters: Black Migration to Kansas after Reconstruction

Incidents in the Life of a Slave Girl (Penguin Classic Edition)

Narrative of Sojourner Truth (Penguin Classic Edition)

For Thadious Marie Davis,
guide through the visual arts
and unwavering sister traveler

OXFORD
UNIVERSITY PRESS

Oxford University Press, Inc., publishes works that
further Oxford University's objective of excellence
in research, scholarship, and education.

Oxford New York

Auckland Cape Town Dar es Salaam Hong Kong Karachi
Kuala Lumpur Madrid Melbourne Mexico City Nairobi
New Delhi Shanghai Taipei Toronto

With offices in
Argentina Austria Brazil Chile Czech Republic France Greece
Guatemala Hungary Italy Japan Poland Portugal Singapore
South Korea Switzerland Thailand Turkey Ukraine Vietnam

Published by Oxford University Press, Inc.
198 Madison Avenue, New York, New York 10016
www.oup.com

Oxford is a registered trademark of Oxford University Press

Library of Congress Cataloging-in-Publication Data
Painter, Nell Irvin.
Creating Black Americans : African-American History
and its Meanings, 1619 to the Present / by Nell Irvin Painter
p. cm
Includes bibliographical references and index.
ISBN-13: 978-0-19-513755-2
ISBN-10: 0-19-513755-8
1. African American—History.
2. African Americans—History—Pictorial Works.
3. African American arts
4 African American artists.
I. Title
E185.P15 2005
973'.0496073—dc22 2005040678

Book design and composition by Susan Day

1 2 3 4 5 6 7 8 9
Printed in China
on acid-free paper

◇ Contents ◇

◇ Preface ◇

Contrary to what many people assume, history exists in two time frames: the past and the present. It is tempting to conclude that what happened in the past is over and done with, utterly unchanging despite the passage of time. But when you think about how much happens—in individual lives, in the lives of peoples and nations—you realize that in order to make sense of what took place, you need to select what is important from all the other, trivial things that happened in the past. At any given point, this selection takes place in the present. We have to select, because if we do not pull out what is important, the past remains a confusing, meaningless morass of detail. Making sense of the past is the work of historians, who create *historical narrative*. Historical narrative constructs a coherent story that makes sense to us now. Historical narrative endows certain people and events with historical importance and denies historical importance to other people and events.

Historical narrative changes over time: what we want to know about the past at one point in time differs from what we wanted to know at an earlier point, or, for that matter, what we will want to know in the future. We can see such changes clearly with regard to American history. Before the Civil Rights revolution of the 1960s—before black people began to be seen as truly American people—American history was largely the story of white people. In the past, relatively few readers of history wanted to know what African Americans were doing and thinking. Now, though, many people want to know. Similarly, before the women's movement of the 1970s—before women began to be seen as equal to men—American history was largely the story of men. Relatively few readers wanted to know what women were doing and thinking in the past. Now many want to know. Changes such as these are still under way, and the writing of history continues to evolve.

As new issues emerge, new questions surface, and the past yields new answers. For this reason, an African-American history written a generation ago no longer gives today's readers all the answers they seek. Not only have things happened in the intervening

years, but also we ask different questions of the past. We want to know what women did as well as men, what people thought who were not politicians, and what ordinary people made of their lives. We want to know how black people were portrayed in popular culture and how they countered ugly stereotypes. We want to know, for instance, that Black Power poetry of the 1960s and 1970s gave rise to rap in the 1970s and 1980s. We want to know the history of the holiday Kwanzaa, which did not even exist in 1964. A historian writing in the twenty-first century can explain these developments; someone writing in 1964 could not. But historians are not unique in asking questions of the past. People without specialized training or doctorates want to know about the past in order better to understand the present.

In this book I share the story with non-historians, notably black visual artists. Unlike academic historians, who are trained to view the past objectively, visual artists view the past in more personal terms—more subjectively. Most artists have not gone through graduate school in history or other preparation that makes them view the past as scholars. Black artists, as black people, have also waged their own struggles against racism in the art world: against art schools that would not admit them, galleries that would not represent them, and museums that did not see value in their work. Black art history, like black history as a whole, includes a crushing burden of racial and gender discrimination. American art history, like American history in general, seldom grapples with the fact of discrimination.

Not having to present injustice dispassionately, artists have felt freer than scholarly historians to present the emotional dimension of this history. Black artists, like most people who are not historians, engage more emotionally with the African-American past. Artists create artwork from their own personal experiences and from their understanding of the culture in which they live. For African Americans, that means recognizing the devastation wreaked by enslavement, segregation, and discrimination. Black artists have often said they aimed to present the unknown greatness of the African-American past. In ways that are different from and more passionate than those of historians, black artists have struggled against the misrepresentation of black people in United States history and culture.[1] African-American art recreates a people and a story that much in American history would obliterate.

Over the course of more than two centuries, black American artists have represented their history—scrupulously, meaningfully, and brilliantly. Their efforts represent a beautiful example of African-American historical *agency*, which makes black people historical actors, not passive victims of history. Thus visual artists play a significant role in the continuing creation of black Americans. The work of black artists contradicts demeaning conventional images of black people and puts black people's conception of themselves at the core of African-American history. Whereas U.S. culture has depicted black people as ugly and worthless, black artists dwell on the beauty and value of black people. Art, by definition, says, "this is beautiful; this is valuable." In many different ways, black artists depict black people as beautiful and their story as valuable. Artists

have also made ugly, racist violence visible, when American culture has tended to bury it or play down its importance. Depicting lynching, for example, artists have said, in effect, "this is meaningful; we need to pay attention to this."

In choosing black artists' images to accompany the narrative, I made several purposeful decisions. For example, the dates of creation fall mostly after the mid-twentieth century, even for images of people and events of earlier times. This is because before the 1920s very little work by black artists existed. Enslavement and poverty kept the number of working black artists pitifully small, and the few who existed seldom had the luxury of depicting black history. For instance, chapter 1, "Africa and Black Americans," begins with a painting from 1944, not an undated illustration presented as though it were an eyewitness account of Africans as they were in the seventeenth century. The 1944 painting represents a mid-twentieth-century artist's image of Africa—as Egypt. I do not pretend that it dates from the seventeenth century. The painting captures a conception of Africa that characterized black thinkers in the mid-twentieth century. In short, "1944" reminds us that every image has its own date and that black artists have a history of their own.

By emphasizing black art, *Creating Black Americans* makes black art history visible. The pitifully few black artists working before the 1920s rarely portrayed black figures. For until then, the art world did not consider black people as appropriate subjects for fine art. Black art history really begins in the 1920s, in the era of the Harlem Renaissance. Only then did a sizeable cohort of African-American artists appear, and only then did their work begin to be appreciated. (Their story appears in chapter 9.) During the mid-twentieth century, black artists produced an enormous number of works, mostly on the subject of workers and farmers. In the Black Power era of the late 1960s and 1970s, African motifs appear prominently in the work of black artists. *Creating Black Americans* reflects these changing styles and preferences. Since the 1980s, black artists have ranged across many genres—abstract as well as figurative—in the era that a prominent art critic termed "post-black."[2]

Virtually all the images in *Creating Black Americans* are by African Americans. By conscious decision, negative stereotypes do not appear, unless in the work of black artists who are reworking them into emblems of empowerment. Although negative imagery still appears in American culture, I do not reinforce humiliating, insulting depictions of African Americans; better that my readers discover a rich new body of images produced by black people themselves.

Creating Black Americans uses images that art historians have already chosen as important (see Further Reading for an introduction to work by prominent black art historians). This selection of images does not begin to represent a cross-section of the work of black artists—far from it. Because this is a general history, not a history of art, it presents only art relating to African-American history and only art that explicitly addresses black themes. It neglects abstract art (even on historical themes) and images with details that do not reproduce clearly in small format. Some art I wanted to include does not appear

for lack of permission from holders of rights if reproduction. In such cases the notes guide readers to sources where images may be found. Concerns about the cost of the book also limit the number of illustrations. The first draft of *Creating Black Americans* contained about 250 images—a bounty that would have priced the book beyond the reach of many potential readers. I hope that readers will use Suggestions for Further Reading to deepen their knowledge of the wealth and variety of black art history.

Although the selection of artwork is limited, readers will notice that black artists have preferred certain subjects to others. Throughout the twentieth century, for example, black visual artists depicted two kinds of images repeatedly that were seldom featured in American fine art: ordinary, working people and violence inflicted upon people of African descent. Black artists illustrated—literally—the importance of these two themes. *Creating Black Americans* reflects the abundance of these images by emphasizing the lives of ordinary people and the violence so common in their lives.

Readers will notice that the dates of creation accompanying each image do not necessarily accord with the dates of the events being discussed. The dates of the art document the changing ways in which African Americans have conceived of their history. The contrast between the recent dates of the images and the age of the slave trade embodies tensions that exist throughout the book. I hope my explanation of method in chapter 2, "Captives Transported," will sustain readers across the many pages that follow. Artists long avoided the all too painful issue of the Atlantic slave trade, and images of this history date only from the recent past. In chapter 2, I elaborate on artists' renditions of the Atlantic slave trade. Readers may debate the reasons for avoidance and embrace of the Atlantic slave trade, knowing—perhaps for the first time—that a willingness to face this historical trauma is relatively new.

While black artists have produced myriad images of ordinary people at work, at home, and in their neighborhoods, until the Civil Rights era of the 1960s, artists seldom turned to subject matter related to war—including the Civil War—politics, business, or the professions. As antiblack stereotypes became less acceptable in American culture in the late twentieth and early twenty-first centuries, black artists have felt less urgency to counter them. The family, on the other hand, remains a favorite topic for black artists, perhaps in response to the continuing stigmatization of black families in American culture. As a result of these preferences, the number of illustrations per chapter varies, in accordance with chapter content.

For interested readers, an alphabetical appendix with brief biographies of all the artists represented in the book appears at the end of this volume. Each entry includes birth and death dates, a list of where their art can be found in the book, a short précis of each artist's life, and a brief guide to relevant print and (where possible) internet sources for further study.

The two central themes of *Creating Black Americans*—in both the narrative and the images—are material conditions and meaning. The theme of material conditions relates to politics, economics, and demographics: how many people were located in particular

places, how much money they made or did not make, what their legal status was. Where appropriate, the book includes tables to convey this information.[3]

The theme of meaning relates to the changing production of historical narrative in two ways: first, knowledge as a *process*, and, second, historical commemoration. The theme of knowledge as a process appears prominently in chapters 1 and 2, and influences the approach and organization of the chapters that follow. At every point in their history, African Americans have thought critically about their situation and their past and interpreted their meaning. Writers, artists, and musicians produced a steady stream of work presenting their versions of historical meaning. Historical commemoration—the process of creating holidays, monuments, and museums—began in the nineteenth century, but commemoration really gained strength at the end of the twentieth century. *Creating Black Americans* takes note of commemoration as part of a process of creating a coherent black American identity that also includes scholarship, art, and commentary.

Creating Black Americans seeks engaged readers who are interested not only in what happened, but also in the myriad meanings African Americans have found in their experiences. Black Americans have always been a numerous, diverse, and creative people whose history is richly varied. And black visual artists have forged a magnificent account of the creation of a people. Welcome to this introduction to a past rich in beauty and creativity, but also in tragedy and trauma. Welcome to the history of the creation of black Americans by black Americans.

✧ Acknowledgments ✧

This book owes its life to two intense intellectuals: my dear friend Thadious Marie Davis, who guided me into African-American art, and Bruce Borland, who envisioned the project in the first place. Both great correspondents, they read, commented, and offered constructive criticism throughout. Their company kept me focused on the task at hand and broadened my mind's reach. Barbara Muller introduced me to a new genre, and her advice continues to shape my ways of organizing thought. Nellie McKay and Glenn Shafer stood back a little, but as always, their presence remains essential.

My clear-sighted agent Charlotte Sheedy helped make Bruce Borland's vision reality. Many people in and around Oxford University Press contributed to the project, including June Kim, Gioia Stevens, and Pamela Carley. I'm particularly grateful to Peter Coveney for his editorial thoroughness and personal integrity. He truly counts as this book's editor, even though no longer with Oxford University Press.

Creating Black Americans could not have been written or so richly illustrated without the crucial support of people at Princeton University. I am grateful to the University Committee on Research in the Humanities and Social Sciences, the Department of History, and the Davis Center for essential material support and to the Program in African-American Studies and the Dean of the Faculty for research assistance. I also owe heartfelt thanks to Jeremy Adelman, History Department chair, for his encouragement. Historians can never express sufficient gratitude to librarians. In this project, Emily Belcher in Firestone Library guided me toward resources in new fields and on the web. Also in Firestone, Susan Bennett White offered needed help with permissions. While I was working from Vermont, Rick Pilaro of the CIT (now OIT) Help Desk talked me through computer glitches. Elaine Wise is no longer at Princeton, but I still value her years of companionate help. Thanks, too, to Eric Yellin and Deborah Becher for research assistance. I am grateful for the criticism and suggestions of the anonymous reviewers of various drafts. They enriched this book immeasurably.

The Dartmouth Program in African and African-American Studies sponsored the first presentation of this book in the fall of 2000. I appreciate the welcome and, especially, the suggestions of Professor Deborah King, who helped me locate quilts. I also want to thank Ula Taylor, Charles Mills, John Murrin, Barry Gaither, Lucius Outlaw, Lewis Gordon, Sharon Patton, Richard Powell, Albert Raboteau, and Eddie Glaude for taking time to reply to my questions. My thanks also go to the many who helped secure permissions for reproducing artwork and texts that appear here.

Creating Black Americans

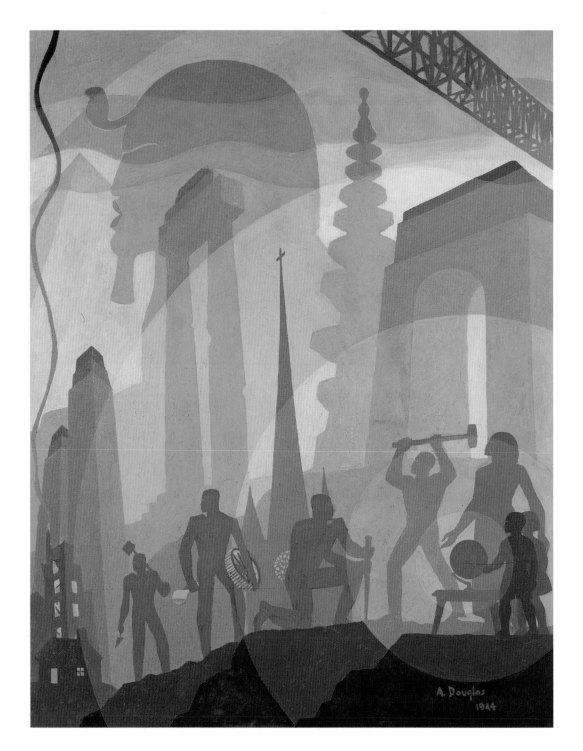

1.1. Aaron Douglas, "Building More Stately Mansions," 1944
In the background Douglas shows a pharaoh in profile and obelisks to symbolize the greatness of ancient Egypt as symbols of African Americans' African ancestry. In the foreground, black workers forge a bridge, skyscraper, and church steeple, the icons of modern culture.

Africa and Black Americans

When and where does African-American history start? The answers are many, and they are not foreordained. Moreover, black people's ideas about accurate answers have changed, as their notions of themselves, their identity, and Africa have changed. Everyone's ideas about the past reflect the concerns of the present. And so it has been with African Americans. African-American art developed alongside African as well as African-American history, both continually reflecting black Americans' approach to Africa.

The idea of Egypt as the symbol of both ancient Africa and the origin of black Americans has enjoyed great longevity. With its classical history, huge monuments, and beautifully decorated tombs featuring people who look like African Americans, Egypt endows black Americans with an illustrious lineage. Ancient Egypt appears here in the work of Aaron Douglas (1899–1979), the quintessential artist of the New Negro or Harlem Renaissance movement of the 1920s and 1930s (1.1). Douglas's "Building More Stately Mansions" brings together emblems of what was then called Negro history over the passage of three millennia: in the background, the profile of a pharaoh, in the middle ground, ancient monuments, and in the foreground, the architecture of modern society. Douglas's evocation of ancient Egypt represents one widely accepted means of coming to terms with African Americans' origins as a people. Today African Americans pre-occupied with ancient Egypt are called "Afrocentric." Their focus has a long but intermittent history.

"African" Americans and Africa

Much culture and history distinguishes African Americans from Americans who are not of African descent, and much culture and history connects people of African descent

across political boundaries. Obviously there is a good deal more to African Americans than mere American-ness. Some believe that Africa alone holds the key to black American identity. For instance, while black Americans speak languages that originated in Europe, they speak them in very special ways. In the United States, we recognize the phenomenon of Black English, whether beloved in poetry and song or ridiculed as "Ebonics." Black Americans gave American culture complex rhythms, as in the polyrhythms of blues, jazz, hip-hop, and Cuban music, and the supple, whole-body dancing that cannot be separated from such engaging music. African musical aesthetics have also lived on in the use of drums and in the ring shout (a dance, despite its name of "shout") found throughout the Americas. Melismata (several notes sung or played in one syllable of a word) gives African descended music a particular emotional depth. The genius of improvisation and the lively current of call and response, in which the audience and the performer talk back to one another, derive from Africa, not Europe. African cultures may not have survived whole in the New World, but they have left a deep imprint.

As more or less dark-skinned people, African Americans have identified themselves and been identified by others as different from first-class citizens. In every New World nation, Africans and their children endured slavery and poverty. Their color stands for poverty and poverty's stigma. Shared culture, as much as the memories of enslavement, segregation, poverty, and racial humiliation, draw together the people who have been dispersed from their African homeland—a process that created the African Diaspora in the Americas. Confronting racial oppression has been as much a part of African Americans' experience as the legacy of an African past.

The struggle against racial oppression helped turn African Americans toward Africa, where the possibility of a proud past might offset a humiliating present. Note that this past is conceived of as "African," not Ndongan (from present-day Angola) or Ibo (from present-day Nigeria) or any of the scores of other ethnicities of black Americans' Old World ancestors. (See chapter 2 for maps of these peoples' home territories.)

Today histories of African Americans customarily begin with a survey of "African" history, for African-American people relate themselves to "Africa": By using the term "*African* Americans," black Americans accent the part of their heritage that is not American. They say they are more than stigmatized Americans; they are proud people descended from Africa. Their past is more than the enforced immigration, slavery, segregation, and oppression that have been much of their lot in the Western Hemisphere. They look back to a history of freedom and greatness.

Many black American Afrocentrics and cultural nationalists choose further to emphasize the African dimension of their heritage by taking African names, wearing African clothing, and displaying African art in their homes and workplaces. Their favored African language in the 1960s was the East African language of Swahili, expressly because it is a language of people of many ethnicities. African Americans speak of an "African" heritage, partly because few know exactly where their African ancestors came

from. Even if they could know, they would discover that over the course of the dozen or so generations their ancestors lived in North America, people of many different African peoples contributed to each individual African American's ancestry. They call themselves "*African* Americans" rather than Ndongan Americans or Ibo Americans because they are a mixture of many African peoples.

The three centuries separating African Americans from their immigrant ancestors profoundly influenced their identity. A strong case can be made for seeing African Americans as a new, Creole people, that is, as a people born and forged in the Western Hemisphere. Language provides the most obvious indicator: people of African descent in the Diaspora do not speak languages of Africa as their mother tongue. For the most part, they speak Portuguese, Spanish, English, and French as a mother tongue, although millions speak Creole languages (such as Haitian Creole and South Carolinian Gullah) that combine African grammars and European vocabularies. As the potent engine of culture, language influences thought, psychology, and education. Language boundaries now divide descendants whose African ancestors may have been family and close neighbors speaking the same language. One descendant in Nashville, Tennessee, may not understand the Portuguese of her distant cousin now living in Bahia, Brazil. Today, with immigrants from Africa forming an increasing proportion of people calling themselves African American, the woman in Nashville might herself be an African immigrant and speak an African language that neither her black neighbors in Tennessee nor her distant cousin in Brazil can understand. Religion, another crucial aspect of culture, distinguishes the different peoples of the African Diaspora. Millions of Africans are Muslims, for instance, while most African Americans see themselves as Christian. They would hardly agree to place themselves under the Sharia, the legal system inspired by the Koran, which prevails in Northern Nigeria.

The three centuries separating the great majority of African Americans from their immigrant ancestors also deprived most African Americans of intimate knowledge of Africans as individuals. The immigrant generations, born in regions that are now Nigeria and Senegal and Angola, knew hundreds of people as friends, family, protectors, enemies, and captors, all who of whom were Africans. They knew them as people they loved and feared, as good people and evil people. They had no need to characterize everyone in a vast continent in only one way, whether good or bad.

Being "African" American is part of a New World identity. Naming people only by the continent of their origin and ignoring their ethnic identity is a consequence of distance in time and space. Only after they had been torn from home and categorized by something called "race" did millions of peoples speaking hundreds of languages come to be seen as "Africans," and as all having the same identity. As longtime inhabitants of the nations of the Americas, black Americans' economic and political history cannot be separated from that of the New World countries their ancestors did so much to build. In the United States this revisioning process began in the late eighteenth and early nineteenth centuries.

Ibos and Ndongans and other African peoples became lumped together as "Africans" against the backdrop of multivalent Western oppression. The appalling realities of the Atlantic slave trade, New World slavery, colonial domination, and poverty stigmatized African-descended people. In addition, the whole apparatus of learned knowledge decried Africans' lack of civilization, beauty, and wealth. In the nineteenth and early twentieth centuries, well-educated people believed Africa to be a dark continent full of ugly people who offered nothing positive to history. Knowledge about black people did not figure in college or high school curricula. Images of Africa and its history fell victim to racist denigration that lasted more than two centuries, as though the homeland of the poorest and most vulnerable people in the Western world had itself to be degraded. Even black Americans' own words were enlisted against Africa. The West African-born Boston poet Phillis Wheatley (ca. 1753–1784) published volumes of poetry, including poems advocating the abolition of slavery. Yet only one of her poems, "On Being Brought from Africa to America," was endlessly quoted—as proof of all black people's preference for America over Africa. The larger body of Wheatley's work, advocating the equal rights of all people, was ignored.

In the nineteenth century, before many African Americans enjoyed access to higher education or were able to travel, depictions of black people depended heavily upon Eurocentric Western learning. Westerners of all races measured African worth in European terms: Had Africans produced great civilizations like ancient Greece? Were Africans progressive in religion, according to the tenets of Protestant Christianity? Why was Africa poor and undeveloped? According to their answers, Westerners judged Africa as "benighted," or shrouded in darkness. Much of what held pride of place in Western letters now sounds ridiculous: during the nineteenth-century reign of so-called "scientific" racism, Europeans and Americans of European descent denied black Africa any history worth the name and claimed the ancient civilizations of Egypt and Ethiopia for white people. Europeans portrayed ancient Egyptians as white people with straight hair and argued that Egyptians curled their hair or wore wigs to achieve hairdos that are, in fact, quite easy to fashion out of very curly hair. (Hairdos like those of ancient Egyptians became commonplace among late twentieth- and early twenty-first-century women of color.) Regardless of the extravagance of these claims, African Americans had to take them seriously, because the educated elite of their country believed them. African Americans constantly disputed the negative and commonplace evaluations of Africa and the Negro race circulating in Western culture, in many different ways.

In the face of racist insult, African Americans shaped their own versions of Africa. The process unfolded across the nineteenth and twentieth centuries, as knowledge of the African past increased and as black Americans discussed the meaning of African history among themselves. They often put several ancient African civilizations together as a single, glorious past they claimed as their own. That way of thinking is called "Ethiopianism."

Ethiopianism: Ancient Egypt + Cush + Ethiopia = the Negro Race

Historically minded people of all races have long known the Nile valley produced a rich, powerful, literate, and influential society. Interest in Egypt and Egyptians increased in the early nineteenth century, after the 1798 Egyptian expedition of the French emperor Napoleon Bonaparte. Just as white Americans and Europeans, regardless of where their ancestors came from, adopted fourth-century B.C. Greeks and imperial Romans as their own cultural ancestors, so many black Americans adopted ancient Egyptians. Ancient Egypt had influenced the rest of Mediterranean antiquity, and one of its richest dynasties had been black—the twenty-fifth dynasty, from Cush, also known as Meroe, in present-day Sudan. White people's fascination with ancient Egypt also nourished black self-esteem. Images of the pyramids and monuments circulated widely after the invention of photography in the mid-nineteenth century. Exhibitions of the treasures of ancient Egypt remained popular in the United States and Europe as archaeologists unearthed the buried treasures of tombs.

The 1826 exhibit of Egyptian mummies in New York City inspired an unsigned editor of *Freedom's Journal*, the first black newspaper in the United States, founded in 1827. Musing on the "Mutability of Human Affairs" the *Freedom's Journal* editor saw himself "as a descendant of Cush" who "could not but mourn over her present degradation . . . and upon the present condition of a people, who, for more than one thousand years, were the most civilized and enlightened. . . . [Ethiopia] was early inhabited by a people, whose manners and customs nearly resembled those of the Egyptians. . . ." The ancient Ethiopians were, he said, "a blameless race, worshipping the gods, doing no evil, exercising fortitude, and despising death."[1] Hoping that past greatness portended future glory, black Americans often recited a verse from the Bible that inspired this hope: "Princes shall come out of Egypt; Ethiopia shall soon stretch forth her hands unto God" (Psalms 63:31).

Psalms 63:31 profoundly influenced nineteenth-century black American thought about Africa. The verse's prophetic phrases linking Egypt and Ethiopia encouraged the Ethiopianist fusion of Egypt, Ethiopia, Cush, Africa, and people of African descent throughout the Diaspora into one whole. Like many of his contemporaries, Frederick Douglass (1817–1895), the leading black African-American abolitionist and post–Civil War statesman, preferred to connect his people to a magnificent, Ethiopianist past, rather than to little-known and little-respected black Africans of his own time.[2]

Nineteenth-century African Americans often argued that Africa's noble past proved that the continent would regain its greatness. This kind of thinking appears in *David Walker's Appeal* of 1829. A Boston used clothes dealer from North Carolina, Walker (ca. 1785–1830) maintained the African races could look back to great achievements: "the arts and sciences—wise legislators—the pyramids and other magnificent buildings—the turning of the channel of the river Nile, by the sons of Africa or of Ham. . . . Yea further, when I view that mighty son of Africa, HANNIBAL, one of the greatest generals of antiquity, who defeated and cut off so many thousands of the white Romans or murderers, and who carried his victorious arms, to the very gate of Rome . . . I say, when I view

retrospectively, the renown of that once mighty people, the children of our great progenitor, I am indeed cheered."[3]

Others emphasized Africa's potential for future progress and cited as contributors the role of African-descended people from Britain and the Americas. The self-proclaimed African-born author of the classic eighteenth-century ex-slave narrative, Olaudah Equiano (1745–1797), glimpsed Africa's latent hopes.[4] He and his black British and North American co-workers strove to uplift Africans by immigrating to Sierra Leone and converting the local people to Protestant Christianity. This settlement and conversion approach held lasting appeal, as embodied in Liberia, an American-sponsored settlement of black Americans on the coast of West Africa, and a counterpart to the British-sponsored Sierra Leone, where Great Britain resettled Afro-Britons and people rescued from illegal slavers. The Reverend Alexander Crummell (1819–1898), one of the most prominent nineteenth-century educated African Americans, actually moved to Liberia, where he worked as a missionary educator from 1853 to 1873.

Early nineteenth-century authors and lecturers such as David Walker and Maria Stewart (1803–1879) echoed the notion that Africa could be redeemed through the efforts of black Americans.[5] Martin Delany (1812–1885), the "Father of Black Nationalism," traveled to what is now Nigeria and signed treaties permitting the settlement of black Americans there. (The outbreak of the Civil War forestalled actual settlement.) For people thinking like Delany, African Americans were destined to foster Africa's future greatness. With the passage of time, African-American Christians' concept of their mission to Africans has changed, but has never completely ended.[6]

The merger of Egypt, Ethiopia, Cush, and sub-Saharan Africa in the minds of African Americans had further consequences. The combined notion transformed Cleopatra, an Egyptian queen of Greek descent, into an emblem of black womanhood and of black people as a whole. Like Egypt, Ethiopia also stood in for all of Africa. Black artists and authors evoked the idea of Ethiopia as a promise to African Americans of their future greatness. One of the most prominent early twentieth-century black American

(Left) 1.2. Meta Warrick Fuller, "Ethiopia Awakening," 1914
"Ethiopia" signals the African identity of the figure in Fuller's sculpture, which, in turn, related it to the composed beauty of black women in the United States.

(Opposite) 1.3. Robert Scott Duncanson, "Man Fishing," 1848
The racial identity of the man in Duncanson's painting is purposefully vague and certainly not particularly African. The figure's ambiguity reflects the American art world's avoidance of black motifs.

artists, Meta Warrick Fuller (1877–1968), captured the idea of future glory in "Ethiopia Awakening" (1.2). Fuller's sculpture is poised and dignified, in a studied pose that recalls the art of ancient Egypt.

With the Atlantic slave trade largely ended by 1808, nineteenth-century African Americans lost independent knowledge of Africa. Those born in Africa belonged to a dying generation. Lacking opportunity to learn African history in school or college, Americans also had no contact with Africans of their own generations. Learned knowledge was the province of scholars who were virtually all white and who denigrated black Americans and Africans. In such a toxic state of knowledge, the topic of Africa often seemed to be one to be avoided.

Absent Africa
During the nineteenth and early twentieth centuries, most African Americans tended to avoid the subject of modern Africa and their African ancestry. Following the example of

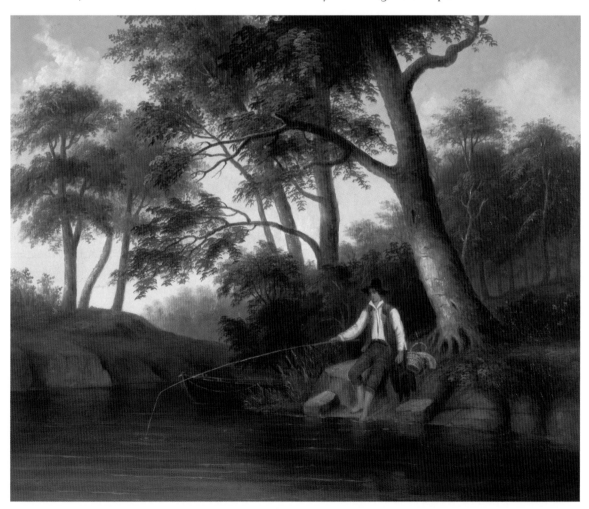

Frederick Douglass, they stressed their American-ness. If they mentioned Africa at all, it was to point to the ancient Egyptian glories that white people also recognized. For the most part, black as well as white Americans saw Africa as a dark continent.

The work of early black artists reflects this avoidance of Africa. Whether because they knew nothing of Africa or because they realized images of Africans would not attract buyers of fine art, the few African Americans working as professional artists shied away from black subjects. One well-known example is Robert Scott Duncanson (1817–1872).[7] A highly skilled landscape and portrait painter working in Cincinnati and one of the most successful black artists in the nineteenth century, Duncanson made several highly regarded paintings of people whose racial identity remained ambiguous, as in his "Man Fishing" (1.3). Duncanson's man could be an African American, but the setting and pose suggest the kind of leisure that few associated with black people at the time.

Reflecting their lack of freedom and their inability to forge an autonomous intellectual tradition, nineteenth-century black Americans often distanced themselves from Africa. They called themselves "colored people" or "Negroes" and ignored the continent whose poverty and powerlessness seemed little more than an embarrassment. Practically impotent in the face of the massive denigration of people of African descent, black writers and artists produced depictions of Africa that were vague, biblical, or, most often, non-existent. This situation began to change as the nineteenth century ended, and ideas about African-American and African history changed.

Black Scholars in an African Diasporic Framework
In the late nineteenth century, as increasing (but still tiny) numbers of black people secured higher education, they began to create African-American history. When black Americans investigated their own history, they went against the grain of the larger society, which assumed they had no history. Prejudice against black people relegated this knowledge to a small circle of readers. For all intents and purposes, black people's past was not a subject of interest in mainstream American culture, whether popular or learned.

Those who took as their mission the making of black history did so as a labor of love and usually without the advantages of institutional support. George Washington Williams (1849–1891), an Ohio clergyman and lawyer, published the first systematic African-American history in two volumes: *History of the Negro Race in America from 1619 to 1880* (1882). Williams followed prevailing assumptions in beginning his history in the Western Hemisphere, not in Africa. Having served in the Union Army as a teenager, Williams also published a Civil War history, *History of the Negro Troops in the War of the Rebellion* (1887).[8] Williams's books inaugurated a broad-based movement; by the early twentieth century, interested amateurs throughout the United States launched clubs, such as the Negro Society for Historical Research, founded in New York City in 1911, to advance the study of Negro history.

Black scholars with and without formal training brought Africa and the African Diaspora into view for masses of African Americans. One of the founders of the Negro Soci-

ety for Historical Research was the leading collector of books by and about black people in the early twentieth century, Arthur Alfonso Schomburg (1874–1938). Originally from Puerto Rico, Schomburg always reminded his colleagues of the diasporic nature of black history. Schomburg also belonged to the American Negro Academy. Founded in Washington, D.C., in 1897, this organization included a number of highly educated black men with international experience, such as Alexander Crummell and the scholar-activist W. E. B. Du Bois (1868–1963). After post-graduate study in Berlin in 1892–1894, Du Bois served as secretary of the Pan-African Conference in London (1900), and became the chief organizer of the first Pan-African Congress in Paris in 1919. Holder of a Ph.D. in history and editor of the National Association for the Advancement of Colored People's *Crisis* magazine, Du Bois regularly published articles on black people in Africa and the Caribbean. Du Bois's and Schomburg's colleague in the American Negro Academy, Alain Locke (1885–1954), was a Howard University philosopher and the first African American to receive a Rhodes Scholarship. During his years of study at Oxford, from 1907 to 1910, Locke helped found and served as secretary of the African Union Society. Accepting an invitation from Schomburg's Negro Society for Historical Research, Locke urged its members to include African history within its purview.[9]

In the early twentieth century, several scholarly books traced African-American history back to Africa and reached a wide audience of largely black readers. Some of the more respected titles were Du Bois's *The Negro* (1915) and *Black Folk Then and Now: An Essay in the History and Sociology of the Negro Race* (1939), and one of the many books by Carter G. Woodson (1875–1950), *The African Background Outlined* (1936). Woodson founded and permanently presided over the Association for the Study of Negro Life and History (which still exists as the Association for the Study of African-American Life and History). Woodson also created Negro History Week. William Leo Hansberry (1894–1965), another Howard University professor, taught courses that situated black Americans in what would come to be called an African diasporic framework. Hansberry's teaching laid the intellectual groundwork for the interdisciplinary black studies movement of the 1960s and 1970s. Taken together, these early twentieth-century authors, books, and institutions explaining black Americans' African past greatly increased African Americans' knowledge of themselves and of Africa.

Book collectors like Schomburg, known as bibliophiles, were also deeply engaged in the work of creating black history. They collected texts on black people, which white institutions largely ignored. These invaluable and unusual collections began as ways to document the history of black scholarship and often furnished the basis of research libraries in black history that served thousands of people seeking information on black history. In 1926 Schomburg sold his collection of more than four thousand books, pamphlets, prints, and manuscripts to the New York Public Library.[10] The Schomburg collection became the core of the Division of Negro History, Literature, and Prints in the 135th Street Branch of the New York Public Library (today the Schomburg Center for Research in Black Culture), a popular center for study of black history from the moment of its creation.

Like many other black bibliophiles, Schomburg was a black nationalist. Black nationalism stresses the kindredness of all peoples of African descent and downplays various national origins. The term "African American" comes out of Black nationalism and replaces "Negro," which while also black nationalist, does not focus black identity on Africa. Schomburg supported the mass black nationalist movement of Marcus Garvey (1887–1940) in the 1920s and continually stressed the relation of African Americans to Africa and the international nature of African-American identity.

Black Nationalism and the New Negro Movement

The great watershed in African-American history is the period of the 1920s. With mass migration from the South as the enabling condition, black Northerners, young and old, embraced their blackness and recognized Africa as their past. Two movements were key to this transformation in the relation of African Americans to Africa: Marcus Garvey's Universal Negro Improvement Association (UNIA) and the New Negro movement, also known as the Harlem Renaissance or Negro Renaissance movement. Departing dramatically from the common, late nineteenth-century tendency to avoid Africa and blackness, African Americans repudiated intellectual white supremacy and embraced their African identity.

Marcus Garvey called for "Africa for the Africans." During the early 1920s the New York *Negro World*, the newspaper of Garvey's Universal Negro Improvement Association, reached thousands of readers on a weekly basis. By featuring regular articles on African history and current events, *Negro World* reinforced the diasporic outlook of millions of people of African descent. As Garvey—imprisoned for mail fraud, then exiled in London—was fading from the New York scene, Alain Locke published *The New Negro* (1925).

Usually appreciated as a showcase for young black writers, *The New Negro* also advocated the study of black history and displayed artwork prominently. Schomburg's essay, "The Negro Digs Up His Past," advised readers, "The American Negro must remake his past in order to make his future. . . . History must restore what slavery took away." Delivering a message that reappeared in 1960s cultural nationalism, Schomburg called the systematic study of African culture and history crucially important for racial well-being.[11] In "The Legacy of the Ancestral Arts," Locke also urged black Americans, especially artists, to embrace Africa. *The New Negro* ended with several pages of bibliography on African and African-American history and culture by Arthur Schomburg and the folklorist Arthur Huff Fauset (1899–1983).[12]

The Call for Racial Art

Art and history developed in tandem, as manifested in Schomburg's and Locke's essays in *The New Negro*. At the same time, European conquest of Africa at the end of the nineteenth century brought the arts of Africa into prominence. Europeans looted the African cities they conquered and carried the booty back to London, Paris, Berlin, and Brussels.

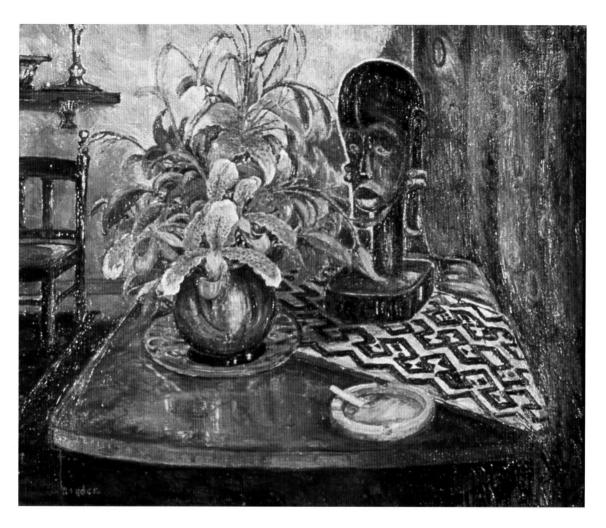

1.4. Palmer Hayden, "Fétiche et Fleurs," (1926)
Hayden replaces the usual fruit, flowers, and vases of the still-life genre of painting with tropical flowers, an African mask, and African fabric.

The 1897 British punitive expedition in Nigeria, for example, took thousands of works of art in many media (brass, ivory, wood, iron, textiles, beads) to London, where they were displayed as trophies of war. As a result of these depredations, the European art world discovered ancient African art. In Paris, especially, where Locke visited annually, Cubists carried the aesthetics of African art into modern art. In turn, the African-inspired work of European Cubists and Expressionists exerted an influence on black Americans. But more important than what happened in Europe, the New Negro movement in the United States revolutionized the ways black Americans envisioned themselves.

Artwork of two sorts appeared throughout the pages of *The New Negro*: contemporary artwork (much of it by the young Aaron Douglas) and sculpture from black Africa.[13]

Locke's own essay called for a "racial art": "The Negro physiognomy must be freshly and objectively conceived on its own patterns if it is ever to be seriously and importantly interpreted. . . . We ought and must have a school of Negro art, a local and racially representative tradition."[14] Harlem's artists quickly complied. "Fétiche et Fleurs," for instance, by Palmer Hayden (1890–1973), is a still life of the sort standard in Western art. But Hayden features an African sculpture and a piece of African cloth where other artists would show fruit and Persian carpet (1.4.).

With Marcus Garvey's mass black nationalist movement and the artists' and writers' turn toward African and African-American subject matter in the Harlem Renaissance, the 1920s wrought a revolution in African-American attitudes toward Africa. In answer to white people's claims that Africans were nothing but savages and always had been savages, black Americans countered with histories that ranged from well founded to extravagant. Whether scholarly or compensatory, African-American histories insisted that Africa indeed had a proud culture and a history that were part of the identity of all African Americans. It took scholarly history another generation to discard white supremacist, anti-African habits of thought.

Textbook Recognition of African History

Recognition of African history by black Americans preceded that recognition by the historical profession. Only in the post–World War Two era of colonial independence did mainstream, scholarly writing come to share black Americans' view. As black African nations became independent (beginning with Sudan in 1956, Ghana [formerly the Gold Coast] in 1957, and Nigeria and many others in 1960), academic history increasingly stressed the achievements of African societies.

From Slavery to Freedom, the longest-lived, most respected, and best-selling textbook of African-American history by the renowned University of Chicago and Duke University historian John Hope Franklin (b. 1915), reflects the increased acceptance of sub-Saharan Africa as the origin of black Americans. Franklin's incorporation of Africa in African-American history contrasts with that of George Washington Williams, which begins in 1619. Franklin opened his first edition (1947) with African history. Over time and several editions, his emphasis has shifted as the status of African nations changed. The 1947 first edition begins with many pages on ancient Egypt and Ethiopia. But after the nations of West Africa gained independence in the early 1960s, Egypt and Ethiopia disappeared. Virtually all histories of black Americans, including Franklin's, now begin with a summary of West African history that includes the civilizations of Ghana, Mali, and Songhay. For textbooks, Ghana, Mali, and Songhay represent African Americans' ancient history. This is a history of warrior kings and empires.[15]

Ghana

Ancient Ghana's origins begin around the time of Jesus, in the headlands of the Senegal and Niger rivers (in the region that is now the modern state of Mali). With its

capital of Kumbi Saleh, an important trading center in the eleventh century, Ghana's influence reached into areas that are now Mauritania, Senegal, and Guinea. Its most powerful dynasty, the Sisse, traded gold and slaves from the south for textiles and salt from the north. King Tenkemenin, whose reign began in 1062, lived in a fortified castle surrounded by beautiful works of art. He supported his life of luxury by collecting taxes on the trade passing through his kingdom and tribute from his far-flung vassals. Tenkemenin's reign flourished only until 1076 when Muslim invaders seized his capital. Drought further weakened the kingdom of Ghana, which never regained its pre-1076 greatness.

Mali

To the south and west of the declining state of Ghana the kingdom of Mali arose in about 1235. Its origins lay in the seventh century, but its period of greatness began in the mid-thirteenth century under the legendary Sundiata Keita. Keita destroyed the remnants of Kumbi Saleh, the capital of Ghana, and paved the way for his Muslim descendant, Mansa Musa, who ruled from 1312 to 1337. Mansa Musa conquered a vast territory stretching from the Atlantic Ocean through the present-day states of Mali, Burkina Faso, and Niger, and he became widely known as a ruler of fabulous wealth. In 1324 Mansa Musa made the Hajj, or pilgrimage to Mecca, dazzling the Mediterranean world with his riches and power: accompanied by hundreds of slaves and camels weighted down with gold and a well-armed military escort, Mansa Musa traveled home from Arabia via much of North Africa. Mali prospered into the mid-fourteenth century, when one of its vassal states, Songhay, conquered it.

Songhay

Centered on the Niger River at Gao (in the northeast part of present-day Mali), Songhay began in the eighth century and became a vassal state of ancient Mali. In 1355 it achieved independence from Mali and grew into an empire under King Sonni Ali (1464–1492). Sonni Ali conquered Mali's main towns of Jenne and Timbuktu by river, then took over the entire older kingdom. After Sonni Ali's death, Askia Mohammed overthrew Sonni Ali's successor, and reorganized the Songhay kingdom along efficient military lines. His professional army conquered a larger territory than had ever before come under unified control in West Africa. The Songhay empire stretched from what is now Mauritania on the Atlantic to present-day Niger and into the northern sections of what are now the states of Nigeria, Benin, Togo, Ghana, Ivory Coast, and Guinea.

A Muslim like Mansa Musa, Askia Mohammed also made the Hajj to Mecca in 1497, but not in Mansa Musa's ostentatious manner. Accompanied by a relatively modest retinue (1,500 soldiers, loyal vassals, and scholars), Askia Mohammed studied Muslim systems of education, law, and administration, which he introduced into Songhay on his return. He routinized trade and established schools and universities. During his time, the universities of Timbuktu and Sankore gained an international reputation.

Askia Mohammed's massive reorganization inspired a backlash, in which his oldest son dethroned him. Internal turmoil laid the Songhay empire open to external attack at the hands of Moroccan and Spanish invaders. Their rule in Timbuktu lasted only briefly, but Songhay never recovered.[16]

As the Atlantic slave trade became massively organized after 1500, no inland empire existed to unify political or cultural identity over a large stretch of West Africa. European traders encountered several different coastal peoples who sometimes came to specialize in the role of middlemen. The rise of the Atlantic slave trade coincided with the end of ancient West African imperial history.

Histories such as this filled in African Americans' pre-colonial African past. As a nationalist history, it worked quite well, and it still works, even though the empires in question were not situated in the places that supplied the Atlantic slave trade (see chapter 2). A history of kings and empires ignores the issue of the slave trade for an additional reason beyond the geographic: African kings were no more complete as African Americans' ancestors than European royalty functioned as the ancestors of white Americans. Everyone's immigrant ancestors had been vulnerable people, whether they were forced to come to the New World or sought it out in order to better their condition. Black Americans' ancestors came to the Americas to be enslaved. Nearly forgotten is the fact that most of their pre-1800 European counterparts also came to the Americas as unfree—indentured—laborers.[17] Only the tiniest number of immigrant American ancestors of any race or ethnicity descended from the warriors and aristocrats whose exploits appeared in history books. Artists as well as historians wrestled with the problem of the slave trade, as we will see in chapter 2. For black Americans' depiction of Africa, personal experience of the continent made all the difference in the world.

Today the national governments of Ghana and Senegal have seized upon African Americans' hunger for ancestry, even though neither region was a prime source of African Americans' ancestors. Ghana and Senegal have fostered "slave route" tourism in Cape Coast Castle and the island of Gorée. Tour guides welcome black American tourists as lost family and urge them to weep for their forcibly transported ancestors as though the tourists, themselves, were the ones subject to captivity.[18]

African-American Artists Encounter Independent Africa

During the first two-thirds of the twentieth century, imperialism deprived black American artists of firsthand knowledge of Africa: European colonialism kept African Americans out of the African colonies as a matter of policy. As a result, the Harlem Renaissance produced a vague and idealized version of what Locke called the "ancestral arts": African masks and other generalized subjects appeared often in the work of black artists, with little specificity within the category of "African," as we saw with Palmer Hayden's "Fétiche et Fleurs" (above).

The 1960s wrought tremendous change. The independence of African nations and

the American Civil Rights and Black Power movements in the 1960s motivated African Americans to go to Africa. By the 1970s, black artists considered at least one trip to West Africa an indispensable part of their training. Many artists visit Africa regularly to revitalize their art.

As black American artists began to travel to Africa, they began to paint real Africans as individual, living subjects taken from life. Africans were no longer simply abstractions in the narrative of black American history. A portrait by John T. Biggers (1924–2001), "Before the Shrine (Queen Mother)" (1.5), was painted from life. Rather than showing vague or stylized Africans, Biggers depicts real persons with individual features whose clothing identifies them as high-ranking Ghanaians. They emerge as particular people rather than symbols of an entire continent.

African Americans' identity with Africa expanded to include a lively interest in African politics as African nations became independent. The antiapartheid struggle in South Africa in the 1980s paralleled the American Civil Rights movement and attracted black artists. South Africa's rebirth in the 1990s seemed to many to offer a new frontier, much as the Reconstruction South beckoned black Northerners in the 1860s and 1870s.

In the 1960s and 1970s, generic evocations of "Africa" sometimes appeared as a counterweight to racial oppression in the United States, as in the murals that enlivened the imagery of the Black Power movement.

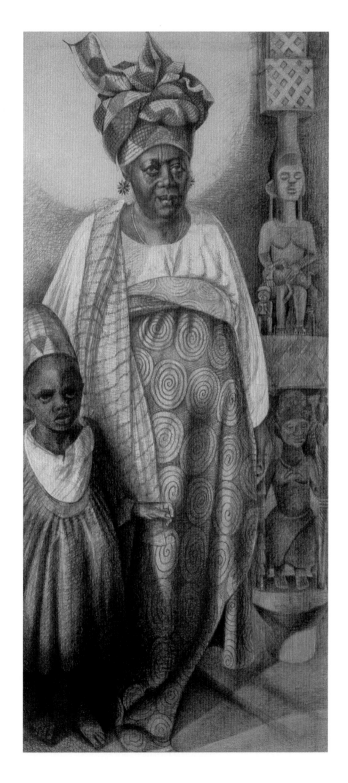

1.5. John T. Biggers, "Before the Shrine (Queen Mother)," 1962
Biggers's painting shows real individuals, not generic symbols, indicating that he painted from life rather than imagination.

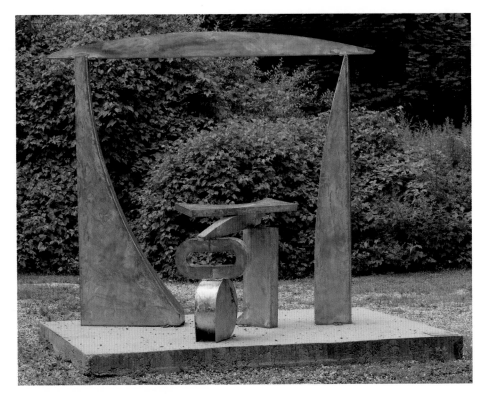

1.6. Melvin Edwards, "Gate of Ogun," 1983
Edwards's sculpture is abstract, but its form recalls traditional Nigerian gates and the wealth of royalty.

Since the very late twentieth century, however, black American artists have dealt with Africa and African themes more abstractly, as in Melvin Edwards's "Gate of Ogun" (1.6), which was displayed in the Bill Clinton White House. This large, abstract sculpture suggests a gate. Polished surfaces also suggest royalty. The title, "Gate of Ogun," says that the subject matter is Yoruba, coming from the people who live in southwest Nigeria. Edwards (b. 1937) is one of many black artists who travel often to Nigeria. Thus his use of abstract form stems from personal knowledge.

Conclusion

African Americans' thinking about Africa has changed over the course of four centuries, according to personal acquaintance, international power relationships, and the availability of knowledge. In the seventeenth century, many black people in what would become the United States had been born in Africa or at least had African parents. By the nineteenth century, African Americans were mostly born in the United States and had less immediate contact with Africa and Africans. Over the course of the twentieth century, African Americans' knowledge of Africa became less abstract and more concrete.

In the twenty-first century, voluntary immigration is bringing Africans to the United States to pursue vocations of their choice. Images of Africa and Africans are bound to reflect their and their children's closer contact with the continent.

Now that African Americans know Africa and Africans—as hosts, colleagues, and sometimes as family members—their ideas of Africa are far more varied and far less ambivalent than before the 1960s. African-American art is decidedly Afrocentric, in that it sees Africa as central to African-American identity. This Afrocentricity grows out of two centuries' worth of evolution in black thought regarding Africa. The crucial turning points were the Black nationalism and New Negro movements of the 1920s.

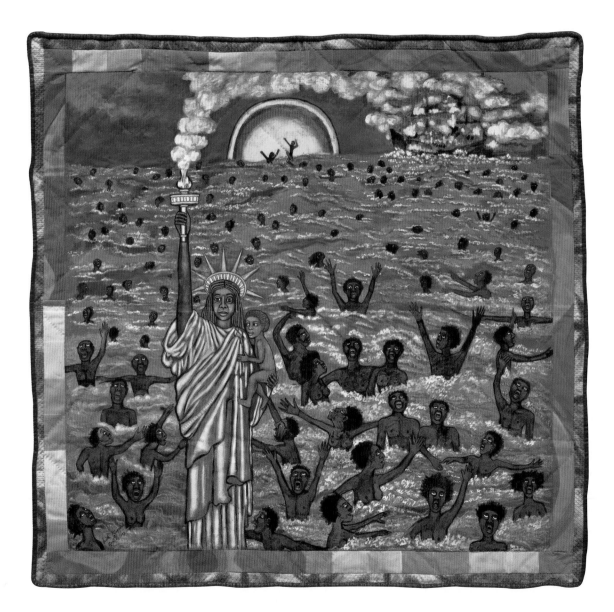

2.1. Faith Ringgold, "We Came to America," 1997
Ringgold's forced immigrants founder in a sea presided over by the Statue of Liberty with an ironic, African-American face. Smoke from Miss Liberty's torch merges with that of a slave ship on fire and links the American pride in liberty to the reality of the traffic in people.

Captives Transported

1619–ca. 1850

The genesis of African Americans as a New World people was the result of forcible capture and transportation of a minimum of ten million Africans from their homeland across the Atlantic Ocean. Yet both historians of the United States and black artists have only quite recently focused on this massive, forcible transfer of people. Faith Ringgold's (b. 1930) story quilt (2.1) and other works by African-American artists depicting the Atlantic slave trade address a traumatic, thorny, and, until recently, virtually unstudied topic. In Ringgold's work, black people cry for help in a sea presided over by an African-American Statue of Liberty. Ringgold's Miss Liberty carries a torch whose smoke joins that of a burning slave ship.

The Atlantic slave trade affected tens of millions of individuals personally and also profoundly shaped the history of the Americas. Africans were already present in the Western Hemisphere before 1619. But the history of black people in the United States is usually dated from the first arrival of a sizeable number in territory that would become the United States. In 1619 about twenty ethnic Ndongans from what is now Angola in West Central Africa landed at Jamestown. Because their arrival in Virginia was recorded, they became African Americans' founding generation.

In the following century, hundreds of thousands of Africans were imported into British North America, part of a huge forcible migration whose numbers are staggering: ten million survivors is accepted as the low number. In the 1990s activists introduced a new word, *Maafa*, to describe the black Holocaust of the slave trade, enslavement, and colonization. *Maafa* is a Kiswahili word meaning "disaster."[1]

Personal testimony from kidnapped Africans enslaved in the Americas shows the individual, psychic dimension of the experience of enslavement. Ex-slave narrators helped

drive the effort to abolish the trade by humanizing the horrific statistics of the Atlantic slave trade. The horror of the slave trade from Africa to the Americas unnerved historians and black artists for a very long time. Only in the 1990s did either group produce a sizeable body of work—artwork and scholarly history—that provides an understanding of this tragic early chapter of African-American history.

1619 and Two Early Slave-Trade Narratives

Africans accompanied Spanish explorers to North America in the sixteenth century, for example, the Moroccan Esteban, who traveled overland from Florida to Texas in 1528.[2] But their numbers remained tiny before the growth of the Atlantic slave trade. The Atlantic trade in people began early in the sixteenth century. A century would pass before the arrival in 1619 of the first sizeable shipment of Africans in English-speaking North America, the colonies that became the United States. Ultimately, commerce between Western Africa and the New World altered the human face of the Americas. From 1620 to 1700, the African population in colonial North America increased from only sixty people (1 percent of the total) to almost twenty-eight thousand (11 percent of the total population) (Table 2.1), in conjunction with the growth of the plantation economy.

The African slave trade grew dramatically during the eighteenth century, before being declared illegal after 1808 and ending in the middle of the nineteenth century. The last known slaver from Africa to the United States was the *Wanderer*, which landed 409 Africans on the coast of South Carolina in 1858, three years before the outbreak of the Civil War and seven years before the abolition of slavery in the United States.[3]

During the three and one-half centuries of the trade, millions of Africans were forcibly transported across the Atlantic ocean. About ten million survived the transit, usually to become enslaved for life. Most of their lives were short, for in Latin America and the Caribbean, the enslaved were literally worked to death. British North America was doubly exceptional: in the territory that would become the United States, people of African descent were always in the minority, and everybody, Africans included, lived longer than elsewhere in the Western Hemisphere. In British North America, the enslaved population grew through the birth of children ("natural increase") as well as through importation.

Over more than two hundred years, the Atlantic slave trade brought more people to

Table 2.1. Black and Total Populations in Colonial North America, 1620–1700

	1620	1640	1650	1660	1670	1680	1690	1700
Black population	60	597	1,600	2,920	4,535	6,971	16,729	27,817
Total population	4,646	26,634	50,368	75,058	111,935	151,507	210,372	250,888
Percent black	1.3	2.2	3.2	3.9	4.1	4.6	8.0	11.1

The figures include an undisclosed number of Indians.

the Americas than bound or free immigration from Europe and Asia. Only in the late nineteenth and early twentieth centuries did the number of Europeans settling in the Americas approach the number of forced African immigrants. And only in the early twenty-first century did the number of voluntary African immigrants surpass the number brought against their will. Although Africans were already in the Western Hemisphere, African Americans' history in the New World begins at a particular time and place: Jamestown, Virginia, August 1619. Today, 1619 is the date most people accept as the founding moment in black people's history in the United States.

The Founders of Black America

The narrative of African-American history begins in Virginia before the arrival of the *Mayflower* in Massachusetts.[4] In August 1619, a year before the arrival of the storied ship symbolizing English settlement in New England, twenty or so people from the Ndongo kingdom of present-day Angola landed at Jamestown. The Ndongans had fallen victim to a brutal wave of warfare that had begun some twenty years earlier. They had been kidnapped by a band of African marauders, known as Imbangala, allies of the Portuguese slave traders on the Atlantic coast at Luanda (Map 2.1).

Like military elites all over the world, African warriors and aristocrats had long gone to war against one another for various reasons of state, engaging in warfare as a means of empowering themselves and their dynasties. In Angola, as elsewhere in the world, poor and vulnerable people paid the price for aristocrats' indulgence. Slavery on the household scale existed in Africa before the Atlantic trade. But it was not organized as a massive commercial undertaking that could people the Americas.

In the late sixteenth century, the pace and character of warfare in West Central Africa changed, and the luxuries of the elite became imported. By the 1590s, warring African aristocrats had formed alliances with the Portuguese of the colony around Luanda, founded in 1575. Portuguese merchants in Luanda on the Atlantic coast were selling firearms to Imbangala warriors. The Imbangala were a band of as many as sixteen thousand warriors from the central highlands of Angola who were willing to sell to the Portuguese the people they defeated. With European firearms, the Imbangala overpowered everyone else and took captives on a massive scale. Warfare to empower the state turned into organized raids to take captives for sale. The Imbangala terrorized local people, who thought they were witches.[5] Now war became more gruesomely productive than ever before, as Europeans seeking commercial gain armed the most brutal warriors in the region.

Map 2.1.
Kabasa, capital of Ndongo Kingdom, 1618–1619 (in present-day Angola) was the origin of Ndongans of Virginia 1619.

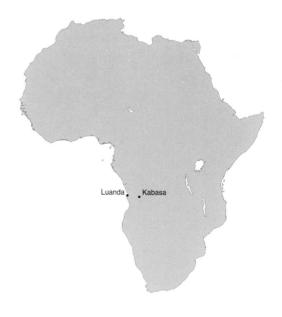

Luanda Kabasa

From 1618 to 1619, Imbangala warriors and Portuguese forces attacked Kabasa, the royal capital of the inland kingdom of Ndongo situated about 200 miles southeast of Luanda. The Ndongo kingdom lay in a plateau 4,000 feet in elevation, some 30 miles wide and 50 miles long between the Lukala and Lutete Rivers. The Ndongo kingdom consisted of large towns enclosed within woven grass stockades. Kabasa contained 5,000 to 6,000 dwellings and 20,000 to 30,000 people. The rural people raised millet and sorghum. (In the late sixteenth century, crops originating in the Americas, like manioc and corn, had not yet become prevalent in Africa.) Ndongans tended large herds of cattle and also raised domestic animals such as goats, chickens, and guinea fowl. They wore bark and cotton clothing they both made themselves and imported from the kingdom of Kongo to the north. Ndongans traded in local and regional markets where they bought iron, steel, and salt from the region south of the Kwanza River.[6] (The name of this river reappears in African-American history in Los Angeles in 1965; see chapter 13.)

Imbangala and Portuguese armed with guns easily defeated Kabasa's defenders, who were armed in the traditional manner with bows, arrows, and axes. The use of firearms by their enemies sealed the fate of the Ndongo people. The devastating Imbangala and Portuguese campaign destroyed the capital of Kabasa and sent thousands of captive Ndongan townspeople on their way to Luanda. In Luanda the captives from Kabasa joined some 50,000 other victims of the Imbangala and Portuguese wars. The capture of the Ndongans tragically embodied the military and commercial dynamics of the African slave trade.

The year 1619 turned out to be a perversely banner year for slaving in Luanda. In that year alone, thirty-six slave ships full of captives—more than ever before—set out across the Atlantic, full of people destined for resale and deadly, unpaid labor on the plantations of Portuguese and Spanish South America. One ship, the *São João Bautista*, headed for Vera Cruz, Mexico, a popular destination in this trade, was attacked by a Dutch warship and forced toward the East Coast of North America.

The twenty Ndongan men and women of the *São João Bautista* were not the first Africans in Virginia. A census taken in the spring of 1619 noted the presence of thirty-two Afro-Virginians whose names, origins, dates of arrival, and ethnicity were not noted. But because the arrival of the Ndongans in Virginia was recorded, they, not their predecessors, entered history as African Americans' founding generation.

The record of 1619 serves as the symbolic beginning of African-American identity, but this was not a record of names. With very few exceptions the record does not give the names of Africans or their descendants in the seventeenth century. Anthony Johnson (ca. 1600–ca. 1670) was one of the rare exceptions. He was originally from Angola and arrived in Virginia in 1621.

Over the course of the seventeenth century, racial slavery took shape, in laws and judicial decisions that by 1680 were defining enslavement in Virginia. In 1690 South Carolina enacted a perfunctory slave code, which was revised in 1696 and made com-

prehensive in 1712. Virginia codified its slave rulings in 1705. By the middle of the eigh-
teenth century, slavery had taken form and become identified with Africans and their
descendants by race.[7]

Most seventeenth-century Africans and their descendants lived and died anony-
mously. In the eighteenth-century age of the Enlightenment, however, individuality
began to count. The novel and extremely controversial ideas of the inherent dignity of
all human life and the rights of all men began to circulate. The first written ex-slave nar-
ratives date from the eighteenth century. For the first time they gave readers in Europe
and the Americas a sense of what it was like to be captured, transported, and enslaved.
The recollections of Ayuba Suleiman Diallo and Olaudah Equiano, two very different
individuals from widely separated regions in West Africa, offer contrasting views from
the invaluable point of view of those with firsthand experience. However, the historical
record lacks testimony from the mass of captives, such as the Ndongans, from West
Central Africa.

AYUBA SULEIMAN DIALLO (JOB BEN SOLOMON)

One of the earliest first-person accounts of the Atlantic slave trade came from Ayuba
Suleiman Diallo (also known as Job ben Solomon) (1701–1773), a member of the Di-
allo Muslim merchant clan of the western Sudan. Ayuba was from Bondu, where the
Faleme River empties into the Senegal River on the western border of present-day Sen-
egal, near Mali (Map 2.2). Traditional items of trade in this Senegambian region were
gold and gum (essential to the textile industry propelling the European industrial revo-
lution). Quite by accident, twenty-nine-year-old Ayuba fell victim to the growing traffic
in people in his part of West Africa.[8]

In 1730 Ayuba was returning to his home in Bondu,
having traveled some 300 miles to the Gambia River
coast to sell two people and buy paper and other provi-
sions. On his way home one hot afternoon, he stopped
to rest at the home of a friend. Because he was with a
friend, he removed his weapons and armor, making
himself vulnerable to capture. According to Ayuba's
narrative,

> It happened that a company of the Mandingoes, who
> live upon plunder, passing by at that time, and ob-
> serving him unarmed, rushed in, to the number of
> seven or eight at once, at a back door, and pinioned
> [him], before he could get to his arms, together with
> his interpreter, who is a slave in Maryland still. They
> then shaved their heads and beards, which [Ayuba]
> and his man resented as the highest indignity; tho'

Map 2.2.
Bondu, homeland
of Ayuba Suleiman
Diallo in present-
day Senegal.

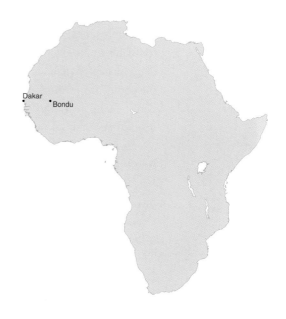

the Mandingoes meant no more by it, than to make them appear like Slaves taken in war [rather than in a raid meant solely for capturing slaves]. On the 27th of February 1730, they carried them to Captain Pike at Gambia, who purchased them; and on the first of March they were put on board.[9]

Taken captive and brought to the coast, Ayuba found himself caught up in a newly burgeoning slave trade from the Senegambian region.

Until the 1720s, the Senegambian slave trade had not amounted to more than a few hundred people, whom French slavers shipped from the coast of Senegal. Then warfare surrounding the rise of the Bambara King Marmari Kulubari (ruled ca. 1712–1755) around Segu (on the upper Niger River in present-day Mali) took hundreds of prisoners of war. These prisoners fed and stimulated the coastal slave trade. By the early 1730s, when Ayuba was captured and transported, nearly three thousand people per year were being shipped to the New World from Senegambia. Because of his high status, Ayuba almost managed to avoid becoming one of that number.

Ayuba let the captain of his slave ship know that his father could pay to ransom him. But word did not reach Ayuba's father in time. Lacking the monetary ransom, the captain shipped Ayuba and his interpreter to Annapolis, Maryland. Ayuba was bought and put to work on the Maryland Eastern Shore. Unaccustomed to hard farm work and depressed by the wretchedness of his situation, Ayuba fell ill physically and psychologically. Like many others in his situation, he ran away. Recaptured, he was imprisoned in the tavern that also served as the Kent County courthouse. There Thomas Bluett, a lawyer on business at the courthouse, discovered him.

Ayuba's ability to write Arabic and his gentlemanly demeanor impressed Bluett: "we perceived he was a Mahometan [a Muslim], but could not imagine of what country he was, or how he got thither; for by his affable carriage, and the easy composure of his countenance, we could perceive he was no common slave."[10] The lawyers found a translator in an elderly African who spoke Wolof, Ayuba's language. Once able to explain himself, Ayuba was purchased, freed, and sent to England. He learned English on the voyage from Annapolis to England. In England he enjoyed the company of prominent people, including the royal family. He had his portrait painted in a costume he insisted be made to resemble the clothing he wore at home in Bondu. In July 1734, after a little more than a year in England, he took an English slaver back to Gambia. Returning home with trade goods, he found only devastation caused by war.[11] Nonetheless, Ayuba regained his former merchant livelihood and, as a man of substance, again owned household slaves.

Ayuba's story was originally published as *Some Memoirs of the Life of Job, the Son of Solomon the High Priest of Boonda in Africa; Who was a Slave about two Years in Maryland; and afterwards being brought to England, was set free, and sent to his native Land in the Year 1734.* It was reprinted several times in French as well as English. Ayuba became known as a man of high station who had wrongly fallen victim to the Atlantic

slave trade. According to the legend growing up around him, Ayuba's natural qualities had shone through the misery of his enslavement and led to his emancipation and restoration to his proper station in life. In England he moved among English gentlemen who appreciated his true rank.

OLAUDAH EQUIANO

The romance of Ayuba's memoirs differed greatly from the best-selling story that became the standard ex-slave narrative of the Enlightenment, the autobiography "written by himself" of Olaudah Equiano (1745–1797).[12] Whereas Ayuba's narrative appeared as the story of an exceptional African captive, Equiano became the enslaved African Everyman whose ill-fortune could have been anyone's fate. Equiano said he came from the Bight of Benin, from what is now eastern Nigeria, which contributed almost one-quarter of the Africans enslaved in British North America. A child at the time he was kidnapped, he embodied the condition of millions of transported Africans, many of whom were children.

Olaudah Equiano said he was born in Iseke among the Ibo people (Map 2.3). Unlike Ayuba's experience, Equiano's was all too tragically typical. Equiano's movingly detailed portrayals of his own gentle people and of his heartless kidnappers present contrasting views of different sorts of Africans. He described his own people as innocent and harmless: Equiano paints the earliest persuasive picture of an Eden-like Africa, a picture that influenced African Americans' subsequent ideas about their ancestral homeland. In contrast, he also described rapacious kidnappers who, with the permission of greedy chiefs, took prisoners for the sole purpose of sale. Equiano's description of his kidnapping at age eleven has become classic:

Map 2.3.
Iseke, homeland of Olaudah Equiano, in present-day Nigeria.

> One day, when all our people were gone out to their works as usual, and only I and my dear sister were left to mind the house, two men and a woman got over our walls, and in a moment seized us both, and, without giving us time to cry out, or make resistance, they stopped our mouths, and ran off with us into the nearest wood. Here they tied our hands, and continued to carry us as far as they could, till night came on, when we reached a small house, where the robbers halted for refreshment, and spent the night. We were then unbound, but were unable to take any food; and, being quite overpowered by fatigue and grief, our only relief was some sleep. . . . [13]

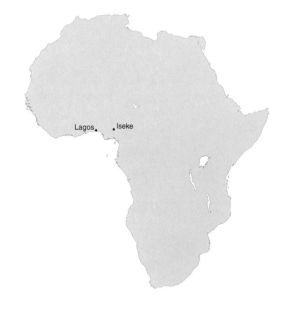

Soon separated from his sister, whom he never saw again, Equiano was sold and traded several times during

the six or seven months of his journey to the Atlantic coast. On the coast he was sold to European traders, who sent him across the Atlantic. His description of his first glimpse of white people has also become classic:

> The first object which saluted my eyes when I arrived on the coast, was the sea, and a slave ship, which was then riding at anchor, and waiting for its cargo. These filled me with astonishment, which was soon converted into terror, when I was carried on board. I was immediately handled, and tossed up to see if I were sound, by some of the crew; and I was now persuaded that I had gotten into a world of bad spirits, and that they were going to kill me. Their complexions, too, differing so much from ours, their long hair, and the language they spoke (which was very different from any I had ever heard), united to confirm me in this belief. . . . When I looked round the ship too and saw a large furnace of copper boiling, and a multitude of black people of every description chained together, every one of their countenances expressing dejection and sorrow, I no longer doubted of my fate; and, quite overpowered with horror and anguish, I fell motionless on the deck and fainted.[14]

The boy Equiano was one of 50,000 Africans sent to the Americas in the single year of 1756.[15] Unloaded in Barbados, he was not purchased, perhaps because he was too small to do the heavy work of sugar plantations. His next stop was Virginia, where a tobacco planter bought him and put him to work among black people wearing instruments of torture as punishment. Subsequently bought by an English naval officer, Equiano visited several parts of the Atlantic and Mediterranean worlds. He learned to read and write English, and after saving the money he earned as a peddler, he purchased his freedom in 1766 and moved to London. He had been enslaved ten years.

As a free man, Equiano continued to travel, becoming increasingly engaged in the campaign against the Atlantic slave trade and slavery. The best-known black abolitionist of his time, he belonged to the London-based black Civil Rights organization, Sons of Africa. (One of his colleagues, Quobna Ottobah Cugoano, from present-day Ghana, had published his own narrative in London in 1787, *Thoughts and Sentiments on the Evil and Wicked Traffic of the Slavery and Commerce of the Human Species, Humbly Submitted to the Inhabitants of Great Britain, by Ottobah Cugoano, A Native of Africa*, which was translated and published in Paris in 1788.)

Equiano also worked with British abolitionists seeking to ameliorate the condition of poor black people in England and Canada by settling them in the new British West African colony of Sierra Leone. He accompanied a group of settlers to Sierra Leone but returned to England, upset by the corruption of the English organizers of the venture. In 1788 he began writing *The Interesting Narrative of the Life of Olaudah Equiano, or Gustavus Vassa, The African, Written by Himself*, published in 1789, as a weapon in the war against slavery. His story laid the foundation of a great American literary genre.

An international bestseller, Equiano's two-volume autobiography achieved greater

success than any of its predecessor volumes. The British press reviewed it favorably, and it was reprinted seven times in its first five years of publication. *The Interesting Narrative of the Life of Olaudah Equiano* appeared in American, Dutch, Russian, and French editions before its author's death in 1797. Known and admired throughout the English-speaking world, Equiano's autobiography is not the oldest ex-slave narrative in English—that honor belongs to Briton Hammon (n.d.), who published his *Narrative of the Uncommon Sufferings and Surprising Deliverance of Briton Hammon, a Negro Man* in London in 1760. But Equiano's is the most widely accepted early text of the English-speaking black world.[16]

Ayuba Suleiman Diallo and Olaudah Equiano were from different generations and different regions of West Africa, but their experiences overlapped. Having been kidnapped by Africans, neither was starry-eyed about his homeland. Nonetheless, each wanted to return to Africa on regaining his freedom. Equiano, especially, recognized the horror of the institutions of slavery and the slave trade, and he worked to abolish the evils he had personally experienced.

Historians ignored the facts of the Atlantic slave trade for many decades. But in the mid-twentieth century—after the writing of African history began to flower in the eras of African independence and the study of African-American history—a great deal of information on the trade came to light. As a result, the experiences of Ayuba Suleiman Diallo and Olaudah Equiano can now be studied in historical perspective.

The Atlantic Slave Trade

For Africans as well as Europeans, the Atlantic slave trade was a profit-making endeavor. At both ends, the trade benefited from state support. African aristocrats allowed kidnappers free rein and collected taxes on captives passing through their realms. European monarchs chartered and taxed the private companies engaged in the Atlantic slave trade. Governmental action in the United States and Great Britain made the trade illegal in 1808 (although illegal shipments of Africans to the United States and other parts of the Western Hemisphere continued well into the middle of the nineteenth century).

Slavery had existed in Africa (as well as in Europe and Asia) long before the organization of the Atlantic slave trade. By and large, slaves in Africa were captives of war who served as household laborers. African slavery was neither racial nor hereditary; the offspring of slaves could escape the stigma of slave origins. However, the Atlantic slave trade altered the scale of African slavery and transformed it into the export of masses of people. Slave trading grew into big business after European traders organized a huge, transatlantic market.

African involvement in the Atlantic slave trade has always pained African Americans. Americans often think of Africa as one country and Africans as all the same people. According to this way of thinking, Africans were raiding and capturing "their

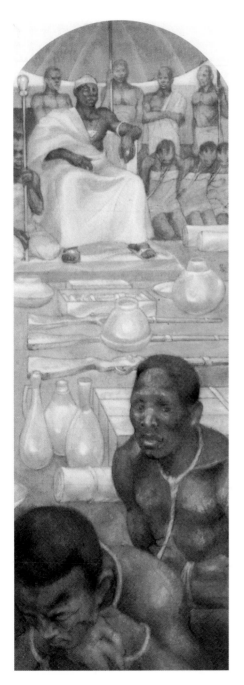

own people," an unconscionable act. Americans often prefer to think that the Atlantic slave trade involved Europeans coming ashore to kidnap innocent Africans. In fact, the trade began in this way. But kidnapping raids along the coast by outsiders could not supply a market for millions of people over the course of hundreds of years.

By the sixteenth century, Africans had organized and controlled the seizure and delivery of captives to European shippers on the coast. The captors and captives came from different ethnic groups. Often the captors were from well-organized kingdoms. The captives were usually peoples who lacked strong, well-armed rulers and armies. The artist Tom Feelings (1932–2003) lived in Ghana in the early 1960s. That experience may have contributed to his ability—rare among artists of any sort—to include an image of the aristocrats who profited from the slave trade. Feelings shows two male captives about to be delivered to Europeans in exchange for guns and other trade goods. Women captives remain with the king (2.2).

Because African captors preferred to keep women captives, they delivered many more men than women for shipment across the Atlantic. Overall, about two-thirds of those transported were male. Over time, African suppliers also reoriented the trade toward the young. In the last century of the Atlantic slave trade, nearly one-quarter of the Africans exported to the Americas were children like Olaudah Equiano.[17]

The Scale of the Forced Migration

Between the discovery of the Americas in 1492 and the end of the Atlantic slave trade in 1867, Europeans transported a minimum of 10 million Africans to the Americas in some 27,000 slaving expeditions—or some 170 slave ships per year.[18] About 95 percent of the Africans transported across the Atlantic were sent to brutal labor in the tropical, sugar-growing regions of Brazil and the Caribbean. Worked to an early death, sugar cane workers did not have enough children to reproduce themselves. Their numbers had to be replenished constantly

2.2. Tom Feelings, from *The Middle Passage*, 1995
Although Feelings shows Europeans as captors in most of the images in *The Middle Passage*, he also includes this depiction of the terms of the trade: human captives in exchange for guns and goods for the king.

through importation. Here are the approximate numbers of captives and their New World destinations:[19]

Brazil	4,000,000 to 5,000,000
British Caribbean	2,500,000 to 3,000,000
Spanish America	2,000,000
French Caribbean	1,600,000
British North America	550,000
Dutch Caribbean	50,000
Danish Caribbean	50,000

The African slave trade grew slowly from the fifteenth through the seventeenth centuries. But in the eighteenth century it increased enormously, as the labor-intensive crops of sugar in the Caribbean and tobacco in North America flourished. At the same time, imports of unfree, indentured Europeans fell short of the demand for labor. It was during this time that Ayuba Suleiman Diallo and Olaudah Equiano were pressed into an enslaved workforce. Of the ten million and more Africans shipped during the eighteenth century, approximately one-half million, or about 6 percent of the total, came to British North America and the United States. Between 1619 and 1808, their forcible immigration was perfectly legal, although ultimately a successful abolitionist campaign ended it.

The massive nature of this forced migration was truly extraordinary. Even before 1700, when the trade picked up significantly, 2.2 million Africans had already been shipped to the Americas. The trade climaxed in the decade of the 1780s, when eighty thousand Africans per year were transported to the Americas. Four-fifths of all those shipped came in the eighteenth and early nineteenth centuries. Not until the 1840s, when masses of impoverished Irish sought refuge in the United States, did the numbers of Europeans coming to the Americas exceed the numbers of Africans. Until then, the majority of non-Indian people in the Americas were of African descent. Therefore, any discussion of the peopling of the Americas owes pride of place to Africans and their descendants. [20]

Three major areas in Africa supplied the bulk of the people transported to the United States: Upper Guinea (Senegambia to Sierra Leone), Lower Guinea (the Gold Coast to the Bight of Benin), and Kongo-Angola (West Central Africa) (Map 2.4).

More than one-third of the Africans imported to British North America and the United States came from

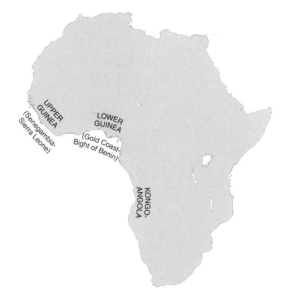

Map 2.4.
Upper Guinea, Lower Guinea, and Kongo-Angola, major sources of the traffic in people.

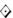

Table 2.2. Africans Arriving in the Americas: American Region of Disembarkation
by Percent of African Region Embarkation, 1662–1867

	Senegambia	Sierra Leone-Wind	Gold Coast	Bight of Benin	Bight of Biafra	W.C. Africa	S.E. Africa	Sample
French-British-Dutch South America	1.2	5.2	46.0	14.4	5.5	27.6	0	(235.0)
Northeast Brazil	5.0	1.7	0.9	0.9	1.4	86.0	4.1	(71.2)
Bahia	0.1	0.2	2.7	86.0	1.3	8.5	1.2	(642.4)
Brazil South	0	0	0.5	1.3	0.8	80.9	16.5	(969.8)
Rio de la Plata	0	8.2	4.7	1.2	31.1	54.8	0	(16.4)
Cuba/Puerto Rico	1.0	11.8	3.6	24.0	21.3	30.9	7.4	(205.7)
St. Domingue	7.2	9.9	5.9	22.3	4.0	47.6	3.1	(606.2)
Martinique-Guadalupe	6.2	8.2	9.9	32.5	11.5	31.2	0.5	(116.7)
Barbados	4.6	5.1	35.1	20.1	16.5	15.6	3.0	(113.2)
Jamaica	2.1	6.1	27.7	9.3	36.1	18.6	0	(360.8)
British Leeward	3.9	18.6	15.8	5.2	42.3	14.2	0	(205.0)
Danish Americas	0.4	7.1	47.4	3.2	13.2	28.6	0	(23.8)
United States	14.2	6.7	9.4	3.1	31.1	34.4	1.1	(74.2)
Central America	1.1	0	41.3	8.4	0	49.2	0	(23.5)
Total								(3661.8)

the Kongo-Angola region. Another quarter came from the Bight of Biafra, and about one-sixth came from the Senegambian region (Table 2.2).

Three Stages of the Journey

The passage from ordinary life in Africa to enslavement in the Americas consisted of three phases: first, the capture and march to the Atlantic coast; second, the ocean voyage from Africa to the Americas; and third, transfer from the initial American point of disembarkation to the workplace. Ayuba was relatively fortunate, for he was transported a short distance to the coast, quickly shipped across the ocean, and delivered to a place of work near his point of disembarkation. Equiano's journey was more typical; his transport to the coast took several months, a passage that proved fatal to many.

During the first leg of the journey to the Atlantic coast, the captive could be put to work and resold several times, as occurred in Equiano's case. Because captives walked from their places of capture to the coast, the trip could consume several months. In Senegambia and Upper Guinea, the people captured for shipment usually came from the ports' hinterland. But in Kongo-Angola, which sent tens of thousands of people abroad every year, captives like the Ndongans of 1619 came from hundreds of miles

inland. If they were to be shipped from the Gold Coast (Cape Coast or Elmina Castle) or Angola (Luanda), captives could also spend an average of three months in holding pens on the coast. They waited until ships were available, until the winds and currents favored westward travel, and until a boatload of captives (on average, about three hundred people) filled the ships. Ships might also make several stops along the West African coast in order to fill their holds. As a result, captives could remain on board ship for months before crossing the Atlantic Ocean, as captains completed their cargoes.

The second leg of the trip, the "Middle Passage," was the ocean voyage from Africa to the Americas. Transit times varied widely, depending upon the time of year, the sailing conditions (currents, winds), and the distance to be covered. Once a ship left the West African coast, the prevailing ocean current usually took it from West Africa to Brazil in about one month. But less favorable currents meant that reaching the Caribbean and North America took two months or more.

The Middle Passage was physically dangerous and psychologically traumatic. Ships were chronically overcrowded, for shippers usually allotted only six to seven square feet of space per person.[21] Decks swam in urine, feces, vomit, and menstrual and fecal blood. Once or twice a day the captives were supplied with scanty rations. Severe overcrowding fostered disease, most commonly dysentery, typhoid, measles, small pox, yellow fever, and malaria. Undernourishment and dehydration also bred disease. Dehydration posed a particularly grave problem: fresh water was always in short supply at sea, and the lack of water aggravated the heat of overcrowding and the presence of disease, diarrhea, and vomiting. Women and girls were subject to sexual assault from the ship's crew, aggravating the physical and psychological trauma of the voyage. The trip produced predictable outcomes among those who survived: depression, shock, and insanity. Historians have not yet focused on the psychological injuries of captivity and passage or on the fates of the infants conceived through the rape of women and girls.

Mortality rates during the Middle Passage were routinely 15–20 percent. They ranged from over 50 percent in the earlier years of the slave trade to a rock-bottom low of 5 percent—achieved in the eighteenth century, when the trade was made more efficient.[22] Portuguese ships had the lowest rates of mortality, English ships the highest. But the trip did not end with arrival in the Western Hemisphere, for the first landfall did not deliver captives to their new homes.

The third leg of the trip, also subject to high mortality, took captives from their initial American point of disembarkation to their point of resale. This passage could take almost as long as the trip from Africa. For example, the Ndongans, who were intended for Mexico in 1619, were intercepted and rerouted to the north Atlantic coast. And Olaudah Equiano was not purchased at his first stop in the Caribbean. Transport from the Caribbean to North America nearly doubled the overall length of the voyage from Africa.

Captives who had been together on the same ship and who had survived the voyage became "shipmates" and often formed lifelong friendships that functioned as new family ties. During the eighteenth century, particularly, when massive numbers of people

were transported across the Atlantic, common languages solidified shipboard friendships. These friendships formed the basis of Africans' psychological bulwark against dehumanization in the Americas.

The proportion of Africans in the North American population shifted considerably over the duration of the slave trade. During the seventeenth century, Native Americans and people of European descent vastly outnumbered Africans and African Americans in British North America. (In the Caribbean and parts of Latin America, in contrast, people of African descent predominated.) Being in the minority forced African immigrants and their children to become Americans. They worked alongside Native Americans and Europeans who were often themselves not free and learned English—some Africans already knew French or Spanish, having lived and worked elsewhere in the Americas. Seventeenth-century workers of all backgrounds also caroused and slept together, quickly creating a multiracial workforce.

Although Africans were not brought to the Americas as free people, the terms of their labor varied widely before about 1680 in British North America. Some Africans were enslaved for life, but others were enslaved for a period of years, like many other European and Native American workers. At this point, large numbers of Virginians of all races were bound, not free workers, who owed their masters unpaid labor for a stipulated number of years. But whereas Africans were often bound to unpaid labor for life, most Europeans worked for a term of years before being freed. Early on, before the English ruled in 1667 that baptism was no longer a basis for freedom, an unknown but significant number of Africans used Christianity as a rationale for emancipation. Even after Christianity disappeared as a requirement for freedom, many Africans and African Americans converted to Christianity. .

Many indentured Africans died before serving out their time, as did many Europeans and Native Americans. One exception was Anthony Johnson, an Angolan who had arrived in Virginia in 1621, who lived longer than his indenture. Johnson married, had children, owned land, and his progeny prospered. In 1677 one of his grandchildren named his own estate on the Maryland Eastern Shore "Angola."[23] Anthony Johnson's grandchildren belonged to the last Southern generation of African Americans before 1865 who could look forward to being free.

Slavery appeared bit by bit, in different ways in each of the different colonies. The first English colony to recognize slavery legally was Massachusetts in 1641. In 1662 Virginia law decreed that children born to an enslaved mother would be slaves for life.[24] This statute made slavery permanent and hereditary. By the 1680s, a piecemeal set of rulings made new African arrivals slaves for life. They and their successors in the South would not be free until the middle of the nineteenth century. In seventeenth-century Virginia, however, prior to the enactment of these laws, free Africans and African Americans were a familiar presence.[25]

Then in the early and mid-eighteenth century an enormous influx of African captives multiplied the numbers of African-descended people in North America. By the

Table 2.3.
Black Population and Total Population in British North America, 1710–1790

	1710	1720	1730	1740	1750	1760	1770	1780	1790
Black population	44,866	68,839	91,021	150,024	236,420	325,806	459,822	575,420	757,208
Total population	331,711	466,185	629,445	905,563	1,170,760	1,593,625	2,148,076	2,780,369	3,929,214
Percent Black	13.5	14.8	14.5	16.6	20.2	20.4	21.4	20.7	19.3

time the first United States census was taken in 1790, almost one-fifth of the popula-
tion was African-American (Table 2.3). They lived throughout the newly created United
States, in the North and West as well as in the South.

The pace of importing Africans into British North American slowed toward the end
of the eighteenth century; the population growth shown in Table 2.3 reflects increase
by natural reproduction as well as by forced immigration. (The European-descended
population also grew dramatically through natural increase, while the numbers of Na-
tive Americans declined precipitously.) By 1810, 85 percent of African Americans were
American born. That percentage would increase during the nineteenth and early twen-
tieth centuries. During that same time period, few Africans, but millions of Europe-
ans immigrated to the United States. For nearly two centuries, almost the entire black
American population was born in the United States of parents and grandparents who
had been born in the United States. During the same period many other Americans and
their parents and grandparents had been born outside the United States. Black Ameri-
cans were the most American people in the United States after indigenous peoples.[26]

The overwhelming majority of Africans shipped to the Americas made a one-way
journey. Unlike the European immigrants to the United States, Africans transported
to the New World could not return home with hard-earned savings to buy property
or start productive businesses. Not only could they not go home again, they could not
send money home, for they earned no wages. The rise of rich African-American philan-
thropists endowing African institutions and African immigrants sending money home
would have to await the late twentieth and early twenty-first centuries. Even those who
somehow became free lost touch with their African families. Severed from their roots,
African Americans could not help build their old countries' national economies, as did
so many immigrants from other lands.[27]

The one-way nature of the slave trade affected more than just the immigrant gen-
erations. Each enslaved generation increasingly lost touch with African kin, a distance
made wider by the passage of some seven generations separating the large, eighteenth-
century immigrant cohort from the era of emancipation in the United States South.
European imperialism in the late nineteenth century continued the separation. Until
African nations became independent in the mid-twentieth century, European colonial
governments barred entry into the colonies of black Americans—whom they perceived

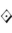

as troublemakers. As a result, Africa became an abstraction for black Americans, a place personally unknown.

Artists Represent the Atlantic Slave Trade

Like other Americans, black Americans have faced extreme difficulty in grappling with the massive numbers and unacknowledged trauma of the Atlantic slave trade. For African Americans, the forced immigration of their ancestors became an integral part of their list of oppressions at the hands of whites in the United States. But nonblacks tended to shut off discussion of the evils of the Atlantic slave trade by pointing out that the original kidnappers and sellers were themselves African—in effect, blaming the victims. Lumping together all Africans of whatever class or ethnicity, nonblacks stigmatized Africans as the sellers of "their own people." In the absence of careful histories, African Americans found no adequate reply. For a very long time, then, the lack of countervailing information meant that African American artists simply avoided the topic of the Atlantic slave trade.

By the 1920s and 1930s, black artists began painting African motifs, and African subjects became evermore popular over the course of the twentieth century. The topic of the Atlantic slave trade, however, was still avoided. Things began to change in the middle of the twentieth century, when African-American artists began to travel to Africa, meet their African counterparts, and confront the inescapable pain of their origins as a New World people. The Atlantic slave trade began to appear as a subject in black art—as a single, originating phenomenon unmodified by time, place, or age of the captives. The specifics of African history were not known and were not addressed; African Americans' ancestors acquired the timeless quality of symbol, lacking the particulars of time and place as described in the eighteenth-century ex-slave narratives of Ayuba Suleiman Diallo and Olaudah Equiano.

John Biggers's "Middle Passage," an exceptionally early image, stands alone (2.3). Attracted to African themes in black American life and known for his depictions of people at work, Biggers did not return to the theme of the Atlantic slave trade for many years. This image remained unique in his work and in the history of black visual art for some thirty years.

Testimony to the difficulty of capturing the horror of the Atlantic slave trade lies in the work of the poet Robert Hayden (1913–1980). Hayden, a native of Detroit who researched black folklore and the Underground Railroad in Michigan on the Federal Writers' Project in 1936, taught at Fisk University in Nashville from 1946 to 1969. Throughout his years at

2.4. Romare Bearden, "Roots Odyssey," 1976

Bearden joins the silhouettes of a black man wearing a U.S. flag and the continent of Africa beside a slave ship with its human cargo laid out like sardines. This depiction of the captives evokes British abolitionist schemas used to condemn the inhumanity of the slave trade.

(Opposite) 2.3. John T. Biggers, "Middle Passage," 1947

Biggers stresses overcrowded conditions by showing the many disembodied hands reaching out of a tiny space or hanging lifelessly in exhaustion.

2.5. Richard Hunt, "Model for Middle Passage Monument," 1987
Hunt's abstraction evokes a ruined ship and ocean, expressing the pitiable
sadness of the slave trade.

Fisk, Hayden worked on one of his best-known creations, the poem "Middle Passage." He
published the poem in its original form in 1944 but continued to rework it until 1962.
He said "Middle Passage" grew out of his interest in black history and was part of a series
of poems on historical themes. Voicing sentiments often repeated by African-American
visual artists, Hayden said he "hoped to correct the false impression of our past, to reveal
something of its heroic and human aspects." Too long to be meaningfully excerpted,
"Middle Passage" describes a slave ship mutiny from several points of view.[28] Romare
Bearden (1914–1988), one of the deans of African-American art, depicted the relation-
ship between the Atlantic slave trade and African Americans in the mid-1970s (2.4).

By the 1980s, black artists were creating abstract images on historical themes. They
also overcame their avoidance of the Middle Passage. Richard Hunt (b. 1935) works on a
variety of themes without being stereotyped as a black artist. Although he does not use his
work to protest the black condition, several pieces of his large public art present themes
from black American life, including the model for a memorial commemorating the foun-
dation of African-American history (2.5). The sculpture shows a broken shape that might
be the hull of a ship or an ark. Steps lead up to the ship/ark, and steps lead out the back.
The shapes on the base recall the ocean on one side and Egyptian statuary on another.
The piece is both grand and tragic.

The Middle Passage also attracted Howardena Pindell (b. 1943), a widely collected
major artist noted for abstraction. Unlike Hunt, Pindell embeds strong political content

2.6. Howardena Pindell, "Autobiography: Water/Ancestors/Middle Passage/Family Ghosts,"
1988
With a self-portrait at the center, Pindell's painting combines personal artifacts with a symbolic slave ship
at lower left.

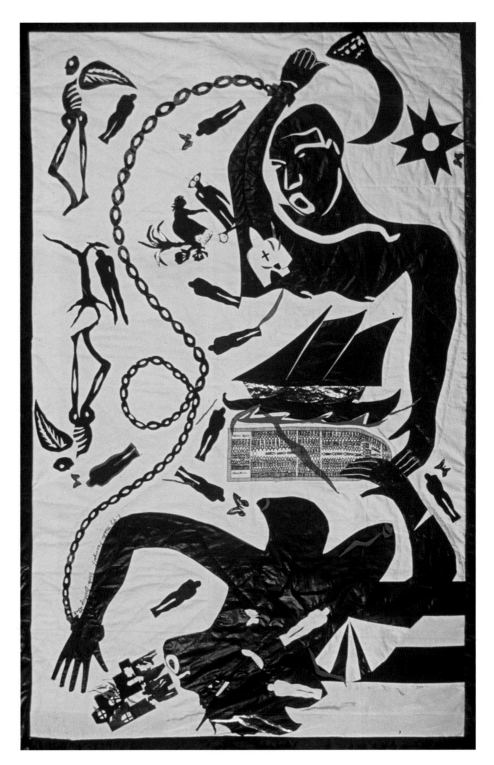

2.7. Viola Burley-Leake, "Middle Passage" quilt, 1994
Burley-Leake's quilt centers two versions of a slave ship in the midst of images of American racism and torture, to unify the Atlantic slave trade and American white supremacy.

in her work. Far more personal than Hunt's work, Pindell's evocation of the Middle Passage, "Autobiography: Water/Ancestors/Middle Passage/Family Ghosts," puts her own identity into the context of a people whose history includes violent uprooting (2.6). Pindell, pictured in the lower middle, loves to swim. But her enjoyment of the water and the many charms it contains does not prevent her associating the ocean with the slave ship. The ship appears in the lower left-hand corner of the painting.

Conjoining the transatlantic journey with experiences in the nineteenth and twentieth centuries, Viola Burley-Leake's "Middle Passage" quilt makes visible the commonplace transition from history to symbolism. The quilt shows male and female African captives and a slave ship between them. It also shows symbols of American racism, such as slavery chains, a lynch victim, burning churches, and a tiny Ku Klux Klansman on the man's breast. For Burley-Leake (n.d.), the slave trade belongs to a long *American* history. The quilt transfers the blame for kidnapping and forcible resettlement from African slavers to the white Americans who inflicted a long train of abuses on black people (2.7).

As historians' recent research has become available to black artists, black art has turned increasingly toward the Atlantic slave trade. Political activists are also reckoning the costs of the *Maafa* to captive Africans and their descendants.

Conclusion

A staggering number of Africans—ten million and more—were uprooted from their homes and forcibly transported to the New World, to be bought and sold as units of work and chattel property. Permanently cut off from their homeland and working without wages, their situation differed dramatically from that of other immigrants. Thousands reached North America from Europe and Asia in conditions of unfreedom. But the bondage of nonblack, unfree workers ended after a given number of years, when they received a small payment and could earn wages or farm on their own account. Of all the Africans brought to America in the Atlantic slave trade, Ayuba Suleiman Diallo was among the rarest few who were able to return home to pick up the threads of his former life. Not so the rest.

As the largest and oldest racial minority in British North America, African Americans became the most Westernized of African-descended people. But their Westernization occurred by default.

3.1. Houston Conwill, "The New Ring Shout" (central rotunda, Federal Office Building, New York City), 1995

Combining the names of the peoples and places of the African Diaspora, the terrazzo floor of the Federal Office Building built over a New York City burial ground expresses the international nature of the black identity. Its inclusion of nonblack symbols reminds the people walking on it that African diasporic identity is multicultural.

A Diasporic People

1630–ca. 1850

Houston Conwill (b. 1947), Joseph De Pace (b. 1954), and Estella Conwill Majozo (b. 1949), a sculptor, architect, and poet, created "The New Ring Shout" (3.1), a public art project in New York City in 1994–1995 to celebrate the Africans of the Americas. A map of New York Bay lies at the center of this complex "New World Cosmogram," overlaid with words relating to acts of transcendence and bodies of water associated with African-American history, such as the Nile and Mississippi Rivers. The names of twenty-four African peoples who were caught up in the Atlantic slave trade encircle the map of New York, encircled in turn by words of wisdom in many languages from around the world. The whole Cosmogram represents an allegorical dance floor for the "ring shout," a traditional black dance (despite the word "shout") found throughout the African Diaspora.

The descendants of the half-million Africans brought to British North America in the slave trade belonged to an international community of people of African descent. Separation from their African homelands made black Americans a diasporic people: a people scattered far from home and settled among strangers.[1]

New World Africans and their children lived in cultural contexts very different from those the immigrants unwillingly left behind in Africa. Usually outnumbered by people of European and Native American descent in North America, they encountered new religions and languages. They also endured the terrors of being oppressed as an impoverished, racialized minority. Black peoples in British North America came to terms with the conditions of their new worlds and over time forged a new identity as African Americans. Many cultural attributes—ideology, ethics, psychology, and health—emerged under the umbrella of religion. At the end of the eighteenth century, religion became a crucial facet of African-American identity.

Religion in the African Diaspora

William H. Johnson (1901–1970) rendered as black all the people in his crucifixion scene
(3.2). The figure of Jesus Christ on the cross appears often in Western art, but usually
as a white person, often as blond. Johnson's painting of a black Christ and black Marys
belongs to a different tradition, that of twentieth-century African-American Christian
imagery. It embodies many of the puzzling questions facing African captives and their
descendants in the Americas.

3.2. William H. Johnson, "Jesus and the Three Marys," 1939
In a move that is still controversial, Johnson painted Jesus and the Marys as black people. Johnson bal-
anced the traditions of Western figurative art, in which Jesus and the Marys appear as both human and
as people belonging to a particular race.

The searing facts of capture and transport to involuntary servitude called into question the efficacy of African worldviews, including religions whether animist or Muslim. Africans in the Americas came from many different religious traditions. Some African religions recognized several gods; other religions, like Islam, recognized one supreme god. All those religions failed their adherents who were captured and forced across the ocean into slavery. Demography also served to weaken the hold of African gods. Whether born in Africa or the children of Africans, those enslaved in British North America in the seventeenth and eighteenth centuries were nearly always in a numerical minority. The nonblack people surrounding them did not grow up practicing African religions, and many were Christian. Large numbers of seventeenth-century black people (like masses of nonblack people) did not attend churches or consider themselves followers of any particular religion. Churches were rare in the Southern colonies before about 1800.

Christianity offered an alternative to hopelessness. According to the Bible, Jesus Christ had died for all people, regardless of how lowly their station in this life. And He particularly cherished the disinherited. In addition, individual nonblack Christians could be quite kind. In early Virginia, Christians could not be enslaved for life. Over the course of the seventeenth century, however, Virginia law decreed that religion meant different things for people of different races. It later became legal to enslave Christians. The existence of Christian Africans came to the attention of the Virginia courts as early as 1624. In 1641 the Virginia court in *In Re Graweere* decided that a black child could be freed in order to be raised as a Christian.[2] By 1667, however, enough Africans and their descendants had converted to Christianity that it was no longer possible to equate African with non-Christian. To preserve the unfree status of so-called Christian Negroes, the Virginia court ruled that Christians could be permanently enslaved.[3]

The evangelical Protestantism preached during the Great Awakening of the mid-eighteenth century and the Second Awakening of the early nineteenth century promised converts an end to the invidious discrimination so pervasive on earth. The racialized appearance of the Christian trinity in the Americas embodied one aspect of that very discrimination: although the Bible does not specify the race or color of Jesus, God, or the Holy Spirit, every church in the land rendered Christ and the Virgin Mary as white. Before the era of the New Negro movement of the 1920s and 1930s, simply to suggest they might be brown seemed tantamount to blasphemy. Indeed, one index of the outrageousness of Marcus Garvey's Universal Negro Improvement Association in the 1920s was its insistence that Jesus and Mary had dark skin. In terms of divine skin color, as in terms of ritual and belief, Americans mixed the religious with the secular.

Dimensions of African-American Religion
The religions of African Americans in the seventeenth, eighteenth, and early nineteenth centuries were expressed in three different dimensions. There was no single type of religion that all African Americans believed in and no one "black church." First, black religion was "syncretic," a mixture of different traditions, drawing upon the wisdom of

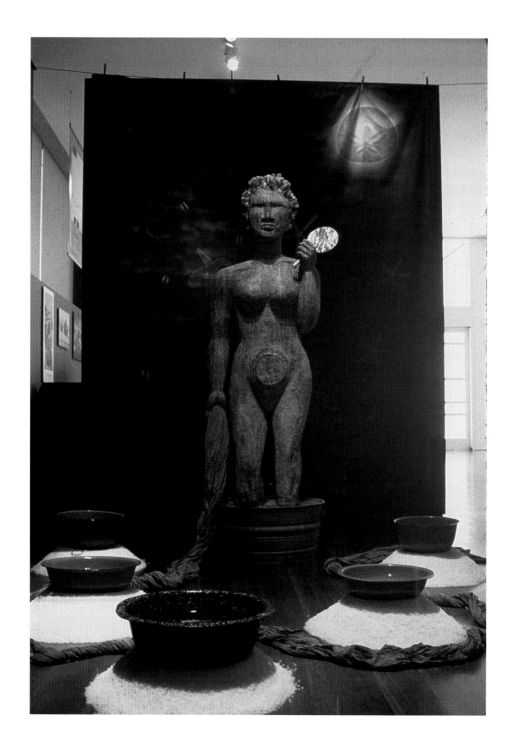

3.3. Alison Saar, "Afro-Di(e)ty," 2000
Saar's goddess combines the tools of the kitchen with pots and other items from central Africa to empha-
size the complexity of her identity.

Africa and calling upon the overlapping traditions of Native Americans and Europeans as well. Black religion was also overwhelmingly a local and folk religion. Rather than being centralized through powerful, formally educated bishops, early African-American religion came from the bottom up. Its preachers, some of whom were women, were not formally educated: Like many of their nonblack counterparts, they gained their authority directly from God or the Holy Spirit, rather than through training at colleges like Harvard, Yale, or William and Mary. No women or black people were admitted to these institutions. In the black folk tradition, women were as likely as men to serve as priestesses, herbalists, doctors, and conjurers.

One name associated with early folk religion, that of Tituba (dates unknown), comes down in history as one of the individuals accused of witchcraft in the Salem, Massachusetts, trials of 1692. Tituba is variously identified as Indian and as African. She may have had ancestors who were both. A skilled weaver originally from Barbados, the slave Tituba was one of nineteen persons hanged as witches in North America's most famous witchcraft trials.[4]

African-American artists have only recently begun to depict folk religion based in African beliefs. Compared to the abundance of Christian depictions, this paucity of images of folk religion is striking. The relative lack of imagery reflects black people's ambivalence toward folk religion. For centuries, Americans dismissed this kind of belief system as inferior to more highly organized, church-based religion—as voodoo, hoodoo, or conjure. Alison Saar's (b. 1956) "Afro-Di(e)ty" depicts a nude female figure drawing strength from African pots and implements (3.3).

The second dimension of seventeenth-, eighteenth-, and early nineteenth-century African-American religion was multiracial and evangelical. Early Methodism and the many independent churches and sects it inspired reflect this dimension. The founder of Methodism, the English Anglican priest John Wesley, spent 1936–1937 in the colony of Georgia. The first two people he baptized there were enslaved women.[5] Methodist congregations often met informally, not in buildings specifically dedicated to worship, but in homes, where people of all races, genders, and stations of life movingly told their own stories of personal salvation. These evangelicals viewed as corrupt the trained ministers who spent years in prosperous churches, preferring to put their trust in unlettered itinerant preachers. One such preacher was Harry Hosier (ca. 1750–1806). Born enslaved near Fayetteville, North Carolina, and known as "Black Harry," Hosier became the first black American Methodist preacher. A participant in the meetings that institutionalized American Methodism, he took over the Trenton, New Jersey, circuit in 1803.[6]

Prominent members of the sects arising around Methodism were women like Isabella, born enslaved in New York State in about 1797, and better known by the name she later gave herself, Sojourner Truth. She emerged as a gifted preacher in her native Ulster County in the Hudson River Valley in the late 1820s. Moving to New York City after she was freed by New York law in 1828, she attended the John Street and Zion Churches and preached in the many camp meetings taking place around the city. In the 1830s she

joined a sect led by a charismatic prophet. On the day of Pentecost 1843, she joined the legions of unlettered preachers, male and female, in the Millerite movement expecting the end of the world.[7] In the 1840s, she began turning her power as a preacher toward antislavery and feminist ends.

A third dimension of black American religion was organized churches. Breaking away from white congregations in the late eighteenth century, black Northerners founded their own church organizations, beginning in Philadelphia. The African Methodist Episcopal (AME) church, the first black church connection, grew out of American Methodism. As was common practice at the time, black Methodists in Philadelphia worshipped in predominantly white churches. Their leader Richard Allen (1760–1831) had impressed Methodist circuit riders with his piety, and his preaching ability moved his owner to allow him to purchase his freedom. After serving as a circuit rider in the Mid-Atlantic states, Allen returned to his hometown of Philadelphia, preaching to the black people of the St. George Methodist Episcopal Church. Subject to increasingly stringent and humiliating regulation, black Methodists, led by Allen and his colleague Absalom Jones (1746–1818), founded their own Free African Society of Philadelphia in 1787. In 1794 they left the white-dominated church and established their own Bethel African Methodist Episcopal Church, which is still known as Mother Bethel Church in Philadelphia. After several years of struggle with St. George Church over control of Mother Bethel, Allen joined forces with Daniel Coker (1780–1846), the leader of Baltimore's black Methodists, and other black Methodists from Salem, New Jersey, and Attleborough, Pennsylvania. They formed the African Methodist Episcopal Church connection in 1816, the first black American denomination.[8]

Daniel Coker was a founder of the African Methodist Episcopal Church. Son of a white indentured mother and an enslaved black father, Coker spent the years 1820–1821 a pioneer in the newly established Maryland colony of Liberia, then lived the balance of his life in Sierra Leone, which Olaudah Equiano had helped found. (Free northern blacks and emancipated slaves had joined the white American Colonization Society to create the new colony of Liberia in West Africa in 1820.) In Sierra Leone, Coker published a number of pamphlets opposing slavery. His portrait (3.4) is the work of one of the leading early African-American artists,

3.4. Joshua Johnston, "Portrait of a Gentleman," 1805–1810, thought to be the Reverend Daniel Coker
Both Johnston and Coker lived in Baltimore, where Coker's vocation made him a gentleman, not a field worker or domestic like most other black Baltimoreans.

Joshua Johnston (ca. 1765–1830) of Baltimore. Johnston specialized in painting the sorts of people who could afford portraits, for example, wealthy families whose children appear prominently in his paintings.

The roots of the African Methodist Episcopal Zion Church (AMEZ), like those of the African Methodist Episcopal Church, go back to a Northern city in the late eighteenth century, this time New York rather than Philadelphia. In New York, black Methodists belonged to the John Street Methodist Church, whose congregation was about 40 percent black in 1793. Blocked from leadership roles, the black members of the John Street Church formed their own African Chapel, also known as the Zion Church, in 1796 under the leadership of Peter Williams (1763–1836). The African Chapel became independent in 1801 and evolved into a separate denomination between 1820 and 1824.[9]

The independent black denominations offered wide opportunities to black men, but they were not hospitable to women preachers. Like white churches, black congregations obeyed St. Paul's stricture against women's speaking out in church, even though most

3.5. Harriet Powers, "Bible Quilt," ca. 1898

Powers tells stories of her family and the people in the Bible in the story quilts of which she was a master. This quilt was a commissioned gift for the president of the Union Theological Seminary and chair of the board of Trustees at Atlanta University.

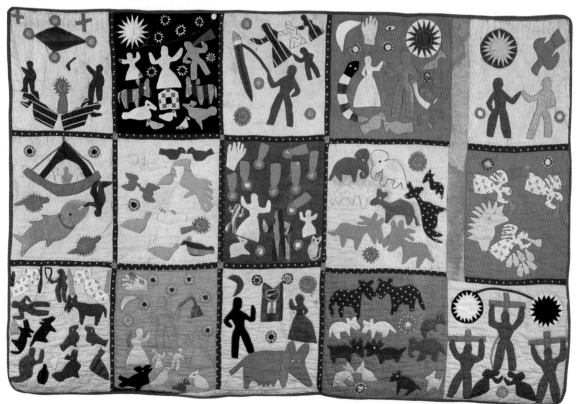

of the rank-and-file membership consisted of women, as was also the case in nonblack churches. However gifted as preachers, women nearly always lacked the formal education that increasingly became a requirement for church leadership. More important, because they were women, all but the least organized American religions of all racial-ethnic identities prohibited them from becoming ministers. Gifted female preachers, such as Jarena Lee (1783–ca. 1850s) and Zilpha Elaw (ca. 1790–ca. 1850s) moved those who heard them preach as itinerants, but these women could not lead their own churches.

Christian Themes in Black Art

African-American artists have long been drawn to Christian motifs, for the Bible, the foundation of Christian ideology, contains no racism. The figure of Hagar, the servant of Abraham and bearer of his child Ishmael, appealed to black people who saw parallels in

3.6. Clementine Hunter, "Baptism," ca. 1964
Hunter shows women, men, and children coming to and going from a Southern church baptism.

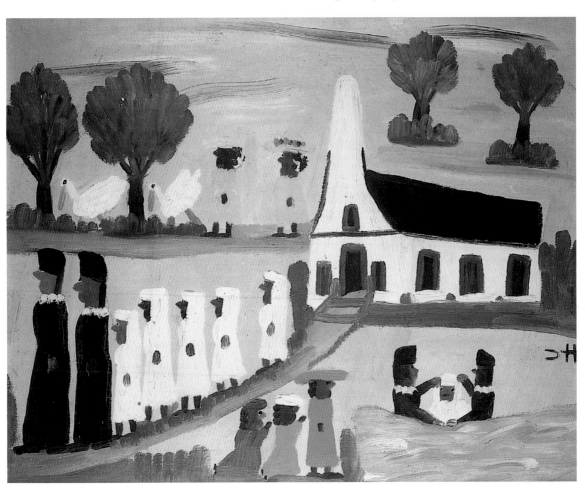

her situation and that of enslaved women (and later, single parents). The name Hagar appears often in black writing. The classically trained Afro-Indian sculptor Edmonia Lewis (1845–ca. 1909) (see chapter 6) created "Hagar" in 1875.[10]

At the other end of the artistic spectrum, Harriet Powers (1837–1911), a self-trained Southern quilter now considered the leader of African-American quilt art, drew inspiration for her Bible quilts from her own life and people as well as from the Bible. Powers belonged to the legions of black women quilters, few of whose names are known today. Her quilts were unusual, in that they were not geometrical. Rather than working abstractly, Powers used stylized figures to tell stories combining Biblical motifs and personal and community history. The panels of this "Bible Quilt" (3.5) show the Garden of Eden, Adam and Eve's expulsion from the Garden of Eden, Satan, Cain and Abel, the baptism of Christ, and the Crucifixion.[11]

The noted Harlem author and Civil Rights activist James Weldon Johnson (1871–1938) asked Aaron Douglas to illustrate his long poem, *God's Trombones: Seven Negro Sermons in Verse* (1927). Douglas rendered scenes from the Old and New Testaments in

3.7. Margo Humphrey, "The Last Bar-B-Que," 1989
This version of Christ's Last Supper plays on the familiar imagery of Christ's Last Supper, featuring traditional Southern foods.

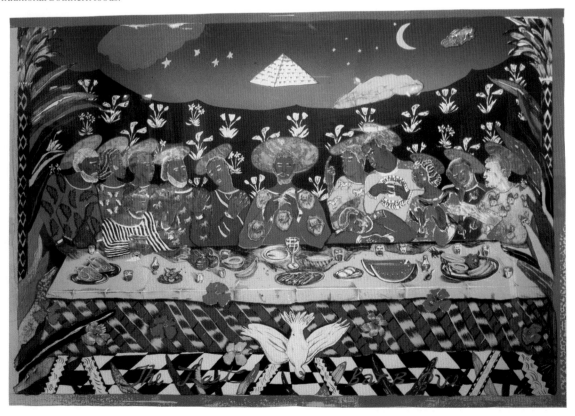

his signature modernist Egyptian style.[12] One of America's foremost untutored ("folk") artists, Clementine Hunter (1886–1988) produced hundreds of paintings dealing with the work, play, and religion of Southern black people. Hunter's "Baptism" (3.6) shows a large family of rural Southerners going to church, and a baptism in the lower right-hand corner.

Evoking stereotypical black cultural practices liberates items used to debase black American culture with the humor characteristic of late twentieth-century black art. Margo Humphrey (b. 1942) is one of several black artists who has reworked the Last Supper as a moment in African-American life. Humphrey depicts an African-American barbeque (3.7).

Spirituals

Like African-American art, black music bestowed a distinctive, characteristic beauty on black Christianity. During the late eighteenth- and early nineteenth-century era of popular Methodism, black Christians began to produce the music known as spirituals. The spirituals feature the styles characteristic of African-American music: African five-tone (pentatonic) scales, call and response, moans, and complex rhythms, combined with Methodist hymnody. The five-tone, or pentatonic, scale is characteristic of Asian, African, American Indian, and some British music. In the United States, it became the basis of the blues and jazz music. Call and response refers to music in which the performer and the audience speak back and forth to each other. The audience becomes part of the performance. Moans and cries are stylized, apparently spontaneous utterances that performers inject into music in addition to words. Complex rhythms play more than one tempo at a time. Methodist hymnody features simple, moving singing that apparently comes from the heart. Some spirituals, such as "Sometimes I Feel Like a Motherless Child," voice the despair of enslavement. Others, like "Steal Away" and "Go Down Moses," with its refrain "Let my people go," reminded black people of freedom after death—and of the hope of escape in this life. The combination of the musical forms inherited from Africa, Christian imagery, and the English language made the spirituals an original, diasporic, artistic creation.

Language and Literature in the African Diaspora

Every African transported to the New World had to learn to use a new, colonial language, often more than one. In Latin America, people of African descent came to speak Spanish and Portuguese; in the Caribbean, they spoke English, French, and Spanish, (and, to a much lesser degree, Dutch and Danish). In the North American colonies, most black people spoke English, although some, like the New Yorker Sojourner Truth (ca. 1797–1883), spoke Dutch as a first language.

During the eighteenth century, black authors employed these new languages to de-

scribe their experiences and demand their freedom. Writing in English allowed men and women like the autobiographer Olaudah Equiano and the poet Phillis Wheatley to join the discussion ranging across the Western world on the wisdom and morality of abolishing the Atlantic slave trade and slavery. The Maryland mathematician and astronomer Benjamin Banneker (1731–1806) is considered the first black American scientist. After helping survey the District of Columbia in 1791, Banneker published widely circulated almanacs for the years 1792 through 1797. Abolitionists cited his mathematical ability as proof that people of African descent possessed all the higher mental capabilities of white people and therefore that slavery was wrong. Understanding his value as a symbol of black intelligence, Banneker sent the Founding Father Thomas Jefferson a copy of one of his first almanacs. It failed to persuade Jefferson, a slave owner, of black people's intellectual potential.[13]

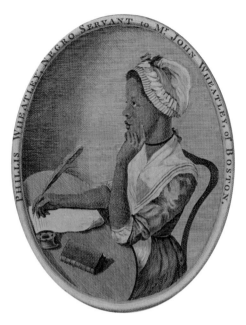

3.8. Scipio Moorhead, "Phillis Wheatley," 1773
Moorhead was a rare black artist in eighteenth-century Boston. He shows Wheatley preparing to write her own poems, also an extremely unusual occupation at the time, especially for a woman.

The poems of African-born Phillis Wheatley of Boston also failed to change Jefferson's mind regarding Negro inferiority, even though few of her fellow Americans of any race or gender equaled her as a poet. Others, however, whose livelihood did not depend on enslaved labor praised her *Poems on Various Subjects, Religious and Moral* (1773), published in England while she was visiting there.[14] In addition to poems dedicated to George Washington and the Methodist preacher George Whitefield, Wheatley also reminded her readers that Africans possessed full humanity and deserved to be free. She also wrote a poem to Scipio Moorhead (ca. 1750–n.d.), the black artist who engraved the frontispiece to her book of poems. Moorhead shows Wheatley in a thoughtful pose, quill in hand, preparing to write (3.8). Her ability to write well was the poet's distinguishing characteristic, one that set her apart from masses of American women of her time.

Writing in European languages allowed black authors to reach readers who did not know African languages. But the different European languages also segmented the African Diaspora. People whose ancestors might have come from the same region—say Angola—would not be able to speak to each other if they grew up in colonies belonging to different European powers. The children of the Ndongans shipped from Luanda in 1619 spoke English if their parents had been on the *São João Bautista*. It had been deflected from its original destination in Mexico to Virginia. Other ships leaving Luanda at the same time as the *São João Bautista* made it to Mexico. The children of those Ndongans spoke Spanish. After three generations, the Ndongans' descendants born in Mexico and Virginia would be Creoles: people born in the Americas. They would not be able to speak to each other in the same language. Language captured the cultural

dimension of Creole, or American, identity. At the same time, the peoples of the Americas were creating new peoples biologically.

Ethnic and Racial Identities

During the first century of Africans' importation into North America, the idea of human races as scientific truth had not yet been invented. As poor, unfree, largely non-Christian, captive workers lacking a government at home or diplomatic representatives in North America, Africans were subject to the sort of humiliating treatment that later earned the name of racism. But in the early seventeenth century, African slaves were not distinguished legally from bound workers of other ethnicities in North America. Enslavement for life evolved over a period of some forty years in mid-seventeenth-century Virginia, the heartland of the British North American slave economy. Americans differentiated African people from Native Americans and people from Europe, and they knew Africans as especially vulnerable workers. However, hereditary slavery for life arose only in the second half of the seventeenth century. The idea of biologically determined races came later. A product of the eighteenth-century scientific Enlightenment, the notion that human beings could be categorized into discrete "races" quickly gained currency in British North America, where it served economic ends. By the time of the American Revolution, North Americans were commonly separated into three "races": "Indians," "Negroes," and "whites." By the late eighteenth century, "Indians" did not count legally in the thirteen colonies.

Before the era of the American Revolution complex schemes of racial categorization reflected the varieties of three-way mixing. By about 1800, however, the very complexity of descent in the Western Hemisphere doomed such schemes to disuse. In Latin America and the Caribbean a three-tiered racial hierarchy divided the populations into black, brown, and white. British North Americans usually lumped people into two categories—white and nonwhite, reflecting assumptions about freedom and slavery. Along with this biracial fiction went the convention that identified as "Negroes" all people with any degree of African ancestry. In the eighteenth and nineteenth centuries, "Negro" meant not only someone of African ancestry, but also someone degraded and enslaved. "Negro"—usually spelled with a small *n*—was a term of reproach, which African Americans adopted in the early twentieth century much as they adopted the term "black" in the latter part of the twentieth century. The act of naming oneself "Negro" or "black" recast what had been bad words in the white supremacist lexicon into badges of racial pride.

With a calculated, racist carelessness, nonwhites were considered Negro, although many had Indian and European ancestors. The practice of identifying as a Negro any person with white and Indian ancestors came to be called the "one-drop rule." This convention meant that "one drop" of "black blood" made a person a Negro, whatever his or her degree of ethnic/racial mixture, class, culture, legal status, or appearance.

Many African Americans have Indian and European ancestors. But historians have not yet quantified the degree to which the increase in the "black" population included increases in the Indian and white populations as well.

Racialized reasoning permitted the creation of the notions of "racial purity," "miscegenation," and "race mixing." According to these concepts, white people were "pure," that is, lacking even distant Indian or African ancestors. "Miscegenation" and "race mixing" meant people of different "races" having sex or marrying. These ideas were based on the assumption that an individual could be categorized according to just one "race." Race was thought to remain permanent and unchanged, even when populations moved and encountered new peoples and even in the face of proof to the contrary over the space of just two generations.

Two eighteenth-century Americans embody the mixed nature of diasporic people of African descent: Jean Baptiste Point du Sable (ca. 1745–1818) and Elizabeth Hemings (1735–1807). Du Sable was born in Haiti of a French father and an enslaved mother of African descent. He was educated in France and spoke English and Spanish as well as his native French. Du Sable worked with his father, a sea captain, before moving to the then French-controlled interior North American mainland. In Peoria he married a Potawatomi Indian named Kittihawa. Du Sable founded Chicago as a permanent trading post in 1779.[15] Elizabeth Hemings of Virginia belonged to John Wayles; Wayles fathered both Thomas Jefferson's legal wife and Sally Hemings, Jefferson's long-time partner and the mother of several of his children. In the 1990s DNA evidence bore out the Hemings family's claim of descent from the third president of the United States.[16]

Africans and Indians

The white/black scheme of race persisted right through the twentieth century, denying a salient place to people of Native American descent. The racial binary bent slightly with the United States Census of 2000, which enabled Americans to assign themselves more than one race. But this acknowledgment came two centuries after individuals with Native American and African ancestors appeared in American history. Eighteenth- and nineteenth-century individuals with one African and one Indian parent appeared in American history as "black." Examples include the Boston massacre martyr Crispus Attucks (1750–1770), the Boston ship-owning merchant Paul Cuffee (1759–1817), and the sculptor Edmonia Lewis. For many years, the Indian heritage of these Americans disappeared beneath the more culturally conspicuous black identity. But Lewis, at least, depicted her dual ancestry in her work by sculpting Indian as well as African figures.

In the late nineteenth century black soldiers, called "Buffalo Soldiers," patrolled the West and protected settlers from Indian attack. Many African Americans found tragedy in duty that pitted black and red people against one another for the benefit of settlers who were mostly (but not entirely) white. African and Native Americans had a long history of intermarriage, and military duties did not end such practices. A photograph

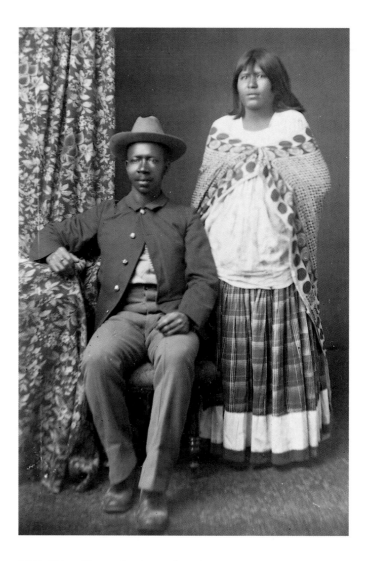

3.9. Buffalo soldier and Indian wife, n.d.
This man and wife pose conventionally, he in his uniform, she in modified traditional dress. This photo was taken in Arizona Territory.

of a late nineteenth-century black soldier and his Indian wife exemplify the continuing tradition of black-Indian intimacy (3.9). They wear clothing that indicates cultural distance between the soldier and the Native American.

The pressure of American racism complicated black Americans' relationship to their Native American ancestors. Oftentimes the acknowledgment of one's Indian heritage signified the intent to deny one's African heritage. For more than a century, this pressure kept most black artists from embracing their Indian ancestors and depicting Indian themes. But in the late twentieth century, black artists began introducing Indians into

3.10. Joe Sam, "Cohia," 1996
Joe Sam reminds his audience that some Americans are simultaneously black and
Indian, without the combination detracting from either identity.

their illustrations of African-American life.[17] Self-taught artist Joe Sam (b. 1939) is less
overtly political. His "Black Indian Series" from the late 1990s stresses the existence of
people of mixed Indian and African descent (3.10).

Africans and Europeans
Like Africans and Indians, Europeans and Africans became marriage and sex partners
early in the seventeenth century as soon as they came to the Americas. In an effort to
protect their access to exploitable workers, Virginia's rulers tried without success to

discourage sex between Europeans and Africans. In 1630 the Virginia court punished a white man, Hugh Davis, for having sex with a black non-Christian.[18] If intimacy among Virginians could not be controlled—and it could not be—the Virginia legislature sought to regulate its outcome. In 1662 the legislature altered patriarchal English rules of inheritance to make the status of American children dependent upon the status of their mothers. The children of unfree mothers were declared unfree, regardless of the status of the father. As a result, white men's unrestrained sexuality no longer threatened the unfree labor supply, and the subsequent "Negro" population of the United States contained thousands of people, many enslaved, with more non-African than African ancestors. African-descended people who looked white became stock figures in American fiction.

African Americans realized early on that their group included people who were as much European as African. They seldom made an issue of racial purity, quite to the contrary. The African-American class structure reflected close relations between people whom others classified as belonging to different "races," just as some white fathers sought to protect their offspring from the poverty and humiliation associated with "Negro" identity. The nineteenth- and early twentieth-century black American upper classes were strikingly lighter in skin color than ordinary African Americans. At the same time,

3.11. Julien Hudson, "Portrait of a Young Man," said to be a self-portrait, 1839
Hudson was from Louisiana, home of a sizeable community of mixed-race people with European, African, and, most likely, Native American roots. His "young man," probably himself, appears as a gentleman.

upwardly mobile black men invariably married women with light skins. In women, light skin color symbolized the beauty, respectability, and femininity that middle-class men of all backgrounds prized.

"Mulatto Population"

The United States census did not divide the nonwhite population into "black" and "mulatto" until 1850. Census enumerators gauged an individual's racial category according to that person's appearance. As a result, an individual's identity as black or mulatto could change from one census to another. Thus, statistics about the mixture of blacks, Europeans, and Indians remain notoriously unreliable. In 1850, the census found that overall, 11.2 percent of the African-American population was mulatto. Rates varied by region: in the South, 10 percent of the nonwhite population was classed as mulatto; in the North, 24.8 percent; in the West, 23.4 percent.[19]

African-American artists captured the complexity of black racial identity by depicting people with light skins and by examining the erotic current running between people classified as "black" and "white." The "Portrait of a Young Man" by Julien Hudson (1811–1844) of New Orleans, usually considered a self-portrait, shows a young man of "mixed" ancestry in Louisiana, where most of the free people of color (*gens de couleur*) were of mixed race (3.11). Hudson's young man is well dressed, showing that he does not consider himself a manual worker.

Minority Status

Africans in the Americas entered societies with wildly varying racial demographics: People of African ancestry dominated the Caribbean and eighteenth-century Brazil. But in British North America, except for South Carolina, people of African descent became a large, permanent minority—so permanent that all subsequent analyses of oppressed Americans rely on African-American metaphors. In a country based on racial slavery, Africans and their descendants were subject to racist values nearly everywhere. Even the safe harbors of black family and black religion were not entirely impervious to the tyranny of whiteness. Overall, whiteness exerted a largely harmful influence on the minds and bodies of black people. Yet at every point and everywhere African Americans have found indispensible allies among the white majority. The support of nonblack allies embodied the American ideology of freedom and democracy and helped black people preserve hopes for their future.

Minority status made African Americans into Westerners, but Westerners with a sober perspective on their surroundings. This unique perspective, this countertradition of knowledge, has enabled black Americans since the late eighteenth century to produce sustained, insightful critiques of Western culture.

While challenging the hypocrisy and materialism of the culture in which they were immersed, African Americans also recognized the value judgments associated with

different shades of skin color. They understood that over the course of four centuries of black presence in North America, intelligence, beauty, progress, and the entire political economy became racialized, to the detriment of blackness.

Black artists rendered the meaning of minority status by depicting not only the mixed nature of African-American culture, but also the beauty of people of African descent, no matter how light or dark the color of their skin. Western racism construed whiteness as equivalent to beauty and blackness as equivalent to ugliness. For two centuries, African Americans confronted Western beauty standards with ambivalence. But since the 1960s Black Power era of Black-is-Beautiful, African-American artists have questioned Western standards of personal beauty. Black hair—long a symbol of black ugliness and, for some, of black inferiority—has become a prized medium. In art, natural black hair vindicates the beauty of Africans and denies the assumption that only white people can be beautiful.

African-American artists such as David Hammons (b. 1943), Reginald Hudlin (b. 1961), Xenobia Bailey (b. 1958), and Chakaia Booker (b. 1953) have produced artwork presenting black hair as a thing of beauty. Their work shows that the topic of black hair—so different from the prevailing standard in American beauty—remains fascinating.

These artworks evoke the challenges and weaknesses of a minority people defined by race and considered ugly simply because of their race. Black artists have taken account of the dangers of America, while they also summon their viewers to keep their critical distance from American values and temptations.

Table 3.1. Black and White Population in the British North American Colonies, 1750 (estimated)

Colony	Black	White
Virginia	101,452	129,581
Maryland	43,450	97,623
South Carolina	39,000	25,000
North Carolina	19,800	53,184
New York	11,014	65,682
New Jersey	5,354	66,039
Massachusetts	4,075	183,925
Rhode Island	3,347	29,879
Connecticut	3,010	108,270
Pennsylvania	2,872	116,794
Delaware	1,496	27,208
Georgia	1,000	4,200
New Hampshire	550	26,955

The Black Population Lived Throughout North America

By the middle of the eighteenth century, African Americans were most numerous in Virginia and other Southern colonies. But black people lived in each of the thirteen British North American colonies, even in northern New England (see Table 3.1).

Conclusion

Some black North Americans remembered an African homeland, and some had spent time in the West Indies and spoke Spanish or French. But most had been born in the land that would become the United States, as had their parents and grandparents. They spoke English and sometimes believed in a Christian god. On land and at sea, they worked shoulder to shoulder with Native Americans and Europeans, with whom they were often biologically and culturally enmeshed. Virtually all black people in North America were impoverished and enslaved, subject to the violence inherent in involuntary servitude. But as an African people or as evangelical Christians, they also knew there was more to their identity than North American enslavement. Working in the British North American colonies, black people were subject to the upheaval of colonial politics in the second half of the eighteenth century.

4.1. Jacob Lawrence, "Frederick Douglass Series No. 30 — The Free Man," 1938–1939
Lawrence shows Douglass reading as proof of his status as a truly free man. He wears the white shirt of a gentleman.

Those Who Were Free

ca. 1770–1859

Jacob Lawrence (1917–2000) painted the man who stood for black freedom: the fugitive slave abolitionist Frederick Douglass (1817–1895) (4.1). As Lawrence shows him, Douglass is engaged in the act of reading, a skill Douglass had taught himself by stealth. Like thousands of American slaves, Douglass seized his own freedom with the help of the woman he married and other friends. He wrote the first best-selling ex-slave autobiography, *Narrative of the Life of Frederick Douglass, Written by Himself* (1845) and became the nineteenth century's most prominent black statesman. As a former slave who remembered bondage, Douglass embodied the fettered meaning of freedom before the Civil War.

The political wars and revolutions of the late eighteenth century deeply involved African Americans. Their captivity and enslavement had inspired the beliefs in liberty and equality that permeated the revolutions of the era. Black people, in turn, applied the rhetoric of natural rights to their own situation. In insurrectionary times, they petitioned legislatures for emancipation and joined revolutionary armies. In the French Caribbean colony of Saint Domingue, slaves gained their own independence.

The revolutionary ideals ultimately ended slavery in the northern regions of the United States. The egalitarian sentiments of the revolutions inspired African Americans for another 200 years and brought crucial nonblack allies. Revolutionary times did not bring racial egalitarianism, however. In the early-nineteenth-century era of the common man, free African Americans faced segregation, disfranchisement, humiliation, and bodily harm on account of their race. The Jacksonian common man, the heir of democracy and republicanism that supposedly applied to all Americans, was not only male, but white. The opportunities associated with this symbol of American democracy did not extend to

white women or nonwhites of either sex. Unable to protect themselves or seek protection as citizens, free African Americans usually found community self-reliance the best assurance of survival. They embraced racial solidarity as a means of self-preservation.

The vast majority of free black Americans were poor, hard-working people with little access to formal education. Few enjoyed enough economic independence to permit their engagement with national political issues. Whether or not they joined reform movements, black Americans harbored abolitionist sentiments. Large numbers supported the American Anti-Slavery Society, subscribed to its newspapers, and supplied the rank and file of antislavery activities on the local level. They made speeches and wrote books vindicating the rights of those excluded from democracy as practiced in the United States. Some became black nationalists, especially during the hard 1850s, when the entire United States became dangerous ground for black people, free as well as enslaved.

The democratic, egalitarian rhetoric of the American Revolution supplied a roomy ideology spurring Northern legislatures to begin the process of abolishing slavery. But the democratic and scientific ideals of the Enlightenment fostered both helpful egalitarianism and the hurtful science ("scientific racism") that decreed races as inherently superior and inferior. Revolutionary enthusiasm for emancipation lasted a generation. Then racist sentiment increased in the United States, actually reducing the proportion of free people in the black population after the 1830s. In the early nineteenth century, slavery flourished in the South and segregation permeated the North. For African Americans, the American Revolution proved woefully incomplete. The Haitian Revolution, republican and thoroughly abolitionist, supplied the example that truly inspired African Americans, including artists.

American and Haitian Revolutions

The roots of antislavery agitation in the British North American colonies reach back to mid-eighteenth-century Pennsylvania and New Jersey. In 1775 the white Quaker abolitionist Anthony Benezet organized the world's first antislavery society in Pennsylvania. Thus antislavery agitation coexisted with slavery as the Founding Fathers complained of their own enslavement to Great Britain and declared all men created equal. African slavery supplied American revolutionaries the word for their predicament, "slavery." The American Revolution eventually emancipated two sets of unfree laborers, indentured whites throughout the new nation and, more gradually, blacks in the Northern states.

Black Soldiers in the American Revolution
When revolutionary conflict broke out in the 1770s, black men had already fought and died in Great Britain's wars in the Americas: King William's War of 1690–1697, Queen Anne's War of 1702–1713, King George's War of 1744–1748, and the French and Indian War of 1755–1763. The egalitarianism of the Declaration of Independence attracted many black Americans to the cause of American independence. The first martyr to the

American cause was the Afro-Indian, Crispus Attucks (ca. 1723–1770), who died in the Boston Massacre of 1770. In 1773, black men also seized the time and petitioned the Massachusetts General Court for their emancipation, on the ground that revolutionary reasoning applied also to them.

Enslaved and free black men fought in the revolutionary battles of 1775 that began the war: Lexington, Concord, and Bunker Hill. The U.S. Park Service estimates that about three dozen African-American militiamen fought at Bunker Hill.[1] For example, the valor of Peter Salem (1750–1816) in war earned him his freedom. A black man appears in the white artist Jonathan Trumbull's painting, "The Battle of Bunker Hill." The black soldier's identity is not known definitively: he may be Peter Salem or Salem Poor (1758–n.d.) of Andover or one of the many other black patriots whose identities have been obscured. Black men's early service to the patriot cause in Massachusetts did not prevent the Virginian commander in chief, George Washington, from applying a slaveholder's logic to his army. In November 1775 Washington forbade new enlistment of black troops and the reenlistment of those who had served in the battles of the spring 1775.

British policy and the pressing need for manpower forced Washington to reverse his ban within a month. In Maryland, North and South Carolina, and Georgia, British commanders offered black men freedom in exchange for enlistment, drawing numerous black recruits and bolstering loyalist sentiment among the enslaved. In 1780 twenty slaves of the eloquent Founding Father Thomas Jefferson joined Lord Cornwallis's invading army.[2]

The British recognized the usefulness of black Southerners early on. But in New England, blacks were more likely to fight for American independence. New England contributed more blacks to the Continental army than any other region. Massachusetts formally opened its militia to black men in 1777. The following year, Rhode Island became the first state to authorize the enlistment of slaves and formed an entire black regiment. Maryland followed Rhode Island's enlistment of slaves in 1780, New York in 1781.[3]

In the North, enslaved, indentured, and other unfree workers of all races took advantage of war and ran away from their owners. The difficulty of physically restraining bound laborers, especially whites (whose skin color did not mark them as unfree), encouraged owners to let their people go. Enlarging the number of free people was also morally attractive in revolutionary times. In the South, enslaved black people applied to their own situation the natural rights expounded in the Declaration of Independence and declared themselves free.[4] They occupied or abandoned their places of work and joined the British. Exposing slavery's constant need for coercion and demanding manpower and other kinds of support from black people, war disrupted existing arrangements of everyday life and work. As would occur in the Civil War of the mid-nineteenth century, the stated causes of the Revolutionary War and the disorder it caused worked in the favor of African-American freedom.

As soldiers, scouts, and workers, African Americans served both sides of the Revolutionary War. Some twenty thousand served with the British. When the British forces withdrew at war's end, between five and six thousand black people accompanied them. Among

them was James Reid (n.d.), who had joined the British commander in the South, Lord Dunmore, and later went to Sierra Leone. Of the three hundred thousand soldiers in the Continental Army, five thousand were black. They fought in North American theaters of war from Vermont to North Carolina.[5] The issues they raised regarding the recruitment and use of black men as soldiers and veterans would reappear in the era of the Civil War.

The earliest works of African-American history chronicle the deeds of black soldiers in the *Revolutionary War: The Services of Colored Americans in the Wars of 1776 and 1812* (1851) and *Colored Patriots of the American Revolution* (1855), by the Boston abolitionist William C. Nell (1816–1874). Nell wrote to counter the impression that blacks played no part in the American Revolution. Like the histories by black authors that followed, Nell's books showed African Americans actively making history and corrected the racially biased histories that deleted black participation.

Petitioning for Emancipation and Civil Rights

During the 1770s black people sent petitions to Northern legislatures and filed suit in Northern courts to demand their emancipation, especially in New England. These suits and the revolutionary fervor of the times brought Northern legislatures face to face with issues of slavery and emancipation. Black Americans embraced the American ideology of democracy and equality. But even so, they perceived the distance separating them from the Revolutionary patriots' ideals. In their 1773 petition to the Massachusetts General Court, Peter Bestes, Sambo Freeman, Felix Holbrook, and Chester Joie struck an ironic tone, as they tugged the logic of revolution in their own direction: "We expect great things from men who have made such a noble stand against the designs of their *fellow-men* to enslave them."[6] Although most petitioners were men, Elizabeth Freeman ("Maum Bett") (ca. 1742–1829) of Massachusetts petitioned Massachusetts for her freedom in 1781. Massachusetts abolished slavery in 1783; this action affected the territory of Maine, which was part of Massachusetts until 1820. New Hampshire followed in 1783. Vermont prohibited slavery in its founding constitution of 1777.

In the Northern states and Western territories, freedom issued from the American Revolution. By 1800, all the Northern states had abolished slavery or at least provided for its gradual elimination. In New York and New Jersey, where tens of thousands of the enslaved contributed significantly to urban and rural economies, emancipation proved very, very gradual. Black people in New York and New Jersey were not mostly free until the 1830s. The Northwest Ordinance of 1787 barred slavery in the Northwest Territories, which lay between the Ohio and Mississippi Rivers and became the states of Ohio, Indiana, Illinois, Michigan, and Wisconsin. The new nation might be on its way to general emancipation.

The United States Constitution approached the institution of slavery indirectly by avoiding the words "slave" or "slavery" or any racial terminology. The issue was so divisive that dealing with it explicitly risked dooming the union to failure. The Constitution recognized the existence of unfree persons and scrupulously protected the "property

rights" of their owners. "Property rights" became a key phrase—a code word for slave ownership—in constitutional debate. The Constitution's protection of property rights laid the basis for the 1793 Fugitive Slave Act allowing owners and their agents to pursue fugitives across state lines. For purposes of congressional representation, the three-fifths clause allowed states to count the enslaved, mentioned euphemistically as "persons held to service or labor," as three-fifths of a person.

Emancipation did not automatically confer citizens' rights on free black men. Black suffrage became a revolutionary issue in only two Northern states. In Dartmouth, Massachusetts, the free Afro-Indian brothers Paul (1759–1818) and John (n.d.) Cuffee claimed the taxpayers' right to representation for themselves. Lacking the right to vote, they refused to pay taxes in 1778, 1779, and 1780 and were thrown into jail. In 1783 the Massachusetts court decided they had a right to vote. Only New York and North Carolina also allowed black male property owners to vote, a right subsequently withdrawn when propertyless white men gained suffrage in the 1830s.[7]

When the United States took its first ten-year census in 1790, the 757,208 African Americans represented nearly one-fifth of the total population (Table 4.1). Virginia was 41 percent black; South Carolina was 44 percent black. Almost 8 percent of New Yorkers

Table 4.1. Black Population, Enslaved and Free, 1790

State/Territory	Free	Enslaved
Virginia	12,866 (4%)	292,627
Maryland	8,043 (7%)	103,036
Pennsylvania	6,531 (64%)	3,707
Massachusetts	5,369 (100%)	—
North Carolina	5,041 (5%)	100,783
New York	4,682 (18%)	21,193
Delaware	3,899 (30%)	8,887
Rhode Island	3,484 (78%)	958
Connecticut	2,771 (51%)	2,648
New Jersey	2,762 (19%)	11,423
South Carolina	1,801 (2%)	107,094
New Hampshire	630 (80%)	157
Maine	536 (100%)	—
Georgia	398 (13%)	29,264
Tennessee	361 (10%)	3,417
Vermont	269 (100%)	—
Kentucky	114 (1%)	12,430
Total United States	59,557 (8%)	697,624

and New Jerseyans were black. Rhode Islanders were more than 6 percent black.[8] Black people lived all over the United States, even in the far reaches of northern New England. Only one state—Vermont—had never allowed slavery; every other part of the country had to wrestle with issues of slavery and freedom.

Slavery in the Northern states and the Western territories did not end deeply ingrained racism. Excluded, segregated, and subject to attacks of physical violence, black Americans soon questioned their future in the United States, even in New England. The Free African Union Society of Newport, Rhode Island, founded in 1780 for purposes of mutual aid and moral improvement, decided in 1787 to establish its own new country in Africa. The Rhode Islanders linked up with seventy-five black Bostonians led by Prince Hall (ca. 1750–1807), founder of the first African-American lodge of Freemasons: the African Masonic Lodge No. 1. Prince Hall spearheaded a petition to the Massachusetts legislature requesting aid in emigrating to Africa: "we yet find ourselves, in many respects, in very disagreeable and disadvantageous circumstances; most of which must attend us, so long as we and our children live in America." The petition was not granted, and the plan, lacking sufficient monetary resources, came to naught. Although he was a prosperous merchant, Paul Cuffee also came to believe that blacks would be better off in Africa. Although his ships carried a group of blacks to Africa in 1815, Cuffee himself ultimately decided against leaving wealthy, familiar Massachusetts for poor, unknown African territory.[9]

African Americans doubtless wondered if the success of the American Revolution served their best interests. After all, slavery remained legal in the independent republic of the United States a generation longer than in the British colonies. Slavery was abolished in the British West Indies on August 1, 1833, a holiday black Northerners in the United States celebrated until American abolition thirty years later. Although celebrating West Indian emancipation remained an abolitionist ritual, the revolution in Saint Domingue immediately acquired positive symbolic status among black Americans.

The Haitian Revolution

The world's first slave-led revolution occurred in Haiti and lasted from 1791 to 1804. From the prize French sugar colony of Saint Domingue, it created the Americas' second republic. The sentiments that inspired the American Revolution of 1776 and the French Revolution of 1789, with its rallying cry of "Liberty, Equality, and Fraternity," inspired the Haitian Revolution as well. The French Declaration of Rights announced that "men are born and remain free and equal in their rights." Such sentiments would seem to apply in the New as well as the Old Worlds. Revolutionary Paris urged the whites of Saint Domingue to grant citizenship rights to a few of the island's free people of color. The suggestion was rejected, and Saint Domingue's free colored people revolted in 1790. Saint Domingue's slaves, the majority of whom were African born, took up the revolt and made it a war for freedom in August 1791. Toussaint L'Ouverture (1743–1803), a devout Catholic and a literate coachman, led the Haitian Revolution, defeating not only

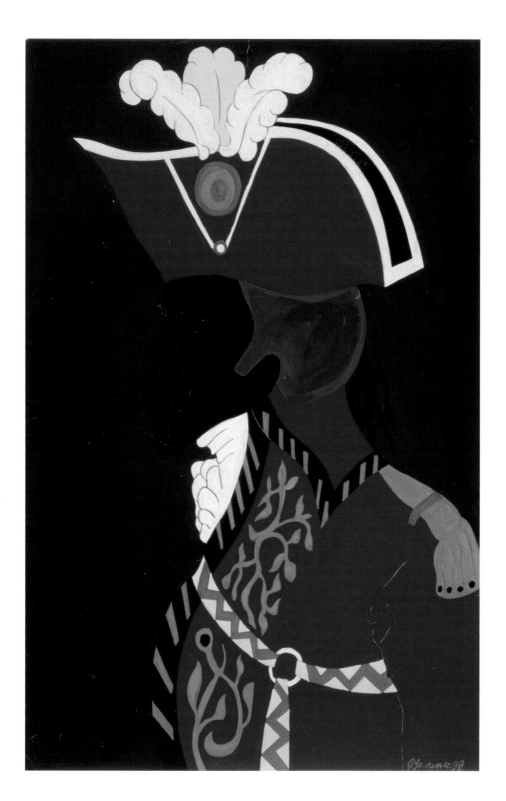

4.2. Jacob Lawrence, "General Toussaint," 1986

For Lawrence, Toussaint is first and foremost a military hero, shown in full eighteenth-century regalia.

French opponents, but also pro-slavery Spanish and British forces. The loss of Saint Domingue dashed French imperial ambitions in the Americas, prompting the French leader Napoleon Bonaparte to sell the territory of Louisiana to the United States in 1803. Haiti became independent on January 1, 1804.[10]

To African Americans, the Haitian Revolution was a beacon of hope, and Toussaint L'Ouverture a hero. Inspired by the Haitian and American Revolutions, Gabriel (ca. 1776–1800), a literate, enslaved Richmond blacksmith, planned to overthrow slavery in Virginia in August 1800. Gabriel claimed 500 to 600 adherents in 10 counties, but his conspiracy was discovered before it took place. In January 1811, Charles Delondes, a Haitian working on a plantation north of New Orleans, organized a revolt of some one hundred men and women that ultimately failed.[11]

The white-majority demography of the United States made it impossible for black Americans to successfully emulate the black Haitians' revolution; in Haiti blacks formed the vast majority of their population. Haiti remained a symbol rather than a blueprint for black American emancipation. L'Ouverture appears as a war hero in black art. One example is Jacob Lawrence's image of L'Ouverture as a military hero in an ornate, late eighteenth-century uniform (4.2).

Free People in the United States

There had always been some free African Americans, as blacks worked out their terms of servitude, purchased their freedom, or escaped slavery by having mothers who were free. However, the American ideology equating "Negro" with "slave" made it difficult for most Americans to acknowledge the presence of black Americans who were free. After slavery came to dominate American labor relations in the late seventeenth and early eighteenth centuries, the proportion of the enslaved in the black population rose dramatically. Free black Americans were never in the majority nationally before the Civil War. And yet some had always been free, such as Anthony Johnson of Northampton County, Virginia, who arrived in Virginia from Angola in 1621 (see chapter 2). Black Americans were never an undifferentiated mass, for at every juncture rare individuals like Johnson managed to amass wealth and enjoy privilege. In the seventeenth, eighteenth, and early nineteenth centuries, however, the propertied few never numbered enough people to constitute a separate class.

The vast majority of free black people remained hard working, unschooled, and poor. Few black men and no black women could participate in politics by voting or holding office. Nonetheless their freedom was precious, though precarious. Freedom made it possible for them to protect family members from being sold.[12] In addition to bolstering the integrity of black families, freedom allowed men and women to change employers, move about (provided they carried the necessary documentation), earn wages, and acquire property they could pass on to their descendants. Had they not been free, moreover, they could not have supported the campaign against slavery—by

harboring fugitives, publishing their views, donating money, speaking in public, or sub-scribing to newspapers.

From 1790 to 1810 the proportion of free black people in the United States increased from 8 percent to 13.5 percent.[13] Most lived in New England, the Mid-Atlantic States, and the Upper South. A few free blacks lived in the rural Lower South and Louisiana. In the North, West, and Upper South, free black people belonged to the poor work-ing class, often clustered in cities. By contrast, in the Lower South, notably in South Carolina and Louisiana, the numbers of free blacks were small, but their situation was sometimes advantageous. Louisiana's *gens de couleur*, who sometimes owned planta-tions and slaves, saw themselves as an intermediate class between whites and Negroes. In the Sumpter district of South Carolina, William Ellison (ca. 1790–1861) bought his freedom and grew wealthy making cotton gins with the help of two slaves of his own.[14]

The absolute number of blacks who were free increased steadily between 1790 and

Table 4.2. Free and Enslaved Black Population, 1790–1860

Area and year	Total black population	Free (percent of black population)	Enslaved (percent of black population)
United States			
1790	757,000	60,000 (8%)	698,000 (92%)
1800	1,002,000	108,000 (11%)	894,000 (89%)
1810	1,378,000	186,000 (14%)	1,191,000 (86%)
1820	1,772,000	234,000 (13%)	1,538,000 (87%)
1830	2,329,000	320,000 (14%)	2,009,000 (86%)
1840	2,874,000	386,000 (13%)	2,487,000 (87%)
1850	3,639,000	434,000 (12%)	3,204,000 (88%)
1860	4,442,000	488,000 (11%)	3,954,000 (89%)
South			
1790	690,000	33,000 (5%)	658,000 (95%)
1810	1,268,000	108,000 (8%)	1,161,000 (92%)
1830	2,162,000	182,000 (8%)	1,980,000 (92%)
1850	3,352,000	236,000 (7%)	3,117,000 (93%)
1860	4,097,000	258,000 (6%)	3,839,000 (94%)
North and West			
1790	67,000	27,000 (40%)	40,000 (60%)
1810	109,000	79,000 (72%)	31,000 (28%)
1830	167,000	138,000 (83%)	29,000 (17%)
1850	287,000	199,000 (69%)	88,000 (31%)
1860	345,000	230,000 (67%)	115,000 (33%)

the Civil War, but after 1810 the percentage of the black population who were free stagnated. After 1830 the proportion of blacks who were enslaved rose (Table 4.2).

Free Black People at Work

Free black people worked throughout the American economy. Many men worked in boats, along shore as fishermen and oystermen or at sea on whaling vessels. (Like many others whose luck did not hold out, Sojourner Truth's son Peter disappeared at sea while on a whaling voyage in the 1840s.) Men and women worked in the households of others, as domestic servants and coachmen. Most but not all black people did hard, unskilled labor. Skilled workers did carpentry, barbering, catering, blacksmithing, barrel making, carting, and any work for which there was a demand. In the North and West, white immigrants steadily displaced skilled blacks after 1830. Irishmen went on strike (as "white men") to prevent black men from finding jobs in their shops. The Jacksonian labor movement of the 1830s was for white men only. In its New York stronghold, the leader of the workingmen's movement was notoriously antiblack. In the South, skilled black workers held their own until after the Civil War, when the need arose to pay them.

Free black Westerners moved about physically and occupationally, as exemplified in James Beckwourth (1798–1866) and Mary Ellen Pleasant (1814–1904). Beckwourth left his native Virginia as a young hunter and trapper. As an adult he fought Mexican forces in Texas in 1847, joined the California gold rush in 1849, and conducted business in Denver in the 1850s and 1860s. He ended his varied life quietly in Crow Indian country in Montana.[15] Pleasant was born in Georgia and served an indenture in Nantucket, Massachusetts, before moving to New Orleans and, in 1852, to San Francisco. She flourished in the prosperity of the gold rush as a restaurant owner and investor. Pleasant used her wealth to support abolitionists, including John Brown of Kansas and his famous 1859 raid at Harper's Ferry, Virginia. Always involved in civil rights, Pleasant in 1868 became one of legions of African Americans campaigning against segregated public transportation in a successful suit against the North Beach [streetcar] Railroad Company.[16]

Education and Voluntary Associations

As poor people who needed to put their children in the paid workforce as soon as possible and as people often barred from public schools because of their race, African Americans were rarely able to attain formal education. In cities like New York and Philadelphia, sympathetic whites like Arthur Tappan helped form schools for blacks. Tappan succeeded in New York, but in New Haven, where he also tried to found a school for black boys in the early 1830s, local opponents (some of whom came from Yale University) stymied the effort, attacked black people, and tore down Tappan's house. In Canterbury, Connecticut, Prudence Crandall allowed a girl of mixed European, Indian, and African descent to enroll in her school for young ladies. Once again, local opposition foiled open-minded educators, this time by destroying the school and forcing Crandall to leave the state.

Most towns in Massachusetts, including Boston, segregated their public schools in

the 1820s. In 1855, after a long struggle, blacks and their antislavery allies won black children access to the public schools. One hundred years before the *Brown v. Board of Education* decision of 1954 declaring school segregation illegal, black parents in Boston won a fight for their children's right to equal access to school. In most other parts of the North and West, black children attended segregated schools when schools for them existed at all. Southern free black children had even less access to public schooling, because of discrimination against African Americans and the generally poor state of public education for everyone in the South. In the Border States, schools for black children operated irregularly and only if local whites tolerated them. In the good years a few free black children might be lucky and secure a basic education, for example, young James Thomas of Tennessee in the 1830s. In a bad year in the same place, the black teacher was beaten and forced to quit his school.[17]

Free blacks in the North and West educated themselves with the aid of white allies but more usually through their own efforts. Self-improvement organizations, like the Pittsburgh Education Society led by the barber John B. Vashon (1824–1878), founded church-based schools for children like the young Martin Delany (1812–1885), later a medical doctor and abolitionist who became the "Father of Black Nationalism." By 1860, half of blacks outside the South were literate.[18]

For the most part, African Americans formed their own religious, educational, and benevolent organizations, which in the early nineteenth century they often called Free African Societies. Some were mainly religious, like Philadelphia's Free African Society, which gave birth to Mother Bethel Church. Others, like the New York Phoenix Society, served mutual aid and educational purposes. The line between sacred and secular purposes could become blurred, especially when churches were the only public buildings black people owned and churches supplied community services. In Boston the first school for black children met in the basement of the African Meeting House.[19] Throughout the nineteenth century, North and South, black churches served as schools as well as meeting places.

Whether in the West, North, or South, free black people were overwhelmingly an urban people. Their institutions—schools, churches, clubs, newspapers—arose in cities. In 1827, the Reverend Samuel Cornish (1795–1858) and John Russwurm (1799–1851), one of the first African Americans to graduate from college, founded the first black newspaper, the New York *Freedom's Journal*. By 1830 some fifty black mutual benefit societies existed in Philadelphia. Throughout the North, societies with "African" in their names gave shape to African-American communities that owed their existence to freedom—Boston's African Masonic Lodge No. 1, Newport, Rhode Island's African Benevolent Society, New York City's African Marine Fund.[20]

Always vulnerable to mob violence, free black Americans had few opportunities to use their cities' public spaces. Exceptions were very early nineteenth-century New Yorkers, who enjoyed the rare privilege of celebrating in public. The Dutch holiday known as Pinkster (or Pentecost, the English Whitsuntide) began as a religious holiday celebrated

by New Yorkers of all races. But after the American Revolution whites gave up this celebration, and Pinkster became black New Yorkers' own holiday, celebrated in New York City but more elaborately in Albany on Pinkster Hill, now the site of the state capitol. Early nineteenth-century black people crowned a king, drummed, paraded, danced, sang, drank, and staged elaborate ceremonies featuring those born in Africa.[21]

Protest in Word and Deed

Segregation, proscription, and antiblack mob violence increased in tandem with the empowerment of poor white men in the late 1820s and 1830s. Racial oppression solidified free black Americans' sense of themselves as a racial people and inspired antiracist protest. For example, *David Walker's Appeal to the Coloured Citizens of the World* (1829) leveled one of the earliest attacks against white Americans' racism and hypocrisy and black people's cowardice for not throwing off their shackles. Born free in North Carolina, Walker dealt in used clothing in Boston. He had helped found the Massachusetts General Colored Association in 1826 and was the Boston agent of Samuel Cornish and John Russwurm's New York *Freedom's Journal*.[22]

The American Colonization Society, founded by prominent whites, embodied the growing sentiment that the United States belonged solely to white men. Rather than abolish slavery, white colonizers favored the expulsion of free African Americans. With few exceptions, black Americans opposed expulsion from their homeland and separation from their enslaved kin. Opposition to the American Colonization movement's proposal that free blacks be expelled from the United States spurred the Negro Convention movement, which began in 1830. Black men met regularly to discuss the status of the race and to protest the discrimination black people faced as they tried to work, move about, and educate their children. Like most of American public life at the time, the Negro conventions offered a forum to men only. A few black women made their voices heard however. Examples include independent lecturers such as Maria Stewart (1803–1879) of Boston, whose speeches were published as *Religion and the Pure Principles of Morality, the Sure Foundation on Which We Must Build* (1831) and *Meditations from the Pen of Mrs. Maria W. Stewart* (1892). After 1840 the antislavery movement offered unusual opportunities to women as lecturers. Sarah Parker Remond (1826–1894) of Salem, Massachusetts, Sarah Mapps Douglass (1806–1882) of Philadelphia, Sojourner Truth (ca. 1797–1883) then living in Northampton, Massachusetts, and Frances Ellen Watkins Harper (1825–1911) of Baltimore and Philadelphia all spoke publicly against racism and for abolition and women's rights.

In deed as well as word, free black people undermined the pro-slavery arrangements of their society. Although the Fugitive Slave Act of 1793 made it illegal to assist people running away from their masters, blacks and their white allies formed vigilance committees to help fugitive slaves to safety in the North and in Canada. After an antiblack, pro-slavery mob burned his lower Manhattan store, David Ruggles (1810–1849) became an officer in the New York Committee of Vigilance in 1835. In Philadelphia William Still

(1821–1902) helped found the General Vigilance Committee in 1837. His chronicle of his work, *The Underground Railroad* (1872), provides an invaluable view of the regular work of black abolitionists in a gateway city to freedom. Still portrays fugitives, rather than their helpers, as the real agents of their quest for freedom. One of the fugitives Still assisted turned out to be his own brother Peter, whom their mother had had to leave enslaved when she sought freedom forty years earlier.

Black Abolitionists

As the backbone of the antislavery movement, which was mostly white, free blacks in the North and West worked on the local and national levels. For the most part, they joined the wing of the abolition movement headed by William Lloyd Garrison. In 1831 Garrison founded the American Anti-Slavery Society in Boston and edited its organ, *The Liberator*. Garrisonians not only demanded the immediate abolition of slavery with no compensation for owners; they also supported women's rights and nonviolence.

In Philadelphia wealthy black entrepreneurs like James Forten (1766–1842) and Robert Purvis (1810–1898) contributed time and money to the abolitionist cause. Harriet Jacobs (ca. 1813–1897) and her brother, John S. Jacobs (1815–1875) battled slavery in several ways after they had escaped from captivity in Edenton, North Carolina. Both Jacobses published ex-slave narratives in 1861: John published his "A True Tale of Slavery" in a London magazine. Harriet published her now-classic autobiography, *LINDA: Incidents in the Life of a Slave Girl, Seven Years Concealed in Slavery, Written by Herself*, in Boston.[23]

More widely known than the Jacobses in the antebellum era, the former slave turned Garrisonian abolitionist Sojourner Truth toured the North and West as a feminist antislavery lecturer. Today Truth is erroneously considered the originator of the famous rhetorical question "ar'n't I a woman?"[24] In fact, Truth

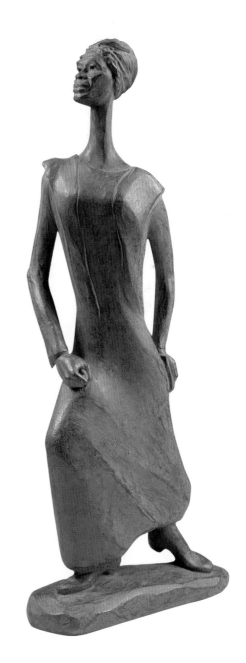

4.3. Inge Hardison, "Sojourner Truth," 1968
Hardison captures Truth's height and grace as an itinerant abolitionist and feminist lecturer. In 1990 the governor of New York presented Hardison's statue to Nelson Mandela of South Africa.

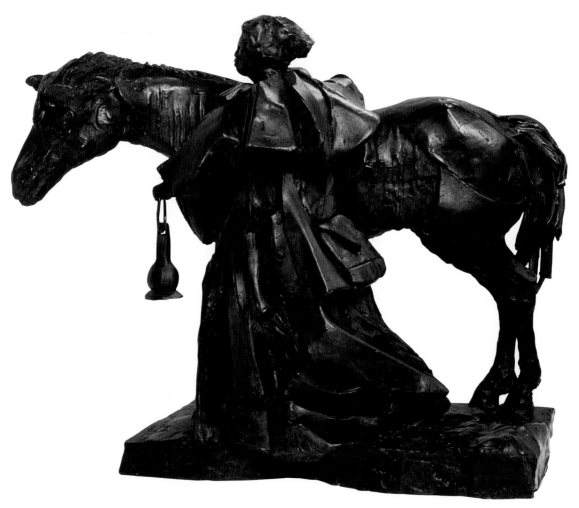

4.4. Barbara Chase-Riboud, "Sojourner Truth Monument" model, 1999
Inserting Truth into the equestrian monument tradition usually reserved for white, male statesmen and generals, Chase-Riboud sets a heroic figure on foot beside her horse. Truth, dismounted, appears as a seeker or a fugitive, rather than a warrior.

contributed to the movement against slavery and for women's rights as the eloquent, witty embodiment of enslaved women. Truth published her as-told-to autobiography, *Narrative of Sojourner Truth*, in Boston in 1850 and sold it herself to her audiences.[25]

Sojourner Truth is one of the few nineteenth-century black women whose image survives, thanks to the existence of several photographic portraits she had made of herself in the 1860s and 1870s. The knowledge of her appearance and her reforming crusade inspired countless renditions in popular culture and by major twentieth-century artists such as Charles White (1918–1979) and Inge Hardison (b. 1914). In her sculpture (4.3) Hardison captures Truth's height and grace as an itinerant lecturer. Recognizing

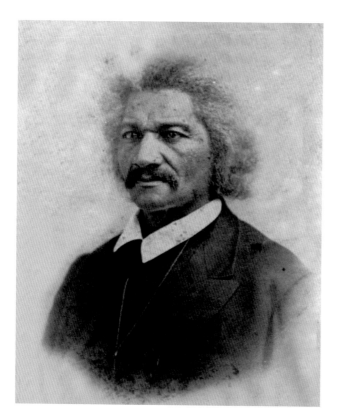

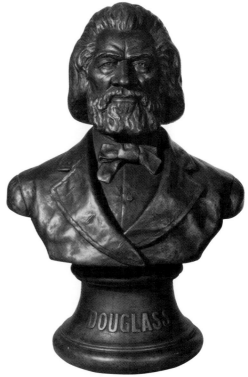

(Left) 4.5. James Pressley Ball, "Portrait of Frederick Douglass," ca. 1860s
One of the early African-American photographers, Ball photographed Douglass as an abolitionist leader on his way to becoming a fervent Republican partisan.

(Right) 4.6. Isaac Scott Hathaway, "Frederick Douglass," 1919
Hathaway's Douglass appears as a statesman in this classic bust.

Truth as the embodiment of defiance of oppressive white authority, New York governor Mario Cuomo gave Hardison's "Sojourner Truth" sculpture to Nelson Mandela, the newly released leader of South Africa's antiapartheid struggle in 1990. The Paris-based sculptor Barbara Chase-Ribaud depicts Sojourner Truth within the monumental tradition of Western art, in which the hero appears with a horse (4.4). By depicting Truth carrying a lantern on foot beside her horse, Chase-Ribaud makes her a seeker rather than a warrior.

Frederick Douglass, the most prominent nineteenth-century black American, escaped from captivity in Maryland in 1838 and joined Garrisonian abolitionists as a speaker in 1841. Douglass moved away from Garrison in the mid-1840s, when the white abolitionist's paternalism threatened to narrow Douglass's scope of activity. The two men also disagreed over political action, which Douglass began to support with the rise of free soil

4.7. Bo Walker, "Frederick Douglass Ikenga," 1978
Walker shows a diasporic, Black Power Douglass in an
Afro hairdo and with an African last name.

political parties—such as the Liberty and Republican par-
ties of the 1840s and 1850s—which opposed the spread
of slavery to the Western territories. Nevertheless Doug-
lass remained a champion of the rights of women and of
blacks until his death in 1895.

Douglass wrote three important autobiographies:
Narrative of the Life of Frederick Douglass (1845), *My
Bondage and My Freedom* (1855), and *Life and Times of
Frederick Douglass* (1881 and 1892). He also inspired nu-
merous portraits by black artists, such as the portrait by
the black photographer James Pressley Ball (1825–1925).
Ball's Douglass looks like a nineteenth-century politician
in a suit coat, ready for engagement (4.5). Isaac Scott Ha-
thaway's (1874–1967) plaster bust, sold by mail order, cap-
tures Douglass as a senior statesman, almost as though
sculpted in marble. Its popularity testifies to Douglass's
enduring status as a race leader (4.6). The artist Bo Walker
(1951–1986) makes Douglass a folksy, 1970s, bell-bottom-
clad figure with an African (or diasporic) flair (4.7). Fred-
erick Douglass, the towering African-American figure of
the nineteenth century, appears in countless paintings,
murals, and sculptures created in his lifetime right up to
the present.

The Reach of Slavery Lengthens

The emancipatory spirit of the American Revolution
dissipated in the early nineteenth century, encouraging
acts of illegal and legally sanctioned negrophobia. White
mobs attacked blacks with impunity in cities such as Phil-
adelphia and Cincinnati, and the Southern-dominated
federal government adopted policies favorable to slave-
holders. Florida, Missouri, Texas, and the Deep South
states carved out of the Louisiana Purchase all enlarged slavery's empire. Despite state
laws against the institution, slavery existed in Western states like California, which had
entered the Union as a free state in the Compromise of 1850.

The Compromise of 1850 toughened the Fugitive Slave Act of 1793 by forcing ev-
ery American to assist slaveholders' recapture of those they claimed as property and
limiting the legal recourse of people claimed as fugitive slaves. The Fugitive Slave
Act of 1850 endangered every runaway slave in the land, including Harriet Jacobs and
Frederick Douglass. Both reluctantly allowed white supporters to purchase them from

their legal owners to prevent their being returned to Southern captivity. In 1857 the United States Supreme Court decided the Dred Scott case, declaring that no one of African descent, slave or free, could ever be a citizen of the United States. By the 1850s, twenty years' worth of nonviolent antislavery agitation seemed to have come to less than naught.

Since the 1830s African Americans had occasionally questioned whether American slavery could be abolished nonviolently, but as Christians, as nonviolent Garrisonians with nonblack colleagues, and as people in the numerical minority, they rarely urged the enslaved to pick up the gun. The worsening racial climate changed the minds of some. As a young abolitionist speaking to the National Convention of Colored Men in Albany, New York, in 1843, Henry Highland Garnet (1815–1882) urged slaves to seize their freedom by any means necessary: "You cannot suffer greater cruelties than you have already. Rather die freemen than live to be slaves."[26] In 1852 Martin Delany (1812–1885) published the first, full-length statement of black nationalism, *The Condition, Elevation, Emigration and Destiny of the Colored People of the United States, Politically Considered*, and joined hundreds of African-American refugees in Canada. By the late 1850s, even privileged free blacks, such as the wealthy, light-skinned, slave-owning William Ellison family of South Carolina, were preparing to make themselves refugees in Haiti or Canada.[27]

Relinquishing claims for an African-American future in the United States, Delany envisioned a black nation for black people and advocated emigration to West Africa. In 1859 Delany traveled to the region that is now Nigeria to sign treaties permitting African-American settlement. The outbreak of the Civil War brought Delany back to the United States where he focused on the war rather than exile.

American racism fostered the first wave of black nationalism, as black people felt revulsion against the policies of their native land. Based in a communal identity, black nationalism forged an alternative to white American race chauvinism. Over the course of the next century and a half, black nationalism established an important American countertradition. The African-American countertradition stressed solidarity over individualism, focused on the condition of working people, saw racial identity as central in American culture, and enunciated a running critique of white American hypocrisy.

In the late 1850s, the peaceful abolition of American slavery seemed impossible. Black nationalism sometimes voiced incendiary sentiments, including exhortations to seize freedom through a resort to warfare. Most African Americans were not able to actually pick up a gun, but a few joined the October 1859 raid of John Brown on the federal arsenal in Harper's Ferry, Virginia. A radical white abolitionist with black allies, John Brown had killed to make Kansas a free rather than a slave state. Brown embraced free black people's preoccupation with abolition, but unlike most of them, he was willing to wage his own war to bring down slavery. Brown and his small black and white army failed to set off an uprising. The United States hanged Brown and his men as traitors, thus making Brown a hero and honorary brother in the eyes of black Americans,

(Right) 4.8. Augustus Washington, "John Brown," ca. 1846–1847
Washington photographed Brown as a patriot beside an American flag early in Brown's abolitionist career.

(Opposite) 4.9. Horace Pippin, "John Brown Going to His Hanging," 1942
Pippin rarely produced political paintings. Here he depicts the memory of his mother, who witnessed the scene.

many artists included. Long before Brown's raid and execution, the Connecticut-based photographer Augustus Washington (1820–1875) posed Brown with an American flag. (The flag as an ironic critique of American racism would reappear in black art of the 1960s and 1970s.) For Washington as for so many African Americans, Brown was the true American patriot (4.8).[28]

Self-taught Horace Pippin (1888–1946), one of the rare early twentieth-century black artists to receive acclaim from the white art world during his lifetime, painted John Brown on the way to his execution, with a lone black mourner in the foreground (4.9).

Conclusion

African Americans recognized the emancipatory potential of the American Revolution, a war waged in the name of freedom and liberty. They fought on both sides of the war that ended slavery in the Northern states. Destroying Southern slavery occupied black

and white abolitionists for another two generations. In 1860, 9 percent of African Americans lived in the half of the United States that was free. However, being free did not make African Americans citizens, gain them entry into public institutions, or exempt them from ill use. Their freedom of movement was curtailed by the need to carry passes and free papers and by laws barring their right to legal entry into the states of the Middle West such as Illinois and Michigan. But becoming free took a necessary first step into personal autonomy. A slave was someone else's possession. But a free person belonged to himself or herself alone. A free person could earn wages, marry, move about, and organize toward religious or educational ends. Free blacks, North, South, and West, relished their freedom, no matter how circumscribed. They also realized their fate was inextricably joined to the 91 percent of their people in the slave half of the United States. They were not truly free because the majority of their people remained captive.

5.1. Elizabeth Catlett, "Harriet," 1975
Catlett's Harriet Tubman exerts armed leadership, as she conducts several enslaved people to freedom.

Those Who Were Enslaved

ca. 1770–1859

For most black Americans, Harriet Tubman (ca. 1821–1913) represents the symbol of enslaved African Americans who repudiated the role her country laid upon her and vindicated her own humanity through flight. Tubman took not only herself into freedom; she also delivered some two hundred others on nineteen emancipatory trips back to the South. Elizabeth Catlett (b. 1919), one of several major African-American artists depicting Harriet Tubman, shows an armed Tubman leading a group out of Southern slavery to freedom (5.1).

While Harriet Tubman stands for the enslaved in the African-American countertradition, mainstream American culture has more often portrayed a fictional character. In Harriet Beecher Stowe's classic novel, *Uncle Tom's Cabin* (1851–1852), the enslaved Christian martyr Tom transcends enslavement through good works and, eventually, a fatal beating. Stowe's Tom loves his fellow slaves as much as his white owners. But subsequent staged and filmed versions of *Uncle Tom's Cabin* downplayed Tom's relationship with his fellow black Americans and emphasized his close relationship with whites. Over time, "Uncle Tom" came to characterize an African American who loved whites and betrayed blacks. In the late nineteenth and twentieth centuries, American popular culture reworked nineteenth-century black figures into emblems of contentment in slavery, including Uncle Tom, Topsy (another character in *Uncle Tom's Cabin*), and other black characters such as "Old Black Joe" of Steven Foster's treacly, pro-Southern ballad. African Americans reacted to this later version of Uncle Tom by turning his name into an insult.

Today many black Americans are looking closely at the historical meaning of the institution of slavery and the lives of the people who were enslaved. Slaves and slavery are no longer hidden as reminders of a shameful past. Rather, African Americans are

reclaiming their enslaved ancestors and embracing them with a new understanding of the hardships they endured.

Slavery flourished throughout the British North American colonies for a century, until Vermont (1777) and Massachusetts (1783) outlawed it. The rise of cotton production halted the progress of emancipation and threatened to make American slavery permanent. More than eighty years, representing some four generations of Americans, separate the abolition of slavery in New England from the abolition of slavery in the United States as a whole. During the nineteenth century, slavery became a Southern regional institution, but one with a national reach. On the eve of the Civil War, slaves accounted for about one-third of the Southern population (half the people in the Deep South, one-third to one-fifth of the people in the Upper South).[1] American slavery was a truly American institution, for the enslaved worked from Maine to Texas. Even the Western regions in which slavery was illegal discriminated against people of African descent and tried to prohibit their entry.

The Enslaved Lay the Foundations of the American Economy

Slaves supplied the foundation of the American economy in three ways: as a basic commodity in the New England–West India trade, as the workers producing agricultural commodities for the market, and as property. The Atlantic slave trade made many an American mercantile fortune. Examples include John Brown of Rhode Island (the patron of Brown University in Providence and founder of the financial institution that would grow into the Fleet Bank-Bank of America), the donors of the first named professorship, scholarship, and library fund of Yale College, and the sugar-planter benefactor of the Harvard Law School. Slaves grew the crops that Americans exported to Great Britain and Southerners sent to the North: cotton, tobacco (in Rhode Island as well as Virginia), rice, hemp, and sugar. Slaves were also personal (or "chattel") property that could be bought, sold, moved about, inherited, given away, insured, and used as collateral for all kinds of business transactions. As items of trade, producers of agricultural commodities, and capital, slaves fed the American and British economies and made possible the industrial revolutions of both countries.

Both the British and American industrial revolutions began with the manufacture of textiles in mills that spun raw fiber into yarn and wove yarn into fabric. After the invention in 1793 of a cotton gin that could separate hardy, short-staple cotton from seeds, slave-produced cotton became the basic industrial fiber. The cotton that fed the mills of Lancashire and Massachusetts came from the Southern United States (Table 5.1). Just as the Atlantic slave trade enriched the eighteenth-century New England economy, so the cotton trade created its own economy of Northern as well as

Table 5.1. Southern Cotton Production, 1790–1860

Year	Southern Cotton Production (in bales)
1790	3,135
1800	73,145
1820	334,378
1860	4,800,000

Southern concerns: banks, shippers, textile manufactures, and insurance companies.[2] Even after the Northern states became free territory in the 1830s, slavery remained a truly national institution economically.

The vast majority of slave owners were white, but Cherokee, Chickasaw, Choctaw, and Creek Indians also owned slaves. Their slaves accompanied them and died beside them in 1832 on the Trail of Tears from their homes in the Deep South to Indian Territory (which became Oklahoma in 1890). A tiny handful of African Americans owned slaves, either as bound workers or as family members. (As Southern states like Virginia sought to limit the number of free African Americans, they linked emancipation with exile. Unless newly emancipated people were still owned by someone—even a family member—they would have to leave the state.)

The nineteenth-century Southern slave-based economy created tremendous disparities of wealth and poverty. At the poor end of the spectrum, the enslaved third of the Southern population earned no wages for their work and owned no wealth. At the rich end of the spectrum, a small minority of Southern families owned any number of slaves. That minority shrank over the course of the nineteenth century: From 1830 to 1850, the percentage of white families who owned slaves dropped from 36 percent to 26 percent. Less than 10 percent of free Southerners owned enough land, slaves, and other property to make them fabulously wealthy. Of the 26 percent of white families owning slaves in 1860, only 2.7 percent owned fifty or more slaves, but these families owned 93 percent of Southern wealth and one-quarter of the slaves. Only 22 percent of American white people were Southerners in 1860, yet two-thirds of all men worth one hundred thousand dollars or more (spectacular wealth at the time) lived in the South.[3] Enslaved workers produced this enormous wealth. In the half century before the Civil War, the Southern land of extreme wealth and extreme poverty was less than a low-wage economy. The South was virtually a no-wage economy.

Enslaved Laborers

Slaves worked at everything that needed to be done. As children, they began working as soon as they could be of use—in the house by about age seven, in the field by age ten. On Northern and Southern farms, slaves did agricultural work alongside their owners and other white people. In 1860, one-quarter of the enslaved worked on farms with one to nine slaves; one half of the enslaved worked on farms and plantations with ten to forty-nine slaves.[4]

Brute force and constant surveillance kept involuntary, unpaid workers on the job and steadily at work. In the seventeenth and eighteenth centuries, owners meted out cruel punishments for unsatisfactory work or absenteeism: branding, chaining, maiming, castration, muzzling, and, most of all, whipping. In the nineteenth century, the most barbarous punishments fell out of favor, but the whips and chains remained, as captured in the mournful slavery memorial by Howardena Pindell (5.2). It features farmland, objects of punishment, and reminders of the Atlantic

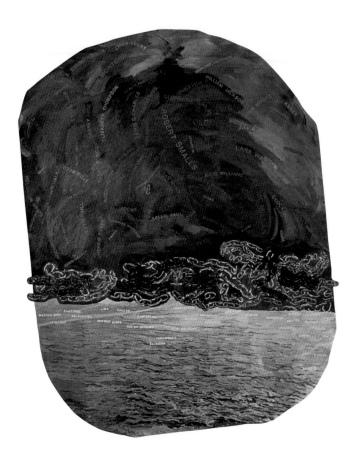

5.2. Howardena Pindell, "Slavery Memorial," 1993
Pindell's memorial to the enslaved shows African motifs at the top, chains and the "Middle Passage" in the center, and "indigenous sovereign nations" at the bottom.

slave trade. The bottom half of the circle commemorates the "indigenous sovereign nations" of American Indians and Africans.

The agricultural workday lasted about fourteen hours in summer, about ten hours in winter. Most women and children worked in both house and field, depending upon where they were needed at any particular time. Women worked double shifts: for their masters and for their own families. After a day in the fields, they came back to cook and care for their husbands and children. They also spun, wove, and sewed for their owners and for their own families. As the artist Kara Walker (b. 1969) shows in her silhouette, young children worked long and hard in conditions that were literally nauseating (5.3).

Slavery did not create different classes among the enslaved (despite long-standing misconceptions such as Malcolm X's popular twentieth-century descriptions of class divisions between privileged slaves who worked in the house and oppressed slaves who

5.3. Kara Walker, "Slavery! Slavery!" 1997
Walker's silhouettes portray tortured enslaved children working in intolerable conditions and vomiting over their situation. The Spanish moss evokes the supposed romance of the Old South, as the chained young worker below struggles with his burden. The enslaved toil under a stormy moon.

worked in the fields). The enslaved worked at various jobs, all of which were unpaid. Vocational diversity did not supply the requirements for the formation of a middle class, including economic mobility, occupational mobility across generations, and the transmission of wealth from one generation to another. Even occupational mobility within a generation was severely limited, for most slaves were not so skilled or specialized that they always exercised their skill. They had no assurance whatever of being able to pass on to their children their skills or whatever favors they may have reaped from their owners.[5] Class formation began among African Americans after emancipation, when freedom permitted their earning wages, owning property, marrying legally, and bequeathing their property to their heirs.

Only large plantations, farms with twenty or more slaves, sorted workers into household and field workers and established separate slave quarters apart from the big house.

Agricultural slaves usually had Sundays to themselves to attend church, tend their gardens, hunt for game to augment their rations, and care for their spouses and children. Household slaves were always on call, subject to never-ending working hours and close supervision. Owners controlling large workforces trained slaves as blacksmiths, cooks, grooms, carpenters, and even factory operatives. In the Tredegar iron works in Virginia, slaves worked the manufacturing jobs, which, after slavery, would pay well and be off limits to African Americans. In the thousands of farms of the North and South, enslaved workers seldom occupied their own quarters. They ate in the kitchen (often a separate little building) and slept wherever they could find a space.

In urban settings, slaves often hired out their own time, working as teamsters, household servants, hotel and tavern keepers, longshoremen, caterers, barbers, and tailors. They might live apart from their owners, to whom they paid most or all of their earnings. Hired out workers who were skilled, frugal, hardworking, and lucky might earn more than they owed their masters and manage to save enough to purchase their freedom. Elizabeth Hobbs Keckley (1818–1907), a skilled dressmaker who became Mary Todd Lincoln's traveling companion and confidante as well as dressmaker, used her business profits to purchase her own and her son's freedom. In 1868 Keckley published her memoir, *Behind the Scenes: or Thirty Years a Slave and Four Years in the White House.*[6]

Many slaves took pride in their ability to work hard and well, even though their efforts benefited others. Many did not, making negative incentives (close supervision reinforced by the whip) necessary to keep them at their tasks. Occasionally owners paid cash bonuses to valued workers, but payment never altered the nature of unpaid servitude. Travelers to the South invariably expressed dismay at the sorry state of the society. For newcomers to the region, the slave South appeared as an overwhelmingly rural, backward place characterized by brutality, poverty, drunkenness, illiteracy, ignorance, and inefficiency. In short, the South seemed sunk in lethargy.[7] Much lethargy there was, for many Southerners were depressed. They had no reason to hope for a better future. It seemed always to have been so. Not only were they held and worked against their will and for nothing, they were likely to lose their spouses, parents, and children to the traffic in slaves.

The Domestic Slave Trade

A well-established commerce—the domestic slave trade—existed within the United States to buy and sell people. Statistics are fragmentary, but at the very least, the domestic slave trade ensnared one million or more of the enslaved.[8] The domestic slave trade satisfied two economic needs: First, it allowed the division of slave owners' property, for example, to pay off debts and settle estates after a slave owner's death. Second, in the older regions of the South, especially Virginia and South Carolina, workers could be sold to farmers and planters in the newer regions in need of labor. The Atlantic slave trade from Africa became illegal in the United States in 1808, just as the boom in slave-

produced cotton began and planters put their workers to the task of clearing the forests to make farmland in the new states along the Gulf of Mexico. Slave prices fluctuated according to business cycles, rising in boom times, falling in hard times. But in general, prices increased, making the sale of people immensely profitable (Table 5.2).

Historians have hardly begun to investigate the extent to which owners bred slaves for this market.[9] However, ex-slave testimony supplies abundant evidence that some owners coerced slaves' sexuality in the interest of profitable reproduction. Virtually all owners engaged in eugenic practices, such as rewarding women who bore children regularly and pressuring and selling women who did not. Slave women bore their first children around age nineteen, some two years earlier than the white women who owned them. Slave women continued having children every two and one-half years until they reached about age forty. (Their mistresses, who could rely on wet-nurses, nursed their children for shorter periods, and bore children closer together.)[10]

Regardless of the degree to which the enslaved were forced to breed, massive numbers of people were sold away from their families. The trade remained legal until general abolition in 1865, and every Southern town, including the United States capital of Washington, D.C., had at least one slave market. Abolitionists created enough of a sense of shame over the trade in human beings that the slave market in Washington was shut down as part of the Compromise of 1850; slavery and private slave sales remained legal in the District of Columbia until the middle of the Civil War.

Well over a million people were forcibly transported within the United States before emancipation in 1865. Some 45,000 people were sold away from the Upper South between 1790 and 1800, even before the traffic picked up after the end of the Atlantic slave trade. Between 1830 and 1860, some 300,000 enslaved people—men, women, and children—were sold from just the state of Virginia to owners in the Deep South and Southwest. About one-third of slaves' first marriages were broken by sale. By 1860 an enslaved child had a 30 percent chance of being sold.[11]

Slave families could be severed without their members being sold. Slaves, particularly women and children, were often given to newlyweds as wedding presents. When younger members of slave-owning families in the Southeast moved west, they took part of their parents' workforce with them. In this way, for example, slaves from the Bennehan-Cameron plantation near Durham, North Carolina, moved to Alabama and Mississippi when Cameron sons struck out on their own. Western moves required young male workers, men of the age to be starting families of their own. Wives and children, less needed in the pioneer stage of cotton culture, stayed home in North Carolina while husbands and fathers drained swamps, cut down trees, and broke land for cotton in Alabama and Mississippi.

Slaves were also moved around according to tensions within their owners' families. In *Incidents in the Life of a Slave Girl*, Harriet Jacobs reports that slave women who had borne her master's children were sold away in deference to her mistress's sensibilities. Jacobs added that the children of masters and their sons with slave women were

Table 5.2. Prices for Best Field Hands, Selected Years, 1800–1860

Year	Price
1800	$500
1804	$600
1814	$450
1819	$850
1828	$450
1834	$650
1837	$1200
1843	$500
1847	$750
1853	$900
1859	$1100
1860	$1200

"unblushingly reared for the market. If they are girls, I have indicated plainly enough what will be their inevitable destiny."[12]

Slavery: A Dehumanizing Institution

Slaves retained their humanity thanks to the support of families and religion, which helped them resist oppression. Nonetheless, slavery was a dehumanizing institution. Assaults on the bodies and minds of the enslaved exposed them to trauma that was both physical and psychological.

Physical Trauma
By the end of the eighteenth century, branding, amputation, and other extremely brutal forms of punishment became rare as means of controlling slaves. But beating continued, causing slaves' most catastrophic physical and psychological trauma. Every ex-slave narrative includes scenes of physical torture inflicted by owners (female as well as male), overseers, and fellow slaves forced to administer their masters' punishments. The narratives also comment on the emotional pain of parents, children, and spouses, forced to watch their kin being beaten. Artists have depicted the physical torture of slavery in countless images, such as "Slave Lynching" by Claude Clark (1915–2001) (5.4). The enslaved woman's nakedness before a crowd of onlookers adds further humiliation to the physical pain of the beating.

In addition to physical injury caused by beating, slaves suffered from the chronic conditions caused by overwork, scanty rations, and insufficient clothing. Frederick Douglass recalled going barefoot and ill clothed all winter and suffering from frostbite as a child.[13] Stealing food to stanch constant hunger earned many a slave a whipping. Years of hard work, often in swampy conditions, left their signs within slaves' bodies. The skeletons of enslaved children and adults working in eighteenth-century New York City bore the traces of lesions denoting excessive, repetitive stress. The remains found in the African burial ground in lower Manhattan indicate that about 50 percent of New York's colonial Africans died before the age of twelve, and 30 to 40 percent of those children died in infancy. Many of the 40 percent of the skeletons in the burial ground belonged to preadolescent children and show the thickening of the skull associated with anemia and osteomalacia (weakening of the bones due to poor diet and nutrition). The skeletons' enlarged muscle attachments are attributable to the heavy loads children were forced to carry. The skeletons also show

5.4. Claude Clark, "Slave Lynching," 1946
For Clark, the meaning of slavery is vicious, as shown this public beating of a woman stripped of her clothing.

signs of arthritis in the neck bones and lesions on the thighbones from muscle and ligament tears, caused by carrying heavy loads.[14]

On large plantations slaves might benefit from the care of a medical doctor. Slave-owning families wealthy enough to pay fees for doctors' services often had their own physicians care for their slaves. Mistresses sometimes ministered to ailing slaves, and slaves with specialized knowledge of herbs, magic, and charms—often of African origin—also saw to their fellow workers' physical and mental health. Slave herbalists and magicians commanded a body of folk wisdom separate from American formal education, which was infused with scientific racism. Slaves like Henry Adams (1843–n.d.) of Georgia and Louisiana knew how to cure illness with medicine and spells. His knowledge earned him the respect of his patients, black and white.[15]

Psychological Trauma

Slaves and, to a certain extent, their owners paid the psychological costs of a society based on violence, obedience, and submission.[16] As the slave Isabella in the Hudson River Valley, Sojourner Truth neglected her own children to work for her owners, including their children.[17] "No Mommy Me (1)" by Joyce Scott (b. 1948) captures the tragedy of the neglected black child (5.5). While the mother plays with the white child in her charge, her own child, disregarded, clings to her skirt.

Slave owners placed great value on slaves' demeanor, which was to remain cheerful and submissive at all times. Above all, slaves were not to appear to be thinking for themselves or to display the anger inevitably flowing from physical violence, whether being beaten oneself or witnessing someone else's torture. The signs of this repressive regime appeared in advertisements for runaway slaves. Slaves were described as stutterers, as people who always looked down, who seemed depressed, who drank liquor excessively, who alternated between periods of withdrawal and outbursts of fierce, uncontrollable rage.[18]

Some slaves suffered from what is now termed post-traumatic stress syndrome, and some inflicted their pain on their kin. But every slave was

5.5. Joyce Scott, "No Mommy Me (1)," 1991
Scott's black child clinging to his mother's skirts loses out to the white child she amuses.

vulnerable psychologically, and every slave was at risk of falling victim to psychological trauma. The enslaved bore the brunt of emotional pain, but their owners did not escape unscathed.

Whites as well as blacks noticed slavery's detrimental effects on white people. Thomas Jefferson could only speak vaguely of "odious peculiarities."[19] Mistresses and slaves spelled out the evils, physical and emotional: Absolute power over other people bred sadism; absolute power over other people also bred sexual abuse. The rape of slave women translated into the pain of adultery for mistresses. Harriet Jacobs, herself the sexual prey of her middle-aged master when she was less than fourteen, summed up slavery's costs to white families: "I was twenty-one years in that cage of obscene birds. I can testify, from my own experience and observation, that slavery is a curse to the whites as well as to the blacks. It makes the white fathers cruel and sensual; the sons violent and licentious; it contaminates the daughters, and makes the wives wretched. And as for the colored race, it needs an abler pen than mine to describe the extremity of their sufferings, the depth of their degradation."[20]

What Slavery Cost Slaves

Slavery cost slaves income and wealth. They made no wages, although some masters paid bonuses as incentives for good work. Lacking wages, slaves could not save. Slaves had no legal right to hold property, and without wages, they were seldom able to accumulate property. As in the case of wages, some masters offered favored slaves the use of property. Sojourner Truth's parents, for instance, lived in a cottage they considered their own and kept a garden they considered theirs. But possession remained strictly contingent upon the owner's pleasure. Slaves had no rights in such property and could not pass on cottage or garden to their children. Without wages, savings, or property, Africans and their descendants could not send money back to their African villages of origin, as did millions of immigrants from Asia and Europe.

Educating slaves in or out of school was illegal in the nineteenth-century South, but not in the North and West. Nonetheless formal education remained outside the reach of most African Americans for several reasons beyond their enslavement. Few black people, slave or free, were allowed in schools; rural areas offered schooling to almost no one, for poor children of all races and ethnicities were destined for the workforce, not the schoolroom. A small minority of the enslaved did learn to read, write, and figure. Often their owners, particularly their mistresses (as in the cases of Frederick Douglass and Harriet Jacobs) helped bright slave children learn their letters. Owners also valued the assistance of slaves who could read or keep accounts. Upgrading one's skill, however, rewarded the owner far more than the slave.

Because slaves could not change employers of their own volition, they could not use the skills they acquired to better their situation by finding improved working conditions or jobs that paid more. They could not work their way up or purchase a share in their business. Closely supervised, they seldom exercised control over their working condi-

tions. Although slaves lacked unions and therefore lacked grievance procedures, they sometimes successfully appealed overseers' orders to their owners. Appeals could go no higher than the master, for masters exercised powers directly on their farms, plantations, and households and indirectly through slave patrols on the roads and other public places. In the South, local governments nearly always deferred to owners, who exercised police power over the land and people they owned.

The combination of physical violence and the requirement to remain cheerful before one's owners bred habits of deceit and anger that turned against oneself and one's own family. Child and spouse abuse were constant dangers in Southern families. One of the most famous works of the late nineteenth-century black poet Paul Laurence Dunbar (1872–1906) commemorates the need to conceal emotions: "We Wear the Mask."

> We wear the mask that grins and lies,
> It hides our cheeks and shades our eyes,—
> This debt we pay to human guile;
> With torn and bleeding hearts we smile,
> And mouth with myriad subtleties. . . . [21]

Powerlessness inspired solidarity in many of the enslaved, but others reacted to their extreme vulnerability with nihilism. They became cold, calculating tricksters looking out only for themselves, even at the cost of fellow slaves' welfare. The fugitive slave author and abolitionist William Wells Brown (ca. 1814–1884) said, "twenty-one years in slavery had taught me that there were traitors even among colored people."[22] Knowing that desperation bred traitors, many slaves found it difficult to place their trust in others.

The poorest and most vulnerable of workers, the enslaved provided a handy target for insult. Working people of every race often appeared in political analyses as shiftless, idle, childlike, and oversexed. Intellectuals in Europe and the Americas focused their most demeaning stereotypes about the working class on black people. In the nineteenth century, when intellectuals believed that race determined the individual's inherent capacities, those adjectives were applied to the enslaved as though they were characteristics of their race.[23]

Slaves without networks of support had difficulty going against the grain of the culture in which they lived. Although many managed to think for themselves, take pride in their abilities, and value themselves as persons, many others gave up the fight and lapsed into what Harriet Jacobs called "degradation"—depression, opportunism, desperation, and apathy. The enslaved who continued to believe in themselves in the face of physical and psychological insult were blessed with extraordinarily strong egos.

The Value System that Slaves Took from Slavery
Slavery took away more than it offered, but slaves developed precious strengths within an inhuman system. Slaves created alternatives to the ideology of the culture in which

they were enslaved. Black people's counterideology included a strong communitarian identity based in mutual aid. This sense of race solidarity ran counter to American individualism. In a less racialized culture, this solidarity might have been called class consciousness. In the United States, where identity began with race, slaves' solidarity became race consciousness. The feeling of belonging to a black community came more easily to those living in their own neighborhoods, the slave quarters of large plantations. Those living on farms, where they were constantly outnumbered by white people, had to work harder to create and maintain a supportive black community.

Slaves rejected prevailing conventions regarding racial inferiority and superiority. As the people who did all the work for those who owned them, African Americans knew that if any race was inferior, it was white people—owners who needed other people to do everything for them. The realization that the culture around them included gross misrepresentations of truth allowed the enslaved to resist the truisms and conventions of American life. This ability to think critically allowed slaves to see exploitation behind pretty surfaces and attractive words, such as "liberty" and "democracy." This lack of sentimentality later came to be called a blues and then a hip-hop sensibility.

Family and Religion as Protection Against Dehumanization

The two foundations of positive black identity were family and religion, both of which African Americans defined in defiance of the norms of the larger society. Black families countered much of the litany of inferiority in the larger society by prizing family members instead of insulting them. Black families gave their members an identity other than slave. In families, slaves acknowledged their value as human beings. Friends, usually also African-American, but sometimes nonblack, offered comfort in a hard world.

Black religion reinterpreted Protestant Christianity to emphasize the God of Daniel, the avenging God who would bring about the second coming of Christ and damn the sinners, that is, the slaveholders. Slaves regarded white religion with a critical eye. The ex-slave narrator Charles Ball cited his African grandfather, who had arrived in Maryland in 1730. Ball's grandfather always insisted that American Christianity was "altogether false, and indeed, no religion at all."[24] In 1829 David Walker castigated white Americans for religious hypocrisy. African Americans were strong Christians, as black artists have shown. But they distinguished their religion from the religion of their owners, which they viewed as phony.

Slave religion created an original American musical genre, spirituals. Spirituals consoled people in misery by reminding them of a better place after death, a place "over Jordan," where they would no longer be overworked, unpaid, despised workers. Black artists entitled their paintings with the names of spirituals, for example, William H. Johnson's "Swing Low, Sweet Chariot" and Malkia Roberts's "My Lord, What a Morning."[25] The loss of family members to sale, death, and other causes encouraged African Americans to form families from non-biological kin. Unrelated adults adopted orphans; working adults shared child rearing. Good friends and supporters became non-kin ("play") brothers and

sisters, people whose relationship surpassed friendship and became like family. Slaves did not always judge one another harshly for what might appear to be moral lapses: women who bore children outside established relationships or with the master were not usually castigated or expelled from the community. Black people were well aware of prevailing power relations and cherished all children, even those born of shame, abuse, or weakness.

With women in the workforce as well as men, slaves developed gender roles that were relatively egalitarian compared to those of other Americans. This accommodation did not arise easily, for men found it difficult to recognize women as equals. Nonetheless, slave families formed around the reality of two parents working for others. Women at work—including married women and mothers—never seemed abnormal in the communities of slaves. Ex-slave women as well as men looking back at their lives in slavery recalled with pride their ability to work hard and expertly.[26]

During their enslavement, African Americans created value systems that critiqued and countered those of mainstream American society. Slaves valued each other as people, not simply as units of labor or property of value. As the poorest people in the society, they rejected white people's materialism and other aspects of American ideology that prized wealth above humanity. Slaves' ability to create identity outside American convention persisted as long as convention devalued African Americans as a people.

Undermining Slavery

By themselves, black people were never able to destroy slavery as an institution, but they constantly struggled against being enslaved. In 1755, in Charleston, South Carolina, a slave woman was burned at the stake for poisoning her master.[27] Poisoning remained one of masters' fears as long as they extracted involuntary labor from their cooks. Individual acts of rebellion occurred continually. But the master class feared slave insurrection the most.

Conspiracies and Insurrections

Some twenty-five conspiracies and insurrections took place in British North America before the American Revolution.[28] They included the 1712 slave revolt in New York City, in which Africans and Native Americans armed with hatchets, guns, knives, and hoes killed nine white people, and the rebellion in Stono, South Carolina, in 1739, in which several dozen slaves killed an unknown number of whites. (South Carolina, like other Southern colonies and states, hushed up information on slave conspiracies and rebellions whenever possible.) In 1741 a slave conspiracy was uncovered in New York City before it came to fruition.

Two other major conspiracies came to light in the early nineteenth-century South. In August 1800 Gabriel Prosser (ca. 1775–1800) organized a thousand slaves, who began to march on Richmond, Virginia. The Governor called out the militia and routed the insurgents. In 1822 Denmark Vesey (ca. 1767–1822), a free carpenter in Charleston,

5.6. Jacob Lawrence, "Cinqué Aboard the *Amistad*," 1991
Lawrence's illustration of Clarke's book stresses Cinqué's use of arms in hand-to-hand combat against his white captors.

South Carolina, sought assistance from revolutionaries in Haiti as he organized an attack on Charleston for July 14, Bastille Day, the revolutionary national day of France. But Vesey's plan, an attack that would involve thousands of slaves, was revealed before it occurred.[29] Vesey and his lieutenants were hanged after a trial in which they refused to reveal their secrets.

In 1839 Africans being transported illegally from Cuba seized their ship, the *Amistad*, and tried to return to Africa. Landing on Long Island, New York, they were captured by the United States Coast Guard and taken to Connecticut for trial. The case of the *Amistad* mutineers reached the United States Supreme Court, which freed them. The leader, known as Cinqué (ca. 1817–n.d.), went to Sierra Leone in 1842. In 1939 Hale A. Woodruff (1900–1980) painted the "Mutiny Aboard the *Amistad*" mural at Talladega College in Alabama. Jacob Lawrence created the 1992 frontispiece of *The Middle Passage—Our Holocaust!* by the historian John Henrik Clarke (1915–1998). Lawrence stresses the hand-to-hand combat of the *Amistad* Africans' struggle against their captors (5.6).

The most deadly American slave revolt occurred in Southampton County, Virginia, in August 1831, organized by the literate slave preacher and visionary Nat Turner (1800–1831). Turner's visions revealed that God designated him as the liberator of the enslaved through the shedding of white people's blood. Before they were caught, Turner and his accomplices killed fifty-nine white people in two days. In retaliation for Turner's revolt, enraged whites carried out a pogrom against African Americans in Virginia and neighboring North Carolina, terrorizing the black population through searches and seizures, beatings, and rapes.[30]

The most famous insurrectionists—Gabriel Prosser, Denmark Vesey, Cinqué, and Nat Turner—became heroes to black people and gave new meaning to the word "bad." In black vernacular, "bad" designated a person of strength and bravery, a good person. Coincidentally such a person was one whom white people saw as dangerous, as a bad person.

Running Away
Organizers of major conspiracies were relatively few, but many slaves ran away to escape whippings, sale, or other misfortune.[31] Most remained near home, sometimes taking ref-

uge with neighboring free blacks. But others spent relatively long periods in wild places like the Great Dismal Swamp on the border between Virginia and North Carolina.

Runaway slaves numbered in the thousands, and their absences disrupted their owners' work routines. Southern newspapers routinely carried advertisements for the capture of runaways, describing the persons and offering rewards. Because these descriptions often mentioned scars, they testified to the brutality of the institution runaways were trying to escape.

Running away was the heroic means of making oneself free, for manumission implied the person being freed had given his or her owners extraordinary service, such as revealing the existence of an insurrectionary plot. Famous fugitive slaves such as Frederick Douglass, William Wells Brown, and William and Ellen Craft wrote stories of their enslavement and escape. (The Crafts had escaped through the use of a ruse depending

5.7. Charles White, "Wanted Poster Series," 1970

White shows twentieth-century black people as nineteenth-century fugitive slaves stressing the similarity of their situations. His dates—1619 and 19??—indicate his conviction that the black situation has not changed. The X in the middle stands for the lost African names and identities.

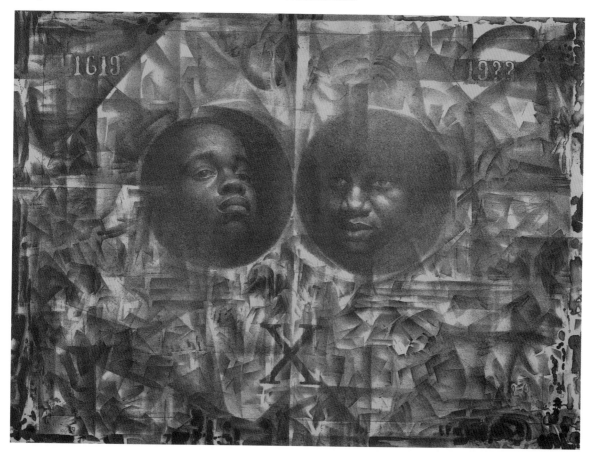

upon the existence of enslaved people who were for all intents and purposes white. Ellen Craft (1826–1891) pretended to be a young white man, while her darker skinned husband William (1824–1900) pretended to be his/her slave.) Fugitive slaves created a genre of original American literature, the ex-slave narrative, which numbered in the hundreds of published autobiographies.

The visual artist Charles White (1918–1979) commemorated those who sought freedom by running away from their owners. In his "Wanted Poster Series," White embeds cameo images of a mother and child against the background of a slave auction poster. In the top left-hand corner White writes "1619," in the top right-hand corner, "19??" (5.7).

Ann Tanksley (b. 1934) painted "Running to Freedom" to show fugitives making their way through a dangerous, confusing forest in nighttime (5.8). Here running away is not for the weakened of body or soul.

The thousands of slaves seeking permanent rather than temporary freedom had to travel very long distances. They left their families and their work sites and set out for the land of the free, in Northern and Western states and in Canada. Volunteers helped them along the route known as the Underground Railroad.

The Underground Railroad

The Underground Railroad was not an actual, physical railroad with steel rails and trains. Rather, it consisted of a largely informal network of some 3,200 people of all races in the North and West who helped fugitive slaves make their way to freedom.[32] The safest and best-organized networks existed in Pennsylvania, where William Still headed the Philadelphia Vigilance Committee; in New York, where David Ruggles (1810–1849) headed the New York City Vigilance Committee; and in Ohio, where the white Quaker, Levi Coffin, helped people arriving in Cincinnati. In the Southern and Border States, Quakers and other church people afforded fugitives refuge. Black churches and free African Americans offered the most dependable shelter to those on the run. The Underground Railroad network reached as far north as Michigan and up into Canada.

Statistics on fugitive slaves are hard to come by, but one estimate sets the number passing through Philadelphia before the Civil War at nine thousand.[33] Although this number was not enough to threaten slavery seriously as an economic institution, it sufficed to deny the pro-slavery claim that child-like African Americans were happy as slaves. After the strengthening of the Fugitive Slave Act in 1850, troops had to be called out in 1851 and 1854 to wrench fugitives from black and white abolitionists in Boston. Such a use of armed governmental force further polarized the opponents and supporters of slavery.

Harriet Tubman, Moses of Her People

The best-known guide to freedom was Harriet Tubman, the mythic heroine of the slave era. Enslaved on Maryland's Eastern Shore, Tubman was a physically strong worker who seized her own freedom in 1849 as she was about to be sold away from her husband and family. Her route of escape took her to Philadelphia, where she worked to finance her

5.8. Ann Tanksley, "Running to Freedom," 1987
The fugitives in Tanksley's painting grope their way through trackless woods in darkness. The light-colored ground may indicate snow and the nearness of free territory.

5. 9. Jacob Lawrence, "Harriet Tubman Series No. 10," 1938–1939
Lawrence shows Tubman making her way to freedom through a very dark night, an immense sky indicating the vastness of the land to be crossed.

Harriet Tubman and her Underground Railroad JBiggers 1952

5. 10. John T. Biggers, "Harriet Tubman and Her Underground Railroad," 1952
In Biggers's rendition, Tubman leads hundreds of suffering slaves, a mighty army of fugitives, to freedom.
In the left foreground he shows a man bound to the cross of cotton. On the right, a naked woman embodies the sexual abuse of enslavement.

return to Maryland for her sister. Tubman went back to Maryland some nineteen times,
so often that planters offered a $40,000 bounty for her capture. By the time she made her
last rescue in 1860, Tubman had earned the name "Moses of Her People."[34]

Tubman is one of the historical figures that black artists depict most often. Jacob
Lawrence's "Harriet Tubman Series No. 10," created early in his artistic career, traced
Tubman's life from her enslavement in Maryland to her delivery of her fellow slaves
to freedom (5.9). Like other fugitives, Lawrence's Tubman takes her bearing from the
nighttime North Star of the Big Dipper.

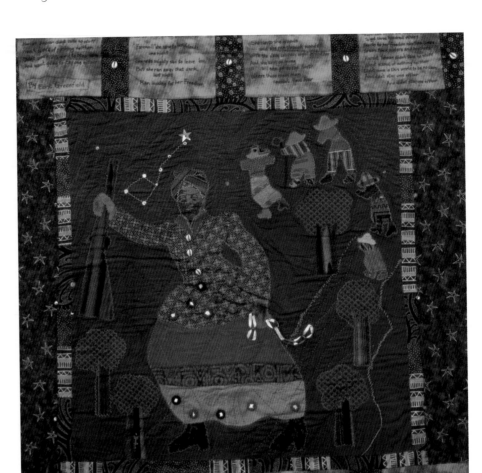

5. 11. Charlotte Lewis, "The Harriet Tubman Quilt," 1996
Surrounded by strips of African cloth, Lewis's Tubman leads a few people off beneath a poem in Tubman's honor.

John T. Biggers, "Harriet Tubman and Her Underground Railroad" (5.10), stresses the magnitude of Tubman's achievement by setting her at the head of a column of hundreds. They flee gruesome Southern cotton fields, the symbolic backdrop to American slavery. (Maryland, however, lay too far North for cotton and was actually a land of wheat and tobacco.)

"The Harriet Tubman Quilt" (5.11) by African-American quilter Charlotte Lewis (n.d.–ca. 2000) shows Tubman carrying a gun and the chains she has sundered. It is still nighttime, and the North Star and the Big Dipper show the way out of slavery. Strips of Ghanian Kente cloth frame Tubman and her followers.

Conclusion

By the time Harriet Tubman had led some two hundred people out of slavery in the 1850s, masses of white as well as black Americans recognized the evils inherent in the institution of slavery. Yet slaves were so fundamental a part of the American economy, especially the Southern economy, that it took armed conflict to set them legally free. The Civil War of 1861–1865 and the Thirteenth Amendment to the United States Constitution ended two and a half centuries of involuntary servitude for the 91 percent of African Americans living in the half of the United States built on enslaved labor.

6.1. Valerie Maynard, "General Fred," 1973

Maynard imagines a black man as a general during the Civil War, a war black men had a huge stake in winning. In actual fact, black men could not be generals or any other ranking officers.

◇ 6 ◇

Civil War and Emancipation

1859–1865

"General Fred" (6.1) by Valerie Maynard (b. 1937) shows a battle-ready black Civil War officer. By presenting Fred as a general, Maynard calls attention to one of the two great controversies that pitted African Americans and their allies against the Lincoln administration during the Civil War: the ban on black officers. The other controversy was unequal pay.[1] The prohibition against black men's becoming officers and their struggle against lower pay remind us that during wartime, black Americans battled on two fronts. Their Civil War enemy was the Confederate States of America, called the "Confederacy." But black Americans also had to combat racial discrimination on their own side—discrimination from the Lincoln War Department, from Northern public opinion, and, sometimes, from President Abraham Lincoln himself. This battle on two fronts is a fundamental story of African Americans in the era of the Civil War.

The Civil War began with a limited objective: to restore the Union. That war could not be won. Only after the United States, called the "Union," attacked slavery and allowed African Americans into the fight did the United States prevail. Only then did slavery end. But black Americans had to struggle to join the war. Once in the war, they had to struggle over the conditions under which they would fight.

The great drama of the Civil War era centers on black men—as the embodiment of "the Negro" and as the heroic figure of the black soldier. For the first time in American history, tens of thousands of black men served in the armed forces, when military service symbolized citizenship. African-American men fought valiantly in both the Revolutionary War and the War of 1812. But the Militia Act of 1792, which closed militia service to all but white men, meant that black soldiers remained exceptions to the rule. The Civil War was different, vastly different, from those earlier conflicts. Not only

was the enslavement of black people the root cause of the war, but the extent of African Americans' involvement was substantial. More than two hundred thousand black men fought—and thirty-seven thousand died—to eradicate slavery in the United States. Their actions brought down the world's most powerful slaveholding class.

The Civil War reshaped the larger American political economy by increasing the power of the federal government, amending the Constitution, and diminishing the vast influence of deeply conservative, rural, slaveholding Southern planters. From the founding of the Republic until the inauguration of Abraham Lincoln in March 1861, the federal government as well as Southern state and local governments had been dominated by the power of what abolitionists called the "slavocracy." Before 1861, a Southern slaveholder had been president for two-thirds of the history of the United States. In the United States Supreme Court, twenty of the total of thirty-five justices up to 1861 came from slave states, giving the court a permanent Southern majority.[2] One of those who belonged to that majority and to that history of slaveholding domination was slaveholder Chief Justice Roger Taney of Maryland, who had crafted the infamous Dred Scott decision declaring all black Americans less than citizens.[3]

The Civil War not only revolutionized American politics generally, it also wrought fundamental, global, human change. Civil War emancipation freed nearly four million people, more than in any other slave society in the world. The end of slavery in the American South signaled the end of slavery as a modern institution. No other emancipation struck so deeply at the institution of human slavery.[4]

While the historical narrative of the Civil War features black men's vindication of their manhood through military service, the era also wrought profound changes in the lives of black women and children. The nine-tenths of African Americans who had been enslaved—men, women, and children—became free. They became free by walking out of slavery; by serving in the Union Army and Navy; by spying, guiding, working for, and nursing Union forces; and by being emancipated through the actions of the federal government. Although the Civil War officially began as a struggle against disunion ("secession"), its great, permanent accomplishment was the human revolution of emancipation.

Men and women played starkly differing roles in the Civil War. Featuring soldiers as the liberators of women and children, the war began the long process of aligning the gender roles of black men and women more closely to those of middle-class Americans.[5] In slavery, women and children, as well as men, were first and foremost workers, and women and men worked side by side in fields, forests, workshops, and households. After the war, freed*men* were recognized as heads of household, freed*women* as wives and mothers of their children.

Emancipation started Southern black Americans on the way to wider recognition as human beings, whereas before the war the whole thrust of American law and society had defined them as property. As free people, black Americans sought to reunite their families and establish their own institutions, such as schools, churches, colleges,

thrifts, and burial societies. Northern African Americans, having been free for a generation or more, had already taken those steps. But with nine-tenths of the black population located in the South, reconstituted families and new institutions revolutionized African-American life as a whole. The image of "the Negro" was no longer an urban Northerner like Frederick Douglass. Rural Southern freedpeople became the most visible image of "the Negro."

Intriguingly, African-American artists have produced relatively little visual art on the themes of the Civil War and emancipation. For whatever reason, military and political subjects have attracted artists far less than black people as workers or even as lynch victims. Until the 1960s, African-American artists dealing with Civil War themes stressed emancipation. Only after the era of the Civil Rights and Black Power movements did they turn to the figure of the black soldier. (See illustrations 6.2, 6.4, and 6.6.)

Sectional Tensions Leading to War

Sectional tensions over slavery began as soon as the United States came into existence in the 1770s and 1780s. These tensions sharpened, as Northern states became industrialized, free territory, leaving Southern states as an agrarian land of bondage. The Missouri Compromise of 1820 and the Compromise of 1850 temporarily bridged the gap between the diverging needs of the Northern, Southern, and Western political economies. Ultimately, however, the vast territory added to the Union in the 1840s after the Mexican War opened a chasm between the free and slave states that political compromise could no longer bridge.

Under the leadership of reactionary South Carolinians (known as "fire-eaters" for their furious hot-headedness), Southern politicians had almost left—seceded from— the United States in 1832 and again in 1850. A series of crises over slavery continued throughout the 1850s, with Southern politicians demanding ever tighter safeguards for slavery and a ban upon even discussing abolition. Such discussions reduced the monetary worth of slave property. The issue of slavery in the territories sparked bloody warfare in the Kansas crisis of the mid-1850s, in which John Brown played a part, and led to the 1856 formation of the Republican party. Strictly speaking, the Republican party was not antislavery.[6] It did not propose to abolish slavery where it existed. But Republicans opposed the spread of slavery, which affected slave prices and seemed to Southern fire-eaters tantamount to abolitionism.

John Brown's October 1859 raid raised the level of sectional tensions almost to the breaking point. Intended to precipitate a slave uprising and crush slavery by force of arms, John Brown's raid on the federal arsenal at Harper's Ferry, Virginia, failed (see chapter 4). But it foreshadowed the slaughter that would finally bring slavery to its end. Just as violence permeated the institution of slavery, so violence caused slavery's demise. More than 620,000 combatants and at least 50,000 civilians died in the Civil War.[7]

Warfare also displaced half a million civilians, most of whom were black. They were

herded into the kinds of unsafe, unsanitary refugee camps that twentieth- and twenty-first-century wars would make sadly familiar. Enraged men raped black and white women in the refugee camps and wherever women were vulnerable to men who saw the women of the enemy as fair game. Violence occurred in the Union as well: rampaging antiblack rioters attacked African Americans in the summers of 1862 and 1863. In the Confederacy, angry former slaves faced angry former owners; white people, being better armed, usually inflicted the worst damage on black men, women, and children. But this was all still to come when the Union began to split apart in late 1860.

The election of 1860 made Abraham Lincoln of Illinois, the Republican candidate, president of the United States.[8] Lincoln's election was the last straw for belligerent Southerners who insisted that slavery's guarantees be made ironclad. Even though Lincoln was not an abolitionist and did not want to free any slaves, Southern politicians saw him as a mortal threat to their political economy. With Northerners unwilling to make further concessions to slaveholders and slaveholders insisting on assurance, the Union faced crisis. Even before Lincoln's inauguration in March 1861, political leaders in South Carolina started leading ten other slave states out of the United States.[9] (The other seceding states were Mississippi, Florida, Alabama, Georgia, Louisiana, Texas, Virginia, Arkansas, Tennessee, and North Carolina.) Secessionists established a new country, the Confederate States of America, and elected President Jefferson Davis—a rich planter, a former United States senator from Mississippi, and a former United States secretary of war. Secession created an additional nation, the Confederacy, on what had been the territory of only one, the United States of America.

A War About Union, Not About Slavery

The Civil War began in April 1861, when Confederate forces fired upon Union forces provisioning Fort Sumter, the federal fort at the head of the harbor of Charleston, South Carolina. With the declaration of war, President Lincoln called for volunteers, a call that black as well as white men answered. As soon as hostilities broke out, African Americans and white abolitionists recognized slavery as the cause of the conflict. Frederick Douglass said, "Any attempt now to separate the freedom of the slave from the victory of the government—any attempt to secure peace to the whites while leaving the blacks in chains—will be labor lost."[10]

Rebuff of Black Volunteers
Throughout the North, black men eager to strike a blow for freedom offered their services to the Union army. They formed militia companies and began drilling in New York City, Philadelphia, Pittsburgh, Providence, Cleveland, Battle Creek, Detroit, and Washington, D.C.[11] The Lincoln administration rudely refused their services on the

ground that the war was about union, not slavery. To African Americans and abolition-
ists, the rebuff was an annoyance but not a surprise, as they knew Lincoln to be soft on
slavery. Frederick Douglass had not supported Abraham Lincoln in the election of 1860.
Douglass's choice had been fellow abolitionist Gerrit Smith, nominee of the small, truly
antislavery Radical Abolitionist party. Douglass realized that in 1861 Lincoln's priority
was the preservation of the Union, not the liberation of the slaves.

Many white Northerners phrased the issue more pithily: "This is a white man's war."
White volunteers claimed that serving alongside black men would degrade them as
white men. Such notions held sway during 1861, as Northerners expected a quick and
easy victory. But 1861 did not produce victory. By mid-1862, it was clear that the war
would last for some time and would need many more men than originally envisioned—
as soldiers and as laborers.

The war went on for over a year before Lincoln's War Department deigned even
to consider accepting black men as soldiers. Only the pressing need for manpower
changed Union policy, and then only in fits and starts. Until the Union became desper-
ate for men, President Lincoln worried more about alienating the four slave states still
in the Union (Missouri, Kentucky, Maryland, and Delaware) than about emancipating
the enslaved.

Fugitive Slaves as "Contraband of War"

As soon as Union troops occupied slave territory along the Virginia coast, black refugees
began to come into Union lines. The Fugitive Slave Act of 1850 required that fugitive
slaves be returned to their owners. But the commander of Fortress Monroe, General
Benjamin F. Butler, realized that returning them would enrich the slave owners and
strengthen their fight against the Union.[12] Better, Butler reasoned, to keep the fugitives
and put them to work for the Union. To circumvent the Fugitive Slave Act, Butler des-
ignated these fugitive slaves as enemy property, as "contraband of war." In August 1861
the U.S. Congress passed the first Confiscation Act, which allowed Union forces not to
return fugitive slaves to their owners. In July 1862 the second Confiscation Act declared
contrabands forever free.

Individual African Americans acted on their own, exerting pressure on the Union
to address the issue of slavery. Masses of the enslaved fled to the Union army, where
they were lodged in refugee camps, which later became fertile recruiting grounds for
the army. Over the night of May 12, 1862, Robert Smalls (1839–1915) of Charleston,
South Carolina, performed an act of great heroism. In the *Planter*, a ship he piloted as
a slave, Smalls sailed himself, his family, and the family of his brother past Confeder-
ates in the Charleston harbor and on to Union forces at Beaufort. The United States
Navy promptly enlisted Smalls, who performed invaluable service for the duration of
the war. Smalls's bravery helped reduce the prevailing prejudice against black men as
combatants.

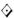

Pressure to Enlist Blacks

In 1862, in Massachusetts, in Kansas, and in recaptured Confederate territory in Louisiana and the Low Country of South Carolina, local politicians and generals began pressing for the enrollment of black men, slave and free, into the Union Army. The Lincoln administration resisted these arguments, whether moral and abolitionist or opportunist and tactical. In the summer of 1862 antiblack riots in more than six Northern cities, including Cincinnati and Brooklyn, bore out the continuing hatred of African Americans. In Brooklyn Irish workers tried to burn down a tobacco factory in which black women and children were working.

The hostility of many white Northerners toward African Americans discouraged many blacks from wanting to serve the war effort. For the most part, however, African Americans continued to demand the right to join the fight, which they knew held the key to freedom. The San Francisco black poet, J. Madison Bell (1826–1902), a former associate of John Brown, urged the enlistment of black fugitives, or contrabands, into the armed service in "What Shall We Do with the Contrabands?":

> Shall we arm them? Yes, arm them! Give to each man
> A rifle, a musket, a cutlass or sword;
> > Then on to the charge! Let them war in the van
> Where each may confront with his merciless lord,
> And purge from their race, in the eyes of the brave,
> The stigma and scorn now attending the slave.
>
> I would not have the wrath of the rebels to cease,
> > Their hope to grow weak nor their courage to wane,
> Till the contrabands join in securing a peace,
> > Whose glory shall vanish the last galling chain,
> And win for their race an undying respect
> In the land of their prayers, their tears and neglect.
>
> Is the war one for Freedom? Then why, tell me, why,
> Should the wronged and oppressed be debarred from the fight?
> Does not reason suggest, it were noble to die
> > In the act of supplanting a wrong for the right?
> Then lead to the charge! for the end is not far,
> When the contraband host are enrolled in the war.[13]

Emancipation and Colonization

By mid-1862 the Union was continuing to lose battles and men, and Great Britain and France were poised to recognize the Confederacy, purchase its cotton, and sell it war matériel. Facing these dire circumstances, the Lincoln administration edged away from

portraying the war as a narrow, white-men-only contest over union. The Militia Act of July 1862 empowered the president to enroll black men in war service, although the president was not yet ready to act. Lincoln still hoped to remove black people from the United States instead of recognizing them as an integral—and, now, necessary—part of the United States.

In 1862 President Lincoln could not yet envision a Union in which free black people lived side by side with whites. He considered freeing the slaves, but he also was drawn to the efforts of private companies to deport African Americans to Haiti. In December 1861 he had urged Congress to appropriate funds to transport the people known as "contrabands" outside the United States. In August 1862 the president met with five black men from the District of Columbia to try to convince them that the races should be physically separated, with black people banished to Central America.

Given the depth of antiblack racism, colonization appealed to some African Americans. In 1859 Martin Delany had traveled to what is now Nigeria in West Africa to investigate possibilities of settling black Americans there. In 1861 well-known black abolitionists, including James T. Holly (1829–n.d.), Henry Highland Garnet, and William Wells Brown, who had also struggled for free black people's civil rights, joined the government-sponsored push for resettlement in Haiti. They saw Haiti, the second republic in the Western Hemisphere (see chapter 4) and the preeminent black nation, as a place ideally suited for full-fledged black American citizenship.

The entry of black men into the Union's armed forces in 1862 changed the minds of black advocates of colonization. But Lincoln and Congress did not give up entirely on the goal of expelling free blacks from the United States until mid-1864. By then nearly one hundred of the 453 colonists from Washington, D.C., and Hampton, Virginia, on Ile à Vache, Haiti, had died of disease, exposure, and starvation.

At home masses of Northern black people had also spoken out against the idea that African Americans should be forced into exile. In the words of Isaiah Wears (1820–1900), a black Philadelphia businessman, colonization would only serve "to gratify an unnatural wicked prejudice . . . after so many years of oppression and wrong have been inflicted in a land and by a people who have been so largely enriched by the black man's toil."[14] As the war ground on, black laborers, soldiers, spies, and scouts belied the notion that the United States should be purged of the people whose unpaid labor had made it rich. Military necessity changed the nature of the war.

The War Against Slavery

The Civil War had begun as a struggle over whether one nation or two would prevail in United States territory. For President Lincoln and thousands of Northerners, the issue was not the existence of slavery, only the preservation of the Union. White men alone would preserve their Union, in which white men alone could be citizens. The failure of the Union to defeat the Confederacy not only demanded fresh sources of manpower. It

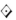

also prodded Lincoln toward admitting the war was a fight over slavery, in which emancipation would serve military ends.

The Emancipation Proclamations

Lincoln issued two Emancipation Proclamations: the preliminary and the final versions. The two versions were not the same. The preliminary Emancipation Proclamation of September 1862 followed a bloody Union victory in the battle of Antietam, Maryland. Like masses of black people and white abolitionists, Frederick Douglass welcomed Lincoln's preliminary announcement: "We shout for joy that we live to record this righteous decree."[15]

6.2. William H. Johnson, "Lincoln at Gettysburg III," ca. 1939–1942

Lincoln appears in Johnson's painting towering above black and white soldiers and white abolitionists. In fact, however, black soldiers were specifically prohibited from joining the battle at Gettysburg. Johnson painted Lincoln during the Second World War, when African Americans were still subject to discrimination in the armed forces.

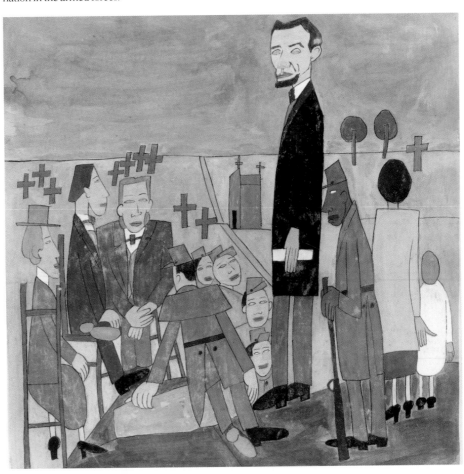

The preliminary Emancipation Proclamation applied only after January 1, 1863, and then only to slaves in territory controlled by Confederates. It did not apply in the four slave states in the Union (Delaware, Maryland, Kentucky, and Missouri). In those four states, politicians held fast to slavery. They rejected Lincoln's pleas for gradual emancipation, even with payment to owners.

The final Emancipation Proclamation of January 1, 1863, differed from the September 1862 version in a crucial respect: The final Emancipation Proclamation provided for the enrollment of freedmen into military service on behalf of the Union. The preliminary proclamation had included no such plan.[16] Like the preliminary proclamation, the final one also pertained only to the Confederate states; hence, it too fell short of the goal of universal, permanent emancipation. Despite the limitations of the Emancipation Proclamations, Abraham Lincoln became a hero for many black Americans.

In subsequent years, African-American artists made Abraham Lincoln one of their two favorite white subjects (John Brown was the other). In 1945, during another war in which black soldiers again suffered unjust treatment, William H. Johnson imagined Lincoln delivering the Gettysburg Address before an audience that included a black soldier (6.2). In 1863, however, black volunteers coming from Philadelphia and Harrisburg had been purposefully barred from taking part in the Battle of Gettysburg in southern Pennsylvania, the only Civil War battle fought in Northern territory.

Black Regiments in the Union Army

The regiments organized in the wake of the Emancipation Proclamation enrolled black men in far larger numbers than previously, thanks to the creation in May 1863 of a bureau in the War Department dedicated to the United States Colored Troops (USCT). The earliest black regiments had been formed in 1862 in Louisiana, Kansas, and South Carolina, against the wishes of President Lincoln and without full-fledged support of the War Department. But in early 1863—nearly two years after black men had begun petitioning to join the Union war effort—the War Department authorized Rhode Island, Massachusetts, and Connecticut to organize black regiments. Black men in the Confederacy waged no such campaign, although a few dozen to a few hundred served in the Confederate Forces.[17]

During 1863 thousands of black men volunteered for service on behalf of the Union. Some traveled long distances across Confederate territory to do so, risking their lives in the effort. Two of Frederick Douglass's sons, Lewis (1840–1908) and Charles (1844–n.d.), quickly volunteered for the Massachusetts 54th Regiment, the best-known of the USCT and the subject of the 1989 feature film, *Glory* (6.3).[18] The Douglass sons' action manifested the reasoning of thousands of African Americans, who believed with a speaker in a meeting of black men in Asbury Church in Washington, D.C.: "When we show that we are men, we can then demand our liberty, as did the revolutionary fathers."[19]

By early August 1863, fourteen black regiments were ready for service or already in the field. Twenty more regiments were being formed. By the end of 1863, more than

6.3. Frederick Douglass's two sons, Lewis (left) and Charles, in army uniforms, ca. 1863
Frederick Douglass's two sons, among the earliest African-American volunteers accepted into the Union Army, both served in the Massachusetts 54th Regiment. Lewis rose to the rank of sergeant major and participated in the Union assault on Fort Wagner in South Carolina in July 1863.

50,000 black men in more than 70 regiments were serving in the Union Army.[20] To them, their military service vindicated their manhood.

African Americans followed the course of the war closely, especially once black men participated. The Reverend Henry McNeal Turner (1834–1915) of the African Methodist Episcopal (AME) Church, the first black chaplain (of fourteen) in the Union Army, sent regular dispatches to the AME newspaper, the *Christian Recorder.*[21] Thomas Morris Chester (1834–1892) was the only African American reporting to a white newspaper. During 1864–1865, Chester sent the *Philadelphia Press* dispatches from Virginia.[22] Black enthusiasm for the U.S. Colored Troops was matched by Confederate hatred for the idea of armed black men in American uniforms.

Confederates did what they could to deny black soldiers respect as worthy opponents. In May 1863 the Confederacy announced its intention to kill or sell into slavery black prisoners of war. During 1864, reports surfaced repeatedly of Confederates' murdering black prisoners of war. The worst instance of murder occurred in April 1864 at Fort Pillow, Tennessee. The Confederate general who commanded the massacre founded the Ku Klux Klan one year after the war. Black soldiers repaid viciousness in

kind. Their battle cry became "Remember Fort Pillow," as they inflicted atrocities in revenge.[23]

Summer 1863: The Turning Point

The summer of 1863 brought a turning point on the battlefield as well as in the politics of the war. In the battles of Gettysburg, Pennsylvania, and Vicksburg, Mississippi, the Union blocked the Confederate push into Northern territory and assumed command of the Mississippi River, a major artery of transportation and trade. Also in July a wave of white attacks on black people in the cities of the Northeast created revulsion against racial violence. In four days of bloodshed in New York City and other locales in New York and New Jersey, draft rioters (three-fourths of whom were Irish) attacked African-American homes, churches, and other institutions. Rioters beat up and terrorized scores of black men and women and stormed the Colored Orphan Asylum with more than two hundred children inside. Rioters lynched eleven black men and beat several others severely. At least 105 people died in New York City in the bloodiest riot in U.S. history.[24]

Despite antiblack violence, black soldiers proved themselves valuable and valiant fighting troops in mid-1863. At Port Hudson and Milliken's Bend, Louisiana, free men of color and former slaves attacked a Confederate stronghold. The black abolitionist author William Wells Brown concluded that the black Louisiana troops' "undaunted heroism . . . created a new chapter in American history for the colored man."[25] More widely known was the Massachusetts 54th Regiment's assault on Fort Wagner, South Carolina. After this battle, Lewis Douglass wrote his fiancée that "this regiment has established its reputation as a fighting regiment . . . not a man flinched, though it was a trying time. Men fell all around me. A shell would explode and clear a space of twenty feet, our men would close up again . . . "[26] The Massachusetts 54th lost half its men and finally had to retreat. Despite the loss, the valor of the 54th dramatized black men's fitness for battle. But battle fitness did not exempt black soldiers from discrimination. They could not achieve high officers' ranks, and enlisted men earned lower wages than their white counterparts.

Struggles Over Officers and Equal Pay

Black soldiers' valor on the battlefield intensified their frustration over their two great problems. Regardless of how well educated or experienced or successful they were as soldiers, black men could not rise through the ranks to become commissioned officers. (The exceptions were chaplains and medical doctors, who could achieve the rank of major—as in the case of Major Martin Delany, a medical doctor.) Black men did serve as noncommissioned officers—sergeants and corporals—taking orders from white commissioned officers, which they transmitted to enlisted men. Black noncommissioned officers lived with enlisted men and counted as "men" in the armed services. By contrast, commissioned officers were considered gentlemen, at a time when most Americans

6.4. John Jones, "The New Order," 1998

Jones imagines the Confederate General Robert E. Lee's anxiety, had he been faced by General Colin
Powell (in the foreground), an equal in rank who could appear only a century later.

could not imagine black men as gentlemen. In the nineteenth century, black men coming out of slavery were still struggling to be acknowledged as men.

The campaign for equal pay became part of the battle. Black soldiers—whether enlisted men or noncommissioned officers—received pay of $7 per month. This rate prevailed whether or not the soldier had been free before the war and regardless of his level of education or military experience. White enlisted men received $13 per month plus a $3 clothing allowance. White noncommissioned officers received a few dollars more per month, depending upon their rank.[27]

Black soldiers and their abolitionist supporters protested the injustice of discriminatory pay. Lower pay insulted black soldiers and imposed dire hardship upon their families. The Massachusetts 54th and 55th refused to accept the lower rate of pay as a matter of honor. They even resisted the equalization offer from the state of Massachusetts on the ground that they fought for the Union, and the Union (not the state) should pay them fair wages. In late 1863 the 3rd South Carolina Volunteers, a regiment of former slaves, stacked their arms and refused to serve until granted equal pay. The army executed their sergeant, William Walker, for treason. Pay was not equalized until late in the war in two steps, in June 1864 and March 1865. The ban on black officers continued to rankle African Americans, reappearing as a point of contention as the United States entered the First World War in 1917.

The artist John Jones (b. 1950) imagined what the Civil War might have been like had black men been able to rise according to their abilities. Jones portrayed General Colin Powell (b. 1937), the commander of American troops in the 1991 Gulf War and secretary of state in the first George W. Bush administration, as Confederate General Robert E. Lee's counterpart more than a century earlier (6.4). Powell, in the uniform of the U.S. Army, rides confidently in the foreground, with Lee (on the black horse) regarding him warily from behind. This is one of relatively few depictions of the Civil War era by black artists. Its effectiveness depends upon its provocative imagination.

African Americans in the War Effort

Hundreds of thousands of black men, women, and children advanced the Union cause inside and around the organized armed forces. Without their active support, the Union would not have won this war on Southern territory. The enslaved were not given their freedom; they earned it. Fighting men garnered the most attention and bolstered black men's claims to manhood.

Two Hundred Thousand Black Soldiers and Sailors

By the time the war ended in April 1865, the Union Army included 179,000 black men—nearly 10 percent of the Union Forces. Some 33,000 black soldiers had enlisted in free states, about 42,000 in Union slave states, and about 98,600 from the Confederate states. Five thousand black men from the Confederate states joined units organized in

Northern states. About two million white soldiers and sailors served in Union Forces, approximately half of whom had been born abroad. Black and white men served proportionally at the same rate.[28]

Black men came into the Union Army from the far North as well as the Deep South, with the three Northern New England states of Maine, New Hampshire, and Vermont furnishing 349 black men (Table 6.1). In the Border States, particularly, black men volunteered for military service in astonishing numbers. Twenty-five percent of eligible black men in Delaware volunteered, as did 28 percent of black men in Maryland, 39 percent of black men in Missouri, and an amazing 57 percent of black men in Kentucky.[29] Overall, 21 percent of black men aged eighteen to forty-five served in the Union Army. This percentage was equal to that of whites. The Confederacy began toying with the idea of arming black men in 1864, finally approving their armed service just as the war ended in April 1865.

In his "Study for Aspects of Negro Life: From Slavery Through Reconstruction" (6.5), the Harlem Renaissance artist Aaron Douglas features black soldiers as the agents of freedom. Like Edmonia Lewis's and Meta Warrick Fuller's images of emancipation from 1867 and 1913 (6.8 and 6.9 below), Douglas's image includes the broken chains of slavery. But his study, unlike theirs, shows armed black soldiers—and even an armed woman perhaps evoking Harriet Tubman—poised to strike off those chains.

About 9,600 black men served in the Union Navy, which had allowed black enlistment from September 1861. The experiences of black sailors are far less well known than those of black soldiers, even though black sailors formed a quarter of the total naval force. Of the 9,600 black men serving in the Union Navy during the Civil War, more than 1,000 came from outside the United States, notably the West Indies. Among African-American sailors, about 3,800 came from the free states, about 2,400 from the border slave states, and 2,300 from the Confederate states.[30] All told, about 37,000 black men died in battle.

When the war ended in April 1865, blacks represented 11 percent of the one million men in the Union Army. Moreover, the Union Army of occupation was heavily black. Nonetheless, the War Department quickly disbanded black volunteer regiments. By October 1867, all African-American volunteers had been sent home, an act that put their lives at great risk. Southern white hostility to emancipation and, especially, to black soldiers, made soldiers and their families targets of vicious attacks. Community leadership by black veterans in the post war period further aggravated their former owners, leading to a loss of life that has never been calculated.

Corporal Thomas Long of the 1st South Carolina Regiment summed up the meaning of black men's armed service despite the manifold hardships and widespread discrimination: "If we hadn't become sojers, all might have gone back as it was before. But now tings can never go back, because we have showed our energy, and our courage and our naturally manhood."[31]

Spies, Scouts, Guides, and Nurses

The obvious black heroes of the Civil War were the soldiers, but women, children, and noncombatant men also aided the Union war effort as spies, scouts, guides, workers, and nurses. The best-known African-American nurse, Susie King Taylor (1848–1912), served with Clara Barton in South Carolina. Taylor, who learned to handle a gun in South Carolina, published an account of her Civil War service in *A Black Woman's Civil War Memoirs: Reminiscences of My Life in Camp with the 33rd United States Colored Troops, Late 1st S. C. Volunteers* (1902).[32] Mary Elizabeth Bowser (ca. 1839–n.d.) worked in the Confederate White House in Richmond, Virginia, where she spied for the Union.[33]

Table 6.1 Black Soldiers in the Union Army, by State

State	Number of Black Soldiers	State	Number of Black Soldiers
Northern Free States		*Union Slave States*	
Maine	104	Delaware	954
New Hampshire	125	Maryland	8,718
Vermont	120	Missouri	8,344
Massachusetts	3,966	Kentucky	23,703
Connecticut	1,764		
Rhode Island	1,837	Total	41,719
New York	4,125		
New Jersey	1,185	*Confederate Slave States*	
Pennsylvania	8,612	Virginia	5,919
District of Columbia	3,269	North Carolina	5,035
Ohio	5,092	South Carolina	5,462
Indiana	1,537	Florida	1,044
Illinois	1,811	Georgia	3,486
Michigan	1,387	Alabama	4,969
Wisconsin	165	Mississippi	17,869
Minnesota	104	Louisiana	24,052
Iowa	440	Texas	47
Kansas	2,080	Arkansas	5,526
		Tennessee	20,133
Subtotal	37,723	Subtotal	93,542
		Black soldiers recruited	
Black soldiers recruited		in Confederate states but	
in Confederate states		credited to Northern free states	5,052
but credited to Northern			
free states	(5,052)	Total	98,594
Total	32,671	Total for all areas	178,975

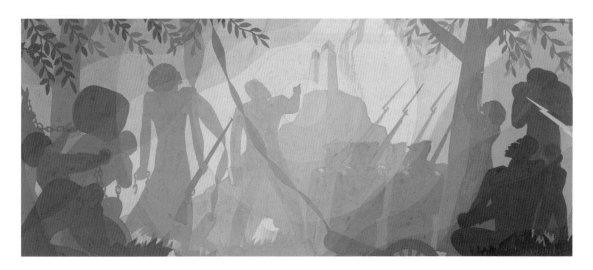

6.5. Aaron Douglas, "Study for Aspects of Negro Life: From Slavery Through Reconstruction," 1934

Douglas brings together workers, emancipated former slaves, Union soldiers, and African statuary (on the far right).

Harriet Tubman, the heroine of the underground railroad, distinguished herself through three years of service as a scout for the Union Army in South Carolina and Florida. A century after the war's end, artist Charles White celebrated Tubman's military prowess as a Civil War nurse, spy, and guide (6.6). White's title, "General Moses," points to the irony of Tubman's double disqualification: as both a black person and a woman, she could not officially gain an officer's rank.

Tubman's work with Union Colonel James Montgomery was unusual for a woman. Women were more likely to organize and staff freedmen assistance societies and schools for black refugees from battle zones. Elizabeth Keckley, a civic leader and the leading dress designer in Washington, D.C., founded one of the earliest societies to aid African-American refugees from the fighting in the Civil War.[34] African-American abolitionists like Sojourner Truth and Harriet Jacobs, author of *Incidents in the Life of a Slave Girl*, moved to Washington, D.C., where they helped poor black refugees find housing, food, clothing, and work.

Memorializing African Americans in the Civil War

African Americans began the work of remembering their Civil War veterans immediately, for other Americans began immediately to forget black soldiers' contributions. Black soldiers were purposely excluded on account of race from victory parades in Washington, D.C., Boston, and other cities.[35] Without black action, memory of the war would be lily-white. The abolitionist William Wells Brown published *The Negro in the Ameri-*

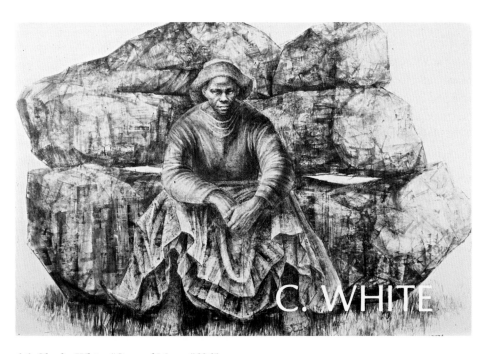

6.6. Charles White, "General Moses," 1965
White terms Harriet Tubman "General Moses" on account of her work as a scout and soldier for the Union Army during the Civil War, not because she could officially be acknowledged as an officer.

can Rebellion: His Heroism and His Fidelity in 1867. By the late nineteenth century, white Americans from the North and South were embracing each other in the name of reconciliation and ignoring the African Americans who had taken part in the war. To vindicate the contributions of black troops, the Union veteran, lawyer, and Ohio state legislator George Washington Williams (1849–1891) published the History of the Negro Troops in the Rebellion (1888).[36] Also in 1888 Joseph T. Wilson (1836–1891) published The Black Phalanx; A History of the Negro Soldiers of the United States in the War of 1775–1812, 1861–'65. By 1895, the noted poet Paul Laurence Dunbar (1872–1906) claimed the civil rights of black men in the name of those—including his father—who had fought in the Civil War in "The Colored Soldiers."[37]

If the muse were mine to tempt it
 And my feeble voice were strong,
If my tongue were trained to measures,
 I would sing a stirring song.
I would sing a song heroic
 Of those noble sons of Ham,
Of the gallant colored soldiers
 Who fought for Uncle Sam.

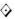

In the early days you scorned them,
 And with many a flip and flout
Said "These battles are the white man's,
 And the whites will fight them out."
Up the hills you fought and faltered,
 In the vales you strove and bled,
While your ears still heard the thunder
 Of the foes' advancing tread.

Then distress fell on the nation,
 And the flag was drooping low;
Should the dust pollute your banner?
 No! the nation shouted, No!
So when War, in savage triumph,
 Spread abroad his funeral pall—
Then you called the colored soldiers,
 And they answered to your call.

And like hounds unleashed and eager
 For the life blood of the prey,
Sprung they forth and bore them bravely
 In the thickest of the fray.
And where'er the fight was hottest,
 Where the bullets fastest fell,
There they pressed unblanched and fearless
 At the very mouth of hell.

Ah, they rallied to the standard
 To uphold it by their might;
None were stronger in the labors,
 None were braver in the fight.
From the blazing breach of Wagner
 To the plains of Olustee,
They were foremost in the fight
 Of the battles of the free.

And at Pillow! God have mercy
 On the deeds committed there,
And the souls of those poor victims
 Sent to Thee without a prayer.

Let the fulness of Thy pity
 O'er the hot wrought spirits sway
Of the gallant colored soldiers
 Who fell fighting on that day!

Yes, the Blacks enjoy their freedom,
 And they won it dearly, too;
For the life blood of their thousands
 Did the southern fields bedew.
In the darkness of their bondage,
 In the depths of slavery's night,
Their muskets flashed the dawning,
 And they fought their way to light.

They were comrades then and brothers,
 Are they more or less to-day?
They were good to stop a bullet
 And to front the fearful fray.
They were citizens and soldiers,
 When rebellion raised its head;
And the traits that made them worthy,—
 Ah! Those virtues are not dead.

They have shared our nightly vigils,
 They have shared your daily toil;
And their blood with yours commingling
 Has enriched the Southern soil.
They have slept and marched and suffered
 'Neath the same dark skies as you,
They have met as fierce a foeman,
 And have been as brave and true.

And their deeds shall find a record
 In the registry of Fame;
For their blood has cleansed completely
 Every blot of Slavery's shame.
So all honor and all glory
 To those noble sons of Ham—
The gallant colored soldiers
 Who fought for Uncle Sam!

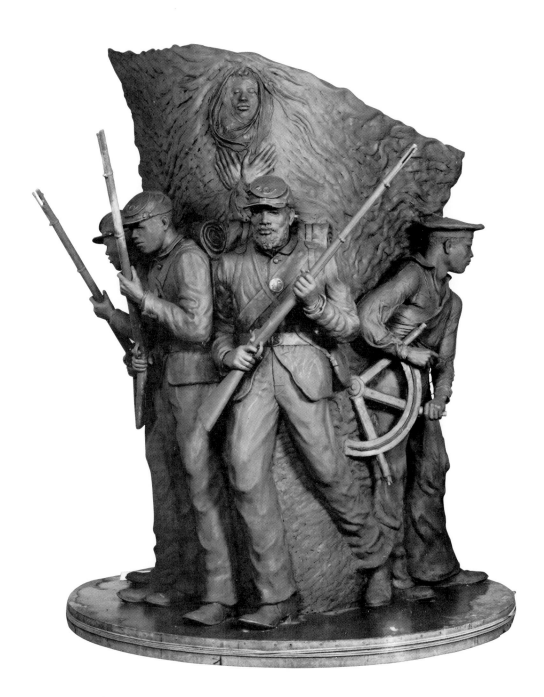

6.7. Ed Hamilton, "Spirit of Freedom" monument, Washington, D.C., 1997–1998
This monument honoring the men who served in the Union Armed Forces is only the second in the
United States depicting black Civil War servicemen and the first purely in their honor. It shows black
soldiers and sailors on duty and, at the back, their family members.

The role of African Americans in the Civil War remained little known except to historians until the feature film *Glory* (1989) showed the heroism of the Massachusetts 54th Regiment.[38] *Glory* encouraged black men and women to join the rolls of Civil War reenactors. In 2000 the historian Allen B. Ballard published *Where I'm Bound*, the first novel featuring a black Civil War soldier.[39] New concern for blacks in the Civil War led to the creation of the African American Civil War Memorial and Freedom Foundation Museum in Washington, D.C., in 1998 and 1999. The nine-foot memorial, by the African-American sculptor Ed Hamilton (b. 1947), dominates the intersection of Tenth and U Streets (6.7).[40] For African Americans living during the Civil War and those coming after, black soldiers made the down payment on emancipation from slavery.

Slavery Destroyed

Enslaved African Americans, like their free, Northern black and white allies, knew immediately that slavery lay at the basis of the war and that if the Union won, they would be free. In dramatic and subtle ways, they began seizing their freedom as soon as fighting broke out. Slavery gave way to freedom in many different ways, depending upon individuals, families, and the circumstances of servitude and warfare.

Even when the Union Forces were far away, owners began to notice changes in their workers. Sometimes the change was manifest in displays of independence or anger, both forbidden in the slave regime. More often the enslaved ran away from their owners, especially when owners sought to move their workers away from hostilities. As soon as Union Forces came anywhere near, black men, women, and children volunteered as workers and, if possible, as soldiers. Such acts inspired the Confiscation Acts of 1861 and 1862. In the Union-occupied territory of tidewater Virginia, the South Carolina, Georgia, and Florida Low Country, and Southern Louisiana, thousands of fugitives made themselves effectively free by flocking to the Union Army.

Whenever owners fled from Union Forces, some slaves stayed put, investing their labor in their gardens and away from their owners' cash crops of cotton, rice, or tobacco. All over the South, black people preferred to raise subsistence crops for food instead of commodities for sale. This was still hard farm work. When young men left home for military service, their heavy work fell to women and children. Years later, people who had been children during the war remembered their labor: James Henry Nelson, only ten in 1865, said, "You know chillun them days, they made em do a man's work." Eliza Scantling, age fifteen at the war's end, "plowed a mule an' a wild un at dat. Sometimes me hands get so cold I jes cry."[41] Despite the hardships, women and children doing men's work took a step into freedom.

As the Union Army occupied more and more Confederate territory, it became an army of liberation. Black soldiers particularly relished the act of informing black people that they were free. Union occupation might offer only an uncertain and transient freedom, however. Union withdrawal from northern Alabama and middle Tennessee in

August and September of 1862 left former slaves at risk of re-enslavement and revenge at the hands of enraged Confederates.[42]

Legal emancipation came haltingly. In April 1862 the federal government abolished slavery in the nation's capital of Washington, D.C., compensating former owners for their loss. The preliminary Emancipation Proclamation of September 1862 voiced President Lincoln's intention to free slaves in Confederate territory. Even though African Americans and their allies celebrated the final Emancipation Proclamation as a Day of Jubilee on January 1, 1863, in fact, it represented symbolic rather than actual emancipation. The abolition of slavery occurred in the Union slave states of Maryland and Missouri in January 1865. In effect, the Confederate surrender at Appomattox, Virginia, in April 1865, abolished slavery nearly everywhere else. Yet black people remained enslaved in three states: Texas, Delaware, and Kentucky.

Confederate surrender took place two months later in Texas, where black people could not celebrate their freedom until June 19. This tardy emancipation gave rise to the enduring African-American holiday of "Juneteenth." The last slaves to taste freedom lived in the Union slave states of Delaware and Kentucky. The few hundred slaves in Delaware and the tens of thousands in Kentucky had to await the December 1865 ratification of the Thirteenth Amendment to the United States Constitution before their enslavement ended.[43]

Emancipation wrought a revolution, but no one moment marked the permanent change from slavery to freedom. For uncertainties surrounded the actual circumstances of emancipation. Looking back, a former slave recalled, "Everytime a bunch of No'thern sojers wold come through, they would tell us we was free and we'd begin celebratin'. Before we would get through somebody else

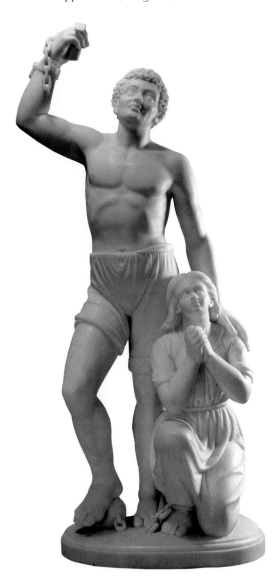

6.8. Edmonia Lewis, "Forever Free," 1867
Lewis's image of emancipation shows a woman kneeling and a man carrying broken chains standing above her, both in poses characteristic of fine art of the time. Lewis's work belongs to the aesthetics of classical, nineteenth-century sculpture, for she was formally trained and worked in Rome.

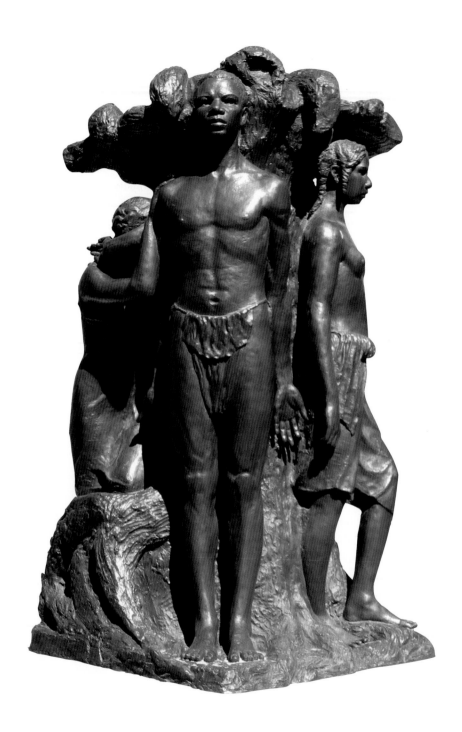

6.9. Meta Warrick Fuller, "Emancipation," 1913
Once again, the towering symbol of emancipation is a barely clothed man, this time obviously of African descent. W. E. B. Du Bois and the New York State Emancipation Proclamation Commission commissioned this monument to celebrate the fiftieth anniversary of emancipation. It is now at the National Center of Afro-American Artists in Boston.

would tell us to go back to work, and we would go." Another said he had celebrated his freedom "about twelve times."[44]

Having endured so much pain and violence as slaves, most freedpeople had learned to conceal their joy as well as their anger. Instead they planned for an unknowable future with thoughtful care. But some acted out their rage in dramatic ways, striking, even murdering owners, burning barns, and desecrating owners' property. In Yazoo City, Mississippi, in June 1864, slaves burned down an entire section of the town.[45] Black artists' depictions of the coming of freedom avoid showing anger, stressing the quiet dignity of those who became free. The earliest is "Forever Free" by Edmonia Lewis (6.8). This sculpture shows a grateful couple, the silky-haired woman kneeling, the curly-haired man brandishing a broken slavery chain.

On the semi-centennial of the Emancipation Proclamation, Meta Warrick Fuller (1877–1968) depicted the suffering of black families that had preceded emancipation (6.9). As in Lewis's "Forever Free," Fuller's central figure is a bare-chested, bare-legged, barefoot man, but recognizably African-American.

Conclusion

The right to fight had demanded a long-running fight of its own. Ultimately the Union victory of April 1865 resulted in universal, legal emancipation, which black and white abolitionists had demanded from the very beginning. During the war, black men, women, and children had seized their freedom by joining the hostilities as soldiers, sailors, scouts, nurses, and laborers. Black men from Maine and Vermont joined the tens of thousands from the Confederacy on the side of the Union. They and their families saw their service as payment for freedom. The Civil War ended in emancipation, but making freedom real demanded a series of struggles lasting another hundred years and more. Those struggles began with the work of Reconstruction.

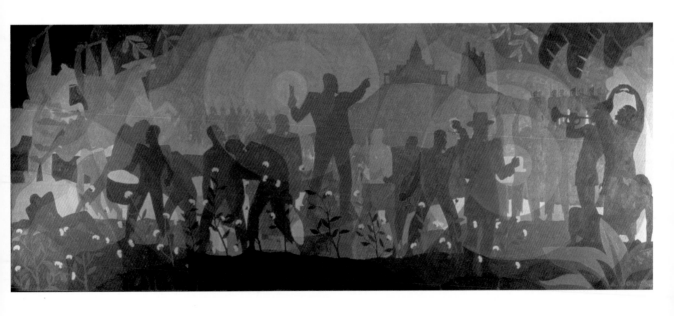

7.1. Aaron Douglas, "Study for Aspects of Negro Life: From Slavery Through Reconstruction,"
1934
For Douglas, standing upright in political exhortation, working in the cotton fields, creating new music,
and building cities in the bright sunlight of freedom symbolize the era of Reconstruction.

The Larger Reconstruction

1864–1896

The Harlem Renaissance artist Aaron Douglas captured the era's promise of active citizenship and its realities of racist violence and unremitting toil in "Study for Aspects of Negro Life: From Slavery Through Reconstruction" (7.1).

Douglas shows men and women busily making music and building up farms (in the foreground) and cities (in the background). Black soldiers (at the rear) march away to fight the Indians. Hooded, night-riding terrorists on horseback approach on the left. The figure on the far right brandishes a broken chain of slavery, while the man on the left front has been struck down. Douglas is reflecting the fact that state and local governments tolerated—and often sponsored—the antiblack terrorism that characterized the age. This is one of relatively few depictions by black artists of the era of Reconstruction. Although Reconstruction began a few years of optimistic promise, the promises remained largely unfulfilled. For the most part, ultimately disappointing nineteenth-century politics did not inspire black artwork.

Black achievement in the South during the era of Reconstruction was enormous. But every success occurred against a backdrop of intimidation and actual bloodshed. African Americans reconstructed their families, pursued formal education, and created their own institutions. Men tried to vote and hold office as though they lived in a democracy. They did not. For black people, democracy proved limited and fleeting. However, the institutions created during the larger era of reconstruction (1864–1896) endured.

In its strictest political sense, Reconstruction proceeded on a state-by-state basis, between 1865 and 1877. Historians divide this period into two parts: "Presidential Reconstruction," 1865–1866, and "Congressional (or Radical) Reconstruction," 1867–1877. After the assassination of President Lincoln in April 1865, President Andrew Johnson of

Tennessee took over the process of readmitting ("reconstructing") the former Confederate states to the Union. Johnson granted pardons wholesale to high-ranking Confederates, restoring their confiscated lands along with their citizenship. Johnson allowed former Confederates to return to office within their states and the federal Congress. Black men did not vote during Presidential Reconstruction.

Congressional Reconstruction began in 1867, after Congress wrested control from the president and enfranchised black men in the former Confederacy. During Congressional Reconstruction, many African-American men exercised the rights of citizens. They voted, in theory at least, until the Compromise of 1877 withdrew federal support for black civil rights. In practice, Congressional Reconstruction empowered black men for a shorter period of time—mainly from 1867 until the early 1870s.

The larger reconstruction, lasting into the 1890s, was the work of black people themselves—as the builders of their own institutions. The period of Reconstruction after the Civil War, bloody through it was, held the promise of black freedom and civil rights. The larger reconstruction ended when the Southern and Border States and localities enacted policies that effectively disfranchised and segregated African Americans, excluding them from public life.

Making Freedom Real

Legal freedom meant that those who had been enslaved could marry, earn wages, change employers, and own property. They were no longer mere extensions of other people's will. Making freedom real meant more than changed legal and economic status. For many freedpeople, families and land of their own came first. They also made freedom real by creating their own educational and religious institutions. Only men could vote, but whole families and communities took an interest in politics.

Reuniting Families and Finding Work

As the war ended, Southern black people sought first of all to reunite their families. Before and during the war, parents, children, siblings, and spouses had been separated by sale, by their owners' migrations, and by the disorder of hostilities. As walking was their main means of getting from one place to another, refugees took to the roads. One man walked the six hundred miles from Georgia to North Carolina in search of the wife and children he had been sold away from as a slave.[1]

Sympathetic newspapers—published by or for African Americans—carried special "lost friends" columns, in which freedpeople described the loved ones they were looking for and sought help locating them. Freedpeople on the move were going home, leaving home, and seeking jobs or farms in more promising places. In the eyes of those who resented the former slaves' freedom, the very fact of their mobility invited attack. In the chaos of 1865, freedpeople on the move fell victim to assault, and corpses appeared alongside the roads that people traveled in search of family.[2]

Family unification entailed conflict as well as harmony. Hundreds of thousands of men and women made their marriages legal, a process that began with black soldiers during the war.[3] But sometimes sorting out who should be married to whom presented thorny problems. Slaves had not been able to marry legally, and slave sales and the disorder of the war had further disrupted relationships. People who had never expected to see their partners again after many years of separation had taken new spouses. In such situations, freedom and reunification could impose wrenching choices.

Freedom also conveyed new meanings about work and individuality. National publications featured hundreds of articles asking whether the freedpeople would "work." The question meant whether they would continue to toil in cotton, tobacco, and rice fields from dawn until dusk for their former owners, as they had while enslaved. This use of the word "work" focused on crops raised for the market and differed from what freedpeople wanted. They fully intended to work, but less for the market or for the good of other people. They meant to work the land, but more to raise crops to feed themselves and their families. They would no longer labor in gangs or work to the point of utter exhaustion. In 1865 and 1866 the former Confederate states passed a series of Black Codes intended to coerce the labor of black men, women, and children through vagrancy and apprenticeship laws. Congressional Reconstruction rendered the Black Codes void for several years.

The conflict between the two definitions of "work" continued throughout Reconstruction and resulted in the sharecropping system. In sharecropping, landless farm families of any race worked land owned by others. Sharecroppers escaped the gang system and close supervision that had characterized slave agriculture. Sharecropping farmers raised crops for sale, notably cotton and tobacco, and shared with owners the profits after sale. The division of profits varied from place to place and according to whether the farmer or owner supplied draft animals and seed. As it turned out, farmers lost out to the owners all too often. At best, sharecropping families made a few hundred dollars per year. At worst, they became mired in never-ending debt.[4] As freedpeople, farming families worked about one-third fewer hours per capita than they had as slaves. Children were no longer forced to work as hard as possible, and women worked fewer hours in the fields, spending more time with their families.

Freedom had more personal meanings as well, for freedpeople wanted to appear more attractive than they had as ragged slaves. They cast off the slave clothing of degraded drudges and adorned themselves as handsomely as possible. Their improved appearance confused and outraged observers as much as their new sense of independence.

The insurrection scare of Christmas 1865 revealed the depth of the division between former slaves and former masters. During the fall of 1865 a rumor spread among white Southerners that the freedpeople planned to rise up and kill their former masters. No such plan existed. The combination of individual acts of anger and the widespread nature of freedpeople's pursuit of their own interests translated into "insurrection" in the minds of former owners. Freedpeople were more interested in owning land than in plotting against the people who had owned them.

Land Ownership: Forty Acres and a Mule

Land ownership stood high on the agenda of Southern black people. To secure land they could farm on their own, they employed a range of means—legal, economic, and forceful. The struggle for land took place on the ground in the South and in the federal and state governments.

In Savannah, Georgia, General William T. Sherman met with local black leaders in early January 1865. They included the Reverend Garrison Frazier (1798–n.d.), who had purchased his freedom in 1857. Speaking for the community, Frazier expressed the meaning of freedom as the ability "to have land, and turn it and till it by our own labor." Shortly after this meeting, General Sherman issued his Special Field Orders No. 15 allocating the South Carolina, Georgia, and Florida Low Country for the exclusive settlement of freedpeople. Each family was eligible for forty acres of land, and the army would lend its mules to help with cultivation.[5]

In Washington, D.C., in March 1865, the act creating the Bureau of Refugees, Freedmen, and Abandoned Lands (the "Freedmen's Bureau") included provision for land redistribution.[6] Freedpeople would be eligible to acquire forty-acre plots from land abandoned by Confederates and confiscated from them. The Bureau was unable to transfer land to freedpeople, however, because President Johnson restored confiscated and abandoned land to its former Confederate owners.

By reinstating the property rights of former Confederate planters, Johnson's Reconstruction policies of 1865 and 1866 frustrated freedpeople's ambition of owning their own land. During the brief life of the Freedmen's Bureau, it was woefully understaffed and minimally funded. Most agents had been withdrawn from the South by 1867, all by 1869.

Dispossessed freedpeople did not easily give back the land, which they believed they owned because they had worked it. Throughout areas of dense black settlement, returning owners confronted former slaves over possession of the land. Near Richmond, Virginia, a freedman named Cyrus informed his former young mistress of the new order: "Der ain't goin' ter be no more Master and Mistress, Miss Emma. All is equal." Cyrus asserted his right of possession, saying he had heard at the courthouse that all the land now belonged to the Yankees. This rumor, however, did not hold the key to his reasoning. Cyrus claimed a particular piece of the big house as his share, because "I help built hit."[7]

Up and down the Low Country from Virginia to Georgia, former owners and Freedmen's Bureau agents reported the freedpeople's determination to hold on to land they saw as their own. The rapid withdrawal of Union troops and officers of the Freedmen's Bureau deprived freedpeople of support. Soon they were left at the mercy of their well-armed and determined former owners. Only about two thousand freedpeople actually received land as a result of governmental policies.[8]

Over time, Southern freedpeople did manage to acquire farms and even a few plantations through purchase. In 1900, the first year for which such figures are available, black farmers owned hundreds of thousands of acres of land throughout the United States. In the North the black population was mostly urban. Those who farmed were far more likely

Table 7.1 Black Farmers in 1900 by Owner Status and Farm Location

Division	Total	Owners	Tenants	Managers
United States	746,715	187,797	557,174	1,744
Geographic Divisions:				
New England	246	197	54	13
Middle Atlantic	1,497	953	490	54
East North Central	5,179	3,064	2,070	45
West North Central	7,076	3,908	3,104	64
South Atlantic	287,933	84,389	202,578	966
East South Central	267,530	49,888	217,318	324
West South Central	176,899	45,141	131,487	271
Mountain	133	104	26	3
Pacific	204	153	47	4
Southern States	732,367	179,418	551,383	1,561

to be owners than tenants. In the Southern states, however, the situation was reversed: more than 500,000 black farmers were tenants, less than 180,000 were owners. The ability of the Southern black minority to buy their own farms represents an enormous achievement, for their parents and grandparents had entered freedom virtually penniless.

In 1910 two-thirds of black farmers were landless, and their numbers increased after that date. This lack of land ownership reflected the poverty not only of black Southerners, but of Southern farmers of all races who lost control of their land over the course of the twentieth century. Steadily climbing tenant rates and debt, rather than ownership, remained the lot of the Southern poor, black and white (Table 7.1).

Education for Freedpeople

As slaves, Southern black people had been kept uneducated, and they rightly regarded their ignorance as a badge of servitude. In 1860 more than 90 percent of the adult Southern black population was illiterate.[9] After emancipation, education became one of their first priorities and earliest preoccupations. In their striving to become educated, they drew support from a variety of institutions: the Union Armed Forces, Northern free blacks, the Freedmen's Bureau, black and white churches, and above all, themselves.

Mary S. Peake (1823–1862), a free black Virginian, had been illegally teaching local black people to read since the late 1840s. She became one of the first teachers in Union-occupied Fortress Monroe, Virginia, in 1861.[10] Her school formed the nucleus of what later became Hampton Institute, one of the earliest centers of African-American higher education. In Natchez, Mississippi, black women founded three schools, and in Savannah, Georgia, they founded two large schools during the war.[11]

Northern black people felt a special tie to Southern blacks, a tie that after the war often

translated into their going South as teachers. Virginia C. Green (n.d.), a Northern teacher of freedpeople said: "I class myself with the freedmen. Though I have never known servitude they are in fact my people."[12] As soon as Union Forces occupied the South Carolina Sea Islands in 1861, black and white abolitionists from the North answered the call for teachers. Among them was Charlotte Forten (1837–1914) of Philadelphia, an African-American abolitionist who had been educated in Salem, Massachusetts.[13]

Whether black or white, Northerners who went to teach the freedpeople encountered tremendous hostility in the South. They were lumped together with profiteering entrepreneurs and aspiring politicians and were called "carpetbaggers," a highly unflattering term for people who threatened prevailing arrangements of political, economic, and social power.[14] Angry former Confederates shunned the whites and abused the blacks, often burning down schoolhouses and driving teachers out by force. Many Northerners gave up after a few years, leaving only the most dedicated to work alongside black Southerners.

Even before the Confederate surrender, black Southerners were attempting to teach each other in whatever schools they could devise. African-American communities taxed themselves to pay teachers. After the war, freedpeople's schools received support from national institutions such as the Freedmen's Bureau, the African Methodist Episcopal Church, and the American Missionary Society. In addition, black Southerners themselves contributed much of the financial support that kept schools going. By the 1870s, poor Southern freedpeople had managed to invest more than a million dollars in their own education.[15]

Before winding down its educational work in 1869–1870, the Freedmen's Bureau spent more than five million dollars educating nearly a quarter of a million freedpeople in more than four thousand schools.[16] The Freedmen's Bureau (together with largely white religious associations such as the American Missionary Association) also helped support institutions of higher education, such as Fisk University in Nashville, Tennessee (founded in 1865); Howard University in Washington, D.C. (founded in 1867); St. Augustine's College in Raleigh, North Carolina (founded in 1867); Atlanta University in Atlanta, Georgia (founded in 1867); and Hampton Institute in Hampton, Virginia (founded in 1868).

Protestant missionary societies such as the Congregational Church's American Missionary Association (AMA) sponsored Northern and Southern teachers, including Mary Peake. The AMA also supported schools that the Freedmen's Bureau had started but no longer supported. And along with other African-American church missionary societies, they founded institutions such as Claflin University in Orangeburg, South Carolina, which began as the Baker Bible Institute in Charleston in 1866.

Education was no panacea, however. It contained its own pitfalls, for the body of formal knowledge in the United States conveyed its assumptions that African Americans were ignorant and inferior as a race. In the pursuit of knowledge, particularly higher education, black educators continually had to negotiate between promoting useful skills and countering antiblack stereotypes.

Despite the troublesome racial assumptions inherent in American education, African Americans made themselves a literate population as soon as education came within their reach. Whereas in 1860 about 90 percent of Southern black people had been illiterate, by 1890 (the first year for which reliable statistics are available) that proportion had decreased to 57.1 percent. And by 1900, only 44.5 percent of African Americans were illiterate. In 1910, the 30.4 percent who were illiterate were mostly older people, and young people were largely literate. At that time 39 percent of black people sixty-five and over could not read or write, compared to only 19 percent of those between ten and fourteen.[17]

Throughout the post-war South—as had been the case in the North before the Civil War—black churches offered spaces where African Americans could confer and worship as they pleased, free of white surveillance. As black people's largest public meeting places, churches also frequently housed schools and voluntary associations. Meeting in church, women and children could participate in political discussion, influencing politics without being able to vote.[18] Along with schools, Southern black churches became a symbol of emancipation, and the political empowerment of Reconstruction, where education, politics, and social life all converged.

Freedpeople's Churches

Protestant churches of many sorts flourished among the freedpeople, as thousands of locally established Baptist congregations grew up and churches stemming from the Northern Methodist denominations took root. Protestants' beliefs and worship practices varied widely, even within denominations. In the African Methodist Episcopal Church (AME), for example, Bishop Daniel Payne (1811–1893) favored an educated ministry, while his colleague, the Reverend Henry McNeal Turner (1834–1915), welcomed exhortation along traditional Southern lines. Some Northern and Southern worshippers practiced the ring shout, while others sat quietly through learned sermons. Until the very late nineteenth century, when the Vatican sponsored missionaries to African Americans in the South, black Catholics clustered mainly in traditionally Catholic Maryland and New Orleans.

Tens of thousands of Southern African Americans, who as slaves had lacked their own churches and belonged to predominantly white congregations, now withdrew to their own places of worship. The 42,000 black Methodists in biracial congregations in 1860 had, by the 1870s, dwindled to only 600.[19] Southern black Baptists, Presbyterians, and Methodists founded their own African-American denominations during Reconstruction.

Black churches from the North attracted large numbers of Southern black members after emancipation. The African Methodist Episcopal Church, for instance, founded in Philadelphia in 1794, had 20,000 members in 1856. By 1865, its membership had increased to 75,000 and to more than 200,000 in 1876.[20]

Black clergymen, often better educated and more experienced in public speaking

than their congregants, were well represented among Reconstruction's emerging politicians. The Reverend Hiram R. Revels (1822–1901) of Mississippi, elected to fulfill Jefferson Davis's unexpired term in the U.S. Senate, was a minister in the African Methodist Episcopal Church who had recruited black soldiers to the Union Army, taught school during the war, and served as chaplain of a black regiment. Originally a free North Carolinian, Revels had received his education in the North and migrated South after the Confederate surrender.[21] As both a clergyman-turned-politician and a man who had been free in the North and come South to serve the freedpeople, Revels represented larger trends of his times.

The Reverend Henry McNeal Turner, also of the AME church, served as a chaplain in the Union Army during the Civil War and was elected to the Georgia constitutional convention and the assembly during Reconstruction. The Georgia assembly expelled all its black representatives, Turner included, in 1870. This miscarriage of democracy, together with the antiblack violence that unraveled Reconstruction, blighted Turner's hopes for Southern civil rights. He supported black emigration to Liberia in 1877.[22]

Voting and Holding Office

While some white abolitionists declared their mission accomplished with the passage of the Thirteenth Amendment outlawing slavery, Frederick Douglass thought the work was only half done: "Slavery is not abolished until the black man has the ballot."[23] Black men in the North as well as the South needed the vote, for before the ratification of the Fourteenth and Fifteenth Amendments, only in New England could Northern black men vote or hold office.

Well before the end of the war, black and white abolitionists had seen black men's enfranchisement as the only way to protect African-American freedom in the South and a necessary right in the North. In 1864 black men met in Syracuse, New York, to form a National Equal Rights League and demand the vote and the range of civil rights (serving on juries, for example) that Northern states had denied black men during the antebellum era.[24]

Northern as well as Southern whites opposed enfranchising black men. In 1864 President Abraham Lincoln had urged limited suffrage for black men upon the leaders of the conquered and readmitted state of Louisiana. He had in mind the well-educated and well-off free men of color in Louisiana, who had fought for the Union. If any group of African-American men were qualified to vote, it would surely be the free colored men of Louisiana. The new, all-white legislature rejected Lincoln's suggestion out of hand. Lincoln's notions of Reconstruction after the war would only tinker with the South's power structure, not overturn it to the degree necessary to permit black suffrage. Virtually all the Northern states of the Union prevented black men from voting as well.

Ultimately, Southern black men gained the vote before Northern blacks. Without Southern black men, who supported the Republicans, the Southern states could not be readmitted into the Union. That is, the former Confederacy could not be "recon-

structed" as a loyal part of the United States. Without black voters, the Southern states would return to the control of the Democrats who had taken the Confederacy out of the Union in the first place. Congressional Republicans faced a tough choice: either they would need to enfranchise black Southerners, who would be Republicans, or they would see the South revert to control by the Democrats who had seceded in 1861.

Congress wrested control of Reconstruction away from President Johnson in late 1866 and impeached him, taking control of the process of readmitting the states of the former Confederacy. Black men were allowed to elect and be elected as delegates to the constitutional conventions that would reconstruct the Southern states. In January 1867, black men throughout the former Confederate states and the District of Columbia voted and held office for the first time, all as Republicans. The Union Army oversaw the process of registering 735,000 black and 635,000 white men. Five states—Mississippi, South Carolina, Louisiana, Alabama, and Florida—had black electoral majorities. Before the 1868 ratification of the Fourteenth Amendment—which reversed the *Dred Scott* decision and declared black men citizens—the former Confederacy was the only place in the United States in which large numbers of black men could vote. The Southern state constitutional conventions abolished property qualifications for voting and holding office, providing for the full enfranchisement of poor men, white and black.

Reconstruction occasionally created extraordinary opportunities, particularly in areas of heavy black population, such as in the Georgia rice coast's McIntosh County, centered on the town of Darien. Tunis Campbell (1812–1891) of New Brunswick, New Jersey, was one of hundreds of Northern African Americans drawn South after the war by the prospect of helping the freedpeople and enlarging their own opportunities. In McIntosh County, Campbell created a political machine that furthered the needs of the local people and protected them from white attack. With Campbell's guidance, freedpeople controlled their own public life. That lasted only until 1876, four years after white supremacist Democrats took over the state of Georgia. Although Democrats resented Campbell's power and even put him on a chain gang when he was seventy, he managed to remain in Georgia until 1882.[25]

In the state legislatures of 1867, black men held the majority only in South Carolina and there only briefly. South Carolina's first Congressional Reconstruction legislature had a black majority, although whites always controlled the state senate. Two black men, Alonzo J. Ransier (1834–1882) and Richard H. Gleaves (n.d.) served as lieutenant governors; Samuel J. Lee (n.d.) and Robert B. Elliott (1842–1884) served as speakers of the house. Francis L. Cardozo (1837–1903), educated in Glasgow and London, served as secretary of state and treasurer.

Black office holders also exercised political influence in Louisiana, where 133 black men held seats in the legislature between 1868 and 1897. Three black men served as lieutenant governor and one, P. B. S. Pinchback (1837–1921), served as acting governor for forty-three days.[26] Elsewhere black officeholders experienced serious difficulties taking and holding office. In Georgia, for instance, white legislators barred elected black

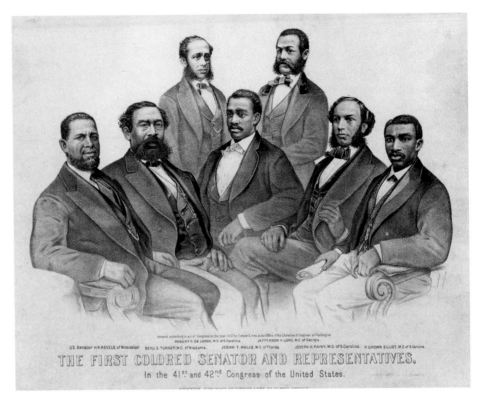

THE FIRST COLORED SENATOR AND REPRESENTATIVES.
In the 41st and 42nd Congress of the United States.

7.2. Currier and Ives Lithography Company, "The First Colored Senator and Representatives, in the 41st and 42nd Congress of the United States," 1872

By the early 1870s seven black men were serving in the United States Congress: (from left to right) Senator Hiram R. Revels (Miss.) and Representatives Benjamin S. Turner (Ala.), Robert C. De Large (S.C.), Josiah Walls (Fla.), Jefferson F. Long (Ga.), Joseph H. Rainey (S.C.), and Robert Brown Elliott (S.C.).

men from taking their seats. Even after the state supreme court reversed that policy, black legislators in Georgia encountered a series of barriers to their service.

More than 600 black men were elected to serve in Southern state legislatures during Reconstruction. In the West, 120 black men served in state legislatures in the late nineteenth century.[27] At no point in any part of the Reconstructed South did black men rule. During and after Reconstruction, conservatives criticized Reconstruction politicians as ignorant and corrupt. There was some truth to the charge, but the problems were not regional or racial in nature; they were national phenomena. In the major scandals of the era, no black politician was ever charged. During and after the era of Reconstruction, the knowledge that black men had held high elective office inspired African Americans whether or not they were able to vote (7.2).[28]

Reconstruction lasted different lengths of time in the various Southern states. In all the former Confederate states except South Carolina, Florida, Louisiana, and Mississippi, Congressional Reconstruction had ended by the very early 1870s, and white su-

premacist Democrats took back the reins of power through violence and intimidation. In Tennessee the former Confederate General Nathan Bedford Forrest created the Ku Klux Klan in 1866. Various other white supremacist militias taking aim at black voters and political organizers followed in the late 1860s. Federal antiterrorist legislation suppressed the violence in the early 1870s, but only temporarily. After the economic crisis of 1873, the federal government focused on the economy instead of conditions in the South.

The Destruction of Democracy

Terrorism brought Reconstruction to an end, though political issues such as public debt, corruption, and economic hard times also played their part. After the 1870s, large numbers of black men lost the right to vote for candidates of their own choosing. Violence destroyed the promise of democracy in the nineteenth-century South.

White Supremacist Violence

Slavery was based in the use and threat of force, and enslaved African Americans' only protection against murder and injury was their value to their owners as property. So brutal a system made violence a common part of the lives of both the owners and the owned. After emancipation, black people's lives lost their value as property, and angry, resentful Southern whites used terrorism to try to reestablish their power over black people. White supremacist violence surged during Reconstruction, eventually destroying the Republican regimes of which black men were a part.

The freedpeople did not suffer in silence during the destruction of Reconstruction. They appealed to Union troops and to Freedmen's Bureau agents following the Confederate surrender. When the troops left and the bureau folded, freedpeople kept their records and petitioned the federal government for protection. In northern Louisiana, for instance, a group of black Union veterans headed by Henry Adams (1843–1883 or later) and called simply "the Committee," investigated the terrorist campaign that Democrats used to prevent black Republicans from organizing and defending freedpeople.

The black veterans of the Committee annoyed employers by reviewing labor contracts to make sure the freedpeople were getting their due: "I figured up accounts for them," said Henry Adams, "and often seen where the whites had cheated the colored people who had made contracts with them out of more than two-thirds of their just rights, according to their contracts. I told a great many of them to take their contracts to lawyers and get them to force the parties to a settlement; but they told me they were afraid they would be killed. Some few reported to the court, but told me afterwards that it did not do. Some even were whipped when they went home."[29]

Between 1866 and 1876, Adams and his group kept a record of 694 beatings and murders of freedpeople in Northern Louisiana. Many assaults targeted the politically active:

164th. Nathan Williams (colored), badly whipped and his cotton taken away without any cause by Bill Mark, a white man, on his place, in 1874, because he voted the Radical [Republican] ticket.

228th. Old man Jack Horse and son was badly beat and shot at by white men— they were as bloody as hogs—at or near Jack Horse's place, going to the election November 7, 1870.

33d. Abe. Young, shot by white men on Angels plantation, spouting about voting Republican ticket, in 1874.

Other violence sprang from personal and economic motives:

518th. Henry Moore, colored, killed by white men and burned; accused of living with a white girl near Homer, in 1873.

559th. Jack, colored, was hung dead, by white men, on De Loche's plantation, about three miles from the town of Saint Martinville, because he sauced a white man. The white man wanted him to leave his crop and he refused, thereupon the white man got a crowd of white men and hung him, and taken his crop from his family; 1875, July.[30]

Once Louisiana returned to Democratic control in 1877, Henry Adams and his Committee could no longer even hope for federal protection. They made themselves into the Colonization Council and began to cast around for a new home outside the South. In North Carolina and South Carolina, other freedpeople were reaching the same conclusion. While many attempted to contact the American Colonization Society (this pre-war organization still existed in Washington, D.C.) and move to Liberia, others thought the American West offered a haven of freedom.

Exodus to Kansas of 1879

When Congressional Reconstruction ended in partisan bloodshed in Mississippi in 1875 and Louisiana in 1877, African Americans feared they would be murdered or reenslaved en masse. In light of the desperate circumstances, their fears were perfectly reasonable. In the spring of 1879, about 6,000 sought refuge in Kansas, which they knew as a state dedicated to freedom since the Kansas-Nebraska conflict of the mid-1850s and John Brown's "free Kansas" campaign.

The fugitives, called Exodusters, took boats up the Mississippi River to St. Louis, then transferred to Missouri River boats, which took them to Kansas City and Topeka. Most lacked enough money to pay their entire way, and many traveled only on the strength of their faith that the federal government would somehow take care of them. When it did

not, the black community in St. Louis took up the cause, and soon St. Louis as a whole contributed to helping them on to Kansas.

Although some Exodusters died along the way and many got no farther than St. Louis, those who escaped the Deep South found a less oppressive future in Kansas than in the Southern states from which they had fled. In Kansas they could send their children to schools, vote, hold office, and aspire to owning their own land.[31] Racial violence occurred in late nineteenth- and twentieth-century Kansas, but it did not compare to the rampant violence in the South.

In the mid-1870s civil wars in Mississippi and Louisiana shed a great deal of Republican blood. In 1874 and 1876, terrorism reigned in South Carolina but Republicans did not completely lose control. A compromise forged in the halls of the U.S. Congress in 1876–1877 deprived South Carolina Republicans of the support needed to discourage Democratic attacks.

By the presidential election of 1876, only three Southern states—South Carolina, Florida, Louisiana—were still nominally in Republican hands, thanks to the Union troops stationed in their state houses to support Republican regimes against their Democratic competitors. The Compromise of 1877 withdrew the troops and returned the last three states to Democratic control. Reconstruction, in the narrower sense, ended.

With noteworthy exceptions, the politics of former slave states in the late nineteenth and early twentieth centuries offered African Americans poverty, segregation, discrimination, and violence. The exceptions were biracial coalitions in Virginia in the early 1880s (the "Readjusters") and in North Carolina in the late 1890s (the "Fusionists"). Black Southerners built their own institutions and kept them going against the tide of their region. Ninety percent of African Americans lived in the South, and, moreover, Southern-style white supremacy spread throughout the whole of the United States. In the North and West, segregation and exclusion (known as "Jim Crow") were customary rather than enshrined in law. In the South, Jim Crow rested on a bedrock of discriminatory custom, state and local laws, and decisions of the United States Supreme Court.

Reconstruction in the larger sense lasted into the 1890s, as black men held on to political influence by creating political machines and by forming coalitions with disaffected whites. The last black congressman of the Reconstruction era, George White (1851–1913) of North Carolina, left office in 1901, having been elected by the Fusionist coalition of Republicans and Populists in 1898. A wave of white supremacist violence ended that coalition just as white supremacist violence had ended Congressional Reconstruction and its offshoots elsewhere in the South.

Undermining of Black Civil Rights by the Supreme Court
Throughout the late nineteenth century the U.S. Supreme Court withdrew legal support for Southern black men's civil rights, summing up developments on the state and local levels. The three *Slaughterhouse* cases of 1873 began a long process of reinterpretation of the Fourteenth Amendment to the Constitution. The Fourteenth Amendment had

originally been drafted to establish the fact of black men's citizenship. But after 1873, the Supreme Court increasingly reinterpreted persons to mean corporations rather than black people. The *Slaughterhouse* cases limited the "privileges and immunities" guaranteed in the Fourteenth Amendment to national, not state governments. Henceforth the Fourteenth Amendment served to protect corporations from regulation, not to secure the civil rights of human beings. In *U.S. v. Reese* and *U.S. v. Cruikshank* (both 1875), the Supreme Court effectively announced the federal government's intention to leave the fate of the freedpeople in the hands of Southern white supremacists. In 1883 the Supreme Court ruled the Civil Rights Act of 1875 unconstitutional, and put individual acts of discrimination outside the reach of the Fourteenth Amendment. This permitted discrimination in public accommodations by individuals, states, and localities.[32]

In 1892 Homer Plessy (1862–1925) took newly segregated Louisiana railroads to court for kicking him out of the first-class coach, for which he had purchased a ticket. Plessy's case went to the United States Supreme Court in 1896 as *Plessy v. Ferguson*. The Supreme Court ruled against Plessy and condoned racial segregation according to the fictional "separate but equal" formula. The landmark *Plessy* decision gave a go-ahead to white supremacists seeking to bar African Americans from American public life, whether in transportation, public accommodations, schools, colleges, swimming pools, libraries, and any other public spaces. "Separate but equal" gave Southern states and localities permission to humiliate black people and exclude them from civic life.

In three court cases decided between 1895 and 1903, the U.S. Supreme Court ruled against black men who had sued their states for racist disfranchisement (depriving of the vote). In *Mills v. Green* (1895), *Williams v. Mississippi* (1898), and *Giles v. Harris* (1903), the Supreme Court ruled against the black men and opened the door to states seeking to take the vote away from African Americans legally. Taken together, these decisions of the U.S. Supreme Court signaled the end of the larger reconstruction by supplying the legal basis for the segregation, disfranchisement, and racial degradation that characterized the South—and much of the North—during the first half of the twentieth century.

Mississippi (in 1890) and South Carolina (in 1895) were the first states to disfranchise black men and masses of poor white men through revisions to the state constitutions. In the first fifteen years of the twentieth century, the other Southern states followed suit. They adopted a wide range of practices, such as poll taxes, literacy tests, property qualifications, and grandfather clauses, which made it impossible for more than a handful of black men to vote.

African Americans and Indians
The fates of Africans and Indians had long been associated, and that association continued through the Civil War, Reconstruction, and afterward. Some Native Americans, especially Cherokee, had owned black people and supported the Confederacy during the Civil War. After the war, black soldiers and Indians remained antagonists, but farther West

and no longer on the opposite sides of slavery. By the late 1860s the black regiments had been withdrawn from the South and redeployed in the West. African-American soldiers protected railroad workers and migrating settlers against Indian attack. In this duty the black regiments became known as "Buffalo Soldiers," because their main duty was fighting Native Americans. The 12,500 Buffalo Soldiers served until the mid-1890s and constituted 20 percent of the U.S. Armed Forces in the West.[33]

In "The History of the Negro in California, Settlement and Development," the twentieth-century artist Hale Woodruff (1900–1980) shows a

(Right) 7.3. Hale A. Woodruff, "The History of the Negro in California, Settlement and Development" (detail), 1949
Woodruff shows soldiers guarding Chinese workers building the transcontinental railroad. This detail comes from a mural Woodruff and Charles White painted for the building of the Golden State Insurance Company in Los Angeles, California.

7.4. Palmer Hayden, "Tenth Cavalry Trooper," 1939
Riding alone, Hayden's Buffalo Soldier masters the West. He belongs to one of the black regiments assigned the duty of protecting settlers from Indian attack.

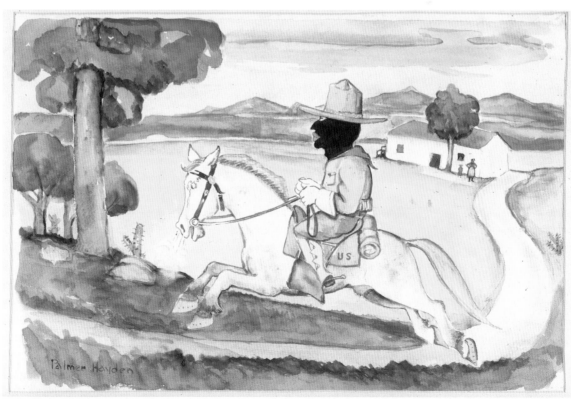

7.5. Erika Rae Allen, "Broken Promises," 1996
For Allen, the United States has broken its promises of land and civil rights to Indians ("treaty") and
African Americans.

black soldier on duty protecting Chinese railroad workers building the transcontinental
railroad (7.3). Another depiction of black men's military history is Palmer Hayden's Buf-
falo Soldier, who gallops merrily through the West (7.4).

Both of these images call attention to the crucial contribution of African Americans
to the development of the West. Instead of protecting Southern freedpeople, who sorely
needed armed protection, black soldiers served the security needs of mostly nonblack
Westerners. In the Western states, the Buffalo Soldiers' adversaries were Native Ameri-
cans, rather than vengeful former slave owners. Black soldiers took great pride in their
fight for emancipation during the Civil War. Now, their regiments could take little part
in the history of Reconstruction.

What Reconstruction Did
Reconstruction governments represented the great majority of Southern people, who
were poor. They raised taxes to cover the costs of schools, prisons, railroad bonds, and
other social services. The fostering of railroads, a very popular practice all over the coun-
try, led to the two most telling criticisms of Reconstruction: debt and corruption, which
Democrats exaggerated in their campaigns to regain power.

Black solidarity and a real, if guarded, optimism (bolstered by relative prosperity) marked
the first half-decade of Reconstruction. But the free use of antiblack violence and a corre-

sponding loss of hope among rural blacks prevailed in the later years. By the late 1870s the South had begun to look almost as though the Confederacy had won the Civil War.

Southern black people did not accept their oppression. They sought means to overcome their poverty, which stemmed from whole lifetimes of unpaid labor. Between the 1890s and the 1910s, Callie House (n.d.), a Nashville seamstress and laundress, led the Ex-Slave Mutual Relief, Bounty and Pension Association. House's massive reparations movement gathered some 600,000 signatures from former slaves demanding pensions as compensation for their unpaid work. The Ex-Slave Mutual Relief, Bounty and Pension Association had five (unsuccessful) pension bills introduced into Congress. But the federal government ultimately broke the movement. House was convicted and imprisoned for mail fraud because, according to the federal government, her cause had no hope of succeeding.[34]

The great historian and civil rights scholar W. E. B. Du Bois (1868–1963) realized that charges of Southern Republican corruption expressed something else: distaste at poor people's appropriating for themselves the trappings of the rich, notably political power, handsome clothing, carriages, and personal independence. In his ground-breaking *Black Reconstruction* (1935), Du Bois touched on virtually every aspect of Reconstruction, construed in the widest possible fashion. He understood that the downfall of Reconstruction and the disfranchisement of poor men meant the failure of democracy in the South. Alert to the historical profession's distortion of American history, Du Bois included a critical essay on historiography in *Black Reconstruction*. Historians, Du Bois charged, used historical sources selectively in order to trivialize revolutionary changes in labor relations and denigrate African Americans' actions during Reconstruction.

Conclusion

The Democratic regimes that followed Reconstruction did not develop the South or end inefficiency and corruption. The big difference was that during Reconstruction, masses of poor men, black as well as white, participated in the political process and made policies in the interests of poor people. After Reconstruction, the Southern states ran according to the mandates of the elite and championed white supremacy as an excellent means of keeping the poor divided along racial lines. Minimal government providing few public services emerged as a hallmark of the Democratic South of the late nineteenth and early twentieth centuries.[35]

In her painting "Broken Promises," Erika Allen (b. 1969) expresses the kindredness of African Americans and Native Americans (7.5). The squares show broken treaties with Indians, the never-allotted forty acres and a mule, Jim Crow, and shed blood. At the bottom center, Allen writes "Shared roots, trails of tears." She remembers that Indians suffered through the Trail of Tears in the 1830s and black Americans were betrayed in the era of Jim Crow: the era of segregation, exclusion, discrimination, and political powerlessness.

8.1. Palmer Hayden, "John Henry on the Right, Steam Drill on the Left, from the John Henry Series," 1944–1954

In Hayden's series of John Henry paintings, the legendary railroad worker prepares to test himself against the machine. (Henry won the competition but paid for the victory with his life.) The working-class crowd is joyous and interracial.

Hard-Working People
in the Depths of Segregation

1896–ca. 1919

African Americans worked hard during the Jim Crow era of segregation, violence, and exclusion. Young and old, women and men, laborers and professionals survived and achieved in an oppressive society. They were subject to much physical attack and ever-present disparaging stereotype in the larger society. An outpouring of black art celebrates the beauty of everyday African Americans and deplores the cruelty of racist violence.

"John Henry" by Palmer Hayden celebrates the African-American workingman, here the mythic, steel-driving, railroad track-laying man, John Henry (8.1). In the oppressive late nineteenth- and early twentieth-century era, black workers produced much. Women, old people, and children as well as young men worked hard jobs for long hours and low wages, although few gained John Henry's mythic status. Black artists recognized working people's centrality to the survival of the race in these tough times. One of the best-known examples of this art is "Sharecropper" by Elizabeth Catlett (b. 1919) a timeless study of the dignity of a rural workingwoman (8.2).

The late nineteenth and early twentieth centuries saw the movement of tens of thousands of rural African Americans into town seeking education and opportunities for employment and business ownership. Northern and Western black people had long been city dwellers. During the long era of segregation, black Americans lived "behind the veil," as W. E. B. Du Bois often noted, invisible to most nonblack Americans except in antiblack stereotype. But among themselves, African Americans worshiped and partied, sang and danced, and made themselves beautiful. They educated themselves and invented American music. They also founded businesses and laid the foundations of a largely separate economy. They created a culture that the majority of Americans later—much later—came to appreciate.

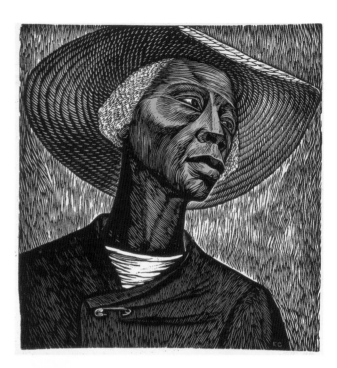

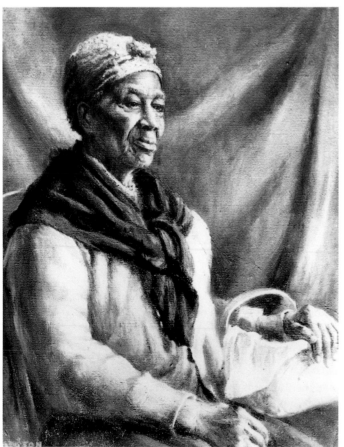

(Above) 8.2. Elizabeth Catlett, "Sharecropper," 1968

Catlett's mature woman dressed in work clothes embodies the dignity and strength characteristic of Catlett's work. The hat indicates that the woman is at work in the fields.

(Left) 8.3. Edwin A. Harleston, "The Old Servant," 1928

There is nothing servile about Harleston's older woman servant; rather he shows a woman with enormous self-respect.

Struggle, Survival, and Success

Hard-Working People

During the post-Reconstruction period, African Americans worked their entire lives. In 1890, more than half of all black Americans of all ages were working: 57.7 percent, compared to 46.6 percent of whites. The principal difference between blacks and whites lay in the proportion of women, children, and old people in the workforce. In 1890, 36 percent of black women over the age of ten were in the workforce, compared to only 14 percent of white women in that age group. Masses of black children and people over sixty-five worked for wages (Table 8.1).[1]

Black artists celebrated the nobility of black working people of all ages and both sexes, even in occupations that were usually despised. In "The Old Servant," Edwin A. Harleston (1882–1931) captured the nobility of an older worker in the vocation that employed about one third of black workers (8.3). One of the earliest prize-winning black paintings was "Newspaper Boy" by Edward Mitchell Bannister (1826–1901) (8.4). "Waterboy" by Samella Lewis (b. 1924) shows a Southern child doing heavy labor, most likely unpaid, carrying water to adult workers in the field (8.5).

At the turn of the twentieth century, the great majority of African Americans worked in low-paying, non-union jobs, more than half in agriculture, a third in domestic service. By contrast, native-born whites were more heavily employed in trade, manufacturing, and professional jobs, while foreign-born whites worked in manufacturing.[2] Allan Rohan Crite (b. 1910) depicts Southern men working in transportation in "Beneath the Cross of St. Augustine" (8.6). One of the hundreds of thousands of black women in domestic service appears at work on her knees in "Cousin-on-Friday" by Leslie Garland Bolling (1889–1955) (8.7).

Sharecropping, Debt, and Prison

At the turn of the twentieth century, the great majority of black farmers did not own land. Credit financing and its attendant debt were constant features of their lives. In return for advances for farming supplies (seed, tools, mules) and consumer goods (food, cloth), tenant farmers and sharecroppers mortgaged their crops. Tenant farmers, who owned their own mules and farm implements, had rights to a larger share of the crop than sharecroppers, who owned nothing. In practice, there was much

Table 8.1. Percentage of Population Employed, by Age and Gender: 1890

Age and Gender	Black	White
Male		
Total, 10 years old and over	80	77
10 to 14 years	30	8
15 to 19 years	73	56
20 to 24 years	94	92
25 to 34 years	97	97
35 to 44 years	98	98
45 to 54 years	98	96
55 to 64 years	97	92
65 years and over	88	72
Age unknown	83	74
Female		
Total, 10 years old and over	36	14
10 to 14 years	20	3
15 to 19 years	43	25
20 to 24 years	47	28
25 to 34 years	37	15
35 to 44 years	37	10
45 to 54 years	38	10
55 to 64 years	37	10
65 years and over	26	7
Age unknown	41	26

Note: "Black" includes persons of "other" races

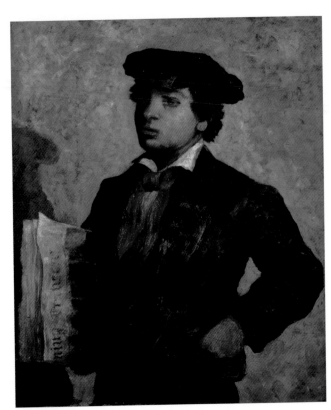

**8.4. Edward Mitchell Bannister, "Newspaper Boy,"
1869**
Rare for an African-American artist, Bannister won a
prize for this charming rendition of an urban black child
at work selling newspapers.

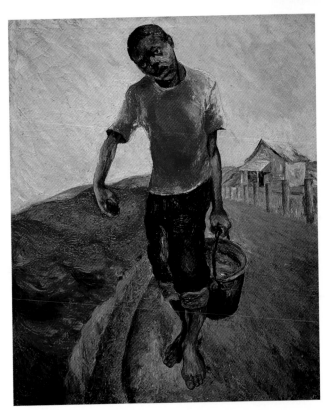

8.5. Samella Lewis, "Waterboy," 1944
Lewis's working child in the fields shows the effort
needed to haul water to adult farm workers. Although
the boy is young, he works alone.

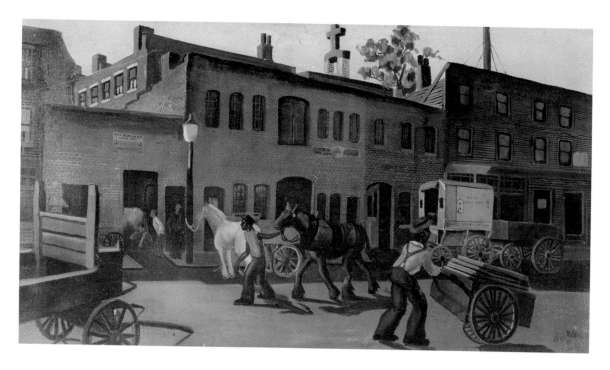

8.6. Allan Rohan Crite, "Beneath the Cross of St. Augustine," 1936
Crite shows black teamsters carting heavy loads through the streets of a Florida city, where they were a familiar sight.

8.7. Leslie Garland Bolling, "Cousin-on-Friday," 1935
Hard-working Cousin is at work, not at play, on Friday,
reminding us of the unending nature of her drudgery.
Her Friday night contrasts vividly with that of Archibald
Motley's Chicago revelers (see 9.2).

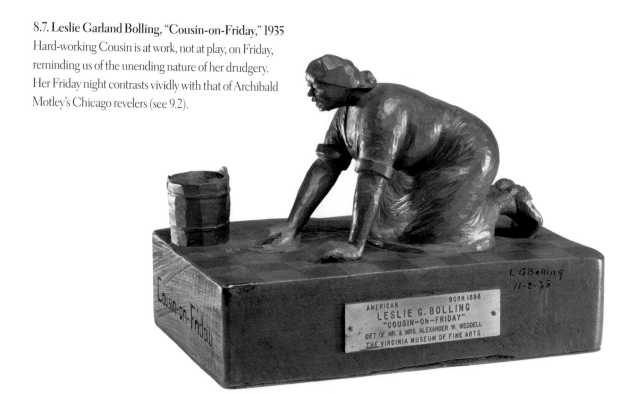

overlap between the conditions of tenants and sharecroppers, both of whom worked the land of others. Sometimes, after paying off planters and merchants, tenants and sharecroppers cleared a little money, up to a few hundred dollars per family per year. But farming families, especially sharecroppers, often ended each year in debt.[3]

Large numbers of black people were sent to prison for debt or for the crimes of the poor—notably theft, disorderly conduct, and vagrancy. In the late nineteenth century, Southern states engaged in convict leasing. This system allowed employers to rent prisoners from the state and put them to work—in forests, on railroads, in mines and fields. The convicts worked extremely hard under brutal conditions, but earned no pay. Sometimes they were worked to death. "These convicts; we don't own em. One dies, get another," said one employer in 1883. In 1906 the state of Georgia made $354,850 from convict lease. The appalling working conditions, disease, injuries, and deaths of convict workers ended the system in the early twentieth century.[4] However, as late as the 1950s, Southern states forced convicts to labor building roads. Convict laborers represented the most oppressed of black workers.[5] William H. Johnson depicted convicts at work in "Chain Gang" (8.8). The issue of convict labor endured as artistic subject matter, as depicted in Herbert Singleton, Jr.'s, "Ain't Gonna Be first, Won't Be Last" (E.1) and Purvis Young, "The Chain Gang" (E.3), in the Epilogue of this book.

Educational Gains

Education stood high on the list of what African Americans wanted for themselves, and during this period a small but growing number gained access to education, even to higher education. However, segregated schools for black pupils were chronically underfunded, regardless of where they were located and whether they were segregated by law or by custom. Only in the various Northern and Western locales in which black students attended the same schools as nonblacks could black children attend school as many months per year as others.

In the South, where schools were rigidly segregated by law, black schools were systematically starved for money. Parents often had to supply buildings and heat as well as give teachers room and board. Black schools were open for shorter periods and black teachers were paid much less than their white counterparts. For example, in South Carolina in 1908-1909, the state spent $1,590,733 to educate 153,807 white pupils, but only $308,153 to educate 181,095 black pupils. White schools in South Carolina were open 25.2 weeks during the year, while black schools were open only 14.7 weeks. White male teachers earned $479.79 per year, while black male teachers earned $91.45 per year. White female teachers earned $249.13, while black female teachers earned $118.17 per year.[6] In other Southern states, black families seeking elementary education for their children faced similar disparities. High schools were even more unfairly allocated by race.

Strict racial segregation in the South made high school attendance problematic. Most Southern towns and cities—including New Orleans; Charlotte, North Carolina; and Charleston, South Carolina—lacked black high schools. Pupils seeking more than

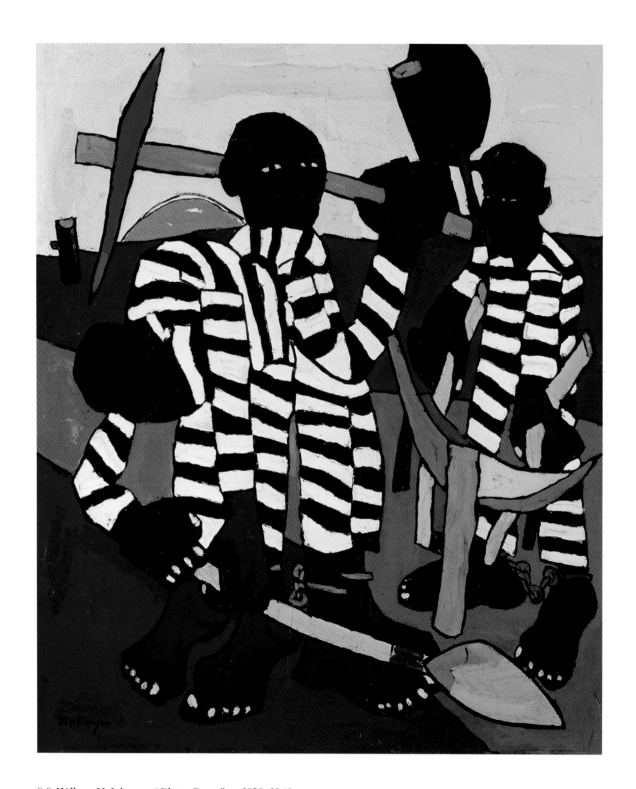

8.8. William H. Johnson, "Chain Gang," ca. 1939–1940

Johnson's convicts, dressed in prison stripes, prepare for heavy labor outdoors with picks and shovels.
Johnson's deceptively simple style includes sophisticated treatment of negative spaces.

8.9. Arthur P. Bedou, "Booker Taliaferro Washington, Portrait of the Educator on His Horse," 1915

Bedou, the photographer of Tuskegee Institute, made several portraits of Washington. This shows the principal of Tuskegee about to make his daily round of inspection.

an elementary education had to leave home or forego further schooling. The lucky ones attended the high school departments of black colleges.[7] In the North and West, young African Americans usually attended integrated high schools. However, poverty sent most out to work before they reached high school.

The scarcity of black high schools reflected the idea that prevailed among some black as well as most white Southerners: that African Americans did not need much education. The controversy in American education over the type of instruction that was appropriate for blacks profoundly influenced black higher education as well. Booker T. Washington (1856–1915), the founding principal of Tuskegee Institute of Tuskegee, Alabama, and the best-known African American of his generation, wanted to prepare African Americans for work. He preached the value of practical, vocational education, such as carpentry, brick making, and agriculture. Washington's educational ideals held sway in his own Tuskegee Institute, in the sixteen state-sponsored land grant colleges, and in Hampton Institute, where Washington had been educated (8.9).

Washington believed that liberal arts education and advanced degrees were imprac-

tical for poor, working people such as African Americans. He summed up his view in a widely heralded speech at the Cotton States Exposition in Atlanta in 1895. In this speech, subsequently criticized as the "Atlanta compromise," Washington urged black Southerners not to study the liberal arts or demand civil rights and the vote. Instead, black Southerners should dedicate themselves to making friends with white Southern-ers and pursuing agriculture, domestic service, manual trades, and business. Increasing black wealth, he said, would ultimately gain the race the respect of Southern whites.

In 1901, at the height of his influence, Washington published a best-selling autobi-ography, *Up from Slavery*, in which he described his climb out of slavery and into na-tional prominence in a deceptively humble tone. Washington's practicality belonged to his broader philosophy of accommodation to late nineteenth- and early twentieth-century white supremacy. Washington's approach to survival mandated silence, hard work, and the accumulation of wealth. He urged African Americans to earn the respect of white people rather than demanding the right to vote or enter white institutions. Until his death in 1915, the conservative Washington exerted more influence than any other black American.

George Washington Carver (1864/5–1943), a longtime member of Tuskegee's faculty, embodied the practical knowledge that Washington prized. Humble and self-effacing, Carver directed the only black agricultural station in the United States and invented hundreds of practical uses for Southern plants, such as the peanut. Ironically, Carver's master's degree from Iowa Agricultural College (now a part of Iowa State University) prepared him for his work at Tuskegee.

Two prominent black educators disagreed with Washington: W. E. B. Du Bois and John Hope (1864–1936) believed that African Americans, like all other Americans, de-served the opportunity to study history, literature, languages, and the classics.[8] Du Bois warned that mere moneymaking would stunt the race and deprive black people of their "manhood." He believed the educated "talented tenth" of African Americans would save the race: "Men we shall have only as we make manhood the object of the work of the schools—intelligence, broad sympathy, knowledge of the world that was and is, and of the relation of men to it—this is the curriculum of that Higher Education which must underlie true life."[9] In 1903 Du Bois published *Souls of Black Folk*, an eloquent challenge to Booker T. Washington's accommodationist ideology. Du Bois's history and sociology in *Souls of Black Folk* revealed the tremendous cost of black political power-lessness and spurred the formation of the Niagara Movement of political protest.

In the era of plain, hard work, it was difficult for educated African Americans and artists to find their place in the United States. The sculptor Edmonia Lewis and the painter Henry Ossawa Tanner (1859–1937) both spent their productive lives outside the United States, Lewis in Rome, Tanner in France. The poet Paul Laurence Dunbar published in national magazines. To his chagrin, however, his black dialect poetry far overshad-owed his verse in Standard English. The novelist Charles Chesnutt (1858–1932) wrote about North Carolina. His next-to-last novel, *The Marrow of Tradition* (1901), exposed

the lies of the white supremacists who had staged a bloody riot in Wilmington, North Carolina, in 1898. Chesnutt's last novel, *The Colonel's Dream* (1907), was the last piece of black fiction to be published by a major publisher until the Harlem Renaissance of the 1920s.

Black Professionals

Higher education for African Americans was practically unheard of until after the Civil War. Before the Civil War, only twenty-two African-American men had graduated from college. With the creation of colleges for black men and women after the war, however, the numbers of college graduates steadily increased (Table 8.2).

Professional education for blacks also began in the late nineteenth century. Several black medical schools existed in the late nineteenth and early twentieth centuries, including Leonard Medical School at Shaw University in Raleigh, North Carolina, Flint-Goodridge in New Orleans, Meharry in Nashville, and Howard in Washington, D.C.[10] The earliest black hospitals, including Dr. Daniel Hale Williams's Provident Hospital and Training Institute in Chicago and Freedmen's Hospital in Washington, D.C., were established in the early 1890s. In 1890, 909 black medical doctors were practicing in the United States. By 1920 there were 3,885 black medical doctors, of whom nearly 70 were women.[11]

American professional organizations such as the American Medical Association and the American Bar Association refused admittance to African Americans on the basis of race. Black professionals formed their own associations, including the National Medical Association in 1895, the National Association of Colored Graduate Nurses in 1908, and the National Bar Association in 1925.[12]

Table 8.2. Black College Graduates by Decade, 1860–1901

Decade	Number of Black College Graduates
1860–1869	44
1870–1879	313
1880–1889	738
1890–1899	1,126
1900–1909	1,613

Bridging the gap between professionals and skilled workers were black inventors. In the late nineteenth century, one thousand black inventors secured patents. Although black inventors contributed to the development of American industry, most lacked the capital to manufacture and market their inventions—limitations often related to their race. Among the most prolific black inventors of the time were Elijah McCoy (1843–1929), Lewis Latimer (1848–1928), and Granville T. Woods (1856–1910). McCoy specialized in engine lubricators and was the individual behind the expression "the real McCoy" used to designate an object of high quality. Latimer specialized in electric lamps and Woods in electrical devices for railroads.[13] In 1899 George F. Grant (1846–1910), a Harvard-educated dentist in Boston, patented the golf tee.[14]

The Golden Age of Black Business

Racial segregation and exclusion created opportunity for black entrepreneurs, particularly in the cities. In rural areas, tenant farmers and sharecroppers lived off debt owed to white planters and shopkeepers and so had little money to spend in black businesses.

But urban black people formed a market more dense than people spread out in the country; they also made cash wages. During the late nineteenth and early twentieth centuries, African Americans founded and patronized their own financial institutions (banks, insurance companies), cooperatives, manufacturers, newspapers, retail businesses, and service industries, such as barber and beauty shops and funeral parlors. Most early twentieth-century black businesses offered services. But black business people also created manufacturing enterprises that operated internationally, especially in the hair-care industry.

At the turn of the twentieth century, both Booker T. Washington and W. E. B. Du Bois—who disagreed about black education—agreed that black business held the key to race progress. During the 1920s, Marcus Garvey and his Universal Negro Improvement Association promoted business as the best means of racial advancement. In and of itself, Washington's Tuskegee Institute represented an African-American institution worth millions of dollars. Washington founded the National Negro Business League (NNBL) in Boston in 1900.[15] The NNBL fostered the creation of several allied business organizations among African Americans: the National Bankers' Association, National Association of Negro Insurance Companies, National Association of Funeral Directors, National Association of Real Estate Dealers, National Bar Association, and National Press Association.[16]

Banks and insurance companies laid the foundation of the separate racial economy, and during this period men born into slavery founded life insurance companies that still exist. In 1899 John Merrick (1859–1919) founded what is still the largest black insurance company in the United States, North Carolina Mutual. Under Charles Spaulding (1874–1952), the company expanded into other segments of the insurance industry. In 1905 Alonzo Herndon (1858–1927) established Atlanta Mutual, after having worked as a laborer, succeeded as a barber, and invested heavily in real estate. At Herndon's death, he was worth more than $500,000.[17]

Profitable insurance companies frequently spawned other successful enterprises. North Carolina Mutual Life Insurance Company gave rise to the Mechanics and Farmers Bank of Durham and Raleigh. Elsewhere insurance companies founded savings banks. By 1912 African Americans operated sixty-four banks. Five were in the black towns in Oklahoma, sixty-one were in the South. But two of the biggest black banks of the era were in Chicago: Jesse Binga's Binga State Bank and the Douglass National Bank. In 1908, Binga (1865–1950), after working as a railroad porter and speculating in land in Utah, founded the first black private bank.[18] Founder of the Douglass National Bank, Anthony Overton (1865–1946) was a versatile entrepreneur. In addition to his banking business, he also created a successful line of cosmetics and founded a newspaper, the Chicago *Bee* (published from 1925 to 1945) and a magazine, the *Half-Century* (published from 1916 to 1925). Like many other black banks, the Binga and Douglass banks failed in the Great Depression. Between 1888 and the depths of the Great Depression in 1934, African Americans founded 134 banks.[19]

Black women created two of the era's most successful businesses.[20] In 1903, Maggie Lena Walker (1867–1934) founded the Richmond, Virginia, St. Luke's Penny Savings Bank. In 1924 the St. Luke operated in twenty-two states and had $3,480,540 in deposits. Walker served as president until her death, and the St. Luke—after several mergers—still exists today.[21] Leading the African-American segment of the hair-care and beauty industry that grew up in the late nineteenth and early twentieth centuries were Annie Turnbo-Malone (1869–1957), founder of the Poro Company and Poro College, and Madam C. J. Walker (1869–1919), founder of the Walker Manufacturing Company and the Madam C. J. Walker Hair Culturist Union of America. In 1920, the earnings of the Walker Company totaled $595,000 in sales in the United States and the Caribbean. Walker's enterprise was the most successful of several companies that manufactured and distributed beauty products for black women. A stunning embodiment of the self-made woman, Walker became a philanthropist and supporter of Marcus Garvey. Her daughter A'Lelia furthered the Harlem Renaissance. Like Maggie Lena Walker's bank, Madam Walker's company still exists today.[22]

Black Towns and Churches: Havens from Racist Oppression

All-black towns and churches offered havens from American white supremacy. The best-known black towns founded between Reconstruction and the First World War were Nicodemus, Kansas (founded in 1879), Langston, Oklahoma (founded in 1891), Boley, Oklahoma (founded in 1904), and Mound Bayou, Mississippi (founded in 1887). But black people also founded towns in California, Illinois, Michigan, and New Jersey.[23] Langston, Oklahoma, was promoted as "the Negro's refuge from lynching, burning at the stake, and other lawlessness and turns the Negro's sorrow in to happiness." More than sixty all-black towns were founded after 1879, but like new American towns generally, they did not all survive. Some thirty towns and thirteen settlements existed in 1910. Many lasted into the 1950s.[24]

The 1890s witnessed the creation of new religious denominations based on beliefs in holiness and sanctification. The new holiness and sanctified churches sought to purify American Protestantism by pulling away from the sinful world. Members of the Church of God in Christ (founded in 1895) and the Church of Christ, Holiness (founded in 1896) sought to live pure lives in the expectation that Jesus would return to earth soon for the final judgment. Holiness and sanctified people did not drink alcohol, listen to sinful music, dance, or use profane language; women dressed modestly and used no make-up.[25] The holiness and sanctified churches created a highly syncopated new gospel music developed by Thomas A. Dorsey (1899–1993) and Theodore Frye (1899–1963). In 1931 Dorsey and Frye organized the first gospel chorus in Chicago. A year later Dorsey founded the National Convention of Gospel Choirs and Choruses, also in Chicago. Gospel music ultimately revolutionized jazz and popular music, reaching far across the color line into all genres of American popular music.

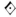

New Black Music

The late nineteenth and early twentieth centuries witnessed the creation of new forms of both classical and popular black music. The cakewalk and ragtime introduced syncopation, the hallmark of twentieth-century American popular music. During this era, black performers also entered into the white-dominated field of minstrelsy. With its racially stereotypical antics, minstrelsy presented a problem for black performers: they could become wildly popular, but in the process they had to ridicule their own people.

In 1901 the first black musicians to be recorded were the minstrel stars George Walker (1873–1911) and Egbert ("Bert") Walker (1874–1921). Beginning as minstrels, they took black performers into the flourishing new field of vaudeville. The "Father of the Blues," W. C. Handy (1873–1958) began his career as a minstrel performer in the 1890s.[26] Minstrelsy lost popularity at the very end of the century, giving way to vaudeville and musicals.

The classical composers included Harry T. Burleigh (1866–1949), the first widely known black composer. He and his generation drew upon black folk music to write music such as Burleigh's "Six Plantation Melodies for Violin and Piano," 1901, and "From the Southland," for piano, 1914. "The Banjo Lesson" by Henry Ossawa Tanner is one of black art's favorite images (8.10). It shows an older man teaching a boy to play the banjo, an instrument invented in Africa and one of popular music's legacies from black folk.

Burleigh also arranged Negro spirituals for concert performance in *Jubilee Songs of the United States of America* (1916). Burleigh's colleague Will Marion Cook (1869–1944), a violinist and composer, wrote concert music as well as musical comedies. Cook produced his first composition, "Scenes from the Opera of Uncle Tom's Cabin," for Colored American Day at the Chicago World's Fair in 1893. In 1898 Cook collaborated with the poet Paul Laurence Dunbar in the musical comedy sketch "Clorindy: or, The Origin of the Cakewalk." Cook became the composer and musical director for the George Walker-Bert Williams Company.[27]

Cook drew on the syncopated new music called the "cakewalk," which originated in the rural South immediately after the Civil War. The cakewalk substituted the piano for the fiddle in late nineteenth-century dance combos. In 1899, Scott Joplin (1868–1917) published "Maple Leaf Rag," which pioneered the new music called ragtime.[28] Ferdinand Joseph ("Jelly Roll") Morton (1885–1941) spanned the gamut of the new twentieth-century black music, gaining a national reputation as a ragtime pianist, composer, bluesman, and jazzman. Morton began playing in the vice district of New Orleans known as Storyville in 1902, just as jazz and the blues appeared in Southern black folk music.

The exact origins of the blues remain unknown. W. C. Handy said he first heard this distinctive new music in about 1902.[29] But William Geary "Bunk" Johnson (1879–1949), a pioneer bluesman, said he had played "nothing but the blues" as a youth in the 1880s. A New Orleans blues fiddler rejected the notion that someone had created the blues at a particular time: "The blues? Ain't no first blues! The blues always been."[30]

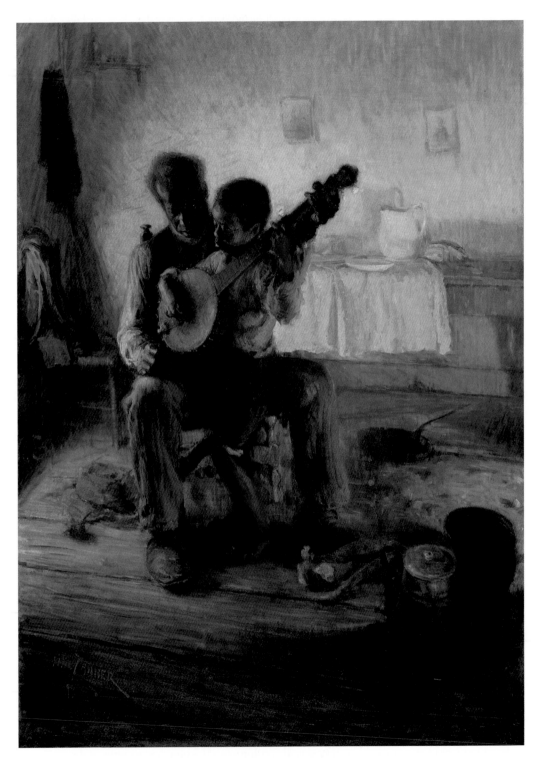

8.10. Henry Ossawa Tanner, "The Banjo Lesson," 1893
Tanner's painting bathes a loving family scene in a golden light. One of the painter's rare depictions of
black subjects, "The Banjo Lesson" shows the handing down of musical skill across the generations.

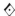

He referred to the country blues of itinerant Southern musicians. The recording artist Gertrude "Ma" Rainey (1886–1939), "Mother of the Blues," made a career singing city blues in the 1920s and 1930s.

Black Athletes

At the same time that black musicians were revolutionizing American popular music and breaking into theater, American sports were coming to terms with triumphant black athletes by barring them from competition against whites after they had shown their ability to win. From 1902 to 1907, boxer Jack Johnson (1870–1946) won a string of fifty-seven bouts, inspiring a hunt for a "great white hope" who could defeat him. None was found. Johnson became a popular hero during his lifetime and remains a heroic subject for black artists and writers.[31]

Professional baseball, developed in the 1870s and 1880s, originally included black players. In 1877, professional baseball ousted its black players, a ban that held until 1947. In response, African Americans organized their own teams, which numbered five by 1900. Rube Foster (1879–1930), the "Father of Black Baseball," began as a pitcher in Texas and went on to found the Negro National League in 1920.[32] Teams such as the Kansas City Monarchs and the Pittsburgh Crawfords featured all-star players, including James "Cool Papa" Bell (1903–1991) who was a better athlete than most of his white peers. Bell played until he was forty-seven, including stints in Cuba, the Dominican Republic, and Mexico.[33] He was said to be so fast that he could turn off the light and be under the covers in bed before the room got dark. During the early twentieth century, gifted African-American baseball players like Bell rarely appeared in American culture outside the black media.

Professional and amateur athletes who were black were usually barred from competition with whites, often even from public playing fields. While professional ball players organized their own African-American leagues, amateur golfers and tennis players founded their own playgrounds and organized their own clubs. Boxing, track and field, horse racing, and cycling interested African Americans most, but tennis and golf also began attracting black players. Walter Speedy (1878–1943), John Shippen (1879–1968), and Joseph Bartholomew (1881–1971) laid the basis for the rationalization of black golf after the First World War. Black tennis players founded the American Tennis Association in 1916, bringing together local tennis organizations to foster tennis playing among African Americans.[34]

Countering Antiblack Stereotypes

Black people produced representations of themselves that ranged from the serious to the funny, from the sacred to the profane. These images did not appeal to nonblack audiences, for most Americans lacked interest in black Americans as fully human individuals. Nonblack magazines and movies usually portrayed black people in stereotypes often drawn from minstrelsy's array of plantation characters: the dumb, lazy rustic; the

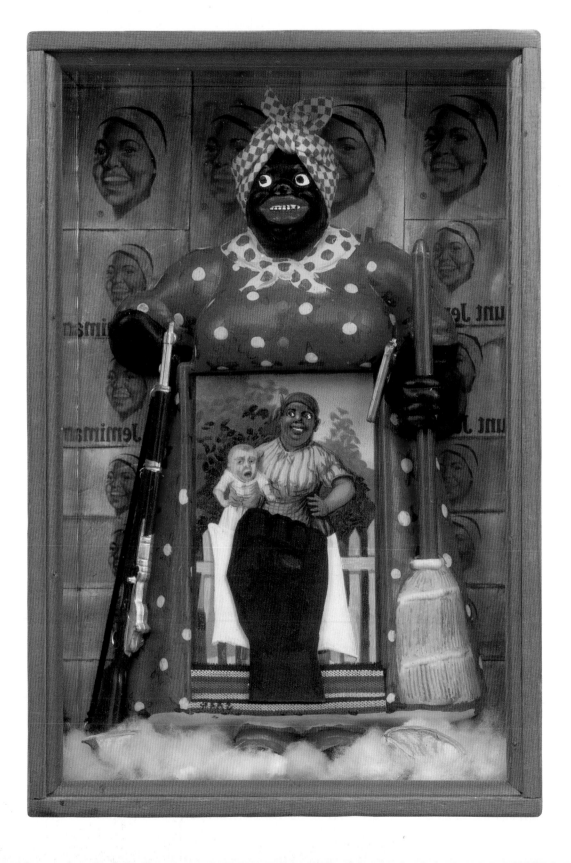

(Above) 8.12. Joyce J. Scott, "Man Eating Watermelon," 1986
Punning on the stereotype of black people eating watermelons, Scott's beaded sculpture shows a water-melon eating a man.

(Opposite) 8.11. Betye Saar, "The Liberation of Aunt Jemima," 1972
This complex image plays on long-standing stereotypes and the emblems of black power. The backdrop shows the familiar, smiling face of Aunt Jemima, and the insert presents another older figure. The large figure, still wearing the talismans of servitude on her head and face, also carries a rifle to be used in the black revolution.

cheating city slicker; the good-for-nothing chicken thief; the grinning watermelon eaters; the mannish wench. When visible at all, African Americans habitually appeared in white culture as natural servants.

At the turn of the twentieth century, African Americans avoided circulating stereotypes. The hundreds of black newspapers and magazines circulating in the late nineteenth and early twentieth centuries offered ample evidence of the rich variety of black experience and expression. Some 136 weekly papers and 3 monthly magazines were publishing in 1900, virtually all in the South or Border States. By 1908, more than 200 black newspapers and magazines were published, increasingly in the North.[35] However, black approaches to these images changed after the mid-twentieth-century era of Civil Rights. Since the 1960s black artists have remade stereotypical images into emblems of Black Power. "The Liberation of Aunt Jemima" by Betye Saar (b. 1926) shows an Aunt Jemima no longer grinning obligingly at her white folks, as in the smaller insert (8.11). Although her face is still stereotyped and her head wrapped in a bandana, the large Aunt Jemima holds a gun, ready to defend her people.

In "Man Eating Watermelon" Joyce J. Scott (b. 1948) plays with the popular stereotype of black people eating watermelon that appeared in countless postcards and movies (8.12). Scott's sculpture, made of glass beads, shows a watermelon that eats a man.

Today cruel and silly stereotypes of black people are called "black collectibles." Middle-class African Americans collect and display them to remind themselves of an ugly past that must not be forgotten. Stereotypes also appear as dangerous in Spike Lee's (b. 1957) 2001 film *Bamboozled*. In this film, minstrel figures and stereotyped images take on a menacing life of their own, finally destroying their creator. Circulating as postcards, kitchen knick-knacks, and jokes in the late nineteenth and early twentieth centuries, black stereotypes made African Americans into useless figures of fun. They were the light-hearted face of a deadly serious context of white supremacy.

White Supremacy: An Attempt to Halt Black Success

Black Southerners came out of slavery with almost nothing. During the period of Reconstruction, they struggled mightily for education and citizenship. Against great odds, they made impressive economic and educational gains in the late nineteenth and early twentieth centuries. This success pleased African Americans and their white allies. But black success threatened and sometimes enraged Southerners unwilling to share power with people they considered little more than slaves. White supremacists resorted to a variety of means to keep white men in charge: disfranchisement, segregation, and physical brutality.

White Supremacy and Disfranchisement

Between 1890 and 1908, a series of maneuvers on the state level and decisions of the United States Supreme Court deprived black men (and many white men) of the right to vote.[36] Poll taxes, the white primary, literacy and understanding clauses, and grandfather clauses made voting practically impossible for the 90 percent of black men who lived in the South. They no longer lived in a democracy in which they could elect their representatives.

Poll taxes were head taxes of $1 to $2 per person per year, payment of which was necessary for voting, but for nothing else. Anyone who wanted to vote had to pay his poll tax well before the election took place, then preserve his receipt for several months to show he had paid. In addition, he had to show he had paid taxes for every single year since he had turned twenty-one. Because paying the poll tax was necessary only for voting and nothing else, it worked well as a way to discourage poor men from voting. Although the Southern states used many different means of disfranchising black men, the poll tax was by far the most effective at barring hundreds of thousands of black men—and tens of thousands of white men, too—from casting their ballots.[37]

The tactic of the white primary declared that the Democratic parties in the Southern states were private clubs. As private clubs, state Democratic parties could decide whom to admit and whom to reject. White men were admitted; black men were rejected. After the 1870s, when Republicans became a minority in the South, Democrats monopolized political power. Whoever won primaries (in which black men could not vote) won general elections.[38]

Literacy and understanding clauses meant that men who wanted to register to vote needed to prove that they could pass tests of reading and comprehension. Individual registrars determined the contents of the tests and decided who passed or failed. Farmers could be asked to read obscure texts. Teachers could be asked to explain the meaning of state constitutions or abstruse writing in legalese. Large numbers of poor white men could not pass such tests, and for them, grandfather clauses offered a loophole. Grandfather clauses enfranchised men whose fathers or grandfathers had been able to vote before 1867, that is, before Congressional Reconstruction, before black men could vote.[39]

Between 1889 and 1910, all the Southern states enacted legislation that used one or more of these techniques to impede black men's and poor white men's voting. Black men lost the ability to take part in Southern politics, as voters or office holders. The last black congressman of the post-Reconstruction era, George White of North Carolina, left office in 1901. Congress remained completely white for nearly thirty years. Leaving Congress, White said: "This, Mr. Chairman, is perhaps the Negro's temporary farewell to the American Congress; but let me say, Phoenix-like he will rise up some day and come again. These parting words are in behalf of an outraged, heart-broken bruised and bleeding, but God-fearing people, faithful, industrious, loyal, rising people—full of potential force." White founded the all-black town of Whitesboro in Cape May County, New Jersey, in 1899.[40] The loss of the vote ushered in more than half a century of white supremacy that eliminated black people from Southern public life. In 1903, the African-American novelist Charles Chesnutt noted, "the rights of the Negroes are at a lower ebb than at any time during the thirty-five years of their freedom, and the race prejudice more intense and uncompromising."[41]

White Supremacy: Segregation

The white-dominated state legislatures and constitutional conventions that ended black voting enacted segregation laws, which came to be known as "Jim Crow" laws. Segregation began with railroads, where it ejected black people from first-class travel and relegated them to dirty, smoky "Negro" cars. From railroads, segregation spread quickly to streetcars and from streetcars into virtually all facets of Southern public life.

Railroad and streetcar segregation had actually begun in the North before the Civil War. But the push for black Civil Rights during the Reconstruction era struck down streetcar segregation in places like New York and Philadelphia. In the South, streetcar segregation began in Georgia in 1891. Black Southerners responded by boycotting segregated streetcars in twenty-five cities between 1891 and 1912, including Jacksonville, Montgomery, Mobile, and Little Rock. They started their own streetcar services and used other forms of private transportation. After the U.S. Supreme Court decided against Homer Plessy in *Plessy v. Ferguson* in 1896, segregated streetcars as well as railroads prevailed.

In the late nineteenth and early twentieth centuries, Southern states and municipalities closed African Americans out of the public realm, including libraries, public colleges, parks, and swimming pools. Black schools kept shorter schedules in inferior

facilities in which black teachers earned less than white teachers. Southern towns did not pave the streets or provide town water or sewage in black neighborhoods. In Oklahoma, even the phone books were segregated.[42]

Humiliation figured prominently in the racist campaign against black people. Regardless of wealth, education, position, or dignity, African Americans had to come and go through the South's back doors as though they were servants. Actual servants could ride in first-class coaches with their employers. But black people who sought to enter the public sphere on their own found the way barred. Southern life seemed designed to dishonor black Southerners and to treat them as though they did not belong in their native land. Even so, Booker T. Washington disapproved of black migration North. "The Negro," he thought, was at "his best" in the South.

In public utterance, Washington accepted segregation. But behind the scenes he departed from this accommodation to Southern white supremacy in the early twentieth century. Working in secret, he underwrote campaigns against disfranchisement. His effort proved to be too little too late. Antiblack violence became more prevalent than black civil rights.

The Reverend Henry McNeal Turner, president of Morris Brown College in Atlanta from 1880 until 1900, had served in the Union Army, the Freedmen's Bureau, and the Reconstruction legislature of Georgia. Turner had been an optimistic patriot after the Civil War: "I used to love what I thought was the grand old flag, and sing with ecstasy about the Stars and Stripes," Turner remarked in 1898. However the Jim Crow era following the end of Reconstruction destroyed this sentiment. Turner continued: "But to the Negro in this country the American flag is a dirty and contemptible rag. . . . Without multiplying words, I wish to say that hell is an improvement on the United States where the Negro is concerned."[43]

Lynching and Antilynching Campaigns

Reports from the Reconstruction era showed that black men and women were killed without having been tried and convicted of a capital offense, such as murder. The very fact of being politically active could result in a black Republican's being killed by a mob during Reconstruction. Extralegal executions increased drastically in the late nineteenth century, after black men lost the vote and could no longer influence politics. Statistics of recorded lynchings date from the early 1880s and show that between 1882 and 1968, mobs acting outside the law killed at least 4,743 people, of whom 3,446 were black men and women (Table 8.3). The largest number of lynchings occurred in Mississippi, Georgia, Texas, Louisiana, and Alabama.

In the late nineteenth century, more than 100 people were lynched nearly every year, with the record number of 230 in 1892 (of whom 161 were black and 69 nonblack). Lynching declined in the twentieth century, to 97 in 1908, 83 in 1919, 30 in 1926, and 28 in 1933.[44] Before the 1890s, lynching served primarily as a means of killing off people who were considered troublesome. In the 1890s and early twentieth century, lynchings

often became white community rituals. Special trains carried spectators to the scene, and professional photographers made picture postcards for sale.[45] Lynching victims were tortured, mutilated, and killed slowly to ensure the maximum of pain and humiliation. These lynchings were staged to entertain spectators and intimidate black people. Black children who witnessed lynchings identified with the victims and remained permanently traumatized.

Table 8.3. Numbers of Black and Nonblack Lynching Victims, 1882–1968

State	Black Victims	Nonblack Victims
Mississippi	539	42
Georgia	492	39
Texas	352	141
Louisiana	335	56
Alabama	299	48

White supremacists defended lynching as the way to punish black men who raped white women. The black Memphis journalist Ida B. Wells (1862–1931) began investigating lynching after three of her friends were killed for running a successful and competitive grocery store. Wells discovered that overall, only a minority of black lynch victims had even been accused of rape or attempted rape. Freida High W. Tesfagiorgis (b. 1946) paid homage to Ida B. Wells in an installation in which a figure of Wells stands between panels listing the names of lynch victims (8.13). In this installation, the trees on each side of the Wells figure stand for the trees on which lynch victims were hung. The bier in the front represents death.

Black men and women were lynched for a wide variety of infractions, including robbery, murder, talking back, and insubordination. Wells published a series of articles in the black and white press and issued two influential pamphlets: *On Lynchings: Southern Horrors* (1892) and *A Red Record* (1895).

Wells's journalism led black clubwomen and prominent men to organize antilynching campaigns. In 1896 black clubwomen formed the National Association of Colored Women (NACW). By 1914 the NACW had some 50,000 members in 1,000 clubs.[46] Organizations devoted to black civil rights, such as the Niagara movement of 1905–1908 and the National Association for the Advancement of Colored People (the NAACP, formed in 1909–1910), continued the campaign against lynching in the twentieth century. Sixteen Southern and Border States passed antilynching legislation by the 1930s, but these laws were enforced unevenly. Under pressure from the NAACP, the United States House of Representatives passed antilynching bills in 1922, 1937, and 1940, but Southern opposition killed them all in the Senate. No federal antilynching bill has ever been enacted into law, although the Civil Rights Act of 1964 bans depriving a person of his or her civil rights through murder.[47]

Black artists have repeatedly portrayed lynching as the ultimate symbol of racist oppression in the United States. Whether abstract or figurative, their work recalls the trauma of the black past and the strength of black people to survive. In "Lynch Fragments" from 1963 (8.14) Melvin Edwards (b. 1937) welds together a variety of steel and iron objects: pipes, blades, railroad spikes, shackles, and chains. They become instruments of torture that recall the oppression of lynching.

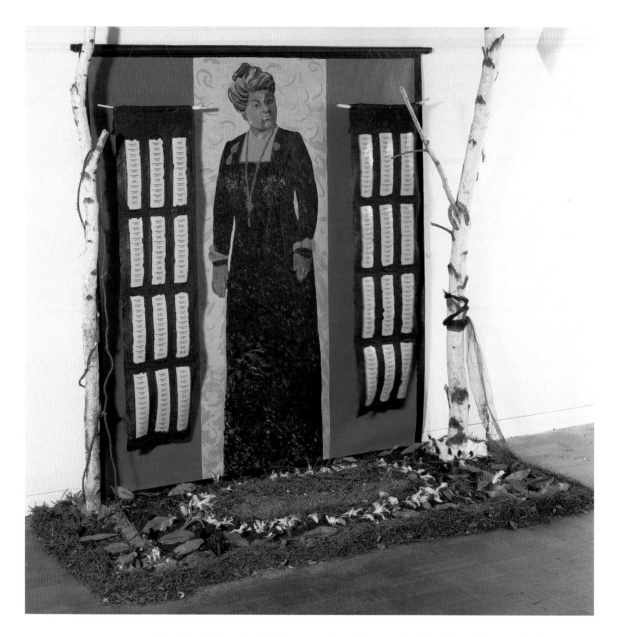

Camille Billops (b. 1933) turns the tables on the Ku Klux Klan in her humorous "The KKK Boutique" (8.15). Billops's laughing black and white women use unintimidated female power against the cross-burning, invading Klansmen, throwing a smaller cross at them as though the Klan were vampires. Totally unafraid, the women chase the Klan away.

"Accused/Blowtorch/Padlock" by Pat Ward Williams (b. 1948) asks the viewer questions about how, exactly, a mid-twentieth-century lynching pictured in *Life Magazine* actually took place (8.16). The images in the middle show the body of the lynch victim,

(Above) 8.14. Melvin Edwards, "Lynch Fragments: Resolved and Afro Phoenix no. 2," 1963/1964
Edwards's series uses found metal objects welded together into instruments of lynching's torture and death.

(Opposite) 8.13. Freida High W. Tesfagiorgis, "Homage to Ida B. Wells," 1990
In Tesfagiorgis's installation, Wells stands behind a funeral bier and between panels listing the names of lynch victims and trees evoking the branches from which they hung.

charred by a blowtorch. Williams asks who took the photo and why the photographer didn't stop the attack. She reminds her audience that lynching still occurs.

Conclusion

The atrocity of lynching came to symbolize a whole range of oppressive practices that made the era of the turn of the twentieth century little better than slavery. Black men in the South lost their right to vote, and all over the United States, men, women, and

8.15. Camille Billops, "The KKK Boutique," 1994

Billops shows black and white women standing up to the Ku Klux Klan and running the invaders away. The KKK has evidently already killed people (burial crosses in the lower left corner) and is burning crosses (upper left corner) in an attempt to frighten the women who are crossing the color line. Billops made a film by the same name.

8.16. Pat Ward Williams, "Accused/Blowtorch/Padlock," 1986

Williams addresses the viewer: "There's SOMETHING going on here. I didn't understand it right away. I just saw that he looked so HELPLESS. He didn't look tortured. He didn't look lynched. WHAT is that? How long has he been LOCKED to that tree? Can you be black and look at this without fear? Life magazine published this photo. Could Hitler show picts of the Holocaust to keep the JEWS in line? WHO took this picture? Couldn't he just as easily let the man go? Did he take his camera home and bring back a BLOWTORCH? And where do you torture someone with a blowtorch? BURN off an ear Melt an eye or scorch a mouth Oh God WHO took this picture? HOW can this photograph EXIST? Life answers—Page 141—no credit. Somebody do something."

children found themselves barred from public spaces. After the relatively hopeful era of Reconstruction, racial oppression made many African Americans despair of their future in the United States. In the depths of the era of Jim Crow, however, African Americans squeezed through every opening freedom afforded, to gain autonomy and education. Although their wages were low, they could earn wages, save wealth, and create businesses. Musicians laid the foundations of American popular culture. Black people succeeded against enormous odds. Their efforts began slowly to pay off in the decades to follow.

9.1. Jacob Lawrence, "Migration of the Negro, Panel 1: During the World War there was a Great Migration North by Southern Negroes," 1940–1941
Lawrence shows masses of black people of all ages crowding on to trains on their way to Chicago, New York, and St. Louis, as indicated by the names over the departure gates.

The New Negro

1915–1932

The "New Negro" of the period during and after the First World War was self-confident, urban, and Northern. Earlier stereotypes of "the Negro" depicted rural Southerners full of Southern humility and deference to white people, signs of an acceptance of black inferiority. The figure of the New Negro of the early twentieth century denied charges of racial inferiority. He—for the race was still envisioned as one man—was proud to be a Negro. He fought back when attacked and proclaimed his pride in his race. The New Negro emerged from his times. During the First World War, hundreds of thousands of African Americans migrated from the South to the North and Midwest. Migrants exchanged the worst of Southern, state-sponsored racial terrorism for relative—strictly relative—freedom.

The "Migration of the Negro" series by Jacob Lawrence celebrates one of the crucial events of African-American history: the Great Migration of more than half a million black people out of the South into the North and Midwest during the First World War (9.1). This migration, the first massive movement out of the South, took black people into cities, where they attended decent schools, made a living wage, voted, and made music and art.

During the First World War, black men distinguished themselves as soldiers in France and experienced themselves as members of an African Diaspora, an international community of people of African descent. Born free, this generation of African Americans believed they were entitled to the rights of American citizenship. But they enjoyed those rights only in part, for the first four decades of the twentieth century remained a Jim Crow era. In the national culture, African Americans were still largely invisible. When and where they did appear, cruel, demeaning stereotype distorted their humanity all too

often. This was still the time of segregation, humiliation, antiblack riots, and lynching, when many Americans saw black people as an inferior, alien race.

In the early twentieth century, African Americans were nonetheless more able to reach the levers of power than in the nineteenth century. Combating racial oppression more effectively, they publicized their own ideas about the race. African Americans and their allies began to influence American culture and politics as never before. The symbol of these better-educated, more militant, and more powerful African Americans was the "New Negro." He was more likely to live in the North or West than the South and sometimes proclaimed himself a black nationalist.

The Great Migration

The Great Migration of more than half a million black people out of the South into the North and Midwest during the First World War was a crucial event in American history. The departure of thousands of European immigrants and Northern soldiers during the First World War created job opportunities for black Southerners. Most Southern families migrated of their own volition, but sometimes labor recruiters urged people toward specific jobs. Black newspapers also encouraged black Southerners to leave. One newspaper played a crucial role: Robert Sengstacke Abbott's Chicago daily *Defender*, in particular its weekly "national" edition aimed at Southerners. Abbott began publishing the *Defender* in 1905. The newspaper's circulation boomed as it talked up the Great Migration and opportunities awaiting migrants in the North. The *Defender* even set a departure date: the Great Northern Drive of May 15, 1917, when it urged Southerners to come North. In 1916 the *Defender* was putting out ten thousand copies of each paper. By 1918 its circulation had reached 93,000.[1] Compared to their parents, New Negroes were more cosmopolitan consumers of national—even international—news.

The Great Migration attracted tremendous attention at the time, as though black migration had never happened before. But in fact, it had happened before. Thousands of black people already lived in the Northern and Western cities to which the wartime migrants moved. The Great Migration accelerated an already existing trend, for large numbers of black Southerners had been leaving the South since the end of Reconstruction. About 200,000 had moved North between 1890 and 1900. By 1900, 72 U.S. cities had more than 5,000 black residents, including Newark, New Jersey (6,694). Philadelphia, New York City, and Memphis were home to more than 50,000 African Americans; Washington, D.C., had more than 86,000 African Americans; Baltimore, more than 79,000; and New Orleans, more than 77,000.[2] By 1910, the cities with more than 5,000 black residents included Denver (5,426) and Los Angeles (7,599).[3]

Black artists captured the exhilaration of black city life. The sheer density of the black population seemed to offer protection from angry white people. In densely populated cities North and South, African Americans relished their own company, their own

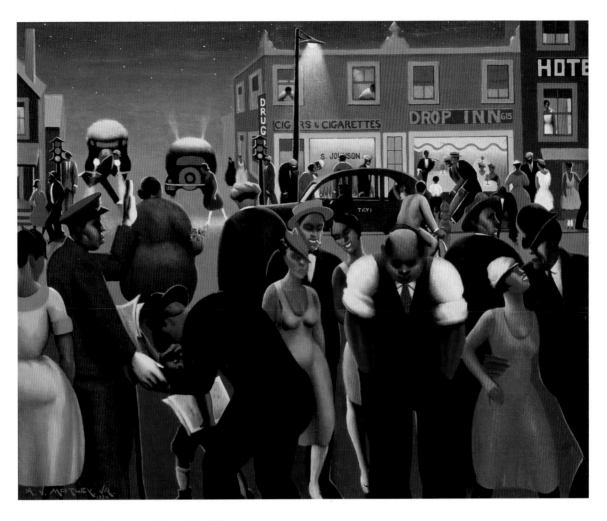

9.2. Archibald J. Motley, Jr., "Black Belt," 1934

Motley depicts the vitality and brilliance of Chicago's South Side, where all sorts of black people mingle freely on Saturday night. An African-American policeman—part of what made Chicago unusual at the time—directs a crowd setting out for the evening: an older white-collar worker, a couple of young lovers, and men and women dressed for the "sporting life."

music, their own leisure. Archibald J. Motley, Jr. (1891–1981), depicted the intensity of his own South Side of Chicago on a Saturday night in "Black Belt" (9.2).

The Great Migration was dramatic because its first wave occurred in the space of only a few years, 1916–1919. It suddenly multiplied the black population in cities where African Americans had hardly been noticed before. The Great Migration increased Detroit's black population by 611 percent; Cleveland, 308 percent; Chicago, 114 percent; New York City, 66 percent; Newark, 62 percent; Indianapolis, 59 percent; Cincinnati,

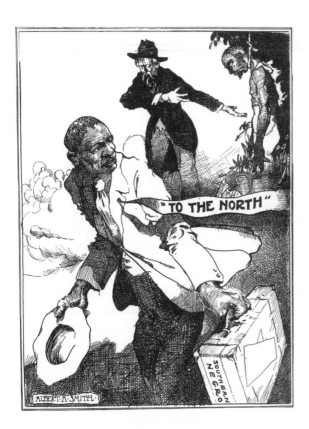

"TO THE NORTH"

SOUTHERN NEGRO

ALBERT A. SMITH

9.3. Albert A. Smith, "The Reason," 1920

Smith, a cartoonist for *The Crisis* magazine, shows a migrant fleeing a white Southern planter trying to call him back South. A lynch victim, a prime reason for flight, appears in the top right corner.

54 percent; and Pittsburgh, 47 percent. The numbers of migrants, too, were remarkable: 65,500 new black people in Chicago, 61,400 in New York City, and 36,200 in Detroit.[4]

Black migrants sought better jobs and higher wages; they also sought to escape from Southern discrimination, segregation, and lynching, aggravated by crop failure caused by the boll weevil. A cartoon from *The Crisis* (organ of the National Association for the Advancement of Colored People) by Albert A. Smith (1896–1940) shows a Southern migrant on his way North, looking back over his shoulder at a lynch victim and a white southerner (9.3).

Jobs were the pull factor of the Great Migration, the promise that wrenched working people out of their old lives. Many of these jobs were in industry. Although most African-American women continued in domestic service, black men found jobs in the meat packing, auto, and steel industries. Sometimes they were initially hired only as strikebreakers. Labor conflict over jobs and strikes aggravated tense race relations in many cities.

To serve the newly enlarged urban black populations, well-educated African Americans also moved to the North and Midwest. Often these educated people worked at any jobs they could get until they accumulated enough capital to set up their own businesses. For example, William Lewis Bulkley (1861–1933), with a Ph.D. from Syracuse University, worked as a janitor and waiter before finding work as a seventh-grade teacher and helping found the National Urban League in 1910. Philip Payton (1876–1917), founder of the Afro-American Realty Company, Harlem's premier real estate company, had worked as a porter and barber. The leading poet of the Harlem Renaissance, Langston Hughes (1902–1967), worked as a farm laborer and ship's mess boy.[5]

The era of the Great Migration out of the South was also the era of black immigration to the United States from other countries. Between 1910 and 1920, 33,464 people of African descent immigrated to the United States. In 1920, the total of 73,803 foreign-born blacks in the United States came overwhelmingly from the Americas, notably the West Indies and Cuba.[6] Considered as a whole, the New Negroes were not only a national people, they were also international, multi-lingual, and ethnically heterogeneous.

Despite the existence in the North of considerable race prejudice—even antiblack violence—racial humiliation was not so fundamental a part of Northern society as Southern society. In Philadelphia, for example, one Southern migrant made enough money to buy health insurance. He could sit where he wanted on the streetcars—appropriate because he was paying the same fare as white people. An added bonus, according to another black Philadelphian, was that you "don't have to mister every little white boy comes along."

Another migrant appreciated this and more about Northern life, as he sounded a note familiar in African-American discourse—that of manhood: "I should have been here twenty years ago," he wrote. "I just begin to feel like a man. . . . My children are going to the same school with the whites and I don't have to humble to no one. I have registered. Will vote in the next election and there isn't any yes Sir and no Sir. It's all yes and no, Sam and Bill."[7] The quest for manhood was older than the Great Migration and would continue long past it. For New Negro men, getting out of the South and casting a vote represented two giant steps into manhood. In 1916–1919, women still could not vote.

In the North, black men were political people, voting and even holding office. In 1928 black Chicagoans elected the first African-American congressman from the North. Oscar DePriest (1871–1951), the Alabama-born son of Kansas Exodusters, took his seat in 1929. It had been a long generation of twenty-eight years since the last black congressman, George White of North Carolina, had departed.

It would take more than black men's voting to reverse the spread of segregation, however. James Weldon Johnson (1871–1938)—composer, poet, diplomat, and NAACP activist—believed that white supremacy would have continued to hold sway in the United States, had it not been for the First World War.[8] Once again, war made all the difference in the world.

The First World War: Struggle on Two Fronts

In 1917, when Congress declared war on Germany, Austria-Hungary, and Turkey, President Woodrow Wilson proclaimed it a war to make the world safe for democracy. African Americans greeted his words with skepticism. Wilson, a Virginian, had segregated the federal service and had remained silent about lynching. Blacks were divided on whether to support the war effort, given the history of racial discrimination in American society, including in the armed forces. They thought of their manifestly undemocratic experiences of disfranchisement, lynching, and segregation.

William Monroe Trotter (1872–1934), publisher of the Boston *Guardian* expressed a common ambivalence: "We believe in Democracy, but we hold that this nation should enter the lists with clean hands." Trotter was willing to support the war effort, but he wanted something in exchange: antilynching legislation, an end to discrimination in federal jobs, and the desegregation of the United States Armed Forces.[9] These demands

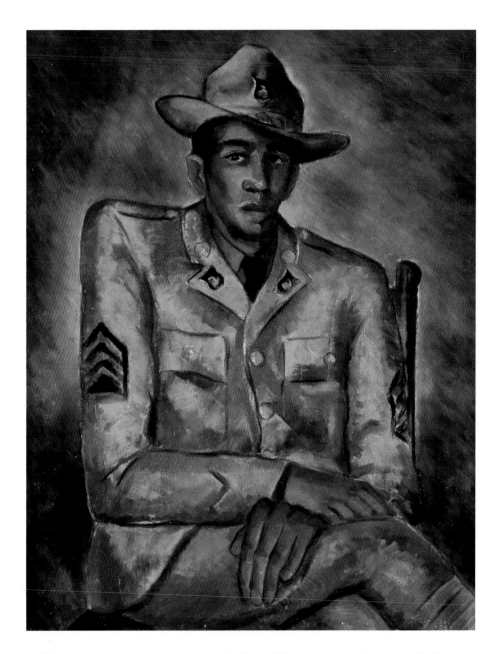

would reappear a generation later, as the United States prepared to enter the Second
World War.

The draft forced African Americans from their ambivalence. Most backed the United
States and hoped that military service would improve the situation of the race as a whole.
In June 1917, hundreds of thousands of black men found themselves in the United States
Army whether or not they supported the war's aims. Malvin Gray Johnson (1896–1934)
summed them up in his wary 1934 "Negro Soldier" (9.4).

W. E. B. Du Bois's 1918 "Close Ranks" edito-
rial in *The Crisis* urged African Americans to
"forget our special grievances and close our ranks
shoulder to shoulder with our own white fellow
citizens and the allied nations that are fighting for
democracy. We make no ordinary sacrifice, but we
make it gladly and willingly with our eyes lifted
to the hills."[10] C. M. Battey (1873–1927), the lead-
ing black photographer of his generation, founded
the photography department of Tuskegee Institute.
Battey photographed the most prominent African
Americans of the early twentieth century, includ-
ing Du Bois in the "close ranks" era and Booker T.
Washington in his prime (9.5).

As in previous American wars, black soldiers'
sacrifices quickly mounted. The U.S. Army in-
tended to use black soldiers merely as laborers. And
assuming that white Southerners understood best
how to deal with African Americans, the Army sub-
jected the black soldiers to discipline along South-
ern lines. Every step black men took beyond the
status of laborer came as a result of protest. Protest
prompted the War Department to name Emmett
Scott (1873–1957), who had been the secretary of
the late Booker T. Washington, to the post of spe-
cial assistant to the Secretary of War to manage
racial crises.

As in the Civil War, a conflict over black officers
quickly surfaced. Originally the War Department

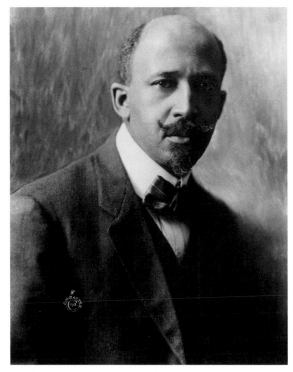

(Above) 9.5. C. M. (Cornelius Marion) Battey, "Portrait of
W. E. B. Du Bois," 1918
Battey shows Du Bois during the era of the First World War, the
crusading gentleman editor of the NAACP's *The Crisis*.

(Opposite) 9. 4. Malvin Gray Johnson, "Negro Soldier," 1934
This soldier with a blues sensibility seems to have accepted his
role with more resignation than idealism.

did not plan to train any black men as officers. This decision sparked an angry uproar
among African Americans and their allies. After a spirited struggle, the NAACP suc-
ceeded in persuading the Secretary of War to extend officer training to college-educated
black men. But the Army stood firm on segregated training. "Negro" and "officer" re-
mained distant and separate concepts.

Even the highest-ranking African-American officer in the Army was barred from Eu-
ropean hostilities. When the United States joined the war, Colonel Charles Young (1864–
1922) had been in Mexico, leading the black 10th Cavalry with General John J. "Black
Jack" Pershing. Young wanted to go to France with the 10th Cavalry. But the prospect of
his outranking white Southern officers led to his immediate retirement for ill health. To
prove his fitness to serve, Young rode on horseback from Ohio to Washington, D.C., but
in vain. The Secretary of War brought him out of retirement only after the war ended.[11]

The experience of black officers was an unhappy one. Segregated, humiliated, and degraded by American whites who refused to salute them, black officers often preferred France to the United States. Rayford W. Logan (1897–1982), a twenty-two-year-old graduate of Williams College who later became a leading historian, stayed in France several years after the war's end. For Logan and other New Negroes, France, Paris in particular, offered a valued sanctuary from American Jim Crow.[12]

Other black officers resolved to undertake Civil Rights activism on their return to the United States. Charles Hamilton Houston (1895–1950), dean of the Howard University Law School, led the legal campaign against segregation in schools and colleges that culminated in the *Brown v. Board of Education* decision of 1954, declaring segregation in education unconstitutional. On his way back from France Osceola McKaine (1892–1955) stopped in Harlem rather than returning to his native South Carolina. He and other graduates of the segregated black officers school in Des Moines founded the League for Democracy and edited its journal, the New York *Commoner*. McKaine went back to Europe in the early 1920s and owned a nightclub in Ghent, Belgium, until the German occupation of 1940 forced his return to the United States.[13] Harry Haywood (1898–1998) was not an officer, but his wartime experiences politicized him. Haywood joined the newly founded Communist Party of the United States and rose quickly in its ranks.[14]

Mistreatment of black soldiers began in the United States. In Houston, racist abuse and police brutality goaded black soldiers into shooting back at attackers, resulting in the death of two blacks and seventeen whites. Even before a complete investigation of the incident was conducted, the Army court-martialed the black soldiers, hanged thirteen, and sentenced forty-one to life imprisonment.[15] In 1906, a similar incident and outcome had occurred in Brownsville, Texas. The Houston riot occurred in the context of antiblack violence against civilians: two months before Houston, whites had brutally attacked black people in East St. Louis. As a result of these events, black soldiers on their way to France to make the world safe for democracy traveled with a sense of irony, if not outright anger.

French people, untutored in American white supremacy, gave black soldiers a welcome that was completely at odds with their treatment by American authorities. The U.S. Army only grudgingly used black soldiers as anything other than overworked drudges. White American officers referred to black soldiers as "niggers," "darkies," and "coons" and warned the French that black men were potential rapists, not to be treated as fully human beings. By contrast, the French Army incorporated black soldiers into their exhausted forces. The whole New York 369th Infantry—an entirely black unit—received the French Croix de Guerre.[16] By war's end, more than 100,000 black men had served overseas and discovered that American racial ideology lacked a universal reach.[17]

The success of African-American soldiers in France annoyed white supremacists

9.6. James A. Porter, "Soldado Senegales," ca. 1935
In Paris Porter came into contact with First World War veterans from all over the French empire, including this man from Senegal or Mali who poses against a backdrop of African fabric.

inside and outside the U.S. Army. The War Department sent Robert Russa Moton (1867–1940), Booker T. Washington's successor at Tuskegee Institute, to France to warn black soldiers not to expect any changes in the American racial status quo. Although the soldiers did not welcome his message, the army persisted in its discriminatory ways. Black Gold Star mothers—women whose sons had died on European battlefields—were barred from the white Gold Star mothers' trip to France. Black mothers had to travel separately to visit their dead in segregated cemeteries after the white event.

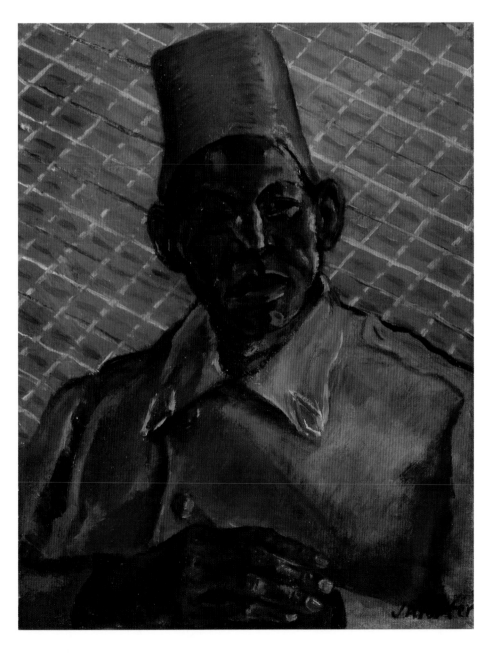

The international experience of African-American soldiers broadened their horizons, much as service in the Union Army had expanded the vision of former slaves during the Civil War. In France black men learned the limits of American racism and discovered the joys of thinking freely. Just as important, African-American combatants encountered other people of African descent—soldiers serving in the colonial services and civilians living in France and Great Britain. The Howard University artist and art historian James A. Porter (1905–1970) painted "Soldado Senegales" while studying art in Paris. The portrait illustrates Porter's admiring interest in the famous Senegalese troops from West Africa (9.6).

African Americans in Europe discovered they had much in common with people from the colonies. The 50,000 African-American soldiers in France were just one segment of a vast army of color fighting for European nations that called themselves white: 1,200,000 from the Indian subcontinent served as soldiers and laborers on Great Britain's behalf; 175,000 African soldiers fought on France's front lines; and more than 200,000 East Asians labored in defense of France.[18]

Conversations with Africans and West Indians broadened black Americans' concepts of the meanings and limitations of racial identity. Despite the commonality that black Americans felt with their counterparts in the colonial troops, two experiences symbolized the difference. Unlike the colonial troops, African-American soldiers were not allowed to march in the Allied victory parade in Paris in 1918. This affront recalled the prohibition against black veterans in Civil War commemorations in the United States. Moreover, the war mural in the Panthéon de la Guerre did not include an image of African-American soldiers. As a result, the official visual representation of the American armed forces was completely white.

Black Military Bands Introduce Jazz

Of greater importance to the identity of the black soldier than the war mural, however, was the positive image of the African-American military bands. Black units in the U.S. Army had had their own bands since 1909, thanks to a prolonged campaign by Emmett Scott. During the First World War, the most renowned black military band was that of James Reece Europe (1881–1919) of the 369th Infantry from New York City.[19] The drum major for the 369th band was Bill "Bojangles" Robinson (1878–1949), who later starred with Shirley Temple in Hollywood movies.

On the Champs Élysées in Paris in 1918, Europe's band played in a joint concert of several allied military bands. Departing from the martial cadences of the European bands, the African-American band played highly syncopated jazz. The crowd went wild, setting off a permanent enthusiasm in Europe for African-American jazz. James Europe explained what made his band's music so infectious:

> With the brass instruments we put in mutes and make a whirling motion with the
> tongue, at the same time blowing full pressure. With wind instruments we pinch
> the mouthpiece and blow hard. This produces the peculiar sound which you all

know. . . . we accent strongly in this manner the notes which originally would be without accent. It is natural for us to do this; it is, indeed, a racial musical characteristic. I have to call a daily rehearsal of my band to prevent the musicians from adding to their music more than I wish them to. Whenever possible they all embroider their parts in order to produce new, peculiar sounds.[20]

Europe's big band of sixty-five musicians made a worldwide tour, spreading jazz music and permanently changing Western musical culture. In February 1919, Europe's band accompanied the 369th's proud march up Fifth Avenue to Harlem. Europe died in 1919, but his death did not hinder the spread of the music that made the 1920s the "Jazz Age."[21]

The 369th Infantry's victory parade symbolized the resolute New Negro. In an editorial in the May 1919 issue of *The Crisis*, W. E. B. Du Bois phrased these convictions in words:

> *We return.*
> *We return from fighting.*
> *We return fighting.*
> Make way for Democracy! We saved it in France, and by the Great Jehovah, we will save it in the United States of America, or know the reason why.[22]

Antiblack Riots and the Red Summer of 1919

Black veterans returning from the European war encountered racial violence in the form of antiblack riots. Attacks sometimes cost veterans their lives before they even took off their uniforms, for some white supremacists saw provocation in the mere fact of a black man in military uniform. The last lines of a poem signed "Razafkeriefo" predicted that black veterans would retaliate against their attackers:

> For by the blood you've spilled in France
> You must and will be free,
> So from now on let us advance
> With this: Don't tread on me![23]

In 1919, the year of the great upheaval in labor relations, white mobs attacked black people in twenty-six cities. James Weldon Johnson named the summer of 1919 the "Red Summer" because of the African-American blood that was shed in antiblack riots, North and South.[24] Soaring prices during the war reduced the value of wages, sending workers out on strike for more pay. After the war, returning white veterans confronted black workers who had filled their jobs. The result was a wave of strikes as well as appalling outbreaks of mob violence. Much of the violence—although not all—was directed

against black workers. White workers, native and immigrant, often transferred their anger at their employers onto more vulnerable black workers. The resulting antiblack riots killed scores of working people between 1917 and 1919.

Like the Great Migration, the Red Summer of 1919 represented a sudden intensification of a long-standing phenomenon. Antiblack riots had a long history, with the Draft Riots of 1863 in New York and other Northern cities standing out as particularly deadly. Race riots had occurred early in the twentieth century, for example, in Atlanta in 1906 and in Springfield, Illinois, in 1908.

In June 1917, whites attacked black workers in East St. Louis, and then in November in Chester and Homestead, Pennsylvania. In East St. Louis the mayor, police, and local militia helped whites burn the houses of blacks with the tenants still inside. One of the dead was a wounded two-year-old child thrown into a burning building. Ida Wells-Barnett went to East St. Louis immediately after the riot to secure legal aid for the victims. At least forty black people died in East St. Louis. To protest the racist slaughter, eight thousand black people wearing black armbands marched silently in New York City. They carried signs reading, "WE ARE MALIGNED AS LAZY AND MURDERED WHEN WE WORK," "YOUR HANDS ARE FULL OF BLOOD," and "MR. PRESIDENT, WHY NOT MAKE AMERICA SAFE FOR DEMOCRACY?"[25]

The worst violence of the Red Summer of 1919 occurred in Chicago in July. Racial violence and labor unrest had been roiling the city since 1917. Crowds of armed whites, led by Irish athletic clubs, roamed the black section of Chicago on foot and in cars, firing upon blacks indiscriminately. New Negroes fought back. They retaliated by killing all the whites who were firing a machine gun from a truck. Whites assaulted blacks, and blacks struck out at any white men within reach. A black soldier who had been wounded in Europe limped along the street, exclaimed that "this is a fine reception to give a man just home from the war." A crowd of whites beat him to death. In more than a week of anarchy, 537 people were injured and 38 people died, 23 black and 15 white. Everyone noticed that African Americans had fought back. Unlike the East St. Louis riot two years earlier, where nearly all the victims were black, the violence in Chicago looked more like a real war between the races.[26]

Many other attacks occurred during the Red Summer. In Longview, Texas, marauding white men scourged the black section of town, beating up a school principal, because a teacher had circulated a report of a lynching from the Chicago *Defender*. After white servicemen ran amok in Washington, D.C., blacks retaliated in kind. Near Elaine in rural Phillips County, Arkansas, black farmers began organizing to end debt slavery and peonage. The sheriff shot up their meeting; the farmers shot back. In the end, more than one hundred blacks and forty whites were injured. In Omaha, Nebraska, a white mob dragged a black man accused of attempting to rape a white woman from his jail cell. The mob shot him more than one thousand times before hanging what was left of his mutilated torso from a downtown trolley pole.[27]

The twenty-six antiblack riots of the Red Summer did not account for all the racial

violence of the time. Some seventy-six black people were lynched in 1919, as the white press stirred up distrust between black and white workers by blaring reports of black crime, especially of black men accused of attempting to rape white girls. Lynching went on into the 1920s, as did the antiblack mobs. In 1921, whites attacked the black business district of Tulsa, Oklahoma. The business district burned and thousands of black people were made refugees. As in Chicago, the dead were not entirely black: ten white people died along with the twenty-six blacks.[28]

Claude McKay (1889–1948), a Jamaican-born leading poet and novelist of the Harlem Renaissance, captured the spirit of the New Negro in a season of racist mob attacks. McKay entitled his 1919 hymn to besieged black manhood "If We Must Die." The poem's theme of fighting back summarized the aggressive new attitude of the New Negro.

If we must die, let it not be like hogs
Hunted and penned in an inglorious spot,
While round us bark the mad and hungry dogs,
Making their mock at our accursed lot.
If we must die. O let us nobly die,
So that our precious blood may not be shed
In vain; then even the monsters we defy
Shall be constrained to honor us though dead!
O Kinsmen! we must meet the common foe!
Though far outnumbered let us show us brave,
And for their thousand blows deal one deathblow!
What though before us lies the open grave?
Like men we'll face the murderous, cowardly pack,
Pressed to the wall, dying, but fighting back![29]

This vital New Negro, the embodiment of the black men who had fought to save democracy in Europe, faced more than lynchings and mob violence. The Ku Klux Klan, an institution from the 1860s and 1870s, reappeared near Atlanta in 1915 in *Birth of a Nation*, a Hollywood feature film about Reconstruction that depicted black soldiers as rapists of white women. During the 1920s the Klan attracted millions of white men and women to its campaign against immigrants, Catholics, disorderly women, and the New Negro.

The New Negroes' Initiatives

What was new about the New Negro? The New Negro fought back. The New Negro embodied the positive changes that had occurred among African Americans since emancipation: education, political sophistication, and migration out of the South. A. Philip Randolph (1889–1979) and Chandler Owen (1898–1967), publishers of the socialist and antiwar *Messenger* of New York, embodied the New Negro. Founded in 1917,

the *Messenger* was one of two leftist black periodicals published in New York City. The other was the *Crusader*, founded in 1918 by Cyril Briggs (1888–1955).[30] The very fact that African Americans in public life could be outspoken in their radicalism was itself relatively new. Not since the pre–Civil War antislavery movement had African Americans criticized American racism so vehemently.

Protest represented a departure from the political accommodation of Booker T. Washington, which appealed to powerful whites, Southerners particularly, and many blacks as well. By the early twentieth century, W. E. B. Du Bois and other Northerners challenged Washington's accommodation to segregation. Du Bois's *Souls of Black Folk* (1903) blamed Washington for black people's lack of citizenship rights. In 1905 Du Bois and like-minded colleagues formed the Niagara movement, pledging to recover black civil rights.

The 1908 riot in Springfield, Illinois—hometown of Abraham Lincoln—motivated white allies in New York to call a conference to discuss the condition of black Americans. In 1909–1910, the conferees organized themselves into the National Association for the Advancement of Colored People (NAACP). At the beginning, Du Bois was the NAACP's sole African-American officer, although Ida B. Wells-Barnett had attended the planning conference. In 1910 black and white New Yorkers organized the National Urban League around efforts led by William Bulkley. The Urban League focused on helping black migrants adjust to Northern city life. Without becoming as radical as the NAACP, the Urban League, focusing on urban workers, nonetheless represented the New Negro. By the time Washington died in 1915, many voices contested his views.

The New Negro was more visible in the North and West. The most influential black periodicals originated in the North, where racial oppression did not enforce silence, rather than in the conservative South. Nearly 90 percent of African Americans still lived in the South, but they were more urban than ever. During the war they made higher wages and closely followed political and racial developments. Wartime prosperity increased the circulation of papers such as the New York *Age*, the Pittsburgh *Courier*, the Cleveland *Gazette*, the Chicago *Defender*, the Washington *Colored American*, the Indianapolis *Freeman*, and the Boston *Guardian*. Starting in 1918, Marcus Garvey's Universal Negro Improvement Association (UNIA) published the *Negro World*. It reached readers in the West Indies and Africa as well as the United States.[31] The circulation of *The Crisis*, the NAACP organ that W. E. B. Du Bois edited, reached 100,000. *The Crisis* and the National Urban League's *Opportunity* were two of the most influential black journals of the war years. They remained the favored journals of the Harlem Renaissance of the 1920s.

The New Negro had an international outlook born of the experience of the First World War, African colonialism, and West Indian immigration to the United States. African Americans had taken an interest in Europe's colonies in Africa as soon as the European powers had divided up the continent in the Berlin conference of 1885. The historian George Washington Williams had even traveled to the Congo of King Leopold

of Belgium in 1889 to investigate atrocities. W. E. B. Du Bois, who had studied in Berlin, knew his educated colonial counterparts. Throughout his long life, Du Bois believed in pan-Africanism, the unity of people of African descent everywhere in the world.[32]

At the end of the war, Du Bois went to the Peace Conference in Paris where allied leaders were drawing up a peace treaty to end the war. Du Bois urged the allies to respect the interests of the colonized peoples of color. He also organized the first Pan-African Congress in Paris in 1919. About sixty blacks from the United States, Africa, and the West Indies attended the Conference. The meeting was smaller than intended because the British and American governments refused passports to their citizens who meant to attend. The U.S. State Department denied passports to businesswoman Madam C. J. Walker and journalists Ida B. Wells-Barnett and William Monroe Trotter.[33]

Du Bois's Pan-African Congresses continued until 1945, but they never reached large numbers of African Americans. Marcus Garvey's Universal Negro Improvement Association did touch the black masses. Garvey, who was from Jamaica, was one of thousands of West Indians who became active in African-American public life. Other prominent West Indians in New York included the activist Cyril Briggs, the poet Claude McKay, and Casper Holstein (1876–1944), who controlled gambling (the "numbers racket") in Harlem and was from the Danish West Indies.

The Universal Negro Improvement Association (UNIA)

In 1916, Marcus Garvey came to the United States to visit Booker T. Washington, in Tuskegee, Alabama. (He did not realize that Washington had died in 1915.) Garvey had founded the Universal Negro Improvement Association in Jamaica in 1914 and admired Washington's practicality and interest in black business. After reading Washington's autobiography, *Up from Slavery* (1901), Garvey had a life-changing insight. He asked himself: "Where is the black man's government? Where is his King and his kingdom? Where is his president, his country, and his ambassador, his army, his navy, his men of big affairs?" Finding none of these things, Garvey resolved: "I will help to make them."[34] Garvey wanted to uplift the Negro race in many different ways, social, economic, and political.

By the time he arrived in New York City in 1917, Garvey had already worked and studied in London and organized black people in Jamaica. Antiblack riots had spurred his American organizing efforts and attracted thousands of adherents into the UNIA fold. The UNIA's inspiring motto encouraged the faithful: "Up, you mighty race, you can accomplish what you will!" The Harlem artist Augusta Savage (1892–1962) sculpted the bust of the man who called himself the "Provisional President-General of Africa" and who created the largest black nationalist movement in American history (9.7). The aim of the UNIA was to transform racial segregation to the benefit of black people. The UNIA boasted its own press (*Negro World*), its own church (African Orthodox Church), its own women's groups (Black Cross nurses), its own businesses (Black Swan Phonograph Company), its own industries (the Negro Factories Corporation, the Berry and Ross Company

9.7. Augusta Savage, "Marcus Garvey," ca. 1930
Savage made several busts of leading African Americans emphasizing the statesmanlike character of the subjects. In this 1970 photograph Garvey's widow, Amy Jacques Garvey (1896–1973), contemplates the bust that Jamaica installed in King George VI Park in Kingston in 1956, as the country was achieving self-government and recognizing prominent native sons.

manufacturing black dolls), and its own police force, choirs, bands, marching society, cooperatives, and labor unions. The UNIA was at its most successful in September 1920, when the First International Convention of the Negro Peoples of the World met in Harlem. At that time the UNIA claimed over one million members (9.8).

Garvey's movement galvanized the black masses. The UNIA created a shipping company, the Black Star Line, and through stock sales of $5 per share, raised $750,000. In 1919 the company purchased a ship, which was intended to physically link the three parts of the black world: the United States, the West Indies, and Africa. The idea of a black-owned company linking the African world proved enduringly powerful. The Black Star Line renamed its ship the SS *Frederick Douglass*, but the ship remained unseaworthy. The UNIA never succeeded in the business of shipping or of transporting black people to new homes in Africa, only one of the organization's many aims.

By 1922–1923 Marcus Garvey was encountering tremendous difficulties with the U.S. federal government and with other African Americans. Scandals rocked the African Orthodox Church, and the Black Star Line racked up an enormous debt. Garvey angered black people by meeting with the Imperial Wizard of the Ku Klux Klan in 1922, while the Klan was still powerfully influencing politics all over the United States. Garvey went

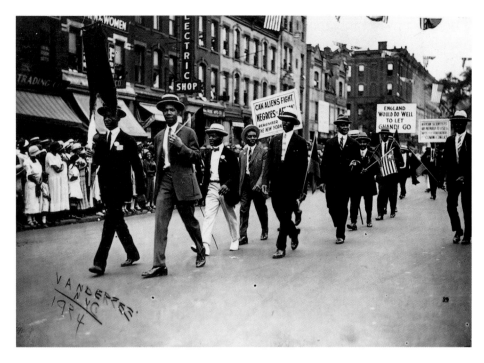

9.8. James Van Der Zee, "UNIA Parade," 1924
Van Der Zee (1886–1983), the official UNIA photographer, made many images of suited and uniformed Garveyites parading in Harlem, New York. They carry signs calling for the independence of Africa and the release of the Indian nationalist Mahatma Gandhi.

on to criticize black people in meetings with the white supremacist U.S. senator from Mississippi, Theodore Bilbo, the head of the Anglo-Saxon League, and other white racist leaders who agreed with Garvey that black and white people should live separately.

A. Phillip Randolph of the New York *Messenger*, Robert S. Abbott of the Chicago *Defender*, and a host of other distinguished African Americans decided that "Garvey Must Go." They resolved to eliminate Garvey from public life. Du Bois said: "Marcus Garvey is, without doubt, the most dangerous enemy of the Negro race in America and the world. . . . He is either a lunatic or a traitor."[35] In 1923 the United States government accused Garvey of mail fraud and found him guilty of defrauding shareholders in the Black Star Line. After his appeals failed in 1925, Garvey served two years in federal prison and was then deported to Jamaica. The UNIA remained the largest black organization well into the 1930s. Garvey's death in London in 1940 ended its massive popularity. But Garveyism endures as a popular ideal of black unity. Marcus Garvey's UNIA knew its finest hours in the very early 1920s. Just as Garvey was experiencing his subsequent legal difficulties, writers, scholars, and activists in Harlem came to the fore in a cultural movement known as the Harlem Renaissance.

The Harlem Renaissance

The black cultural flowering in New York City in the 1920s was both unique and characteristic of the time. The Harlem Renaissance grew out of the New Negro's race pride and sense of connection to black people around the world. Black writers, musicians, and artists were succeeding in other Northern cities, but New York was the site of the American publishing industry and both the NAACP and the National Urban League, with their journals, *The Crisis* and *Opportunity*. During the 1920s, *The Crisis* and *Opportunity* regularly offered literary prizes. New York was also a center for visual art, theater, and music, as well as home to many wealthy patrons of the arts. The New York Public Library had an active branch in Harlem on 135th Street.

Music of the Harlem Renaissance
Musicians and theater people succeeded immediately, building upon pre-war successes. James Weldon Johnson and his younger brother, J. Rosamond Johnson (1873–1954), had written for the theater before the war. One of their compositions, "Lift Every Voice and Sing," gained enormous popularity in the 1920s as the "Negro National Anthem," even though it had been written in 1900.

> Lift ev'ry voice and sing,
> Till earth and heaven ring,
> Ring with the harmonies of Liberty.
> Let our rejoicing rise
> High as the list'ning skies,
> Let it resound loud as the rolling sea.
> Sing a song full of the faith that the dark past has taught us,
> Sing a song full of the hope that the present has brought us;
> Facing the rising sun of our new day begun,
> Let us march on till victory is won.
>
> Stony the road we trod,
> Bitter the chast'ning rod,
> Felt in the days when hope unborn had died;
> Yet with a steady beat,
> Have not our weary feet
> Come to the place for which our fathers sighed?
> We have come over a way that with tears has been watered,
> We have come, treading our path through the blood of the
> slaughtered,
> Out from the gloomy past,

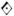

Till now we stand at last
Where the white gleam of our bright star is cast.

God of our weary years,
God of our silent tears,
Thou who hast brought us thus far on the way;
Thou who hast by Thy might,
Led us into the light,
Keep us forever in the path, we pray.
Lest our feet stray from the place, our God, where we met Thee;
Lest our hearts, drunk with the wine of the world, we forget Thee;
Shadowed beneath Thy hand,
May we forever stand,
True to our god,
True to our native land.[36]

"Lift Every Voice and Sing" is a deeply moving national anthem cast in a nine-teenth-century mold. Its stateliness does not express the syncopated rhythm that struck many as a natural emanation of the Negro soul. James Reese Europe, leader of the 369th Infantry Band, said he came back from France "more firmly convinced than ever that Negroes should write Negro music. . . . We won France by playing music which was ours. . . . The music of our race springs from the soil."[37] Again and again, classical and popular musicians expressed the desire to publicize black people's especial musical genius.

Black musical landmarks appeared in quick succession in the early 1920s. In February 1920, as the recording industry was just getting under way, Mamie Smith (1883–1946) made the first record aimed exclusively at black consumers. A vaudeville and cabaret singer, Smith recorded "You Can't Keep a Good Man Down" and "This Thing Called Love."[38] In 1921, black musicals returned to Broadway with the sensational hit, "Shuffle Along," by Flournoy Miller (1887–1971) and Aubrey Lytel (n.d.). The cast included Josephine Baker (1906–1975) and Paul Robeson (1898–1976), both of whom went on to long and distinguished international careers.

Black and white audiences in Chicago, New York, and all across the United States and Europe reveled in the music of the great black musicians of the era, such as Will Marion Cook (1869–1944), Sidney Bechet (1897–1959), Ferdinand "Jelly Roll" Morton (1890–1941), Louis Armstrong (1900–1971), Duke Ellington (1899–1974), Gertrude "Ma" Rainey (1886–1939), and Ethel Waters (1896–1977). The careers of these performers shifted into high gear during the 1920s, as jazz swept the world and lasted through the succeeding decades. The artist Romare Bearden (1911–1988) captured the intensity of jazz musicians in the midst of creation (9.9).

9.9. Romare Bearden, "Jammin' at the Savoy" (n.d. [before 1982])
Bearden pioneered the use of the collage technique to capture the energy and creativity of black jazz musicians.

Roland Hayes (1887–1979) was the first African American to achieve a global reputation as a concert artist. To make his art more accessible to black audiences, he charged them lower fees than whites. Hayes's female counterpart in opera and concert music, Marian Anderson (1902–1993) made her debut at Town Hall in New York City and won first place in the New York Philharmonic singing competition in 1925. Her career extended through the beginning of the television era. Paul Robeson, trained as a lawyer, made his solo singing debut in 1925. He sang the role of Joe in the London production of *Show Boat* in 1928 and starred as an actor and singer until the Cold War of the 1950s.[39]

Literature of the Harlem Renaissance
American audiences of all types welcomed black music as one of the presumably natural gifts of the Negro race. Audiences were not so predisposed for black achievements in literature, visual art, and scholarship. They perceived these pursuits as belonging to a higher order (that is, one belonging to whites) and so not automatically within the province of the descendants of slaves. Much more work was needed to bring black intellectual and artistic achievement to national audiences.

The literature, art, and scholarship of the Harlem Renaissance became well known

as the result of careful networking by seven visionary and well-connected African Americans in Harlem and their white allies. At the NAACP were W. E. B. Du Bois, editor of *The Crisis*; Jessie Fauset (1863–1935), book editor of *The Crisis*; James Weldon Johnson, executive secretary; and Walter White (1893–1955), assistant secretary. At the National Urban League was Charles S. Johnson (1893–1956), editor of *Opportunity*. In Harlem, Paris, and Howard University in Washington, D.C., was the philosopher Alain Locke (1886–1954). Harlem's numbers-racket king, Casper Holstein, supplied the money.

These seven mentors of the Harlem Renaissance sought a path toward racial advancement through the arts. With Southern mobs lynching black people by the score and most African Americans unable to cast a ballot, the leaders of the Harlem Renaissance questioned the value of democracy for their people. They surmised that wealthy and educated white people were more likely to be converted away from antiblack racism than the white masses. Working with white allies like Carl Van Vechten, the Harmon Foundation, and other writers and publishers, the seven black facilitators discovered talented young black artists and shepherded their work into print. Folklorist and novelist Zora Neale Hurston (1891–1960) laughingly called the artists the "Niggerati" and their publishers and patrons "Negrotarians."[40]

For the first time since the very early years of the twentieth century, major publishers brought out the work of black writers such as Jean Toomer (1894–1967), Claude McKay, Langston Hughes, Jessie Fauset, Zora Neale Hurston, Countee Cullen (1903–1943), Nella Larsen (1891–1964), Wallace Thurman (1902–1934), and a host of others. Their luxurious playground was the Irvington-on-Hudson manor of A'Lelia Walker (1885–1931), heir of the fortune of her mother, Madam C. J. Walker.

Black pride was a central theme of the Harlem Renaissance. Jessie Fauset saw Harlem Renaissance writing as a race-conscious quest to "find our own beautiful and praiseworthy, an intense chauvinism that is content with its own types." The younger writers thought in generational terms. They would shoulder aside the older writers (such as Fauset and Du Bois). In 1926 the younger writers put out their own periodical, *Fire*, "to burn up a lot of the old, dead, conventional Negro ideas of the past."[41] But *Fire* lasted only one issue.

The year 1925 marked the coming-of-age of the Harlem Renaissance. Notable books had already appeared: James Weldon Johnson's *Book of American Negro Poetry* and Claude McKay's *Harlem Shadows* in 1922; Jean Toomer's *Cane* in 1923; and in 1924, Jessie Fauset's *There Is Confusion*, Walter White's *Fire in the Flint*, and Countee Cullen's *Color*. The 1925 publication of Alain Locke's *The New Negro*, with its poetry, stories, and essays on black art and culture marked the flowering of the movement.

The New Negro, published in 1925, began as "Harlem: Mecca of the New Negro," a best-selling special issue of *Survey Graphic*, a periodical aimed at social workers and liberals. Alain Locke edited the book edition and retitled it *The New Negro*. The book included essays by leading creative writers, such as the poet Langston Hughes, the collector of books and manuscripts Arthur A. Schomburg (1874–1938), and the white art

collector Alfred Barnes. Photographs of African masks appeared throughout the book, emphasizing the New Negro's vision of African art as ancestral art.

Arthur A. Schomburg's essay, "The Negro Digs Up His Past," began with these words: "The American Negro must remake his past in order to make his future. . . . For him, a group tradition must supply compensation for persecution, and pride of race the antidote for prejudice. History must restore what slavery took away . . . " Schomburg was originally from Puerto Rico, and he always stressed the international identity of the New Negro. A founding member of the American Negro Academy in 1897 and its president in 1922, Schomburg had created the Negro Society for Historical Research in 1911 and supported Marcus Garvey's black nationalism. In 1926 the New York Public Library purchased his collection of some five thousand books, three thousand manuscripts, and two thousand artworks.[42] This invaluable collection enriched the 135th Street (Harlem) branch of the New York Public Library and laid the foundation for the present-day Schomburg Center for Research in Black History and Culture.

The New Negro also marked the beginnings of a transition of expertise regarding African Americans. Until the 1920s, virtually all the recognized experts on black people were white. Their portrayals very often stressed the supposedly alien character of African Americans associated with jungles, drumbeats, and frenzied dancing. The black journalist George Schuyler (1895–1977) complained of such white writing about blacks, in which "even when he appears to be civilized, it is only necessary to beat a tom tom or wave a rabbit's foot and he is ready to strip off his Hart Schaffner & Marx suit, grab a spear and ride off wild-eyed on the back of a crocodile."[43] Commentary on black people usually spoke of the "Negro problem"—as though African Americans were, by definition, a problem, rather than an integral part of American life.

Scholarship of the Harlem Renaissance

W. E. B. Du Bois had achieved recognition as a Negro scholar with the 1896 publication of his Harvard Ph.D. dissertation, "The Suppression of the African Slave Trade to the United States of America, 1638–1870," which was the first volume of the Harvard Historical Studies. Carter G. Woodson (1875–1950) earned a Harvard Ph.D. in history in 1912 and began the professionalization of African-American history through the creation of the Association for the Study of Negro Life and History (1915) and the *Journal of Negro History* (1916).[44] The all-white historical profession hardly noticed Woodson's association and journal. However, two African-American sociologists managed to comment publicly on Negro issues: Charles S. Johnson, later of the National Urban League and Fisk University, and George E. Haynes (1880–1960), later of the National Urban League and the United States Department of Labor; both scholars produced influential studies of the Great Migration.

Although black scholarship began to appear in the 1920s, with Charles S. Johnson's *The Negro in Chicago: A Study of Race Relations and a Race Riot* (1922), its time had not yet come for proper recognition. Even the emergence of a generation of black schol-

ars in the 1930s and 1940s did not establish black scholars' right to comment on black issues, much less on American issues generally.

Art of the Harlem Renaissance

During the Harlem Renaissance, large numbers of African Americans produced visual arts for the first time. And, the first time, black artists routinely used black subjects. The visual artists of the Harlem Renaissance took their cue from Harlem's New Negro black pride and the pan-Africanism of Marcus Garvey and W. E. B. Du Bois. Harlem Renaissance artists also heeded the influence of African art on European cubist artists like Georges Braque and Pablo Picasso. African-American art history begins in the 1920s, as visual artists acquired more than token status.

Central to the flourishing of black artists was the support of the Harmon Foundation. Bestowing annual awards, the Harmon Foundation gave black artists much needed visibility and monetary support. The most famous Harlem Renaissance artist, Aaron Douglas, illustrated *The New Negro*. Douglas made African stylization a hallmark of his art, which remains extremely popular.

As in the case of Douglas, the Renaissance attracted the sculptor Augusta Savage to Harlem. In 1923 Savage won a fellowship for art study in France. But when two other fellows from Alabama objected to her presence, she was unable to accept the award. She worked in laundries to save for European study, finally winning a Rosenwald Fellowship for 1929–1931. Savage excelled as an educator, but as an artist, she never recovered from the loss of opportunity early in her career.

When the stock market crash of 1929 ushered in the Great Depression in the early 1930s, African-American writers and artists had only begun to establish themselves. Most were never able to live on the proceeds of their art. They found it extremely difficult even to sell their work.

Conclusion

The patrons of the Harlem Renaissance had hoped that the Great Migration out of the South, black participation in the First World War, and the race-proud art of the New Negro would end racial discrimination and violence. That did not happen. However African Americans gained a sense of themselves as members of an international community of people of African descent, whether through military service in France, attention to W. E. B. Du Bois's Pan-African Congresses, or membership in Marcus Garvey's UNIA. The hard times of the 1930s increased the number of lynchings. Yet the Harlem Renaissance permanently weakened the hold of demeaning stereotype by publicizing black people's own notions about themselves. In time the Great Migration's voters revolutionized the Democratic party and made black Americans a political force once again.

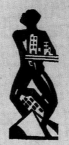

THE NEGRO WAGE EARNER

THE DEVELOPMENT OF THE NEGRO
IN THE VARIOUS OCCUPATIONS
IN THE UNITED STATES SINCE 1890

THE
NEGRO
WAGE
EARNER

GREENE
AND
WOODSON

$3.00
NET

ASSOCIATION
FOR THE STUDY
OF NEGRO LIFE
AND HISTORY,
·INC·

**THE NEGRO
WAGE EARNER**

LORENZO J. GREENE AND CARTER G. WOODSON

LORENZO J. GREENE AND CARTER G. WOODSON

10.1. James Lesene Wells, book jacket for *The Negro Wage Earner*, 1930
Wells's cover for a scholarly work by black social scientists shows the black worker as a white-collar man
poised before factories as well as fields.

Radicals and Democrats

1930–1940

The Great Depression of the 1930s threw millions of Americans out of work. This economic crisis of unparalleled proportions transformed national politics and the whole of American culture. During this era, the needs and rights of working people were very much in the public eye. Encouraged by federal policy, the labor movement organized hundreds of thousands into unions. For the first time in American history, large numbers of black workers gained access to unions. These new unions represented the rights of ordinary people, as both workers and citizens. This spotlight on workers made politics more radical and more concerned with the democratic rights of everyone. Black Americans began to exert political influence in the United States and sought to influence policy relating to people of African descent even outside their own country.

At the beginning of the 1930s, Carter G. Woodson (1875–1950) and Lorenzo J. Greene (1899–1988) two African-American historians published a major study of black workers, *The Negro Wage Earner* (1930). Their book recognized the ongoing transformation of African Americans from agricultural laborers and domestic servants into members of the modern, industrial working class. The cover image by master printmaker James Lesene Wells (1902–1993) portrays a worker in an urban coat and tie rather than the overalls of rural workers (10.1). He stands before a factory, not alongside a mule in a cotton field. And he is a man, for black people were still thought of collectively as male.

The Negro Wage Earner, a book on black workers written by black scholars, illustrated by a black artist, and published by a black publishing house embodies many of the important characteristics of the decade of the Great Depression. African-American scholars launched an activist mission: to counter the prevailing, racist, and negative reputation of black people, especially as workers. The illustrator, James Lesene Wells, the "Dean of

Negro Printmakers," taught art at Howard University. Wells had been deeply influenced by Alain Locke's *The New Negro* (1925) and heeded Locke's exhortation to black artists to emulate African art. The authors, Lorenzo J. Greene and his mentor, Carter G. Woodson, were two of the pioneers of Negro history; their books played a crucial role in earning recognition for black scholars as experts on their own people. In the previous generation, only white authors were widely accepted as reliable experts on any subject, including black people. During the 1930s nearly two hundred black people earned doctorates, increasing by a factor of four the number of black Ph.D.s in the United States.[1]

The Negro Wage Earner, published by Woodson's Association for the Study of Negro Life and History, was the product of vigorous black print media. White-owned publishing houses rarely published African-American scholarship on any topic.[2] Whereas white media ignored African Americans or depicted them as criminals, servants, or lazy buffoons, black newspapers flourishing in the 1930s and 1940s presented a much fuller picture. African-American newspapers like the Pittsburgh *Courier* circulated nationally, covering the activities and chronicling the concerns of black people throughout the world. In addition, black newspapers protested against the segregation, insult, and racist violence to which black Americans were so often subject. Black institutions produced excellent artists and scholars, but once African Americans left those institutions, they girded for battle in a white supremacist society.

During the Great Depression, black people's central concerns were crushing unemployment and poverty. The economic crisis and its consequences overwhelmed social resources—not only private charities, but also local and state governments. The federal government seemed to offer the only hope for aid. In the election of 1932, voters rejected the laissez-faire Republican administration of president Herbert Hoover. They elected the Democratic candidate, Franklin D. Roosevelt (FDR), governor of New York, who promised vigorous action and a "New Deal" for the American people. Roosevelt's Democratic administration created a series of new departments to raise farm prices, institute minimum wages, encourage labor unions, and bring back prosperity.

Because black people were the poorest people in the United States, New Deal measures ultimately helped them tremendously. But New Deal programs perpetuated existing racial discrimination and were nearly all segregated; they remained segregated despite vigorous black protest that did succeed in reducing the worst racial inequities. Minimum wages, union representation, and other New Deal changes eased black people's economic plight and helped bring them back into politics. Roosevelt's New Deal did not bring back prosperity, nor did it make African Americans equal citizens. But the political mobilization of the era and the New Deal reoriented American national politics.

The Depression Crisis

The stock market crash of 1929 set off a worldwide economic crisis. In the United States masses of workers lost their jobs as wealth disappeared. By 1932, more than a quarter of

American workers of all races and ethnicities were out of work. For black workers, the proportion of unemployed was closer to one-half or more.

Catastrophic Black Unemployment

African Americans worked in segments of the economy, such as agriculture, which were particularly hard hit during the Great Depression. In domestic service and manufacturing, employers often fired blacks in order to employ whites. In Harlem the median family income fell by one-half between 1929 and 1932.[3] Throughout the South, whites clamored for African Americans' jobs as domestic servants, longshoremen, bellboys, and garbage collectors. Men in black shirts (in the style of Italian and German fascists) marched through Atlanta carrying signs, "Niggers back to the cotton fields—city jobs are for white folks."[4] While about a quarter of all workers lacked jobs in the early 1930s, more than half the black men in cities were unemployed (Table 10.1).

In Southern cities, two-thirds to more than three-quarters of African-American families turned to public assistance for relief.[6] The quest for work took men and women far away from home, although men moved more freely than women out of doors. Migrants gathered in hobo villages, often located near the railroads, which furnished hoboes their principal means of transportation. In "Can Fire in the Park" (10.2) Beauford Delaney (1901–1979) captured this characteristic scene from the Great Depression, in which homeless men seek warmth around a fire in an oil barrel.

Table 10.1. Proportion of Unemployed Black Men in Selected Cities, 1934[5]

City	Percent of Black Men Unemployed
Chicago	40
Pittsburgh	48
Harlem	50
Philadelphia	56
Detroit	60

In urban settings, the frustration born of unemployment was heightened by routinely callous treatment by white shop owners and police brutality. Against the backdrop of racial discrimination, rumors of police brutality circulating in hard times set off a new kind of riot in Harlem in 1935. This time the rioters were not whites assaulting black people, as in Atlanta in 1906 and in the Red Summer of 1919 across the United States. In the 1930s (and in later decades), black rioters attacked white-owned property in segregated black neighborhoods. This new kind of riot deepened the isolation of African Americans in depressed city districts.

The New Deal and Political Realignment

The New Deal invigorated the federal government, which loosened the hold of local white rulers clinging to their power in the name of states' rights. In particular, the New Deal focused attention on the South, home to the poorest Americans (white as well as black). Northern black voters cared deeply about the South from which many had come and where nearly 90 percent of black people still lived. For black people, the New Deal's

10.2. Beauford Delaney, "Can Fire in the Park," ca. 1946
Delaney shows unemployed men around a fire in the kind of hobo jungle that sprang up around rail-road tracks throughout the United States.

promise to better conditions in the South translated into a battle for Southern civil and economic rights.

Ever since Reconstruction, African Americans had favored the Republican party: the party of Abraham Lincoln and Republican Reconstruction. Well into the 1930s, reactionary white Southerners and urban machines dominated the Democratic Party. In the Southern states and at the national level, white supremacist Democrats prevailed. Urban machines, so often in the 1930s ruled by Irish-Americans, also paid little heed to the needs of black citizens. However, in the election of 1936, in which Franklin D. Roosevelt was reelected for the first time, Northern black voters (most Southern black people could not vote) flocked to the party of Roosevelt and the New Deal. They switched

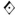

allegiance from the Republicans to the Democrats because the Democratic Roosevelt administration was serving their needs better than had the Republicans.

The partisan political battle that dismantled the Solid (Democratic) South outlasted the 1930s. But during the 1930s, changes in the Democratic party, in the constitutional law of the land, and in world events began to undermine the white supremacy, segregation, and discrimination that had characterized Southern and American life.

The Scottsboro Cases and Protests Against Lynching

A series of important legal cases grew out of the racial injustices of this period. Prominent among these were accusations against nine young black men hoboing (hitchhiking) on a freight train to Memphis in March 1931. Hoboing on freight trains provided a common means of transportation for young people looking for work. "Leaving Macon Georgia" by Walter Ellison (1899–1977) shows a couple of young hoboes atop a freight train excitedly looking forward to more favorable opportunities (10.3).

The nine young black men found neither work nor opportunity. After a fight among black and white hoboes broke out on the moving train, railroad police took the nine African Americans and four whites into custody. Two of the whites turned out to be young women dressed as men. An all-white jury in Scottsboro, Alabama, quickly found the black men guilty of raping the white women and sentenced them to death. Such casual, deadly sentencing amounted to what was called a "legal lynching." The young men, who came to be known as the "Scottsboro Boys," became the central figures in the decade-long antilynching campaign.

Such miscarriages of justice were all too common in the white supremacist South. Usually they attracted minimal attention. But in the context of the radicalized 1930s, the young black men of the Scottsboro cases were not sacrificed as so often in the past. The Scottsboro cases became international news, as Communists, black people, and their allies rallied to the defense of the young men convicted in Scottsboro. Stepping in on behalf of the men were two organizations: first, the International Legal Defense (ILD), the civil rights arm of the Communist Party of the United States (CPUSA), and, second, the NAACP. In a series of trials, state appeals, and appeals to the United States Supreme Court, the ILD was able to prevent the execution of the young men. The last of the "Scottsboro Boys" was released from prison in 1950.

The Scottsboro cases and others exposed the many injustices prevailing in the South, such as all-white juries rushing to judgment on the basis of their prejudices without taking evidence into account. These cases also brought many African Americans into the Communist Party, for example, Angelo Herndon (b. 1913) of Atlanta and Hosea Hudson (1898–1988) of Birmingham, Alabama.[7] CPUSA offered both Southerners a means of political struggle. In addition, Hudson said, "The Scottsboro case had got me interested in trying to read."[8]

In the 1930s, CPUSA was the only political party in the United States that assigned high priority to black civil rights. Finally, after decades of injustice, a national organi-

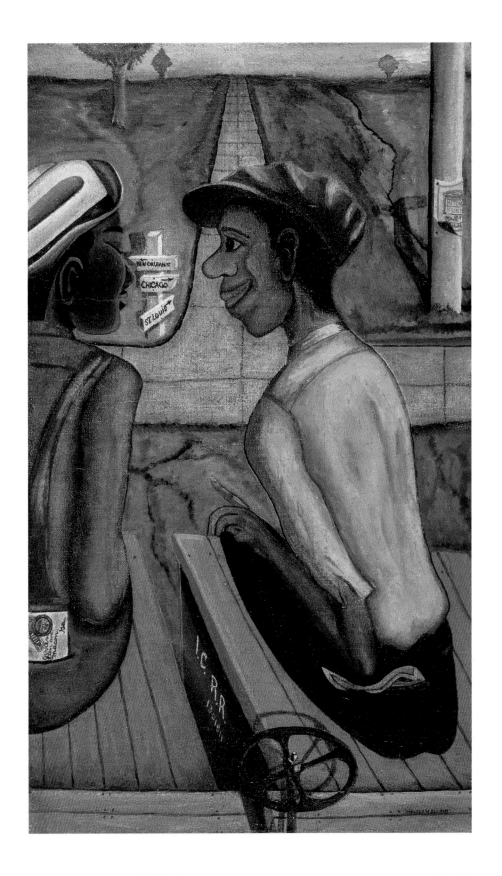

zation not composed mostly of African Americans seemed to care about lynching and other miscarriages of justice. Communists remained a tiny but influential group during the 1930s. They enjoyed considerable prestige because the Communist-governed Union of Soviet Socialist Republics (USSR) did not experience a catastrophic financial crisis in the 1930s like the capitalist countries of Great Britain, France, Germany, and the United States. In addition, Communists embraced Harry Haywood's theory in which black Americans figured not as mammies and buffoons but as a nation within a nation. With its "self-determination for the Black Belt" position, CPUSA played up the genius of black folk culture and fostered black artists. At the same time, Communists supported black protests against racial prejudice in general and against lynching in particular.

Black Americans had protested against extralegal murder (or, as in the Scottsboro cases, legal lynching) since the late nineteenth century. In the 1930s, CPUSA joined black people and their traditional allies to protest against racial violence. A broad range of people decried lynching, from political figures advocating federal antilynching legislation (which failed) to the jazz singer, Billie Holiday (1915–1959). Abel Meeropol, a left-wing New York teacher writing under the pseudonym Lewis Allen, wrote an antilynching song, "Strange Fruit," which Holiday performed regularly. The song made Holiday a race hero.

"Don't Buy Where You Can't Work" Boycotts and Self-Help Campaigns

White-owned businesses in black neighborhoods routinely refused to employ African Americans. As black unemployment soared, such a policy became unbearable. In cities such as Chicago, New York, Washington, D.C., Baltimore, and St. Louis, African Americans waged "Don't Buy Where You Can't Work" boycotts starting in 1930 and stretching into the 1940s. The Reverend Adam Clayton Powell, Jr. (1908–1972), who represented Harlem in the U.S. House of Representatives from 1945 to 1970, made his reputation during the Great Depression as a defender of black rights in New York City. Morgan (1910–1993) and Marvin (1910–2003) Smith photographed the people of Harlem over the course of five decades: ordinary people, newsworthy events, and prominent figures. All three appear in a news photograph from 1942 (10.4).[9] "Don't Buy Where You Can't Work" campaigns stressed the "double-duty dollar," which honored the boycott and advanced two goals: increasing job opportunities for black workers in white businesses, and supporting the black businesses in which the dollars were spent.

The depression hit black businesses hard. The number of black businesses declined by one-tenth, and sales dropped from $98.6 million in 1929 to $47.96 million in 1935—by more than one-half. Jesse Binga's Chicago bank went under, along with 121 other black banks around the United States.[10] "Don't Buy Where You Can't Work" and other boycotts succeeded in breaking down the color bar in urban businesses and getting

10.3. Walter Ellison, "Leaving Macon Georgia," 1937
Ellison's young hoboes atop a train share their dreams as they leave the South.

10.4. Morgan and Marvin Smith, "The Reverend Adam Clayton Powell, Jr., leads a protest on 125th Street in Harlem—'Don't Buy Where You Can't Work'" campaign, 1942
The Smith twins documented Harlem life as news photographers from the 1930s until their retirement in 1975.

African Americans hired in communities like Harlem. But the boycotts did not restore black businesses to health. Long-term economic changes favored larger enterprises with bigger inventories and better access to credit. As racial segregation weakened, so did black business's hold on black consumers. By 1940, black employers and their employees counted for less than 1.5 percent (some 87,475) of the total black workforce.[11] The Great Depression marked the beginning of the end for African-American business, its employees as well as its owners.

Churches and missions helped assist those in need. Throughout the United States, the Peace Missions of Father Divine (ca. 1880–1965) fed, clothed, and sometimes sheltered the poor in "heavens" that charged only one dollar per week rent and ten to fifteen cents per nourishing meal.[12] In Detroit, W. D. Fard (ca. 1891–post-1934) founded the

Nation of Islam in 1930. His successor after 1934, Elijah Muhammad (1897–1975), had been inspired by Marcus Garvey. Following Garvey's pattern of fostering black business, Muhammad built a network of temples, schools, and businesses meant to ease poverty and make African Americans economically self-sufficient.[13] (Further discussion of the Nation of Islam appears in chapter 13.)

The magnitude of the crisis outstripped the ability of volunteer missions like those of Father Divine, the Nation of Islam, and other churches and benevolent associations. The Depression even overwhelmed city and state relief agencies. Only the federal government possessed sufficient resources to succor a nation.

The New Deal

As soon as Franklin D. Roosevelt took office in March 1933, his administration pushed through a series of measures that became known as the New Deal.[14] New Deal agencies became known by their acronyms (NRA, AAA, WPA), and the whole era featured innumerable abbreviations. The "alphabet agencies" laid the groundwork for policies helping ordinary people. In addition, the First Lady Eleanor Roosevelt cared deeply for the rights of workers and racial justice. African Americans expressed particular fondness for Mrs. Roosevelt.

New Deal Goals and Programs

The New Deal consisted of a series of laws and policies enacted by a Democratic Congress under the leadership of a Democratic president. Writing in *Opportunity*, the publication of the National Urban League, in 1934, University of Chicago doctoral candidate Lawrence D. Reddick (1910–1995) described the New Deal as "the greatest chance which has come to the Negro in America since the World War."[15] Even though it did not challenge segregation, the New Deal helped black Americans because it served all Americans in need.

The New Deal recognized workers' rights to unionize, reversing federal policy of the 1920s. Section 7a of the National Industrial Recovery Act (NIRA) of 1933 and the Wagner Act of 1935 decreed that workers had the right to elect their own representatives. These laws encouraged a wave of union organizing that helped black industrial workers in three ways: unions raised wages; unions provided workers a way to challenge unfair treatment; unions helped workers exercise their citizens' rights, such as voting. Birmingham ironworker Hosea Hudson quickly recognized the usefulness of his United Steelworkers local union, of which he became a leader. The United Steelworkers was one of several new industrial unions arising in the 1930s and forming the Committee (later the Congress) of Industrial Organizations (CIO). Unlike the older American Federation of Labor unions, CIO unions were open to unskilled as well as skilled workers.[16] Black workers were more likely than nonblacks to be classified as unskilled.

The New Deal was not intended to be especially friendly to black people, nor was it

ever. As the Democratic party was rooted in the South, the New Deal measures adopted in 1933 respected the racial segregation and discrimination prevailing at the time. New Deal policy was set in Washington, but local elites administered it to suit their own purposes. Those purposes usually conflicted with the interests of the poor. As a result, the implementation of the programs tended to protect the oppressive racial status quo. A black woman in Reidsville, Georgia, captured the discrimination in the distribution of relief: "releaf officials here . . . give us black folks each one, nothing but a few cans of pickle meet and to the white folks they give blankets, bolts of cloth and things like that."[17]

Three major New Deal agencies affected large numbers of black people: The Agricultural Adjustment Administration (AAA) paid farmers not to grow crops in order to raise prices; the National Industrial Recovery Act (NIRA) set standards for wages and prices in industry through the National Recovery Administration (NRA). The many programs of the Works Progress Administration (WPA) paid the unemployed to work.

The AAA's crop reduction policies primarily benefited land-owning farmers. Most black and many white Southern farmers did not own land. They tilled land belonging to others as tenants and sharecroppers and lived in houses owned by landowners. In 1933 landowners limiting crop production simply discharged their tenants and sharecroppers and kept checks from the AAA for themselves. Landless farming families lost their homes as well as their livelihoods. In 1934 black and white farmers in Arkansas formed the Southern Tenant Farmers Union (STFU) to protest this practice. The STFU succeeded in modifying the terms of the AAA so that tenants and sharecroppers could claim a part of crop reduction payments. Even so, AAA policies resulted in large numbers of tenant and sharecropper families—who were disproportionately black—becoming homeless due to eviction.

Just as the AAA served wealthier rather than poorer farmers, the policies of the NRA served employers more than workers. The NRA's provision for the payment of minimum wages did not extend to two categories in which the majority of black workers were employed: farming and domestic service. Later on, the New Deal's Social Security Administration would also deny farmers and domestics government-funded old age pensions.

The New Deal Home Owners Loan Corporation and Federal Housing Administration, created to foster home ownership during the Depression, advocated discrimination against African Americans through the use of restrictive covenants to bar sale to them and "redlining" to discourage mortgage lending in their neighborhoods (see chapter 12). During hard economic times housing discrimination did not appear prominently in African Americans' list of complaints against federal policy. During the housing boom that followed the Second World War, however, New Deal discrimination crippled black Americans' ability to purchase their own homes.

The Works Progress Administration (WPA) and Black Artists
The relationship between the WPA and black artists encapsulates both the discrimination and the support New Deal policies offered African Americans generally.

10.5. Palmer Hayden, "The Janitor Who Paints," 1937

Hayden's depiction of a friend captured the situation of an artist who had to support himself and family
at one of the few jobs black men could hold in the 1930s.

10.6. Allan Rohan Crite, "Marble Players," 1938
A longtime resident of Boston, Crite shows young people engaged in a popular pastime. This is one of hundreds of street scenes by black artists celebrating everyday black life.

The WPA made it possible for many black artists to paint and sculpt during the hard economic times of the 1930s. Although the WPA arts projects came to play a crucial role in African-American art history, WPA administrators initially saw black people solely as laborers and did not support African-American artists as artists. In response, black artists in New York City organized the Harlem Artists Guild, led by Aaron Douglas. By contesting the original policy, Douglas and the Guild succeeded in getting recognition for black artists. They had to protest further to secure supervisory positions for senior artists like Charles Alston (1907–1977) and Augusta Savage (1892–1962). Savage and Alston fostered the work of younger artists such as Jacob Lawrence and Gwendolyn Knight

10.7. Hale Woodruff, "The Cigarette Smoker," n.d.
Like so many black artists during the Great Depression, Woodruff captured the beauty of ordinary African Americans engaged in everyday life and dressed in everyday clothing.

(1913–2005) and the photographers Morgan and Marvin Smith.[18] By the time the WPA scaled back its work in the late 1930s, it had supported many black artists, including Douglas, William Henry Johnson, and Palmer Hayden in New York, Archibald Motley in Chicago, Dox Thrash (1893–1965) in Philadelphia, and Allan Rohan Crite in Boston. In 1939–1940, when Palmer Hayden created "The Janitor Who Paints" (10.5), he was on the WPA. Hayden was one of many black artists who normally supported himself and his art through manual labor. This painting shows Cloyd Boykin (1877–n.d.), a good friend and fellow painter who founded the Primitive African Arts Center in New York and also worked as a janitor.

During the Great Depression, artists of all racial-ethnic backgrounds, including African-American, took working people as their favorite subjects. Jacob Lawrence produced his series on the Great Migration from the South to the North as a WPA artist (see chapter 9). William Henry Johnson also produced many paintings while the WPA paid him a basic wage that allowed him to paint full time. One of several of Allan Rohan Crite's Boston street scenes shows "Marble Players" (10.6). Hale Woodruff's sensitive portrait of an unnamed black man presents a working-class African American engaged the ordinary act of smoking a cigarette (10.7).

Most WPA workers built and maintained public works projects such as roads, sidewalks, and libraries. In addition, WPA arts projects sponsored artists, writers, and scholars. WPA stipends enabled Richard Wright (1908–1960) and Ralph Ellison (1914–1994), for instance, to concentrate on their writing. In 1938 Wright won a WPA prize for *Uncle Tom's Children*, his collection of Southern stories. Historically black colleges such as Fisk University and Kentucky State College initiated local oral history projects in which students interviewed people who had been enslaved. The WPA adopted the project and expanded it to thirteen volumes, one each for all the former slave states.[19]

Like many other New Deal agencies, the WPA made a crucial difference in the careers of black artists. For without WPA support, most black artists and writers would not have been able to continue making art during the Depression. Here as elsewhere, the positive results came only after well-disposed administrators responded to black protest.

African Americans Confront New Deal Racism

Black Americans and their allies found much to criticize in the early years of the New Deal. The agricultural and economic strategies of the New Deal aimed to fix economic, but not racial problems. As a result, New Deal agencies perpetuated the prevailing segregation and exclusion. African Americans said, only half jokingly, that "NRA" stood for "Negroes Robbed Again."

Seeing that the New Deal preserved white supremacy, several African-American intellectuals and associations organized the Joint Committee on National Recovery (JCNR). Leading the JCNR were lawyers John P. Davis (ca. 1905–1973) and Charles H. Houston (1895–1950), Howard University professors Ralph Bunche (1904–1971) and

Abram Harris (1899–1963), and Walter White (1893–1955), the executive secretary of the NAACP.[20] The JCNR offered a careful critique of racism within the New Deal.

In 1936 Davis, Bunche, and A. Philip Randolph (1889–1979), head of the Brotherhood of Sleeping Car Porters and Maids, the leading black labor union, founded a new and more radical organization seeking to organize working-class black people and their allies: the National Negro Congress (NNC). The NNC consisted of more than 500 black organizations that considered the NAACP too conservative to press effectively for economic change. Whereas the NAACP worked on racial issues, the NNC operated on the premise that African Americans had interests related to class as well as to race. Accordingly, the NNC concentrated on the economic needs of black people. In 1938 the NNC spun off the Southern Negro Youth Congress (SNYC) to deal with Southern racism.[21]

Denouncing injustices in the implementation of the New Deal from outside the government, the JCNR and the NNC were playing familiar roles in African-American history. But something entirely new was also taking place: Black people not only had nonblack allies in the federal government; for the first time, a handful of influential African Americans actually worked inside a presidential administration. This had never happened before, not even with Frederick Douglass or Booker T. Washington.

The "Black Cabinet"

Within the Roosevelt administration, the National Youth Administration (NYA) included a Division of Negro Affairs. Heading this division was Mary McLeod Bethune (1875–1955), the founding president of Bethune-Cookman College in Florida and of the National Council of Negro Women. Bethune's role in the Roosevelt administration exceeded simply running a division of the NYA. She exerted considerable influence throughout the federal government whenever black interests came into play. In 1936 Bethune created the Federal Council on Negro Affairs to advise President Franklin D. Roosevelt. It became known as the "Black Cabinet."

The Black Cabinet consisted of some thirty African-American professionals working in the federal government. The mere existence of a presidential "Black Cabinet" marked a turning point in the relations between the federal government and African Americans. Black Cabinet members such as sociologist Robert Weaver (1907–1997) remained in public service long after the end of the Roosevelt administration. Weaver became the first African American in an official presidential cabinet in 1964, when Lyndon Johnson appointed him secretary of Housing and Urban Development.[22] In 1949 William Hastie (1904–1976) became the first black federal appeals judge. He served on the Third Circuit in Philadelphia. After the Black Cabinet, African Americans were able to exert influence on the federal government directly. This occurred first in Democratic administrations. By the early twenty-first century, Republican administrations also included highly placed black officeholders, including men and women in positions never before occupied by African Americans.

Black Activism Increases in Depth and Range

During the 1930s, African-American activism grew deeper and was more widespread. Amplifying a long-standing concern with Africa and European colonialism, black people protested the Italian invasion of Ethiopia. They also followed European events closely, seeing similarities between Nazism in Germany and white supremacy in the U.S. South. A decades' long campaign against discrimination in education began, as extraordinary individuals disproved notions of black racial inferiority and a white master race.

African Americans Rally to Support Ethiopia

With century-old ties to Africa and the Caribbean, black Americans had long seen themselves as a diasporic people. In the 1920s, Garveyites expressed diasporic concerns. The Italian invasion of Ethiopia in 1935 galvanized African-American opinion and brought a wave of support for the African symbol of independence. The Ethiopian conflict carried special meaning to black Americans, who knew the words by heart of Psalms 63:31: "Princes shall come out of Egypt; Ethiopia shall soon stretch forth her hands unto God" (see chapter 1). African Americans had identified with Ethiopia for as long as they had been Christian. The late nineteenth-century European conquest of Africa colonized virtually the entire continent, with the exception of Ethiopia, deepening African Americans' relation to the kingdom. African-American involvement with Ethiopia made the Italian attack feel like an attack on black Americans themselves. William H. Johnson's "Haile Selassie" (ca. 1945) shows Selassie, the besieged emperor of Ethiopia, in a wartime scene with the flags of Ethiopia and the imperialist nations at the top and bottom (10.8). Black soldiers from the American Revolutionary and Civil Wars also appear, uniting the war in Ethiopia with other causes to which African-American soldiers contributed.

Black Americans recognized the imperialist nature of the Italian assault and organized companies of volunteer soldiers to defend Ethiopia. The U.S. government foiled their intentions, making it impossible for African Americans to aid Ethiopia militarily. But many black Americans—including rising New York minister-politician Adam Clayton Powell, Jr., the NAACP's Roy Wilkins (1901–1981), and the head of the Brotherhood of Sleeping Car Porters, A. Philip Randolph—railed against fascist Italy. W. E. B. Du Bois and Walter White led a "Hands Off Ethiopia" rally in Harlem. All across the United States black college students organized support groups for Ethiopia. Robert Vann (1879–1940), the publisher of the Pittsburgh *Courier* newspaper, sent the popular historian Joel A. Rogers (1880–1966) to Ethiopia to cover the war.[23] Rogers's dispatches from Ethiopia increased the *Courier*'s circulation by twenty-five thousand.[24]

Even after the end of the Ethiopian conflict, black Americans continued to take an interest in world events. The poet Langston Hughes and the writer Louise Thompson (1902–1999) covered the Spanish Civil War of 1936–1939 for African-American newspa-

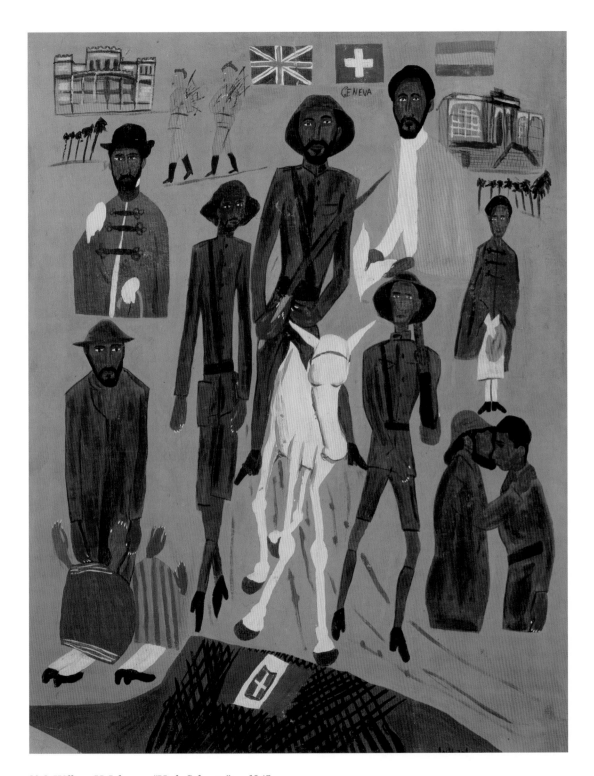

10.8. William H. Johnson, "Haile Selassie," ca. 1945

Johnson combines motifs of black soldiering from the American Revolution, the Civil War, and the First World War—with the protection of the Emperor of Ethiopia from Italian attack.

pers. Hughes and his readers took special interest in the eighty or more black Americans fighting for the Spanish Republicans in the Lincoln Brigade.[25] During the 1930s imperial governments prevented black Americans from visiting sub-Saharan Africa, although, they could and did visit the Caribbean Republic of Haiti. Aaron Douglas, Zora Neale Hurston, and Katherine Dunham (b. 1912) traveled to Haiti and produced art based on Haitian themes. Rayford Logan, a First World War veteran with a long-standing interest in foreign affairs, received his Harvard Ph.D. in 1932. Logan published his dissertation in 1941 as *The Diplomatic Relations of the United States with Haiti, 1776–1891*, reflecting African-American scholarly interest in Haiti.

Black Heroes of the Depression Years

During the Great Depression, black Americans became more visible in American culture than before the First World War and the era of the New Negro. Athletes and entertainers, especially, made national news and filled African Americans with pride. Two black athletes, the runner Jesse Owens (1913–1980) and the boxer Joe Louis (1914–1981), sparked rejoicing by defeating symbols of white supremacy. Owens became the first competitor in the modern Olympic games to win four gold medals. More importantly, the 1936 Olympic games took place in Berlin, the capital of ultra-racist Nazi Germany. Joe Louis defeated two symbols of fascism: In 1935 he beat Primo Carnera, an Italian-American who for black people symbolized Italian fascism and its attack on Ethiopia. In 1938, Louis defeated the German Max Schmeling, belying the Nazis' claim to Aryan racial superiority. The rising movie star Lena Horne (b. 1917) spoke for many: "Joe was the one invincible Negro, the one who stood up to the white man and beat him down with his fists. He in

(Left) 10.9. Poster for Joe Louis movie, *The Fight Never Ends*, 1949

A decade after Joe Louis's great boxing triumphs, he made this unremarkable movie with Ruby Dee (b. 1924), who went on to a great career as a politically engaged actor with her husband, Ossie Davis (1917–2005).

(Opposite) 10.10. Jean-Michel Basquiat, "St. Louis Surrounded by Snakes," 1982

A star of pop art, Basquiat remakes the Christian martyr St. Sebastian into St. Joe Louis surrounded by the snakes of white racism.

a sense carried so many of our hopes, maybe even dreams of vengeance."[26] Louis starred in a movie whose poster featured him in boxing gloves (10.9).

As a symbol of black strength deployed against the symbols of white supremacy and as a beautiful human body, Joe Louis inspired several African-American artists. The young New York artist Jean-Michel Basquiat (1960–1988) painted "St. Louis Surrounded by Snakes" in his characteristic, fast-moving, pop-art style (10.10).

In 1939 the African-American opera singer Marian Anderson, together with the Franklin Roosevelt administration and First Lady Eleanor Roosevelt, struck another blow against prejudice. When the Daughters of the American Revolution refused on racial grounds to let Anderson perform in their Constitution Hall in Washington, D.C., Eleanor Roosevelt resigned from the organization in protest. Prompted by Walter

White, Mrs. Roosevelt arranged for Anderson to perform at the Lincoln Memorial, where Anderson began her sunrise concert with "My Country, 'Tis of Thee." Beauford Delaney's portrait of Anderson captures the beauty of her art and her strong, restrained presence.[27]

Fighting Racial Oppression in the Courts

After years of struggle and organizing, African Americans and their allies were able to take their case to the U.S. Congress, the Roosevelt administration, and the Supreme Court. But they seldom won. Southern Democrats controlled Congress, and President Roosevelt usually deferred to congressional prejudices. But in a few key cases, Supreme Court rulings struck down laws enforcing racial discrimination.

The NAACP had led the way early, starting with successful Supreme Court challenges to residential segregation ordinances in the 1910s. In 1930 NAACP Executive Director Walter White spearheaded a successful campaign against a nominee to the U.S. Supreme Court who believed black people should not vote. The NAACP and the NAACP Legal Defense Fund, under the leadership of Charles H. Houston, then brought a long series of court challenges to racial discrimination and the exclusion of African Americans from the American public sphere.

One set of cases focused on public education. The first victory in education came in 1938, when the U.S. Supreme Court ruled in *Missouri ex rel. Gaines v. Canada* that the state of Missouri must admit Lloyd Gaines (1914–n.d.) to the University of Missouri Law School.[28] Education cases continued for nearly twenty more years.

Another set of cases took aim at election laws, notably the poll tax and other impediments to voting (see also chapter 8). In order to vote, each year after the age of twenty-one, Southern voters had to pay poll taxes well in advance of elections. Poll taxes disfranchised poor people of all races, but they hit Southern black people especially hard because they were the poorest of the poor. In white primary states like Texas, the state declared the Democratic party a private club to which only white people could belong—a practice that produced white primary elections. The poll tax was not totally outlawed until 1964, with the adoption of the Twenty-fourth Amendment to the United States Constitution.[29] The assault on the white primary had begun in the 1920s. It finally succeeded in 1944 in the *Smith v. Allwright* decision. The legal struggle took place in the courts. But on the ground, black Southerners took matters into their own hands. In Birmingham, Alabama, for instance, Hosea Hudson, a black Communist, formed a Right to Vote Club in 1938.[30]

Campaigns for Civil Rights and Workers' Rights in the South

By treating African Americans as American citizens, the New Deal furthered black political engagement. Countering white supremacists' claim that Southern black people were happy not voting, as early as 1934, black people in South Carolina, Alabama, Georgia, and Texas were forming voting clubs and attempting to vote in white prima-

ries. When these efforts failed to crack the official voting apparatus, African Americans elected "bronze" protest slates to prove they really wanted to vote.[31]

In addition, the CIO unions advocated citizens' as well as workers' rights by helping working people register to vote. Registering black people to vote was an ambitious undertaking at a time when poll taxes, white primaries, and property and educational restrictions, plus the dead weight of custom obstructed their way to the ballot box. By 1938 NAACP Field Secretary Ella Baker (1903–1986) had revived hundreds of Southern branches of the NAACP, a revival crucial to the campaign to enfranchisement.

Civil rights agitation in the South reached a high point in 1938. The NAACP, NNC, SNYC, and the CIO unions attacked discrimination in jobs and civil rights. In addition, a new, interracial Southern organization, the Southern Conference for Human Welfare, came into being with the blessing of Eleanor Roosevelt. Together these organizations and grassroots activists pressed for black civil rights, notably equal schooling and the right to vote. The year 1938 also signaled the high-water mark for workers' rights, as the Un-American Activities Committee of the U.S. House of Representatives began pursuing "Communists" in New Deal agencies and shutting down funding for WPA projects. One sign of being Communist was being concerned with the rights of black people. As a result, many African Americans and their allies came under suspicion for not being sufficiently patriotic.

The threat of war further weakened the government's commitment to WPA programs as authoritarian regimes in Germany, Italy, Japan, and Spain threatened to invade their neighboring countries. Most African Americans opposed nazism and fascism, likening them to American white supremacists. Kelly Miller (1863–1939), an elder statesman among black intellectuals, entitled an article on Nazi Germany "The German Ku Klux."[32]

By 1939 war had again broken out in Europe and Asia. The United States was soon supporting the Allied powers of Great Britain, China, and France with loans of money and war materiel. Even before December 1941, when the Japanese bombardment of Pearl Harbor, Hawaii, formally brought the United States into the war, production in American industries accelerated dramatically. Once again, job discrimination hurt African Americans' opportunities to find jobs and make decent wages.

Conclusion

The era of the Great Depression created enormous economic hardship for African Americans, who were already the poorest and most vulnerable sector of the population. The New Deal, the federal government's response to the crisis, deeply affected black people. By including African Americans as Americans (though of a second class), it altered preexisting political assumptions and bound them to the Democratic Party. Black Americans protested against partial inclusion in the New Deal and in American society in campaigns that long outlasted the New Deal. Perhaps ironically, hard times fostered a guarded optimism.

11.1. Dox Thrash, "Defense Worker," ca. 1942
Not only does Thrash's defense worker actually have a job, he also operates machinery, something black
workers had rarely been allowed to do earlier. He advances the war effort through construction.

The Second World War
and the Promise of Internationalism
1940–1948

The Second World War brought African Americans jobs, but it also confronted them with familiar problems: segregated and exclusionary armed forces, bans on black officers, and racial discrimination in the workplace. Their responses, too, were familiar: protest and struggle. However, the 1940s were not the 1910s or the 1890s or the 1860s. By the early 1940s, black Americans had acquired enough self-confidence, experience, and allies as workers and citizens to protest effectively against all-too-pervasive discrimination. Now protest bore some fruit—in defense jobs and in the armed services. "Defense Worker" by Dox Thrash (ca. 1892–1965) celebrates the strength of black men doing crucial jobs (11.1).

The Second World War kept African Americans' attention turned outward: toward their traditional concern with Africa, and also toward Europe and the colonized world. African Americans identified with the colonized peoples of Africa, the Caribbean, and Asia. They took special interest in India's drive toward independence, a concern the UNIA had voiced in the 1920s. The 1945 founding of the United Nations seemed to open a new avenue toward the achievement of full human rights in the United States. However, the promise of internationalism only lasted until 1948. Then Cold War anti-Communist and antilabor politics gave internationalism a bad name in the United States. Throughout the entire era, black veterans expressed their deep determination to exercise their rights as American citizens who had defended their country against foreign enemies.

Struggles at Home and Abroad

Once again, war confronted African Americans with the need to struggle for the United States' war aims and against American racism. In the 1940s, this two-faced struggle

became known as the "Double Vee" strategy. Black men and women joined the armed forces, but the right to fly airplanes demanded a fight that ultimately produced the Tuskegee Airmen. Another war for democracy overseas produced another groundswell for black civil rights that continued into the next two decades.

Familiar Issues

The war in Europe began in 1939 with the German invasion of Poland. Even though the United States was not yet in the war, black Americans equated American white supremacists with German fascism, for Nazi anti-semitism sounded much like American racism and Southern Jim Crow.

German forces bombed Britain and invaded France in 1939 and 1940. Although the United States had not entered hostilities, it backed the Allies—Great Britain, France, the Soviet Union, and China—against the Axis powers of Germany and Japan. As the United States sent the Allies money and war materiel (for instance, trucks, guns, ammunition), American industries began rehiring.[1] President Roosevelt called his rationale for supporting the Allies the "Four Freedoms": freedom of speech, freedom of worship, freedom from want, and freedom from fear. The Allies upheld them; the Axis suppressed them. Black Americans welcomed this rationale, for they sorely lacked those freedoms themselves.

African Americans were experiencing all-too-familiar forms of racial discrimination in defense industries and the armed services. As in the past, employers discriminated against black workers. The federal government funded defense spending, but did not mandate equal access to jobs. The result was racial discrimination: black workers remained unemployed while whites monopolized defense jobs. In the crucial aircraft industry, for example, fewer than 300 out of 100,000 workers were black.[2] Whites-only policies prevailed even when the refusal to hire African Americans created labor shortages and halted production lines. In the face of continuing unemployment and discrimination, African-American anger increased.

The "Double Vee" Strategy and the FEPC

Even before the United States became a belligerent, the Pittsburgh *Courier* newspaper, the Brotherhood of Sleeping Car Porters, and the NAACP orchestrated pivotal discussions of racial policies related to a possible war. For African Americans, victory would have to be twofold, hence a "Double Vee" strategy. A mass march on Washington would make the case energetically.

The protest against wartime discrimination that led to the Double Vee strategy began in 1940, when Walter White of the NAACP, A. Philip Randolph of the Brotherhood of Sleeping Car Porters, and several other prominent African Americans sent President Roosevelt recommendations to combat discrimination. When these recommendations did not produce a vigorous response, Randolph decided to take strong action. He informed President Roosevelt that he would lead 100,000 black Americans in a protest

march on Washington, D.C., in November 1941, unless the government implemented two reforms: first, fair employment practices in defense industries; and, second, desegregation of the armed services. "A. Philip Randolph (detail)" by Tina Allen (b. 1955) shows Randolph as the statesman he became with the March on Washington Movement (MOWM) (11.2).

11.2. Tina Allen, "A. Philip Randolph (detail)," 1988
Allen depicts Randolph as he usually appeared, in coat and tie as black labor's most eminent leader.

In 1941, however, Randolph's threat of mass direct action seemed rash to many Americans, black as well as white. Mary McLeod Bethune, head of the president's Black Cabinet and friend of the First Lady, preferred to work through established channels rather than see African Americans take to the streets. Randolph came under intense pressure to call off the march in the name of the national war emergency. Randolph did not back down, and the president capitulated. In the late summer of 1941, as conflict with Japan threatened, the president signed Executive Order 8802 mandating fair employment in defense industries. Randolph called off the March on Washington.

Executive Order 8802 did not desegregate the armed forces. That would not begin until the very end of the war under President Harry S. Truman, and it would not come to fruition until the 1960s. But Executive Order 8802 took an important first step by creating a Fair Employment Practices Commission (FEPC) to investigate discrimination in war industries. In fact, it was the need for war materiel rather than the limited activities of the FEPC that reduced discrimination in hiring. Howard University historian Rayford W. Logan observed ruefully, "Hitler has provided more jobs for Negroes than all our pressure groups put together."[3] Nonetheless, the creation of the FEPC marked a symbolic turning point: for the first time, the U.S. government took a position against employment discrimination. The threat of direct action stimulated positive change.

Black Men and Women in the Second World War
The Japanese surprise bombardment of Pearl Harbor on December 7, 1941, brought the United States into the war. The attack also produced an instant black hero—Dorie Miller (1919–1943), a Navy steward on the USS *West Virginia*. In the midst of the Japanese bombardment, Miller carried the wounded (including the captain) to safety, then manned a machine gun. Although he had no gunnery training, Miller shot down four or six Japanese planes (the number varies according to the report). Initially, the Navy identified the hero only as an "unnamed Negro Messman," but African Americans insisted on learning his identity. Miller then received the Navy Cross, the Navy's highest award, and became a national hero. He survived Pearl Harbor but not the war, dying when his ship went down in 1943.[4]

As in the past, the United States Marine Corps barred black men. The U.S. Navy allowed them only as servants. The U.S. Army remained strictly segregated, limiting black soldiers to labor brigades and inferior base conditions. Once again, official policy obstructed African Americans' service as commissioned officers. Harlem Renaissance poet Langston Hughes wondered about the armed forces:

. . . Jim crow Army,
And Navy, too—
Is Jim Crow Freedom the best
I can expect from you?[5]

African Americans questioned their place in the war that was taking shape in Europe. They repeatedly equated Nazi racism, American white supremacy, and European imperialism. In the pages of the nationally influential Pittsburgh *Courier*, columnist George Schuyler (1895–1977) compared German expansion in Europe to British colonialism in Africa. African Americans had no stake in such a conflict, Schuyler declared: "Why should Negroes fight for democracy abroad when they were refused democracy in every American activity except tax paying?"[6] Dizzy Gillespie (1917–1993), the irreverent bebop trumpeter, got called up before his local draft board. He said he had never seen a German and would not know whom to shoot: "In this stage of my life here in the United States whose foot," he asked rhetorically, "has been in my ass?"[7]

Time and again in the early 1940s, black Americans drew comparisons with their own enemies in the South. A skit in New York City showed a black soldier saying, "I'll fight Hitler, Mussolini, and the Japs all at the same time, but I'm telling you I'll give those crackers down South the same damn medicine." A. Philip Randolph saw "no difference between Hitler of Germany and Talmadge of Georgia or Tojo of Japan and Bilbo of Mississippi." A black North Carolinian commented, "No clear thinking Negro can long afford to ignore our Hitlers here in America." And Langston Hughes wrote:

You tell me that Hitler is a mighty bad man
He must have took lessons from the Ku Klux Klan.[8]

For black Americans, the war produced skepticism as well as heroes. They remembered the rhetoric of democracy during the First World War and how little it meant in the United States. This time around, black Americans were no longer so naïve. Irreverent, zoot-suited young men—black and Latino—defied pleas to conserve fabric for military uniforms. Zoot suiters wore broad-shouldered, narrow-waisted, full-legged, narrow-cuffed suits with broad-brimmed hats and gold chains. They purposefully defied military discipline, thereby becoming targets of attack in Los Angeles, San Diego, Long Beach, Chicago, Detroit, and Philadelphia.[9]

Racial discrimination and segregation worsened nationwide housing shortages and aggravated racial tensions. Urban violence broke out all over the United States during the war, especially in 1943. Rumors of white civilian and police attacks on blacks set off riots in more than forty cities. The gravest disturbances occurred in Detroit and New York City, as frustrated, angry black people lashed out at white property. At least thirty-four people died in Detroit, and at least five in Harlem. Virtually all the dead were African Americans. William Henry Johnson portrayed the 1943 riot in Harlem, showing

11.3. William H. Johnson, "Lessons in a Soldier's Life," ca. 1942
In Johnson's painting, both the instructors and the new soldiers learning to man a gun are black.

a wounded black man and woman surrounded by liquor bottles and black civilian and military police.[10]

After the Italian invasion of Ethiopia, African Americans translated the racial dynamics of European colonialism in Africa and Asia into American racial terms. Black draftees joked about the wording that would go on their tombstones: "Here lies a black man killed fighting a yellow man for the protection of a white man." The Nation of Islam opposed participation in what its members saw as a white man's war. Elijah Muhammad and other Muslims spent three years in federal prison for their opposition.[11]

Once again, poor conditions of service emerged as a central issue. In Port Chicago, California, an explosion of ordinance killed more than three hundred people. But when the black sailors charged with continuing to load war materiel in obviously deadly conditions refused to do so, fifty were court-martialed and convicted of mutiny.[12]

Violent confrontations occurred between angry white civilians and black servicemen in Louisiana, North Carolina, Indiana, and Texas. Yet, thanks to a more flexible War Department and more effective protest politics, this war did not play out like the previous world war. The War Department conducted the draft more fairly in the 1940s than in the 1910s. And African Americans and their allies had two decades' worth of experience in recognizing and protesting against unfair policies. This time black men and women entered branches and ranks of the services as never before.

William H. Johnson created a series of paintings showing black men's experiences in the war, beginning with leaving home in the South and training for combat. Johnson's "Lessons in a Soldier's Life" shows black recruits learning to handle artillery under the guidance of a black officer (11.3). Despite such training and its symbolic importance for black artists, most black soldiers found themselves relegated to noncombat duty as laborers and truck drivers. In "Bayonets" Charles White depicts an African-American soldier engaged in combat, a role that remained off-limits to many (11.4).

11.4. Charles White, "Bayonets," 1943
White's apprehensive black soldier engages in close combat. He is not relegated to labor detail, as occurred so often in both the First and Second World Wars.

African-American women entered the Women's Auxiliary Corps, which was founded as a branch of the armed services early in the war. Black women's important role in the military marked a contrast with the previous all-male armed services and set an enduring pattern of involvement. The most dramatic breakthrough for black women occurred through the effective campaigning by Mabel Staupers (1890–1989) on behalf of graduate nurses. Director of the National Association of Colored Graduate Nurses (NACGN), Staupers spearheaded a successful campaign against exclusion and quotas in the U.S. Navy and Army Nurses Corps.[13]

After the U.S. declaration of war in December 1941, the Navy began allowing black men to serve in general service and reluctantly began training the first black naval officers, who were commissioned in 1944. The army gradually opened officer training schools to black men and women.[14] But the most memorable example of the wartime history of segregation, protest, and opportunity is the creation of the Army Air Corps' flight school at Tuskegee Institute in Alabama.

Black Flyers Disprove Stereotypes and Win Medals

American racial stereotype had long held that black people lacked the intelligence to operate machinery, in particular machines as technologically advanced as airplanes. The exploits of black flyers like Besse Coleman (1892–1926) and Hubert Julian (1897–1983), plus twenty-five years' worth of African-American protest against exclusion from the Army Air Corps finally paid off in 1941.[15] Building on Tuskegee Institute's existing program in aeronautical engineering, the Army Air Corps opened a small flight school for thirty-three black college men under the command of West Point–educated Captain Benjamin O. Davis, Jr. (1912–2002).

Known as the Tuskegee Airmen, these pilots manned the all-black 99th Pursuit Squadron. The 99th also included men trained in Michigan, California, and Texas, such as Daniel (Chappie) James (1920–1978), who became a four-star general. Initially the War Department refused to let the pilots of the 99th fly in battle. William Hastie (1904–1976), an aide to the Secretary of War, resigned in protest. Hastie's resignation and wartime demands sent the 99th into combat against German and Italian troops.[16] The 99th and its successor, the 332nd fighter group, flew more than 3,000 missions and shot down some 300 enemy planes. Eighty-eight pilots received the Distinguished Flying Cross.[17] Black flyers provided African Americans with a great source of pride, given that the ideology of white supremacy denied black people the intelligence necessary for flight (11.5).

By the last year of the war, the successes of the African-American flyers and other black men and women in the armed forces encouraged the War Department to give desegregation a try. Desegregated units performed well. Nevertheless, segregation remained entrenched as policy until several years after the war. Racial humiliation continued, especially in the South. For instance, black soldiers guarding German prisoners of war were refused service in white restaurants that readily served their German prisoners. In North

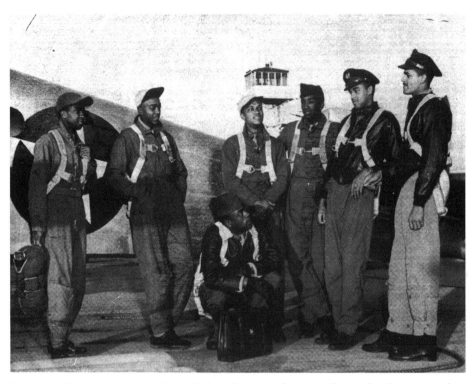

11. 5. Seven flyers from the state of New York on the cover of a nationally circulated magazine, the NAACP's *The Crisis*, February 1945.
The U.S. Air Force, which took the picture, was aware of the goodwill the image created.

Carolina, a white bus driver beat a black soldier to death, but was found not guilty of murder. In Kentucky three policemen assaulted black women in the Women's Army Corps. Military posts and their outskirts remained bastions of segregation and shoddy treatment.[18] Meanwhile, black Americans were engaging fully in the political process. As in the First World War, soldiers gained a reputation for demanding first-class citizenship. Thus any black person wearing a military uniform could become a target for antiblack violence.

The Battle for Civil Rights in the South

Black Southerners pressed hard for their citizenship rights on many fronts and against several injustices. They found allies in the Southern Conference for Human Welfare, the Highlander Folk School, CIO unions, the Communist Party and its affiliates, and in YMCAs, YWCAs, and churches. In 1942 black and white champions of civil rights formed the Congress of Racial Equality (CORE). After the U.S. Supreme Court struck down the white primary in 1944, black Southerners organized and attempted to vote with more or less success.

South Carolinian Osceola McKaine (ca. 1890–1955) was a black veteran of the First

World War who spent twenty years in Belgium after the war. After the German invasion of Belgium in 1940, McKaine returned to South Carolina, where he worked with the Southern Conference for Human Welfare and led black veterans marching on Birmingham, Alabama, to demand the right to vote. In South Carolina he spearheaded a campaign to equalize teachers' salaries across the color line. The effort was successful; in 1944 black teachers won equal pay.

In 1944 McKaine and an important black newspaper editor, John H. McCray (1910–1987), helped create the South Carolina Progressive Democratic Party (PDP).[19] The PDP quickly attracted some 45,000 members. McKaine ran for the U.S. Senate on the PDP ticket. Violence and intimidation surrounded the 1944 balloting. But the U.S. Justice Department paid no heed to the PDP's complaint of irregularities in the vote. Nonetheless, eighteen black PDP delegates, including McKaine, went to the national

11.6. Joseph Delaney, "Times Square, V-J Day," 1961 [20]

Delaney's depiction of the celebration of the victory over Japan ("V-J") shows New Yorkers of many races and sexes overjoyed by the end of the war.

Democratic nominating convention in Chicago in 1944 and challenged the seating of the official, all-white South Carolina delegation.[21] The South Carolina PDP's fight for recognition occurred twenty years before the Mississippi Freedom Democratic Party brought a similar, but better known claim to Atlantic City in 1964.

Osceola McKaine and the PDP lost their fight in 1944, but they gave tremendous momentum to the battle for black Southern civil rights. McKaine believed the New Deal and the ferment of war created new opportunities for black people: "We are living in the midst of perhaps the greatest revolution within human experience. Nothing, no nation, will be as it was before when the peace comes. . . . there is no such thing as the status quo."[22] African-American servicemen and women were determined not to go back to the humiliation, discrimination, and disfranchisement they had experienced before the war. The end of the war in 1945 seemed to open a new chapter full of promise. In "Times Square, V-J Day," Joseph Delaney (1904–1991), captures the hopes for a new era of inter-racial cooperation and an end to the American color line that so limited black Americans' opportunities and cramped their achievements (11.6).

"No Such Thing as the Status Quo"

Although black Southerners largely failed to gain the right to vote during the Second World War, they won some victories and vowed to fight on. Speaking for many, Osceola McKaine pronounced an end to the pre-war racial status quo. In the years following the war, black Americans innovated culturally as well as politically.

The Invention of Bebop
Everything changed dramatically in jazz in the early 1940s. In big dance bands and in gospel quartets, black musicians had created new music in the 1930s. In the 1930s jazz meant the big bands, and big-band jazz gained worldwide recognition as truly American music. The musical career of big-band leader Edward Kennedy "Duke" Ellington (1899–1974) had begun in the 1920s and flourished in the 1930s. His music was smooth, sophisticated, and perfect for dancing. The Ellington band toured continuously, playing for white as well as black audiences. Occasionally the big jazz bands of the 1930s brought together black and white artists. But for the most part, popular music remained strictly segregated. The most important changes in black music of the 1940s occurred in jazz in the first half of the decade.

The bebop revolution of the early 1940s remade jazz from big-band dance music into small group music to be listened to intently. Musicians like the trumpeter John Birks "Dizzy" Gillespie and saxophonist Charles Christopher "Bird" Parker (1920–1955) created a new music they called "bebop." Paul Goodnight (b. 1946) painted Dizzy Gillespie playing one of his original numbers, "Salt Peanuts," in his signature puffed-out cheek style (11.7). Gillespie explained the 1943 origin of the name bebop: "We played a lot of original tunes that didn't have titles. We just wrote an introduction and a first cho-

11.7. Paul Goodnight, "Salt Peanuts Don't Belong to Jimmy Carter," 1980

Goodnight's title reminds viewers that Dizzy Gillespie made salt peanuts famous before the 1976 presidential election of Jimmy Carter, a self-styled Georgia peanut farmer.

rus. I'd say, 'Dee-da-pa-da-n-de-bop . . . ' and we'd go into it. People, when they'd wanna ask for one of those numbers and didn't know the name, would ask for bebop. And the press picked it up and started calling it bebop."[23]

Bebop was intense and driving, full of complex rhythms and choppy phrases. Bebop tunes often began with a trumpet and a saxophone playing in unison, usually a standard like "How High the Moon" or "Night and Day." Then the middle part of the number would consist of intricate improvisations. All the instruments would play variations on the chords, flattening the fifth interval of a chord to change its sound. The flatted fifth became a "bent" or characteristically altered "blue note." The tune would close with a return to the horns and the original melody.[24] Bebop held sway through the 1940s and 1950s. A gifted singer like Ella Fitzgerald (1918–1996) spanned the 1930s era of swing and the 1940s and 1950s era of bop. She sang her own "scat" lyrics—improvised, made-up words—that became the vocal equivalent of instrumental bop.

Broadened Horizons, Increased Opportunities

African Americans associated their drive for citizenship rights with the global struggle of colonized peoples for independence from European control. During the war it was apparent that the cost to Great Britain for Indian assistance would be self-government. Indian leaders like Mahatma Gandhi and Jawaharlal Nehru took an interest in the situation of African Americans. African Americans repaid this concern with particular affection. Indian independence in 1947 opened a hopeful, new historical era. In a post-war world dedicated to human rights, people of color would no longer be subject to white overlords—in the colonized world or in the American South.

By war's end in 1945, some half-million African Americans had served overseas in the U.S. Armed Forces. Most did traditional "Negro jobs" in which they built camps, unloaded ships, and drove trucks rather than engaging in armed combat. But some flew airplanes, officered troops, fought the enemy, and liberated conquered cities. As in the First World War, black American soldiers met people of African descent from around the world. The war enlarged the horizons of service personnel by showing a new generation that the whole world did not practice American-style Jim Crow.

The Promise of the United Nations

The United Nations (UN) was formed in San Francisco in June 1945 in a conference at which Walter White, Mary McLeod Bethune, and W. E. B. Du Bois served as "consultant observers," that is, as honored guests (11. 8). The UN Charter's preamble reaffirmed "faith in fundamental human rights, in the dignity and worth of the human person, in the equal rights of men and women . . . "[25] It summed up black people's hopes for recognition and human rights. President Truman appointed Bethune's friend, the former First Lady Eleanor Roosevelt, to lead the official American delegation.[26]

Also in 1945, the Fifth Pan-African Congress took place in Manchester, England. Du Bois, long an organizer of pan-Africanism, now played a merely ceremonial role. The

11.8. Mary McLeod Bethune (1875–1955), 1945
Mary McLeod Bethune, center, as a consultant observer to the U.S. delegation at the 1945 founding conference of the United Nations in San Francisco. W. E. B. Du Bois is on the left; Walter White, executive secretary of the NAACP, is on the right.

true headliners of this 1945 conference were the men who led the struggle for African independence: Kwame Nkrumah of the Gold Coast (later Ghana) and Nnamdi Azikiwe of Nigeria. Both had studied at Lincoln University, a traditionally black institution in Pennsylvania. Africans were claiming their own countries, and the United States was taking its place as an international beacon of democracy. African Americans addressed their petitions for civil rights to the United Nations.

In 1946 the National Negro Congress (NNC) submitted a petition to the UN. It claimed that lynching, poverty, and inadequate housing, schooling, and other public services amounted to violations of African Americans' human rights. However by 1945 the NNC had become closely associated with the Communist Party—an association

that precluded its influence with the U.S. government and masses of Americans. In 1946 the more moderate NAACP also submitted a book-length petition to the UN on behalf of African Americans: "An Appeal to the World: A Statement on the Denial of Human Rights to Minorities in the Case of Citizens of Negro Descent in the United States of America and an Appeal to the United Nations for Redress."[27]

Both the NNC and NAACP petitions were buried in United Nations committees, but the Union of Soviet Socialist Republics (USSR or Soviet Union), a member of the permanent UN leadership, rescued the NAACP petition. By 1947 tensions between the United States and the USSR, which had been wartime allies, tainted the NAACP petition. The UN never addressed African-American demands.

Post-war Confrontations in the South over Citizenship Rights
Black veterans came back from the war behaving like United States citizens. For example, on his twenty-first birthday in 1946, Medgar Evers (1925–1963), his brother Charles (b. 1922), and a group of black veterans went to the Decatur, Mississippi, county courthouse intending to vote in the Democratic primary election. Around the state that year, several thousand other black Mississippians made the same attempt. In Decatur, an armed white mob turned the veterans away from the polls.[28] This sort of challenge occurred repeatedly throughout the South immediately after the war. Such attacks on black veterans left many mutilated, dying, or dead.

Between mid-1945 and mid-1947, at least twenty-four racial killings, plus at least one racial blinding, occurred in the Deep South: The Birmingham, Alabama, police killed five African-American veterans in the first two months of 1946. In Butler County, Georgia, Maceo Snipes (n.d.), a veteran, was murdered shortly after becoming the first black person in his county registered to vote. Four young people, of whom two were women, were executed in cold blood because their assailants believed they wanted to exercise their civil rights in Monroe, Georgia. John C. Jones (n.d.), an army veteran, was tortured to death with a meat cleaver and a blowtorch in Minden, Louisiana. Isaac Woodard (n.d.), who was blinded, and at least ten of those killed were veterans of the Second World War.

No one was convicted of any of these assaults. Usually no one was even accused. Throughout the post-war years, at every stage—from police to district attorneys to juries—Southern law enforcement failed to arrest, prosecute, or sentence whites who murdered black people. In a South Carolina case, forty to fifty whites abducted a black man and mutilated him with knives, clubs, and point-blank shotgun blasts. The national media covered the trial—*Time*, *Life*, and *The New Yorker* magazines and the *New York Times*. Yet, again, as usual, there was no conviction.[29] Many wondered whether convictions for crimes such as these would ever be possible.

In a confrontation between black and white veterans in Columbia, Tennessee, in 1946, however, no African Americans died. In this riot, black veterans armed themselves and shot back.[30] In Clarendon County, South Carolina, Joseph Albert DeLaine (1900–

1974), a black schoolteacher, shot back at a mob firing on his house. DeLaine got away and continued to press for black civil rights. He filed one of the suits that became *Brown v. Board of Education* in the early 1950s.[31] Throughout the violent post-war years, black activists kept guns in their homes and mounted armed patrols against the mobs that attacked and bombed those fighting for civil rights. During the 1950s and 1960s, the act of trying to register to vote invited deadly attack. Therefore the civil rights community began to debate the question of armed self-defense.

The Truman Administration and the Progressive Party Embrace Black Civil Rights
The Truman administration indirectly answered the injustices laid out in the NNC and NAACP petitions to the United Nations by recognizing the need to improve American race relations. In late 1946 President Truman created a special commission on civil rights. Its report, *To Secure These Rights*, called for much of what the NAACP and others had been recommending since the 1910s: a federal antilynching law; equal opportunity in housing, education, and employment; an end to the poll tax; and desegregation of the armed forces. In a special message to Congress in early 1948, Truman asked for immediate implementation of the report. When Southern senators obstructed legislation through filibuster, Truman issued Executive Order 9981 desegregating the United States Armed Forces.[32]

At the same time that President Truman was taking steps to bind black voters to the Democratic Party, black and white liberals were supporting the Progressive Party's presidential candidate, Henry Wallace. Wallace campaigned for black civil rights throughout the South, refusing to let his audiences be segregated. Hosea Hudson, a Birmingham, Alabama, black Communist, was one of Wallace's Southern supporters. Like Hudson, many of Wallace's backers came from CPUSA, which ultimately doomed Wallaces's candidacy. To further draw votes from Wallace and the Progressive Party, the Democratic nominating convention adopted Hubert Humphrey's civil rights plank. For the first time, the Democratic Party came out strongly in favor of black rights. In 1948, a new era of black rights seemed to be on the horizon. That new era failed to dawn in the 1940s or 1950s.

Two forces, one international, one domestic, obstructed Truman's civil rights initiatives. The Cold War between the United States and the USSR breathed new life into the anti-Communism that had appeared in the late 1930s. High-ranking, conservative Southern Democrats defeated any congressional initiatives aimed at weakening racial segregation or enfranchising black voters, often by accusing civil rights activists and organizations of being Communists. Such accusations were called "red-baiting." In fact, many of the organizations most committed to black civil rights did include Communists, including CPUSA itself, of course. By the mid-1940s, Communists dominated the NNC and the Southern Negro Youth Congress. Communists also held high offices in the Southern Conference for Human Welfare and in some CIO unions. The biggest civil rights organization, the NAACP, took vigorous steps to purge its membership of

Communists or anyone close to the CPUSA. However the purge did not succeed in refuting the accusation of Communist influence.

Red-baiting severely crippled civil rights organizations during the late 1940s and 1950s. This period, known as the Cold War, saw the coexistence of four contradictory patterns: First, black Southerners continued to be abused and killed for trying to exercise their basic civil rights. Second, organizations and individuals speaking out for black civil rights ran the risk of being tainted with Communism. Third, the federal government of the United States became sensitive to charges from the Soviet Union that African Americans did not live in a truly democratic society. And fourth, the federal government of the United States attempted to counter Soviet charges by defending black civil rights and sending black artists abroad as representatives of American culture. Together these circumstances made the Cold War era a repressive as well as a promising time.

Table 11.1. Population Increase in Six Western Cities, 1940–1950

| City | 1940 | | 1950 | |
	Black Population	% of Total	Black Population	% of Total
Los Angeles	63,774	4.2	171,209	8.7
Oakland	8,462	2.8	47,562	12.4
San Francisco	4,846	0.8	43,502	5.6
Seattle	3,789	1.0	15,666	3.3
San Diego	4,143	2.0	14,904	4.5
Portland	1,931	0.6	9,529	2.5

Table 11.2. Incomes of Black and White Men and Women, 1939 and 1947

| Sex and Race of Workers | Annual Income | | Black Income as a Percentage of White Income | |
	1939	1947	1939	1947
Black Men	$460	$1,279	41%	54%
Black Women	$246	$432	36%	34%
White Men	$1,112	$2,357		
White Women	$676	$1,269		

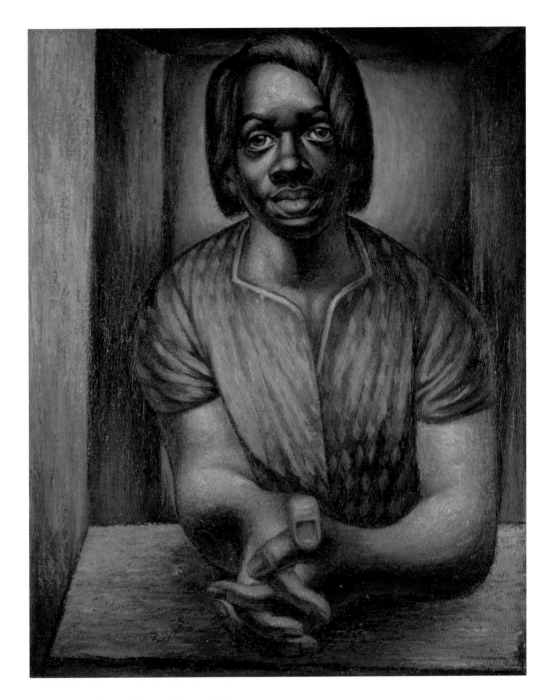

11.9. Charles White, "Woman Worker," 1951

White's subject wears a housedress, which means that she is a household worker like the majority of black women workers at the time. Although a few black women joined the relatively well-paid manufacturing workforce during the Second World War, most remained in the low-paid fields of domestic and agricultural labor.

Migration and Increased Incomes: Long-Term Changes Wrought by War

The war also changed the millions of black Americans who stayed in the United States. Job opportunities drew 1.6 million Southerners to Detroit, Chicago, New York, as well as to the West, where black people had been living since the late nineteenth century. The black populations of Los Angeles, Oakland, San Francisco, and Seattle increased dramatically (Table 11.1). By 1950, 462,172 African Americans lived in California; 30,691 in Washington; 11,529 in Oregon; 20,177 in Colorado; and more than 1,000 in Idaho and Montana. More than 2,500 black people lived in Wyoming and Utah.[33]

Full employment raised black men's and women's incomes, in dollar amounts and in relation to white incomes (Table 11.2). Charles White's 1951 "Woman Worker" shows one such hard-working woman (11.9).

Conclusion

During the war, Southern black migrants to the North and West found good jobs and exercised the right to vote. Black Southerners pressed for the same right, sometimes with hard-won success. All around the country, African Americans contributed a large, active, progressive body of voters to the Democratic Party. Between 1940 and 1946 the Southern black electorate tripled, from 200,000 to 600,000.[34]

The era of the Second World War and the years immediately following marked a turning point in African Americans' status in the United States, as soldiers and as citizens. As in the First World War, official rhetoric about a war for democracy and freedom offered black Americans an argument against racial discrimination. During the Second World War black Southerners pressed this argument by actually attempting to vote. Although violent attacks kept the ballot largely beyond reach in the South, black people began to influence the Democratic Party during the post–Second World War period. African Americans also appeared more prominently in American culture, at home and abroad.

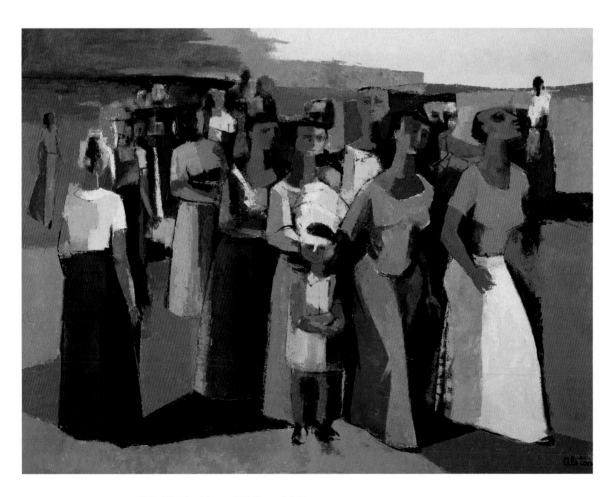

12.1. Charles Alston, "Walking," 1958
Alston stresses the role of the women and children who walked rather than rode the city buses during the Montgomery bus boycott, although most accounts focused on male leadership of the movement.

◈ 12 ◈

Cold War Civil Rights

1948–1960

At the height of the Cold War, global competition with the Soviet Union preoccupied the United States and highlighted the situation of African Americans. During this era, the United States presented itself to the world as the leader of the democratic "Free World" as against the socialist Union of Soviet Socialist Republics (USSR), which championed colonial movements for independence. The USSR continually criticized the United States for its treatment of its African-descended citizens. In this setting, the Cold War exerted contradictory influences: it made Americans less hostile to black civil rights and more hospitable to black creativity. At the same time, the political culture fostered an anti-Communism that attacked prominent African Americans and weakened organizations dedicated to defeating racial oppression. National civil rights groups such as the NAACP were distracted by accusations that they harbored Communists. Such accusations—known as "red-baiting"—did not need to be founded in fact.

On the local level, however, red-baiting could not stop the rising protest against racial discrimination that had begun during the war. In 1955 in Montgomery, Alabama, a grassroots boycott of segregated local buses organized through churches mobilized thousands of black people: the poor, the workers, and the professionals. Charles Alston's (1907–1977) "Walking" captures the spirit of the Montgomery, Alabama, bus boycott of 1955–1956 (12.1).

When the Montgomery bus boycott began in 1955, black human rights seemed to have been completely buried beneath the conservative glacier of the Cold War. A decade earlier, the Truman administration had promised to support black Southerners' drive for civil rights. But after a flurry of positive statements, the desegregation of the U.S. Armed Forces in 1948, and Truman's election in 1948, the Truman administration

turned away from racial issues. Through the 1950s the federal government was preoccupied with foreign affairs, specifically the Cold War. Anyone suspected of harboring "Communist sympathies" faced the possibility of being hauled before a congressional committee. One indication of "Communist sympathies" was a concern for black civil rights. In the South, local and state officeholders worked to maintain white supremacy. In such a discouraging national political climate, the Montgomery bus boycott arose as a purely local affair.

Sustaining the Montgomery protest against everyday humiliation in the Deep South meant walking to work and keeping an alternative transportation network running, day after day after day. The Montgomery bus boycott represented a triumph of local organizing on a mass scale. It inspired African Americans and their allies all across the United States and people around the world. It also brought international fame to the Reverend Martin Luther King, Jr. (1925–1968). The boycott and the heroic effort it required foreshadowed the Civil Rights era that would follow. Years later, it was recognized in retrospect as the beginning of a revolutionary Civil Rights movement that destroyed the legal underpinnings of segregation. But at the time no one could know what lay in the future. Anti-Communism seemed to shadow the era.

As they had for more than a century, black artists and intellectuals sang, painted, and published their interpretations of events unfolding around them. To a hitherto unprecedented degree now, however, they reached wide audiences that included nonblacks. Segregation in old and new forms (including the white suburbs), antiblack violence, and economic inequities also characterized the era. In the 1950s increasing numbers of black people expressed emphatic unwillingness to tolerate the old racial status quo.

Human Rights in a Cold War Context

In 1945–1946, the years immediately following the end of the Second World War, the United Nations (UN) seemed to offer an international forum for the debate of African-American human rights. But by 1947, the U.S.-USSR arms race and global political competition had cast a cloud of suspicion over internationalism as embodied in the UN. The anti-Communist witch-hunt that ensued injured prominent African-American figures who had been active internationally. Two highly respected African Americans of the era fell victim to the witch-hunt: W. E. B. Du Bois and Paul Robeson.

Anti-Communism Eclipses Internationalism
As the poorest Americans, many black people identified with the "Third World" of developing countries. During this era, Americans divided the world's nations into three groups: (1) the "Free World" of the United States and western Europe, (2) the "Communist World" of eastern European nations, the USSR, and the People's Republic of China, and (3) the "Third World" of poor countries that had been colonies of Europe and Japan. These poor countries were termed "underdeveloped" or, euphemistically,

"developing," in comparison with the wealthier or "developed" industrialized and democratic countries of the "Free World" and the nations dominated by the one-party, Communist USSR. W. E. B. Du Bois and Paul Robeson, the most prominent black American internationalists, also associated with Communists throughout the world.

In the 1920s, 1930s, and 1940s, Paul Robeson was an internationally admired actor and singer. He appeared on Broadway and sang in several movie musicals. During the 1940s he was one of the ten leading concert artists in the United States.[1] As a popular artist during the Second World War, he performed on national radio programs celebrating diversity. In "Paul Robeson as Othello" the sculptor Richmond Barthé (1901–1989) honors Robeson in one of his most famous roles (12.2). Two decades later, Emma Amos (b. 1936), in "Paul Robeson Frieze," used photographs from the 1930s to portray Robeson as a beautiful man in the manner of classical Greek art (12.3).

Robeson's enormous fame did not protect him from charges of un-Americanism, however. Robeson had long admired the USSR because he was

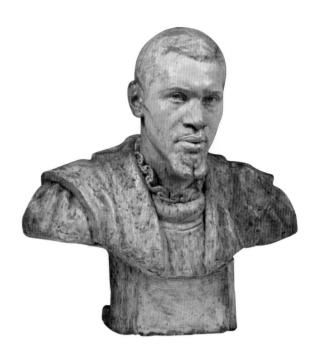

12.2. Richmond Barthé, "Paul Robeson as Othello," 1974
Barthé's bust of Robeson, simply by virtue of being a bust, makes him into a classical hero. The Venetian costume refers to the Shakespearean role of Othello.

convinced that Communism offered hope to all people of color and because Soviets from all walks of life had welcomed him. In the late 1940s he came under fire when he stated publicly that African-American men would not take up arms against the Soviet Union, which had championed black rights worldwide. In 1950 the U.S. government revoked Robeson's passport. In 1951 he joined African-American Communists to sponsor a petition to the United Nations, "We Charge Genocide." The petition documented 153 murders and 344 other violent assaults, and numerous other human rights abuses against black Americans from 1945 to 1951. The UN took no action on the petition.[2]

Anti-Communism also victimized the most respected African-American intellectual of the twentieth century, W. E. B. Du Bois. Longtime editor of the NAACP's *The Crisis*, Du Bois had served as a special American observer at the founding of the UN in 1945. But in 1950 he no longer worked for the NAACP. He headed a peace organization with Communist ties, and "peace" had become a code word for "Communist." Du Bois was indicted as an agent of a foreign power (the USSR). Although the case was thrown out of court, the U.S. government revoked Du Bois's passport in 1951.

Robeson and Du Bois denied belonging to the Communist Party. But they associated with Communists and had international ties in the Soviet-dominated world. For the U.S.

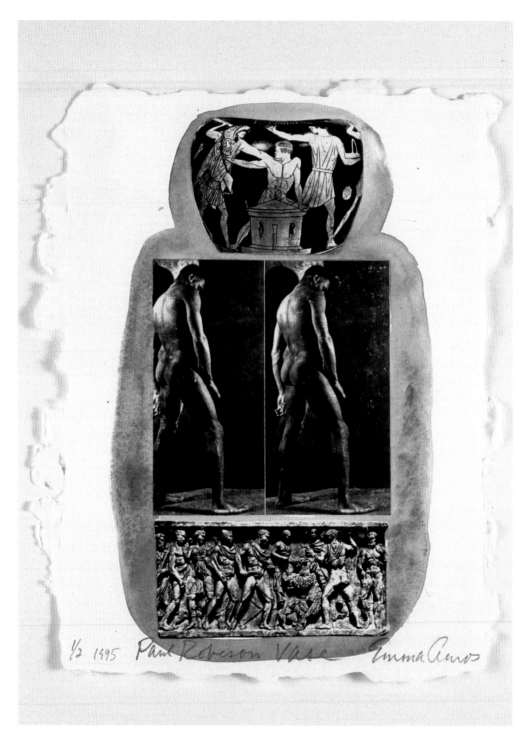

12.3. Emma Amos, "Paul Robeson Frieze (Robeson photograph by Nikolas Muray, ca. 1930s)," 1995
Like Barthé, Amos also plays upon Robeson's classical appearance, but by using a photo from the 1930s
that emphasizes the beauty of his naked body. Portraying Robeson unclothed, Amos also purges him of
the anti-Communist attacks that marred his mature years.

government, such associations and interests were enough to make them suspect as un-American, even traitors to the United States.[3] For eight years they were unable to leave the United States. They did not regain the right to travel internationally until 1958.

Although in the United States internationalism often became equated with Communism, many African Americans remained interested in global developments in the 1950s. For example, they welcomed the African-Asian solidarity of the 1955 Bandung (Indonesia) Conference of unaligned, "developing" nations. To cover the Bandung Conference, the Chicago *Defender* sent its veteran reporter Ethel Payne (1911–1991). Also attending the conference from his home in Paris was the black expatriate novelist Richard Wright (1908–1960), who published his views in *The Color Curtain* (1956).

Black Americans also remained interested in independence movements in India and Africa, and in the battle in South Africa against *apartheid* (the Afrikaans word for extreme separateness or segregation that resembled Southern U.S. Jim Crow). People around the world returned this interest with close attention to U.S. racial affairs. Indian and African newspapers led the world press in denouncing American segregation and racism. The world press picked up on a series of ugly incidents that occurred when segregated restaurants along Highway 40 in Maryland denied service to dark-skinned diplomats commuting between the UN headquarters in New York City and the U.S. capital of Washington, D.C.[4] Racist incidents such as these occurred all too frequently and embarrassed the country on its home turf as it sought to portray itself as the leader of the "Free World." Now people all over the world were watching challenges to American racial discrimination. The legal challenge focused on the fundamental democratic right to equal public education as the legal struggle to equalize education begun in the 1930s continued in a Cold War context.

Brown v. Board of Education *and Cold War Politics*

Around the world, and especially in the Third World, the separation of children on the basis of race provoked intense criticism. School segregation made the United States vulnerable to charges of hypocrisy when it proclaimed itself a champion of democracy. Worldwide criticism of American racism played a part in the U.S. Supreme Court's 1954 *Brown v. Board of Education* decision, which declared racial segregation in public schools unconstitutional. The *Brown* decision was the fruit of a long legal battle against segregation. The NAACP Legal Defense Fund had laid the groundwork for this landmark decision in the 1930s by bringing a long series of cases challenging unequal conditions for teachers and students in Southern schools.[5]

The litigation that culminated in the *Brown* decision actually encompassed four separate cases arising in 1950 and 1951. In South Carolina, Delaware, Virginia, and Kansas, black parents had sued their local school boards, claiming that their children were barred from nearby schools reserved for whites. Among the complaints was that black children had to walk long distances to inferior schools, while white pupils were bused shorter distances to schools with superior facilities. Together these cases challenged the

basic premise of school segregation: that separate education was, in fact, equal. The U.S. Supreme Court had established the "separate but equal" doctrine in *Plessy v. Ferguson* (1896). The Supreme Court accepted the school cases in 1952 and took two terms to reach a decision in 1954.

By unanimously rejecting the "separate but equal" formula of *Plessy* with regard to schooling, the Court declared racial segregation illegal. However, the Court did not set a timetable for the actual desegregation of schools. More than half a century later, the desegregation of schools in the United States is still not fully implemented. Nonetheless *Brown* marked an important turning point in American law by stating that separate facilities were "inherently unequal"—at least in public schools.[6]

The *Brown* decision was a part of the Cold War as well as a part of the struggle for black civil rights. Emphasizing the international importance of the cases, the Truman administration's Justice Department had taken the unusual step of filing a "friend of the court" (*amicus curiae*) brief on behalf of the black parents.[7] This action placed the Truman administration squarely on the side of African Americans, a revolutionary occurrence at the time that underlined the significance of the cases. Without the Justice Department's support, the parents in the *Brown* cases might not have won, or won unanimously. After the stunning, unanimous decision against segregation in 1954, the United States Department of State and the United States Information Agency (USIA) quickly broadcast the news. The international response to the *Brown* decision was overwhelmingly favorable.[8]

The *Brown* decision met a positive response among African Americans and their allies around the world. School segregation, after all, had relegated previous generations to far inferior schooling. In the South, where segregation had been entrenched in laws, white supremacist politicians mounted "massive resistance" against desegregation. In the North and West, where school segregation stemmed from segregated housing patterns, the creation of suburbs extended separation by race and economic class.

Southern "Massive Resistance" to Legal Desegregation
The positive *Brown* decision and the international visibility of talented black Americans played well around the world. But they alarmed other Americans who based their worldview in the subordination of black people. In particular, the *Brown* decision's condemnation of racial segregation aggravated Southern white supremacists, who mounted what they called "massive resistance" to desegregation. Segregationists had denounced the desegregation of the armed forces and the Democratic Party's embrace of black civil rights in the presidential election of 1948. The hastily formed States' Rights Democrats ("Dixiecrats") ran their own candidate for president in that election. However the Dixiecrats' alarm proved premature. For after the election, the Truman administration quickly pulled back from black civil rights. Nonetheless, white supremacists remained on the alert in the 1950s, and *Brown* rendered them murderously vigilant.

In July 1954, only two months after the *Brown* decision, White Citizens Councils,

dedicated to segregation, began organizing in Mississippi.[9] Several states created more or less secret agencies of government to preserve white supremacy and segregation. For example, Mississippi's Sovereignty Commission used taxpayer money to prevent desegregation through intimidation and harassment. The state legislatures of Alabama and South Carolina made membership in the NAACP illegal. And once again, antiblack violence increased, especially against African Americans who appeared likely to exercise their citizens' and human rights.

In mid-1955, white supremacists in Mississippi murdered at least two African Americans. In May of that year, the Reverend George Lee (n.d.–1955) was shot to death in Belzoni, Mississippi, for civil rights activism. The local newspaper headlined the story, "Negro Leader Dies in Odd Accident."[10] Fourteen-year-old Emmett Till (1941–1955) was too young to be involved in political action. In August 1955, his mother, Mamie Bradley (1922–2002), had sent him from Chicago to spend the summer with his uncle in Money, Mississippi. One week after he arrived, Till's body was found in the Tallahatchie River, with an eye gouged out and a bullet in his battered skull. Reportedly, Till had said "bye, baby" or something similar to an adult white woman. He was never accused of having *done* anything that could be construed as illegal. But in jittery white supremacist Mississippi, merely speaking led to his kidnapping and brutal murder.

Till's body was so badly mauled that his mother could identify him only by a ring bearing his initials. She brought her son's mutilated body back to Chicago for an open-casket funeral that shocked the world. Mamie Bradley asked, "Have you ever sent a loved son on a vacation and had him returned to you in a pine box, so horribly battered and water-logged that someone needs to tell you this sickening sight is your son— lynched?"[11]

Till's attackers were tried by an all-white, all-male jury and acquitted of the murder, even though they confessed to kidnapping. In a subsequent conversation with a journalist, they confessed to murder. This unpunished lynching of a child shocked and puzzled Americans of all races and ethnicities. It was hard to understand why the preservation of white supremacy and segregation should be worth murdering someone so young. Angry African Americans questioned yet again whether they could ever receive justice in the United States. David Driskell's (b. 1931) collage of death and American flags bears the title "Of Thee I Weep" (12.4). It looks a little like Emmett Till after he was lynched. [12]

State agencies like Mississippi's Sovereignty Commission and Un-Official Murders, as in the cases of George Lee and Emmett Till, represented two ways of protecting segregation enshrined in law (*de jure*). At the same time, however, the segregation of neighborhoods throughout the United States was receiving a crucial boost. Residential segregation was not enshrined in law. Therefore it was called *de facto* (existing in fact, but not in law). Discriminatory federal lending policies in the post-war housing boom magnified *de facto* segregation. The *Brown* decision did not apply to residential segregation, which produced schools segregated by race and by socioeconomic class.

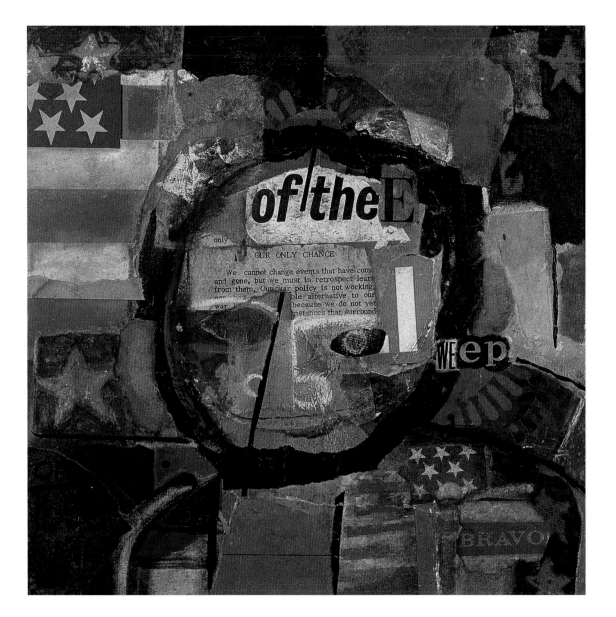

12.4. David Driskell, "Of Thee I Weep," 1968
Driskell changes the words "of thee I sing" in the "My Country 'Tis of Thee" to a phrase of grief. This collage of American flags and the face of a child recalls the battered body of Emmett Till.

New Segregation: The Growth of All-White Suburbs
During the post–Second World War era, new suburbs sprang up around the major cities, adding a vast, new, residential dimension to racial segregation. These new suburbs were for white people only. Federal policy made and kept them all white. In the 1940s, 1950s, and early 1960s the Federal Housing Authority (FHA) was the prime home mortgage-

lending agency, holding about one-half the mortgages for homes. The FHA and the Veterans Mortgage Guarantee program lent more readily than savings and loan institutions and banks and required only a small down payment. Their interest rates were attractively low and fixed for thirty years so people with modest incomes could pay for their homes over the long term.

However the FHA and the Veterans Administration seldom lent to anyone in black or integrated neighborhoods in older cities. As a result, white people received 98 percent of the FHA's and Veterans Administration's mortgage lending in the period from 1934 to 1964.[13] Many of those mortgages went to whites who were leaving cities for new suburbs like the Levittowns. The earliest and best-known new suburbs were the two Levittowns of Long Island, New York, and Bucks County, Pennsylvania.

The Levittowns used a popular means for barring African Americans: restrictive covenants. Restrictive covenants prevented an owner from selling or renting to anyone not white.[14] The FHA advocated racial restrictions in order to "preserve neighborhood stability" and prevent "Negro invasion."[15] None of the 82,000 people initially moving into Levittown, New York, was black. Eugene Burnett (b. 1929), a Second World War veteran, sought a house there in 1949 but was turned away because of his race.[16] Bill (ca. 1925–1989) and Daisy Myers (b. 1925) became the first black family in Pennsylvania's Levittown in 1957. For weeks on end, their white neighbors burned crosses on their lawn, threw bottles through their windows, and shouted racist language. The governor of Pennsylvania had to intervene to reestablish order.[17]

Governmental and private mortgage lending policies also upheld racial segregation through a process known as "redlining." Redlining designated certain areas as "high risk," where buyers could not get loans in order to buy homes or businesses. In practice, "high-risk" areas meant poor or black city neighborhoods. The FHA redlined property in black neighborhoods. Banks and savings and loan associations followed federal practice.[18] With credit hard to come by for purchase, maintenance, and improvement, urban property steadily declined. A few African Americans found individual white allies to help them sidestep restrictive covenants and buy homes outside decaying inner cities. But for the most part, African-American families rarely acquired their own homes.

Federal lending policies harmed black families through more than discriminatory lending. These policies put the prime source of family wealth beyond most black families' reach. Since the Second World War, home ownership has provided the main source of family wealth. Racial disparities in home owning created and continue to aggravate vast racial disparities in family wealth that still exist.[19]

Lending practices also hastened neighborhood decay. Run-down neighborhoods, in turn, invited destruction through "urban renewal." With the FHA and other lending agencies unwilling to make loans for the purchase of apartment buildings, people living in apartments found it difficult to purchase the buildings in which they lived. Absentee landlords let urban property deteriorate. Neglect produced blight, and blight became the target of urban renewal. The Housing Act of 1949 fostered urban renewal of older

cities throughout the United States through the destruction of run-down areas. More often than not, blighted areas turned out to be African-American neighborhoods. Developers leveled whole tracts of housing and businesses, substituting high-rise rental projects, highways, or, often, nothing at all. In Boston, urban renewal destroyed the city's West End. More than 60 percent of those displaced were African-American and Latino. The others were Italian Americans.[20] African Americans answered racism with protest in writing and in deed.

Activism and Anger

All over the United States, African Americans were growing increasingly impatient with their lack of basic rights and vulnerability to bodily attack. Even youngsters like Emmett Till were vulnerable to lynching for virtually nothing. Everyday practice often made black life into a humiliating obstacle course. After the Second World War, black Americans increasingly pushed against the obstacles. One great campaign against legalized racial oppression occurred in the Deep South of Montgomery, Alabama. The target was abuse on the segregated city buses that black people relied upon to go to and from work.[21]

The Montgomery Bus Boycott of 1955–1956

As in the nineteenth century at the time of the *Plessy v. Ferguson* decision, many confrontations occurred in segregated public transportation. Black people had organized boycotts when segregation ordinances first went into effect in Southern cities in the late nineteenth and early twentieth centuries. Those protests ultimately died down as segregation pervaded the public sphere. After the Second World War, segregated public transportation again became a sensitive issue for restive African Americans. In Baton Rouge, Louisiana, as elsewhere, seating was not the only issue in play. Bus drivers, who were all white, assaulted and humiliated black paying customers at will. The Reverend T. J. Jemison (b. 1919), the inspiring leader of the Baton Rouge bus boycott, explained: "The Negro passenger had been molested and insulted and intimidated and all Negroes at that time were tired of segregation and mistreatment and injustice."[22] Several churches and organizations conducted a well-organized boycott of city buses in Baton Rouge in seven days in June 1953 under the leadership of the United Defense League. The boycott established seating on a first-come, first-seated basis, with blacks filling in from the back and whites from the front.

In Alabama, as in Louisiana and throughout the South, bus drivers and conductors assaulted black riders. In Montgomery, Alabama, Professor Jo Ann Robinson (b. 1912), a faculty member in the English Department of the historically black Alabama State College, had suffered abuse on a city bus in 1946. As president of the Women's Political Council, Robinson fought to end the harassment of black people on Montgomery's buses.[23] Despite that group's petitions and lobbying for black drivers and flexible seat-

ing, incidents continued in the 1950s. In the spring of 1954, students at Alabama State briefly boycotted buses in protest. Although Robinson opposed mass action at that time, she warned the mayor of Montgomery of a widespread boycott if ill treatment of black riders continued.

Montgomery's bus drivers did continue to abuse black women. In March 1955 a fifteen-year-old was the victim. In October 1955, two months after Emmett Till's lynching, an eighteen-year-old was arrested for violating Montgomery's segregation statutes. On December 1 of that year, Rosa Parks (b. 1913), a forty-two-year-old well known for her dedication to the cause of civil rights, was arrested for not giving up her seat to a white man. With her activist history, Parks knew the significance of her action. She said she "had been pushed as far as I could stand to be pushed. . . . I had decided that I would have to know once and for all what rights I had as a human being and a citizen." She felt that "all of our meetings, trying to negotiate, bring about petitions before the authorities . . . really hadn't done any good at all."[24]

As soon as word spread of Parks's arrest, Jo Ann Robinson and the Women's Political Council distributed leaflets throughout black Montgomery, urging everyone to attend a mass meeting at Dexter Avenue Baptist Church and to follow up with a one-day bus boycott. The newly appointed minister of Dexter Avenue Baptist Church was the very young Reverend Martin Luther King, Jr. (1929–1968), of Atlanta. His speech at the mass meeting at Holt Street Baptist Church on December 5, 1955, encouraged the boycotters to extend their action beyond one day. He also endowed their boycott with great historical and moral significance:

> We are here in a general sense because first and foremost we are American citizens, and we are determined to apply our citizenship to the fullness of its meaning. . . .
>
> We are not wrong in what we are doing. If we are wrong, the Supreme Court of this nation is wrong. If we are wrong, the Constitution of the United States is wrong. If we are wrong, God Almighty is wrong. If we are wrong, Jesus of Nazareth was merely a utopian dreamer that never came down to earth. If we are wrong, justice is a lie. Love has no meaning. And we are determined here in Montgomery to work and fight until justice runs down like water, and righteousness like a mighty stream.

The boycott began the next day and lasted more than a year. In the newly created Montgomery Improvement Association, the most visible leaders were King, Robinson, the Reverend Ralph Abernathy (1926–1990), and E. D. Nixon (1899–1987) of the Brotherhood of Sleeping Car Porters.[25] Bayard Rustin (1912–1987), a peace activist and colleague of A. Philip Randolph, advised King from New York City and rallied support throughout the North with the aid of Ella Baker (1903–1986).[26] Despite crucial help from around the United States, the bus boycott would not have succeeded without the enthusiastic support of the masses of black people in Montgomery. Most were poor and

working-class people who were risking their jobs to make a point about human dignity. Even derelicts helped by keeping watch over the boycotters' car pool.[27] Thanks to a group of able local organizers and the commitment of thousands, the boycott ultimately desegregated buses in Montgomery and all over the South.

Inspired by the nonviolent movement for independence in India and the long African-American Christian recognition of evil and the need to confront it, Martin Luther King, Jr., led a massive, nonviolent, political action centered in Protestant churches. Given white supremacists' penchant for violence, nonviolence appeared as both wise and dangerous. Nonviolence was wise, because black people in the South were outnumbered and out-gunned by white supremacists and their allies among police and sheriff departments. During the Montgomery bus boycott, for instance, the police commissioner announced publicly that he had joined the White Citizens Council.[28] Nonviolence was also dangerous, because many Southern black people were angered past the point of forbearance. Nonviolence did not prevent the jailing of leading boycotters, including King and Abernathy. But massive, nonviolent protest triumphed in Montgomery and became the principal tactic of the Southern Civil Rights movement of the 1960s.

The Montgomery bus boycott was a large, sustained protest that broke with the NAACP pattern of using the courts to dismantle white supremacy. The U.S. Supreme Court did play a role, however. In November 1956, it upheld a federal court ruling striking down bus segregation laws. In the *Browder v. Gayle* decision, the U.S. Supreme Court not only ended segregation in Montgomery's city buses, but also invalidated the *Plessy* decision of 1896 that declared separate transportation facilities legal. Although *Brown* established the principle that separate was never really equal, it addressed schools, not transportation. *Plessy* had been a transportation case. And *Browder* specifically declared segregation unconstitutional in transportation, not just education. *Browder* was implemented in December 1956. The bus boycott ended, and on December 21, 1956, King and his colleagues took a ceremonial ride on a Montgomery city bus.

King, his wife Coretta Scott King (b. 1929), and many other colleagues identified the Montgomery bus boycott as a part of the worldwide movement of colonized people toward independence. In March 1957, the Kings attended the independence ceremonies of the West African nation of Ghana (formerly the British colony of Gold Coast).

In 1955 and 1956 changes occurred that both weakened and strengthened racial segregation. Bus boycotts against segregation took place in Tallahassee, Florida, and Cape Town, South Africa. Also at the same time, nineteen Southern U.S. senators and eighty-two members of the U.S. House of Representatives issued a "Southern Manifesto" denouncing *Brown* as a threat to segregation.

Desegregation of Little Rock, Arkansas, Central High School
The desegregation of public transportation began in the Deep South with the Montgomery bus boycott, but the desegregation of Southern schools began in Border States. The first highly publicized crisis occurred in Arkansas. Other Southern states slowly desegre-

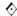

gated their schools during the 1960s and 1970s. Northern school districts, as in Boston, Massachusetts, took longer to even begin to break down racial barriers in schools.

Immediately after the first *Brown* decision, Arkansas began desegregating its schools. In Charleston and Fayetteville, desegregation proceeded uneventfully. But in the state capital of Little Rock, Central High School fell prey to politics. Governor Orval Faubus made resistance to desegregation a central part of his 1956 reelection campaign. And he fulfilled his promises in 1957, when the Little Rock school board mandated desegregation.

To prevent nine African-American students from entering Central High School, Governor Faubus called out the Arkansas National Guard. President Dwight Eisenhower did and said nothing to challenge Faubus. Earlier in the summer Eisenhower had said publicly that he would not enforce school desegregation. Laws were useless, the president thought, for only a change in heart could improve American race relations.[29] President Eisenhower's inaction so incensed famous jazz musician Louis Armstrong that in 1957 he canceled a State Department tour of the Soviet Union, refusing to act as an ambassador of the U.S. government. Armstrong said, "The way they are treating my people in the South, the government can go to hell." Armstrong wondered what he could say when people in the USSR asked him "What's wrong with my country."[30]

Day after day television cameras showed huge, seething white mobs assaulting the nine quiet African-American students outside the high school. Thanks to wide media coverage, the story from Little Rock Central High School sent the first in a long series of sensational images of out-of-control white fury contrasted with quiet black dignity. For the first time—but not the last—masses of Americans witnessed the deep and vicious hatred that had long been inflicted on Southern black people.

After the black students had endured weeks of torment at the hands of enraged mobs, the local congressman and the mayor of Little Rock finally asked President Eisenhower to send in federal troops. Eisenhower complied with this request in order to uphold federal power. This was the first time since the end of Reconstruction that federal troops had offered protection for black people.

During the crisis at Little Rock Central High School, the Civil Rights Act of 1957 was moving through Congress. It was a weak piece of legislation, the only kind of civil rights act that could pass the United States Congress at the time. Focused on voting, the Civil Rights Act of 1957 reinforced federal oversight by making the Civil Rights Section of the Justice Department into a full-fledged division. The act also required that records be kept of denials of voting rights. Even though the act was mild, the Eisenhower administration did little to enforce it. It is remarkable primarily for being the first civil rights legislation enacted since Reconstruction after the Civil War. At the time it made no visible difference.

Unremitting Antiblack Violence Stirs Bitterness and Anger

The advances in Montgomery and Little Rock did not stop the bloodletting in the South or the police brutality in the North and West. The violent record presented in the 1951

"We Charge Genocide" petition to the UN appeared to be little more than an interim report. Forty black families in the South were bombed in 1951 and 1952. White allies of black civil rights were threatened and sometimes also bombed.[31] Bodily attack represented only part of the problem. In the aftermath of the *Brown* decision, White Citizens Councils made sure that African Americans who sought to exercise their citizens' rights lost their jobs, their mortgages, or, if they were self-employed, their black clients who worked for white employers. African Americans with some money and status in the South usually avoided agitation over rights for fear of losing their hard-won material gains. Those who did not stay in their place paid a price: John McCray, the forty-year-old editor of the Columbia, South Carolina, *Lighthouse and Informer* ("the political bible of the new Negro voter in South Carolina") was sentenced to sixty days on the chain gang for his journalism.[32] Many besides Emmett Till and the Reverend George Lee lost their lives: Two Florida activists, Harry T. Moore (1905–1951) and his wife Harriette (1902–1952), died when their home was fire bombed on Christmas Eve in 1951 as they were celebrating their twenty-fifth wedding anniversary.[33] Clinton Melton (n.d.) was murdered for arguing over the cost of gas.[34] As ever, no convictions, no punishments.

In Monroe, North Carolina, Robert F. Williams (1925–1996), a Second World War veteran, came home angry over the endless bloodshed and ready to fight for his rights as a black man: "When we passively submit to these barbaric injustices," Williams concluded, "we most surely can be called the 'sissy race' of all mankind."[35] In 1953 he published "Go Awaken My People," a pan-African poem referring to the anticolonial Mau Mau movement in Kenya:

Go awaken my people from Texas to Virginia,
Tell them of our glorious brothers in the colony of Kenya.
Go tell my people that the dawn has come,
Sound the trumpet, beat the drum!
Let the tyrant shudder, let the oppressor tremble at the thunder,
For the tide of humanity rises to sweep the despot under.
Go awaken my people wherever they sleep,
Tell them that we have a rendezvous that we must keep.[36]

Williams formed a Monroe chapter of the NAACP with a bigger-than-usual working-class membership. Recruited in pool halls and tobacco fields, Williams's branch was noteworthy for its lack of concern for respectable tactics. In 1957, Williams and a local black medical doctor, Albert E. Perry (n.d.) led a group of African-American children to a segregated public swimming pool and demanded they be allowed to swim. In retaliation, the Ku Klux Klan tried to force the NAACP out of Monroe, threatening Williams and Perry with death.

Williams and Perry responded with what they called "armed self-reliance" and began defending their families in military style. They built their own rifle range, where they

practiced in steel helmets with M-1s, Mausers, and German semi-automatic rifles. They dug foxholes around Dr. Perry's house and guarded it in rotating shifts. When the Klan attacked Perry's house, Williams and his men fired back from behind barricades. According to one of Williams's group, "When we started firing, they run. We run them out and they started just crying and going on. [They] hauled it and never did come back."[37]

"Armed self-reliance" scattered the Monroe, North Carolina, Klan, but it did not end the injustice. The Monroe "kissing case" of 1958 nearly cost the lives of eight- and ten-year-old children. The incident began when a white girl child kissed two black boys in a game. For the parents of the white girl, such a game warranted capital punishment for the boys. The police arrested and jailed the boys, beating them up in the process. Klansmen broke into the jail and menaced the boys with lynching—as a joke, the Klansmen said. The boys were tried and convicted for attempted assault. The white parents wanted the boys killed instead of being imprisoned until they were twenty-one. The case attracted international attention, embarrassing the Eisenhower administration but not freeing the boys.[38]

Two more outrageous instances occurred in 1959 to anger Robert F. Williams: In Poplarville, Mississippi, the lynching of Mack Charles Parker (n.d.–1959) by a mob that included ministers and town officials; and in Tallahassee, Florida, the assault and gang-rape of four black students at Florida A & M University. With no end in sight to the violence and no legal recourse, Williams concluded that courts held no justice for African Americans. He renounced the theory of nonviolence. Southern black people, he reasoned, would have to take matters into their own hands and defend themselves through the force of arms.

Williams's actions stymied the civil rights community. They denounced Williams as dangerous and foolhardy but offered no better answers. From the NAACP in New York, Executive Secretary Roy Wilkins (1901–1981) admitted that elsewhere as well, it was becoming ever harder to keep "some of our branches from boiling over." Wilkins reported the existence of widespread "bitterness and anger."[39] The Southern Christian Leadership Conference (SCLC), successor to the Montgomery Improvement Association, did little. Ella Baker moved from New York City to Atlanta to set up the SCLC office. But the ministers in charge of the organization did not implement her grassroots plans for voting. Many other African Americans were sadly coming to agree with Williams.

Williams likened Southern white supremacists to rattlesnakes or fascists who were immune to appeals to conscience or morality: "When Hitler's tyranny threatened the world," he noted, "we did not hear very much about how immoral it is to meet violence with violence." Williams's armed self-defense ultimately caused him and his wife to flee North Carolina and the United States for Cuba and China. From Cuba, Williams broadcast his political views back into the South over "Radio Free Dixie." The Monroe Defense Committee, a national organization, supported his legal defense. After decades abroad, the Williamses finally returned to Monroe in 1995. Now more 1990s hero than renegade, Robert F. Williams rode as marshal in the 1995 annual Winchester Avenue

High School reunion parade. Rosa Parks, the heroine of the Montgomery bus boycott and nonviolent protest, spoke at his funeral in 1996.[40]

But in the late 1950s, when Williams and his wife sought refuge outside the United States, African Americans and their allies could hardly envision his story's ending. They wondered why black people faced such hatred and why antiblack violence was ignored. How long would the brutality and oppression continue? What could they do to gain their civil and human rights in the United States?

The Nation of Islam Grows

Thousands expressed their skepticism toward American culture by joining the Black Nationalist Nation of Islam (NOI). The Nation considered white people to be "devils" from whom nothing good could ever come. Rather than seeking first-class citizenship by tearing down the walls of racial segregation through political action, the NOI avoided the American public sphere and attempted to create a self-sufficient black nation within the American nation.

The Nation of Islam embodied the suspicions of African Americans regarding non-black people. Membership blossomed in the North following the 1946 release of its leader, Elijah Muhammad, from prison for refusing to serve in the armed forces during the Second World War. In the midst of a horrendous tide of racial killings, Minister Muhammad offered answers to questions that puzzled African Americans: An evil black scientist, Yakub, had created white "devils," through selective breeding out of the original Blackman. Yakub's white devils would rule for six thousand years, but their time would start to end in 1914, the beginning of the First World War. Elijah Muhammad said white people would fall in the mid-1960s. By joining the Nation of Islam and following its creed, black people would once again become great.

Meanwhile, black people should separate from whites as much as possible, maintaining their own businesses and communities.[41] Rather than suing for their rights in the courts of the United States, the Nation of Islam created as separate as possible a black society—a nation within a nation. Members of the Nation of Islam were often called "Black Muslims." The best known of all Black Muslims was Malcolm X, who—as Malcolm Little (1925–1965) was incarcerated in Norfolk State Prison in Massachusetts in the 1940s. The NOI reached out to those in prisons, inspiring them to pursue education and take control of their lives. Seeking an identity more satisfying than that of downtrodden Negro, Malcolm Little read widely in the prison library and joined the Nation of Islam while still in prison.[42] Upon his release in 1952, Little visited Elijah Muhammad and received a new surname: X. The provisional "X" indicated that Malcolm X, like all black Americans, did not know his real, African name. According to the NOI, the rejected "Little" was merely a "slave name," bestowed by white people. In the 1950s Malcolm X became the most prominent and charismatic of all Black Muslims, surpassing the leader, Elijah Muhammad. Malcolm X recruited members in Detroit, and then established the pre-eminent mosque in Harlem. Robert

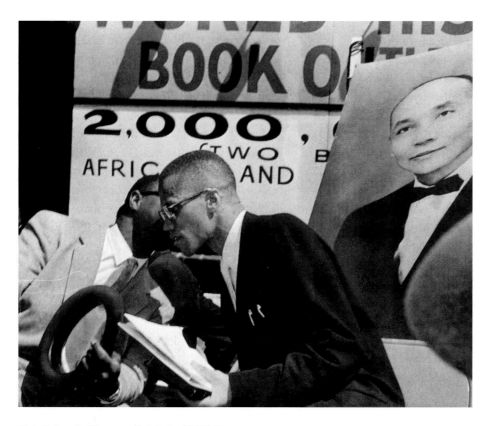

12.5. Robert L. Haggins, "Malcolm X," 1963
Malcolm X appears with Minister James Shabazz at a Harlem rally in front of Lewis Micheaux's National Memorial African Bookstore on 125th Street near Lenox Avenue. Elijah Muhammad's photo is on the right, behind Malcolm X.

Haggins (1922–ca. 2000), Malcolm X's own photographer, took hundreds of photos of Malcolm X at work in Harlem (12.5).

Malcolm X's eloquence attracted many followers to the Nation of Islam, people who doubted African Americans would ever be respected as American citizens. He advocated self-education, black pride, and black power, in the form of separate schools and all-male self-defense. The NOI created the Fruit of Islam, an all male, self-defense branch of carefully disciplined guards in black suits, white shirts, and plain ties. Muslims were to defend themselves when attacked, but they were not to initiate violence. These seemingly commonsensical positions remained immensely controversial, especially regarding self-defense. For even outside the South, police and sheriffs assumed any armed black person to be an outlaw.

The Muslim message attracted people whom conventional civil rights organizations could not reach, notably men in prison. Incarcerated men knew the cost of loose living and often responded well to the NOI's severe code of self-discipline, self-defense, and

economic uplift. NOI members were told not to eat the Southern "slave diet" of pork, cornbread, and chitterlings. They must not smoke or drink alcoholic beverages. They must not gamble. They must dress respectably and cleanly. They must not fight or speak disrespectfully of others. They must cherish and protect their families.[43]

Although the vast majority of African Americans remained Christian, thousands of others agreed with the NOI's rejection of Christianity as the white man's religion and a religion of slaves. When the Ku Klux Klan paraded itself as Christian, murdering and beating innocent black people, even children, on a regular basis, the Christian religion seemed tainted. Black Christian nonviolence seemed suicidal. While the Montgomery nonviolent bus boycott kept poor people walking for more than a year, the NOI took another tack. Elijah Muhammad and Malcolm X taught that a race war would start soon. When white people en masse took up arms, black people would have to know how to fight back.

In the late 1950s, the teachings of the NOI had attracted at least 50,000 members and tens of thousands more sympathizers. An incident in Harlem made Malcolm X widely known outside the organization. Learning that a Muslim had been badly beaten in police custody, Malcolm X marched a contingent of NOI Fruit of Islam (the self-defense unit) to a Harlem police station. Malcolm X asked for guarantees that the injured Muslim would receive medical treatment and the guilty police would be punished. The angry crowd had grown to 800, but it dispersed when Malcolm X gave the order. This example of discipline and power attracted the attention of the white media.[44] In 1959, CBS broadcast a news program about the NOI, "The Hate That Hate Produced." The program made Malcolm X nationally famous. It also warned white Americans that anti-black violence was creating a militant response among blacks. African Americans did not have to reject American society to follow the urge to protest the racial status quo.

African-American Visibility in the Mainstream Culture

Public utterance—spoken, played, painted, and written—offered means of demanding full citizenship. In the 1950s black voices succeeded in breaking through the racial barrier as never before, as eloquent African-American intellectuals and artists began to be heard as critics of segregation and as cultural innovators.

Black Intellectuals Speak to America and Are Heard

Ever since the late eighteenth century, African-American intellectuals had been speaking to Americans—white as well as black. For the most part, however, only other black people and a small number of nonblack allies attended to those words. African Americans remained invisible to nonblacks, separated by what W. E. B. Du Bois called the "veil" of segregation. When black figures appeared in popular culture, they were more likely to be broad stereotypes not made by African Americans themselves. This state of affairs began to change in the 1950s, as television carried the images of Southern white

supremacy into millions of American homes. And nonblacks began to wonder what was going on in the South.

In 1940 the novelist Richard Wright (1908–1960) had published *Native Son*, the first novel by a black author to be distributed by the Book-of-the-Month Club. *Native Son* was the story of a poor black man from Mississippi who migrated to Chicago and murdered his white employer and his black girlfriend. A dramatic, social realist novel with an uneducated, working-class hero, *Native Son* became a bestseller. In 1947, however, as the political climate in the United States became less hospitable, Wright permanently relocated to Paris. He continued to write fiction and to attend to international affairs. In addition to reporting on the Bandung Conference of 1955, he wrote two books on emerging Africa: *Black Power: A Record of Reactions in a Land of Pathos* (1954) and *White Man Listen!* (1957). Despite the range of his work, Wright is remembered as a protest writer. Younger black writers defined themselves in contrast to his reputation. One of the most successful of Wright's successors was Ralph Ellison (1914–1994), whose novel *Invisible Man* (1952) departed from the left-wing Wright tradition to reveal the hypocrisy of African Americans as well as whites. *Invisible Man* won the National Book Award, the first for a black author.[45]

The U.S. State Department and the United States Information Agency (USIA) began utilizing the new post-war generation of African Americans in the Cold War competition with the Soviet Union. Rather than continuing to deny or cover up racial discrimination, the U.S. government began to send black artists and intellectuals on goodwill tours throughout the world. The Hampton Institute English professor and writer J. Saunders Redding (1906–1988) traveled to India in 1953. Journalist Carl T. Rowan (1925–2000) visited India and Southeast Asia in 1954 and 1955. The Harlem Globetrotters lived up to their name, touring in Europe and Asia. Jazz musicians, including Dizzy Gillespie and Louis Armstrong, were spectacularly successful as American ambassadors of international goodwill. The "Louis Armstrong" quilt by Chris Clark (b. 1958) captures the vividness of Armstrong's music (12.6). His colorful performances made Armstrong a favorite representative of the United States around the world. Clark places his Louis Armstrong before a backdrop recalling the traditional quilting artistry of southern women.

These travelers did not deny the existence of racism in the United States, nor did they paint American race relations in overly positive terms. But their own personal successes undercut the notion that all African Americans were oppressed and downtrodden.[46] African Americans who appeared to be free and successful put the United States in a favorable light internationally. They disproved the Soviet version of American conditions.

In response to the challenges of Montgomery and Little Rock, two especially noteworthy new African-American writers emerged: James Baldwin (1924–1987) and Lorraine Hansberry (1930–1965). Wright had mentored Baldwin in New York in the 1940s, as Baldwin was establishing himself in the periodical press. With Wright's support, Baldwin moved to Paris in 1948. In Paris Baldwin wrote his autobiographical first novel, *Go Tell It on the Mountain* (1953) and essays in *Notes of a Native Son* (1955). Beauford

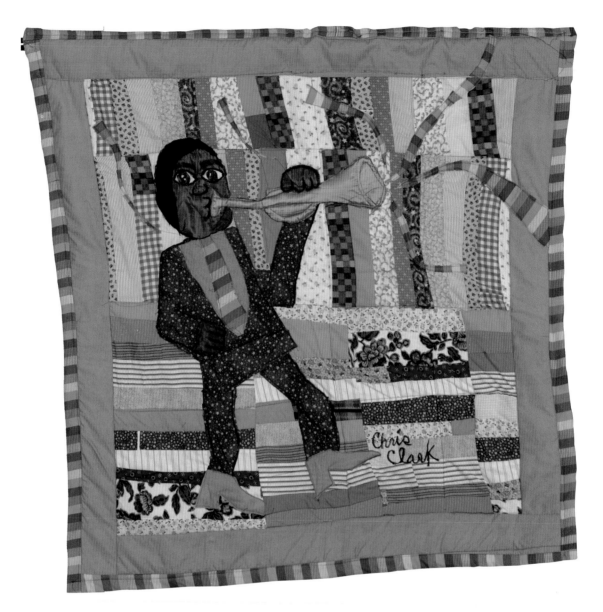

12.6. Chris Clark, "Louis Armstrong" quilt, 2005
Clark's strong male Armstrong plays a golden trumpet against a pieced backdrop that plays on the conventions of traditional southern women's quilting.

Delaney, also an expatriate black American in Paris, painted several portraits of his friend James Baldwin. In "Portrait of James Baldwin" Delaney expresses his love for Baldwin in vivid colors and strong line.[47]

The Montgomery bus boycott and the crises of school desegregation drew Baldwin back to the United States in 1957. He traveled throughout the South, reporting on what

he saw in nationally circulated magazines such as *Commentary*, *Esquire*, and *Partisan Review*. He collected these essays in a best-selling volume, *Nobody Knows My Name* (1961). In the late 1950s and early 1960s, Baldwin's prophetic phrasing warned white Americans that their oppression of blacks threatened not only to produce a black explosion, but also to ruin their own society.

Baldwin addressed white Americans directly in the cadences of the black church. In contrast, Lorraine Hansberry focused first on one African-American family, the Youngers. Hansberry's 1959 play, *A Raisin in the Sun*, shows the generational tensions within a Northern, working-class family trying to better itself through conflicting strategies of identification with Africa, home owning, the liquor business, and resistance to white supremacy. Hansberry depicted the ways in which gender differences might be expressed within a family faced with difficult choices. Amazingly, *A Raisin in the Sun* ran for 538 performances on Broadway and won a Drama Critics Circle Award. Hansberry was the first black woman whose work reached a Broadway theater and the first black person to win this award. *A Raisin in the Sun* was made into a feature film starring Sidney Poitier. To avoid offending the movie-going public, Columbia Pictures severely censored Hansberry's script.[48] Although the presentation was sometimes butchered, African-American writing was finding its way into American mass culture with figures whom blacks could recognize as themselves.

The Growing Popularity of African-American Music

The influence of black music in American popular culture increased over the course of the twentieth century. By the 1920s, the lively syncopation and blue notes of African-American sound had become the emblem of American sound. In the 1930s and 1940s, pop musicians and Country and Western performers borrowed freely from the blues, with and without attribution to its origin. Jazz—Southern, bebop, and big band— characterized the 1930s and early 1940s. Bebop flourished in New York, with Dizzy Gillespie and Charles "Bird" Parker continually breaking new musical ground. Parker's classic saxophone playing drew on the blues, but it added cascades of notes, low and full, high and shrill. Parker died of a drug overdose in the mid-1950s, but his influence endures in jazz and American popular music. David Hammons's visual pun in "Bird," plays on the vernacular term for a black man, "spade," and Parker's genius on the saxophone (12.7). Negro spirituals, work songs, ragtime, blues of all sorts, and many kinds of jazz began to penetrate the concert halls and receive wide recognition. In the 1940s and 1950s, these kinds of black vernacular musical forms, rather than classical artists, came to the fore.

Gospel music, invented in the 1930s and perfected in Chicago by the "Father of Gospel Music," Thomas A. Dorsey (1899–1993), and his protégée Mahalia Jackson (1911–1972), reached radio and television audiences in the 1940s and 1950s. Joe Bostic (1908–1988), the "Dean of Gospel Disc Jockeys," regularly broadcast "Gospel Train" on WLIB in New York in the early 1940s. A decade later, Bostic was reaching audiences from beyond his

studio. He produced the first Negro Gospel and Religious Music Festival at New York City's Carnegie Hall in 1950. Bostic's gospel festivals subsequently outgrew Carnegie Hall. In 1959, Bostic filled Madison Square Garden for the First Annual Gospel, Spiritual, and Folk Music Festival. Mahalia Jackson became the first black gospel artist to appear on the popular, nationally syndicated "Ed Sullivan Show" and to broadcast her own "Mahalia Jackson Show" in 1954.

Gospel entered the world of jazz in 1957. The Clara Ward Singers appeared at the Newport Jazz Festival, followed by Mahalia Jackson in 1958. Since that time, gospel musicians have performed regularly at the Newport and other jazz festivals. In 1961, gospel music reached a milestone when Mahalia Jackson performed at an inaugural party for President John F. Kennedy.[49]

A tiny number of black musicians achieved fame as pop artists in the 1950s. Billy Eckstine (1914–1993), a swinging singer of ballads, paved the way in the 1940s. Sarah "Sassy" Vaughan (1924–1990) began her career singing with Eckstine's band in 1944. Starting in the 1950s she made a long, respected career as a jazz singer. Eckstine's successor in the pop market was Nat "King" Cole (1919–1965). Cole also began in jazz, as a swing pianist. "Straighten Up and Fly Right" reached number one on the pop chart in 1944. In 1948 the King Cole Trio was the first black jazz group to have its own radio series. Nat "King" Cole moved on from jazz to pop in the late 1940s. His recording of "Mona Lisa" reached number one on the pop chart, and by 1952 he was one of the leading crooners in the United States.[50] Cole's enormous success as a pop recording artist led to his own fifteen-minute television show in 1956–1957, another first in the history of black artists. However the failure to find

12.7. David Hammons, "Bird," 1973

Hammons's tribute to the jazz saxophone pioneer Charlie Parker, whose nickname was "Bird," comes in the shape of a shovel, saxophone, and hands and puns on "spade," the slang term for a black man.

a sponsor for a black show doomed it. Cole was inducted into the Rock and Roll Hall of Fame in 2000.

The great revolution in American music came in the popular genre, in which record companies, radio, and, later, television, played major roles. Big white companies made most recordings and most hits. Yet smaller, black-owned, independent labels could also reach the hit charts. Vivian Carter Bracken (n.d.), James Bracken (n.d.), and Calvin Carter (n.d.) founded Vee Jay Records in Chicago in 1953. Vee Jay recorded a wide range of artists, black and white, before closing down in 1966.[51]

In 1949 *Billboard* magazine introduced a new category, "rhythm 'n' blues," which replaced "race records," the older term for music of any sort that was marketed to black consumers. Rhythm 'n' blues was a distinct genre that drew on blues and gospel music in its own new way. It featured electric guitars, horns, piano, and drums playing complex, driving rhythms. Ike Turner (b. 1931) and his first band, the Kings of Rhythm, made "Rocket 88," recognized as the first rock 'n' roll record, in Sam Phillips's Memphis recording studio in either 1949 or 1951 (accounts vary). With its driving new "back beat" (rhythmic emphasis on the second and fourth beats rather than on the first and third, as in marches and much European music), "Rocket 88" went to number one on the rhythm 'n' blues chart. Ike Turner was inducted into the Rock and Roll Hall of Fame in 1990.[52]

Hard-driving rock 'n' roll shared cultural space with the mellow doo-wop music of the boy and girl quartets of Northern cities, for example, Philadelphia. Doo-wop music featured high falsettos, low basses, and nonsense syllables summed up in the back-up singers' "doo-wop, doo-wop." The Orioles ("It's Too Soon to Know," 1948), the Ravens ("Rock Me All Night Long," 1950), and the Platters ("Only You" and "The Great Pretender," 1955) made some of the most popular doo-wop records of the late 1940s and 1950s. Essentially youthful love songs, doo-wop records were made for slow dancing.

Alan Freed, a white disc jockey who played black music for white radio listeners, gave rock 'n' roll its name in 1951. Drawing heavily on rhythm 'n' blues for driving rhythm and unsentimental lyrics, rock 'n' roll also included elements from pop and Country and Western music. Elvis Presley was rock 'n' roll's first megastar, but many black artists contributed hit songs to the genre. One of the earliest "crossover" hits (recordings that sold in more than one market category) was the Chords' doo-wop hit, "Sh-Boom," the first rhythm 'n' blues record to reach the top ten on both the pop and rhythm 'n' blues charts. Its success inspired a white Canadian group, the Crew Cuts, to "cover" the Chords' version.

"Covering" was the result of the racially segregated marketing of American popular music. In the 1950s American radio and television programs rarely featured black artists. Because of segregation, black artists could reach only black audiences (some 10 percent of the United States population). As a result, black artists' opportunities remained severely limited. The exclusion of African-American musicians from the national media did more than simply penalize black musicians. It also created an opportunity for white

12.8. Paul A. Houzell, "Chuck Berry: Nadine Honey Is That You?" 1999
In Houzell's illustration of one of Chuck Berry's many hits, Berry plays guitar and does his famous chicken walk for a beautiful, light-skinned Nadine.

groups to re-record—or "cover"—rhythm 'n' blues hits and market them to larger, white audiences. (African-American artists suffered most from the appropriation of their music and their arrangements. But Country and Western hits were also subject to covering. For country musicians, too, seldom appeared on non-Country radio and television programs.) A few of the many white covers of black music of the 1950s were Bill Haley and the Comets' cover of Joe Turner's "Shake, Rattle, and Roll" in 1954; Pat Boone's cover of Fats Domino's "Ain't That a Shame," and Little Richard Penniman's "Tutti-Frutti."[53]

During the 1950s, African Americans revitalized American popular music through the invention of rock 'n' roll. But segregation and exclusion prevented black artists from reaping the rewards of their creativity. Some like Clyde McPhatter (1932–1972, "Money Honey") died before the barriers facing black performers fell. Others, like LaVerne Baker (1930–1997, "Jim Dandy"), were in fragile health when the industry opened up.

But hardy artists—like Little Richard Penniman (b. 1932, "Long Tall Sally"), Chuck Berry (b. 1926, "Maybellene"), and the bluesman B. B. King (b. 1925, "The Thrill Is Gone")—survived into and beyond the 1980s to appear before large, appreciative audiences. They finally reaped the fruit of their 1950s inventiveness.[54] Paul A. Houzell (b. 1943) shows Chuck Berry, still doing his famous chicken walk, alongside a lovely woman who must be named Nadine in "Chuck Berry: Nadine Honey Is That You?" (12.8).

Conclusion

In the context of the U.S.-USSR competition for world leadership that followed the Second World War, African-American militancy took two forms: The Montgomery bus boycott expressed one form that paid heed to the promise of American democracy. It took aim at segregation through nonviolence. The other form of militancy grew out of anger toward a country that sacrificed black life so carelessly. The Nation of Islam and the Monroe (North Carolina) Defense Committee embraced racial self-sufficiency, separation from whites, and self-defense. At the same time, black artists and intellectuals gained a foothold in American culture. As international ambassadors, they also undercut Communist accusations of American hypocrisy. International competition made African Americans into symbols of American worthiness to lead the "Free World." Protests to come made symbolic American-ness more and more real.

13.1. Willie Birch, "Memories of the 60s," 1990
Birch's paper mâché sculpture shows a mature quilter commemorating Martin Luther King, Jr., and Malcolm X together, even though the two martyrs represented contrasting approaches to the black situation in the United States.

Protest Makes
a Civil Rights Revolution

1960–1967

In the "Memories of the 60s" sculpture by Willie Birch (b. 1942) a quilter commemorates the Civil Rights revolution (13.1). The seamstress wears Ghanaian symbols around her neck as she sews a quilt featuring Malcolm X and Martin Luther King, Jr., two contrasting martyrs to the struggle against racial injustice. Although the two men appeared as antagonists in the 1950s and 1960s, artists often show them together in retrospect. For many African-American artists, no great gulf separates one man and his philosophy from the other. They simply represent two facets of the protests that revolutionized race relations in the United States in the space of a very few, very full years. Malcolm X and King were both assassinated before reaching the age of forty, an all too common fate for people fighting for black rights. Around the two portraits, Birch arranges images of the Civil Rights era: jails; Klansmen; police dogs; fire hoses; and protesters, black and white, singing arm-in-arm. Words on the quilt—"freedom is not free" and "the price of freedom is death"—remind us that black freedom carries a stiff bodily price.

During the Civil Rights era of the 1960s, African Americans and their allies took massive "direct action" in marches, demonstrations, sit-ins, and boycotts. Direct action rejected the legal strategy of the NAACP and the slow process of preparing black Southerners to pass the battery of obscure tests for voting. It drew the attention of television, the new entertainment medium, which eagerly covered the events, especially when white supremacists inflicted unimaginable acts of violence on peaceful protesters. The protests in the South made for excellent television. In turn, television coverage made nonblack Americans and people all over the world aware of the struggle for black rights.

All across the United States in 1960, African Americans lacked political power. But only in the South did campaigns for the vote stir up sensational violence. All across the

United States, black life was subject to more or less rigid segregation. But only in the South was segregation enforced by law and therefore vulnerable to changes in the law. In 1964 and 1965 Congress passed sweeping civil rights legislation that struck down the basis of legal segregation and disfranchisement. This legislation revolutionized American law. The legal changes, though sweeping, did not reverse structural inequities in places where segregation was not enshrined in law.

All across the United States, black public services were manifestly inferior to those of whites. All across the United States, urban "renewal" meant razing black neighborhoods and business districts and building new structures on them for other people, running highways through them to let suburbanites bypass city streets, or simply leaving them vacant. White people moved from the cities into suburbs that were kept white through the use of restrictive covenants and other discriminatory schemes. At the same time, industries left urban areas, starving cities of tax revenue and cutting public services, especially in black and poor neighborhoods. Banks curtailed lending to inner-city homebuyers and entrepreneurs. In the mid-1960s the war in Vietnam diverted federal funds and public attention away from the needs of the black and the poor and fractured the Civil Rights movement into factions arguing over whether to stress the war or poverty.

The Early 60s: Action Direct and Indirect

The origins of the direct action phase of the Civil Rights movement lay in the mid-1950s, in the Montgomery bus boycott led by the Reverend Martin Luther King, Jr. In the five years that followed the boycott, King became a highly sought-after speaker. He and his colleagues reorganized the Montgomery Improvement Association (which had organized the boycott) into the Southern Christian Leadership Conference (SCLC), located in Atlanta. As a new organization with "Christian" in its name, SCLC represented the ethics and the leadership of Southern black churches. Ella Baker (1903–1986) set up SCLC, but the organization accomplished little toward its goal of registering large numbers of Southern blacks to vote. While the voting project bogged down, students in the upper South inspired their counterparts all around the United States by occupying public spaces set aside for whites only—activities that came to be known as "sit-ins."

Student Movements of the Early 1960s
The sit-ins began in late 1959 and early 1960, in Nashville, Tennessee, as well as in Greensboro, North Carolina, which is usually considered the cradle of the sit-in movement. Four freshmen at North Carolina Agricultural and Technical College (A & T) decided to confront the exclusion of black people from the lunch counter of the local Woolworth dime store. Their efforts were inspired by Martin Luther King, Jr., and Rosa Parks of the Montgomery bus boycott and by the brave black students of Little Rock. The lunch counter sit-in quickly gained the support of other A & T students and black women at Greensboro's Bennett College. Then white women at the North Carolina

Women's College at Greensboro and students elsewhere in North Carolina began supporting the sit-ins.[1] Soon young people all around the South, even in Mississippi, were sitting-in at restaurants, churches, libraries, bowling alleys, and bus and train waiting rooms. White supremacists tormented them verbally and physically by calling them abusive names, dumping bottles of ketchup and mustard on them, even grinding out lighted cigarettes on their bare skin. Despite the provocation, the students remained nonviolent. The scenario was similar in Nashville, where the well-disciplined activists included Marion Barry (b. 1936), Diane Nash (b. 1938), John Lewis (b. 1940), and James Bevel (b. 1936).[2]

In March and April, adult veterans of civil rights and union struggles helped organize the students who were engaged in the sit-ins. The Highlander Folk School in Tennessee held a workshop at which the students learned to sing "We Shall Overcome" for the first time. The song became the anthem of the black Civil Rights movement. In April Ella Baker organized a students' meeting on nonviolence at her alma mater, Shaw University in Raleigh, North Carolina. About two hundred students formed a new organization nominally under the sponsorship of SCLC. The Student Nonviolent Coordinating Committee (SNCC, pronounced "Snick") came to embody the student movement. Inspired students such as Spelman College's Ruby Doris Smith-Robinson (1942–1967) gave heart and soul to the grassroots movement concentrating on local people.

In contrast to the top-down approach of the minister-led SCLC, SNCC bore the imprint of Baker's populist philosophy of organizing. She believed in bringing out the leadership ability of ordinary people rather than elevating a few leaders above the people. The movement would remain nonviolent, and it would not be racially exclusive. Most of those who attended the initial meeting at Shaw University were black and Southern. But SNCC welcomed nonblacks: "This movement should not be considered one for Negroes but one for people who consider this a movement against injustice. This would include members of all races." Marion Barry became SNCC's first chair.[3] The sit-ins spread to segregated facilities all over the United States and, recalling the "Don't Buy Where You Can't Work" campaigns of the 1930s and 1940s, to the picketing of businesses that did not hire African-American workers.

In mid-1961 student activists from SNCC and from the Congress of Racial Equality (CORE) tested the desegregation of interstate transportation as "Freedom Riders." A recent Supreme Court decision had struck down segregation in bus terminals. (In 1955 the *Browder* decision had outlawed segregation in transportation, thereby concluding the Montgomery bus boycott victoriously.) Like the CORE Freedom Riders of 1947 who only reached North Carolina, the Freedom Riders of 1961 encountered a staggering campaign of violence, this time especially in Alabama. In Anniston, Alabama, a mob set the Freedom Riders' bus on fire and attacked the riders as they tried to escape the smoke and flames. In Birmingham, Alabama, as in Anniston, the police did nothing to protect the riders.

Images of bloodied black and white Freedom Riders made world news, alarming

the Kennedy administration. Attorney General Robert Kennedy prompted the Interstate Commerce Commission to end segregation in interstate transportation. The Freedom Riders achieved victory, but at a terrible bodily and psychological cost. One white Freedom Rider never regained his health after a savaging in Alabama.

The Albany, Georgia, movement of 1961–1962 failed to produce change. Unlike their counterparts in Alabama and Mississippi, city leaders in Albany refrained from roughing up protesters before television cameras and running afoul of federal law. Out of the television camera's eye, Albany's leaders waited out the movement without altering the city's segregation. The Albany movement did not succeed, but it taught many useful tactical lessons about picking adversaries with an eye toward the use of television. And it brought to the fore one of the Civil Rights movement's most enduring contributions to American culture: the freedom songs of Bernice Johnson Reagon (b. 1942).[4]

In northwestern Mississippi in 1962, one black man's entry into the state-funded University of Mississippi ("Ole Miss") provoked a constitutional crisis between the state of Mississippi and the federal government. Defiant white Mississippians included student mobs and the governor. The conflict between state and federal power ultimately forced the reluctant Kennedy administration to mount a federal military occupation on the order of those in Korea and Berlin. James Meredith's enrollment at Ole Miss required 31,000 U.S. troops to restore order. Meredith (b. 1933) graduated in 1963.[5] Even before Meredith entered Old Miss protected by tens of thousands of soldiers, the Kennedy administration was seeking ways to cool down confrontations between activists and white supremacists. Voter registration appeared to offer a less controversial approach to black civil rights.

In 1961 SNCC shifted attention away from direct action and toward voter registration—a shift the Kennedy administration encouraged. Voter registration would seem less likely to attract the kind of sensational antiblack violence that made for good television but bad international press. A pivotal figure in SNCC's voter registration in Mississippi was Robert Parris Moses (b. 1935), a graduate student in philosophy at Harvard. Moses heeded the advice of older NAACP officials in Mississippi, who were demanding an end to segregation. One of the veterans was Medgar Evers (1925–1963), executive director of the Mississippi NAACP.

Moses and a few colleagues began registering black Mississippians to vote during 1961 and 1962. They were beaten, and Herbert Lee (ca. 1940–1962), a local man who had served as a volunteer driver, was murdered by a Mississippi state legislator.[6] The voter drive, the beatings, and the murder went little noticed at the time. But the roll call of the civil rights dead ran long. Most, but by no means all, were African American (see Table 13.1).

In 1962–1964, the voter registration drive in the Mississippi Delta depended upon the support of local people. In Ruleville, forty-four-year-old Fannie Lou Hamer (1917–1977) tried to register to vote and was savagely beaten for it. She and her husband lost their jobs and their home. Nonetheless Hamer kept on as a field secretary of SNCC. Her speeches

Table 13.1. Violence Aimed at Civil Rights Workers, 1961–1968

Date	Assault
May 14, 1961	Freedom Riders attacked in Alabama while testing compliance with bus desegregation laws.
September 25, 1961	Voter registration worker Herbert Lee killed by a white legislator, Liberty, Miss.
April 9, 1962	Roman Ducksworth, Jr., taken from bus and killed by police, Taylorsville, Miss.
September 30, 1962	Riots erupt when James Meredith, a black veteran, enrolls at the University of Mississippi. Paul Guihard, European reporter, killed.
April 23, 1963	William Lewis Moore slain during one-man march against segregation, Attalla, Ala.
May 3, 1963	Birmingham police attack marching children with dogs and fire hoses.
June 12, 1963	Medgar Evers, civil rights leader, assassinated, Jackson, Miss.
September 15, 1963	Schoolgirls Addie Mae Collins, Denise McNair, Carole Robertson, and Cynthia Wesley die in the bombing of the Sixteenth St. Baptist Church, Birmingham, Ala.
September 15, 1963	Virgil Lamar Ware killed during racist violence, Birmingham, Ala.
January 31, 1964	Louis Allen, witness to the murder of civil rights workers, assassinated, Liberty, Miss.
April 7, 1964	The Reverend Bruce Klunder killed protesting construction of segregated school, Cleveland, Ohio.
May 2, 1964	Henry Hezikiah Dee and Charles Eddie Moore killed by Klan, Meadville, Miss.
June 21, 1964	Civil rights workers James Chaney, Andrew Goodman, and Michael Schwerner abducted and slain by Klan, Philadelphia, Miss.
July 11, 1964	Lt. Col. Lemuel Penn killed by Klan while driving north, Colbert, Ga.
February 26, 1965	Jimmie Lee Jackson, civil rights marcher, killed by state trooper, Marion, Ala.
March 11, 1965	Selma-to-Montgomery march volunteer, the Reverend James Reeb, beaten to death, Selma, Ala.
March 25, 1965	Viola Gregg Liuzzo, a white supporter, killed by Klan while transporting marchers, Selma Highway, Ala.
June 2, 1965	Oneal Moore, black deputy, killed by nightriders, Varnado, La.
July 18, 1965	Willie Wallace Brewster killed by nightriders, Anniston, Ala.
August 20, 1965	Jonathan Daniels, seminary student, killed by deputy, Hayneville, Ala.
January 3, 1966	Samuel Younge, Jr., student civil rights activist, killed in dispute over whites-only restroom, Tuskegee, Ala.
January 10, 1966	Vernon Dahmer, community leader, killed in Klan bombing, Hattiesburg, Miss.
June 10, 1966	Ben Chester White killed by Klan, Natchez, Miss.
July 30, 1966	Clarence Triggs slain by nightriders, Bogalusa, La.
February 2, 1967	Wharlest Jackson, civil rights leader, killed when police fired on protesters, Jackson, Miss.
February 8, 1968	Students Samuel Hammond, Jr., Delano Middleton, and Henry Smith killed when highway patrolmen fire on protesters, Orangeburg, S.C.
April 4, 1968	Dr. Martin Luther King, Jr., assassinated, Memphis, Tenn.

inspired local people like herself to take the great and dangerous step of attempting to register to vote.[7]

Trick questions, intimidation, and violence made successful registration a rare achievement. Pointing to the low numbers of black voters, segregationists argued that African Americans simply did not want to vote. To disprove that claim, Hamer, Moses, and other civil rights workers conducted a mock election in 1962. Some 80,000 black Mississippians cast Freedom Votes. The campaign for voting rights in Mississippi continued.

The Protests of 1963,
the One Hundredth Anniversary of the Emancipation Proclamation

In the spring of 1963, SCLC lent its weight to the campaign against segregation and police brutality in Birmingham, Alabama. The Birmingham campaign coincided with hundreds of anti-segregation and anti-discrimination demonstrations all around the country on the one hundredth anniversary of the Emancipation Proclamation that abolished slavery during the Civil War. Birmingham black people had been trying to gain their civil rights since the Second World War. More than fifty bombings had met African Americans' attempts to exercise civil rights between the end of the Second World War and 1965. In bitter humor, African Americans nicknamed the city "Bomingham." The Birmingham commissioner of police, Eugene "Bull" Connor, was notorious for his readiness to attack radicals, union members, and black people.

In 1962 the Reverend Fred Shuttlesworth (b. 1922) and the Alabama Christian Movement for Human Rights had forged an agreement with the city and business leaders for the removal of the "white" and "colored" signs from downtown stores and the opening of municipal facilities to African Americans. But the business leaders and city officers reneged on the agreement, and nothing changed. Shuttlesworth then appealed to SCLC for help.

SCLC organized a series of mass protest marches. City police attacked and jailed the protesters, preserving segregation and discrimination in Birmingham. King and the Reverend Ralph Abernathy (1926–1990), his closest colleague, were arrested for marching on Good Friday. While in jail, King answered local white ministers who were trying to persuade him to call off the demonstrations. The ministers thought the time was not right and the protesters should wait. King's response, "Letter from Birmingham City Jail," became part of his movement classic, *Why We Can't Wait* (1964). After the adult protesters were jailed, school children took their places in the streets. The children had assembled at the Sixteenth Street Baptist church before marching out to meet the dogs.

The footage of police dogs attacking and fire hoses knocking children off their feet and tearing off their clothes shocked people around the world. Those images still serve as emblems of the campaign for ordinary citizens' rights in a self-proclaimed democracy. King's letter and Birmingham's vicious attack on marching children gained crucial support for the movement. Birmingham lived up to its nickname of Bomingham

when Klansmen bombed the home of King's younger brother and the motel serving as King's headquarters.

Shortly after the Birmingham attack, the governor of Alabama, George Wallace, tried to prevent two African-American students from registering at the University of Alabama. President Kennedy sent the National Guard to the university to enforce the federal court order admitting the students.

Southern segregationists' defiance angered black people all across the country. The writer James Baldwin had returned from France to support the struggle. He joined a delegation of African Americans meeting with the president and the attorney general to demand federal action. By this time Kennedy had recognized the need for the United States to counter Soviet criticism regarding black people's lack of civil rights. Events convinced Kennedy to urge Congress to pass the pending civil rights bill. According to the president, the United States preached freedom around the world and now must be as good as its word. American troops in Vietnam and Berlin, he said, were black as well as white. Military needs justified Congress's passage of a sweeping civil rights bill. One of the first replies to Kennedy's address occurred on June 12, 1963—the assassination of Medgar Evers, a veteran, in his driveway in Jackson, Mississippi. All-white juries twice acquitted his assassin, a notorious white supremacist named Byron De La Beckwith. Beckwith was finally convicted of Evers's murder in 1994.

Although the killing continued, Congress did not share the president's sense of urgency and took no action. Civil rights demonstrations also continued. Nearly eight hundred direct actions took place in the South in the summer of 1963. Some twenty thousand people were arrested and ten were killed.[8] In New York, A. Philip Randolph, the dean of black organized labor, and his colleague Bayard Rustin reckoned it was time for a new March on Washington. Unlike the March on Washington planned for 1941, the march in 1963 did take place—on the day after W. E. B. Du Bois died in Ghana. On August 28, 1963, a quarter of a million people crowded around the Lincoln Monument.

The 1963 March on Washington made Martin Luther King, Jr., the most prominent symbol of the Civil Rights movement. Artists have depicted King more than any other African American. He is a favorite of black artists, for example, Howardena Pindell. Her "Homage to MLK," mentions the March on Washington on the upper left corner and shows a pensive King below (13.2).

In "Dream 2: King and the Sisterhood," Faith Ringgold (b. 1930) honors King along with the "sisters," the crucial, but lesser-known black women (13.3). Although King attracted much more money and media attention, these women, like Fannie Lou Hamer and Ella Baker, formed the backbone of the movement. They accomplished the essential, day-to-day work that kept the movement alive.

The title of Paul Andrew Wandless's (b. 1967) "American Dreamer" recalls King's famous 1963 phrases and wraps him ironically, perhaps bitterly, in the American flag (13.4).

Today the March on Washington is remembered primarily for Martin Luther King's "I Have a Dream" speech, which envisions a society in which race does not blight life's

13.2. Howardena Pindell, "Homage to MLK," 1968
Pindell shows the faces of civil rights activists, including a Martin Luther King, Jr., deep in thought and the red of shed blood.

aspirations. However, the March on Washington was more than just socially visionary. In line with Randolph's concerns about rampant unemployment, the march was for "jobs and freedom." Young John Lewis of SNCC had two other concerns. One was police brutality, the other was full citizenship, such as newly independent Africans were achieving. "There's not one thing in the [proposed civil rights] bill that will protect our people from police brutality," Lewis wanted to say. He also faulted the voting rights section of the bill with one eye on emerging Africa: "'One man, one vote,' is the African cry. It is ours, too. (It must be ours.)" Fearing Lewis would seem too critical of pending civil rights legislation, the organizers of the march toned down these sentiments before they would let him speak.[9]

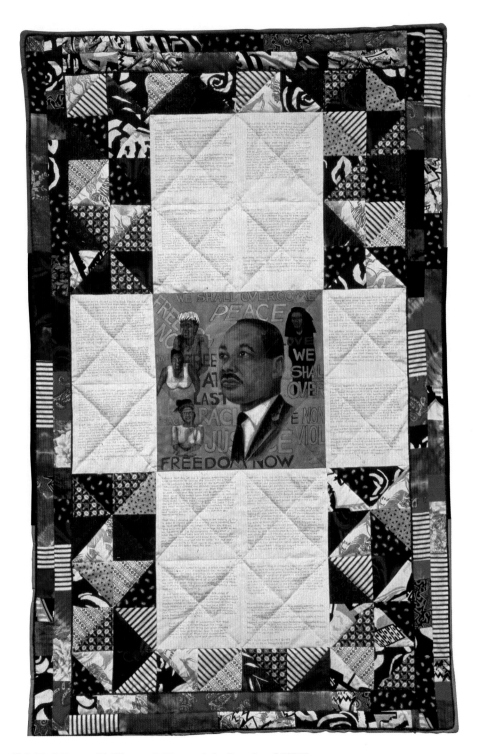

13.3. Faith Ringgold, "Dream 2: King and the Sisterhood," 1988
Ringgold shows King when he delivered his "I Have a Dream" speech in 1963, surrounded by the women who organized and raised money to sustain the freedom movement.

13.4. Paul Andrew Wandless, "American Dreamer," 2000
This painting also echoes King's "I Have a Dream" speech, but ironically. Wandless's King is a dreamer covered with the flag of the nation in which he was jailed and assassinated.

More violence followed the March on Washington. In mid-September 1963, white supremacists bombed the Sixteenth Street Baptist Church in Birmingham on a Sunday morning. Four children died in the blast. By 1965 the Federal Bureau of Investigation knew the identity of the four bombers but did nothing. The FBI's head, J. Edgar Hoover, disapproved of the Civil Rights movement and seldom investigated attacks upon activists. After Hoover's death in 1972, one assailant was convicted in 1977; another died in 1994. Two others were finally convicted in 2001 and 2002.[10] In November 1963 President Kennedy was assassinated in Dallas, and Vice President Lyndon B. Johnson of Texas became president. Johnson pressed the civil rights bill, but a filibuster blocked its passage in the Senate.

Freedom Summer, Mississippi, 1964
With federal civil rights legislation bottled up in Congress, the steady sacrifice of black people killed for civil rights seemed pointless. With these frustrations in mind, Bob Moses and Amzie Moore (1911–1982) of Cleveland, Mississippi, a Second World War veteran and long-time civil rights activist, decided to change tactics. Although white people had provided crucial support in previous civil rights struggles, the 1960s movement had been largely black. In 1964 Moses and Moore invited Northern white students to come to Mississippi for the summer of 1964, "Freedom Summer." The white students would join black students, registering black Mississippians to vote in the Democratic primary, and setting up children's Freedom Schools. White students would also bring much needed visibility to the struggle.

Just as Freedom Summer was getting under way, white supremacists in Mississippi murdered three volunteers, James Chaney (1943–1964) of Mississippi and Michael Schwerner and Andrew Goodman from the North. Chaney, who was black, had been savagely beaten. Schwerner and Goodman, who were white, had been shot. These murders, unlike those of black activists, received worldwide attention, sadly validating Moore's and Moses's reasoning about the relative value of human life in America.[11]

The great achievement of Freedom Summer was the election of sixty-eight Mississippi Freedom Democratic Party (MFDP) delegates to the Democratic nominating convention in Atlantic City, New Jersey. Fannie Lou Hamer was one of these delegates. In televised hearings, she told of the beating she and other black Mississippians had endured for seeking to register to vote. MFDP, she said, not the regular Mississippi delegation, should be seated. The regular Democratic delegation was all-white and had rejected the civil rights portion of the national Democratic Party platform. The MFDP accepted the entire platform. Despite Hamer's moving account of the human costs of black voting in Mississippi, the convention seated the Democratic regulars. Two male members of the MFDP delegation were offered at-large admission to the convention. The MFDP rejected the compromise.

Fannie Lou Hamer stayed in civil rights work in Mississippi until her death in 1977. She still symbolizes the empowerment of poor black Southerners in the Civil Rights

13.5. Calvin Burnett, "Fannie Lou Hamer," 1977
Burnett brings together two emblems of the Southern black struggle for civil rights: Fannie Lou Hamer, the hero of Mississippi voting rights, and a snarling police dog attacking protesters in Southern cities like Birmingham.

movement whose bravery revolutionized the South. Calvin Burnett (b. 1921) places Hamer next to the police dogs of Birmingham, another symbol of the Civil Rights movement, in "Fannie Lou Hamer" (13.5).

Black Mississippians continued to register to vote after 1964. Whereas in 1964 6.7 percent of eligible African Americans were registered, by 1969, the proportion had increased to 66.5 percent, higher than the national average.[12]

Malcolm X's Evolution from the NOI to Pan-Africanism, 1964–1965
Freedom Summer attracted wide support, even from those supposedly estranged from the struggle for civil rights, including Malcolm X. The Nation of Islam (NOI), for instance, refused to join Christian churches' campaign for rights. The NOI scoffed at nonviolent protest, calling it begging the white man for crumbs. The NOI preached that blacks should separate from white people, not try to integrate their rotten institutions. NOI's leader, Elijah Muhammad, held Muslims back from political action, certain that divine power would sort out American racial issues. Countering NOI doctrine, however, Malcolm X drew increasingly closer to the Civil Rights movement. In 1964, he went to McComb, Mississippi, to support the volunteers.

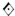

By the time Malcolm X visited civil rights workers in Mississippi in 1964, tensions between him and Elijah Muhammad had already led to Malcolm's suspension from the NOI, supposedly for callous comments he made following the assassination of President Kennedy.[13] Malcolm X is remembered now as the embodiment of manly black self-assertion, as summed up in the ambiguous statement "by any means necessary." At the time of his assassination, however, he was very much in transition. He had been educating himself for decades, beginning with his stint in prison in the late 1940s. Throughout his life he continued to read and to learn. He ultimately outgrew the narrow, isolationist beliefs of the Nation of Islam.

Whereas the NOI sought to create a separate black world apart from whites, Malcolm wanted to contribute to African Americans' human rights within the United States and the world as a whole. The NOI called all white people "blue-eyed devils," but Malcolm increasingly saw race as only one facet of an international imbalance of power. The NOI had always been interested in international events, especially in the Muslim world. But after Malcolm's 1964 suspension and later resignation from the NOI, he began to see African Americans as a colonized people who were part of the international struggle against imperialism. He shared this perspective with many others who would become active in the Black Power movement of the late 1960s and early 1970s. Malcolm X brought American Negroes face to face with Africa, preparing them for a further new identity as "African Americans."

In 1964 and 1965 Malcolm X traveled to Kwame Nkrumah's Ghana in West Africa and made the orthodox Muslim Hajj (pilgrimage) to Mecca in Saudi Arabia. In February 1965, gunmen assassinated Malcolm X in Harlem's Audubon Ballroom, in front of an audience that included his wife and young daughters. NOI gunmen were convicted of the crime. Nonetheless, Malcolm's murder struck many as yet another sacrifice to white racism. At the time of his assassination in 1965 his name was El-Hajj Malik El-Shabbazz, and he headed the Organization of Afro-American Unity (inspired by the Organization of African Unity). Returning from Africa, he said, "You can't understand what is going on in Mississippi if you don't know what is going on in the Congo. They are both the same. The same interests are at stake."[14] Having discovered in his international travels that more than just race determined human fate, Malcolm X was edging toward a more class-based analysis of the problems of the African Diaspora when he died. Death prevented his submitting a petition for African-American human rights to the United Nations. Had he succeeded, Malcolm would have joined the NAACP, the Civil Rights Congress, Paul Robeson, and W. E. B. Du Bois in the quest to have black issues debated as human rights in an international forum.

Throughout his career, Malcolm X preferred self-defense to nonviolence. As a Muslim in 1959, Malcolm had welcomed Robert F. Williams of Monroe, North Carolina, to his NOI Temple No. 7 in Harlem. Williams had practiced armed self-defense in North Carolina and was exiled in Cuba for his militant stance. While the Reverend Martin Luther King, Jr., spoke of loving one's enemy, Malcolm dismissed this aspect of

Christianity: "It is not possible to love a man whose chief purpose in life is to humiliate you and still be considered a normal human being."[15]

For Malcolm and many others, violence was "as American as apple pie," in the words of SNCC volunteer H. Rap Brown (b. 1943). In "Aunt Jemima & the Pillsbury Dough-boy" the artist Jeff Donaldson (1932–2004) envisions antiblack violence as a manifestation of thoroughly American consumerism. Reworking familiar advertising characters, he recasts the Pillsbury doughboy as a brutal policeman attacking nonviolent Aunt Jemima of the pancake mix (13.6).

13.6. Jeff Donaldson, "Aunt Jemima & the Pillsbury Doughboy," 1963
Donaldson led black artists of the 1960s and 1970s in the strategy of inserting familiar icons of American popular culture into current events, here the ever-sensitive issue of police brutality.

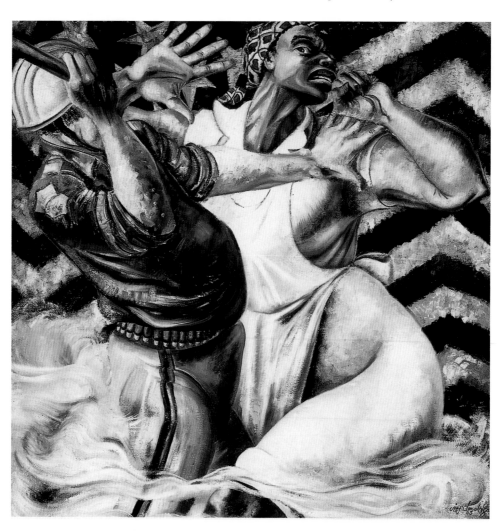

Mid-1960s Legislation and Opposition

The movement for black civil rights that had been building since the Second World War finally paid off in federal legislation passed in the wake of the 1963 assassination of President John F. Kennedy. President Lyndon B. Johnson pushed through civil rights laws and, with Congress, created a series of policies known as the War on Poverty. However, these achievements set off a countermovement (a "backlash") against black empowerment and the mobilization of the poor. The war in Vietnam, together with the backlash against Johnson's policies, created tremendous upheaval in the politics of the United States. Reaction and upheaval limited the implementation of civil rights laws and the War on Poverty.

The Civil Rights Act of 1964 and the Great Society

The Civil Rights movement and the savagery of the opposition arrayed against it in the South moved many nonblack Americans, including the new president, Lyndon Baines Johnson. In the grief-stricken days following President Kennedy's assassination, Johnson was able to prod Congress into passing the Civil Rights Act of 1964. This was the most sweeping civil rights legislation in American history. It gave the federal government the power to prosecute those who discriminated against people on account of their race, religion, sex, or national origin. It desegregated public accommodations, such as lunch counters and transportation waiting rooms. It demanded equal opportunity in the workplace, from labor unions as well as from employers. As John Lewis sought to point out at the March on Washington, the Civil Rights Act of 1964 was not complete. It did not specifically address police brutality. It also did not strike down the tricky literacy and understanding tests that barred black Southerners from voting. Protection for voting rights was still very much needed.

SNCC volunteers went to Selma, Alabama, to register voters in 1964. Selma was one of many Deep South cities where only a tiny fraction of blacks could vote. Of approximately 15,000 eligible black voters in Selma, only 335 had managed to register. The city proved resistant to even a concerted campaign. Between March 7 and 21, 1965, SCLC and Martin Luther King, Jr., staged two marches from Selma to Montgomery, the state capitol. State troopers on horseback charged the marchers and beat them mercilessly. The murder of two white volunteers in this demonstration brought hundreds of nonblacks into the movement.[16]

A week after the Selma-to-Montgomery marchers had been so badly bloodied, President Johnson proposed legislation specifically to protect the right to vote. In the course of his speech at historically black Howard University, Johnson repeated the words of the best-loved freedom song, "We Shall Overcome." The Voting Rights Act of August 1965 outlawed the elaborate tests that Southern registrars had used to disqualify black voters.[17] Its implementation brought the U.S. Department of Justice to the side of black Southerners seeking to vote and helped create a broad-based, Southern black electorate.

In Mississippi, for instance, the percentage of eligible black voters who were registered increased from 5 percent in 1960 to nearly 60 percent in 1968.

In the belief that sweeping federal legislation would fix the nation's racial injustices, President Johnson turned next to the remaining fundamental American problem: poverty. Proposing a "war on poverty," Johnson sent Congress legislation that became the Economic Opportunity Act of 1964. The War on Poverty created Head Start; Volunteers in Service to America (VISTA), a domestic equivalent to the Peace Corps; Job Corps; work-study funding for college students; Community Action Programs (CAPs); and other programs intended to lift the poor out of poverty once and for all.

Community Action Programs became the most controversial part of the War on Poverty. CAPS called for the "maximum feasible participation" of poor people themselves, meaning that poor people rather than experts would set policy. Experts understood limitations of funding, but poor people and their supporters chafed at funds that could provide only Band-Aids, rather than real improvement. Not only did poor people need and want more than the scantily funded War on Poverty could provide, but many of its administrators were educated young black people whose CAP experience radicalized them. Viewing conditions through the eyes of the poor, most CAP administrators saw the program's limitations as an argument for going even further into more sweeping reform, even revolution. A few others, like Shelby Steele (b. 1946) became conservative and turned against the CAPs. For Steele, the War on Poverty was bad for the poor, because, he concluded, it disempowered African Americans by making them dependent on white guilt.[18] President Johnson agreed more with the champions of the poor and pushed on further in the same direction.

In 1965 President Johnson proposed and Congress enacted a series of laws creating the Great Society. The Great Society included Medicare and Medicaid, the National Endowments for the Arts and Humanities, and the creation of the Department of Housing and Urban Development (HUD). As black people had long shown special concern for housing issues, it was appropriate that Robert C. Weaver (1907–1997), an African American who had been active in the federal government since the New Deal, became the first HUD secretary in 1966. Weaver was the first African American to serve in a presidential cabinet.

The Civil Rights movement, the Civil Rights Act of 1964, and the Voting Rights Act of 1965 dismantled the legal basis of segregation. This enormous achievement triggered immediate opposition. Opportunistic politicians ran against the Civil Rights revolution. Not only Southerners like George Wallace, but also Westerners like Arizona Senator Barry Goldwater. Goldwater, the Republican nominee for president in 1964, supported states rights and opposed the Civil Rights Act of 1964, Social Security, the Great Society, and the progressive income tax. Goldwater lost the election to Johnson, but he carried five Southern states. His campaign spurred the migration of Southern conservatives out of the Democratic Party and into the Republican Party, beginning with J. Strom Thurmond of South Carolina.

The Vietnam War Consumes the Great Society's Resources

At the same time that President Johnson created the Great Society and the War on Poverty, the United States became increasingly involved in a war in Vietnam. Even before masses of American combat troops went to Vietnam, the war diverted funding from domestic programs. Whereas the War on Poverty received about $1 billion, the Vietnam War cost about $150 billion. In Martin Luther King's words, "The promises of the Great Society have been shot down on the battlefield of Vietnam."[19]

The United States fought to prevent Communists in North and South Vietnam from unifying the country under Communist control. The struggle had begun in 1945, as France sought to re-impose its colonial rule when defeated Japanese forces withdrew after the Second World War. The United States funded the French campaign against Vietnamese independence until 1955, when the French gave up and the country was partitioned. For ten years, American advisors helped South Vietnam hold off North Vietnam. In 1964 President Johnson sent 23,300 American troops to South Vietnam. A year later the number had risen to 185,300. In April 1969, at the height of American engagement, 543,400 American service personnel were in Vietnam. In the early years of the war, black men were more likely than others to be killed in combat in Vietnam.[20]

Black opinion on the war remained divided, although prominent African Americans were among the first to speak out against the war. They often pointed to the hypocrisy of a nation's sending black men to die for "freedom" while denying them basic human rights at home. Speaking to SNCC volunteers in McComb, Mississippi, in 1964, Malcolm X told them that the United States is "supposed to be a Democracy, supposed to be for freedom," but "they want to draft you . . . and send you to Saigon to fight for them." At home, black people hardly enjoyed "a right to register and vote without being murdered."[21] In 1966 SNCC came out against the war and supported draft evasion. A black draft evader in Canada shared SNCC's reasoning: "I'm not a draft evader, I'm a runaway slave. I left because I was not going to fight white America's war."[22]

Martin Luther King, Jr., took note of the injustice: "We have been repeatedly faced with the cruel irony of watching Negro and white boys on TV screens as they kill and die together for a nation that has been unable to seat them together in the same schools. So we watch them in brutal solidarity burning the huts of a poor village, but we realize they would never live on the same block in Detroit."[23] For King, class issues counted as increasingly important. He knew that American troops were mostly poor and working class, and that the Vietnamese they attacked were poor also. By 1967, King, Malcolm X, Muhammad Ali (b. 1942), Georgia State Senator Julian Bond (b. 1940), and, of course, the Nation of Islam had come out in opposition to the war.

The Nation of Islam had long been antiwar. Elijah Muhammad and other Muslims had gone to prison for refusing to take part in hostilities in the Second World War. The world heavyweight boxing champion Cassius Clay had joined the NOI in 1964 and changed his name to Muhammad Ali. Ali refused to report for induction

when he was drafted in 1966, reportedly saying that "no Viet Cong ever called me 'nigger.'" A Supreme Court decision saved him from imprisonment, but the World Boxing Association stripped him of his heavyweight title. Nearly one hundred other Muslims served prison time for draft evasion. Draft boards did not consider the Nation of Islam a bona fide religion and denied Muslims conscientious objector status on religious grounds.[24]

Vietnam was the first American war in which black soldiers and sailors were thoroughly integrated (as opposed to token desegregated) into the armed forces. It was also the first in which medals for distinguished service did not mention a black man's race.[25] Some thought the integration too thorough, for black soldiers and marines were represented in combat units well beyond their proportion of the population. In 1965 one-quarter of those killed in combat were black, a figure that angered King and the black press. Their protests against heavy black casualties led to reductions in the proportion of African-American deaths. But the black death rate remained about 30 percent higher than the white until American forces withdrew in 1973.[26]

Black men remained more likely to be drafted, partly because they received fewer student and medical deferments. The National Guard, a popular refuge for whites, accepted few African Americans. In 1964 only 1.45 percent of Army National Guardsmen were black.[27] The officer corps was also nearly all white. About 20 percent of combat troops in Vietnam and 2 percent of officers were African American. Colin Powell (b. 1937) served two tours of duty in Vietnam. In 1962 he was an advisor to the Army of the Republic of Vietnam. A major in 1968, he served as a battalion executive officer. Powell earned eleven medals in Vietnam, including a Purple Heart and a Bronze Star.[28]

Black artists turned to the theme of the Vietnam War. Kay Brown's (b. 1932) "The Black Soldier" bears the word "Vietnam" (13.7). Just above "Viet," Uncle Sam of the recruitment poster points to the viewer. In the lower right corner, Huey Newton (1942–1989) of the Black Panther Party carries a gun for his fight for black people at home. The clearest word in the painting is "BLACK."

As in earlier wars, black soldiers fought on two fronts. For many, defining the enemy was complicated. Some identified with the Vietnamese as colonized people of color subject to white American attack. Others simply saw Vietnamese as the enemy. Whether or not they saw themselves in the Vietnamese, African-American troops had to contend with white racism in the form of racist graffiti, name-calling, Confederate flags, even bodily attack. In the mid-1960s, the armed services tolerated racist graffiti and Confederate flags, but came down hard on African Americans' symbols of black pride. For the black soldiers, there was as much racial antagonism in Vietnam as in the United States, where black people set the cities on fire.

Urban Revolts of the Mid-1960s
On the heels of civil rights agitation in the North, West, and South, black people in the cities staged a series of revolts within the space of a few years. The basic causes lay in

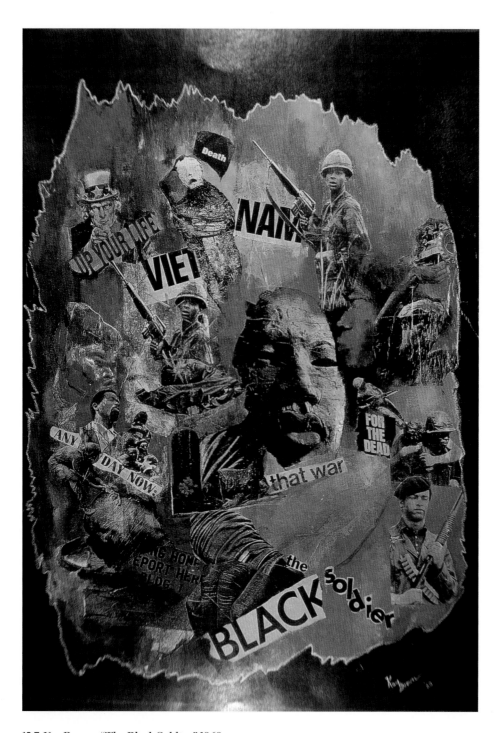

13.7. Kay Brown, "The Black Soldier," 1969

Brown combines icons of black pride ("black," Huey Newton) with icons of the United States (Uncle Sam, "war") to show the mixed nature of the identity of black soldiers in Vietnam.

unemployment, a general withdrawal of city services, and all-too-common instances of police brutality. The uprisings put a sensational face on cities that had been declining for years through the loss of jobs and services. Most of the uprisings clustered in the four years from 1964 to 1968, although Miami went up in flames much later, in 1980. In every case, a rumored or actual case of white-on-black police brutality sparked the unrest. City dwellers burned down white-owned local businesses, destroying much of the local infrastructure and compounding inner-city ruin for decades to follow.

In 1964, Philadelphia, Harlem, and Rochester, New York, exploded. In 1965 the Watts section of Los Angeles went up in flames. After four days of chaos, the National Guard reestablished order. In Los Angeles 34 people lay dead, 1,000 were injured, 4,000 had been arrested, and $35,000,000 worth of property was destroyed. Revolts in economically devastated Detroit and Newark in 1967 left 66 dead and millions of dollars in property damage.

In 1968 the nation was shocked by the assassination of Martin Luther King, Jr., the apostle of nonviolence, the symbol of a belief in the fundamental goodness of American democracy. Black anguish affected Americans of all races and ethnicities, and African Americans in 125 cities rebelled. Some nonblacks in cities, colleges, and universities recognized that racial exclusion lay behind the unrest and pledged to open their institutions to black people. The Kerner Commission investigating the riots concluded that the causes lay in social and economic injustices that had developed over the course of two decades.

Others decided African Americans were a problem to be dealt with harshly and voted for candidates promising to restore "law and order." In 1968 the Republican candidate Richard Nixon won the presidential election, and the segregationist governor of Alabama, George Wallace, garnered 13 percent of the vote and carried five Southern states as a third-party candidate. Even before the riots, many white people voted for segregation: Wallace had done well in Democratic primaries in 1964.

Background Causes of the Riots

The riots were spectacular events, revealing underlying problems that had not attracted the media attention focused on the violence of the South. A variety of factors and circumstances contributed to the frustration that boiled over in the mid-1960s. In addition to police brutality, increasing segregation between cities and suburbs, unfair mortgage lending policies, urban renewal, and deindustrialization all played a role.

During the Jim Crow decades of the 1940s, 1950s, and 1960s, African Americans continued to leave the South in search of better job opportunities. They moved to the Northeast and Midwest. Increasingly, they sought work in the West (Table 13.2). The demographic changes in the years between the Second World War and 1970 were profound. In 1940 African Americans accounted for less than 10 percent of the population of Northern cities. Thirty years later, those same cities held large black minorities or even majorities. Chicago and Philadelphia were one-third African American in 1970; Cleveland, St. Louis, and Detroit were 40 percent black. Newark, Gary, Indiana, and Washington, D.C.,

Table 13.2. Estimated Net Migration of Blacks, by Region: 1940–1970
(Numbers in thousands)

Time Period	South	Total North	Northeast	North Central	West
1940–1950	-1,599	+1,081	+463	+618	+339
1950–1960	-1,473	+1,037	+496	+541	+293
1960–1970	-1,380	+994	+612	+382	+301

had black majorities. In the South, Atlanta and New Orleans were about one-half black.[29] This migration accompanied a shift in urban housing patterns. As African Americans were moving into American cities, white people were moving out. Cities like Newark had long lacked sufficient housing for working people. Racial discrimination aggravated an existing problem made worse by the Italian-American dominated city government's high-handed decision to dispossess black people living in 150 acres to make way for a new hospital complex of the University of Medicine and Dentistry of New Jersey.

Facing shortfalls of tax revenues after industries departed, urban governments reduced services they provided, reductions that fell unequally by race. Many city governments refused to supply normal services to black neighborhoods or allow black students to transfer from overcrowded schools. Unemployment made things worse for workers who could not find jobs and for cities that lost property taxes from industries that had closed or moved away.

The loss of industry, known as "deindustrialization," deepened urban problems caused by decay, destruction, and highways. In the early twentieth century, the cities of the North and Midwest had offered well-paid jobs in industry. By the 1950s, however, manufacturers sought cheaper labor in the South and overseas.[30] City dwellers faced soaring levels of unemployment, so that overall black unemployment rates regularly doubled those of whites. Relative to whites, African Americans have long experienced very high rates of unemployment, usually about twice the rate of whites. (See Table 13.3.)

Unemployment meant poverty. Poverty—along with racism—took its toll on crucial public services such as schools, recreational facilities, garbage collection, and snow removal. The contrast between well-supplied white suburbs and neglected cities inspired anger as well as effort.

During the 1950s and early 1960s, African Americans and their allies sought to better conditions in the cities, notably the schools. In Cleveland, for instance, African American parents and their allies sought to end the *de facto* racial segregation that condemned black pupils to inferior schools. They began by working through the system, but negotiation in the late 1950s made very little progress. In the early 1960s, the Southern Civil Rights movement offered examples of more aggressive tactics.

Like many other Northern and Western cities, Cleveland had gained black migrants and lost whites to the suburbs in the 1950s. Between 1950 and 1965 the black population

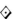

Table 13.3. Unemployment Rates, by Gender and Age: 1954–1975

Annual Averages

Sex, age, and race	1954	1960	1965	1970	1974	1975
Black and Other Races						
Total, 16 years and over	9.9	10.2	8.1	8.2	9.9	13.9
Both sexes, 16-19 years	16.5	24.4	26.2	29.1	32.9	36.9
Men, 20 years and over	9.9	9.6	6.0	5.6	6.8	11.7
Women, 20 years and over	8.5	8.3	7.4	6.9	8.4	11.5
White						
Total, 16 years and over	5.0	4.9	4.1	4.5	5.0	7.8
Both sexes, 16-19 years	12.1	13.4	13.4	13.5	14.0	17.9
Men, 20 years and over	4.4	4.2	2.9	3.2	3.5	6.2
Women, 20 years and over	4.1	4.6	4.0	4.4	5.0	7.5
Ratio: Black and Other Races to White						
Total, 16 years and over	2.0	2.1	2.0	1.8	2.0	1.8
Both sexes, 16-19 years	1.4	1.8	2.0	2.2	2.4	2.1
Men, 20 years and over	2.3	2.3	2.1	1.8	1.9	1.9
Women, 20 years and over	1.7	1.8	1.9	1.6	1.7	1.5

of Cleveland increased from 147,847 to 279,352. The city's overall population dropped from 914,808 to 810,858. In 1950, African Americans accounted for 16.2 percent of Cleveland's total population. By 1965 that proportion had grown to 34.4 percent, and 54 percent of Cleveland school children were black. Virtually the entire black population lived rigidly segregated in the East Side corridor.[31]

Black children attended overcrowded neighborhood schools on split sessions that cheated them out of two months of study per academic year. Black schools had inexperienced teachers, high student-teacher ratios, decaying physical plants, and few libraries and other services. At the same time that black children attended makeshift schools for half a day, hundreds of classrooms stood empty in schools on the white West Side. West Side schools also had experienced teachers, full services, well-maintained buildings, and low student-teacher ratios. Desegregation was the answer to school inequity.

After a yearlong campaign of negotiation, picketing, mass demonstrations, sit-ins, boycotts, legal action, and the death of a white supporter, black Clevelanders achieved only minimal reforms. They realized they needed to enter politics and drafted state representative Carl B. Stokes (1927–1996) to run for mayor in 1965. He lost by only 2,142 votes in 1965, but he won in 1967. Stokes became the first black mayor of a major U.S. city.[32]

African Americans did not generally achieve political power until after the dramatic

revolts of the mid-1960s disrupted the white-dominated, segregationist status quo. Beginning in the late 1960s, city dwellers succeeded in electing African-American city council members and mayors.

Election of First Black Mayors in Major U.S. Cities[33]
1967: Cleveland, Gary, Indiana, Washington, D.C.
1970: Newark
1973: Detroit, Atlanta, Los Angeles
1977: New Orleans
1979: Birmingham
1983: Chicago and Philadelphia
1987: Baltimore
1989: New York
1991: Denver

Like the riots in Harlem and Detroit in 1943, the urban revolts of the 1960s were protests against segregation, lack of equal city services, and discrimination. For a quarter of a century or more, "urban" meant segregated, African-American, poor, and troubled central cities that were termed "ghettoes."

Black artists presented a range of urban images. The year Newark and Detroit went up in flames, Willis "Bing" Davis (b. 1937) created "Ghetto Voice" showing the city as a prison (13.8).

The artist Dana Chandler's (b. 1941) mural "Noddin Our Liberation Away" comments on the human waste caused by unemployment and drug addiction (13.9). Chandler uses motifs from the American flag as a background, tying governmental policies to the loss of African-American young men to drugs. During the 1960s and 1970s the American flag appears repeatedly in black art as a means of highlighting the systemic nature of urban problems.

Other African-American visual artists rejected the negative equation of cities with ghettoes and

13.8. Willis "Bing" Davis, "Ghetto Voice," 1967
Davis's black man is imprisoned behind the walls of the segregated city.

13.9. Dana Chandler, "Noddin Our Liberation Away," 1974

Chandler, pictured in front of his mural, deplores the toll that drug abuse takes on African Americans. The American flag in the background makes the drug problem American, not uniquely African American.

crime. In the 1960s, as in earlier decades, artists depicted black city neighborhoods with affection. Perhaps because Romare Bearden (1911–1988) was an older artist who had worked in New York for years before the riots, his collage "Black Manhattan" lacks the distress of younger artists' work (13.10). New York had had its revolt a generation earlier during the Second World War. Although Harlem was very poor in the 1960s it had been a black neighborhood since early in the twentieth century.

Artists' various renditions of the city manifest African Americans' mixed feelings about their neighborhoods. Mid-century cities were places of poverty and pain. But they were also home to millions of African Americans. It was the cities, in the years after the Civil Rights revolution, the urban revolts, and the searing assassinations, that witnessed the rise of Black Power in politics and the arts.

Conclusion

The 1960s saw the enactment of the most sweeping civil rights legislation in United States history. The Civil Rights Act of 1964 and the Voting Rights Act of 1965 crowned the Southern Civil Rights movement with resounding success. At the same time, however, structural changes such as deindustrialization and suburbanization generated crises in American cities, symbolized in the urban unrest of 1964–1967. The Vietnam

13.10. Romare Bearden, "Black Manhattan," 1969
Bearden shows a brightly lit, colorful Harlem street scene, with normal people—not junkies—at their apartment windows and sitting on their stoops under a bright, blue sky.

War diverted federal funds from programs aimed at bettering the economic situation of the poor, including urban African Americans. The reaction against black rights was much older than the 1960s, but it gained force in the face of black empowerment. As the cities became largely black, they came to be called ghettoes. It was in these "ghettoes" that African-American artists and activists grasped the beauty and promise of black neighborhoods.

14.1. Elizabeth Catlett "Negro es Bello II," 1969 [1]

Catlett combines African-American faces stylized as African masks with badges reading "Black is Beautiful" with a black panther—for the Black Panther Party for Self-Defense—in the center.

Black Power

1966–1980

Elizabeth Catlett's "Negro es Bello II" (14.1) translates the Black Power maxim, "Black is Beautiful," into Portuguese, the language of multiracial Brazil, in which "Negro" means black. For African Americans, the Black Power movement emphasized their African heritage rather than their American-ness. People who had earlier been known as "American Negroes," or, simply, "the Negro," became "black" and "Afro-American" in the late 1960s. In "Negro es Bello II," Catlett accents the resemblance of two black faces to ancient Nigerian sculpture. The circular emblems framing the faces evoke the most prominent Black Power organization of the 1960s: the Black Panther Party (BPP). As the most visible embodiment of Black Power, the BPP's origins, strengths, weaknesses, and evolution characterized a multitude of local movements. Summing up the revolution of values within Black Power, Catlett inscribes the words "Black is Beautiful" around each panther. Black Power repossessed what had formerly been a stigmatized identity. It made "black" into a badge of pride and proclaimed black as beautiful.

The war in Vietnam, with its heavy toll of poor and black soldiers, furthered black doubts about American politics. The war itself radicalized black soldiers, who created their own symbols of black pride. By 1967 many in the Civil Rights movement, including the Reverend Martin Luther King, Jr., were speaking out publicly against the war, as well as against poverty. King's assassination in 1968 destroyed the remnants of faith in nonviolent protest and shook many people's faith in American democracy.

By the late 1960s, many African Americans were turning away from the American majority that had elected Republican Richard Nixon president in 1968 and had given millions of votes to George Wallace, the segregationist governor of Alabama.

The growing separation of the American population into poor, black, neglected inner cities and prosperous, thriving, white suburbs worsened racial tensions.

During the Black Power era of the late 1960s and early 1970s, masses of African Americans—workers, intellectuals, artists—looked inward. They broke from the prevailing American mind-set of seeing black people as a problem and found beauty and value in blackness. Almost paradoxically, racial separation began to weaken in the 1970s, even as whites vigorously fought desegregation. At the same time that local police were acquiring tanks and helicopters to control black neighborhoods, black people began to enter the national political economy in unprecedented numbers. But the changes came gradually, almost too piecemeal to be perceived in deeply agitated times.

While many embraced separatist Black Power rather than continuing to petition for the rights of American citizenship, others seized new economic and political opportunities. In Detroit, Berry Gordy, Jr.'s (b. 1929), Motown Records produced a string of hits that made his company the richest in African-American history. Seeking to rescue their communities, local Black Power activists made their way into local politics. Northern urban voters began electing black mayors and congressional representatives in unprecedented numbers. The number of black elected officials continued to climb, although many other black people lost their jobs after the oil embargo of the mid-1970s set off a catastrophic economic collapse.

By the late 1970s the glory days of Black Power had ended. In the presidential election of 1980, Republican Ronald Reagan won overwhelmingly. He attracted millions of white Democrats, North and South, in a campaign calling for "states' rights"—a campaign that was launched in Philadelphia, Mississippi, the site of the murder of three civil rights volunteers in the Freedom Summer of 1964.

The Emergence of Black Power

The justice of the demands for civil rights and white supremacists' tenacity produced both success and frustration. On the one hand, the federal legislation of the mid-1960s dismantled the legal basis of segregation and exclusion. On the other hand, federal laws were spottily enforced, and new forms of discrimination were appearing. Continuing antiblack violence led many African Americans to question the logic of nonviolent protest. And Malcolm X's steady criticism of nonviolence in the face of racist assault had supplied a counternarrative since the late 1950s (see also chapters 12 and 13). His assassination in 1965, the publication of his *Autobiography of Malcolm X* (1965), and his recording *Message to the Grass Roots* (1966) brought his critique to a very wide audience.

"Black Power" meant black people defining themselves positively, regardless of what white people thought. Black Power turned African Americans away from American values, even away from American identity. The phrase "Black Power" antagonized most white people and dismayed many blacks. Black Power carried multiple, even contradic-

tory, meanings. Fundamentally, however, Black Power meant that African Americans would tend to themselves without paying heed to white people.

In the mid-1960s, Malcolm X's long-standing support of self-defense rang true to the young men in the Southern Civil Rights movement, where so many black people were being beaten and killed. Antiblack violence deeply disturbed Stokely Carmichael (1941–1998) and H. Rap Brown, SNCC (Southern Nonviolent Coordinating Committee) volunteers in the South.[2]

In 1966 Carmichael gave prominence to the words "Black Power" on the occasion of James Meredith's Mississippi "Walk Against Fear." An assailant had shot Meredith on the first day of his march. Carmichael and fellow SNCC volunteer Willie Ricks (b. ca. 1943) hurried to Meredith's side, addressing a rally in his support. Rather than voice the usual call for "Freedom," Ricks and Carmichael demanded "Black Power," to thunderous applause.

Black Power as Self-Definition and Self-Defense

Stokely Carmichael and the African-American sociologist Charles V. Hamilton (b. 1929) laid out the meaning of Black Power in 1967. In *Black Power: The Politics of Liberation in America* (1967), they stressed Black Power as self-defense as well as self-definition. They traced the need for Black Power to the weaknesses of the nonviolent Civil Rights movement. While the beating and murdering of civil rights workers and little girls in Sunday school angered black people everywhere, nonviolent civil rights workers "had nothing to offer . . . except to go out and be beaten again." Nonviolence may have led to sweeping federal legislation. But those laws failed to improve black lives because their scope was limited and because even with their limitations, they were not enforced on the local level where they would make a difference. The laws did not take aim at the *de facto* structural and economic inequities of Northern and Western cities.

According to Carmichael and Hamilton, Black Power meant that black people would no longer look to American institutions or try to gain entrance into the American mainstream. Middle-class white America had nothing to offer blacks, for its core value was "material aggrandizement." Black Power was to be all-black in nature. African Americans would do for themselves, by themselves. White supporters could be helpful, but too often their approach was paternalist or escapist: They wanted black people to provide meaning to otherwise sterile, middle-class American life.[3] Some nonblack volunteers had played positive roles in the Civil Rights movement, but the assumptions of American society made it difficult for whites to work under black leadership. The national media focused on whites rather than blacks, even in a mass black movement. Therefore, according to Carmichael and Hamilton, whites needed to leave the black liberation struggle and work to reduce racism among whites.

Empowered black people would find new means of addressing their needs, beginning with their own identities, said Carmichael and Hamilton. They warned that "black people are going to use the words they want to use—not just the words whites want to

hear."[4] No longer would they accept the name "Negro," which came from the oppressor. They would call themselves "black," or "African American," or "Afro-American," "because that is *our* image of ourselves." Black people must also reeducate themselves away from white American "cultural terrorism." Reeducation would produce new ways of thinking and organizing, because the old ways simply had not worked. These new solutions did not need to be respectable or acceptable in the eyes of white Americans or of blacks who identified with the status quo. Black Power would give African Americans an entirely new value system. Black Power meant a total break with the past.[5]

For Carmichael and Hamilton, something new—Black Power—was needed to address the fundamental needs of African Americans for decent housing, decent jobs, and adequate education. They saw institutional racism as the major barrier to black equality. They gave institutional racism another name that echoed Malcolm X: "colonialism." Carmichael and Hamilton termed African Americans colonial subjects, very much like the people struggling against imperialists in Southern Africa and Vietnam.[6]

One chapter of *Black Power* describes SNCC's organizing black voters in Lowndes County, Alabama, under Carmichael's leadership. Where there had been no black voters in 1964, there were nearly 4,000 in 1965. Black voters formed a Freedom Organization whose symbol was the black panther. Reminiscent of the South Carolina Progressive Democratic Party of 1944, the Freedom Organization held its own caucuses and ran its own candidates for county office.

Even more important, the Lowndes County Freedom Organization defended itself against white attack. In the short run, the poor black voters of Lowndes County proved economically vulnerable to the dictates of the white planters who employed them. But their organization inspired the creation of Black Panther Parties all around the United States. In 1966 a network of Lowndes County-related Black Panther groups existed in Chicago, New York, and San Francisco. The San Francisco Panthers were in contact with Robert F. Williams, the self-defense advocate from Monroe, North Carolina, by that time living in exile in Cuba (see chapter 12).[7]

Black Power immediately proved controversial. Young African Americans welcomed it as long overdue. Older and more conservative African Americans saw it as racial separation, a youth-led repudiation of the older generation. Virtually all white people rejected it, calling it black racism. Even black people sympathetic to Black Power values recognized its potential for misinterpretation. Martin Luther King, Jr., understood nonviolent activists' frustration with endless antiblack violence. He heard "Black Power" as "a cry of daily hurt and persistent pain." But King also foresaw the inevitable public relations nightmare: in the context of American culture, "Black Power" would inevitably be misconstrued as an incitement to antiwhite violence. With an eye toward the rest of the American population—especially toward their nonblack allies—SCLC, the NAACP, and the National Urban League all denounced Black Power in 1966. At the same time, young men who cared nothing for white sensibilities organized around the manly symbol of the black panther.

The Black Panther Party

Two Oakland, California, students, Bobby Seale (b. 1936) and Huey P. Newton (1942–1989) founded the organization that became synonymous with Black Power. They created the Black Panther Party for Self-Defense (BPP) in 1966 to address a series of black community needs ranging from economic to cultural to political. Seale and Newton identified more with colonized peoples in the Third World than with middle-class white Americans. They based much of their thinking on the work of anti-imperialist authors: Franz Fanon, the French West Indian psychiatrist of the Algerian war for independence; Mao Tse-Tung, the Chinese Communist leader; and Che Guevara, the Latin American Marxist revolutionary hero of the Cuban Revolution.[8]

Envisioning urban black Americans as colonial subjects, Seale and Newton called for self-determination of the black ghettoes. The BPP Ten-Point Program demanded full employment, decent housing and schools, and an exemption of black men from the U.S. military. From the very beginning, the Black Panthers opposed the Vietnam War as an exercise in colonial domination.[9]

Initially, Seale and Newton called their party the Black Panther Party for Self-Defense and attacked police brutality in Oakland in fiery words and deeds. Seale said the only way to Black Power, "brothers and sisters, is to get our guns organized, forget the ins and shoot it out." Huey Newton preached that "only with the power of the gun can the Black masses halt the terror and brutality perpetrated against them by the armed racist power structure. . . . Black people were forced to build America and if forced to we will tear it down."[10]

Seale and Newton had studied California law and knew that carrying firearms openly was legal in California in 1966. In their patrols shadowing the police, the Panthers carried their weapons openly. Newton, Seale, and some thirty other Black Panthers brandishing rifles burst onto the national scene in 1967, demonstrating at the California state capitol in Sacramento. The image of armed Black Panthers captivated young black men all around the country. They flocked into the BPP, eager to take on abusive local police.

The Black Panthers' attraction to guns inspired black artists to create images of black warrior heroes defending the black community. In 1963 Jeff Donaldson painted the Pillsbury doughboy as a policeman beating up Aunt Jemima (see chapter 13). By 1968 Donaldson's images of women had become more militant and more diasporic. His "Wives of Shango" named the legendary *orisha* (deity) of thunder and lightning from the Yoruba tradition, who was also a legendary king, and showed his glamorous, well-armed wives in Afro hairstyles, mini-dresses, and bandoleers of bullets (14.2).

In the mid-1960s, the police and the Panthers saw themselves at war with one another. Both sought confrontation, which occurred regularly across the country. As the BPP became national, the Federal Bureau of Investigation (FBI) as well as local police targeted Panthers for destruction. The FBI's COINTELPRO (counter-intelligence program) used informants, disinformation, and rumors to pit Panthers against each other and against other black organizations.

14. 2. Jeff Donaldson, "Wives of Shango," 1968
These wives (in the plural, to stress their African heritage) represent black women as warriors who retain
their femininity by wearing fashionable mini-skirts. Shango is the Yoruba god of thunder.

In 1967 Newton exchanged gunfire with the Oakland police. In Los Angles in 1969, two Black Panthers died at the hands of a rival Black Power group, the US Organization (see below). In California and elsewhere, local police attacked Panthers, who were eager and ready to fight. Between 1967 and 1969, twenty-seven Panthers died in attacks led or provoked by local police or the FBI. In the most shocking attack, police in Chicago killed Fred Hampton (1948–1969) and his colleague Mark Clark (n.d.) in their beds.[11] As a result of armed confrontations, some Panthers spent half their lives incarcerated, for example, Elmer Geronimo Pratt (b. 1947) of Los Angles, a decorated Vietnam veteran. Pratt's conviction was reversed in 1997, after more than a quarter century of imprisonment.[12] The writer Mumia Abu-Jamal (b. 1954) is still on death row in Pennsylvania, and his conviction for shooting a policeman is the subject of continuing protest.

After a series of murders and much bloody internal dissent in the late 1960s and early 1970s, the BPP changed tactics. It became less macho and stopped brandishing guns and confronting police. The Panthers also toned down their rampant male chauvinism, although the Panthers never became feminists. BPP members also became more politically radical, calling themselves Marxist-Leninist and forging alliances with whites in the New Left. Huey Newton, the most visible Panther leader, was in and out of jail, exiled in Cuba, and evolving politically. Seeing the cost in lives of conflict with the police, Newton stressed class struggle and Marxist revolution. Newton argued that the Panthers should mobilize the hopeless black lower class, the "lumpenproletariat." He theorized the need for "revolutionary intercommunalism." Until the revolution, the Black Panther Party would salve some of the wounds of urban poverty through an ambitious program of community service.[13]

Bobby Seale created the free breakfast program, one of the Panthers' most successful ventures. The Panthers' free breakfasts began in Berkeley and spread quickly in churches throughout the San Francisco Bay Area. By late 1969, the Black Panther Party was serving breakfasts to more than twenty thousand poor children in nineteen cities throughout the United States.[14]

In Oakland and New Haven, the Panthers set up free medical and dental clinics. They also created freedom schools. The Oakland Community School became so successful that the California legislature gave it an award. The New Haven school attracted admiring bureaucrats from the Nixon administration. Around the country, but most effectively in Oakland, Panthers offered the urban poor of all races free clothing, free shoes, free transportation to prisons, screening for high blood pressure and sickle cell anemia, and day-care centers. The BPP also published *The Black Panther* newspaper publicizing its services and revolutionary theories.[15]

By the mid-1970s, however, the Black Panther Party had disintegrated. FBI harassment, police attack, self-inflicted murders, criminal justice convictions, imprisonment, and internal conflicts over ideology together destroyed the organization and scattered its leadership. From a high of 2,000 to 5,000 members in 1968, membership fell to 150 in 1974.[16] Newton, in jail, theorized global economic revolution. Eldridge Cleaver (1935–

14.3. Carroll Parrott Blue, "Angela Davis in Los Angeles," 1972

Blue's photograph shows a pensive Davis at a political rally, most likely vindicating the rights of American prisoners. Davis wears the big Afro hairdo that became an emblem of Black Power.

1988), author of the best-selling autobiography *Soul on Ice* (1968), preferred armed struggle. Bobby Seale turned toward the political process, running (unsuccessfully) for mayor of Oakland in 1973. Ericka Huggins (b. 1948) ran the valuable free breakfast and school programs. Cleaver left the BPP in 1973; Newton fled to Cuba in 1974; Seale left the BPP in 1974. Huggins remained in Oakland, working with poor children.

Angela Davis (b. 1944), a California philosophy professor, worked with SNCC and the BPP in the late 1960s and early 1970s. She shared the Panthers' concern for the high level of incarceration of young black men. In 1970 she appeared on the FBI's Ten Most Wanted List. Young Jonathan Jackson (1954–1970) had used a gun registered in her name to try to free his brother George (1942–1971) from the Soledad State Prison in California. Like many others close to the Panthers, Davis was jailed for more than a year awaiting trial on charges of murder and conspiracy. On her release from prison, Professor Davis continued her activism. Photographer Carroll Parrott Blue (b. 1943) caught her at a political rally: "Angela Davis in Los Angeles." Davis wears her signature big Afro hairdo, which became a symbol of black radicalism (14.3).

Unlike so many Panthers, Davis was acquitted of all charges. She remains a college professor and continues to protest against the American "prison industrial complex" in which for-profit prisons make money off the incarceration of black and poor people.[17] As an activist, Davis outlasted and outlived many of her comrades in the Black Panther Party.

For all their changing ideology and internal disagreements, the Black Panthers kept their focus on the political economy. They downplayed the adoption of African names, clothing, and ritual, and showed little patience with one dimension of Black Power: cultural nationalism.

Cultural Nationalism: Emphasis on African Roots

In 1964 Malcolm X saw culture as a crucial weapon in the struggle for black liberation, one as important as political action. Recognizing the psychological damage that oppression and minority status had inflicted, Malcolm called for "a cultural revolution to un-brainwash an entire people."[18] Carmichael and Hamilton's *Black Power* echoed the need

for black people to free their minds of American "cultural terrorism" that reinforced feelings of inferiority. In the wake of the revolt of black people in the Watts section of Los Angeles and the assassination of Malcolm X, both in 1965, Black Power advocates around the United States saw cultural regeneration as a vital means toward black liberation.

The poet and playwright LeRoi Jones changed his name to Imamu Amiri Baraka (b. 1934). In New York in 1965, then in Newark, New Jersey, in 1966, Baraka created theaters and schools in which black people could express themselves freely. Baraka's long career as a poet of black liberation has inspired black artists. "LeRoi?" by Lev Mills (b. 1940) pictures a transcendent, visionary Baraka, head in the sky, inspiring the black youth who run toward the future below him (14.4).

In Los Angeles Maulana Karenga (b. 1941) formed the US Organization (*Us* as opposed to *them*) in 1966 as a means of regenerating the Los Angeles black community after the people of Watts exploded in frustration against police brutality and political neglect. The Watts uprising graphically revealed the community's desperation, which Karenga believed a reconnection with African roots would address.

Karenga wanted black people to see themselves as Africans in the United States, not second-class Americans. He mandated the study of Swahili, a non-tribal African language spoken in several East African countries by many different peoples. He and his co-workers created the Kwanzaa holiday and celebrated it for the first time between December 26, 1966, and January 1, 1967.[19] "Kwanzaa" means "first fruits" in Swahili. The holiday is an invented tradition. It draws upon the harvest celebrations of several different African peoples and is purposely situated near the American Christmas holiday.[20] Kwanzaa was created as a critique of American materialism. For Black Power advocates, including Carmichael and Hamilton, materialism (along with racism) is a prime characteristic of corrupt American culture. Roland L. Freeman's (b. 1947) "Kwanzaa Quilt" shows the African-inspired apparatus of Kwanzaa against a backdrop of African fabric (14.5).

Karenga and Baraka, allies in the late 1960s, had revolutionary Black Power goals. They believed that cultural nationalism would overcome black Americans' colonial mentality and transform feelings of inferiority into pride.

Black Power ideals had first emerged in the 1950s. They became more widely known with the 1965 assassination of Malcolm X and the publication of his autobiography. Black Power as a phrase broke into American national consciousness in 1966 with Stokely Carmichael. It produced organizations such as the Black Panther Parties in 1966 and 1967. In the mid-1960s, cultural nationalists and Black Panthers were beginning to convince some black people they needed to separate psychologically from middle-class white America. Then the 1968 assassination of Martin Luther King, Jr., the apostle of nonviolence, opened a deep chasm between black and white Americans. The triumph of conservative, antiblack politics later that year convinced many black people that the majority of whites opposed their aspirations for first-class citizenship. In the face of white opposition, many African Americans concluded they could count only on themselves.

14. 4. Lev Mills, "LeRoi?" 1972

The genius of a pensive Amiri Baraka (formerly LeRoi Jones), an inspiration to young black people, is so towering that his head touches the clouds.

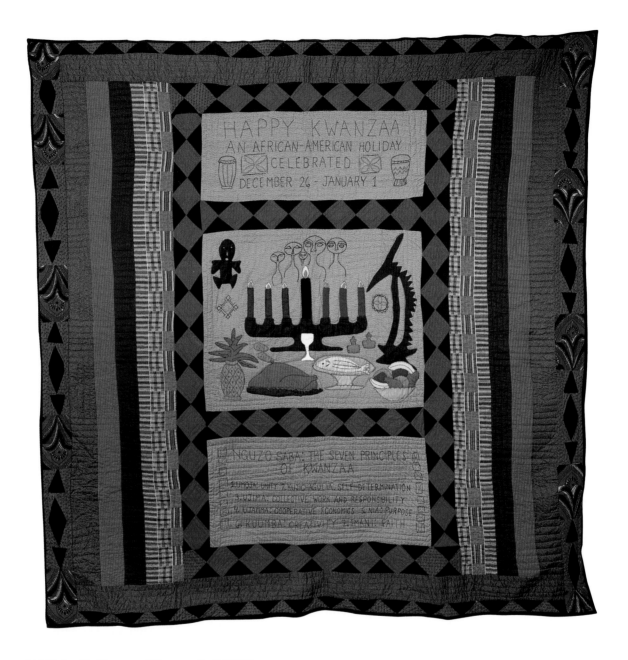

14.5. Roland L. Freeman, "Kwanzaa Quilt," 1989

Freeman wishes his viewers a "Happy Kwanzaa" and lists the seven principles of Kwanzaa. The quilt combines several different motifs from the African-American Kwanzaa celebration and traditional African art.

Black Power after 1968

Throughout the 1960s, many African Americans were coming to doubt the ability of nonviolent protest to tear down the walls of racial segregation and make black people first-class American citizens. Until the assassination of Martin Luther King, Jr., in 1968, these doubts mostly remained just doubts. The assassination of the minister of the gospel who symbolized nonviolence seemed to show that America would kill any black person with aspirations, no matter how Christian, no matter how unwilling to use violence himself. King's assassination seemed both to express America's hatred for black people and to vindicate all those calling for self-defense. The King assassination gave the idea of Black Power a tremendous boost.

Assassination and Aftermath

The assassination of Martin Luther King, Jr., in 1968 shook hundreds of thousands whom Black Power had not yet reached. In the immediate aftermath of King's assassination in April 1968, black people in 125 cities revolted out of anger and anguish. African-American artists paid homage to King's sacrifice in a variety of ways. In her 1968 "In Memoriam: Martin Luther King, Jr.," the Black Power poet June Jordan (1936–2002) expressed the shrinking from America that many African Americans felt. It begins:

> honey people murder mercy U. S. A.
> the milkland turn to monsters teach
> to kill to violate pull down destroy
> the weakly freedom growing fruit
> from being born
>
> America[21]

Like many other black visual artists, Archibald Motley, Jr., (1891–1981) put together black and white martyrs. John Kennedy, Robert Kennedy, and Martin Luther King, Jr., often appear together in American art dealing with the 1960s. Motley's "The First One Hundred Years: He Amongst You Who Is Without Sin Shall Cast the First Stone: Forgive Them Father For They Know Not What They Do" shows the head of slain President John F. Kennedy on the upper left. The head of Martin Luther King, Jr., figures in the center, on a tree branch, as though lynched. A Confederate flag hangs just below King's head, and Ku Klux Klansmen parade at the bottom left (14.6).

Richard Hunt's (b. 1935) "I've Been to the Mountaintop" echoes King's last speech, to striking sanitation workers in Memphis, Tennessee. It features an Egyptian motif reminiscent of the work of early African-American artists like Edmonia Lewis and Meta Warrick Fuller. Hunt's King is monumentally royal (14.7).

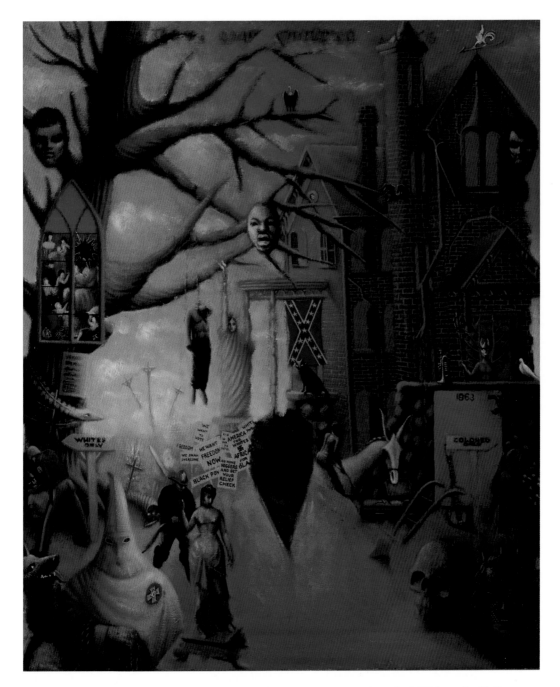

14.6. Archibald Motley, Jr., "The First One Hundred Years: He Amongst You Who Is Without Sin Shall Cast the First Stone: Forgive Them Father For They Know Not What They Do," ca. 1963–1972

Motley makes King and Kennedy (whose heads appear in the center and upper left) the victims of white supremacy, as symbolized in the Confederate flag and a Ku Klux Klansman. Before the haunted house are many emblems, including the Statue of Liberty, a woman who combines a fugitive slave and Rosa Parks being marched off to jail, the three crosses of Jesus's crucifixion, a snake, a scene of police brutality, and a "whites only" sign.

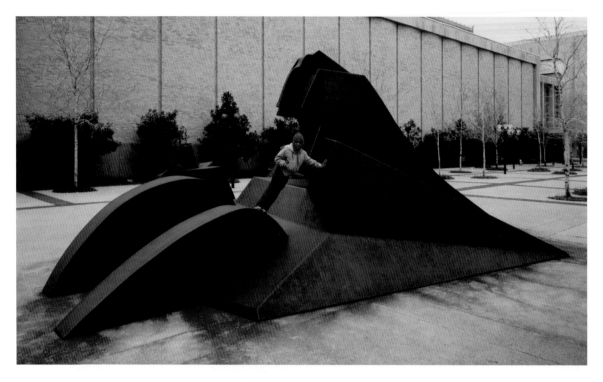

(Above) 14. 7. Richard Hunt, "I've Been to the Mountaintop," 1977
The title of this sculpture echoes the speech King delivered just before his assassination. Using an ancient Egyptian sphinx motif, it makes King into a sage for the ages.

(Opposite) 14.8. Glenn Ligon, "Malcolm, Martin," 1991
This painting repeats the names of the two martyred heroes again and again, until they blur into one another as a joint black sacrifice.

Glenn Ligon's (b. 1960) "Malcolm, Martin" repeats the names of Malcolm X and Martin Luther King, Jr., again and again, with less and less clarity from the top to the bottom. Ligon often uses words in his work. Here the blurring of the names mourns two tragic, early deaths (14.8).

Dovie Thurman, a welfare rights activist, spoke for masses of African Americans when she said King's assassination "changed things":

> I got so angry. What was King saying? What was he talking about? Here he is so nonviolent, always praying, and they beat him up and they put him in jail and now they killed him. I was saying, "Give me a gun, give me a gun, give me something . . ."
> I just broke loose from all my white friends. I didn't want to see them. I didn't want to talk to them. All I wanted to do was get the one who killed Dr. King.[22]

Whitney Young (1921–1971), head of the normally conservative National Urban League, voiced kindred sentiments. Young said he did not care how white people felt or whether they were sorry about the assassination. *There are no moderates today,*" he said. "Everybody is a militant." Young took part in the 1968 National Black Power Conference in Newark and the Congress of African People in Atlanta in 1970.[23]

The barbarity of the King assassination radicalized many moderates, such as Whitney Young. Like King, Young deplored the Vietnam War's drain of resources from the War on Poverty and was already beginning to doubt white America. Young and King were certainly warming up to Black Power. The month before his assassination King spoke in Newark, New Jersey, urging his audience to "stand up with dignity and self-respect." King uttered the Black Power phrase: "Now I'm Black, but I'm Black and beautiful!" In a show of black solidarity, King visited Amiri Baraka at his Spirit House headquarters in Newark's inner city.[24]

Newark emerged as one of the centers of Black Power after 1968, in large part due to the cultural and political work of Amiri Baraka. In the mid-1960s, Baraka had already come out for black solidarity. His tone hardened after the King assassination. At the 1968 Newark Black Power convention, Baraka demanded black institutions for black people. Interracial institutions, he contended, offered nothing to African Americans: "We mean the freeing of ourselves from the bondage of another, alien, people," Baraka said. "These pigs are no kin to us. We are trying to destroy a foreign oppressor. It is not 'revolution' but *National Liberation.*"[25]

After 1968, black artists portrayed African Americans in struggle against their native land. Such a notion broke with the assumptions of the 1950s and early 1960s. In the earlier period, black civil rights usually appeared as the fulfillment of American democracy. After the King assassination, many African Americans doubted they would ever become full-fledged American citizens. Many questioned whether they even wanted to belong to a country they saw as fundamentally repressive. Black athletes winning medals at the 1968 summer Olympic Games in Mexico City expressed black pride, rather than American pride.[26] John Carlos (b. 1945) and Tommie Smith (b. 1944) raised their fists in Black Power salutes rather than placing their hands over their hearts at the playing of the American national anthem. They stood barefoot in remembrance of black people's poverty and wore black armbands for Malcolm X, Martin Luther King, Jr., and the other martyrs to the struggle for black liberation.

The assassinations of Malcolm X and Martin Luther King, Jr., as well as those of the two Kennedy brothers, came to seem like natural products of warped American values. To be sure, the murderers of Malcolm X and Martin Luther King, Jr., were not representatives of American power. Yet the fact of official harassment and attack on Black Panthers and other black radicals was widely known and deeply resented. In the work of many black artists, Nation of Islam (NOI) gunmen striking down Malcolm X and a crazed assassin killing King became emblematic of the United States.

Black Power advocates saw the needs of black and white Americans as fundamentally

in conflict. Whatever or whoever gained white approval became suspect. White disapproval earned Black Power points. For instance, the word "bad," spread as an index of the good or admirable when applied to African Americans.

In much black art from the late 1960s and 1970s, the American flag functioned as a symbol of black people's oppression. Phillip Lindsay Mason's (b. 1939) "Deathmakers" shows police, surrounded by the American flag, as the agents of black death (14.9).

Claude Clark's (1915–2001) "Polarization" recalls Malcolm X's frequent reference to field-workers as the authentic embodiment of African Americans (14.10). Clark shows the black man in overalls arm wrestling Uncle Sam. Uncle Sam, who has given himself the powers of royalty (a crown sits beneath his chair) cheats by not placing his hand on

14.9. Phillip Lindsay Mason, "Deathmakers," 1968
This protest against police brutality, shows white police and life in the United States (symbolized in the American flag) as the killers of black people.

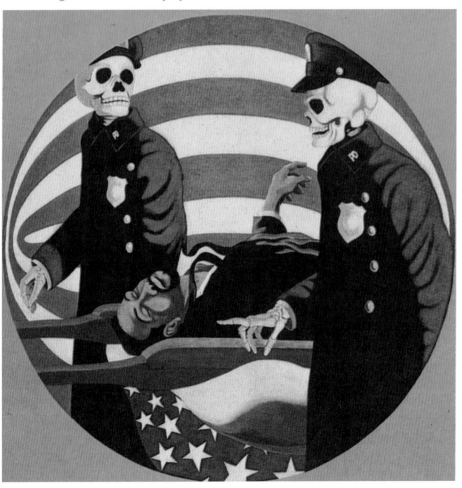

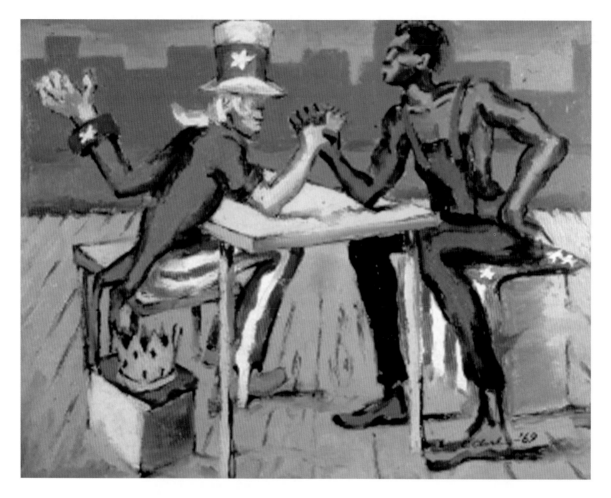

14.10. Claude Clark, "Polarization," 1969
Clark depicts the fundamental conflict of the cities: Uncle Sam wears an American flag, the black American sits on another, but they struggle against, not beside, each other in a city by the sea.

his side as does the black man. Only one of them can win this rigged contest, in which white America and the black man are pitted against one another.

Faith Ringgold's "Flag for the Moon: Die Nigger" interprets the meaning of the American flag planted on the moon landing in 1969. In place of stripes, it reads "Die Nigger," as though killing black people were the core American value (14.11).

Playing on the long-standing pattern of black men's incarceration and reflecting the concern for the many who were imprisoned, David Hammons's "Injustice Case" shows a black man—Hammons himself—shackled within a frame depicting the American flag (14.12).

Well into the 1990s, black artists echoed the conflict between African Americans

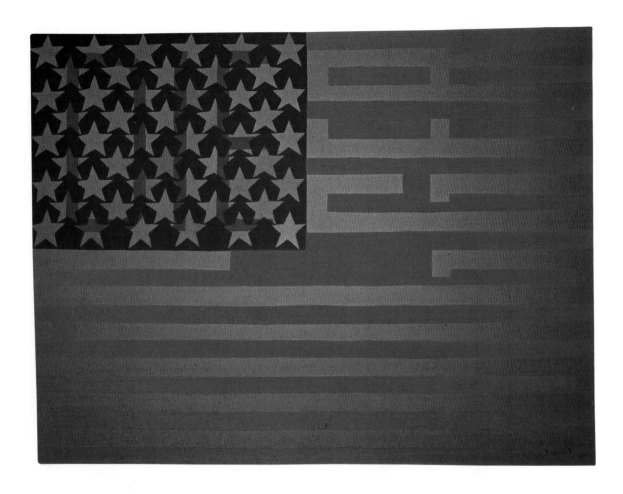

14.11. Faith Ringgold, "Flag for the Moon: Die Nigger," 1969
Ringgold's flag makes hating black people a basic component of American identity by replacing stripes with the legend "Die Nigger."

and the United States at the heart of Black Power. Much of their art portrays the United States as the oppressor of black people.

Angry Reaction in Vietnam
The King assassination occurred at a time of intense fighting in Vietnam. As always, African-American armed service personnel faced two kinds of opponents. The Army base at Cam Ranh Bay had an active Ku Klux Klavern, and Confederate flags were a familiar sight. Racist graffiti, such as "I'd rather kill a nigger instead of a gook," appeared in latrines and enlisted men's clubs. Some white base personnel greeted the news of King's assassination with an impromptu, celebratory Klan rally.[27]

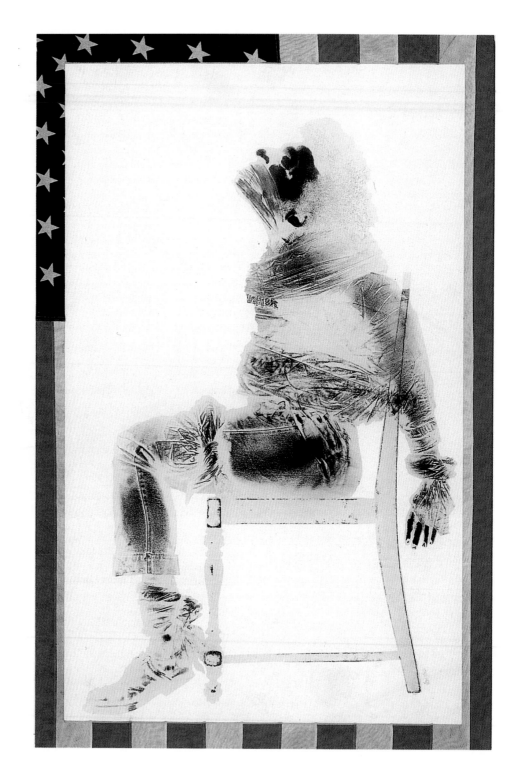

14.12. David Hammons, "Injustice Case," 1970
The ghostly black man (Hammons himself) is bound and gagged within the frame of the American flag.
Once again, the oppression of black people appears as a basic component of American culture.

At the same time, 1968–1969 witnessed the deadliest hostilities in the war. The proportion of black casualties had dropped from the high of nearly 25 percent in 1965 to 13 percent in 1968. Nevertheless black men and women continued to be significantly underrepresented among the people making decisions. Less than 2 percent of the officers were black in 1962. In 1968, the proportion was only slightly more than 2 percent: out of a total officer corps of 400,000 only 8,325 were black.[28] This racial disparity took its toll on troop morale.

After King's assassination, black soldiers grew impatient with the racism in the armed forces. African-American students in the Air Force Academy formed a Malcolm X society. Enlisted men in bases in the Southern United States and in Vietnam formed a variety of Black Power organizations: the Black Mau Mau, the Blackstone Rangers, the Black Panthers. Black Marines at Da Nang designed a Black Power flag in red and black, with crossed spears and a Swahili legend. Versions of the flag circulated in South Korea, Germany, and throughout Vietnam. Black Power canes topped by clenched fists and slave bracelets woven of bootlaces further manifested African-American soldiers' black pride.

Black soldiers spent their leisure time with other blacks, no longer disguising their distaste for white people: "Look," said one black soldier, "you've proven your point when you go out and work and soldier with Chuck [the white man] all day. It's like you went to the Crusades and now you're back relaxing around the round table—ain't no need bringing the dragon home with you."[29] "Say It Loud, I'm Black and I'm Proud," the 1968 hit record by James Brown (b. 1933), the "Godfather of Soul," was as wildly popular in Vietnam as it was stateside.

Black assertiveness led to outright brawls and race wars. In 1971 the newly formed Congressional Black Caucus held hearings on racism in the military. By the early 1970s, the U.S. Armed Forces were recognizing their serious racial problems. They began cracking down as hard on the symbols of white nationalism as on black pride and educating whites on black concerns. Affirmative action policies sought to make sure that the names of qualified black as well as white candidates appeared on previously lily-white promotion lists. Colin Powell became a major in 1968. In 1975 Daniel "Chappie" James, Jr. (1920–1978), a former Tuskegee airman, became the first black four-star general ever. And in 1979 Hazel Winifred Johnson (b. 1927) became the first black woman army brigadier general as chief of the Army Nurse Corps.[30]

Black Power advocates drew parallels between the African-American situation and that of other oppressed peoples. The most common analogy likened black Americans to colonized people in the Third World fighting for their independence. Huey Newton of the Black Panther Party compared the American "police action" in Vietnam to the wars on black people in Newark and Detroit. For Newton, Seale, and many others, African Americans were not fellow citizens to white Americans. African Americans' true brethren were to be found in the revolutionary movements in Guinea Bissau, Mozambique, and South Africa.[31] For some, this identity with the underdog extended to identification with the Palestinians of the Middle East.

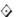

Black Power Workers, Artists, Feminists, and Intellectuals

The nationally recognized Black Panther Party was only one facet of the huge, decentralized Black Power movement of the late 1960s and early 1970s. African Americans in many walks of life formed Black Power organizations. For the most part these new organizations centered around work, whether in auto plants, churches, or colleges. In addition, black women formed groups to protect their interests as people subject to both racism and sexism.

Black workers, especially men in the auto industry, became more militant in 1967. In Mahwah, New Jersey, 500 African Americans walked off the assembly line of a Ford plant after a foreman called one of them a "black bastard." The workers stayed off the job three days, resisting their union, until the foreman was removed. They formed the United Black Brothers of Mahwah Ford.[32]

Detroit was the center of workers' Black Power. After police followed shoot-to-kill orders during the uprising of 1967, workers at the Dodge main plant formed the Dodge Revolutionary Union Movement (DRUM) to fight discrimination in the plant and the union. DRUM inspired similar Revolutionary Union Movements (RUMs) in Ford, General Motors, and International Harvester.[33] The various RUMs joined together in the League of Revolutionary Black Workers that was most active between 1968 and 1969. Like the BPP, the RUMs split into factions that were either more black nationalist or more concerned with class oppression.

The Black Arts movement included a wide array of artists working in words, images, and sound. Hundreds of artists of all sorts heeded Black Power's call to create art to further the black liberation struggle. The images that appear in this chapter represent only a few drops in the flood of art on black themes. Readers will have noticed that much of the art in this book dates from the mid-1960s and later, when the numbers of black artists increased dramatically. In addition, themes of black history became attractive to artists who saw themselves as part of the Black Arts movement.

Some of the outpouring took the form of public art. Murals depicting the heroes of black history appeared on buildings in American inner cities. One of the best known and frequently emulated was Chicago's "Wall of Respect," painted in 1967 by several artists under the guidance of Sylvia Abernathy (n.d.) and Jeff Donaldson. It shows Malcolm X, Fannie Lou Hamer, and a series of other heroes of black American history and culture (14.13).

In Boston black construction workers commissioned a mural by Nelson Stevens (b. 1938) to honor African-American workers and their families. It reads: "Work to Unify African People" (14.14). The black family has remained a popular theme in African-American murals.

Like wall art, Black Power poetry also functioned as public art. Amiri Baraka of Newark, the "Malcolm X of Literature," has been writing liberation poetry for more than forty years.[34] For Baraka, as for Malcolm X, culture is a tool for liberating black people: "BLACK ART IS CHANGE, IT MUST FORCE CHANGE, IT MUST BE CHANGE."[35] Bara-

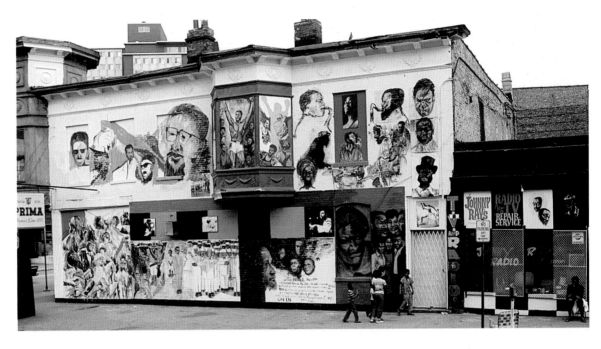

14.13. Sylvia Abernathy, Jeff Donaldson, et al., "Wall of Respect," 1967 (original version), 43rd and Langley, Southside Chicago
One of the first great black history murals, the "Wall of Respect" features several African-American heroes, Malcolm X most prominently.

ka's poetry uses black English as the national language of African Americans for his black art relates to the people in black communities, not academics or literary critics. It uses black people's words and reflects their values, speaking as they speak about lives in poverty that may not be aesthetically pretty. Nonetheless, black art sees beauty in the poor urban black people whom the rest of America would rather ignore.

Sonia Sanchez (b. 1934) joined Amiri Baraka in Harlem in 1965 and remains active as a Black Power poet in Philadelphia. Her 1969 "Summer Words of a Sistuh Addict" addresses drug addiction without judging the user. Sanchez's lowercase letters close the space between the poet and the young woman in the poem:

> the first day i shot dope
> was on a sunday.
> i had just come
> home from church
> got mad at my motha
> cuz she got mad at me. u dig?
> went out. shot up
> Behind a feelen against her.

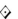

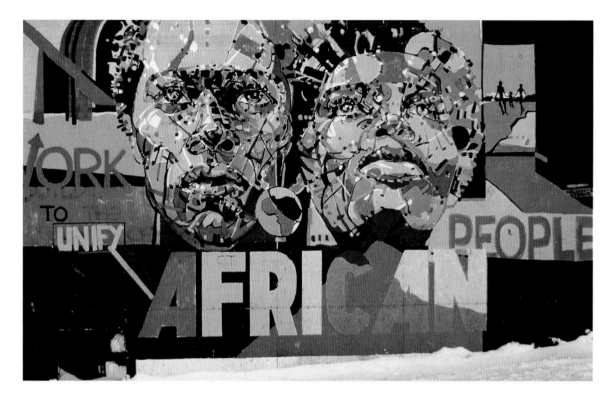

14.14. Nelson Stevens, "Work to Unify African People," mural, 1973, United Community Construction Workers Labor Temple, Roxbury, Boston, Massachusetts
Stevens's mural portrays a black working couple and reads "Work to Unify African People" in the red and black colors associated with black nationalism.

> It felt good.
> gooder than doing it. yeah. . . . [36]

Sanchez's poem ends with the young sister in tears.

Spoken poetry was the most popular art form of the Black Arts movement. Poets like Sanchez, Baraka, and Haki Madhubuti (b. 1942) read their poems aloud, often outside, often to jazz accompaniment. Their audiences participated in the performance, in the call-and-response so familiar to black music and religion. The Last Poets, a changing mix of African-American and Latino poets in New York, began rapping after the assassination of Malcolm X in 1965 and became popular in the late 1960s. The Last Poets saw themselves as portents of revolution—hence "last" poets. Their records, such as "Black People What Y'all Gon' Do?" urged race unity and discipline. Gil Scott Heron (b. 1949), another Black Power performance poet, was not a Last Poet. But Heron's spoken poetry, like theirs, inspired the rap and hip-hop spoken music that appeared in New York in the late 1970s.

With its black subject matter, black language, and black concerns, black art disregarded the conventions of American literature. Because the American publishing industry was dominated by whites who did not grasp its beauty or value, black art needed new outlets. Independent black publishers sprang up across the country, including Dudley Randall's (1914–2000) Blackside Press of Detroit, W. Paul Coates's (b. 1945) Black Classic Press of Baltimore, and Haki Madhubuti's Third World Press of Chicago. Third World Press has published the poets Gwendolyn Brooks (1917–2000), Amiri Baraka, Sonia Sanchez, the historian John Henrik Clarke (1915–1998), and the legal theorist Derrick Bell (b. 1932).[37] Black Classic Press has published the novelist Walter Mosley (b. 1952). Of the ten or so Black Arts publishing houses founded in the late 1960s and early 1970s, only Third World Press and Black Classic Press are still in business. Large, white-owned publishing houses now issue the work of black writers, seldom the case when the black presses began.

The Black Power movement gave rise to an array of new institutions and turned existing institutions like churches in new directions. Black churches that had sought civil rights began to offer more community services ranging from housing, youth tutoring, to credit unions. These services blossomed in the last two decades of the twentieth and the early twenty-first centuries. Among Black Power's new institutions were African-American museums. Black teachers in cities including Philadelphia, Boston, and Chicago remedied the absence of black history in existing museums by creating their own institutions, such as the DuSable Museum of African American History in Chicago. As in publishing, the success of black museums in reaching African Americans eventually changed the way white institutions conducted their own business. By the 1990s largely white museums were including black history and black artists in their collections. They held Kwanzaa celebrations as a way to reach out to the people of their cities.

Black Power had further intellectual repercussions. In academia, where with few exceptions black history and culture were ignored, black students demanded the creation of black studies programs and departments in 1968 and 1969. In religion, black theologians created "Liberation Theology" to address the experiences of black Christians. Both developments produced whole new bodies of scholarship. The student movement attracted a great deal of attention in the late 1960s.

Some black students and their white allies occupied campus buildings in an attempt to force reluctant administrations to create something entirely new: black studies. Most but not all demonstrations were peaceful, demanding the admission of more African-American students, the hiring of black faculty, and various services for black students. Some students demanded exclusively black dormitories and programs. Some students insisted that students play a part in the organization of black studies programs and faculty hiring. Tragedy marked the birth of black studies in Los Angeles. At the University of California, Los Angeles, disagreements between students associated with the Black Panthers and with the US Organization ended in the murder of two Panthers by US gunmen. At Cornell, black students armed themselves Panther-style

before occupying a building. By the 1970s black studies programs and departments had been established at San Francisco State University, Cornell, the University of California at Berkeley, Harvard, Princeton, and many other large institutions. For the first time, traditionally white institutions contained centers that specialized in the study of African Americans.

Black theologians refashioned American Christianity. The Reverend Albert B. Cleage (1911–2000) rejected the imagery of white religion in his Shrine of the Black Madonna, founded in 1954 in Detroit. Cleage taught black Christian nationalism and published *Black Power and Urban Politics* in 1968. Whether or not they followed Marcus Garvey's Universal Negro Improvement Association and the Reverend Cleage in making God, Jesus, and Mary black, liberation theologians made racial justice a core tenet of their belief. Womanist (black feminist) theologians like Katie Cannon (b. 1950), Jacquelyn Grant (b. 1948), Cheryl Townsend Gilkes (b. 1947), and Renita Weems (b. 1954) reshaped Christianity around the lives of black women.

In Newark, New Jersey, Oakland, California, and many other U.S. cities and towns, Black Power had an unexpected outcome: The election of black women and men to public office led to their incorporation into state and local partisan political systems. Black Power, after all, began with separation. But separation by itself left political and economic power in nonblack hands. Separation perpetuated black powerlessness, as manifested in inferior services in black communities. In 1970, with the backing of Amiri Baraka and his Congress of African People, and a few white allies, Kenneth Gibson (b. 1932) became the first black mayor of Newark and the first black mayor in a major Northeastern city. The movement toward elective office took place at all levels of U.S. society.

In 1972 Shirley Chisholm (1924–2005), the first black woman elected to the U.S. House of Representatives in 1968, ran for president. She complained later that her sex as much as her race had crippled her candidacy. Black men did not take women seriously and so had not supported her. Chisholm's campaign revealed yet again the sexism rampant in the Black Power movement. Black male chauvinism had an illustrious ancestry in the Nation of Islam and the thought of Malcolm X. Cultural nationalists inclined toward a family-oriented male dominance, in which black women were idealized as wives and mothers. The militarism of the Vietnam War era reinforced the macho urban guerrilla ideals of groups like the Black Panthers. The image of the Black Panthers often included armed women like Elaine Brown (b. 1943), who headed the BPP while Huey Newton was incarcerated, and Kathleen Cleaver (b. 1945). But in practice, the group usually treated women like domestic servants. Other Black Power organizations also equated "the black man" with black people in general. Black women's concerns were not considered racial issues.

At the same time that black was equated with men, the women's movement generally saw women as white. Even though the black Civil Rights movement had directly inspired 1960s feminism, black women's concerns were not considered "women's" issues.

The title of one of the classic books of black women's studies by Gloria T. Hull (b. 1944), Patricia Bell Scott (b. 1950), and Barbara Smith (b. 1946) summed up the matter: *All the Women Are White, All the Blacks Are Men, But Some of Us Are Brave: Black Women's Studies* (1982). In the 1960s and 1970s, black women organized as black women and as poor black women.

The National Welfare Rights Organization (NWRO), founded in 1967, gave voice to poor women on welfare. The group was not exclusively black or female: its first director was a black man. But the NWRO furthered Black Power by organizing a group of mostly black women who had been disempowered and invisible. It pressed for respect, child care, and medical care for women and their children. Like the NWRO, the National Black Feminist Organization (NBFO), founded in 1973, refused to make black women choose between being black and being female. In consciousness-raising sessions for black women, the NBFO rescued black women's issues from oblivion.[38] Its theme song might well have been "Respect," the first big hit on Atlantic Records of Aretha Franklin (b. 1942), the "Queen of Soul," in 1967.

Like the more highly visible Black Power organizations, the National Welfare Rights Organization and the National Black Feminist Organization collapsed in the mid-1970s. The recession following the oil crisis, a hostile national political climate, internal dissension, and police and FBI harassment all took their toll. In its most obvious manifestations, Black Power had wound down by 1976. However Black Power did not disappear. It persisted in the guise of black caucuses and professional organizations.

Black Power Lives On

In the 1970s African Americans began to enter institutions and vocations that had been virtually all-white. The governmental policy of affirmative action made most of the difference. Growing out of the enforcement of the Civil Rights Act of 1964 and the Equal Opportunity Act of 1972, affirmative action mandated the inclusion of blacks in institutions receiving federal funding. As black people entered new occupations, they discovered that everyday habits worked against the interests of black people as a whole and the black people in that particular occupation. In the 1970s, especially, black professionals created a wide array of organizations within organizations and vocations to advance black interests (Table 14.1). These organizations have become means of black empowerment along occupational lines.

Conclusion

The Black Power era of the 1960s and 1970s began as a controversial repudiation of the nonviolent movement for black civil rights. Black Power deeply affected African Americans whether or not they subscribed to its separatist ideals, its stress on African clothing, languages, and ritual, or its macho posturing. The 1968 assassination of the symbol of nonviolence, Martin Luther King, Jr., convinced masses of African Americans that the

Table 14.1. African-American Organizations Founded Since the Civil Rights Movement, a partial selection

Date Founded	Organization Name	Date Founded	Organization Name
1965	A. Philip Randolph Institute	1970	National Black Child Development Institute
1966	New York State Black, Puerto Rican and Hispanic Legislative Caucus	1970	National Black MBA Association, Inc.
1967	California Legislative Black Caucus	1970	Northwest Conference of Black Public Elected and Appointed Officials
1967, 1986	Federation of Southern Cooperatives/Land Assistance Fund	1970	Pennsylvania Legislative Black Caucus
1967	Missouri Legislative Black Caucus Foundation, Inc.	1971	Association of Black Foundation Executives
		1971	Conference of Minority Transportation Officials
1967	Ohio Legislative Black Caucus	1971	National Black Nurses Association, Inc.
1968	African-American Women's Clergy Association	1971	National Urban Affairs Council
1968	Association of Black Psychologists	1971, 1985	Rainbow/PUSH Coalition
1968	National Association of Black Social Workers, Inc.	1972	Coalition of Black Trade Unionists
		1972	National Black Police Association
1968	National Black Law Students Association	1972	National Black United Fund, Inc.
1969	African Heritage Studies Association	1972	National Naval Officers Association
1969	National Association of Black Accountants, Inc.	1973	National Brotherhood of Skiers
		1974	Alabama Legislative Black Caucus
1969	National Association of Minority Contractors	1974	American Association for Affirmative Action
		1974	Black Flight Attendants of America, Inc.
1969	National Conference of Black Political Scientists	1974	National Association of Blacks in Criminal Justice
1969	Virginia Legislative Black Caucus	1974	National Conference of Black Mayors, Inc.
1969	Congressional Black Caucus	1974	North Carolina Legislative Black Caucus
1970	Association of Black Admissions and Financial Aid Officers of the Ivy League and Sister Schools, Inc.	1975	Black Data Processing Association
		1975	National Association of Black County Officials
1970	Association of Black Anthropologists	1975	National Association of Black Journalists
1970	Black Caucus of the American Library Association	1975	National Black Women's Consciousness-Raising Association
1970	International Association of Black Professional Fire Fighters	1975	National Society of Black Engineers
		1975	South Carolina Legislative Black Caucus
1970	Joint Center for Political and Economic Studies	1975	Tennessee Black Caucus of State Legislators
		1976	Association of Black Women Historians
1970	Maryland Legislative Black Caucus	1976	Michigan Legislative Black Caucus
1970	National Black Caucus of Local Elected Officials	1976	National Association of Black Owned Broadcasters
		1976	Organization of Black Airline Pilots, Inc.

Table 14.1. (*continued*)

Date Founded	Organization Name	Date Founded	Organization Name
ca. 1976	Kansas Black Legislative Caucus	1983	National Coalition of Black Meeting Planners
1977	Afro-American Historical & Genealogical Society	1983	National Alliance of Black SalesMen and SalesWomen/Black Sales Institute
1977	American Association of Blacks in Energy	1984	National Political Congress of Black Women, Inc.
1977	Black Women's Agenda		
1977	Louisiana Legislative Black Caucus	1985	Caribbean American Chamber of Commerce and Industry, Inc.
1977	National Black Caucus of State Legislators		
1977	New Jersey Legislative Black and Latino Caucus	1985	National Trust for the Development of African-American Men
1977	TransAfrica, Inc./TransAfrica Forum	1986	Miss Black USA Foundation
1978	Black Filmmaker Foundation	1986	100 Black Men of America, Inc.
1978	National Black Association for Speech-Language & Hearing	1987	Alliance of Black Entertainment Technicians
ca. 1978	Illinois Legislative Black Caucus	1987	National Black Arts Festival
1979	Black Women's Network	1988	Black Women Mayors' Caucus
1979	Indiana Black Legislative Caucus	1989	National Black Graduate Student Association, Inc.
1980	National Black United Front		
1981	National Black Women's Health Project	1992	National Association of African-American Studies
1982	Associated Black Charities		
1982	Association of African-American Women Business Owners	1993	National Black Chamber of Commerce
		1994	Filmmakers and Actors of Color, Inc.
1982	Florida Conference of Black State Legislators	1996	Ronald H. Brown Foundation
1982	National Black Public Relations Society, Inc.	1998	Black Radical Council

United States was fundamentally antiblack and that they would have to depend upon themselves to overcome racial oppression. Black Power emancipated African Americans psychologically. It freed them from the negative characterization prevailing in American culture. Black Power created a counternarrative of American culture, in which black people are prized and beautiful and possess a glorious history. Black Power focused attention on ordinary black people living in poor, inner cities and sought to address their needs. Black Power unleashed the extraordinary force of artistic creativity expressing black pride. It endowed the individuals who embraced it with a powerful, positive group identity.

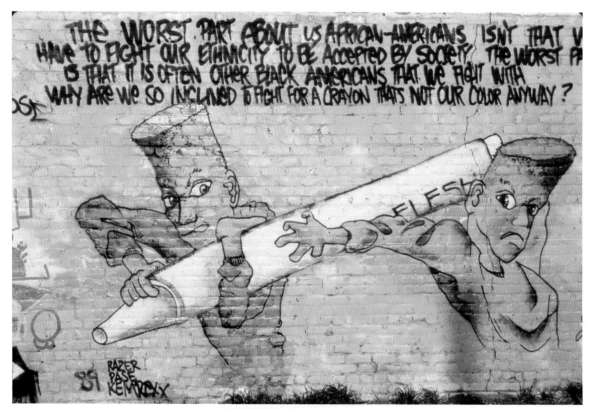

15.1. Brett Cook (Dizney), "Why Fight for a Crayon That's Not Our Color?" 1988. Psycho City, San Francisco, California. Approximately ten-feet high.

Cook says, "The worst part about us African-Americans isn't that we have to fight our ethnicity to be accepted by society. The worst part is that it is often other black Americans that we fight with. Why are we so inclined to fight for a crayon that's not our color anyway?" The crayon says "flesh."[1]

◇ 15 ◇

Authenticity and Diversity
in the Era of Hip-Hop
1980–2005

Brett Cook (Dizney) (b. 1968) painted the graffiti-style mural "Why Fight for a Crayon That's Not Our Color?" in California. Graffiti is one of the five dimensions of hip-hop culture. (The other four are DJ-ing, rap music, break dancing, and clothing.) Hip-hop has exerted tremendous influence on popular culture all over the world since its appearance in New York City in the late 1970s. Cook says his mural depicts the struggles of his generation of black Americans, a generation born since the mid-1960s and variously termed "hip-hop," "post-Black," "post-Soul," and "post–Civil Rights." Even though racial obstacles still exist in American society, younger black people have far more access to opportunity than their elders.

This first generation of African Americans to grow up free of legalized segregation has often succeeded beyond their parents' and grandparents' imaginations. Each week seems to bring the announcement of a black person's heading a Fortune 500 company, being crowned Miss America, winning at golf or tennis, being appointed Secretary of State, or becoming a billionaire. But Cook realizes that when success often seems to demand turning white, it tempts younger black people to compromise their black identity (15.1). Like hip-hop artists, Cook wants young African Americans to remain true to their blackness. After the end of legalized segregation, the notion of authentic blackness became a preoccupation of the hip-hop generation. The need to define what constituted authentic—as opposed to inauthentic—blackness related to the increasingly visible diversity among people considering themselves African American.

Racial Politics and Economics after Black Power: Increased Diversity

The post-1980 fixation with individual success contrasts sharply with the race-based emphases of the eras of civil rights and Black Power. In the 1950s, 1960s, and 1970s, the most visible black people were in protest against the status quo. They defined themselves in racial terms against white middle-class America. After 1980, however, the most visible black people achieved success as individuals on American society's own terms. Women as well as men rose to the top of companies and institutions serving a broad range of people, nonblack as well as black.

While black people as a group continued to be the poorest, most vulnerable, and most frequently incarcerated Americans, more and more African Americans were able to realize the promise of American life. Fundamental changes in college admissions, hiring and promotion, and family wealth facilitated individual success. These changes opened opportunity for people whose forebears had endured generations of exclusion on account of racial slavery and segregation. The new policies in college admissions and in hiring and promotion were called "affirmative action," a phrase that lumped together various governmental and non-governmental policies aimed at increasing the numbers of blacks, Latinos, Native Americans, and white women in institutions that had previously discouraged their presence.

Affirmative Action: Controversial And Effective

The phrase "affirmative action" first appeared in 1961, when President John F. Kennedy issued Executive Order 10025 calling on the federal government to hire African Americans aggressively. Affirmative action became more assertive in the mid-1960s, through Title VII of the Civil Rights Act of 1964 and President Lyndon B. Johnson's Executive Order 11246, which affected large private companies doing business with the federal government.[2] These companies were required to file plans that included goals and timetables—not quotas—for hiring minority and white women workers.

Affirmative action demanded a rethinking of the meaning of qualification for college admission and hiring and job promotion. Before affirmative action, all–white, all–male student bodies and professional workforces seemed natural and did not cause widespread concern. No means existed to increase the representation of white women or people of color. There seemed little reason to investigate the relationship between admissions and hiring on the one hand and actual effectiveness on the other.

Further complicating the workings of affirmative action was the fact that African Americans usually did not score as high as whites on the objective tests that served as means of accepting and rejecting applicants. Underlying reasons for disparities in test results have not been explained definitively. Among the possibilities that have been advanced to explain differences in test scores are the nation's long history of exclusion and segregation, poverty, substandard K–12 schools, and even genetic difference between

black and white Americans. Amazingly, hard data on the long-term consequences of affirmative action are not readily available. But some information is at hand. A 1998 book by the former presidents of Princeton and Harvard Universities found that beneficiaries of race-based affirmative action went on to careers that were productive for themselves and their communities. A study by the University of Michigan found similar results.[3] Whatever the eventual accounting, it is clear that white women have been better able than African Americans to take widespread advantage of affirmative action.

In the 1960s affirmative action was intended to compensate for past discrimination. But rulings by the United States Supreme Court in the 1970s and 1980s barred the use of affirmative action to address discrimination in the past except in extremely narrow circumstances. The most notable among these rulings was the court's 1978 decision in *Regents of the University of California v. Bakke*. Before *Bakke* it was assumed that African Americans carried certain handicaps from their past that warranted addressing: in the parlance of the time, the racial playing field was not level. After *Bakke*, the racial playing field was assumed to be level unless proved otherwise.[4] Supreme Court decisions also weakened the use of timetables and goals for achieving results, seeing in them unacceptable quotas. After the *Bakke* decision, "diversity" became the prevailing, acceptable rationale for affirmative action. Any measure smacking of quotas was declared illegal.

In *Gratz v. Bollinger* and *Grutter v. Bollinger*, the University of Michigan cases of 2003, the Supreme Court decided that affirmative action remained a legal means of achieving racial, ethnic, and gender diversity but narrowed the means that could be used to achieve it. By declaring that each applicant to every educational institution deserved individual judgment without the use of weighted categories, the Court made it extremely difficult for large institutions receiving tens of thousands of applications to pursue affirmative action.

In *Gratz* and *Grutter* the Supreme Court received pro-affirmative action friends-of-the-court briefs from leading colleges and universities, retired officers of the U.S. military, and leading American corporations. The briefs argued that racial, ethnic, and gender diversity served the best interests of American institutions operating in a global setting.

Retired generals contended that the U.S. Armed Forces' service academies needed affirmative action. The academies train the U.S. officer corps, a perennial subject of concern for African Americans in every war since the mid-nineteenth century. According to the military briefs, without affirmative action the officer corps would resemble that of the Vietnam War era. In the 1960s and 1970s the difference between heavily black troops and a nearly all-white officer corps badly undermined morale. The lack of black officers in Vietnam diminished fighting effectiveness.[5]

Most African Americans support affirmative action, believing that it encourages equal access to jobs and higher education and discourages racial discrimination. Certainly the vast difference between virtually all–white and all–male student bodies and professions before and diversity after affirmative action supports that reasoning. However, two groups of Americans oppose affirmative action aggressively: first, people who

claim that affirmative action amounts to "reverse discrimination" against whites and entails the use of "quotas"; and, second, African Americans who believe that affirmative action prevents their white colleagues from respecting them as individuals.

A series of Supreme Court decisions and administrative policies have embraced the logic of reverse discrimination and drastically limited the scope of acceptable policies. Many white and black conservatives such as Supreme Court Justice Clarence Thomas (b. 1948) applaud this trend. However, black people who attended college or got jobs before the implementation of affirmative action recall the stereotyping that affected black people even when they were admitted to college and hired on exactly the same basis as whites. The assumption that African Americans are not qualified for skilled jobs or professional training is much older than affirmative action and runs very deep in American culture. No recent policy created this assumption.

Affirmative action is one of several issues dividing black conservatives (most are Republicans) from the majority of African Americans (who tend to favor the Democratic Party). Black conservatives emerged after the election of Ronald Reagan to the U.S. presidency in 1980. Although there have always been conservatives among the millions of black Americans, for example, Booker T. Washington (see chapter 8), they have never before been so numerous, so visible, and so influential.

Black Conservatives Gain Prominence

Ronald Reagan won a landslide presidential victory in 1980 with a "Southern strategy" promising to restore "states' rights" and end affirmative action. Reagan's monumental popularity among white voters of all parties sent black people two widely differing messages: Most African Americans heard an attack on black civil rights, if not on black people generally, in the slogan "states' rights." But a minority glimpsed in Republican conservatism the prospect of being respected as individuals, not stereotyped as members of a race.

The Reagan and first Bush administrations of the 1980s and early 1990s made black conservatism a movement to be reckoned with. Black conservatives hold positions such as anti-Communism, the use of strong military power as a tool in foreign policy, opposition to affirmative action and to abortion, support of the death penalty, school prayer, privatizing social security, school choice, and the state of Israel. Black conservatives advocate individualism and limited government, even to redress discrimination.[6]

Economist and syndicated columnist Thomas Sowell (b. 1930) is the elder statesman of black conservatives.[7] Sowell and other black conservatives lay the blame for African Americans' poverty on a faulty black culture and black people's lack of individual initiative. They believe the marketplace, not government, solves human problems most efficiently. (Such an anti-government philosophy is called "laissez-faire," meaning "let-alone.") Sowell was the most influential black conservative of the first Reagan administration.

Conservatives like Sowell oppose the governmental policies that most African Americans believe have helped them, such as the 1954 *Brown v. Board of Education* Supreme

Court decision against segregation in schools, anti-discrimination laws such as the Civil Rights Act of 1964, public education, affirmative action, welfare, and minimum wage laws. They oppose affirmative action even when it helped them gain admittance to law school or lucrative government contracts. While Sowell focuses mainly on economics, black "neo-conservatives" like U.S. Supreme Court Justice Clarence Thomas, author and former college professor Shelby Steele, and California businessman Ward Connerly (b. 1939) concentrate more on opposing affirmative action.[8] Steele's widely quoted articles and books argue that black people's habit of protesting against racism has outworn its usefulness.[9] As a member of the Board of Regents of the University of California system, Connerly spearheaded a successful campaign to force the university not to take race into account in admissions. Connerly intends to outlaw the use of race in public life in the United States as a whole. Glenn Loury (b. 1948), a Boston University economist, was the most prominent black conservative of the second Reagan administration. Like other conservatives, Loury opposed affirmative action on two grounds: he felt it imposed a group identity that ran counter to the American tradition of individualism and that it betrayed the creed of Martin Luther King, Jr., that black people should be measured by "the content of our character" rather than skin color.

Another prominent black conservative, Republican Alan Keyes (b. 1950), opposed the income tax and abortion in his 2000 presidential campaign.[10] J. C. Watts (b. 1957) was first elected to Congress in 1994 from a majority white district in Oklahoma. He quickly rose to the position of chair of the House Republican Conference, a high-ranking leadership position in the House Republican hierarchy.[11]

African-American conservatives became leaders in the administrations of President George W. Bush starting in 2001. Those two administrations have included higher ranking black Cabinet officials than any previous administration, notably two black secretaries of state: Colin L. Powell and Condoleezza Rice (b. 1954, who served as national security advisor in the first George W. Bush administration). A beneficiary of affirmative action when Clifford Alexander (b. 1933) served President Jimmy Carter as Secretary of the Army, Powell led the U.S. Armed Forces during the first Gulf War in 1990.[12] He became the first African-American chair of the Joint Chiefs of Staff under President George H. W. Bush.[13] Powell, a supporter of affirmative action and a relatively moderate Republican, stood out as the Bush administration's most internationally minded figure during the war in Iraq of 2003. Secretary of State Condoleezza Rice, an expert on foreign policy and Russia, comes from an academic background and the provostship of Stanford University. As national security advisor, Rice advocated the controversial policy of "preemptive war," in which the United States could attack any country, such as Iraq, regardless of whether that country had threatened it. Education secretary in the first George W. Bush administration, Rodney Paige (b. 1935) was formerly a coach and dean of education at Texas Southern University and later school superintendent of Houston. Paige accompanied Bush from Texas. Paige opposed the power of teachers' unions and applauded the role of religion in schools.[14]

Black conservatives have prospered since the 1980s. However, two retreated some-what from their conservative positions—Professor Glenn Loury and former Congress-man J. C. Watts. In the early twenty-first century Loury began to disagree with his conservative colleagues over several crucial issues, notably race and IQ, the persistence of racism, and affirmative action.[15] And Watts—after having achieved the fourth-highest position in the Republican hierarchy in the House of Representatives—unexpectedly retired from Congress in 2003. Black Republicans remain relatively rare in American politics, facing ambivalence from both white Republicans and large numbers of Afri-can Americans. The great majority of black elected officials and aspiring officeholders are Democrats.

Black Democrats: More Numerous, More Influential
Bill Clinton's two-term presidency (1993–2001) brought many black Democrats into po-sitions of prominence. Saying he would appoint a racially and ethnically diverse cabinet that "looked like America," Clinton in 1993 included four African Americans in his first cabinet: Ronald H. Brown (1941–1996), formerly the chair of the Democratic National Committee, as secretary of commerce; Hazel O'Leary (b. 1937), a Minnesota energy company executive, as secretary of energy; Mississippi Congressional Representative Mike Espy (b. 1953) as secretary of agriculture; Jesse Brown (b. 1944), executive director of the Disabled American Veterans, as secretary of Veterans Affairs. In addition, Gen-eral Colin Powell remained chairman of the Joint Chiefs of Staff.[16]

These appointments, in addition to Clinton's Southern origin and his ease around American Americans, prompted the novelist Toni Morrison (b. 1931) to term him jok-ingly "America's first black president." However, Clinton began the appointments pro-cess by humiliating his friend and fellow student from Yale Law School, Lani Guinier (b. 1950). After nominating Guinier for the position of assistant attorney general for civil rights, Clinton quickly withdrew her nomination when conservatives attacked her for being too liberal.[17]

Numerous black presidential appointments bring instant high visibility, but they de-pend upon the existence of a pool of experienced potential appointees. The post–Civil Rights generation has witnessed the election of ever-increasing numbers of black men and women to political office. Majority black districts in the South and in the urban North and West have elected black representatives (mainly Democrats) to Congress and to state and local offices. In 2000, the most recent year for which statistics are avail-able, 9,040 black men and women were elected officials at all levels of government. With the exception of Illinois and Michigan, all the states with large numbers of black elected officials were Southern.[18] Although prominent black politicians in California and New York have run for governor, the only African American to be elected state gov-ernor was L. Douglas Wilder (b. 1931) of Virginia, 1990–1994. In 1992 Carol Moseley Braun (b. 1947) of Illinois became the first black woman elected to a seat in the U.S. Senate. She was defeated in 1998 after one term. The U.S. Senate then remained all-

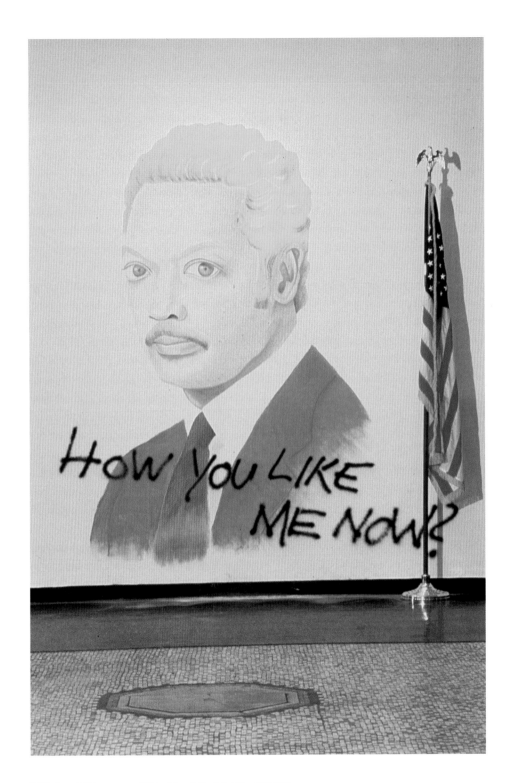

15.2. David Hammons, "How You Like Me Now?" 1988
Hammons wonders whether more Americans would have voted for Jesse Jackson if he had been a blond white man with blue eyes. Irate viewers attacked this work with a sledgehammer.

white until 2005, when Barack Obama (b. 1961) of Illinois took his seat after defeating Alan Keyes. Keyes had moved to Illinois from Maryland in order to oppose Obama.

The Reverend Jesse Jackson (b. 1941), a civil rights veteran from South Carolina and Chicago, ran for president in 1984. Jackson received some 3.5 million votes and garnered nearly 400 delegates. His presidential run in 1988, managed by Ronald H. Brown, was even more successful. He came in second in the primaries with seven million votes. In 1987 the rapper Kool Moe Dee (b. ca. 1962) recorded "How Ya Like Me Now?" Like much rap music, "How You Like Me Now?" featured the ritualized, taunting rhymes of the African-American word game tradition called the "dozens." Also like much rap music, "How Ya Like Me Now?" begins with a "sample" (a spliced-in bit of another recording) from rap's favorite artist, James Brown: "All Aboard the Night Train."[19]

Kool Moe Dee's record inspired the artist David Hammons. In 1988, as Jesse Jackson was making his second and most spectacular run for the U.S. presidency, Hammons reworked Jackson into a winning candidate in "How You Like Me Now?"—a Washington, D.C., billboard that stirred enormous controversy among viewers of all races (15.2).

Jackson's presidential campaigns showed that black voters cared passionately for politics. Many nonblack voters rallied to Jackson's populist campaign that championed the political and economic rights of working-class Americans of all races and ethnicities. With his strong civil rights background, Jackson embodied opposition to racial discrimination. As a successful negotiator who had freed American hostages in the Middle East, Jackson also stood for an American foreign policy rooted in negotiation rather than in war. Jackson did not run for president in the 1990s, but he remained a visible and influential figure in the national Democratic Party headed by President Bill Clinton. In the early twenty-first century, Jackson's son, Congressman Jesse Jackson, Jr. (b. 1965), emerged as a figure of note in Democratic national politics.

The defeat of Al Gore in the presidential election of 2000 and Republican control of both houses of Congress and the U.S. Supreme Court relegated black Democrats to the sidelines of national politics. The electoral abuses of the election of 2000 spotlighted African Americans' long-standing difficulties in getting their votes fully counted.

Black Voters Disfranchised in the 2000 Presidential Election

In the presidential election of 2000 African-American voters were disfranchised in ways that recalled the nineteenth and early twentieth centuries and that had existed all along to a certain extent. The Democratic candidate, Al Gore, actually gained more popular votes than George W. Bush, the Republican candidate. But because the outcome of American presidential elections is determined by votes in the electoral college rather than by popular votes, Bush won. For the first time in American history, the U.S. Supreme Court stopped the recounting of contested local races in Florida. As a result, Florida's electoral votes went to George W. Bush. In 2000, votes in the state of Florida made Bush president. The voting process worked against black voters.

Black voters supported Gore overwhelmingly, but the state of Florida obstructed their

ability to cast votes that would all be counted. An investigation by the U.S. Commission on Civil Rights discovered that police had set up irregular checkpoints that delayed and discouraged voters on their way to the polls. The certification of many voters (of all races and ethnicities) who had registered to vote in motor vehicle offices ("motor voter" registration) were not processed. In some counties, ballots were misleading. Some polling places closed early. Translators were not always available for non-English-speaking voters. In general, polling places lacked workers and support. In heavily black districts, voting machines failed to count ballots properly.[20]

The Commission on Civil Rights discovered another underlying problem in Florida related to voter eligibility: the state, controlled by Republicans, had removed felons from the rolls of qualified voters. (Like many other states, Florida deprives convicted felons of the right to vote, even after they have completed their prison terms.) But in 2000 the process had been deliberately sloppy. As a result, some seven thousand Florida voters who were not felons were wrongly eliminated.[21] Had black voters been able to cast their ballots freely, Florida would doubtless have gone for Gore. But problems in Florida disfranchised thousands of black voters and violated the Voting Rights Acts of 1965 and 1975.[22] The Congressional Black Caucus protested against this disregard for black voters, but no senator, not even the losing candidate Al Gore, upheld their complaint to the senate.[23]

The flawed presidential election of 2000 spurred two black politicians to run for president in 2004: the New York City activist Al Sharpton (b. 1955) and the former U.S. Senator from Illinois Carol Moseley Braun.[24] Sharpton and Braun pursued the interests of African Americans, working people, and people of color from within the Democratic Party. While their candidacies seemed to show that the Democratic Party welcomed African Americans, many black activists concluded that neither of the two major parties would adequately serve black political needs.

All across the United States, new, radical black organizations sprang up in the post–Black Power era. They were small and mostly local, but many have organized nationwide. New activist organizations include the black nationalist International People's Democratic Uhuru movement; the anti-Semitic, self-defense-oriented New Black Panther party; the religiously oriented New Nation of Islam; and the left-wing, intellectual Black Radical Congress. All demand Black Power through control of police, schools, health care, and housing. And all denounce police brutality and the wholesale incarceration of black men and women. Often they demand reparations for the injustices black Americans suffered during the eras of slavery and segregation.[25]

The Reparations Movement
The notion that the United States should repay black Americans for slavery is not new. During Reconstruction after the Civil War, many Americans recognized the need to supply former slaves with an economic stake in society. By the twentieth century, African Americans sought compensation for slavery and discrimination almost alone. However, after the U.S. federal government compensated Japanese Americans for their

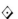

incarceration during the Second World War and German corporations and governments compensated Jews and enslaved workers, the black reparations movement gained renewed visibility.

In the late 1990s and early twenty-first century, the issue of reparations gained acceptance. A generation after the Civil Rights revolution, African Americans continued to be discriminated against in health care, housing, and jobs. Entrenched poverty continued to afflict the descendants of slaves. One influential book summed up the economic and intellectual costs to blacks of slavery, segregation, and discrimination: *The Debt: What America Owes to Blacks* (2000), by Randall Robinson (b. 1941). Robinson's book makes two arguments: first, that black people owe it to themselves to reclaim their past; and, second, that the United States owes black people financial retribution for centuries of unpaid slave labor and discrimination in education and employment.[26]

The heterogeneous reparations movement pursues Robinson's two principal aims. First, the movement seeks to compensate the descendants of workers who were unpaid and subjected to discrimination. The compensation sought by the reparations movement would be institutional, not individual--that is, reparations would advance those institutions that serve the needs of large numbers of African Americans, not individuals. Second, and more important, the reparations movement aims to illuminate the economic dimension of African-American history. Such a discussion would focus attention on issues such as the role of slavery and the enslaved in the U.S. economy, on the loss of wealth on account of federal mortgage discrimination, and on continuing job discrimination.[27]

The reparations movement is part of a wider initiative among African Americans to reclaim their just role in American history. Every year since 1989 U.S. Representative John Conyers (b. 1929), a Michigan Democrat, has introduced HR 40—the "40" stands for "40 acres and a mule." This bill would create a committee to study the role of black workers—who were enslaved—in the building of the U.S. capitol and the possibilities for restitution. Every year the U.S. House of Representatives has tabled HR 40 without considering it. In 1994, the Florida Legislature awarded reparations to survivors of a 1923 attack on black people in Rosewood, Florida.[28] In 2000 the state of Oklahoma created the Tulsa Race Riot Commission to investigate the 1921 attack on the city's black community that destroyed a thriving, thirty-five-block neighborhood and killed hundreds. The Tulsa Race Riot Commission concluded its work without awarding reparations. But black Tulsans, including the noted historian John Hope Franklin (b. 1915), sued the state of Oklahoma for redress.[29]

The reparations movement represents one dimension of a broad-based approach to the work of recovering African-American history. Advocates of reparations insist that their goal is aimed principally at getting all Americans to recognize the importance of black people in United States history. Beyond the movement for reparations, hundreds of cultural workers and tourism entrepreneurs have created a network of historical commemorations.

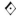

Reclaiming Black History

In the generation since the Civil Rights and Black Power movements, black people and their allies have sought to commemorate the struggle for civil rights.[30] They have also built on the cultural nationalism of leaders like Maulana Karenga of the US movement (see chapter 14) by creating black and African-American studies departments, studying African languages, wearing African-inspired clothing, and preferring to be called "African Americans" rather than "Negroes."

The Kwanzaa holiday provides one telling example of the way cultural nationalism became an accepted facet of American life. At the same time that hundreds of local organizations were spreading Kwanzaa as a black nationalist holiday, Americans as a whole were becoming more self-consciously multicultural. Schools and museums realized that Kwanzaa offered a way to attract black support in cities that were now majority African American. Corporations saw Kwanzaa as a way to proclaim their fair-mindedness. In 1997 the U.S. Postal Service issued a Kwanzaa stamp. Maulana Karenga published *Kwanzaa: A Celebration of Family, Community and Culture* to go along with the stamp and codify a regular ritual. In thirty years Kwanzaa had gone from a new, separatist black nationalist observation to a corporate celebration of American multicultural marketing.[31] Afrocentric values turned out to resonate well with nonblack as well as black Americans.

Black cultural (or heritage) tourism originated in the desire of African Americans and their allies to preserve the memory of the heroic struggles of the Civil Rights era so that they did not disappear as activists aged and died.[32] Civil rights museums now exist in many places in the South: they include the Martin Luther King, Jr., Center, Atlanta; Freedom Park/Kelly Ingram Park, Birmingham; the Birmingham Civil Rights Institute; the Voters Rights Museum and Rosa Parks Museum, Montgomery, Alabama; and the Memphis, Tennessee, National Civil Rights Museum.

Black heritage tourism is now big business. Two of its pioneers were Caletha Powell (n.d.) of the African-American Travel and Tourism Association, Inc., and Thomas Dorsey (b. 1951) of Soul of America. American cities and states have joined African-American travel agents inviting tourists to historic black neighborhoods, such as Harlem in New York and Roxbury in Boston. Slavery, too, has spawned tourism, to sites such as the slave market in Charleston, South Carolina. The United States National Slavery Museum in Frederiksburg, Virginia, still in the planning stage, will open in 2007.[33] The West African nations of Ghana and Senegal invite black Americans to rediscover their African roots through visits to coastal slave castles that were their ancestors' embarkation sites.[34]

States, localities, and the federal government foster the commemoration of black history out of a variety of motives ranging from commercial to civic. The United States designated the annual federal holiday marking the birthday of the Reverend Martin Luther King, Jr., in 1986. In the fall of 2003 the United States government sponsored two important events making black history more prominent: In October the U.S. General Services

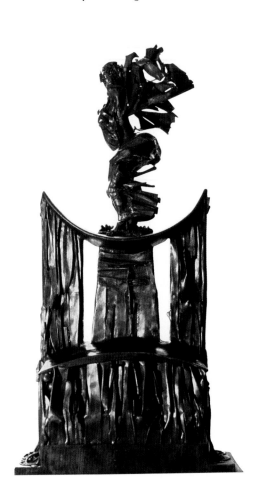

15.3. Barbara Chase-Riboud "Africa Rising," 1998
Chase-Riboud's monumental sculpture recalls the bowsprit (female figure on the bow) of sailing ships like those transporting African captives to the Americas. Chase-Riboud gave the bowsprit prominent buttocks to honor Saartje Bartmann, the so-called "Hottentot Venus" from South Africa. Below the bowsprit are ropes that bound the enslaved.

Administration joined the Schomburg Center of the New York Public Library and Howard University to re-bury the remains of four hundred enslaved people in the African Burial Ground. (Their remains had been taken to Howard University for anthropological study.) A twenty-foot-tall monument by the sculptor Barbara Chase-Riboud (b. 1939) in the new federal building erected over the burial ground commemorates the tragedy of New York's enslaved (15.3). In November 2003 Congress finally passed legislation to build a National Museum of African-American History and Culture. The measure had originally been requested by black Civil War veterans in 1915.[35] The envisioned museum will be part of the Smithsonian Institution and contain information on four hundred years of African-American history at a site to be determined in 2006.

Afrocentrism Provokes Controversy
In contrast to black heritage tourism and historical commemoration, which stress the American-ness of the African-American past, Afrocentrics stress the African-ness of black Americans and their relation to others in the African Diaspora. The broad intellectual tendency known as Afrocentrism encompasses a variety of ideas and practices. Afrocentrism puts black people at the center of historical narrative. Certain tendencies also insist on the greatness of ancient Egypt and African Americans' direct descent from the pharaohs. Some Afrocentrists, such as Molefi Kete Asante (b. 1942), believe that African-descended peoples are uniquely oral and community minded.[36] Other Afrocentrists go so far as to draw sharp contrasts between black "Sun people" and white "Ice people," ideas that simply reverse the assumptions of white supremacy.

The tenets of extremists made Afrocentrism controversial in the late 1980s and early 1990s. By that time, Kwanzaa commemorations were becoming widespread, and a white scholar, Martin Bernal, had published a book defending black nationalists' claims that ancient Egypt had inspired European civilization. The ideas have been around since the nineteenth century and lived on in the twentieth century in the work of Chancellor

Williams (1902–1993), George G. M. James (n.d.), Cheikh Anta Diop (1923–1986), and Ivan Van Sertima (b. 1935).[37]

The fight over Afrocentrism was in some ways a battle over African-American studies departments and programs, in which people of African descent formed the core of an academic curriculum. By the mid-1990s there were some 380 academic African-American studies programs and departments, at least 140 of which offered degrees. Black faculty represented only about 5 percent of college and university faculty. (Not all of them taught in African-American studies.) But even so small a number of black professors challenged older notions of what should be taught and by whom in colleges and universities.[38] Even when African-American studies did not draw lines between the races, many in academia found it difficult to accept black people as the subjects of scholarship and black professors as full-fledged scholars. By the end of the twentieth century, the Afrocentric controversy had largely subsided. African-American studies and African-American faculty have become permanent—though vulnerable—features of American academic life.

Quarrels over Afrocentrism and African-American studies took place among people engaged in higher education. At the other end of the cultural spectrum, young people in the streets were creating new cultural forms called hip-hop that in a quarter of a century remade American popular culture.

African Americans Remake American Culture

In the post–Civil Rights and post–Black Power era, black Americans became highly visible throughout American culture. They had long appeared as athletes and entertainers. But in the late twentieth and early twenty-first centuries, their popularity reached heights not imaginable before the Civil Rights revolution. Sports figures such as Michael Jordan (b. 1963) not only excelled on the basketball court; they also appeared as well-paid corporate spokespersons. Eldrich "Tiger" Woods (b. 1975) and the sisters Venus (b. 1980) and Serena (b. 1981) Williams dominated the hitherto exclusive sports of golf and tennis. The recordings of musicians Tina Turner (b. 1939) and Michael Jackson (b. 1958) broke sales records. Spike Lee (b. 1957) made movies about black heroes like Malcolm X, and, for television, on the football player and movie star Jim Brown (b. 1936), and Huey P. Newton. Bill Cosby (b. 1937) and Oprah Winfrey (b. 1954) became television's most popular personalities. Movie stars Denzel Washington (b. 1954) and Halle Berry (b. 1968) did the seemingly impossible by winning Oscars for Best Actor and Best Actress in the same year (2002). In the single year 1993, Toni Morrison (b. 1931) won the Nobel Prize for Literature, Rita Dove (b. 1952) became the United States Poet Laureate, and Mae Jemison (b. 1956) became the first black woman astronaut. (Guion S. Bluford, Jr., [b. 1942] had become the first black astronaut in 1983.)

Despite the daily breakthroughs and the emergence of black women as embodiments of beauty in popular culture, many black women, especially those with dark skin,

15.4. Kyra E. Hicks, "Black Barbie" quilt, 1996

Hicks's quilt corrects her suspicion that "Barbie, America's [tall, thin, fashionable] Doll was never intended for me." Hicks invents a brown Barbie with a fuller figure, one more akin to the bodies of black women.

continued to feel invisible in American culture. Kyra E. Hicks's (b. 1965) quilt, "Black Barbie," says "Barbie, America's Doll was never intended for me" (15.4).

Black women in the era of hip-hop seized upon dazzling new opportunities, even as they remained vulnerable to racism and sexism that were often intertwined. The idea of American women's femininity continued to be young, white, or light skinned. Meanwhile the idea of black Americans often remained masculine, with black men virtually monopolizing the notion of racial authenticity. In hip-hop culture, black women were often abused as whores and bitches.

Hip-Hop Culture Presents a New Vision of the Inner City

Impoverished inner-city neighborhoods beset by unemployment—the "'hood"—that nurture crime and drug abuse and police brutality are the same places that hip-hop culture celebrates.[39] Artists like N. W. A. (Niggaz with Attitude) and Run DMZ made records documenting life in the mean streets of the 'hood. The rapper Ice Cube (b. 1969) said, "We call ourselves underground street reporters. We just tell it how we see it, nothing more, nothing less."[40]

Hip-hop culture symbolizes the younger generation of urban African Americans born since 1965. More than just rap music, hip-hop culture encompasses music, dance, graffiti artistry, sampling, clothing, and the claim of authentic blackness.[41] Hip-hop culture conveys an attitude and a style as well as its specific art forms. One index to the spread of hip-hop culture is the growth of rap music. Over the course of a quarter century, rap music grew from a purely local performance style in the Bronx of New York City in the 1970s to become the top-selling musical format in the United States in 1998.[42]

Graffiti art appeared on walls and subway cars in New York City in the late 1960s, earlier than rap music and break dancing. Most graffiti artists attain only local success, because building owners and the New York Transit Authority try to clean buildings and subway cars as quickly as possible. However the most famous graffiti artist of the 1970s and 1980s, Jean-Michel Basquiat (1960-1988), realized commercial success at an early age. His "tag" (the label he wrote on buildings and subway cars) was "SAMO," meaning "same old shit." New York gallery owners discovered Basquiat in the early 1980s. His work was subsequently exhibited internationally. Basquiat was subject to paranoia and heroin addiction, which ultimately killed him at age twenty-seven.[43]

Melvyn Henry Samuels, Jr. "Noc" (b. 1961), created the Style Wars subway train graffiti (15.5). This masterpiece covers the entire seventy-two-foot subway car from end to end and from top to bottom. The painting acknowledges the older, wild style of letter painting in the middle of the car. Graffiti became a part of fine art during the 1990s. In the early years of the twenty-first century it made a comeback as outdoor art.

From its earliest beginnings, hip-hop culture has drawn on international sources, notably the Jamaican reggae that was developing at the same time. Yet it also remains intensively local. Hip-hop began as outdoor party music, as a way for young people lacking

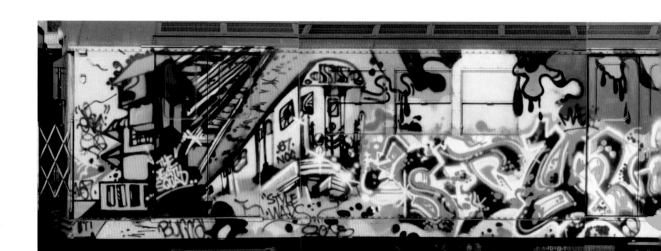

15.5. Melvyn Henry Samuels, Jr. "Noc," New York subway car, 1981
Like all graffiti artists, Noc had to create his paintings in secret, while subway cars were garaged over-
night. This car shows a subway car on the left, and the words "Style war" painted in two different styles,
one early, one late.

other outlets for recreation to have a good time. Jamaican popular music ("dub" and
"dance-hall") inspired the basketball court parties where hip-hop originated.

The acknowledged founder of hip-hop, DJ Kool Herc (Clive Campbell), was born
in Jamaica in 1955 and immigrated to the Bronx in 1967. He blasted out the music on
giant speakers, which he called "Herculords." As a DJ, Kool Herc worked two turntables
at a time, playing two copies of the same record. He not only selected the records; Herc
would stop one record, then the other, repeating favorite phrases to create looping "break
beats." Working the turntables, Herc improvised rhymes to recognize friends or convey
messages of political import. His rhymes followed in the tradition of Gil-Scott Heron (b.
1949) and the Last Poets, who were also active in New York in the late 1960s and early
1970s. During Herc's break beats, "B-boy" dancers (and very occasionally "B-girl" danc-
ers) would get up on the stage and dance jerky and original moves. Herc was also a break
dancer and graffiti artist.[44]

Among the other early DJs were Afrika Bambaataa (b. 1955) and Grandmaster Flash
(b. 1958). They divided the Bronx into personal territories and battled against each other
in non-violent competitions.[45] The DJs' rhymes or "raps" offer playful alternatives to
physical violence. Break dancing also simulated battles, in which dancers competed
with one another without touching. Graffiti artists also tried to outdo one another to see
who could write his (or, very occasionally, her) name or "tag" the most often or make the
most creative art with spray paint.

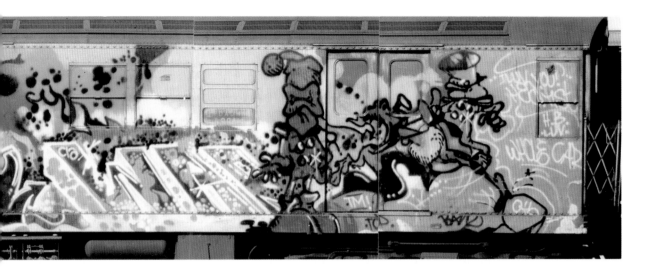

Grandmaster Flash perfected the critical rap music innovation of scratching. He used two turntables, scratching one record in rhythm or against the rhythm of another record while the second record is playing. Scratching, like break-beats and sampling, makes turntables into musical instruments.[46]

Rap music is the most widely circulated aspect of hip-hop culture, in large part because music can easily be mechanically reproduced in studios and sold for profit. (Graffiti art and break dancing are much harder to reproduce and distribute by the millions.) Sylvia Robinson (b. 1948) of the small, independent Sugar Hill Records produced the first hit rap record in 1979, the Sugar Hill Gang's "Rapper's Delight." Within a few months "Rapper's Delight" sold millions of copies, reaching the top of the pop charts. "Rapper's Delight" demonstrated rap's money-making potential.[47] In the early 1980s rappers began to appear on the popular television show "Soul Train." Grandmaster Flash and the Furious Five recorded the first socially conscious raps, and "Planet Rock" by Afrika Bambaataa and the Soul Sonic Force sold 100,000 records (that is, it "went gold"). Rap's first decade—the mid-1970s to the mid-1980s—is fondly remembered as "Old School," or "Back in the Day," an era when rapping was not commercial, and rappers created music out of personal experience in their disadvantaged neighborhoods.

Rap music's preoccupation with police brutality and graphic sex made it controversial. Nonetheless the genre continued to make headway in American popular culture. Political rap surged to the top of the charts during the golden age, 1988 to the mid-1990s. Police brutality remained a staple topic in rap. The artist KRS-1 (n.d.) presents just one example in "Who Protects Us from You?" (1989):

You were put here to protect us, but who protects us from you?
Everytime you say, 'that's illegal,' does it mean that it's true?

In "Illegal Search" (1990), LL Cool J (b. 1968) spins out a drama of racial profiling (selectively targeting black motorists on the basis of their race) on the New Jersey Turn-pike inspired by incidents then in the news:

The car, the clothes, and my girl is hype
But you want to replace my silk for stripes.
You're real mad, your uniform is tight
Fingerprint me, take my name and height
Hopin' it will, but I know it won't work.
Illegal Search.[48]

The first women rappers to achieve great success were the group Salt 'N' Pepa. Their debut album, "Hot, Cool and Vicious" (1986), sold two million copies (that is, "double platinum"). Music Television (MTV), which had first refused to feature black artists, be-gan to broadcast rap music, including an entire show called "Yo! MTV Raps!" in 1989. Starting with *The Source*, magazines devoted to rap began to circulate. Rap's fabled golden age lasted from 1988 into the mid-1990s.

Rap's golden age inspired gritty movies about inner-city life in the 'hood, such as Mario Van Peebles's (b. 1957) *New Jack City* (1991); John Singleton's (b. 1968) movie starring the NWA rapper Ice Cube, *Boyz N the Hood* (1991); Ricardo Cortez Cruz's (b. 1964) *Straight Outta Compton* (1992) and *Menace II Society* (1993).[49] Tough, violent, and sexist, these films attracted white and Latino as well as black audiences. They glam-orized the raw masculinity of poor black men battling the evils of white supremacy and finding wealth in drug trafficking.

During the golden age of rap, Los Angeles joined New York City as a major source of rap. West Coast rappers specialized in criminal-minded, blood-curdling, woman-beating lyrics, earning their art the name "gangsta rap." In the mid-1990s, the com-petition between East Coast and West Coast rap turned violent, spawning fights and, ultimately, sensational murders. The 1996 drive-by shooting deaths of Tupac Shakur (1971–1996) and the Notorious B.I.G./Biggie Smalls (Christopher Wallace [1972–1997]) ended rap's golden age. Years after his death in 1996, Tupac Shakur remains the representative figure of the hip-hop generation. He was born into a family of Black Panther activists that experienced poverty and drug addiction.[50] A beautiful, heavily tattooed artist whose demons included weaknesses for drugs, sex, and violence, Shakur combined political and artistic sophistication, the materialism and violence of the thug life, and the sexual abuse of women in his music and his life. As gangsta rap's most in-fluential star, he symbolized the many contradictions of hip-hop culture and embodied its fetish for young black male authenticity.

Rap music defies easy characterization, for its messages are varied and even conflict-ing. Rap music is many things: politically critical, culturally astute, hedonistic, social realist, degrading to women, homophobic, homoerotic, moralizing, feminist, materialis-

tic, violent, black nationalist, entertaining, pornographic, and just plain fun—sometimes all at the same time. Women rappers like Lil' Kim (b. 1975) and Foxy Brown (b. 1979) produce some of the raunchiest raps. Others, like Salt 'N' Pepa, Queen Latifah (b. 1970), and Lauryn Hill (b. 1975) rap as feminists.

Rap artists use the word "Niggaz" to designate a particular group of black people who are said to be authentically black—the young, poor, oppressed black men of the ghetto. They are the victims of police brutality, the drug culture, and a lack of opportunities for legal success. Niggaz come from the impoverished 'hood to which they are fiercely loyal. Rappers surround themselves with their friends from the 'hood, their posse or crew. Their songs evoke the 'hood in specific terms, and their videos are set in the heart of the rapper's own 'hood. Niggaz cannot be middle class, because in hip-hop culture, the black middle class cannot be authentically black.[51] Even hip-hop artists who once were considered Niggaz can lose their authenticity by selling out through too much American material success. They might sell their music to advertisers, become movie stars, or seem to go out of their way to seek the approval of white people.[52]

In addition to rap music, hip-hop culture has given rise to its own versions of movies, poetry, and fashion. Hip-hop culture has also brought new wealth to artists and behind-the-scenes professionals, including producers, talent scouts, camera operators, editors, and recording executives. In 2001 Antonio "L.A." Reid (b. 1958) moved from a small hip-hop and R & B company to head Arista, a major pop label. Russell Simmons (b. 1958), founder of Def Jam Records, created television and Broadway shows with music, comedy, and poetry. In 1999 Lauryn Hill (b. 1975) was nominated for eleven Grammy Awards and won five, including Album of the Year and Best New Artist. She appeared on the cover of *Time* magazine.[53]

As the best-selling genre of popular music in the early years of the twenty-first century, rap music reaches millions of non-African-American consumers all around the world. Similarly, rap artists now come from every country. Rap in other countries gives voice to the poor, the oppressed, and the youth in revolt against official harassment.

Rap music and hip-hop culture create a coherent image of black people as centered in poor, urban neighborhoods. At its best, it levels a powerful critique against injustice in the name of black people as a whole. At its worst, it treats women as objects of abusive sex and glorifies bloodshed. In hip-hop culture, the middle-class, wealthy, and educated black people who were becoming more numerous either disappear or pose a threat to authentic African Americans.

Monuments, commemorations, Afrocentrism, and hip-hop represent important outgrowths of the cultural nationalism that flowered in the 1960s and 1970s. Although cultural nationalism began with an emphasis on the African dimension of African-American identity, much of that emphasis has shifted with the passage of time. The opening of American institutions to black people offered new opportunities, especially to the young. As one of the core institutions of American culture, the U.S. military presents a prime example.

Opportunity in the Military, Opposition to War

For a generation following the war in Vietnam, the U.S. military contended with white supremacy in its ranks. As a result, African Americans encountered a more level playing field there than in civilian businesses, and military service offered thousands of black Americans a relatively open route into the American middle class. The all-volunteer army engaged in combat in the Gulf War of 1991, and the Iraq War of 2003 consisted of young women and men seeking broader economic opportunities, such as college tuition and job training.. Many came from the South, where more than half of African Americans still live.

In stark contrast to the situation in Vietnam (and any earlier American wars), 12 percent of army officers were black during the two Gulf wars.[54] During the Gulf War of 1991, General Colin Powell led the American Armed Forces as Chairman of the Joint Chiefs of Staff. In the Iraq War of 2003, other African Americans were especially visible. Vincent K. Brooks (b. 1959), an African-American brigadier general, conducted daily briefings for the press. Enlisted woman Shoshana N. Johnson (b. 1973) was among the first Americans to be taken as prisoner in the first days of the war.

In the Gulf War of 1991 and the Iraq War of 2003, African Americans formed nearly one-quarter of the fighting forces. The self-taught Southern artist Herbert Singleton, Jr. (b. 1945), created a sculpture portraying the trade-off for black enlisted personnel serving in the Persian Gulf: "Blood for Oil" (15.6). Singleton's young nephew, Steven Beaty, was serving in the U.S. Army during the approach of the first Gulf War.

Despite the ubiquity of black servicemen and servicewomen in Iraq, African Americans were the least enthusiastic segment of the U.S. population toward the war. Black opposition surfaced early. Following the terrorist attacks on New York City and Washington, D.C., on September 11, 2001, only one member of Congress, a black woman Barbara Lee (b. 1946), representing Oakland and Berkeley in the San Francisco Bay Area, voted against an open-ended resolution giving President George W. Bush unlimited power to wage a "war on terrorism."[55] The Congressional Black Caucus and the NAACP both opposed the war as a misuse of funds that were needed in black communities and poor neighborhoods.

As the Iraq War approached in late 2002 and early 2003, opinion polls showed that most African Americans did not support the war, although majorities of others favored the policies of President George W. Bush. Polls taken between October 2002 and April 2003 found that between 20 percent and 44 percent of African Americans supported the war, compared with overall American support at around 70 percent. A philosophy student at the traditionally black Lincoln University in Pennsylvania spoke for many African Americans: "Bush is more of an immediate threat to me [than Saddam Hussein]" because Bush opposes affirmative action.[56]

African Americans offered many reasons for not supporting the American invasion of Iraq, ranging from opposition to President Bush's policies in general to a sense that other, domestic needs better deserved the money spent on the war. However, the Georgia artist

15.6. Herbert Singleton, Jr., "Blood for Oil," 1990

Singlegon depicts his nephew, Steven Beaty, who risked shedding his blood for American access to oil in the Middle East. The phrase "no blood for oil" became an antiwar rallying cry during the first and second Gulf wars.

15.7. O. L. Samuels, "Saddam Husein," 1992
In a rare depiction by a black artist of a foreign policy issue,
Samuels presents the deposed president of Iraq as a horned
monster.

O. L. Samuels (b. 1931) shows that black opinion on policy toward the Middle East is not monolithic. Samuels envisioned Saddam Hussein, the president of Iraq, as a monster in "Saddam Husein" (15.7).

Conclusion

Hip-hop's preoccupation with authentic blackness reflects the increasing difficulty of characterizing African Americans as a whole. During the late twentieth and early twenty-first centuries, black people were both more visible in American culture and more diverse politically. With black conservatives as prominent as rap artists—two black secretaries of state, and a black man and woman running for president—observers have been tempted to call the early twenty-first century the "post-black era."

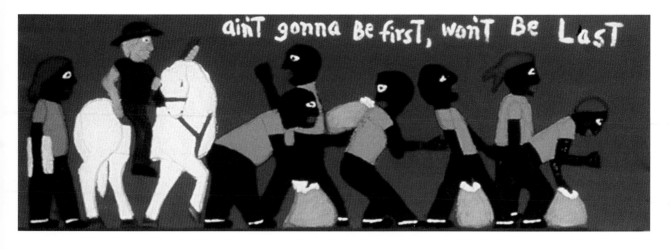

E.1. Herbert Singleton, Jr., "Ain't Gonna Be First, Won't Be Last," 1997
Singleton shows black prisoners today doing forced labor under conditions reminiscent of the nineteenth and twentieth centuries: under the eye of a white overseer.

A Snapshot of African Americans in the Early Twenty-First Century

African Americans, including artists, have taken note of the recent dramatic growth of the numbers of incarcerated black people, particularly men, but increasingly women. The self-taught artist Herbert Singleton, Jr., depicts his own prison experience in his painting "Ain't Gonna Be first, Won't Be Last"(E.1). Singleton emphasizes the racial differences between inmates and guards and gives instructions on how to survive: by not attracting attention. The dismaying numbers of black people in prison forms a counterpoint to the increase in the numbers of African Americans who live in relative ease and freedom. Millions of black people are in each of these contrasting situations. In the early twenty-first century, it is difficult to sum up in simple terms the condition of black people as a whole.

During the post–Black Power era, African Americans grew more obviously diverse, in terms of class and ethnicity. This does not mean that distinctions of class, gender, and geographical origin had not existed in the past. They had. But in the past, race—as African descent—trumped every other facet of identity: mixed-race people became simply black, and other ancestors simply disappeared. Immigrants of African ancestry, regardless of where they came from or what languages they spoke, became simply black. No matter how rich or poor, no matter where they lived, no matter how well or little educated, African Americans of any class became simply black.

In the post–Black Power era, however, such simplification no longer prevails. On the one hand, twenty-first-century African Americans are wealthier and better educated than ever before. On the other hand, the disadvantaged are more vulnerable than ever to incarceration and the family disarray it fosters. A snapshot of African Americans in the early twenty-first century reveals a growing divide between those doing well and

those doing poorly. This divide mirrors the economic situation of Americans as a whole. The United States Census of 2000 also showed the degree to which African Americans are ethnically and racially diverse. More black Americans come from other countries than at any time since the closing of the Atlantic slave trade in the early nineteenth century. By 2002 voluntary immigrants from Africa outnumbered those who had been forcibly transported in the Atlantic slave trade. In addition, millions of African Americans proclaim themselves to be of more than one race.

The Black Middle Class

The clearest gauge of overall well-being is socioeconomic status, although cultural life remains extremely important. The 1990s heard much of the emergence of a black middle class. Indeed, such a class does exist, based largely on increased educational opportunities after the end of legal segregation. While more black people than ever before are in the middle class according to income, their family wealth is extremely small. This relative lack of family wealth means that African Americans' middle-class status remains tenuous.

To be considered "middle class," a family generally must make between $34,000 and $54,400 (in 2003 dollars), with at least one member college-educated. By that definition, a sizeable black middle class is of recent origin. Before Southern emancipation in 1865, too few African American families earned enough income or owned enough wealth to constitute a class. During the era of segregation, the black middle class was tiny, consisting of business and professional people serving other African Americans. The other 90 percent of blacks worked as ill-paid agricultural, service, and unskilled laborers. As late as 1960, only 10 percent of African-American families were middle-class.[1]

The great era of growth for the black middle class occurred between the Second World War and the 1970s. Then full employment in wartime and the opening up of middle-class occupations to black women and men greatly increased the proportion of black people in the middle class. However the recession of the mid-1970s cost African Americans dearly. Since the mid-1970s, income inequality has continued to grow for all Americans: the extremely wealthy few are becoming much richer, while poor and working-class families are losing economic ground.

The boom times of the mid-to-late 1990s helped black Americans find more and better jobs. But the collapse of the boom in 2000 hit African Americans severely, particularly in terms of job loss and difficulties in getting rehired. In January 2004 the overall unemployment rate in the United States was 5.6 percent of workers in the workforce. The corresponding figure for black workers was 10.5 percent. Discrimination still exists in employ-

Table E.1. Median Family Income, by Race: 1950–1998 (in 1998 dollars)

Year	All Races	Black	White	B/W Ratio
1998	$46,737	$29,404	$49,023	59.0%
1990	35,353	21,423	36,915	58.0
1980	21,023	12,674	21,904	57.9
1970	9,867	6,279	10,236	61.3
1960	5,620	3,230	5,835	55.4
1950	3,319	1,869	3,445	54.3

Table E.2. Median Income in 1999 by Educational Attainment: Black Non-Hispanic Men and Women Age 25–34, March 2000 (in 1999 dollars)

	Total	Not High School Graduate	High School Graduate or GED	Some College, No Degree	Associate Degree	Bachelor's Degree or More
Men	$27,748	$17,058	$26,781	$26,165	$26,577	$37,968
Women	24,166	16,860	18,660	24,463	25,774	31,871

ment in the early twenty-first century. In Massachusetts and Pennsylvania, for instance, black applicants encountered discrimination almost half the time. Nationwide, discrimination occurred about 40 percent of the time.[2]

Over the long term, the gap in black-white income has closed only slightly since the mid-1970s.[3] In 1950, black families made almost 55 percent of white families' income; that percentage peaked at 61.3 percent in 1970. By the boom year of 1998, that proportion reached only 59 percent (Table E.1).

Comparing family income, in 2001 the median income for black families was $33,598, compared with $51,407 for all American families. Figured in constant 2001 dollars, black family income rose from $24,789 in 1970 to $25,788 in 1980, and $28,135 in 1990. In 1999, 6.1 percent of black families earned annual incomes of $100,000 or more.[4]

African Americans are able to earn higher lifelong incomes because they are better educated. A black person with a college degree now earns a life total of $1.7 million, compared to $1 million for a black worker with a high school education. A black worker who has not finished high school will earn a lifetime total of less than $1 million. A black person with an advanced degree earns $2.5 million over his or her working life (Table E.2).[5]

In 1980, 8 percent of black people over the age of twenty-five were college graduates. In 1990, the proportion had increased to 11 percent. In 2000, 17 percent of black Americans had graduated from college.[6] Black women, like all American women, attend college more than men. By 2002 more black women (17.5 percent) than black men (16.4 percent) had earned at least a B.A. degree (Table E.3).[7]

Table E.3. Increase in Number of Students Enrolled, by Race, Sex, and Level of Study, 1976 to 1997[8]

Degree Level	African-American Women	African-American Men	White Women	White Men
Undergraduate	68%	21%	31%	-5%
Graduate	91%	34%	41%	-12%
First Professional	209%	27%	91%	-26%

Family Structure Influences Class

Family structure influences economic well-being, for families headed by a single parent generally fare badly in economic terms. Because women of all races earn less than men, and young people earn less than older people with more education, skill, and seniority, families headed by single women, especially young single women, are more likely to be poor. In 1999, 8.9 percent of black men and 24 percent of black women aged twenty-five to thirty-four were living below the poverty level.[9] Not surprisingly, given these poverty figures, 58 percent of black families headed by a single woman had incomes of less than $25,000. Thirty-eight percent of black families headed by single men had incomes of less than $25,000.[10] More than half (51 percent) of black children younger than eighteen lived in female-headed households. (Eighteen percent of white children lived in families headed by single women.)[11]

Among all races and ethnicities, married people are better off economically than those who are unmarried. Between 1970 and 1998, married-couple black families reduced the income gap with white married-couple families by 14 percent. In 1970 black married couples made 73 percent of white family income. In 1998 black married couples made about 87 percent of white married-couple income. By 2002, 52 percent of black married-couple families had incomes of $50,000 or more. In 2002, 48 percent of black families were married couples, 43 percent were headed by single women, and 9 percent were headed by single men.

Because age and family structure influence family income, sociologists have closely watched rates of births to teenaged mothers, who risk not being married. Births to all women aged fifteen to nineteen have fallen steadily since their high point in 1991. Between 1991 and 2002, young black women registered the sharpest birthrate decline of all, from 118.2 to 68.3 births per one thousand women aged fifteen to nineteen, a drop of more than 40 percent.[12]

Black people have lower sex ratios (the number of men to women) and lower rates of marriage than other Americans. In the eighteen-to-thirty-four age group, there are only eighty-three black men to one hundred black women. Over the course of many decades, black people have increasingly tended to marry late, divorce, and remain single. Black men are more likely than black women to be married: 36.2 percent of black men compared to 28.9 percent of black women are married. (In 2000, 54.4 percent of the entire U.S. population over fifteen was married.)[13] Black men are about three times more likely than black women to marry someone of another race.[14] As a result of the confluence of all these forces, black women are likely to find themselves without partners who are also black. A quilt by Kyra E. Hicks (b. 1965) sums up the lonely situation of thousands of single black females wishing for the companionship of a single black male (E.2).

Wealth: A Sound Measure of Financial Well-being

Because income changes with fluctuations in employment, family wealth provides a better measure of financial well-being than income. Wealth includes all assets—

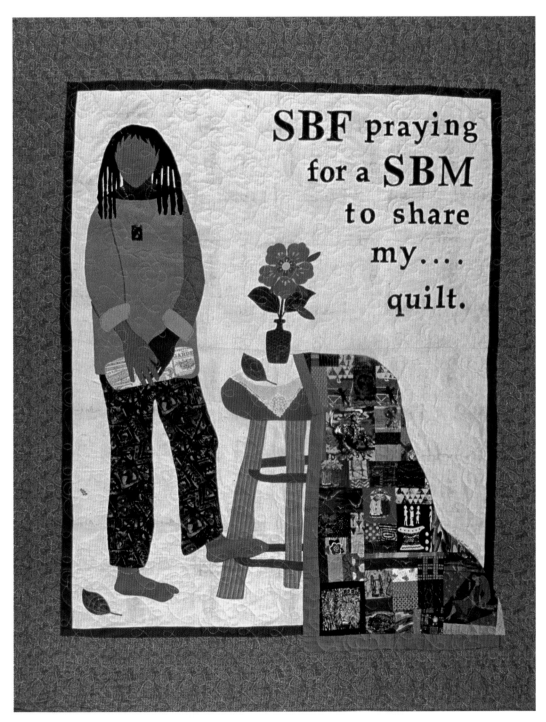

E.2. Kyra E. Hicks, "Single Black Female" quilt, 1994
Echoing the language of personal ads, Kyra Hicks shows a single black female who seeks the company of a single black male. The quilt within the quilt depicts happy couples consisting of people and pets.

houses, cars, bank accounts, investments, and other resources. Wealth influences whether families can purchase their own homes, send their children to college, and survive hard times without catastrophic loss. African-American family wealth lags very far behind the wealth of white families and slightly behind that of Latino families.[15] In 1995 (the most recent figures available) the median wealth for all American households was $40,200. White families had a median wealth of $49,030; Latino families, $7,255; African-American families, $7,030.

Much of the disparity in family wealth relates to home ownership. The value of homes accounted for 44 percent of the total net worth of households in 1995.[16] In 2001, 68 percent of all American households lived in their own homes. The figures were much lower for black people: only 47.5 percent of black families owned their own homes in 2001. This lower rate reflects lower incomes as well as continuing discrimination in mortgage lending. A study by the Urban Institute released in April 2002 showed that African-American applicants for home loans faced what the study called "a significant risk of receiving less favorable treatment than comparable whites." (The study did not quantify "significant.") In 2002 Ishmael Reed (b. 1938), a noted African-American writer and professor at the University of California, Berkeley, discovered that he was being asked to pay higher interest charges on a home equity loan than applicants in the parts of town that were dominated by whites.[17]

Although black family wealth has increased, black families remain far poorer than white families. If the patterns of the last fifteen years hold in the future, it would take two hundred years for the median black family wealth to equal half of that of white families.[18]

African Americans at the Extremes of Wealth and Poverty

Wealth and income inequality have increased drastically for all families in the United States. This is also the case among African Americans. Sports stars and entertainers make huge incomes, but usually only for a few years when they are young. A few African Americans have become extremely wealthy over the course of several decades. Bill Cosby (b. 1937), a television star since the 1960s, was the most popular sit-com star of the 1980s in the internationally syndicated "Cosby Show." He and his wife Camille (b. 1944) own a fine art collection and have donated millions to black colleges such as Spelman College in Atlanta and Bennett College in Greensboro, North Carolina. (Both colleges serve black women. The anthropologist and gifted administrator Johnnetta Cole [b. 1936] headed Spelman in the 1990s and Bennett in the early twenty-first century.)

Reginald Lewis (1942–1993), Robert Johnson (b. 1946), Oprah Winfrey, and Alphonse Fletcher, Jr. (b. 1966), are highly visible as earners and philanthropists. The sources of their wealth differ from those of an earlier black millionaire, Madam C. J. Walker. Living in the era of segregation, Walker's clientele was virtually all black. But the wealth of Lewis, Johnson, and Winfrey comes from people of all races and ethnicities.

After graduating from Harvard Law School, Lewis founded the first black Wall Street

law firm in 1970, and in 1983 he established the TLC Group to buy and sell companies. TLC bought the McCall Pattern Company for $22.5 million and sold it four years later for $90 million. In 1987 Lewis made the largest leveraged buyout of a foreign company in U.S. history by acquiring the French-based Beatrice Food Company for $985 million. TLC-Beatrice became the largest black-owned and managed company in the world, with annual sales of $2.2 billion. Lewis established the Reginald F. Lewis Foundation in 1987 and gave away about $10 million to educational, children's, civil rights, and arts causes. He gave Howard University $1 million and Harvard Law School $3 million.[19] Lewis died suddenly in 1993.

In 2001 Robert Johnson became the first African-American billionaire. Johnson made his fortune with Black Entertainment Television (BET), which he founded in 1980. In 2000 he sold BET to the Viacom entertainment conglomerate for $3 billion. In addition to his $1.5 billion worth of Viacom stock, Johnson owns numerous businesses, including hotels, restaurants, lotteries in Latin America and the West Indies, recording and publishing companies, and a professional basketball franchise team in Charlotte, North Carolina.[20]

Winfrey became a billionaire in 2003, one of only 37 women among the world's 476 billionaires, and the first black woman billionaire. Her national career began in 1986, when her Chicago television talk show went into national syndication. Winfrey formed a film company that produced movies based on novels by black women authors: *The Color Purple* (by Alice Walker), *Beloved* (by Toni Morrison), and *Their Eyes Were Watching God* (by Zora Neale Hurston). Winfrey also founded *O, The Oprah Magazine* and the cable network Oxygen. The winner of several Emmy awards for television programming and an Academy Award nomination, Winfrey exerts significant influence in the entertainment and publishing industries. Like Reginald Lewis and Bill Cosby, Winfrey has donated millions of dollars to those in need in the United States and Africa. Among her philanthropic donations are gifts to black South Africans and to Morehouse College in Atlanta, among many other charities. (Morehouse, Martin Luther King, Jr.'s, alma mater, serves black men.)

Alphonse Fletcher, Jr., a Wall Street financier, gave $50 million to institutions and individuals working to close the economic divide between different classes of African Americans to mark the fiftieth anniversary of the *Brown v. Board of Education* decision. He had earlier endowed a university professorship at his alma mater, Harvard University, which the Princeton University philosopher Cornel West (b. 1954) was the first to hold.[21]

While a tiny handful of African Americans have achieved wealth and success at a level never before possible, a sizeable minority of African Americans are poorer, more isolated, and more vulnerable to disease, drugs, crime, and mistreatment than ever. The plight of the inner-city poor inspired hip-hop culture. But hip-hop has proved no match to the scourge of HIV/AIDS and the incarceration of black men and women on a vast scale.

The Crisis of Drugs and Incarceration

The percentage of incarcerated individuals who are African American increased in the last generation. The number of black male inmates increased fivefold between 1980 and 2000.[22] Between 1972 and mid-2002 the prison population of all races rose 500 percent, to 2,019,234 inmates. About 600,000 of the 2 million inmates were black men between twenty and thirty-nine years old. In January 2004, 818,900 black men were incarcerated (compared to 630,700 white men). Such numbers mean that 12 percent of black men in their twenties and early thirties were incarcerated in 2002. Black women are the fastest growing segment of the prison population.[23]

Such large numbers of black inmates wreak havoc on families by reducing opportunities for marriage and separating spouses, parents, and children. In cultural terms, the prevalence of incarceration has made jail part of the symbolism of black masculinity. Rappers introduced prison garb into American fashion. Gangsta rap, with its criminal imagery, equates blackness with outlaw status.

High rates of criminal conviction influence politics by reducing the number of African Americans who can vote. In fourteen states (including Florida and Virginia), felons lose the right to vote for life. Other states suspend the right to vote for a matter of years. Disfranchisement for felony convictions keeps as many as a quarter of black men in various states from voting. Felony disfranchisement in Florida played an important role in the outcome of the presidential election of 2000. A conviction for drug possession can also deprive former inmates of access to governmental services, including public assistance, public housing, and civil service jobs.[24] Without these basic forms of assistance, poor individuals and families encounter obstacles when they attempt to gain education or hold their families together.

Some forms of punishment are meant solely to humiliate. In 1995 the state of Alabama reinstituted the chain gang, even though there was no market for the rocks that chain-gang prisoners broke up. No evidence exists to show that the chain-gang experience actually deters crime in Alabama. Virtually all the inmates condemned to the chain gang are African American, as the artist Purvis Young (b. 1943) shows in his protest painting, "The Chain Gang" (E.3).[25]

The War on Drugs Sends Hundreds of Thousands of African Americans to Prison

In 1990 the rapper Ice Cube asked, "Why more niggas in the pen than in college?"[26] Ice Cube's question sums up dramatic changes in incarceration in the last quarter of the twentieth and early years of the twenty-first centuries. In the mid-1990s, California and New York—the states with the largest prison populations—spent more on prisons than on higher education. In 2000, more black men were in prison than in college: 781,600 were incarcerated, 603,032 were in college. But the ratio was different as recently as 1980, when 143,000 black men were incarcerated and 463,700 were in college. What caused the dramatic increase in black men's incarceration rates? The single most important factor was the "war on drugs," which criminalized the

E.3. Purvis Young, "The Chain Gang," 1996
This painting, done in the light springtime colors of youth and based on Young's own experience, shows young black men shackled together on a chain gang.

nonviolent possession of illegal drugs and imposed mandatory prison sentences for drug possession.

The war on drugs also established more serious punishments for possessing the form of cocaine associated with black people than for possessing the form of cocaine associated with whites. Crack cocaine and powder cocaine are the same drug. Yet a person convicted in federal court of the intention to sell *five hundred* grams or more of powder cocaine—the form associated with whites—could receive a conviction of five years. Possession of five grams of powder cocaine usually results in probation. But a person convicted of the intention to sell five grams of crack cocaine—the form associated with blacks—automatically receives a five-year prison term. Conviction for possessing crack cocaine for the first time triggers a mandatory prison sentence.[27]

The war on drugs does not function impartially. Ninety percent of people convicted of crack cocaine offenses in 1994 were black (6 percent were Latino and less than 4 percent were white). In California the majority of crack cocaine users are white. Yet between 1988 and 1994 not a single white person was convicted for crack cocaine offenses.[28]

More black people go to prison for drugs of all kinds, even though more white people are drug users. Studies show that 13 percent of drug users are black people. But 35 percent of people arrested for drug possession are black; and 55 percent of those convicted are black. Of the convicted of all races, 74 percent of the people sent to prison are black. All across the United States, black men are 20 to nearly 60 percent more likely than whites to serve time for drug possession.[29] In light of such glaring racial disparities, the Congressional Black Caucus has called for a revision of the drug laws. Rap producers and artists like Russell Simmons have demanded that the state of New York reform its mandatory sentencing drug laws. The National Hip-Hop Political Convention in Newark in June 2004 focused on prison reform and voting.[30]

The Nation of Islam recognized the crisis of black inmates as early as the 1940s. The NOI reached out to men in prison like Malcolm Little, who became Malcolm X. Recognizing the pain of black men who were subject to stereotyping and violence, Minister Louis Farrakhan (b. 1933) organized the Million Man March (MMM) in Washington, D.C., in 1995. A men-only affair, the Million Man March was actually a rally that gave black men from all over the United States and from all walks of life a chance to come together and disprove their negative image. The Million Man March encouraged African-American men to organize 318 neighborhood committees to combat crime and encourage healthy families.[31] The MMM also spurred the organization of a Million Woman March for love and respect in 1997 in Philadelphia.

However inspiring they were in 1995 and 1997, the Million Man and Million Woman Marches could not defeat the poverty, unemployment, and resulting drug addiction that contributes to the incarceration of African Americans. Prisoners come overwhelmingly from poor neighborhoods with high rates of unemployment. In 1991, 64 percent of inmates in state prisons had not finished high school (compared to 19.8 percent of the gen-

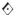

eral population). About 45 percent of the inmates lacked full-time jobs when they were arrested, and 33 percent were unemployed. Seventy percent made less than $15,000 per year (compared to 23.5 percent of all households).[32]

Prisoners' neighborhoods are the neglected, deindustrialized neighborhoods that lost jobs, public services, and financing in the 1960s and 1970s. They are the neighborhoods blighted by urban renewal and abandoned by city and state governments and by white people moving to the suburbs. HIV/AIDS and other diseases of drug use and neglect have blighted these neighborhoods since the 1980s.

In answer to the devastation of deindustrialization, unemployment, drugs, incarceration, and family disarray, black churches have created a range of social services. And black churches, even those in straitened economic circumstances, are more likely than nonblack churches to run community services.[33] Unlike the community action of the Civil Rights era of the 1950s and 1960s, which addressed segregation and racism, today's church activism addresses the devastation wrought by drugs and the war on drugs. Drug problems inspired 130 Washington, D.C., churches to create the Church Association for Community Services (CACS) in 1989. Today the CACS sponsors programs for children, adolescents, parents, and the unemployed, and it aggressively urges members to become homeowners.[34]

Although larger churches are more likely than smaller to engage in community service, Shiloh Missionary Baptist Church in New Orleans, with only about 200 members, transformed its crack-ridden neighborhood by purchasing and cleaning up the crack houses nearby.[35] Churches have contributed enormously to the regeneration of their neighborhoods since the 1980s. However, one area churches generally avoid is HIV/AIDS, despite the growing crisis.

Poor Health: A Chronic Problem for African Americans
As the poorest group in the United States, black Americans have always suffered disproportionately from the diseases associated with want, stress, and limited access to health care. In the past, black poverty and crowded conditions made African Americans tragically susceptible to tuberculosis. In the early twenty-first century, diabetes, homicide, asthma, and HIV/AIDS take a heavy toll in the black population, young and old. African Americans are twice as likely as white Americans to suffer from diabetes and five times more likely than whites to be victims of homicide.

African Americans are nearly ten times more likely than whites to contract HIV/AIDS. In the 1980s, when HIV/AIDS was first identified, gay white men suffered from it the most. But in 1996 black people became the most severely affected group in the U.S. population. By 2001, 38 percent of the total HIV/AIDS cases and 36 percent of the total HIV/AIDS deaths had occurred among African Americans. By 2001, 55 percent of people newly diagnosed with HIV/AIDS were black. Black women constitute the fastest growing population with HIV/AIDS. In 2003, black women were contracting HIV/AIDS twenty times more often than white women and five times more often than

Latinas. HIV/AIDS is one of the three leading causes of death among black women aged thirty-five to forty-four.[36]

The black HIV/AIDS crisis represents only one facet, albeit catastrophic, of African Americans' increased susceptibility to illness and death. Studies show that even when income and access to health care are made equal, black people fall ill and die more frequently than others. This is the case even though black people are less likely than whites to be addicted to alcohol or commit suicide.

Racial and Ethnic Diversity of African Americans

Although hip-hop culture idealizes a unified black people, in the early twenty-first century, African Americans are tremendously diverse. Americans of Indian, African, and European ancestry have produced children together, whether voluntarily or involuntarily, since the seventeenth century. Consequently African Americans have always been multiracial, ranging in color from very dark to very light. In the past, however, the tiniest drop of African ancestry made one black. The possibility of Irish or Welsh biological ancestry lingered only in the preponderance of Irish (for instance, McCall) and Welsh (for instance, Jones) names among black Americans.

In 2000, for the first time in history, the U.S. Census recognized that Americans could be of more than one race. Of the 36,419,434 people reporting themselves as black or African American, 34,658,190 said they were only black; 1,761,244 (4.8 percent) said they were black in combination with another race. Those people were likely to be young and to live in the West.[37]

The situation of people declaring themselves of more than one race is complex: Two percent of the population declaring itself black alone also said they were Latino, while 18.5 percent of black people reporting themselves as more than one race reported themselves as Latino.[38] After reporting mixed-race statistics for the Census of 2000, the Census Bureau soon returned to reporting the population as though people were of only one race. In his "Boondocks" comic strip, which went into national syndication in 1999, the cartoonist Aaron McGruder (b. 1974) introduces Jazmine, a biracial neighbor of Huey, the central figure, a black nationalist named for Black Panther Party founder Huey P. Newton. Huey and Jazmine live in a largely white suburb, the "boondocks." (E.4).

In 2001, the Census Bureau announced that the largest minority group in the United States was the 37 million Latinos, outnumbering the 36.2 million African Americans. The story turned out to be more complicated than the headlines. When people declaring themselves of more than one race (including Latinos) were taken into account, African Americans numbered 37.7 million. Black Americans were still more numerous than Latinos, who can be of any race.[39]

African Americans are ethnically diverse. They speak many different languages, especially various regional versions of English and Spanish. Their parents and grandparents come from all over the United States and from many other countries. In 2000, 2.2 million people, or 6.3 percent of the black population were foreign born. This propor-

E.4. Aaron McGruder, "Boondocks," 1999

In this Japanese *anime*-influenced cartoon, black nationalist Huey, the leading figure, meets Jazmine, his biracial neighbor. Reflecting the reluctance of some biracial youth to identify as black, Jazmine does not see her nappy hair as an afro and has not heard of Angela Davis. Huey calls Jazmine "Mariah" to insinuate that she is denying her blackness like the singer Mariah Carey.

tion was up from 4.9 percent in 1990. The most recent detailed information regarding the geographical origins of black immigrants comes from the Census of 1990. Most of the 1.6 million foreign-born people identifying themselves as black came from the West Indies (notably 230,000 Haitians and 334,000 Jamaicans) and Africa.[40]

Immigrants from Africa were better educated than native-born Americans of all races in 1999, when 94.9 percent of Africans in the United States were high school graduates or had higher education. The proportion of native-born Americans with at least a high school education was 92 percent. Sixty-eight percent of West Indians had at least a high school education. Although Africans were the best educated immigrants in the country, they did not earn the most. Families headed by Africans earned $36,371 in 1999, compared to $41,733 for families headed by an immigrant from Europe and $28,701 for families headed by a West Indian. Families headed by a native-born American earned $41,383 in 1999.[41]

The approximately one million voluntary African immigrants in the United States in 2002 represent a stunning symbolic milestone in African-American history. For the first time since the late eighteenth century, a sizeable proportion of "African Americans" are literally *African* Americans, having been born in Africa.[42] In 2002, the five African nations sending the largest numbers of immigrants to the United States were Nigeria (8,129), Ethiopia (7,574), Egypt (4,875), Somalia (4,537), and Ghana (4,256). More than half the African immigrants arrived in the United States between 1990 and 2000.[43]

Like other immigrants, Africans send earnings back to families at home: African residents in the United States send back about one billion dollars annually.[44] Like other immigrants, Africans can harbor negative stereotypes of native-born African Americans and hold themselves above people they think lack initiative. Immigrants' children's success in higher education has created tensions between black native-born and immigrant communities and somewhat complicates the workings of affirmative action. (Even though in

the 1970s U.S. courts barred the use of affirmative action to redress past injustice, many continue to see such policies in historical terms. Were affirmative action intended to redress historical wrongs, immigrants would hardly be eligible. But family background matters less in policies aimed at insuring racial-ethnic diversity.)

The long-term impact of African immigration remains to be seen. In the early twenty-first century, however, immigrants from Africa and their children heighten the visibility of ethnicity and culture among black Americans.

African Americans Are People of the City

In March 2002, thirty-six million Americans (13 percent) were black. More than half of all African Americans lived in central cities (51.5 percent) and/or in the South (55.3 percent). (For non-Hispanic whites, in comparison, 21.1 percent lived in central cities and 33.3 percent in the South.) Employment status has changed black Americans' regional distribution since 1970. As older Midwestern and Northeastern workers born in the South retired to the South, the Midwest and Northeast lost African-American population. As younger workers moved to the South for work, the South gained African-American population. The proportion of African Americans living in the South has increased from a low of 53 percent in 1970 and 1980 to 54.8 percent in 2000.[45]

Recent population changes are apparent in Newark, New Jersey. Newark's foreign-born black population is small but increasing. In 1980 5,085 of Newark's black people were born outside the United States. By 2000 that number had more than doubled to 11,129. This increase parallels developments in New Jersey and the United States as a whole.

In 2000, African Americans were still more than 50 percent of Newark's 273,546 residents, but since 1980 the black population had decreased almost 24 percent. Newark's Southern-born black population fell by 37,649 people between 1980 and 2000.[46] At the same time, the Latino population increased dramatically. By 2000 Latinos represented 30 percent of Newark's population.[47] Early in the twenty-first century, Latinos outnumbered African Americans in Newark's North Ward, threatening the version of black political power that prevailed in the 1970s. Overall Newark's political future may not be under siege, but the African-American-led, black-and-Latino coalition that wrenched power from Italian Americans in the 1970s may soon be a thing of the past.

At no point in African-American history have people of African descent in North America or the United States constituted a simple monolith. Differences of gender, geography, wealth, ethnicity, and political orientation have always existed. Rather than reflecting reality, the singular formulations of the past—"THE Negro," "THE black man"—answered American culture's demand for a faceless group lacking individuality. Black as well as nonblack people felt the need to simplify, for reasons of empowerment or victimization. Over the course of the nineteenth and twentieth centuries, and against great odds, African Americans have created themselves as a people. As visual artists among the creators have shown, the creation displays a beautiful variety.

After the end of slavery and legal segregation, many black people grasped new opportunities in American life. Some have gained more wealth and power than their ancestors, even their parents, could ever have imagined. They have held offices and won prizes that remained off limits for black people over the decades. A few have become so rich they can donate millions to favored charities. Some have become conservatives, gracing the entire spectrum of American politics with black and brown faces. As just one example of the new order, a black woman, Ruth Simmons (b. 1945), presides over Brown University in the Ivy League.

So many shining examples of achievement can blot out the sad realities that persist. After decades of deindustrialization, neglect, and segregation, the people living in American cities face desperate conditions. The warning signs appeared in the 1960s, in the urban uprisings that were so often and so wrongly ascribed to the racial failings of black people. (In the twenty-first century, those same conditions have come to affect white people in deindustrialized New England and the Midwest, producing sadly familiar results: unemployment, poverty, family break-up, drug addiction, crime, and incarceration.) Cities in the United States have not yet recovered the jobs needed to heal the ills of the poor. Until jobs return to the places where they live, African Americans will find it difficult to overcome the legacies of their past. That past includes the violence and economic injustice of slavery and the paltry opportunities within the bounds of segregation. "Racial profiling," the unjust targeting of people solely on account of their race, is a familiar phrase in the early twenty-first century. It stands for a whole range of burdens of race that remain all too present in African-American life. The burdens range from racial violence to discrimination and harassment.

As familiar as these burdens of race are, they cannot tell the story of African Americans making themselves as a people. This book reflects a range of creations, to show that at every point in history, African Americans have protested injustice and commemorated their heroes and their history. Until very recently, the commemorations remained little known, because the nonblack people who influenced media coverage and scholarship did not consider black commemoration worthy of notice. That situation changed dramatically in the late twentieth century, yielding a continuing bounty of remembrance.

Black artists have figured all along among the tellers of history, presenting everyday people and heroes alike in the beauty of visual art. The illustrations in this book represent only a small sample of art on historical themes by black artists. May readers recognize the richness of this art and add art to their study of African Americans' past!

⬥ Timelines ⬥

1: Africa and Black Americans

3000 B.C.	Ancient Egypt.
ca. 1–ca. 1076 A.D.	Ancient Ghana.
ca. 1235– mid-1300s	Ancient Mali.
ca. 700– ca. 1500	Ancient Songhay.
1798	Egyptian expedition of the French emperor Napoleon Bonaparte.
1826	Exhibit of Egyptian mummies in New York City.
1827	"Mutability of Human Affairs" in New York *Freedom's Journal*.
1829	*Appeal* of David Walker (ca. 1785–1830).
1882	*History of the Negro Race in America from 1619 to 1880*, by George Washington Williams (1849–1891).
1897	British punitive expedition in Nigeria takes thousands of works of art to London.
1897	American Negro Academy, founded in Washington, D.C.
1911	Negro Society for Historical Research founded in New York City.
1915	*The Negro*, by W. E. B. Du Bois (1868–1963).
1917	Marcus Garvey (1887–1940) founds Universal Negro Improvement Association (UNIA) and its newspaper, the New York *Negro World*.
1925	*The New Negro*, edited by Alain Locke (1885–1954).

2: Captives Transported, 1619–ca. 1850

1528–1534	Esteban (ca. 1503–n.d.) travels overland from Florida to Texas.
1575	Luanda founded.
1618–1619	Imbangala warriors and Portuguese forces attack Kabasa.
Spring 1619	Thirty-two Africans counted in Virginia.
August 1619	Twenty Ndongans landed at Jamestown.
1640–1680	British North American colonies pass a series of rules and statutes making Africans into slaves for life.
1712–1755	Bambara King Marmari Kulubari (n.d.) engages in warfare in Senegambian region.
1730	Ayuba Suleiman Diallo (1701–1773) captured.
1734	*Some Memoirs of the Life of Job, the Son of Solomon the High Priest of Boonda in Africa; Who was a Slave about two Years in Maryland; and afterwards being brought to England, was set free, and sent to his native Land in the Year 1734.*
1756	Capture of Olaudah Equiano (1745–1797).
1789	*The Interesting Narrative of the Life of Olaudah Equiano, or Gustavus Vassa, The African, Written by Himself.*

3: A Diasporic People, 1630–ca. 1850

1630	In *Re Davis* the Virginia court punishes Hugh Davis for having sex with a black person.

1641	In *Re Graweere* the Virginia court decides a black child could be freed in order to be raised as a Christian.
1662	Virginia court rules that children's status follows that of the mother.
1667	Virginia court rules that Christians can be enslaved for life.
1680	Virginia codifies rulings on enslavement.
1690	South Carolina's first slave code.
1692	Tituba (ca. 1670–1692) hung as an accused witch in Salem, Massachusetts.
1696	South Carolina's slave code revised.
1705	Virginia's slave code strengthened.
1712	New York City slave revolt, nine whites killed.
1712	South Carolina's slave code made comprehensive.
1730–1750	The Great Awakening.
1739	Stono rebellion in South Carolina: several dozen slaves kill a number of whites.
1741	New York City conspiracy.
1755	Charleston slave woman burned at stake for poisoning her master.
1773	Phillis Wheatley (ca. 1753–1784) publishes *Poems on Various Subjects, Religious and Moral* in London.
1779	Jean Baptiste Point du Sable (ca. 1745–1818) from Haiti founds Chicago.
1794	Richard Allen (1760–1831) leads founding of Bethel African Methodist Episcopal Church in Philadelphia.
1792–1797	Benjamin Banneker (1731–1806) publishes his Almanacs.
1796	Peter Williams (1763–1836) leads founding of the African Chapel in New York City.
1803	Harry Hosier (ca. 1750–1806) takes over the Methodist circuit of Trenton, New Jersey.
1816	African Methodist Episcopal Church connection founded.
1820–1824	African Methodist Episcopal Zion Church connection founded.
1820–1840	Second Awakening.
1850	United States census begins enumerating "blacks" and "mulattoes."

4: Those Who Were Free, ca. 1770–1859

1770	Boston Massacre. Crispus Attucks (1723–1770) becomes first martyr to the cause of the American Revolution.
1773	Black men petition the Massachusetts General Court for their freedom.

1775	Anthony Benezet organizes first anti-slavery society in the world.
Spring 1775	Battles of Lexington, Concord, and Bunker Hill in Massachusetts.
November 1775	George Washington bars black men from Continental Army. Earl of Dunmore offers black men freedom in exchange for fighting for the British. Twenty thousand blacks help the British Army by the end of the war.
December 1775	George Washington allows black men to fight in the Continental Army. Five thousand do so by the end of the war.
1777	Vermont's founding constitution outlaws slavery.
1778, 1789, 1780	Denied the right to vote, Paul (1759–1818) and John (n.d.) Cuffee refuse to pay property tax in Massachusetts.
1780	Twenty of Thomas Jefferson's slaves join the British Army.
1781	Elizabeth Freeman (ca.1742–1829) successfully petitions Massachusetts for her freedom.
1783	Slavery abolished in Massachusetts.
1787	Northwest Ordinance bars slavery from Western territories.
1789	Ratification of United States Constitution, including three-fifths clause.
1793	Passage of First Federal Fugitive Slave Act.
1791–1804	Haitian Revolution makes Haiti an independent republic.
1804	New Jersey becomes the last Northern state to provide for gradual abolition of slavery.
1827	First black newspaper, New York *Freedom's Journal*, founded.
1829	*David Walker's Appeal* published.
1830	Negro Convention movement begins.
1838	Frederick Douglass (1817–1895) escapes from slavery.
1850	Compromise of 1850. Fugitive Slave Act strengthened.
1857	*Dred Scott* decision rules no black people have rights as citizens.
1859	John Brown attacks the federal arsenal at Harper's Ferry, Virginia. Martin Delany (1812–1885) goes to West Africa seeking a new home for African Americans.

5: Those Who Were Enslaved, ca. 1770–1859

1793	Cotton gin invented for short-staple cotton.

1800	Gabriel Prosser (ca. 1775–1800) conspiracy, Richmond, Virginia.
1831	Nat Turner (1800–1831) insurrection lasts two days; fifty-nine white people are murdered.
1839	*Amistad* mutiny.
1849	Harriet Tubman (ca. 1821–1913) escapes from slavery.
1851–1852	Publication of Harriet Beecher Stowe's classic novel, *Uncle Tom's Cabin*, first serially, then as a bound book.

6: Civil War and Emancipation, 1859–1865

1859	John Brown's raid on Harper's Ferry, Virginia.
November 1860	Republican Abraham Lincoln elected president of the United States, reelected in 1864.
December 1860–April 1861	Eleven Southern states secede. Confederate forces fire on Fort Sumter in Charleston, South Carolina, harbor.
April 1861	Civil War begins, pitting the Union against the Confederacy.
May 1861	Fugitive slaves at Fortress Monroe, Virginia, recognized as "contraband of war."
August 1861	Union passes First Confiscation Act allowing fugitive slaves behind Union lines not to be returned to their owners.
July 1862	Union passes Second Confiscation Act declaring fugitive slaves and their families forever free and the Militia Act empowering the president to enroll black men in war service.
September 1862	Lincoln issues preliminary Emancipation Proclamation announcing his intention to free Confederate-held slaves.
January 1863	Emancipation Proclamation frees the enslaved in Confederate-held territory only. Black men officially admitted to service in the armed forces of the Union. Ultimately some 179,000 black men serve in the Union Army, and 9,600 in the Union Navy. Taking part in fifty-two engagements, 37,000 black men die in battle.
May 1863	Creation of the Bureau of Colored Troops in the War Department.
May and June 1863	Black troops help win battles of Port Hudson and Milliken's Bend, Louisiana, opening the Mississippi River to Union forces.
July 1863	Battle of Gettysburg in southern Pennsylvania, a turning point in the war.

	Battle of Fort Wagner, South Carolina; Massachusetts 54th takes heavy black casualties.
	Draft Riots in New York City and throughout Northeastern United States. Irish and other white workers attack black homes and institutions.
April 1864	Battle of Fort Pillow, Tennessee. Confederates massacre black troops.
June 1864 and March 1865	Pay of black soldiers equalized with pay of white soldiers.
April 1865	Civil War ends with Confederate defeat, Union victory. President Abraham Lincoln assassinated.
September 1865	Thirteenth Amendment to United States Constitution ratified, outlawing slavery in the entire nation, emancipating all who had been enslaved.

7: The Larger Reconstruction, 1864–1896

October 1864	Negro Convention meets in Syracuse, New York, calling for the vote for black men.
January 1865	Union General William Tecumseh Sherman's Special Orders No. 15 sets aside Georgia and South Carolina Sea Islands for black settlement.
March 1865	Creation of the federal Bureau of Refugees, Freedmen, and Abandoned Lands, known as the Freedmen's Bureau to last one year. The permanent Freedmen's Bureau bill vetoed by President Andrew Johnson in March 1866 and passed over his veto in April 1866.
1865–1867	Presidential Reconstruction. Former Confederates returned to power. Former Confederate states pass Black Codes.
1866	Ku Klux Klan formed in Tennessee. Passage of the Civil Rights Act, invalidated by U.S. Supreme Court in 1875.
May 1866	Memphis riot against Republicans.
July 1866	New Orleans riot against Republicans.
1867–1877	Congressional, or Radical Reconstruction begins. Black men vote in former Confederacy in 1867.
1867	Foundation of Howard University, Washington, D.C., and Fisk University, Nashville, Tennessee.
1868	Fourteenth Amendment added to the United States Constitution granting citizenship to freedmen (not women) reverses the *Dred Scott* decision of 1857.
1870	Fifteenth Amendment added to U.S. Constitution, giving freedmen (not

women) the conditional right to vote. The Reverend Hiram Revels (1822–1901) of Mississippi becomes first African-American member of U.S. Senate, replacing Jefferson Davis, former president of the Confederacy.

1873	Panic of 1873 creates economic hard times and orients politics away from Reconstruction and toward labor issues.
1877	Republican Rutherford B. Hayes becomes president after Compromise of 1877, which ends Reconstruction and abandons African Americans to the politics of Southern states.
1881	Foundation of the Grand United Order of the True Reformers in Richmond, Virginia.
1881	Foundation of Tuskegee Institute in Tuskegee, Alabama. Booker T. Washington (1859–1915), principal.
1884	Ida B. Wells (1869–1931), a Memphis, Tennessee, school teacher, removed from first-class railroad accommodation on account of her race. She sues the company, wins, then loses on appeal.
1890, 1896	T. Thomas Fortune (1855–1928) forms the National Afro-American League and Afro-American Council to press for black civil rights.
1892	Frances Ellen Watkins Harper (1825–1922) publishes *Iola Leroy*, one of the earliest novels by a black American.
1892, 1895, 1896, 1899	Paul Laurence Dunbar (1872–1906) gains fame through the publication of four books of poetry.
1892	Ida B. Wells denounces lynching in her newspaper, the *Memphis Free Speech*. She publishes an antilynching pamphlet, *Southern Horrors: Lynch Law in All Its Phases*.
February 1895	Death of Frederick Douglass, the nineteenth century's most prominent African American.
June 1895	W. E. B. Du Bois (1868–1963) receives a doctorate from Harvard University. He is the first African American to earn a Ph.D.
September 1895	Booker T. Washington emerges as most visible black American with an accommodating speech (the "Atlanta Compromise") at the Cotton States and International Exposition in Atlanta, Georgia.
1896	In *Plessy v. Ferguson* the U.S. Supreme Court declares segregation legal under the "separate but equal" formula, barring African Americans from Southern public life and civil rights.

8: *Hard-Working People in the Depths of Segregation, 1896–ca. 1919*

1896	African-American clubwomen found the National Association of Colored Women (NACW).
1896	Creation of the National Association of Colored Men in Detroit.
1897	Victoria Earle Matthews (1861–1898) founds the White Rose Mission and Industrial Association in New York City for the care of black working women.
1897	Formation of the American Negro Academy in Washington, D.C.
1898–1899	Spanish-American War makes the Philippines, Puerto Rico, and Cuba dependencies of the United States. The "Buffalo Soldiers" serve in Cuba and Puerto Rico with Theodore Roosevelt's "Rough Riders."
1899	W. E. B. Du Bois publishes *The Philadelphia Negro*, the first sociological study of African Americans.
1900	First Pan-African Conference in London.
1900	Booker T. Washington fosters foundation of the National Negro Business League in Boston.
1901	Booker T. Washington publishes his autobiography, *Up From Slavery*.
1903	W. E. B. Du Bois publishes *The Souls of Black Folk*, analyzing African-American life and criticizing Washington for blocking black civil rights.
1905	W. E. B. Du Bois leads the foundation of the Niagara movement of black intellectuals demanding equal civil rights.
1905	Robert Abbott (1870–1940) begins publication of the Chicago *Defender*.
1909–1910	Formation of the National Association for the Advancement of Colored People (NAACP) in New York City.
1911	Foundation of the National Urban League to aid black migrants to cities.

9: *The New Negro, 1915–1932*

1915	The pro-Ku Klux Klan film *Birth of a Nation* spurs the formation of a new Ku Klux Klan in Atlanta, Georgia.
1915	Formation of the Lincoln Motion Picture Company, which folded in 1921.

1916–1919 Great Migration of some half million black Southerners to Northern cities like Chicago, New York, and Detroit.

1917 A. Philip Randolph (1889–1979) and Chandler Owen (1889–1967) begin publishing *The Messenger* in New York City.

1917 Cyril Briggs (1888–1955) founds the African Blood Brotherhood in New York City as a revolutionary secret order against lynching and racial discrimination.

1917 The United States enters the European War, which had broken out in 1914. Some 380,000 black men served in the conflict, almost one-half in Europe.

1917 Antiblack riot in East St. Louis, Illinois.

1919 W. E. B. Du Bois convenes second Pan-African Congress.

1919 The Red Summer of antiblack riots, including Chicago, Washington, D.C., and Longview, Texas.

1919 Veterans of the 369th Infantry Division of the U.S. Army parade in New York City.

1920 Mamie Smith (1883–1946) records "Crazy Blues" for Okeh Records, the first recorded blues.

1921 *Shuffle Along* becomes the first black Broadway hit musical.

1921 W. E. B. Du Bois convenes third Pan-African Congress.

1923 Publication of Jean Toomer's (1894–1967) *Cane,* opening the era of the Harlem Renaissance.

1923–1926 Marcus Garvey (1887–1940) and his Universal Negro Improvement Association (UNIA) at their peak, when they published the *Negro World* weekly newspaper.

1925 *The New Negro,* edited by Howard University Professor Alain Locke (1885–1954)

1926 Harlem Renaissance authors Langston Hughes (1902–1967) and Claude McKay (1889–1948) publish *Weary Blues* and *Home to Harlem.*

1927 W. E. B. Du Bois convenes fourth Pan-African Congress.

1931 Elijah Muhammad (1897–1975) founds the Nation of Islam in Detroit, Michigan.

1932 Thomas A. Dorsey (1899–1993) turns from blues to gospel music with "Precious Lord."

1937 Publication of Zora Neale Hurston's (1891–1960) novel, *Their Eyes Were Watching God.*

10: Radicals and Democrats, 1930–1940

1929 New York stock market crashes, ushering in the Great Depression of the 1930s.

1931 Nine young black men accused of rape and condemned to death in Scottsboro, Alabama. They become internationally known as the "Scottsboro boys" cause celebre.

1931 Foundation of the Alabama Sharecroppers Union.

1932 Black urban unemployment at 50 percent nationwide.

1932 Mary Church Terrell (1863–1954) writes pamphlet: "Colored Women and World Peace."

1932 New York governor Franklin D. Roosevelt elected president.

1933 The Brotherhood of Sleeping Car Porters and Maids, led by A. Philip Randolph, represents some 35,000 workers.

1933 The federal "First New Deal," in which recovery policies discriminate against African Americans.

1933 NAACP, NUL, and thirteen other organizations form the Joint Committee on Economic Recovery.

1934 African Americans attempt to vote in Georgia and South Carolina.

1934 Creation of the interracial, socialist Southern Tenant Farmers Union in Arkansas.

1935 The federal "Second New Deal," in which recovery policies discriminate less against African Americans.

1935 W. E. B. Du Bois publishes *Black Reconstruction in America, 1860–1880,* refuting white supremacist histories of the period.

1935 Fascist Italy bombs and occupies Ethiopia.

1935 Breaking away of the Committee (in 1938 the Congress) of Industrial Organizations from the American Federation of Labor.

1935–1942 "Don't Buy Where You Can't Work" campaigns in Northern cities.

1935 Riot in Harlem, New York, set off by rumor of police brutality.

1936 Creation of the National Negro Congress, headed by Ralph Bunche (1904–1971) and John P. Davis (1905–1973).

1936 Franklin D. Roosevelt reelected president with enthusiastic African-American backing. Blacks switch from Republican

to Democratic Party allegiance, becoming part of the New Deal coalition.

1937 Southern Negro Youth Congress founded.

1938 NAACP assault on separate-but-equal in education under Charles Hamilton Houston (1895–1950) achieves its first success with *Missouri ex rel. Gaines v. Canada*.

1939 E. Franklin Frazier (1894–1962) publishes first sociological study of black families: *The Negro Family in the United States*, refuting racist scholarship on the topic.

1939 Horace Mann Bond (1904–1972) publishes *Negro Education in Alabama: A Study in Cotton and Steel* detailing the effects of capitalism and segregation in Southern education.

1940 Richard Wright (1908–1960) publishes *Native Son*, the first best-selling novel by a black author.

1941 Publication of William Attaway's (1911–1986) novel of black steelworkers, *Blood on the Forge*.

11: The Second World War and the Promise of Internationalism, 1940–1948

1937, 1942 Paul Robeson (1898–1976) and Max Yergan (1892–1975) found and revive the Council of African Affairs to publicize colonial issues.

1941 The United States joins the Second World War after the Japanese attack on Pearl Harbor. Hostilities in Europe and Asia had broken out in 1939. Nearly half a million African Americans, women and men, served in Europe and Asia during the war.

1941 March on Washington movement's Double Vee campaign against segregation and exclusion. President Franklin D. Roosevelt issues Executive Order 8802 against discrimination in war industries and for Fair Employment Practices Commission.

1941–1945 Some 1.6 million Southern blacks move to the North and West.

1942 Formation of the Congress of Racial Equality (CORE).

1943 After police killing of a Harlem resident, Harlem riot.

1943 Whites attack blacks in Detroit riot.

1944 U.S. Supreme Court decides *Smith v. Allwright*, striking down the white primary in Texas and, by extension, in other Southern states.

1944 South Carolina Progressive Democratic Party sends delegates to the Democratic nominating convention in Chicago. They are not seated.

1944 Publication of *An American Dilemma: The Negro Problem and Modern Democracy* under the leadership of Swedish economist Gunnar Myrdal.

1945 Second World War ends with the surrender of Germany and then Japan.

1945 Pan-African Conference in Manchester, England, presaging African independence.

1945 John H. Johnson (b. 1918) founds *Ebony* magazine.

1945 Creation of the United Nations Organization in San Francisco, to be housed in New York City.

1946–1947 Southern black Second World War veterans attempt to register to vote. Some two dozen racially motivated killings in the South; at least ten of those murdered were veterans.

1947 India becomes independent.

1947 President Harry S. Truman's Civil Rights Commission issues report, *To Secure These Rights*.

1947 CORE begins its "Journey of Reconciliation" to test the desegregation of interstate commerce.

1947 Jackie Robinson (1919–1972) of the Kansas City Monarchs (a Negro League team) breaks the color bar in big league baseball, signing with the Brooklyn Dodgers.

1948 Progressive Party presidential candidate Henry A. Wallace attracts support from blacks on the left and CPUSA.

1948 The Democratic party's nominating convention adopts a strong civil rights plank. Southern delegates walk out and form the States' Rights ("Dixiecrat") party.

1948 President Truman signs Executive Order 9981 desegregating the United States Armed Forces.

12: Cold War Civil Rights, 1948–1960

1946 Winston Churchill of Great Britain gives speech announcing the existence of an "iron curtain" between the Communist and "Free" worlds. Signal for the

beginning of the Cold War between the United States and the Soviet Union.

1948 Harry S. Truman wins the presidential election, running on a civil rights platform and defeating Wallace (Progressives) and Thurmond (Dixiecrats).

1949 Indochinese (Vietnamese) nationalists win independence from the French.

1950–1953 Korean War, the first in which U.S. Armed Forces are desegregated.

1950, 1951 U.S. government revokes passports of W. E. B. Du Bois and Paul Robeson, depriving them of the right to travel outside the United States.

1951 John P. Davis (1905–1973) and William L. Patterson (1981–n.d.) submit petition to United Nations demanding black civil rights.

1952 Ralph Ellison (1914–) publishes his critically acclaimed novel, *Invisible Man*.

1954 In *Brown v. Board of Education*, the U.S. Supreme Court declares segregation in education illegal.

1955 Richard Wright attends the Bandung Conference of unaligned nations.

1955 James Baldwin (1924–1987) publishes *Notes of a Native Son*.

1955 Marian Anderson (1897–1993) becomes first black soloist in the New York Metropolitan Opera.

1955–1956 The Reverend Martin Luther King, Jr. (1926–1968), emerges as civil rights leader during bus boycott in Montgomery, Alabama.

1957 The British colony of the Gold Coast becomes self-governing as Ghana. Ghana becomes a republic in 1960. Black Americans move to this beacon of pan-Africanism.

1957 Passage of federal Civil Rights Act of 1957 on voting rights.

1957 School desegregation crisis in Little Rock, Arkansas.

1958 Berry Gordy, Jr. (b. 1929), founds Motown Records.

1959 Play by Lorraine Hansberry (1930–1965), *A Raisin in the Sun*, becomes first serious black play to succeed on Broadway and wins Drama Critics Circle Award. (Hansberry was the first black person to win this award.)

1959 Robert F. Williams (1925–1996) of Monroe, North Carolina, starts publishing *The Crusader*.

1960 The British colony of Nigeria and other former colonies in Africa become independent. Ambassadors from Nigeria and other newly independent African nations take seats in the New York–based United Nations.

13: Protest Makes a Civil Rights Revolution, 1960–1967

1960 Student Non-Violent Coordinating Committee (SNCC) formed.

1960 John F. Kennedy elected president of United States.

1961 Freedom Riders attacked in Deep South.

1961 Albany, Georgia, movement fails to desegregate city but showcases movement music with Bernice Johnson Reagon (b. 1942).

1962 Thirty-one thousand U.S. troops occupy riot-torn Oxford, Mississippi, as James Meredith (b. 1933) registers for classes at the University of Mississippi.

1963 Southern Christian Leadership Conference (SCLC) demands civil rights in Birmingham, Alabama. Police use dogs and fire hoses on children. Martin Luther King, Jr., jailed. Writes "Letter from Birmingham Jail," published in 1964 as *Why We Can't Wait*.

1963 Medgar Evers (1925–1963) assassinated in Jackson, Mississippi. His assassin was retried and convicted in 1994.

1963 W. E. B. Du Bois dies in Ghana, West Africa.

1963 More than 250,000 people attend the March on Washington. King delivers "I Have a Dream" speech.

1963 Bombing of Sixteenth Street Baptist Church, Birmingham, kills four girls.

1963 President John F. Kennedy assassinated in Dallas, Texas. Malcolm X (1925–1965) suspended from Nation of Islam.

1964 Malcolm X resigns from Nation of Islam, founds the Muslim Mosque, Inc., makes his first pilgrimage to Mecca, and founds the Organization of Afro-American Unity.

1964 Freedom Summer in Mississippi institutes freedom schools and registers voters. James Chaney (1943–1964), Michael Schwerner, and Andrew Goodman murdered, Philadelphia, Mississippi. Mississippi Freedom Democratic Party (MFDP), led by Fannie Lou Hamer (1917–1977), attends Democratic

1964 Nominating Convention, Atlantic City, New Jersey.

1964 Urban revolts in Philadelphia, Jersey City, Rochester, and New York City.

1964 President Lyndon Johnson signs into law the Civil Rights Act of 1964.

1964–1965 Great Society legislation creates Job Corps, Head Start, Medicare, Medicaid, and other programs to wage war against poverty.

1964 Muhammad Ali (born Cassius Clay) (b. 1942) reveals his membership in Nation of Islam, having joined in 1961.

1964 Martin Luther King, Jr., wins Nobel Peace Prize.

1965 Malcolm X assassinated in New York City.

1965 Urban revolt in Watts district of Los Angeles.

1965 Montgomery to Selma, Alabama, march for voting rights.

1965 Passage of Voting Rights Act of 1965.

1967 Thurgood Marshall (1908–1993) becomes the first black U.S. Supreme Court justice.

1967 Martin Luther King, Jr., opposes war in Vietnam.

14: Black Power, 1966–1980

1965 Publication of *Autobiography of Malcolm X* and "Message to the Grass Roots."

1966 SNCC chairman Stokely Carmichael and Willie Ricks (b. ca. 1943) call for Black Power on James Meredith's "Walk Against Fear" in Mississippi.

1966 Black Panther Party for Self-Defense founded in Oakland, California. Later drops "Self-Defense" from its name.

1966 Maulana Karenga (b. 1941), head of US Organization, creates the African-American holiday Kwanzaa ("First Fruits") in Los Angeles.

1967 Urban revolts in Newark, New Jersey, and Detroit, Michigan.

1967 Stokely Carmichael (1941–1998) and Charles V. Hamilton (b. 1929) publish *Black Power: The Politics of Liberation in America.*

1968 Tet offensive by Vietnamese Communists reveals weakness of U.S. and South Vietnamese troops.

1968 Martin Luther King, Jr., assassinated in Memphis, Tennessee. Revolts in more than 100 cities around the United States.

1968 SCLC's multiracial Poor People's Campaign.

1968 Poet and playwright LeRoi Jones (b. 1934) changes his name to Imamu Amiri Baraka. He had founded the Black Arts Repertory Theatre/School in Harlem in 1965 and the Spirit House Players in Newark in 1967.

1968 Richard Nixon elected president. Running as a third-party candidate, George Wallace carries five Southern states.

1968–1969 Initial Black and Afro-American studies programs and departments in colleges around the United States.

1968–1972 Black Arts movement.

1969 Founding of the Congressional Black Caucus.

1970 Angela Davis (b. 1944) drawn into the Soledad Brothers' cases in San Quentin, California. She is acquitted of all charges in 1972.

1970 Toni Cade Bambara (1939–1995) publishes *The Black Woman.*

1971 Melvin Van Peebles (b. 1932) produces the feature film *Sweet Sweetback's Badass Song,* the first "blaxploitation" movie.

1972 Coalition of Black Trade Unionists founded.

1972 National Black Political Assembly meets in Gary, Indiana.

1972 Shirley Chisholm (1924–2005) runs for president of the United States.

1972 Richard Nixon reelected president of the United States He resigns from presidency in 1974.

1973 Founding of the National Black Feminist Organization in New York City.

1975 Elijah Muhammad (1897–1975) dies in Chicago. Son Wallace Muhammad reorganizes NOI as World Community of al-Islam in the west and admits whites.

1975 North Vietnamese conquer South Vietnam, ending Vietnam War.

1976 Jimmy Carter elected president of the United States.

1977 Television series based on Alex Haley's (1921–1992) best-selling novel, *Roots,* attracts 130 million viewers as a miniseries and inspires Americans to investigate their genealogies.

1980 Robert Johnson (b. 1946) founds Black Entertainment Network (BET).

1980 Urban revolt in Miami, Florida, after

police who killed unarmed black motorist are acquitted.

1980 Ronald Reagan elected president of the United States after launching campaign in Philadelphia, Mississippi, and advocating "states' rights."

1980 National Black Independent Political party founded.

15: Authenticity and Diversity in the Era of Hip-Hop, 1980–2005

1978 Minister Louis Farrakhan (b. 1933) breaks from Wallace Muhammad's World Community of al-Islam in the West to reestablish the Nation of Islam. The rivalry between the two sects ended in 2000.

1978 In *University of California v. Bakke*, the U.S. Supreme Court allows affirmative action but bars quotas.

1979 Sugar Hill Gang records first commercial rap hit, "Rapper's Delight." In early 1980s it heads the pop charts.

1980 Ronald Reagan promises to end affirmative action.

1981 Journalist and former Black Panther Mumia Abu-Jamal (b. 1954) sentenced to death for alleged murder of a police officer. His case is the subject of much controversy and many appeals.

1982 Publication of Alice Walker's (b. 1944) novel, *The Color Purple*, which receives the American Book Award and Pulitzer Prize.

1983 Harold Washington (1922–1987) elected mayor of Chicago. He is reelected in 1987, and dies shortly thereafter.

1983 Reginald F. Lewis (1942–1993) founds TLC Group, which buys and sells international companies worth billions of dollars.

1983 Guion "Guy" S. Bluford, Jr. (b. 1942), becomes the first black astronaut to go into space on the shuttle Challenger.

1984 Vanessa Williams (b. 1963) becomes the first black Miss America. She relinquishes her crown to Suzette Charles (b. 1963) after a scandal over nude photographs of Williams.

1984 The Reverend Jesse Jackson (b. 1941) runs for president of the United States, receiving some 3.5 million votes and nearly 400 delegates.

1984 The "Cosby Show" debuts on national television, running eight seasons and becoming the most popular show from 1985 to 1988 and in the top twenty through 1994.

1986 Following passage of Public Law 98-144, President Ronald Reagan declares the third Monday in January a public holiday in honor of Martin Luther King, Jr.

1988 The Reverend Jesse Jackson runs for president of the United States and comes in second in the primaries with seven million votes.

1989 Douglas L. Wilder (b. 1931) of Virginia becomes first African American elected governor of an American state.

1989 General Colin Powell (b. 1937) becomes first black chair of the Joint Chiefs of Staff of the U.S. military.

1989 David Dinkins (b. 1927) becomes first black mayor of New York City.

1991 Clarence Thomas (b. 1948) joins the U.S. Supreme Court as second African-American justice (after Thurgood Marshall).

1991 Robert Johnson's Black Entertainment Network (BET, founded 1981) becomes first black American corporation traded on the New York Stock Exchange.

1991–1992 Four Los Angeles police officers' beating of Rodney King (b. 1965) captured on video. Their acquittals spark a multiracial uprising.

1992 Carol Moseley Braun (b. 1947) is the first black woman elected to the U.S. Senate.

1992 Bill Clinton, governor of Arkansas, is elected U.S. president.

1993 Dr. Joycelyn Elders (b. 1933) becomes the first African-American woman to serve as surgeon general.

1993 Toni Morrison (b. 1931) receives the Nobel Prize for Literature.

1993 Mae Jemison (b. 1956) becomes the first African-American woman in space as part of the crew of the space shuttle Endeavour.

1993 Poet Rita Dove (b. 1952) becomes the first African-American Poet Laureate of the United States.

1994 Former football player O.J. Simpson (b. 1947) is charged with the murder of his ex-wife Nicole and her friend Ronald Goldman. He was acquitted in 1995 after a controversial trial.

1994 The Florida legislature agrees to

compensate survivors of a 1923 incident in which a white mob destroyed the African-American town of Rosewood, located on the Gulf Coast.

1995 Minister Louis Farrakhan, head of the Nation of Islam, organizes the Million Man March of African-American men in Washington, D.C.

1996 HIV/AIDS is found to be the leading cause of death among African-American women aged twenty-five to forty-four.

1996 Alan Keyes (b. 1950) is first prominent black candidate for Republican presidential nomination. He runs again in 2000.

1997 Eldrich "Tiger" Woods (b. 1975) becomes first African American and youngest person ever to win a Masters' Golf Tournament. In 2005 he wins his fourth Masters.

1997 Haitian immigrant Abner Louima (b. ca. 1967) is beaten and sodomized with a broomstick by officers while in New York City Police Department custody, causing a national outcry. In 2002, a federal court overturns the conviction of the three NYPD officers.

1998 Julius Caesar "J.C." Watts (b. 1957), a Congressman from Oklahoma, becomes the first African American to be elected to a position of leadership in the Republican party (the House Republican Conference). In 2002 he publishes his autobiography, *What Color Is a Conservative? My Life and My Politics.*

1998 DNA evidence shows that President Thomas Jefferson most likely fathered at least one child with his wife's enslaved half-sister.

1999 Amadou Diallo (1975–1999), an unarmed African immigrant from Guinea, is mistakenly shot and killed by four white policemen in New York City, raising a national furor.

2000 Venus Williams (b. 1980) wins singles title at Wimbledon, first African-American woman to do so since Althea Gibson (1927–2003) in 1958.

2001 President George W. Bush appoints Colin Powell as secretary of state. Condoleezza Rice (b. 1954) becomes national security advisor (first woman to hold the post), having already served in the first Bush administration.

2002 Halle Berry (b. 1966) becomes first African-American woman to win Academy Award for Best Actress for *Monster's Ball.*

 Denzel Washington becomes second African-American man to win Academy Award for Best Actor for *Training Day.* (Sidney Poitier [b. 1927] won Best Actor for *Lilies of the Field* in 1963.)

2002 The Slavery Reparations Coordinating Committee, led by prominent African-American lawyers and activists, announces plans to sue companies that profited from slavery.

2002 Robert Johnson becomes the first black billionaire.

2002 Serena Williams (b. 1981) wins twenty-one straight major tennis matches, becoming top-ranked women's tennis player. She wins Wimbledon, the French Open, and the U.S. Open, each time defeating her sister Venus.

2003 Oprah Winfrey (b. 1954) becomes the first black woman billionaire.

2003 African Americans represent about one-quarter of the troops invading Iraq in the second Gulf war.

2003 U. S. Supreme Court upholds the University of Michigan's affirmative action policy.

2005 Condoleeza Rice becomes first African-American woman secretary of state.

◇ Notes ◇

Preface

1 Art historian Lisa Gail Collins notes the existence of a paradox in African-American intellectual history: On the one hand, black thinkers have long deplored the negative visual stereotypes of American culture that have dehumanized black people. On the other hand, these same thinkers have neglected the visual art of black artists, seeing texts—words—as the most effective counterweight to negative visual depiction. See Collins, *The Art of History: African American Women Artists Engage the Past*. New Brunswick, N.J.: Rutgers University Press, 2002: 1–10.

2 Thelma Golden (b. 1967) of the Studio Museum in Harlem curated a show in 2001 that she said embodied blacks artists' freedom to create in the "post-black" era. During the "black" era, the imperative to portray only sanitized, positive images restricted artists' ability to express themselves as individuals. See Holland Cotter, "Art Review; a Full Studio Museum Show Starts with 28 Young Artists and a Shoehorn," *New York Times*, May 11, 2001: E, 2, 36.

3 While tables express material conditions clearly, they can convey the impression of more precision than the historical record actually contains.

1: Africa and Black Americans

1 Wilson Jeremiah Moses, *Afrotopia: The Roots of African American Popular History*. Cambridge, U.K.: Cambridge University Press, 1998: 51–52. *Afrotopia* contains a full discussion of African-American views of Africa.

2 Moses, *Afrotopia*, 16, 24, 26, 51–52, 61–63.

3 The Walker quote comes from Moses, *Afrotopia*: 58–59. See also Peter P. Hinks, ed., *David Walker's Appeal to the Coloured Citizens of the World*. University Park: Pennsylvania State University Press, 2000: 21–22.

4 In his introduction to the Penguin Classic edition of Equiano's *Interesting Narrative*, Vincent Carretta casts doubt on Equiano's account of his early life and even his place of birth. Carretta says: "Equiano's baptismal record in 1759 and naval records from his Arctic voyage in 1773 suggest that he may well have been born in South Carolina, not Africa. . . . From the available evidence, one could argue that the author of *The Interesting Narrative* invented an African identity rather than reclaimed one. If so, Equiano's literary achievements have been underestimated." Vincent Carretta, ed., *Olaudah Equiano: The Interesting Narrative and Other Writings*, rev. ed. New York: Penguin Classics, 2003: xi. Because *The Interesting Narrative* is still accepted as a non-fiction account and because it mentions African captors, I have treated it as reliable testimony.

5 In addition, Robert Young (n.d.), a free black New Yorker, published a pamphlet in the same year

that David Walker published one in Boston. Young's was entitled *The Ethiopian Manifesto, Issued in Defence of the Black Man's Rights in the Scale of Universal Freedom* (1829).

6 This mission appears in Alice Walker's (b. 1944) best-selling 1982 novel, *The Color Purple.*

7 Henry Ossawa Tanner (1859–1937), who spent most of his career in France painting religious themes, became even better known than Duncanson. Tanner's "Banjo Lesson" (1893) appears in chapter 8.

8 Williams realized notable success as a historian, lecturing widely and traveling to Europe, where he met King Leopold of Belgium. Leopold had given himself the Congo Free State, a personal colony in West Central Africa. Williams initially supported Leopold's plan to recruit black Americans as educators in the Congo. But as egregious abuses of human rights came to light, Williams became a sharp critic of Leopold's policies. He died in Blackpool, England, after an investigative tour of Leopold's Congo and other European colonies. See John Hope Franklin, "Williams, George Washington," in Rayford W. Logan and Michael R. Winston, *Dictionary of American Negro Biography.* New York: W. W. Norton, 1982: 657–659, and John Hope Franklin, *George Washington Williams: A Biography.* Chicago: University of Chicago Press, 1985.

9 Elinor Des Verney Sinnette, *Arthur Alfonso Schomburg, Black Bibliophile and Collector: A Biography.* Detroit: Wayne State University Press, 1989: 41–46. In Luxor, Egypt, Locke had represented Howard University and the Negro Society for Historical Research at the reopening of the tomb of King Tutankhamen in 1924.

10 While Schomburg was recognized as the greatest African-American book collector, other black Americans also compiled impressive collections that often became the core of the research libraries at black colleges. The Congregational minister and YMCA organizer Jesse E. Moorland (1863–1940) gave his collection to Howard University in 1914. Howard later combined the Moorland Collection and that of the white NAACP activist Arthur Spingarn to make the Moorland-Spingarn Collection. The collection of Henry Proctor Slaughter (1871–1958) went to the Atlanta University Library in 1946, and Charles Blockson's (b. 1933) collection went to Temple University in 1983. All these collections are self-consciously diasporic in reach.

11 Alain Locke, ed., *The New Negro* (originally published 1925), reprint ed., with preface by Robert Hayden. New York: Atheneum, 1975: 231, 237.

12 The younger half-brother of the Harlem Renaissance novelist Jessie Redmon Fauset, Arthur Huff Fauset contributed an article on Negro folklore to *The New Negro.* He published *Sojourner Truth: God's Faithful Servant* in 1938; the best known of his five books, *Black Gods of the Metropolis: Negro Religious Cults of the Urban North* (1944), was a revision of his University of Pennsylvania Ph.D. dissertation of 1942. See John C. Stoner, "Fauset, Arthur Huff," in Jack Salzman et al., eds., *Encyclopedia of African-American Culture and History*, Vol. 2. New York: Macmillan, 1996: 937–938.

13 The African sculpture pictured in *The New Negro* came from the Barnes Collection in Pennsylvania, which for a very long time was the only museum collecting black art. Its creator, Albert C. Barnes, a white doctor, wrote the second essay in *The New Negro*, "Negro Art and America." Barnes opened his essay by citing the development of "a distinctively Negro art in America" as a "natural and inevitable" creation of a "primitive race, transported into an Anglo-Saxon environment and held in subjection to that fundamentally alien influence." Locke, *The New Negro* (1975): 19.

14 For a complete selection of the art, see Alain Locke, *The New Negro.* New York: Boni and Liveright, 1925: 262–266. See also Du Bois, "Criteria of Negro Art," *The Crisis*, October 1926; Locke, "The Legacy of the Ancestral Arts," in Alain Locke, ed., *The New Negro* (1925): 254–267. See also Richard Powell, *Rhapsodies in Black: Art of the Harlem Renaissance.* Hayward Gallery and Berkeley: University of California Press, 1977: 16–33; Beryl J. Wright, "The Harmon Foundation in Context: Early Exhibitions and Alain Locke's Concept of a Racial Idiom of Expression," in Gary A. Reynolds and Beryl J. Wright, eds., *Against the Odds: African-American Artists and the Harmon Foundation.* Newark: The Newark Museum, 1989: 13–25; and Romare Bearden and Harry Henderson, *A History of African-American Artists from 1792 to the Present.* New York: Pantheon, 1993. Locke published a great deal on black art. In addition to his classic piece in *The New Negro*, he also published two full-length studies: *Negro Art: Past and Present.* Washington, D.C.: Associ-

ates in Negro Folk Education, 1936, and *The Negro in Art: A Pictorial Record of the Negro Artist and of the Negro Theme in Art*. Washington, D.C.: Associates in Negro Folk Education, 1940.

15 Currently in its eighth edition (2000), John Hope Franklin's *From Slavery to Freedom* has remained in print and sold widely since its first edition in 1947. Over the course of half a century, the African history in it has constantly grown more comprehensive.

16 This history comes from John Hope Franklin and Alfred A. Moss, Jr., *From Slavery to Freedom: A History of African Americans*, 8th ed. New York: McGraw-Hill, 2000: 2-9; Colin Palmer, "The First Passage: 1502–1619," in Robin D. G. Kelley and Earl Lewis, eds., *To Make Our World Anew: A History of African Americans*. New York: Oxford University Press, 2000: 5–7; and James Oliver Horton and Lois E. Horton, *Hard Road to Freedom: The Story of African America*. New Brunswick: Rutgers University Press, 2001: 8–10.

17 See Colin A. Palmer, ed., *The Worlds of Unfree Labour: From Indentured Servitude to Slavery*. Brookfield, Vt.: Ashgate, Variorum, 1998; Sharon V. Salinger, *"To Serve Well and Faithfully": Labour and Indentured Servants In Pennsylvania, 1682–1800*. Cambridge, UK: Cambridge University Press, 1987; and James Curtis Ballagh, *White Servitude in the Colony of Virginia: A Study of the System of Indentured Labor in the American Colonies*. Baltimore: Johns Hopkins Press, 1895. Piggybacking on the movement for black reparations for enslavement, neo-Nazis are building a case that white Americans, too, have been enslaved and are, therefore, due reparations. See Michael A. Hoffman, II, *The Forgotten Slaves: Whites in Servitude in Early America and Industrial Britain*; also issued as *They Were White and They Were Slaves: The Untold History of the Enslavement of Whites in Early America*, both self-published, no further information available beyond the citation on the website of the National Alliance (American Neo-Nazis: www.natvan.com/cgi-bin/webc.cgi/st_prod.html?p_prodid=326&sid=4YRKcz104K4u6qL-19104347070.eb).

18 In 1972 UNESCO designated the Ghanaian slave castles at Elmina and Cape Coast as World Heritage Monuments. After the phenomenally successful televising of Alex Haley's *Roots* miniseries on television, black Americans began visiting slave castles in pursuit of their past. Today black heritage tourism is a multi-million dollar industry. See Cheryl Finley, "The Door of (No) Return," *Common-Place* I, No. 3 (July 2001): www.common-place.org/vol-01/no-04/finley/. See also Saidiya Hartman, "The Time of Slavery," *South Atlantic Quarterly* 101, No. 4 (Fall 2002): 757–777.

2: Captives Transported, 1619–ca. 1850

1 See Raymond A. Winbush, ed., *Should America Pay? Slavery and the Raging Debate on Reparations*. New York: HarperCollins, 2003: 9, 210, 254–255, 280, 309, 322.

2 See Quintard Taylor, *In Search of the Racial Frontier: African Americans in the American West, 1528–1990*. New York: W. W. Norton, 1998: 27, and Peter Wood, "Strange New Land: 1619–1776," in Robin D. G. Kelley and Earl Lewis, eds., *To Make Our World Anew: A History of African Americans*. New York: Oxford University Press, 2000: 53–54.

3 Tom Henderson Wells, *The Slave Ship Wanderer*. Athens: University of Georgia Press, 1967: 86, cited in Lisa Gail Collins, *The Art of History: African American Women Artists Engage the Past*. New Brunswick: Rutgers University Press, 2002: 89.

4 Lerone Bennett, Jr., alerted readers that the founding generation of Africans came to North America prior to the arrival of the *Mayflower* in his *Before the Mayflower: A History of the Negro in America, 1619–1962*. Chicago: Johnson Publications. (Originally published in 1962).

5 The information in this discussion comes from John Thornton, "The African Experience of the '20. And Odd Negroes' Arriving in Virginia in 1619," *William and Mary Quarterly*, 3rd Series, 55, No. 3 (July 1998): 421–434.

6 Thornton, "The African Experience of the '20. And Odd Negroes'": 430–432.

7 Peter Kolchin, *American Slavery, 1619–1877*. New York: Hill and Wang, 1993: 17–18.

8 See Philip D. Curtin, *Africa Remembered: Narratives by West Africans from the Era of the Slave Trade*. Madison: University of Wisconsin Press, 1967: 17–59. Ayuba dictated his memoir to Thomas Bluett. It was published in London in 1734 as *Some Memoirs of the Life of Job, the Son of Solomon the High Priest of Boonda in Africa; Who was a Slave about two Years in Maryland; and afterwards being brought to England, was set free, and sent to his native Land in the Year 1734*.

9 Curtin, *Africa Remembered*: 39–40.

10 Ibid.: 41–42.

11 Ayuba's experiences on his return to Africa are in the journal of Francis Moore: *Travels into the Inland Parts of Africa*, published in London in 1738. See Curtin, *Africa Remembered*: 55–58.

12 Vincent Carretta's 2003 Penguin Classic edition of *The Interesting Narrative of the Life of Olaudah Equiano* casts doubt on Equiano's place of birth. Carretta cites recent research that would indicate that Equiano was born in South Carolina. Vincent Carretta, ed., *Olaudah Equiano: The Interesting Narrative and Other Writings*, rev. ed. New York: Penguin Classics, 2003. See note 4, chapter 1.

13 Robert J. Allison, ed., *The Interesting Narrative of the Life of Olaudah Equiano*, Written by Himself. Boston: Bedford Books, 1995: 47.

14 Ibid.: 53–54.

15 Allison, "Introduction," in ibid., 3, 21.

16 William L. Andrews, "Preface," and Henry Louis Gates, Jr., "Introduction," in Henry Louis Gates, Jr., and William L. Andrews, eds., *Pioneers of the Black Atlantic: Five Slave Narratives from the Enlightenment, 1772–1815*. Washington, D.C.: Civitas, 1998: ix–x, 8.

17 Herbert S. Klein, *The Atlantic Slave Trade*. Cambridge, UK: Cambridge University Press, 2000: 161–164.

18 David Eltis and Stanley L. Engerman, "Fluctuations in Sex and Age Ratios in the Transatlantic Slave Trade, 1663–1864," *The Economic History Review*, New Series 46, No. 2 (May 1993): 310. See also David Eltis, "The Volume and Structure of the Transatlantic Slave Trade: A Reassessment," *William and Mary Quarterly*, 3rd Series, LVIII, No. 1 (January 2001): 17–46.

19 Colin Palmer, "The First Passage, 1502–1619," in Robin D. G. Kelley and Earl Lewis, eds., *To Make Our World Anew: A History of African Americans*. New York: Oxford University Press, 2000: 16.

20 John Thornton, *Africa and Africans in the Making of the Atlantic World, 1400–1800*, 2nd ed. Cambridge, UK: Cambridge University Press, 1998: 14, 171, 193; Klein, *The Atlantic Slave Trade*: 128.

21 Klein, *The Atlantic Slave Trade*: 113.

22 Thornton, *Africa and Africans*: 153–161.

23 Thornton, "The African Experience of the '20. And Odd Negroes'": 434.

24 Public Broadcasting Service, "Africans in America: The Terrible Transformation. From Indentured Servitude to Racial Slavery": www.pbs.org/wgbh/aia/part1/1narr3.html.

25 See Philip D. Morgan, *Slave Counterpoint: Black Culture in the Eighteenth-Century Chesapeake and Lowcountry*. Chapel Hill: University of North Carolina Press, 1998: 10–12.

26 Thornton, *Africa and Africans*: 44. See also Ira Berlin, *Many Thousands Gone: The First Two Centuries of Slavery in North America*. Cambridge: Harvard University Press, 1998: 314–315.

27 Klein, *The Atlantic Slave Trade*: 128.

28 The poem may be found in Michael S. Harper and Anthony Walton, eds., *The Vintage Book of African American Poetry*. New York: Random House, 2000: 165–166. Hayden became the first African-American faculty member at the University of Michigan in 1970. He was named consultant in poetry at the Library of Congress (a position later renamed United States poet laureate) in 1976. See also Françoise Charras, "Landings: Robert Hayden's and Kamau Brathwaite's Poetic Renderings of the Middle Passage in Comparative Perspective," in Maria Diedrich, Henry Louis Gates, Jr., and Carl Pedersen, eds., *Black Imagination and the Middle Passage*: 57–62. The quotation comes from Charras, "Landings": 60.

3: *A Diasporic People, 1630–ca. 1850*

1 Strictly speaking, the concept of the African Diaspora encompasses people of African descent living outside the continent of Africa. But the term is often used to include Africans living in Africa.

2 A. Leon Higginbotham, "The Ancestry of Inferiority (1619–1662)," in Edward Countryman, ed., *How Did American Slavery Begin?* Boston: Bedford/St. Martin's, 1999: 88–90.

3 In 1667 Virginia passed a statute aimed at petitions for emancipation based on the fact of baptism

and closing that loophole leading to freedom. See Philip D. Morgan, *Slave Counterpoint: Black Culture in the Eighteenth-Century Chesapeake and Lowcountry.* Chapel Hill: University of North Carolina Press, 1998: 11.

4 Ann Petry, "Tituba," in Darlene Clark Hine et al., eds., *Black Women in America: An Historical Encyclopedia*, Vol. II. Brooklyn, N.Y.: Carlson Publishing, 1993: 1171–1172. See also Elaine Breslaw, *Tituba, Reluctant Witch of Salem.* New York: New York University Press, 1996.

5 Cheryl Townsend Gilkes, "Religion," in Hine, *Black Women in America*: 968.

6 Peter Schilling, "Hosier, Harry 'Black Harry,'" in Jack Salzman et al., eds., *Encyclopedia of African-American Culture and History*, Vol. 3. New York: Macmillan Library Reference USA, 1996: 1305.

7 William Miller calculated the end of time based on the numbers in the *Biblical Book of Daniel*. His followers narrowed the time frame to the year between the middle of 1843 and mid-1844. A widespread movement in the Northeast arose around his prophecy and captivated thousands of men and women, including Sojourner Truth. Although the faithful were disappointed when the world did not end, Millerites founded the Seventh Day Adventist church, centered in Battle Creek, Michigan, Sojourner Truth's hometown after the mid-1850s. See Nell Irvin Painter, *Sojourner Truth, a Life, a Symbol.* New York: W. W. Norton, 1996: 79–83.

8 Dennis C. Dickerson, "African Methodist Episcopal Church," in Jack Salzman et al., eds., *Encyclopedia of African-American Culture and History*, Vol. I. New York: Macmillan Library Reference USA, 1996: 63.

9 Sandy Dwayne Martin, "African Methodist Episcopal Zion Church," in Salzman et. al., *Encyclopedia of African-American Culture and History*, Vol. I: 67–68.

10 For an image of Edmonia Lewis's "Hagar" see www.amico.davidrumsey.com/saam.1983.95.178.jpg.

11 See Doris M. Bowman, *The Smithsonian Treasury: American Quilts.* Washington, D.C.: Smithsonian Institution, 1991, and http://historywired.si.edu/detail.cfm?ID=362.

12 The Crucifixion theme, a staple of Western art, has also drawn many African-American artists, e.g., Allan Rohan Crite's "Our Lady of Africa" (1951), which showed the Madonna and Christ child as black people and also placed saints from the African Diaspora at her sides. Crite's lettering reads "Jesus son of man savior," "our lady of Africa America," "Moses of Ethiopia," and "Martin de Porres of Lima Peru SA," referring to the first black American, a Peruvian, made a Catholic saint.

 Elizabeth Catlett and Alison Saar have also turned Christian motifs into symbols of African-American life. Catlett's Madonna wears an Afro, or natural hairstyle. Saar's Queen of Sheba's dark skin and scanty clothing entice King Solomon. Although the historical Queen of Sheba is thought to have come from Arabia to visit King Solomon, she is often considered a woman of color, and therefore available as a foremother of African Americans. The self-trained, New Orleans artist Roy Ferdinand, Jr. (b. 1959), painted the Last Supper in the black vernacular, this time using hip-hop imagery. Ferdinand's Last Supper dresses the apostles like playas and gangsta rappers.

13 Silvio A. Bedini, "Banneker, Benjamin," in Rayford W. Logan and Michael R. Winston, eds., *Dictionary of American Negro Biography.* New York: W. W. Norton, 1982: 22–25.

14 Saunders Redding, "Wheatley, Phillis," in Logan and Winston, *Dictionary of American Negro Biography*: 640–643.

15 Du Sable inspired Margaret (b. 1917) and Charles Burroughs (b. ca. 1915), who founded the first museum of African-American history in 1961, the Du Sable Museum of African American History in Chicago. In addition to historical material, it holds a rich collection of visual art by black artists. See www.dusablemuseum.org/index.html; www.chipublib.org/004chicago/timeline/dusable.htm; http://hometown.aol.com/efirpo/du_sable.html; and www.chipublib.org/digital/lake/DuSable.html.

16 See Brent Staples, "Interracialism among the Jeffersons Went Well beyond the Bedroom," *New York Times*, July 16, 2003: A20.

17 Artists Freida High Tesfagiorgis and L'Merchie Frazier use American flags, horses, feathers, and antiracist activists from both traditions in order to stress the common oppression of these two American peoples.

18 Higginbotham, "The Ancestry of Inferiority": 90. The case is *Re Davis*, decided in 1630.

19 Jessie Carney Smith and Carrell Peterson Horton, eds., *Historical Statistics of Black America*, Vol. 2. New York: Gale Research, 1995: 1422.

4: Those Who Were Free, ca. 1770–1859

1 See this National Park Service website: www.nps.gov/revwar/about_the_revolution/salem_poor.html.

2 Darlene Clark Hine, William C. Hine, and Stanley Harrold, *The African-American Odyssey*, Vol. 1. Upper Saddle River, N.J.: Prentice Hall, 2000: 81.

3 Daniel C. Littlefield, "Revolutionary Citizens: 1776–1804," in Robin D. G. Kelley and Earl Lewis, eds., *To Make Our World Anew: A History of African Americans*. New York: Oxford University Press, 2000: 114–116.

4 See Sylvia R. Frey, *Water from the Rock: Black Resistance in a Revolutionary Age*. Princeton: Princeton University Press, 1991.

5 Hine et al., *The African-American Odyssey*: 77, 81; Littlefield, "Revolutionary Citizens": 116; and James Oliver Horton and Lois E. Horton, *Hard Road to Freedom: The Story of African America*. New Brunswick, N.J.: Rutgers University Press, 2001: 71.

6 Quoted in Hine et al., *The African-American Odyssey*: 77. Italics in original.

7 Littlefield, "Revolutionary Citizens": 158–160.

8 Jessie Carney Smith and Carrell Peterson Horton, eds., *Historical Statistics of Black America*, Vol. II. New York: Gale Research, 1995: 1699–1700.

9 Littlefield, "Revolutionary Citizens": 138–139, 159–160.

10 Ibid.: 162.

11 Hine et al., *The African-American Odyssey*: 110.

12 As slavery ended in the North, hundreds of uncounted black Northerners were sold into perpetual bondage in the South, among them Sojourner Truth's son Peter. Truth, then known as Isabella, sued successfully for her son's return to New York from Alabama.

13 Peter Kolchin, *American Slavery: 1619–1877*. New York: Hill and Wang, 1993: 81–82.

14 *The Known World*. New York: Amistad, 2003, the first novel of Edward P. Jones (b. 1950), relates the story of Henry Townsend and his wife Caldonia, who are black slave owners reminiscent of the Ellison family of South Carolina. The novel won the Pulitzer Prize for fiction and the National Book Critics Circle Award and was a finalist for the National Book Award for fiction. In 2004 Jones received a MacArthur Foundation "genius" award.

15 Beckwourth Pass in the Sierra Nevada Mountains is named for him. See Quintard Taylor, *In Search of the Racial Frontier: African Americans in the American West, 1528–1990*. New York: W. W. Norton, 1998: 50–51.

16 See Lynn M. Hudson, *The Making of "Mammy Pleasant": A Black Entrepreneur in Nineteenth-Century San Francisco*. Urbana: University of Illinois Press, 2002.

17 John Hope Franklin and Alfred A. Moss, Jr., *From Slavery to Freedom*, 7th ed. New York: McGraw-Hill, 1994: 161.

18 Hine et al., *The African-American Odyssey*: 156, and Horton and Horton, *Hard Road to Freedom*: 96, 130.

19 Horton and Horton, *Hard Road to Freedom*: 96.

20 Ibid.

21 See Nell Irvin Painter, *Sojourner Truth, a Life, a Symbol*. New York: W. W. Norton, 1996: 27–28.

22 See Peter P. Hinks, ed., *David Walker's Appeal to the Coloured Citizens of the World*. University Park: Pennsylvania State University Press: 2000, and Horton and Horton, *Hard Road to Freedom*: 127–129.

23 John S. Jacobs served as the corresponding secretary of Boston's black New England Freedom Association and toured as a paid lecturer of the Massachusetts Anti-Slavery Society in 1848 and 1849. In 1849 he purchased the Rochester Anti-Slavery Office and Reading Room located above the offices of Frederick Douglass's newspaper, the *North Star*. Harriet Jacobs helped her brother in his bookstore and assisted the efforts of the white abolitionists Amy and Isaac Post. See Harriet

Jacobs, *Incidents in the Life of a Slave Girl, Written by Herself with "A True Tale of Slavery,"* ed. Nell Irvin Painter. New York: Penguin Classics, 2000.

24 Although Truth uttered statements supporting the rights of black women as women and as blacks, she did not say "ar'n't I a woman?" (much less, the corruption "ain't I a woman?"). The question was the invention of a white feminist writer, Frances Dana Gage, twelve years after Truth appeared at a women's rights meeting in Akron, Ohio, in 1851. See Painter, *Sojourner Truth*: 164–178.

25 See Nell Irvin Painter, ed., *Narrative of Sojourner Truth; a Bondswoman of Olden Time, with a History of Her Labors and Correspondence Drawn from Her "Book of Life"; Also, a Memorial Chapter.* New York: Penguin Classics, 1998.

26 Quoted in Horton and Horton, *Hard Road to Freedom*: 148.

27 Deborah Gray White, "Let My People Go: 1804–1860," in Kelley and Lewis, *To Make Our World Anew*: 225.

28 In the era of the longer reconstruction Edmonia Lewis portrayed Brown as a statesman.

5: *Those Who Were Enslaved, ca. 1770–1859*

1 Peter Kolchin, *American Slavery, 1619–1877*. New York: Hill and Wang, 1993: 100.

2 Anthony Dugdale, J. J. Fueser, and J. Celso de Castro Alves, *Slavery and Abolition*. New Haven: Amistad Committee, 2001: 3–5

3 Stephan Thernstrom, *A History of the American People. Volume One: To 1877*. San Diego: Harcourt Brace Jovanovich, 1984: 247.

4 Kolchin, *American Slavery*: 100, 179–180, and Deborah Gray White, "Let My People Go" in Robin D. G. Kelley and Earl Lewis, eds., *To Make Our World Anew: A History of African Americans*. New York: Oxford University Press, 2000: 178.

5 Kolchin, *American Slavery*: 105–111.

6 Kathleen Thompson, "Keckley, Elizabeth," in Darlene Clark Hine, *Black Women in America: An Historical Encyclopedia*. Brooklyn, N.Y.: Carlson, 1991: 672–673. See also Jennifer Fleischner, *Mrs. Lincoln and Mrs. Keckley: The Remarkable Story of the Friendship between a First Lady and a Former Slave*. New York: Broadway Books, 2003.

7 Kolchin, *American Slavery*: 174–175.

8 See Robert Edgar Conrad, *In the Hands of Strangers: Readings on Foreign and Domestic Slave Trading and the Crisis of the Union*. University Park: Pennsylvania State University Press, 2001: 111–121. See also Michael Tadman, *Speculators and Slaves*. Madison: University of Wisconsin Press, 1989; Frederic Bancroft, *Slave Trading in the Old South*. (Originally published 1931.) Michael Tadman, ed. Columbia: University of South Carolina Press, 1996; and Walter Johnson, *Soul by Soul: Life inside the Antebellum Slave Market*. Cambridge, Mass.: Harvard University Press, 1999.

9 See Richard Sutch, "The Breeding of Slaves for Sale and the Westward Expansion of Slavery, 1859–1860," in Stanley L. Engerman and Eugene D. Genovese, eds., *Race and Slavery in the Western Hemisphere: Quantitative Studies*. Princeton: Princeton University Press, 1975: 173–198.

10 White, "Let My People Go": 183.

11 Conrad, *In the Hands of Strangers*: 112, 116–118, 119–120; White, "Let My People Go": 171; and Michael Tadman cited in Kolchin, *American Slavery*: 96–97, 126.

12 Harriet Jacobs, *Incidents in the Life of a Slave Girl, Written by Herself with "A True Tale of Slavery,"* ed. Nell Irvin Painter. New York: Penguin Classics, 2000: 56, 61.

13 Frederick Douglass, *Narrative of the Life of Frederick Douglass, an American Slave, Written by Himself.* (Originally published 1845.) New York: Library of America, 1994: 33.

14 Dr. Michael Blakey said: "These people were obviously working at the very margins of human endurance and capacity. Arguably, a few were worked to death in a time when it was considered cost-effective to work slaves to death. Even some six-year-old children show signs of being worked in what we would today consider an extreme way." www.nih.gov/news/NIH-Record/04_22_97/story01.htm. See also www.gsa.gov/Portal/gsa/ep/contentView.do?noc=T&contentType=GSA_BASIC &contentId=13389.

15 Nell Irvin Painter, *Exodusters: Black Migration to Kansas after Reconstruction*. New York: A. A. Knopf, 1977: 71–72.

16 See Nell Irvin Painter, "Soul Murder and Slavery: Toward a Fully-Loaded Cost Accounting," in *Southern History across the Color Line*. Chapel Hill: University of North Carolina Press, 2002: 15–39.

17 See Nell Irvin Painter, ed., *Narrative of Sojourner Truth; A Bondswoman of Olden Time, with a History of Her Labors and Correspondence Drawn from Her "Book of Life"; Also, a Memorial Chapter*. New York: Penguin Classics, 1998: 22–23.

18 Alex Bontemps, *The Punished Self: Surviving Slavery in the Colonial South*. Ithaca: Cornell University Press, 2001: 152–153.

19 Thomas Jefferson, *Notes on the State of Virginia*. (Originally published 1787.) New York: W. W. Norton, 1972: 162. Similarly, an advice manual for slave-owning mothers published in 1830, *Letters on Female Character*, noted that slave owning encouraged "all the most malignant vices of his nature" in the child. Quoted in Catherine Clinton, *The Plantation Mistress: Woman's World in the Old South*. New York: Pantheon Books, 1982: 91.

20 Jacobs, *Incidents in the Life of a Slave Girl*: 58.

21 Henry Louis Gates, Jr., and Nellie Y. McKay, *The Norton Anthology of African American Literature*. New York: W. W. Norton, 1997: 896.

22 Quoted in Kolchin, *American Slavery*: 158.

23 Two early and extremely influential commentaries that insulted enslaved people of African descent came from the philosophers David Hume ("Of National Characters," in *Essays Moral, Political and Literary*, 1753 and 1777 editions) and Immanuel Kant (*Observations on the Feeling of the Beautiful and Sublime*, 1764), who mentioned Hume's findings. See Emmanuel Chukwudi Eze, ed., *Race and the Enlightenment: A Reader*. Oxford, England: Blackwell, 1997: 29–33, and Robert Bernasconi and Tommy L. Lott, eds., *The Idea of Race*. Indianapolis: Hackett Publishing, 2000: 8–22.

24 Quoted in Kolchin, *American Slavery*: 54.

25 William H. Johnson, "Swing Low, Sweet Chariot," ca. 1939, in *Harlem Renaissance Art of Black America*. New York: Studio Museum in Harlem, 1987; 1994: Plate 51. Malkia Roberts, "My Lord, What a Morning," 1981, in Robert Henkes, *The Art of Black American Women: Works of Twenty-Four Artists of the Twentieth Century*. Jefferson, N.C.: McFarland, 1993: 200.

26 William L. Andrews, "The Representation of Slavery and the Rise of Afro-American Literary Realism 1865–1920," in Deborah E. McDowell and Arnold Rampersad, eds., *Slavery and the Literary Imagination*. Baltimore: Johns Hopkins University Press, 1989: 67–69.

27 White, "Let My People Go": 196.

28 Jessie Carney Smith and Carrell Peterson Horton, eds., *Historical Statistics of Black America*, Vol II. New York: Gale Research, 1995: 1848.

29 Franklin and Moss, *From Slavery to Freedom*: 145–147.

30 Jacobs, *Incidents in the Life of a Slave Girl*: xvii.

31 See John Hope Franklin and Loren Schweninger, *Runaway Slaves: Rebels on the Plantation*. New York: Oxford University Press, 1999.

32 Franklin and Moss, *From Slavery to Freedom*: 185.

33 Donald Yacovone, "Underground Railroad," in Jack Salzman, David Lionel Smith, and Cornel West, eds., *Encyclopedia of African-American Culture and History*. New York: Macmillan Library Reference, 1996: 2699–2701.

34 Darlene Clark Hine, "Tubman, Harriet Ross," in Darlene Clark Hine, ed., *Black Women in America: An Historical Encyclopedia*. Brooklyn: Carlson, 1991: 1176–1180.

6: Civil War and Emancipation, 1859–1865

1 Until the mid-twentieth century, no black person could become a general or (with a few exceptions) rise into the ranks of commissioned officers. Commissioned officers—above the rank of lieutenant—form a separate, higher category in the armed forces. They are the officers who give commands, and they benefit from special rights and privileges accorded to those who bear the responsibilities of power. For a brief discussion of early African-American officers, see chapter 9, note 11.

2 James M. McPherson, *Battle Cry of Freedom: The Civil War Era*. New York: Oxford University Press, 1988: 859–860.

3 Taney died in October 1864 and was succeeded by the Republican Salmon P. Chase. In February 1865 Chase swore in John Rock (1825–1866) of Massachusetts, the first black man admitted to practice before the United States Supreme Court. Such an act would have been extremely difficult—if not impossible—for Taney to perform.

4 My analysis here and throughout my discussion of black men's service in the Civil War draws heavily on the documents in "The Black Military Experience, 1861–1867," in Ira Berlin, ed., *Freedom: A Documentary History of Emancipation, 1861–1867, Selected from the Holdings of the National Archives of the United States. Series II: The Black Military Experience*. Cambridge, U.K.: Cambridge University Press, 1982: 1–34.

5 Berlin, ed., *Freedom, Series II*: 30.

6 Abolitionists founded the Liberty party in 1839, but won only 3 percent of votes in the presidential election of 1844. Free Soilers thrust slavery into the 1848 campaign but also remained a small minority until they joined the Republican Party.

7 About 360,000 Union and at least 260,000 Confederate soldiers died in the conflict. McPherson, *Battle Cry of Freedom*: 619, 854.

8 Lincoln defeated three other candidates for the presidency: John Bell of the Constitutional Union Party, Stephen A. Douglas of the Regular Democratic Party, and John C. Breckinridge of the Southern Democratic Party. Two Midwesterners opposed one another in the Northern states: Lincoln and Douglas. In the Southern and Border States, two Border State slaveholders ran against each other: Bell, a Tennessee planter, ran on the Constitutional Union Party ticket; former vice president John C. Breckinridge of Kentucky.

9 For a map of the Confederate States of America, Union states, and slave states remaining in the Union, see www.geocities.com/Pentagon/8610/.

10 Quoted in Wilbert L. Jenkins, *Climbing Up to Glory: A Short History of African Americans during the Civil War and Reconstruction*. Wilmington, Del.: Scholarly Resources, 2002: 3.

11 Jenkins, *Climbing Up to Glory*: 4.

12 The Fugitive Slave Act of 1850 required Union officers to return fugitive slaves to their owners. Butler's refusal was unusual in 1861.

13 Quoted in James M. McPherson, *The Negro's Civil War: How American Blacks Felt and Acted during the War for the Union*. (Originally published in 1965.) New York: Ballantine, 1991: 165.

14 Quoted in McPherson, *The Negro's Civil War*: 94–99.

15 Quoted in McPherson, *Battle Cry of Freedom*: 558.

16 Berlin, ed., *Freedom: Series II*: 7.

17 A regiment ordinarily contained ten companies of one thousand men each. Historians have not produced statistics on black soldiers in the Confederate Forces. Confederate supporters claim thousands of black Confederates, but academic experts like James McPherson of Princeton University allow for less than one hundred voluntary Confederates of African descent. The Louisiana Native Guards, consisting of free black men, offered their services to the Confederacy when Louisiana joined the Confederate war effort. Once Union Forces occupied New Orleans in mid-1862, the Native Guards joined the Union and became known as the First Louisiana Company.

18 Lewis Douglass was wounded in the bloody assault on Fort Wagner in South Carolina in which half his company (including its commanding white officer) died. Denzel Washington earned an Oscar for best supporting actor for his role in *Glory*.

19 Sayles Bowen, quoted in McPherson, *The Negro's Civil War*: 181.

20 Keith Krawczynski and Steven D. Smith, "African Americans in the Civil War," in Steven D. Smith and James A. Ziegler, eds., *A Historic Context for the African-American Military Experience*, 1998: www.denix.osd.mil/denix/Public/ES-Programs/Conservation/Legacy/AAME/aame1.html. This text exists primarily in electronic format, although copies are available from U.S. Army Construction Engineering Research Laboratories (USACERL), P.O. Box 9005, Champaign, Ill. 61826-9005, by request to the National Technical Information Service, 5285 Port Royal Road, Springfield, Va. 22161.

21 For detailed information on Turner, see the PBS-Blackside documentary, *This Far by Faith*, 2003: www.pbs.org/thisfarbyfaith/people/henry_mcneal_turner.html.

22 Chester had lived in Liberia before becoming a reporter. After the Civil War, he moved to Great Britain, studied law, and became the first black American called to the English bar. On returning to the United States, he became the first black member of the Louisiana bar. See R. J. M. Blackett, ed., *Thomas Morris Chester, Black Civil War Correspondent: His Dispatches from the Virginia Front*. Baton Rouge: Louisiana State University Press, 1989.

23 General Nathan Bedford Forrest, a former slave trader and commander of the assault on Fort Pillow, led his men in a slaughter in which they cried "Kill the last God damned one of them." Jenkins, *Climbing Up to Glory*: 37–39.

24 McPherson, *Battle Cry of Freedom*: 610, and Leslie M. Harris, *In the Shadow of Slavery: African Americans in New York City, 1626–1863*. Chicago: University of Chicago Press, 2003: 279–288.

25 Quoted in McPherson, *The Negro's Civil War*: 189.

26 Quoted in Ibid.: 194. In its entirely Douglass's letter to his fiancée about the battle is at http://historymatters.gmu.edu/d/6215/ and in Carter G. Woodson, ed., *The Mind of the Negro as Reflected in Letters Written during the Crisis, 1800–1860*. Washington: The Association for the Study of Negro Life and History, 1926: 544.

27 White noncommissioned officers received $17 as company sergeants, $20 as first sergeants, and $21 dollars as regimental sergeants. All black noncommissioned officers received the same pay as enlisted men: $7 per month. Berlin, ed., *Freedom: Series II*: 1364.

28 McPherson, *Battle Cry of Freedom*: 563–564, 606–607. Figures for the numbers of black troops vary: According to Krawczynski and Smith, "Eventually, some 186,000 African Americans served as Federal soldiers in the Civil War, constituting approximately 7 percent of the entire Union Army. Of these, over 134,000 came from the slaveholding states. Louisiana led the list with 24,052 black soldiers, while Texas contributed the fewest, with 47. Among the Northern states, Pennsylvania mustered 8,612 blacks to the armed forces, followed by New York with 4,125 and Massachusetts with 3,996. These men were organized into 120 infantry, 12 heavy artillery, 7 cavalry regiments, and 10 light artillery batteries. They were led by some 7,000 white and approximately 109 black officers. [United States Colored Troops] and other black units took part in some 251 separate battles during the Civil War." See www.denix.osd.mil/denix/Public/ES-Programs/Conservation/Legacy/AAME/aame1.html.

29 "The Destruction of Slavery," in Ira Berlin et al., eds., *Freedom: A Documentary History of Emancipation, 1861–1867, Selected from the Holdings of the National Archives of the United States. Series I, Volume I: The Destruction of Slavery*. Cambridge, U.K., Cambridge University Press, 1985: 47.

30 David L. Valuska, "The Negro in the Union Navy," in *Freedom: Series II*: 14, note 22. See also Noralee Frankel, "Breaking the Chains," in Robin D. G. Kelley and Earl Lewis, eds., *To Make Our World Anew: A History of African Americans*. New York: Oxford University Press, 2000: 235.

31 Quoted in Jenkins, *Climbing Up to Glory*: 77.

32 This text is available on the internet at http://digilib.nypl.org/dynaweb/digs/wwm97267/. Living in Boston after the war, Taylor helped organize Corps 67, Women's Relief Corps, auxiliary to the Grand Army of the Republic, the Union veterans' organization, in 1886. See also Patricia W. Romero, "Taylor, Susie Baker King," in Darlene Clark Hine, ed., *Black Women in America*, Vol. II. Brooklyn, N.Y.: Carlson, 1993: 1145–1147.

33 Bowser was inducted into the U.S. Army Military Intelligence Corps Hall of Fame in 1995. See www.timesdispatch.com/blackhistory/MGBQM54OAIC.html, www.lkwdpl.org/wihohio/bows-mar.htm, and Darlene Clark Hine, William C. Hine, and Stanley Harrold, *The African-American Odyssey*. Upper Saddle River, N.J.: Prentice Hall, 2000: 247. Bowser kept a journal during her years in the Confederate White House, but it remains in private hands and unavailable to historians.

34 Keckley was also an autobiographer and confidante of first lady Mary Todd Lincoln. Keckley's 1868 autobiography, *Behind the Scenes: or Thirty Years a Slave and Four Years in the White House*, described her early years in slavery, her dressmaking business, and her association with the Lincoln family. This text is available on line at http://docsouth.unc.edu/keckley/keckley.html. See also chapter 5, note 6.

35 General William T. Sherman specifically barred black troops from taking part in the Washington, D.C., parade. See Louise Schiavone, "Long-ignored black civil war soldiers honored with parade," CNN, September 9, 1996, www.cnn.com/US/9609/09/civil.war.parade/.

36 Williams had enrolled in the Union Army as a young teenager. He also published the two-volume *History of the Negro Race in America from 1619–1880* in 1882. Williams died after investigating Belgian cruelty in the Congo. See John Hope Franklin, *George Washington Williams, a Biography*. Chicago: University of Chicago Press, 1985.

37 Dunbar's father Joshua fought with the Massachusetts 55th, which liberated Charleston on February 21, 1865. Henry Louis Gates, Jr., and Nellie Y. McKay, eds., *The Norton Anthology of African American Literature*. New York: W. W. Norton, 1997: 889–891. Paul Laurence Dunbar wrote "The Colored Soldiers" in 1895 and first published it in the book of poems that made his reputation: *Lyrics of Lowly Life*. New York: Dodd, Mead, 1896, for which William Dean Howells wrote the Introduction. *Lyrics of Lowly Life* includes Dunbar's most famous poems, including "When Malindy Sings," "We Wear the Mask," and "Ode to Ethiopia." See also Hine et al., *African-American Odyssey*: 229.

38 The modern historiography of blacks in the Civil War began with Benjamin Quarles, *The Negro in the Civil War*. Boston: Little, Brown, 1953, 1969.

39 Allen B. Ballard, *Where I'm Bound, a Novel*. New York: Simon & Schuster, 2000.

40 For the "Spirit of Freedom" monument, see www.edhamiltonworks.com/spirit_of_freedom. htm. The African American Civil War Memorial and Freedom Foundation Museum & Visitors Center are at www.afroamcivilwar.org/ourstory. Ed Hamilton also sculpted a monument to the *Amistad* mutineers in New Haven, Connecticut. For his biography, see www.edhamiltonworks. com/biography.htm.

Until the erection of Hamilton's "Spirit of Freedom" monument, the only such commemoration of black soldiers appeared as part of the Boston monument to Robert Gould Shaw, a white officer who fell with his troops of the Massachusetts 54th.

See also www.cnn.com/US/9807/18/black.civil.war.mem/. Some black reenactors call themselves Black Camisards. See *Black Camisards: African-American Civil War Art and Collectibles* at www.blackcamisards.com/.

41 Nelson and Scantling quoted in Jenkins, *Climbing Up to Glory*: 67.

42 Berlin et al., eds. *Freedom, Series I, Volume I*: 36.

43 Ibid.: 49, 52–53.

44 Quoted in Jenkins, *Climbing Up to Glory*: 82.

45 Ibid.: 81.

7: *The Larger Reconstruction, 1864–1896*

1 Eric Foner, *Reconstruction: America's Unfinished Revolution, 1863–1877*. New York: Harper & Row, 1988: 82.

2 Nell Irvin Painter, *Exodusters: Black Migration Following Reconstruction*. (Originally published 1976.) New York: W. W. Norton, 1992: 73.

3 See Herbert G. Gutman, *The Black Family in Slavery and Freedom, 1750–1925*. New York: Pantheon, 1976.

4 For a detailed explanation of the economics of post-war Southern agriculture, see "The Economics of Oppression" in Painter, *Exodusters*: 54–68, and Foner, *Reconstruction*: 139–149.

5 Foner, *Reconstruction*: 70–71, and Andrew Billingsley, *Mighty Like a River: The Black Church and Social Reform*. New York: Oxford University Press, 1999: 24–34.

6 African-American historians long ago recognized the historical importance of the Freedmen's Bureau. For instance, W. E. B. Du Bois published "The Freedmen's Bureau" in the *Atlantic Monthly* 87 (1901): 354–365.

7 In Leon F. Litwack, *Been in the Storm So Long: The Aftermath of Slavery*. New York: Alfred A. Knopf, 1979: 399.

8 The story is actually quite complicated. In 1865 Congress created the Freedmen's Bureau to last only one year. The following year Congress voted to make the Freedmen's Bureau permanent. President Johnson vetoed the 1866 bill, which contained provision to give freedpeople clear title

for an additional three years to the land General Sherman had set aside for them in Special Field Orders No. 15 on the islands and the mainland. According to the Freedmen's Bureau Act Congress passed over Johnson's veto in 1866, only land that was held by the federal government on the South Carolina and Georgia Sea Islands—not the mainland—was open to freedpeople. Because owners had reclaimed most of this land by late 1866, only about two thousand freedmen families were able to take permanent title.

The South Carolina Land Commission and the Southern Homestead Act also attempted, with minimal success, to provide freedpeople with land. The South Carolina Land Commission, created in 1869, sold land to 14,000 families, most of whom were black. But it soon went out of business, accused of corruption and inefficiency. The Southern Homestead Act made little difference, because the public land available for homesteading was of poor quality and because freedpeople lacked the necessary capital for settling on virgin land and supporting themselves through to a harvest. Only a few thousand freedmen families claimed farms under the Southern Homestead Act, and only about one thousand of them were able to remain on their land long enough to fulfill the requirements to obtain permanent title. See Painter, *Exodusters*: xi.

9 Foner, *Reconstruction*: 96.

10 See Marilyn Dell Brady, "Peake, Mary Smith Kelsey," in Darlene Clark Hine, ed., *Black Women in America: An Historical Encyclopedia*. Brooklyn, N.Y.: Carlson, 1993: 914.

11 John Hope Franklin and Alfred A. Moss, Jr., *From Slavery to Freedom*, 7th ed. New York: McGraw-Hill, 1994: 202.

12 Quoted in Foner, *Reconstruction*: 100.

13 Granddaughter of the wealthy sailmaker James Forten, Charlotte Forten grew up surrounded by black abolitionists. As a student she belonged to the Salem Female Anti-Slavery Society and knew prominent Boston abolitionists like William Lloyd Garrison and Wendell Phillips. In the spring of 1862 she joined the Port Royal Project in South Carolina, publishing two essays on her experience in the May and June 1864 issues of the *Atlantic Monthly*. Back in Boston, she recruited teachers for the freedpeople through the Freedmen's Relief Association. In 1878 she married the Reverend Francis J. Grimké (1850–1937). She continued to write and protest against racial discrimination. See Janice Sumler-Edmond, "Grimké, Charlotte L. Forten," in *Black Women in America*: 505–507.

14 The term "carpetbagger" comes from the word "carpetbag." In the nineteenth century, before the rise of an industry dedicated to the production of items intended strictly for travel, people moving about made their luggage out of old pieces of carpet. Therefore to be a carpetbagger was to be someone living out of a suitcase, someone without an established residence, an itinerant lacking a commitment to a particular community, that is, an opportunist.

15 Foner, *Reconstruction*: 98.

16 Franklin and Moss, *From Slavery to Freedom*: 230–231.

17 *United States Bureau of the Census, Negro Population, 1790–1915*. Washington, D.C.: United States Government, 1918: 404–405. Among older African Americans in 1910, women were more likely to be illiterate than men. But among younger black people, this was reversed: girls were less likely than boys to be illiterate.

18 See Elsa Barkley Brown, "Negotiating and Transforming the Public Sphere: African-American Political Life in the Transition from Slavery to Freedom," in Glenda Gilmore, Jane Dailey, and Bryant Simon, eds., *Jumpin' Jim Crow*. Princeton, N.J.: Princeton University Press, 2000: 28–66, and Ralph E. Luker, *The Social Gospel in Black and White: American Racial Reform, 1885–1912*. Chapel Hill: University of North Carolina Press, 1991.

19 Foner, *Reconstruction*: 91.

20 Franklin and Moss, *From Slavery to Freedom*: 231.

21 Ibid.: 242.

22 See Stephen Ward Angell, *Bishop Henry McNeal Turner and African-American Religion in the South*. Knoxville: University of Tennessee Press, 1992, and Edwin S. Redkey, *Black Exodus: Black Nationalist and Back-to-Africa Movements, 1890–1910*. New Haven: Yale University Press, 1969.

23 Quoted in Noralee Frankel, "Breaking the Chains: 1860–1880," in Robin D. G. Kelley and Earl Lewis, eds., *To Make Our World Anew: A History of African Americans*. New York: Oxford University Press, 2000: 245.

24 Ibid.

25 See Russell Duncan, *Freedom's Shore: Tunis Campbell and the Georgia Freedmen*. Athens, Ga.: University of Georgia Press, 1986.

26 Franklin and Moss, *From Slavery to Freedom*: 239–240.

27 Frankel, "Breaking the Chains": 251. For a table listing the names of the Western legislators, see Quintard Taylor, *In Search of the Racial Frontier: African Americans in the American West*. New York: W. W. Norton, 1998: 130–133.

28 Fifteen black men served in Congress during Reconstruction: Hiram R. Revels, Senator, Mississippi, 1870–1871; Blanche K. Bruce, Senator, Mississippi, 1875–1881; Jefferson P. Long, Congressman, Georgia, 1869–1871; Joseph H. Rainey, Congressman, South Carolina, 1871–1879; Robert C. DeLarge, Congressman, South Carolina, 1871–1873; Robert Brown Elliott, Congressman, South Carolina, 1871–1875; Benjamin S. Turner, Congressman, Alabama, 1871–1873; Josiah T. Walls, Congressman, Florida, 1873–1877; Alonzo J. Ransier, Congressman, South Carolina, 1871–1873; Richard H. Cain, Congressman, South Carolina, 1873–1875, 1877–1879; John R. Lynch, Congressman, Mississippi, 1873–1879, 1881–1887; Charles E. Nash, Congressman, Louisiana, 1875–1877; John A. Hyman, Congressman, North Carolina, 1875–1877; Jere Haralson, Congressman, Alabama, 1875–1877; Robert Smalls, Congressman, South Carolina, 1875–1879, 1881–1887. Source: www.duboislc.org/BlackPerspective/BlackPerspectivePart9.html.

29 Quoted in Painter, *Exodusters*: 75.

30 Ibid.: 33–34.

31 In the larger Kansas towns the schools were racially segregated, leading to the *Brown v. Board of Education* U.S. Supreme Court decision of 1954 declaring school segregation inherently unconstitutional. The whole story of the exodus to Kansas is in Painter, *Exodusters*.

32 The court advanced the development of modern capitalism by recognizing the incorporation of businesses into corporations. Corporations became legal persons with the same rights as natural persons. Actually, in the late nineteenth and early twentieth centuries, corporations enjoyed more rights than natural persons who were black. See Charles J. Ogletree, Jr., "Brown at 50: Considering the Continuing Legal Struggle for Racial Justice," in Lee A. Daniels, ed., *The State of Black America 2004*. New York: National Urban League, 2004: 82–83.

33 See Wilbert L. Jenkins, *Climbing Up to Glory: A Short History of African Americans during the Civil War and Reconstruction*. Wilmington, Del.: Scholarly Resources, 2002: 125–126, and Quintard Taylor, "Buffalo Soldiers in the West, 1866–1917," in *In Search of the Racial Frontier: African Americans in the American West, 1528–1990*. New York: W. W. Norton, 1998: 164–191.

34 The Pension Bureau and the Post Office convicted and imprisoned Callie House on curious reasoning: The government never intended to give reparations to old ex-slaves and, therefore, any attempt to gain pensions or reparations was fraudulent. See Mary Frances Berry, *My Face Is Black Is True: Callie House and the Struggle for Ex-Slave Reparations*. New York: Alfred A. Knopf, 2005; Deadria C. Farmer-Paellman, "Excerpt from *Black Exodus: The Ex-Slave Pension Movement Reader*," in Raymond A. Winbush, ed., *Should America Pay? Slavery and the Raging Debate on Reparations*. New York: HarperCollins, 2003: 27; and Adjoa A. Aiyetoro, "The National Coalition of Blacks for Reparations in America (N'COBRA): Its Creation and Contribution to the Reparations Movement," in Winbush, *Should America Pay?*: 209–210.

35 See Painter, *Exodusters*: xii–xiii, 16.

8: Hard-Working People in the Depths of Segregation, 1896–ca.1919

1 In 1900, 62.2 percent of all black people were working, compared to 48.6 percent of whites. This disparity held up until the 1960s, when nonblack women entered the workforce in large numbers. As black workers found better paid employment beyond agriculture and domestic service, children and old people worked less. Jessie Carney Smith and Carrell Peterson Horton, *Historical Statistics of Black America*, Vol. I. New York: Gale Research, 1995: 1047–1048, 1096.

2 Smith and Horton, *Historical Statistics of Black America*, Vol. I: 1094.

3 Juliet E. K. Walker, *The History of Black Business in America: Capitalism, Race, Entrepreneurship*. New York: Macmillan, 1998: 151, and Nell Irvin Painter, *Exodusters: Black Migration to Kansas after Reconstruction*, 2nd ed. Lawrence: University of Kansas Press, 1986: 58–59.

4 Systems of convict leasing varied from state to state, and the causes of their demise also varied according to the efficacy of reform campaigns, investigative reporting, abuses of especially savage character, and the erection of prisons. Although the practice of forcing prisoners to work continued after convict leasing ended, states rather than private employers controlled prisoners' labor. See Matthew J. Mancini, *One Dies, Get Another: Convict Leasing in the American South, 1866–1928*. Columbia, S.C.: University of South Carolina Press, 1996. See also Darlene Clark Hine, William C. Hine, and Stanley Harrold, *The African-American Odyssey*. Upper Saddle River, N.J.: Prentice Hall, 2000: 329, and Florette Henri, *Black Migration: Movement North, 1900–1920. The Road from Myth to Man*. New York: Anchor/Doubleday, 1975: 40.

5 In 1995 the state of Alabama reinstituted the chain gang, supposedly as a deterrent to crime, but certainly as a means of humiliating the incarcerated. After a guard killed a prisoner on the chain gang and the Alabama Corrections Commissioner threatened to put women prisoners on chain gangs, public outcry forced the state to suspend the practice.

6 See Hine et al., *The African-American Odyssey*: 335.

7 Ibid.: 335–336.

8 Less well known at the time and virtually forgotten today, William Sanders Scarborough (1852–1926) was a classicist who taught at Wilberforce University in Ohio, where he also served as president. A member of several white scholarly societies and active in Ohio politics, Scarborough nevertheless waged a continual battle against prevailing assumptions that African Americans were not smart enough to master Greek and that they had no need for education in the classics, when the classics stood as the symbol of the finest in higher education. See Michele Ronnick, ed., *The Autobiography of William Sanders Scarborough: An American Journey from Slavery to Scholarship*. Detroit: Wayne State University Press, 2004.

9 Quoted in John Hope Franklin and Alfred A. Moss, *From Slavery to Freedom: A History of African Americans*, 7th ed. New York: McGraw-Hill, 1994: 274.

10 The Carnegie Foundation recommended that all but the most stringent medical schools in the United States be closed. As a result, all the black medical schools but Howard and Meharry closed down in the 1920s.

11 Hine et al., *The African-American Odyssey*: 352.

12 For information on the history and activities of the National Bar Association, go to http://209.96.140.91/about/index.shtml.

13 Walker, *The History of Black Business in America*: 201–203. See also Burt McKinnley, Jr., *Black Inventors of America*. Portland, Oreg.: National Book Company, 1969: 141–148.

14 On George F. Grant and other early black golfers, see Calvin H. Sinnette, *Forbidden Fairways: A History of African Americans and the Game of Golf*. Chelsea, Mich.: Sleeping Bear Press, 1998: 7–12.

15 By 1915 the NNBL's 5,000 to 40,000 members belonged to more than 600 chapters in 34 states and the Gold Coast (now Ghana), West Africa. The spread of the possible numbers hints at the difficulty of determining who was or was not a "member" of the NNBL.

16 Walker, *The History of Black Business in America*: 183–185.

17 Ibid.: 190–191.

18 Binga's colorful career included a conviction for embezzlement, three years of incarceration, and janitorial work during his final years.

19 Walker, *The History of Black Business in America*: 190–192.

20 Although both share the last name Walker, and both companies still exist, the two women were not related. Nor is Juliet Walker, the historian of business, related to the two turn-of-the-twentieth-century entrepreneurs.

21 Walker, *The History of Black Business in America*: 164–166, 187–188, and Hine et al., *The African-American Odyssey*: 350.

22 Walker, *The History of Black Business in America*: 210. See also A'Lelia Bundles, *The Life and Times of Madam C. J. Walker: The True Story of Madam Walker's Life*. New York: Scribner, 2001.

23 Henri, *Black Migration*: 35.

24 Walker, *The History of Black Business in America*: 172–174. See also Kenneth Hamilton, *Black Towns and Profit: Promotion and Development in the Trans-Appalachian West, 1877–1915*. Ur-

bana: University of Illinois Press, 1991, and Quintard Taylor, *In Search of the Racial Frontier: African Americans in the American West, 1528–1990*. New York: W. W. Norton, 1998. Hamilton and Taylor list forty-nine black Western towns, including four in California, one in Colorado, and twenty-nine in Oklahoma. John Hope Franklin (b. 1915), the dean of African-American historians, grew up in all-black Rentiesville, Oklahoma.

25 The sanctified and holiness movements began on an interracial basis, but the white supremacy of the time made it difficult for white people to join black people, even in the worship of God. By the early years of the twentieth century, the Church of God in Christ and the Church of Christ, Holiness were all-black.

26 In 1890 there were 1,490 full-time black actors and showmen, many of whom performed as minstrels. See Eileen Southern, *The Music of Black Americans: A History*, 2nd ed. New York: W. W. Norton, 1983: 233–237.

27 Southern, *The Music of Black Americans*, 2nd ed.: 266–269.

28 Joplin moved from Sedalia, Missouri, to New York City in 1905, the same year he completed his second opera, "Treemonisha." The opera's central figure is a young teacher, Treemonisha, in rural Arkansas in 1884. Joplin saw the race's teachers as its saviors. "Treemonisha" was not performed in Joplin's short life. It had its world premier in 1972 in Atlanta and moved to Broadway in 1975. The Houston Grand Opera's production of "Treemonisha" was filmed in 1982. See ibid.: 310–311, 321.

29 Handy had originally written his classic "Memphis Blues" of 1912 as a 1909 campaign song for "Boss" Edward Crump. Ibid., 336.

30 Ibid.: 330.

31 See Thomas R. Hietala, *The Fight of the Century: Jack Johnson, Joe Louis, and the Struggle for Racial Equality*. Armonk, N.Y.: M. E. Sharpe, 2002. In January 2005 the filmmaker Ken Burns showed his four-hour film, *Unforgivable Blackness: The Rise and Fall of Jack Johnson*, on the Public Broadcasting System (PBS).

32 See David K. Wiggins and Patrick B. Miller, *The Unlevel Playing Field: A Documentary History of the African American Experience in Sport*. Urbana: University of Illinois Press, 2003: 92–95.

33 See ibid.: 92–95. See also Hine et al., *The African-American Odyssey*: 356. Between the beginning of his career in 1922 and his retirement in 1950, Bell played with seven different teams in the United States. He was too old to join the white Big Leagues when they desegregated in 1947, but he helped prepare his younger teammate, Jackie Robinson, to make the transition. Bell was elected to the National Baseball Hall of Fame in 1974. See also www.negroleaguebaseball. com/1999/October/cool_pap_bell.html and http://library.thinkquest.org/3427/data/bell.htm?tqs kip1=1&tqtime=0801. See also Donald Spivey, ed., *Sport in America: New Historical Perspectives*. Westport, Conn.: Greenwood Press, 1985.

34 See Sinnette, *Forbidden Fairways*: 7–30, and the United States Tennis Association: www.usta. com/misc_pages/custom.sps?iType=1927&icustompageid=9062.

35 W. E. B. Du Bois made the first accounting; the second was by the white journalist Ray Stannard Baker. Henri, *Black Migration*: 167. See also Noliwe Rooks, *Ladies Pages: African American Women's Magazines and the Culture that Made Them*. New Brunswick, N.J.: Rutgers University Press, 2004.

36 The Fifteenth Amendment to the United States Constitution gave black men a conditional right to vote. According to the Amendment, states that disfranchised large numbers of men would have their congressional representation decreased. The disfranchisement of masses of poor white and black men in the South prompted an effort in the U.S. Congress in 1901 to reduce the disfranchising states' congressional representation. This effort failed, and Southern representation was never cut back. See Michael Perman, *Struggle for Mastery: Disfranchisement in the South, 1888–1908*. Chapel Hill: University of North Carolina Press, 2001: 224–244.

In the twentieth century, Southern congressmen and senators came to exercise overweening power in Congress by dint of being constantly reelected by very small electorates. Southern representatives accumulated great seniority, which gave them influential committee chairmanships and allowed them to block federal aid to education and any federal Civil Rights legislation. In the first half of the century, Southern representatives and senators were all Democrats. During and after

the Civil Rights era of the 1960s, Southern conservatives switched to the Republican party. By the early twenty-first century, Southerners still ruled Congress as conservatives, but as Republicans.

37 Perman, *Struggle for Mastery*: 314.

38 See Darlene Clark Hine, *Black Victory: The Rise and Fall of the White Primary in Texas*. Millwood, N.Y.: KTO Press, 1979.

39 Nell Irvin Painter, *Standing at Armageddon: The United States, 1877–1919*. New York: W. W. Norton, 1987: 227.

40 In 1906 Whitesboro, New Jersey, had a population of more than eight hundred. White himself moved to Philadelphia in 1905 to practice law. See George W. Reid, "White, George H[enry]," in Rayford W. Logan and Michael R. Winston, eds., *Dictionary of American Negro Biography*. New York: W. W. Norton, 1982: 645–646.

41 Henri, *Black Migration*: 18.

42 Ibid.: 16.

43 Quoted in Hine et al., *The African-American Odyssey*: 341.

44 Robert L. Zangrando, "Lynching," in Eric Foner and John A. Garraty, eds., *The Reader's Companion to American History*. Boston: Houghton Mifflin, 1991: 685.

45 In 2000 a sensational exhibition of postcards of lynchings began touring the United States. The graphic and shocking images are collected in James Allen, Hinton Als, and Leon Litwack, *Without Sanctuary: Lynching Photography in America*. San Francisco: Twin Palms, 2000.

46 The NACW's motto was "Lifting as We Climb." The ex-slave narrator Harriet Jacobs attended the NACW founding meeting with her daughter Louisa (1833–1917).

47 In 1964 the lynchers of James Chaney (1943–1964), Andrew Goodman, and Michael Schwerner were prosecuted in Mississippi under the Civil Rights Act of 1964. In January 2005 Edgar Ray Killen, a seventy-nine-year-old preacher and Klansman, was arrested in connection with the 1964 murders. See page 275. In June 2005, Killen was convicted of the lesser charge of manslaughter, and sentenced to 60 years in prison.

 At this writing, the most recent lynching of a black person, James Byrd, occurred in Texas in 1998. It is too soon to say when the last lynching will have occurred in the United States.

9: The New Negro, 1915–1932

1 Florette Henri, *Black Migration: Movement North, 1900–1920. The Road from Myth to Man*. New York: Anchor/Doubleday, 1975: 63–65, and http://newswatch.sfsu.edu/milestones/decade1900_abbott.html. Abbott commissioned Pullman porters and black entertainers to distribute the *Defender* nationwide. By 1920, *Defender* circulation reached 283,570, with each issue touching more than a million black people.

2 Southern cities also experienced increases in their black populations. Between 1900 and 1910, the black population of Birmingham, Alabama, increased 216 percent. The black population increased 213 percent in Fort Worth, Texas, 137 percent in Jackson, Mississippi, and between 45 and 99 percent in Atlanta, Charlotte, Dallas, Houston, Richmond, and Shreveport. White Southerners actually migrated North in far greater numbers than blacks, but their migration did not attract the same notice or violence. See Nell Irvin Painter, *Standing at Armageddon: The United States, 1877–1919*. New York: W. W. Norton, 1987: 337, and Henri, *Black Migration*: 51, 168–169. See also James Grossman, *Land of Hope: Chicago, Black Southerners, and the Great Migration*. Chicago: University of Chicago Press, 1989; Peter Gottlieb, *Making Their Own Way: Southern Blacks' Migration to Pittsburgh, 1916–30*. Urbana: University of Illinois Press, 1987; and Malaika Adero, ed., *Up South: Stories, Studies, and Letters of This Century's Black Migrations*. New York: The New Press, 1993. Clement Alexander Price, "The Afro-American Community of Newark, 1917–1947: A Social History," unpublished Ph.D. dissertation, Rutgers University, 1975: 9.

3 In 1910, 3,055 black people lived in Oakland, 4,426 in Omaha, and 2,296 in Seattle. See Quintard Taylor, *In Search of the Racial Frontier: African Americans in the American West, 1528–1990*. New York: W. W. Norton, 1998: 193.

4 Henri, *Black Migration*: 69, and Price, "The Afro-American Community of Newark": 9.

5 Henri, *Black Migration*: 164–165.

6 Most of the immigrants settled in the states of New York (with 31,971 black immigrants), Florida

(with 10,665 black immigrants), and Massachusetts (with 9,037 black immigrants). About 52,400 came from the Caribbean (including Cuba), about 5,700 from Canada. In addition, about 5,400 came from the Azores and other islands in the Atlantic Ocean. About 4,000 came from Europe and 3,100 from Mexico. See Jessie Carney Smith and Carrell Peterson Horton, *Historical Statistics of Black America*, Vol. I. New York: Gale Research, 1995: 1640–1642.

7 Painter, *Standing at Armageddon*: 337, and Henri, *Black Migration*: 60.

8 See James Weldon Johnson, *Along This Way: The Autobiography of James Weldon Johnson*. New York: Viking, 1933: 301.

9 Henri, *Black Migration*: 275.

10 David Levering Lewis, ed., *W. E. B. Du Bois, a Reader*. New York: Henry Holt, 1995: 697.

11 Henri, *Black Migration*: 278–284.
 Charles Young was the ninth black man to attend (but only the third to graduate from) West Point. See www.army.mil/cmh-pg/topics/afam/davis.htm and Nancy Gordon Heinl, "Young, Charles," in Rayford W. Logan and Michael R. Winston, eds., *Dictionary of American Negro Biography*. New York: W. W. Norton, 1982: 677–679.
 Racial discrimination severely hampered the career of Benjamin O. Davis, Sr. (1877-1970), the first black American to achieve the rank of general. He served in the Philippine Islands and rose through the ranks to become a second lieutenant and taught military science at Wilberforce College during the First World War. He served in the Second World War. Davis's son, Benjamin O. Davis, Jr. (1912–2002), was the second black general. Unlike his father, he attended the United States Military Academy at West Point, graduating in 1936. One of the famous Tuskegee Airmen, Davis commanded the 99th Pursuit Squadron and the 332nd Fighter Group during the Second World War. After distinguished service in the Korean War, he became the first black American to become an air force brigadier general.

12 Henri, *Black Migration*: 288.

13 Miles Richards, "McKaine, Osceola Enoch," in ed. Thomas Downey, *Encyclopedia of South Carolina*. Columbia: University of South Carolina Press, forthcoming.

14 Haywood spearheaded the Communist focus on African Americans in the 1930s and also fought for the Spanish Republicans during the Spanish Civil War of the mid-1930s.

15 Henri, *Black Migration*: 271.

16 David Levering Lewis, *When Harlem Was in Vogue*. New York: Oxford University Press, 1982: 3.

17 Henri, *Black Migration*: 289.

18 Marc Gallicchio, *The African American Encounter with Japan and China: Black Internationalism in Asia, 1895–1945*. Chapel Hill: University of North Carolina Press, 2000: 32–33.

19 Arthur Little, an officer of the 369th, narrated Europe's experiences in *From Harlem to the Rhine* (1936). See Eileen Southern, *The Music of Black Americans: A History*, 2nd ed. New York: W. W. Norton, 1983: 301, 349.

20 Quoted in Southern, *Music of Black Americans*: 352.

21 In May 1919, during a concert in Boston, an enraged member of the band murdered Europe on stage. See Southern, *Music of Black Americans*: 353–354.

22 Quoted in Lewis, *When Harlem Was in Vogue*: 15. Emphasis in the original.

23 Quoted in Henri, *Black Migration*: 312.

24 The year 1919 also produced an antisocialist, antianarchist, antilabor "Red Scare." The "red" in Red Scare referred to the color associated with socialism, not with the color of blood of the "Red Summer." See Painter, *Standing at Armageddon*: 344–390.

25 The signs were in all capital letters for emphasis. Painter, *Standing at Armageddon*: 337–338. The attack in East St. Louis finally moved President Wilson to issue a statement deploring racial violence. John Hope Franklin and Alfred A. Moss, Jr., *From Slavery to Freedom: A History of African Americans*. New York: McGraw-Hill, 1994: 344.

26 Painter, *Standing at Armageddon*: 364.

27 Ibid.: 365, 374, and Franklin and Moss, *From Slavery to Freedom*: 351–352.

28 The Tulsa attack became the subject of legal action seventy-five years after the fact. After much agitation on the part of black Oklahomans and their allies, the Oklahoma State legislature set up an investigatory commission. In 2000 the commission recommended the payment of reparations

to the black community because officials of the city and state had committed crimes against African Americans. The state did not pay reparations, and survivors, led by the distinguished historian John Hope Franklin, filed suit against the city and state.

29 Henry Louis Gates, Jr., and Nellie Y. McKay, eds., *The Norton Anthology of African American Literature*. New York: W. W. Norton, 1997: 984.

30 Briggs was West Indian. In the 1920s he became one of the founders of the African Blood Brotherhood and the Communist Party of the United States of America.

31 By 1920 the *Negro World's* circulation of two hundred thousand had outgrown even the *Defender*. Henri, Black Migration: 333.

32 Du Bois died in the West African nation of Ghana in 1963. He had become a citizen of Ghana and a member of the Communist Party of the United States.

33 Trotter was editor of the Boston *Guardian* newspaper. Wells-Barnett had married the Chicago lawyer and publisher Claude Barnett in 1895. Trotter reached Paris by subterfuge, shipping out as a cook on a freighter. Walker died later in 1919. See Painter, *Standing at Armageddon*: 355–356.

34 Quoted in Gates and McKay, *The Norton Anthology*: 973.

35 Quoted in Lewis, *When Harlem Was in Vogue*: 43–44. See also Henri, *Black Migration*: 335.

36 Gates and McKay, *The Norton Anthology*: 768–769.
 "Lift Every Voice and Sing" inspired Augusta Savage's monumental sculpture created for the New York World's Fair of 1939. It shows a line of inspired black singers in the shape of a harp.

37 Quoted in Southern, *Music of Black Americans*: 289. During the wave of professional organizing of 1919, African-American musicians formed the National Association of Negro Musicians "to discover and foster talent, to mold taste, to promote fellowship, and to advocate racial expression."

38 Smith's recording of "You Can't Keep a Good Man Down" sold so well that in August 1920 she recorded "Crazy Blues" and "It's Right Here for You." Smith's African-American manager, Perry Bradford, had written all four songs. For a comprehensive discussion of music during the New Negro years, see Southern, *Music of Black Americans*: 365, 395–456.

39 Ibid.: 400–405. Hayes sang at a concert on his seventy-fifth birthday; Anderson sang in fifty-one farewell concerts in the 1964–1965 season. The U.S. State Department suspected Robeson of being a Communist and withdrew his passport in 1950.

40 Lewis, *When Harlem Was in Vogue*: 193.

41 Gates and McKay, *The Norton Anthology*: 934.

42 Ibid.: 937–938.

43 Quoted in Lewis, *When Harlem Was in Vogue*: 92.

44 Woodson's institutions endure as the Association for the Study of African-American Life and History and the *Journal of African-American History*.

10: Radicals and Democrats, 1930–1940

 1 Darlene Clark Hine, William C. Hine, and Stanley Harrold, *The African-American Odyssey*. Upper Saddle River, N.J.: Prentice Hall, 2000: 429.

 2 Woodson had established the Associated Publishers, the publishing arm of the ASNLH (now the Association for the Study of African-American Life and History) in 1921-1922 for the advancement of the scientific study of African Americans. The son of a slave, Woodson had worked his way through college as a coal miner. He ultimately received a Ph.D. in history from Harvard in 1912. The author of several books on black history and education and the long-time founding editor of the *Journal of Negro History* (now the *Journal of African-American History*), Woodson dedicated most of his career to the activities of the ASNLH.
 Lorenzo Greene received his Ph.D. from Columbia University. The Columbia University Press published his revised dissertation, *The Negro in Colonial New England*, in 1942. As a young historian, Greene worked as Woodson's assistant. He spent most of his career at Lincoln University in Missouri, retiring in 1972.

 3 James Oliver Horton and Lois E. Horton, *Hard Road to Freedom: The Story of African America*. New Brunswick, N.J.: Rutgers University Press, 2001: 250.

 4 Patricia Sullivan, *Days of Hope: Race and Democracy in the New Deal Era*. Chapel Hill: University of North Carolina Press, 1996: 21.

5 Comparable statistics on white men and black women are not available.

6 Hine et al., *African-American Odyssey*: 420–421.

7 Angelo Herndon, a hero of Southern Communism, published an autobiography in 1937, *Let Me Live*. Hosea Hudson, an ironworker and longtime Communist, published his autobiography, *Black Worker in the Deep South* in 1973. Hudson is also the subject of Nell Irvin Painter, *The Narrative of Hosea Hudson: His Life as a Negro Communist in the South*. (Originally published 1979.) New York: W. W. Norton, 1992. See also Robin D. G. Kelley, *Hammer and Hoe: Alabama Communists during the Great Depression*. Chapel Hill: University of North Carolina Press, 1990.

8 Quoted in Painter, *Narrative of Hosea Hudson*: 195. Hudson explained his allegiance to the CPUSA in the late 1970s: "My position was that in the Party I would be bettering my condition by helping to get conditions better for other people. And I wasn't the onliest one suffering. I was suffering along like all the rest. Everybody else was unemployed. I had learned enough to know that the working class have their own problems. But we all going to have to solve our problems together in the struggle. I stuck to that argument and I stuck to the Party." Painter, *Narrative of Hosea Hudson*: 95.

9 The Reverend Adam Clayton Powell, Jr., succeeded his father, Adam Clayton Powell, Sr. (1865–1953), as minister of the Abyssinian Baptist Church in Harlem, the city's largest black congregation. The younger Powell defended black working-class New Yorkers in a series of direct actions, including strikes and boycotts. His constituency elected him to the New York City Council in 1941 and to Congress in 1944. Considered left-leaning and flamboyant, Powell challenged Congress's whites-only policies and championed his constituency's interests in issues pertaining to labor and education. For more on the career of this important and controversial figure, see Charles V. Hamilton, *Adam Clayton Powell, Jr.: The Political Biography of an American Dilemma*. New York: Atheneum, 1991; and Powell's autobiography, *Adam by Adam: The Autobiography of Adam Clayton Powell, Jr.* New York: Dial Press, 1971.

10 Juliet E. K. Walker, *The History of Black Business in American: Capitalism, Race, Entrepreneurship*. New York: Macmillan, 1998: 192–193, 225–226. By 1934, in the depths of the Great Depression, only 12 black banks still existed of the 134 that had been founded in the United States since 1888. By the Second World War, half of those survivors had gone under, leaving only 6 surviving black banks. Four of those had been founded at the turn of the twentieth century and were still in existence at the turn of the twenty-first century. They included the banks founded by Maggie Lena Walker in Richmond, Virginia, and Charles C. Spaulding in Durham, North Carolina. See Walker, *History of Black Business in America*: 193.

11 Ibid.: 226–229.

12 Ibid.: 234, and Horton and Horton, *Hard Road to Freedom*: 252. Father Divine, born George Baker in Georgia, moved to Brooklyn, New York, in 1914 and founded his Universal Peace Mission. In the early 1930s the Peace Mission was relocated in Sayville, New York, and included white as well as black women. A judge who sentenced Father Divine to jail for disturbing the peace suddenly died, giving rise to the belief that Father Divine possessed extraordinary powers. The Peace Mission moved to Harlem in 1932, where it bought hotels and offered room, board, and employment to the needy. After the death of his first wife, who was black, Father Divine married a white follower, who continued the mission's work after his death. Divine's Peace Missions still exist in cities such as Philadelphia. See www.americanreligion.org/cultwtch/frdivine.html.

13 Fard (Wallace Dodd Fard, also known as Wali Farad or Wali Farad Muhammad), whose dates are unknown, founded the Nation of Islam in 1930 and disappeared in 1934. Fard had taken the place of Noble Drew Ali (1886–n.d.), founder of the Moorish Holy Temple of Science, who also disappeared mysteriously. For more on the early history of the Nation of Islam, see William H. Banks, Jr., *The Black Muslims*. Philadelphia: Chelsea House, 1997: 28–46.

14 Until 1933 presidents of the United States had been inaugurated in March of the year following their election. During the crisis of the Great Depression, the American economy worsened during the months between Roosevelt's election in November 1932 and his inaugural in March 1933. Amendment XX to the United States Constitution of 1933 moved the date of the inaugural to January 20.

15 Quoted in Sullivan, *Days of Hope*: 41.

16 The CIO began as a committee of the American Federation of Labor (AFL) in 1935. When it became larger and more powerful than the AFL in 1938, the AFL expelled the CIO unions. The two union federations existed separately until 1955, when they reunited in the AFL-CIO, which still exists.

17 Quoted in Colin A. Palmer, *Passageways: An Interpretive History of Black America, Vol. 2: 1863–1965.* Fort Worth: Harcourt Brace, 1998: 194.

18 In 1938 Martin Dies's House Un-American Activities Committee accused Augusta Savage of being a Communist, effectively cutting off funding for her work. Lawrence and Knight married in 1941. See Romare Bearden and Harry Henderson, *A History of African-American Artists: From 1792 to the Present.* New York: Pantheon, 1993: 132, 153, 164; Deirdre Bibby, "Savage, Augusta," in Darlene Clark Hine, ed., *Black Women in America*, Vol. II. Brooklyn, N.Y.: Carlson Publishing, 1993: 1010–1013, and David Leming, *Amazing Grace: A Life of Beauford Delaney.* New York: Oxford University Press, 1995: 72.

19 The historian Lawrence Reddick initiated the Kentucky State College project in 1934 while working for the Federal Emergency Relief Administration (FERA) in Kentucky. The WPA succeeded the FERA and enlarged the ex-slave oral history project. The Fisk oral history project, which began in 1938, was later published as *God Struck Me Dead* (1945). The white historian George P. Rawick edited the WPA ex-slave narratives and published them as *The American Slave: A Composite Autobiography*, Supplement Series 1 and Series 2. Westport, Conn.: Greenwood Publishing, 1977 and 1979. See also http://memory.loc.gov/ammem/snhtml/snintro07.html.

20 In 2000 the headquarters of the U.S. Department of Housing and Urban Development was renamed the Robert C. Weaver Federal Building.

21 Charles H. Houston, dean of the Howard University Law School, piloted the NAACP Legal Defense Fund's assault on segregation in public education that began with the 1938 Gaines victory over racial exclusion from the University of Missouri Law School and culminated with the *Brown* decision of 1954. Ralph Bunche, who earned a Ph.D. in political science from Harvard, did the research that underlay Gunnar Myrdal's *American Dilemma* (1944). Bunche worked for the U.S. State Department, then the United Nations, where he held office from 1946 until 1971. He received a Nobel Peace Prize in 1950 for bringing peace to Israel-Palestine.

22 Membership in the National Negro Congress was open to people of all races. The NNC flourished in the late 1930s, founding the Southern Negro Youth Congress (SNYC) to capitalize on young Southern African Americans' concern for racial and economic justice. However, the NNC and SNYC fell victim to partisan politics in the late 1930s. John P. Davis joined the Communist Party, and Communists of both races aligned the NNC and SNYC organizations so closely with the European policies of the Communist Party of the United States that A. Philip Randolph resigned as president of the NNC. See Hine et al., *African-American Odyssey*: 439, and Beth Tompkins Bates, *Pullman Porters and the Rise of Protest Politics in Black America, 1925–1945.* Chapel Hill: University of North Carolina Press, 2001: 132, 145.

23 Born in Jamaica, Joel Augustus Rogers came to the United States in 1917, at about the same time as Marcus Garvey. Rogers educated himself and became a prolific journalist and author of histories and collective biographies of great black figures. He published his books himself and reached a wide audience with titles such as *World's Great Men of Color* (1947). Five years before the Pittsburgh *Courier* sent Rogers to cover the Ethiopian war, the New York *Amsterdam News* sent him to cover the coronation of Haile Selassie I. See http://members.aol.com/klove01/joelaugu.htm and www.cwo.com/~lucumi/rogers.html.

24 Brenda Gayle Plummer, *Rising Wind: Black Americans and U. S. Foreign Affairs, 1935–1960.* Chapel Hill: University of North Carolina Press, 1996: 37, 43–52.

25 Peter N. Carroll, *The Odyssey of the Abraham Lincoln Brigade: Americans in the Spanish Civil War.* Stanford: Stanford University Press, 1994: 18, and Plummer, *Rising Wind*: 61. Louise Thompson, one of the earliest African-American graduates of the University of California, Berkeley, was a Harlem Renaissance colleague of Langston Hughes and Zora Neale Hurston, with whom she collaborated on the play *Mule Bone*. Thompson led a delegation of African-American writers to the Soviet Union in 1932. During the 1930s she formed an artists and writers club with Augusta Savage. A longtime friend of Paul Robeson, she married the prominent black American Commu-

nist William L. Patterson in 1940 after divorcing the writer Howard Thurman. See Robin D. G. Kelley, "Patterson, Louise Thompson," in Hine, ed., *Black Women in America*: 911.

26 Quoted in Horton and Horton, *Hard Road to Freedom*: 261.

27 The denial of permission to reproduce this image prevents its appearance here. It can be seen in Audreen Buffalo, ed., *Explorations in the City of Light: African-American Artists in Paris, 1945–1965*. New York: The Studio Museum in Harlem, 1996: 830.

28 The all-white law school of the University of Missouri rejected Gaines (a graduate of Lincoln University in Missouri, where Lorenzo J. Greene taught for many years) on racial grounds. The state of Missouri offered to pay Gaines's tuition at an out-of-state law school, a common Southern practice. The U.S. Supreme Court struck down that practice and ordered the University of Missouri to admit Gaines. In 1995 minority alumni and the Southwestern Bell Foundation endowed a Lloyd Gaines Scholarship Program at the University of Missouri Law School.

29 See Darlene Clark Hine, *Black Victory: The Rise and Fall of the White Primary in Texas*. Millwood, N.Y.: KTO Press, 1979.

30 In 1980 the city of Birmingham declared February 26, 1980, Hosea Hudson Day in recognition of his work as a pioneer in the struggle to gain the right to vote for black people in Birmingham. See Painter, *Narrative of Hosea Hudson*: xiii, 255–268.

31 Sullivan, *Days of Hope*: 4, 74, 91.

32 Quoted in Horton and Horton, *Hard Road to Freedom*: 260.

11: The Second World War and the Promise of Internationalism, 1940–1948

1 Strictly speaking, the United States was only lending and leasing money and materiel, but in practice, these contributions entailed the manufacture of a great deal of durable goods.

2 Eric Foner, *The Story of American Freedom*. New York: W. W. Norton, 1998: 242.

3 Quoted in Kenneth Robert Janken, *Rayford W. Logan and the Dilemma of the African-American Intellectual*. Amherst: University of Massachusetts Press, 1993: 131.

4 Keith Krawczynski, "African American Navy, Marine Corps, Women's Reserves, and Coast Guard Service During World War II," in Steven D. Smith and James A. Ziegler, eds., *A Historic Context for the African-American Military Experience*, 1998: www.denix.osd.mil/denix/Public/ES-Programs/Conservation/Legacy/AAME/aame3a.html. This text exists primarily in electronic format.

5 Quoted in Colin A. Palmer, *Passageways: An Interpretive History of Black America, Vol. 2: 1863–1965*. Fort Worth, Tex.: Harcourt Brace, 1998: 172.

6 Quoted in Robert F. Jefferson, "African Americans in the US Army during World War II," in Smith and Ziegler, *A Historic Context for the African-American Military Experience*.

7 Quoted in Brenda Gayle Plummer, *Rising Wind: Black Americans and U. S. Foreign Affairs, 1935–1960*. Chapel Hill: University of North Carolina Press, 1996: 73–74.

8 Quotes from Timothy B. Tyson, *Radio Free Dixie: Robert F. Williams and the Roots of Black Power*. Chapel Hill: University of North Carolina Press, 1999: 28–30, 38.

9 See Eduardo Pagán, *Murder at the Sleepy Lagoon: Zoot Suits, Race, and Riot in Wartime L.A.* Chapel Hill, Unversity of North Carolina Press, 2003.

10 The denial of permission to reproduce this image prevents its appearance here. It can be seen in Richard J. Powell, *Homecoming: The Art and Life of William H. Johnson*. Washington, D.C.: Smithsonian Institution, 1991: Plate 159, p. 179.

11 Quoted in David Leeming, *Amazing Grace: A Life of Beauford Delaney*. New York: Oxford University Press, 1998: 72, and Plummer, *Rising Wind*: 74–75.

12 This extraordinary case of collective and discriminatory punishment in the Navy was only corrected through a pardon granted in 1999 by President Bill Clinton. See www.cccoe.k12.ca.us/pc/.

13 Staupers was born in Barbados and came to the United States with her parents in 1903. She trained as a nurse at the Howard University College of Nursing and worked in tuberculosis control in Philadelphia and New York before heading the NACGN in 1934. She was also a founder of the National Council of Negro Women along with Mary McLeod Bethune in 1935. See Darlene Clark Hine, "Staupers, Mabel Keaton," in Hine, ed., *Black Women in America*: 1106–1108, and Darlene Clark Hine, *Black Women in White: Racial Conflict and Cooperation in the Nursing Profession, 1890–1950*. Bloomington: Indiana University Press, 1989.

14 Jefferson, "African Americans in the US Army during World War II."

15 Besse Coleman was the first African American to earn an international pilot's license. She died in 1926 practicing for an air show. The United States Postal Service dedicated a stamp in her honor in 1995. Hubert Julian, "The Black Eagle of Harlem," was associated with Marcus Garvey. He also flew at the coronation of Haile Selassie in 1930 and flew one flight against the Italian invaders of Ethiopia in 1935. In 1965 Julian published an autobiography, *Black Eagle*.

 Walter White of the NAACP had opposed the ban on black fliers during the First World War. See www.aetc.randolph.af.mil/ho/tuskegee_amn.htm and www.cr.nps.gov/museum/exhibits/tuskegee/intro.htm. The National Park Services now maintains a site at Tuskegee Institute that includes commemoration of the Tuskegee airmen.

16 Jefferson, "African Americans in the US Army During World War II."

17 www.archives.gov/exhibit_hall/a_people_at_war/new_roles/99th_pursuit_squadron.html.

18 John Hope Franklin and Albert Moss, Jr., *From Slavery to Freedom: A History of Negro Americans*, 6th ed. New York: Alfred A. Knopf, 1988: 396.

19 John H. McCray edited and published the crusading South Carolina *Lighthouse and Informer* from 1938 to 1954. He and his newspaper played influential roles in black South Carolinians' campaign for civil rights. A large collection of McCray's paper is housed in the South Caroliana Library Manuscripts at the University of South Carolina in Columbia.

20 Miles Richards, "McKaine, Osceola Enoch," in Thomas Downey, ed., *Encyclopedia of South Carolina*. Columbia: University of South Carolina Press, forthcoming, and Patricia Sullivan, *Days of Hope: Race and Democracy in the New Deal Era*. Chapel Hill: University of North Carolina Press, 1996: 170–171, 189–191, 195–197.

21 Quoted in Sullivan, *Days of Hope*: 141.

22 Joseph Delaney was the younger brother of Beauford Delaney, also a painter.

23 Quoted in Eileen Southern, *The Music of Black Americans: A History*. 3rd ed. New York: W. W. Norton, 1997: 490.

24 Ibid.: 490–492.

25 www.un.org/Overview/Charter/preamble.html.

26 With Franklin Roosevelt's death in April 1945, Harry S. Truman became president and Eleanor Roosevelt former first lady.

27 Plummer, *Rising Wind*: 171, 178, 180–181.

28 John Dittmer, *Local People: The Struggle for Civil Rights in Mississippi*. Urbana: University of Illinois Press, 1994: 1–2.

29 John Egerton, *Speak Now against the Day: The Generation before the Civil Rights Movement in the South*. New York: Alfred A. Knopf, 1994: 358–373.

30 Gail Williams O'Brien, *The Color of the Law: Race, Violence, and Justice in the Post-World War II South*. Chapel Hill: University of North Carolina Press, 1999: 3–55.

31 Richard Kluger, *Simple Justice: The History of* Brown v. Board of Education *and Black America's Struggle for Equality*. New York: Alfred A. Knopf, 1976: 3–11.

32 www.usinfo.state.gov/usa/infousa/facts/democrac/35.htm.

33 Quintard Taylor, *In Search of the Racial Frontier: African Americans in the American West, 1528–1990*. New York: W. W. Norton, 1998: 253, and U.S. Census Bureau, www.census.gov/population/documentation/twps0056/tab65.xls.

34 Sullivan, *Days of Hope*: 218–219.

12: *Cold War Civil Rights, 1948–1960*

1 Eileen Southern, *The Music of Black Americans: A History*, 3rd ed. New York: W. W. Norton, 1997: 413.

2 Mary L. Dudziak, *Cold War Civil Rights: Race and the Image of American Democracy*. Princeton: Princeton University Press, 2000: 63.

3 Du Bois and Robeson opposed the Marshall Plan for aid to western Europe; they opposed the Korean War, in which the United States led UN forces against North Korea. Both men spent much of their time with Communists, which in the climate of the time, seemed to prove not only that their politics were socialist, but that they were enemies of the United States. Du Bois and Robe-

son were not under house arrest, 1951–1958, but many black and nonblack organizations treated them as though they were contaminated.

4 In 1947 the personal physician of Mahatma Gandhi, the father of Indian independence, was denied entry into a restaurant in the United States. The incident appeared prominently in the Indian press. A year later, a hotel in Mississippi hosting an international meeting tried to segregate the Haitian secretary of agriculture. Rather than subjecting himself to such humiliation, the Haitian official left the meeting and lodged a complaint with the U.S. secretary of state. In 1961, the first ambassador from the newly independent West African nation of Chad was barred from a Maryland diner on Route 40. This highway became infamous for Jim Crowing dark-skinned diplomats during the 1960s. See Dudziak, *Cold War Civil Rights*: 39–43, 152, 167–168.

5 A 1920s bequest by the Left-leaning American Fund for Public Service, known as the Garland Fund, created a permanent legal defense arm of the NAACP. The legal department came into being in 1933, when the NAACP hired the dean of the Howard University Law School, Charles Hamilton Houston, to head it. Bit by bit, the cases showed that separate education was not really equal, for neither the teachers nor the students. They were *Missouri ex rel. Gaines v. Canada* (1938), *Sipuel v. Oklahoma State Board of Regents* (1948), and *McLaurin v. Oklahoma* and *Sweatt v. Painter* (both in 1950). At the same time, the NAACP Legal Defense Fund was bringing cases related to voting rights that struck down grandfather clauses (*Guinn v. United States*, 1915) and the white primary (*Nixon v. Herndon*, 1927, and *Smith v. Allwright*, 1944). See Kenneth V. Janken, *White: The Biography of Walter White, Mr. NAACP*. New York: New Press, 2003: 76, 92, 157, 162.

6 The first *Brown* decision set no timetables for compliance. In 1955 the Supreme Court decided *Brown II*, in which it urged school districts to desegregate "with all deliberate speed." The vagueness of this decision allowed school boards to postpone desegregation until local parents brought suit, school district by school district. See Richard Kluger, *Simple Justice: The History of* Brown v. Board of Education *and Black America's Struggle for Equality*. New York: Alfred A. Knopf, 1976.

7 The Anti-Defamation League (established in 1913 by B'nai B'rith in response to the anti-Semitic attacks on Leo Frank, a Jew accused of murdering one of the young women workers in his Atlanta factory and later lynched) also filed a friend of the court brief in the *Brown* case. During the pre-affirmative action era before the 1970s, American Jewish organizations enthusiastically supported African-American civil rights.

8 Dudziak, *Cold War Civil Rights*: 79–114.

9 The White Citizens Councils flourished in the 1960s and endure in the Council of Conservative Citizens. In 1992, U.S. Senator Trent Lott (Rep. Mississippi) delivered a keynote speech to the group in which he said, "The people in this room stand for the right principles and the right philosophy. Let's take it in the right direction and our children will be the beneficiaries." See www.ishipress.com/lottties.htm.

10 John Dittmer, *Local People: The Struggle for Civil Rights in Mississippi*. Urbana: University of Illinois Press, 1994: 54.

11 Quoted in Juan Williams, *Eyes on the Prize: America's Civil Rights Years, 1954–1965*. New York: Viking, 1987: 44. The first segment of Blackside's *Eyes on the Prize* video deals with the Emmett Till lynching and shows the shocking photo of Till's battered face in his casket.

12 In the fall of 2002 the filmmaker Keith Beauchamp showed his documentary, *The Murder of Emmett Louis Till, Revisited*. Till's mother helped in the production and promotion of the film. Both she and Beauchamp hoped the documentary would prompt the state of Mississippi to reopen the case. Only Till's two main assailants, Ron Bryant and J. W. Milam (both now dead) were tried in 1955. Others are still living and liable to legal action. See the *Travis Smiley Show*, National Public Radio, November 14, 2002: www.npr.org/ramfiles/tavis/20021114.tavis.06.ram and Rick Bragg, "Emmett Till's Long Shadow; A Crime Refuses to Give Up Its Ghosts," *New York Times*, December 1, 2002: Sect. 4, 1. In April 2004 Senator Charles Schumer and Representative Charles Rangel, Democrats of New York, asked Congress to reopen the Till case on the ground that Beauchamp had uncovered new evidence.

13 The FHA and Veterans Administration financed more than $120 billion in housing between 1934 and 1964, the great bulk of which in the 1950s and early 1960s. During this period, millions

of Jewish, Italian, and other working-class white ethnic families bought their own homes and assumed that their economic stake in society came as a result purely of their own virtues. Because so few black families were able to purchase homes, white suburbanites concluded that blacks people lacked a solid work ethic. See www.developmentleadership.net/current/worksheet.htm. See also Leigh Burns et al., *Atlanta Housing, 1944 to 1965*. Case Studies in Historic Preservation, Georgia State University, Spring 2001. See also www.state.ga.us/dnr/histpres/pdf/atlhouse.pdf: 4–8.

14 Restrictive covenants applied to city property as well. In 1957 even the baseball great Willie Mays (b. 1931) could not buy a home in an exclusive, all-white section of San Francisco.

15 Restrictive covenants can be used for a variety of ends, from stipulating lot size to regulating where owners can cut down trees. However the restrictive covenants in question here deal with race.

When the Roosevelt administration created the FHA in 1934, its manual to sellers included a model racially restrictive covenant on the ground that "if a neighborhood is to retain stability, it is necessary that properties shall continue to be occupied by the same social and racial classes." After the U.S. Supreme Court outlawed the enforcement of racially restrictive covenants in *Shelley v. Kraemer* (1948), the FHA and the Veterans Administration continued to practice segregation, but not in writing. Their lending did not open suburban housing to African Americans until the 1970s. See www.developmentleadership.net/current/worksheet.htm.

16 Burnett took an active part in public life on Long Island. He became Babylon's first black police officer and served as the first regional director of the Long Island chapter of the NAAC P. Burnett appears in "The House We Live In," part of the PBS documentary series *Race: The Power of an Illusion*, shown in May 2003. According to Lynda Richardson, the seventeen-thousand-home community in Nassau County "remains virtually all white today. Blacks make up one half of 1 percent of the population." See "The Sting of Racial Exclusion Is Easily Recalled," *New York Times*, May 7, 2003: B2.

17 Eric Bickford, "White Flight: The Effect of Minority Presence on Post World War II Suburbanization," n.d., www.eh.net/Clio/Publications/flight.shtml, Andrew Broman, "Key Players in Racial Battle Meet in York Today," *York Daily Record*, May 3, 2002, ydr.com/history/black/1blck1020503.shtml, and Geoffrey Mohan, "Suburban Pioneers" and "Levitt's Defenses of Racist Policies," in *Long Island: Our History*, www.lihistory.com/specsec/hslevone.htm and www.lihistory.com/specsec/hslevrac.htm. The Myers stayed in Pennsylvania's Levittown until 1961. In 2000 only 3 percent of this Levittown's population was nonwhite.

18 Robert Fishman, "The American Metropolis at Century's End: Past and Future Influences," Fannie Mae Foundation, *Housing Facts and Findings* 1, No. 4 (Winter 1999), www.fanniemaefoundation.org/programs/hff/v1i4-metropolis.shtml.

The term "redlining" refers to the practice of the federal Home Owners Loan Corporation (HOLC), the New Deal predecessor of the FHA. The HOLC classified neighborhoods according to their suitability for lending for savings institutions. The most desirable areas were outlined in green, the least desirable in red. Poor and black neighborhoods were outlined in red, hence "redlined." Lenders would not extend mortgages and loans in redlined areas.

19 Here are two examples of the way a home can increase a family's wealth: A little house built in 1948 in Rutherford, New Jersey, outside Newark, initially sold for $7,500 and for $270,000 in 2002. The increase in value, adjusted for inflation, was 382 percent. A house in Rockville Centre on Long Island sold for $4,000 in 1944, for $13,500 in 1954, for $22,500 in 1967, and was on the market for $550,000 in 2004. The increase, adjusted for inflation, amounted to 1,179.7 percent. Dennis Hevesi, "Charting Real Estate's Biggest Winners," *New York Times*, July 18, 2004: Sect. 11, 1 and 11.

20 Joseph Soares, *The Social Life of Cities*. Department of Sociology, Yale University, 1996, www.yale.edu/socdept/slc/.

21 Robin D. G. Kelley notes the frequency of confrontations in public transportation during and after the Second World War in "Congested Terrain: Resistance on Public Transportation," in *Race Rebels: Culture, Politics, and the Black Working Class*. New York: Free Press, 1994: 55–75.

22 Quoted in Aldon D. Morris, *The Origins of the Civil Rights Movement: Black Communities Organizing for Change*. New York: Free Press, 1984: 17. See also ix–x, 17–25.

23 Professor Mary Fair Burks (n.d.), chair of the Alabama State English Department, had formed the Women's Political Council after being turned away from the League of Women Voters on account of her race and witnessing the actions of racist police. After much petitioning of the city regarding bus mistreatment, by 1954 Robinson was beginning to consider the possibility of boycotting Montgomery's buses. See www.alasu.edu/Asutoday/jan01/alumni/alumni.htm.

 Southern city buses were the sites of many conflicts in the 1950s. In early 1955, Sarah Mae Flemming sued the city of Columbia, South Carolina, for racist mistreatment. See www.newsouthbooks.com/resources/mia/boycott.htm. Other Southern bus boycotts occurred around the same time as that in Montgomery. For more on Jo Ann Robinson, see www/stanford.edu/group/king/about_king/details/55120/b.htm.

24 Quoted in Stewart Burns, ed., *Daybreak of Freedom: The Montgomery Bus Boycott*. Chapel Hill: University of North Carolina Press, 1997: 9.

25 In 1943 and 1946 Nixon had led campaigns to register black people to vote.

26 Baker later organized the Southern Christian Leadership Council (successor organization of the Montgomery Improvement Association). She was one of the boycott's main fundraisers in New York City. See Barbara Ransby, *Ella Baker and the Black Freedom Movement: A Radical Democratic Vision*. Chapel Hill: University of North Carolina Press, 2003.

27 Burns, ed., *Daybreak of Freedom*: 4.

28 Ibid.: 42.

29 On Eisenhower's views, see www.historylearningsite.co.uk/little_rock.htm.

30 The FBI maintained a file on Armstrong that contained a letter accusing Armstrong of being a Communist and demanding that his passport be seized. See Dudziak, *Cold War Civil Rights*: 66.

31 John Egerton, *Speak Now against the Day: The Generation before the Civil Rights Movement in the South*. New York: Alfred A. Knopf, 1994: 562.

32 Ibid.: 549, 550.

33 The Moores had been active in the NAACP-led struggle for voting rights in Brevard County, Florida, since the mid-1930s. Information on the Public Broadcasting System documentary on Harry T. Moore is at www.pbs.org/harrymoore/. Brevard County is making the Moore home into a historical site.

34 Dittmer, *Local People*: 58.

35 Quoted in Timothy B. Tyson, *Radio Free Dixie: Robert F. Williams and the Roots of Black Power*. Chapel Hill: University of North Carolina Press, 1999: 141.

36 Quoted in ibid.: 69–70.

37 Quoted in ibid.: 84–89.

38 Ibid.: 92–140.

39 Quoted in ibid.: 143–144, 149, 152.

40 Ibid.: 306–307.

41 Elijah Muhammad published his views in several editions of *The Message to the Blackman in America*, first published in 1965. Much better known is the *Autobiography of Malcolm X* (1965), which served as the basis for a Spike Lee feature film, *Malcolm X*, in 1992.

42 Ever since the 1940s, the Nation of Islam has had great success attracting members in American prisons. See C. Eric Lincoln, *The Black Muslims in America*, 3rd ed. Trenton, N.J.: W. B. Eerdsmans and African World Press, 1994, and Martha F. Lee, *The Nation of Islam, An American Millenarian Movement*. Lewiston, N.Y.: Edwin Mellen Press, 1988.

43 William H. Banks, Jr., *The Black Muslims*. Philadelphia: Chelsea House, 1997: 38–41.

44 Ibid.: 60–64.

45 One of the rare black writers to receive broad acclaim during his lifetime, Ellison was also the subject of a 2004 PBS "American Masters" documentary. See www.pbs.org/wnet/americanmasters/database/ellison_r_homepage.html.

46 Penny Von Eschen, *Race against Empire: Black Americans and Anticolonialism, 1937–1957*. Ithaca, N.Y.: C10. Cornell University Press, 1999: 148, 177–178, and *Satchmo Blows Up the World: Jazz Ambassadors Play the Cold War*. Cambridge, Mass.: Harvard University Press, 2004.

47 Baldwin was a good friend and frequent subject of the painter Beauford Delaney, who also lived

and worked in Paris. This affectionate portrait testifies to the depth of the two artists' friendship. Unfortunately the portrait cannot appear here because permission to reproduce it has been denied. It can be seen in Audreen Buffalo, ed., *Explorations in the City of Light: African-American Artists in Paris, 1945–1965*. New York: The Studio Museum in Harlem, 1996: 80.

48 Henry Louis Gates, Jr., and Nellie Y. McKay, eds., *The Norton Anthology of African American Literature*. New York: W. W. Norton, 1997: 1652–1653, 1725–1727.

49 Southern, *The Music of Black Americans*, 3rd ed.: 485–486.

50 Early in his career Nat "King" Cole recorded "When It's Sleepy Time Down South" and "When the Swallows Come Back to Capistrano" with a black company in Los Angeles owned by Otis and Leon René. In 1946 Cole's recording of "(Get Your Kicks On) Route 66" reached number three on the race record chart and rose almost into the top ten on the pop chart. See Southern, ibid.: 514, and www.nat-king-cole.org/nathallofame.htm.

51 Vee Jay's first top ten record was the Spaniels' "Goodnight, Sweetheart, Well It's Time to Go" in 1954. The label mostly recorded rhythm 'n' blues artists such as the Dells and Jerry Butler. But it also recorded bluesmen such as John Lee Hooker, gospel groups like the Staple Singers, and white groups such as the Four Seasons ("Sherry" and "Big Girls Don't Cry"). In 1964 Vee Jay introduced the Beatles to American audiences. See Southern, *The Music of Black Americans*, 3rd ed.: 514–515.

52 Turner's singer and saxophonist was Jackie Brenston, who had "Rocket 88" credited to "Jackie Brenston and his Delta Cats." Brenston soon left the Kings of Rhythm for a solo career. In the late 1950s Turner joined Tina Turner (b. 1939), and the two of them turned out a series of rhythm 'n' blues and pop hits in the 1960s as leaders in the genre known as soul music. In 1966 and 1969 the Ike and Tina Turner Review opened for the British rock group the Rolling Stones and reached a massive nonblack audience. Ike (born Izear Luster Turner, Jr.) and Tina Turner (born Annie Mae Bullock) were married from 1960 until their divorce in 1978. See www.iketurner.com/ and www. wikipedia.org/wiki/Ike_Turner. For a description of Ike Turner at sixty-four—after Tina Turner's movie *What's Love Got to Do With It*, in which he appears as an arch villain, and after serving prison time on a drug charge—see www.bluesworld.com/JBIke.html.

53 Other covers included Georgia Gibbs's cover of Etta James's "Roll with Me, Henry" as "Dance with Me, Henry," and LaVerne Baker's "Tweedle Dee"; Gale Storm's cover of Smiley Lewis's "I Hear You Knocking." Most famous of all was Elvis Presley's cover of "Big Mama" Thornton's "Hound Dog," Arthur "Big Boy" Crudup's "That's All Right," and Thomas A. Dorsey's "Peace in the Valley." Southern, *The Music of Black Americans*, 3rd ed.: 511–512. On the white appropriation of black culture see Greg Tate, *Everything but the Burden: What White People Are Taking from Black Culture*. New York: Broadway, 2003.

54 See the Rock and Roll Hall of Fame list of inductees: www.rockhall.com/hof/inductee.asp.

13: Protest Makes a Civil Rights Revolution, 1960–1967

1 One of the students joining the sit-in was the A & T quarterback Jesse Jackson (b. 1941). See Vincent Harding, Robin D. G. Kelley, and Earl Lewis, "We Changed the World, 1945–1970," in Robin D. G. Kelley and Earl Lewis, eds., *To Make Our World Anew: A History of African Americans*. New York: Oxford University Press, 2000: 482.

In 1963 the North Carolina Women's College became the University of North Carolina at Greensboro.

2 Marion Barry was mayor of Washington, D.C., from 1978 to 1990 and from 1994 to 1998. In 1992 James Bevel ran as Libertarian Lyndon LaRouche's vice-presidential running mate in the Democratic primary in Mississippi. He also associated with the Reverend Sun Myung Moon and Louis Farrakhan. See www.larouchepub.com/pr/1996/mississippi_tour.html and www.salon.com/news/1998/04/28news.html.

3 Harding, Kelley, and Lewis, eds., "We Changed the World": 488–492. The quote is on 491.

4 Bernice Johnson Reagon founded Sweet Honey in the Rock, a women's a cappella singing group that became sought after around the world in the mid- to late twentieth century.

5 William Doyle, *An American Insurrection: The Battle of Oxford, Mississippi, 1962*. New York:

Doubleday, 2001: 278. Two people died, a European journalist and a townsperson, and 350 people, mainly U. S. marshals, were wounded during the uprising against Meredith's entry into the University of Mississippi.

Meredith's subsequent career has included working for Jesse Helms, the Republican arch-conservative U.S. senator from North Carolina, in 1989.

6 Harding, Kelley, and Lewis, "We Changed the World": 501.

7 See Chana Kai Lee, *For Freedom's Sake: The Life of Fannie Lou Hamer.* Urbana: University of Illinois Press, 1999.

8 Darlene Clark Hine, William C. Hine, and Stanley Harrold, *The African-American Odyssey.* Upper Saddle River, N.J.: Prentice Hall, 2000: 517.

9 Jonathan Birnbaum and Clarence Taylor, eds., *Civil Rights since 1787: A Reader on the Black Struggle.* New York: New York University Press, 2000: 501.

10 See http://afroamhistory.about.com/library/weekly/aa051401a.htm.

11 In January 2005 Edgar Ray Killen, a seventy-nine-year-old preacher and Klansman, was arrested in connection with the murders of Chaney, Goodman, and Schwerner. In June 2005, Killen was convicted of the lesser charge of manslaughter and sentenced to 60 years in prison.

12 See www.watson.org/~lisa/blackhistory/civilrights-55-65/mississipi.html.

13 Malcolm X was also distressed by Elijah Muhammad's fathering of children out of wedlock with his secretaries. Such behavior ran counter to NOI moral precepts.

14 Quoted in Timothy B. Tyson, *Radio Free Dixie: Robert F. Williams and the Roots of Black Power.* Chapel Hill: University of North Carolina Press, 1999: 237.

15 Quoted in ibid.: 2, 145, 205.

16 The National Park Service has designated the fifty miles of highway from Brown Chapel African Methodist Episcopal Church to the state capitol in Montgomery a National Historic Trail.

17 The Voting Rights Act of 1965 empowered the U.S. Department of Justice to oversee registration in districts in which fewer than half the eligible voters were registered. Actually, literacy tests were only made illegal where half or more of the eligible voters were not registered. The Voting Rights Act of 1965 was amended and extended in 1970, 1975, and 1982. See the website of the Congress on Racial Equality: www.core-online.org/history/voting_rights.htm.

18 See Shelby Steele, "The Age of White Guilt," *Harper's Magazine* 305 (November 2002): 33–42.

19 Quoted in Christian G. Appy, *Working-Class War: American Combat Soldiers and Vietnam.* Chapel Hill: University of North Carolina Press, 1993: 19.

20 George C. Herring, *America's Longest War: The United States and Vietnam, 1950–1975*, 4th ed. Boston: McGraw Hill, 2002: 182.

21 Quoted in James E. Westheider, *Fighting on Two Fronts: African Americans and the Vietnam War.* New York: New York University Press, 1997: 18–19.

22 Quoted in Westheider, *Fighting on Two Fronts*: 20.

23 Quoted in Appy, *Working-Class War*: 20.

24 Westheider, *Fighting on Two Fronts*: 27. During the Iraq war of the early 2000s, most Muslim chaplins in the U.S. Armed Forces were from the Nation of Islam.

25 Ibid.: 1.

26 Ibid.: 13.

27 Appy, *Working-Class War*: 25–27. President George W. Bush was one of thousands of privileged Americans who avoided Vietnam through National Guard service.

28 Westheider, *Fighting on Two Fronts*: 15. Powell became the first African-American chairman of the Joint Chiefs of Staff in 1989.

29 Kenneth L. Kusmer, "African Americans in the City since World War II: From the Industrial to the Postindustrial Era," in Kenneth W. Goings and Raymond A. Mohl, eds., *The New African American Urban History.* Thousand Oaks, Calif.: Sage, 1996: 323.

30 Cheap labor and tax breaks were only part of the story. Transportation and architecture also played their parts in encouraging manufacturers to move to the suburbs, the South, and overseas. Highway expansion made trucking more attractive than rail transport. Newer factory buildings spread out horizontally rather than vertically, demanding more space than was available in

older cities. See Robert Fishman, "The American Metropolis at Century's End: Past and Future Influences," Fannie Mae Foundation, *Housing Facts and Findings* 1, No. 4 (Winter 1999) www.fanniemaefoundation.org/programs/hff/v1i4-metropolis.shtml.

31 Leonard Nathaniel Moore, "The School Desegregation Crisis of Cleveland, Ohio, 1963–1964: The Catalyst for Black Political Power in a Northern City," *Journal of Urban History* 28, No. 2 (January 2002): 135–136, 149–150, 155.

32 Gary, Indiana, also elected a black mayor in 1967. Its population in 1970 was 175,415, compared with in 750,829 in Cleveland that same year. Stokes was reelected in 1969, despite a riot in 1968 sparked by a confrontation between African Americans and white police.

33 In Kusmer, "African Americans in the City since World War II": 334.

14: Black Power, 1966–1980

1 Catlett had rendered "Negro es Bello" somewhat differently in 1968, but still playing on black is beautiful and the Black Panther Party logo.

2 Stokely Carmichael embraced pan-Africanism in the early 1970s and moved to West Africa in 1972. He changed his name to Kwame Turé, in honor of two pan-African leaders, Kwame Nkrumah of Ghana and Sekou Touré of Guinea. He died of cancer in 1998 at age fifty-seven. Michael T. Kaufman, "Stokely Carmichael, Rights Leader Who Coined 'Black Power,' Dies at 57," *New York Times*, November 16, 1998, www.interchange.org/Kwameture/nytimes111698.html.

 H. Rap Brown, Carmichael's successor as head of SNCC in 1967, was one of the many incarcerated Black Power activists. While imprisoned in New York State, Brown converted to orthodox Islam and changed his name to Jamil Abdullah Al-Amin. He made the Muslim pilgrimage to Mecca, then moved to Atlanta to begin a new life as a Muslim holy man. In 1995 the Atlanta police charged Al-Amin with murder, then dropped the charges. In 2000 he was again charged with murder. As of early 2003, the case was still pending. See Ekwueme Michael Thelwell, "H. Rap Brown/Jamil Al-Amin: A Profoundly American Story," *The Nation* 274, No. 10 (March 18, 2002): 25–35.

3 Stokely Carmichael and Charles V. Hamilton, *Black Power: The Politics of Liberation in America*. New York: Vintage, 1967: 40, 50–52, 80, 83.

4 Stokely Carmichael, "Power & Racism," in Floyd B. Barbour, ed., *The Black Power Revolt: A Collection of Essays*. Boston: Extending Horizons Books, 1968: 62.

5 Carmichael and Hamilton, *Black Power*: 34, 37, 166.

6 Ibid.: 5, 155.

7 Komozi Woodard, *A Nation within a Nation: Amiri Baraka (LeRoi Jones) and Black Power Politics*. Chapel Hill: University of North Carolina Press, 1999: 72–73.

8 Fanon's *The Wretched of the Earth*, advocating violence as psychologically liberating to colonized peoples, was translated into English from French and published in the United States in 1965.

9 Rod Bush, *We Are Not What We Seem: Black Nationalism and Class Struggle in the American Century*. New York: New York University Press, 1999: 194–197.

10 Quoted in Yohuru Williams, *Black Politics/White Power: Civil Rights, Black Power, and the Black Panthers in New Haven*. St. James, N.Y.: Brandywine Press, 2000: 130.

11 Bush, *We Are Not What We Seem*: 196.

12 The City of Los Angeles is to pay $2.75 million and the U. S. Department of Justice is to pay $1.75 million to Pratt for false imprisonment. See *Jet* 97, No. 23 (May 15, 2000): 12, and Linn Washington, Jr., "Revisited: The Black Panther Party," *The New Crisis* 106, No. 5 (September/October 1999): 24–25. Pratt published his autobiography, *Last Man Standing: The Tragedy and Triumph of Geronimo Pratt* in 2000.

13 Newton saw global capitalism as "reactionary intercommunalism." Black Americans were colonized people whose situation would only improve with the overthrow of capitalism. See Robert Self, *"To Plan Our Liberation": Black Power and the Politics of Place* in Oakland, California, 1965–1977," *Journal of Urban History* 26, No. 6 (September 2000): 759–792. See also Robert Self, *American Babylon: Race and the Struggle for Postwar Oakland*. Princeton, N.J.: Princeton University Press, 2003.

14 Bush, *We Are Not What We Seem*: 201–203.

15 Ibid., and Williams, *Black Politics/White Power*: 161.

16 Williams, *Black Politics/White Power*: 117, 161.

17 David Barsamian, "Angela Davis," *The Progressive*, February 24, 2001: 33–38.

18 Al-Hadj Malik El-Shabazz, "Statement of the Basic Aims and Objectives of the Organization of Afro-American Unity," quoted in Errol A. Henderson, "The Lumpenproletariat as Vanguard? The Black Panther Party, Social Transformation, and Pearson's Analysis of Huey Newton," *Journal of Black Studies* 28, No. 2 (November 1997): 171–199.

19 A pan-Africanist, Karenga taught that black Americans should ground their lives in the seven African values of Kwanzaa: Umoja (unity), Kujichagulia (self-determination), Ujima (collective work and responsibility), Ujamaa (cooperative economics), Nia (purpose), Kuumba (creativity), and Imani (faith). Waldo E. Martin, "Karenga, Maulana (Everett, Ronald McKinley)," in Salzman et al. eds., *Encyclopedia of African-American Culture and History*: 1526. See also Keith A. Mayes, "Rituals of Race, Ceremonies of Culture: Kwanzaa and the Making of a Black Power Holiday in the United States." Unpublished Ph.D. dissertation, Princeton, 2002, and Scot Ngozi-Brown, "The US Organization, Maulana Karenga, and Conflict with the Black Panther Party: A Critique of Sectarian Influences on Historical Discourse," *Journal of Black Studies* 28, No. 2 (November 1997): 157–170. See also Scot Brown, *Fighting for US: Maulana Karenga, the US Organization, and Black Cultural Nationalism*. New York: New York University Press, 2003.

20 Nancy Yousef and Robyn Spencer, "Kwanza," in Salzman et al., eds., *Encyclopedia of African-American Culture and History*: 1560–1561.

21 In Henry Louis Gates, Jr., and Nellie Y. McKay, *The Norton Anthology of African American Literature*. New York: W. W. Norton, 1997: 2229.

22 Quoted in Darlene Clark Hine and Kathleen Thompson, *A Shining Thread of Hope: The History of Black Women in America*. New York: Broadway Books, 1998: 298.

23 Quoted in Woodard, *A Nation within a Nation*: 95. Emphasis in original.

24 Quoted in ibid.: 93.

25 Quoted in ibid.: 111, 114. Emphasis in original.

26 The protest was the idea of Harry Edwards (b. 1942), a young black sociologist of sport. Edwards originally proposed a boycott. But it proved too unwieldy to enforce. He published *The Revolt of the Black Athlete* in 1969.

27 James E. Westheider, *Fighting on Two Fronts: African Americans and the Vietnam War*. New York: New York University Press, 1997: 5, 97–98.

28 By 1972 that proportion had risen to only 2.3 percent. Westheider, *Fighting on Two Fronts*: 120–121.

29 Quoted in Westheider, *Fighting on Two Fronts*: 35–36, 65–67, 92, 86, 88, 142.

30 Ibid.: 15, 164, 168, 174. General Daniel "Chappie" James, Jr., was a great patriot. The U.S. Air Force museum quotes him as saying: "I've fought in three wars and three more wouldn't be too many to defend my country. I love America and as she has weaknesses or ills, I'll hold her hand." www.wpafb.af.mil/museum/history/vietnam/james/htm.

31 Bush, *We Are Not What We Seem*: 198.

32 William L. Van Deburg, *New Day in Babylon: The Black Power Movement and American Culture, 1965–1975*. Chicago: University of Chicago Press, 1992: 92.

33 Bush, *We Are Not What We Seem*: 205–208, and Van Deburg, *New Day in Babylon*: 93–94. See also Heather Ann Thompson, *Whose Detroit?: Politics, Labor, and Race in a Modern American City*. Ithaca: Cornell University Press, 2001.

34 See also Woodard, *A Nation within a Nation*: xii.

35 Quoted in Van Deburg, *New Day in Babylon*: 199.
 While Baraka was New Jersey's state poet laureate in 2002, he created an uproar with his poem on the September 11, 2001, attack on the World Trade Center in New York City. The poem, "Somebody Blew Up America," compared the September 11 attackers with those perpetrating attacks such as the Holocaust and the Atlantic slave trade. Baraka's lines alleging that Israeli workers had previous knowledge of the attack angered many and led the governor and legislature to defund Baraka's position. For Baraka's statement refusing calls for his resignation see www.amiribaraka.com/speech100202.html.

36 Gates and McKay, *Norton Anthology of African American Literature*: 1905.

37 Jeffrey Gambles, "Trailblazers: Top Ten Black Publishers," *Black Issues Book Review* No. 5 (September–October 1999): 25–27, and Angela Ards, "Haki Madhubuti: The Measure of a Man," *Black Issues Book Review* 4, No. 2 (March–April 2002): 42–46.

38 Deborah Gray White, *Too Heavy a Load: Black Women in Defense of Themselves, 1894–1994*. New York: W. W. Norton, 1999: 206–217.

15: Authenticity and Diversity in the Era of Hip-Hop, 1980–2005

1 The company making Crayolas, Binney & Smith, changed the name of the pertinent crayon from "flesh" to "peach" in 1962. In 1991 the company introduced "My World Colors," containing 16 colors representing skin, hair, and eye colors from around the world. Correspondence with Beth Golubiewski, Binney & Smith Inc., Consumer Affairs Representative, memo to Nell Irvin Painter, March 21, 2003 by email.

2 Executive Order 11246 applied to companies holding government contracts worth more than fifty thousand dollars and fifty or more employees. See also Philip F. Rubio, *A History of Affirmative Action, 1619–2000*. Jackson: University Press of Mississippi, 2001.

3 William G. Bowen and Derek Bok, *The Shape of the River: Long-term Consequences of Considering Race in College and University Admissions*. Princeton, N.J.: Princeton University Press, 1998. See also www.commondreams.org/views01/0207-05.htm.

4 See Charles J. Ogletree, Jr., "*Brown* at 50: Considering the Continuing Legal Struggle for Racial Justice," in Lee A. Daniels, ed., *The State of Black America 2004*. New York: National Urban League, 2004: 92. See also Charles J. Ogletree, Jr., *All Deliberate Speed: Reflections on the First Half Century of* Brown v. Board of Education. New York: W. W. Norton, 2004.

5 Adam Clymer, "Service Academies Defend Use of Race in Their Admissions Policies," *New York Times*, January 28, 2003: A17.

6 Clarence Thomas, "Be Not Afraid," *The American Enterprise* 12, No. 3 (April/May 2001): 44–45. This is the 2001 Francis Baver Lecture given at the annual dinner of the American Enterprise Institute for Public Policy Research in Washington, D.C., on February 13, 2001.

7 Sowell holds a doctorate from the University of Chicago and has written some twenty-five books. He came to prominence in 1975 with the publication of *Race and Economics*. Sowell opposes the use of tax monies for social ends and says: "I'm against the use of public funds. I believe in private property, and that it stay private and that taxpayers should not have to subsidize it." (Reading *Race and Economics* deeply inspired U.S. Supreme Court Justice Clarence Thomas.) Sowell has been a Senior Fellow at the Hoover Institution at Stanford University since 1980. Sowell quoted in David Fettig, "An interview with Thomas Sowell," *Minneapolis Region* 15, No. 3 (September 2001): 28–36. See also Angela D. Dillard, "Multicultural Conservatism: What It Is, Why It Matters," *Chronicle of Higher Education* 47, No. 25 (March 2, 2001): B7–B10.

8 Shelby Steele, like Thomas Sowell, is a Fellow of the Hoover Institution at Stanford University. See Seth N. Asumah and Valencia C. Perkins, "Black Conservatism and the Social Problems in Black America: Ideological Cul-de-Sacs," *Journal of Black Studies*, 31 No. 1 (September 2000): 51–73. See also Ward Connerly, *Creating Equal: My Fight against Race Preferences*. San Francisco: Encounter Books, 2000.

9 See Shelby Steele, "The Age of White Guilt," *Harper's Magazine* 305, No. 1830 (November 2002): 33–42.

10 In the 1990s Keyes hosted a radio program, "The Alan Keyes Show." He made unsuccessful runs for the U.S. Senate in Maryland in 1988 and 1992, in Illinois in 2004, and for president in 1996 and 2000. Keyes says: "America's most pressing problems are rooted in the decline of our moral identity. Crime, rampant illegitimacy, the deteriorating environment in many of our schools, and especially the spectacle of national shame that unfolded in the Clinton White House, *all these can be traced to lack of respect for moral principle.*" Emphasis in original. Keyes is the co-founder, with Alvin Williams of Black America's Political Action Committee (BAMPAC). BAMPAC is the largest minority political action committee in the United States. See www.renewamerica.us/keyes/issues.htm.

11 Watts was formerly a quarterback for the University of Oklahoma football team. He differed from other black conservatives by supporting affirmative action and defending black farmers who had suffered discrimination in federal loan administrations. He also championed historically black colleges and universities. See *US Black Engineer & Information Technology* magazine BlackEngineers.Com, www.blackengineer.com/people/jcwatts.shtml.

12 As President Carter's Secretary of the Army, Alexander insisted that the promotion board proposing colonels to be promoted to general also examine the records of distinguished black colonels. This review resulted in the addition of black candidates to what had been a lily-white list. See Brent Staples, "What the United States Army Teaches Us about Affirmative Action," *New York Times*, January 6, 2003: A20.

13 Powell continued to hold the chair of the Joint Chiefs of Staff under President Bill Clinton, before retiring to private life in 1993.

14 Paige is known for supporting school vouchers that allow public school children to attend private schools, including religious schools. Like Rice, Paige offers only lukewarm support of affirmative action. He has advocated the teaching of "Christian values" in public schools.

15 Loury resigned from the conservative think tank American Enterprise Institute in 1995 and pulled farther away from conservative orthodoxy on race in his 2002 book, *The Anatomy of Racial Inequality*. While by no means coming to agree with most African Americans, Loury no longer embraces the extreme individualism and laissez-faire philosophy of conservatives who blame African Americans for their own failure. With his new book, Loury completes an intellectual *volte-face* that began with his 1995 resignation from the American Enterprise Institute. The conservative think tank supported Dinesh D'Souza, author of *The End of Racism* (1995), a particularly vitriolic assault on "black failure" in America that advocates the revocation of the Civil Rights Act of 1964.

 In William Jelani Cobb, "On Second Thought: A Black Conservative Reconsiders," *The New Crisis* 109, No. 2 (March/April 2002): 49, Watts expresses disappointment with his treatment by white Republicans. See also James T. Campbell, "Habits of Mind," *Dissent* 49, No. 3 (Summer 2002): 90–94.

16 Brown and thirty-four others died in a plane crash in Croatia in 1996.

17 In addition to making high-ranking, extremely visible appointments, Clinton employed many other African Americans in critical White House positions. Journalist DeWayne Wickham lists several: chief of White House personnel, budget director, director of public outreach, deputy chief of staff, and liaison between the White House and the Congress. See www.salon.com/books/int/2002/02/20/clinton/index2.html.

18 The states with the largest numbers of black elected officials in 2000 were Mississippi: 897; Alabama: 731; Louisiana: 701; Illinois: 621; Georgia: 582; South Carolina: 540; Arkansas: 502; North Carolina: 498; Texas: 475; and Michigan: 340. See Joint Center for Political and Economic Studies: www.jointcenter.org/DB/detail/BEO.htm.

19 Tricia Rose, *Black Noise: Rap Music and Black Culture in Contemporary America*. Hanover, N.H.: Wesleyan University Press/University Press of New England, 1994: 86, 90.

20 Mary Frances Berry, chair of the U.S. Commission on Civil Rights, "Status Report on Probe of Election Practices in Florida during the 2000 Presidential Election," in "Black Election: 2000," *The Black Scholar* 31, No. 2 (Summer 2001): 2–5 and 6–7, and Hanes Walton, Jr., "The Disenfranchisement of the African American Voter in the 2000 Presidential Election: The Silence of the Winner and Loser," in "Black Election: 2000," *The Black Scholar* 31, No. 2 (Summer 2001): 21.

21 Hermon George, Jr., "Putting Election 2000 in Perspective: A Declaration of War," in "Black Election: 2000," *The Black Scholar* 31, No. 2 (Summer 2001): 11. More than four hundred thousand Floridians are ex-felons. Among them are nearly one-third of voting-age black men in Florida.

22 Berry, "Status Report on Probe of Election Practices in Florida": 2–5.

 According to Hanes Walton, "[At the U.S. Civil Rights Commission hearings] stories surfaced about how Florida state politicos and highway patrolmen set up road-blocks in African American neighborhoods on election day to conduct license checks, car checks, etc. Stories surfaced about polling places [that] closed with long lines of voters not served and about missing and incomplete voting lists. New voter registrants could not find their names on the list of voters. . . . Even a white Supervisor of Elections was sent a letter telling her that she was a felon and had to be purged from

the list. [A Washington *Post* investigation's computer analysis suggests that spoiled ballots were higher in predominantely African-American precincts.]" See Hanes Walton, Jr., "The Disenfranchisement of the African American Voter in the 2000 Presidential Election": 23.

23 For a visual record of the Black Caucus's protest, see Michael Moore's 2004 movie, *Fahrenheit 9/11.*

24 A former U.S. attorney, member of the Illinois House of Representatives, and Cook County Recorder of Deeds, Braun became the first African-American woman elected to the U.S. Senate in 1992. Her Southern white colleagues (e.g., Jesse Helms of North Carolina) treated her disrespectfully. But Braun was able to spearhead legislation to repair schools and block the federal fostering of Confederate insignia. See Jodi Wilgoren, "Leaping Past Triumphs and Debacles," *New York Times*, March 14, 2003: A19.

 A long-time minister, Sharpton also worked for the singer James Brown for many years. Sharpton is known for his advocacy of black New Yorkers victimized by white mobs and police. He has helped Abner Louima, the heirs of Amadou Diallo and of Alberta Spruill, all of whom the New York police attacked. Louima survived, but Diallo and Spruill died as a result of the unprovoked police attacks. See Scott Sherman, "Just Keep Talking," *Transition: An International Review* 12, No. 1 (Issue 91)n/d: 62–86.

25 See Manning Marable, "Along the Color Line: The Black Radical Congress: Moving on Up to Congress 2000," *The Black Collegian* on-line at www.black-collegian.com/african/archives/marable1199.shtml and the International People's Democratic Uhuru movement at www.inpdumchicago.com/index.html. See also Justin Bachman, "New Black Panther Party Leader Dies," *The Associated Press*, February 17, 2001, http://archiver.rootsweb.com/th/read/MICHIGAN-AFAM/2001-02/0982445311, Alexandra Marks, "Activists Revive the Black Panthers, at Least in Name. The new generation of African Americans is too radical for original members, who are suing the group," *Christian Science Monitor*, March 8, 2002, edition, www.csmonitor.com/2002/0308/p05s01-ussc.htm; and Regina Jennings, "Black Panther Party Reunion and Conference," www.seeingblack.com/x052402/panthers35.shtml.

26 Robinson was one of many prominent African Americans—including Jesse Jackson and Mary Frances Berry ([b. 1938] head of the U.S. Commission on Civil Rights in the 1990s and early twenty-first century), and the Congressional Black Caucus—who participated in the sit-in at the embassy of South Africa in 1984. This sit-in began the divestiture movement that helped end the intensely segregationist "apartheid" regime in South Africa.

27 To hear a speech on reparations by Randall Robinson, go to www.jcu.edu/pubaff/newsandevents/randall_robinson.htm.

28 The Florida legislature awarded $150,000 each to nine survivors of the 1923 attack on blacks in Rosewood, Florida, and $500,000 to heirs of Rosewood property and created a $100,000 scholarship fund. Jane DuBose, "Conference to Address Reparations for Slavery: Fisk University Event Is Part of Efforts around U.S. to Seek Compensation for African Americans for Historical Wrongs." *Atlanta Journal and Constitution*, January 15, 2001: 4A, http://web.lexis-nexis.com/universe/document?_m=55c0825203eeb9eed7e137df57ef1c75&_docnum=2&wchp=dGLbVtb-lSlAl&_md5=a42779a14bc3606fe9c6e0707f88c243. See Michael D'orso, *Like Judgment Day: The Ruin and Redemption of a Town Called Rosewood.* New York: Putnam, 1996. In 1997 the African-American director John Singleton (b. 1968) issued the feature film *Rosewood.*

29 Brent Staples, "Coming to Grips with the Unthinkable in Tulsa," *New York Times* editorial, March 16, 2003: sect. 4: 12.

30 Suzi Parker, "African-Americans' Heritage Set in Stone," *Christian Science Monitor*, June 20, 2001, http://csmweb2.emcweb.com/durable/2001/06/20/p3s1.htm.

31 See Keith A. Mayes, "Rituals of Race, Ceremonies of Culture: Kwanzaa and the Making of a Black Power Holiday in the United States." Unpublished Ph.D. dissertation, Princeton University, 2002. Karenga wrote the mission statement for the 1995 Million Man March: "The Million Man March/Day of Absence Mission Statement," *Black Scholar: Million Man March* 25, No. 4 (Fall 1995): 2–3.

32 Suzi Parker, "African-Americans' Heritage Set in Stone," and Lawrence H. Williams, *Civil Rights Historical Commemorations*, Luther College, Iowa, College Tour, Spring 2003. For a comprehensive listing, visit the website of the National Park Service: www.cr.hps.gov/nr/feature/afam.

33 The idea for a slavery museum in Virginia came from L. Douglas Wilder (b. 1931), the first African American to be elected governor of a state. Wilder proposed the creation of a museum of American slavery after returning from Gorée Island in Senegal in 1992. See Vonita W. Foster, "The U.S. National Slavery Museum: The First of Its Kind," *Public History News* 24, No. 3 (Spring 2004) and http://usnationalslaverymuseum.org/news/asp for the newsletter *New World*.

34 David Johnson, "African-American Travel Hits New Heights," www.soulofamerica.com (n.d.), Joanne Harris, "Where Black Heritage Tours Are," *American Visions*, February–March 1998, Matthew Mosk, "Ghana Drawing Black Tourists Tracing Their Cultural Roots," Cleveland *Plain Dealer*, November 19, 2000: 3K, and Suzi Parker, "African-Americans' Heritage Set in Stone."

35 See Renwick McLean, "Congress Backs New Museum on Black History and Culture," *New York Times*, November 23, 2003, www.nytimes.com.

36 Molefe Kete Asante's principal texts are *Afrocentricity* (1988), *The Afrocentric Idea* (1989), and *Kemet, Afrocentricity and Knowledge* (1992), all Trenton: African World Press.

37 Key texts in the Afrocentrism controversy: Chancellor Williams, *The Destruction of Black Civilization: Great Issues of a Race from 4500 B.C. to 2000 A.D.* Dubuque, Iowa: Kendall/Hunt, 1971. The second edition of 1974, published by the Third World Press of Chicago, included illustrations by the noted black artist, Murry N. DePillars. George G. M. James, *Stolen Legacy: The Greeks Were Not the Authors of Greek Philosophy, but the People of North Africa, Commonly Called the Egyptians.* London: African Publication Society, 1972, 1954. The Senegalese historian Cheikh Anta Diop published several works in African history and anthropology. His most famous Afrocentrics books are *The African Origin of Civilization: Myth or Reality?* (Translated from French by Mercer Cook, 1974) and *Parenté génétique de l'égyptien pharaonique et des langues négro-africaines: processus de Sémitisation* (The Genetic Parentage of Pharaonic Egypt and the Black African Languages: The Process of Semitization) (1977). Ivan Van Sertima's books include *The African Presence in Early America* (1992) and *Egypt: Child of Africa* (1994), both New Brunswick, N.J.: Transaction. Frank Snowden, *Blacks in Antiquity: Ethiopians in the Greco-Roman Experience.* Cambridge, Mass.: Harvard University Press, 1970, is not considered an Afrocentric text. For a historical review of Afrocentrism, see Wilson Jeremiah Moses, *Afrotopia: The Roots of African American Popular History.* Cambridge, U.K.: Cambridge University Press, 1998. Martin Bernal, *Black Athena: The Afroasiatic Roots of Classical Civilization.* London: Free Association Books, 1987, republished in the United States by Rutgers University Press in 1989, heated up the controversy over Afrocentrism. A white opponent of Afrocentrism is Mary Lefkowitz, *Not Out of Africa: How Afrocentrism Became an Excuse to Teach Myth as History.* New York: Basic Books, 1996.

38 Nell Irvin Painter, "African-American Studies in Historical Perspective," Program in African-American Studies, Princeton University, October, 10, 2001: 5, and Nell Irvin Painter, "Black Faculty," *Chronicle of Higher Education*, December 15, 2000. Some twenty-two African-American studies programs and departments offered M.A.s, and nine offered Ph.D.s (including the University of California at Berkeley, Harvard, and Yale).

39 Historian of hip-hop, Tricia Rose, says: "In the postindustrial urban context of dwindling low-income housing, a trickle of meaningless jobs for young people, mounting police brutality, and increasingly draconian depictions of young inner city residents, hip hop style is black urban renewal." Tricia Rose, *Black Noise*: 61.

40 Quoted in Robin D. G. Kelley, "Kickin' Reality, Kickin' Ballistics: Gangsta Rap and Postindustrial Los Angeles," in William Eric Perkins, ed., *Droppin' Science: Critical Essays on Rap Music and Hip Hop Culture.* Philadelphia: Temple University Press, 1996: 117–158. Quote on p. 121.

41 Bakari Kitwana divides the hip-hop generation into three subgroups: the older group favors KRS-One and LL Cool J; the middle group likes Wu-Tang Clan; and the youngest group prefers the Hot Boys and Lil' Bow Wow. See Bakari Kitwana, *The Hip Hop Generation: Young Blacks and the Crisis in African American Culture.* New York: Basic Civitas Books, 2002: xiii–xiv.

42 "Sales of rap and hip-hop music made up 84.6 million—about 12 percent—of the 681 million albums sold in the United States in 2002, according to SoundScan. It is the third-largest-selling genre in the country, after rhythm and blues (161.9 million) and alternative (126.4 million)." See Andrew Guy, Jr., "Bling Bling: Hip-hop Culture Outtalks Its Bad Rap," Houston *Chronicle*, May 4, 2003: Lifestyle Section, 1, http://web.lexis-nexis.com/universe/document?_m=

75ed22a79aeb174a9051adb0f26a79a3&_docnum=3&wchp=dGLbVtb-lSlzV&_md5=f240703 2f97603c380e05c63fd6967b1. Other sources note that the best-selling rap artist of 2002 was the white Detroiter Eminem, with both an original album and the soundtrack to his autobiographical movie, *8 Mile*.

43 M. Franklin Sirmans, "Chronology," in Richard Marshall, ed., *Jean-Michel Basquiat*. New York: Whitney/Abrams, 1992: 233–250 and www.emory.edu/ENGLISH/Bahri/Basquiat.html. Basquiat was the subject of a 1997 feature film, *Basquiat*, by his fellow artist Julian Schnabel.

44 Rose, *Black Noise*: 51–53.

45 Kool Herc's territory was the West Bronx. Afrika Bambaataa controlled the Bronx River East, and Grandmaster Flash's territory ruled the southern and central sections of the Bronx. See Rose, *Black Noise*: 53.

46 Ibid.: 52–53.

47 Ibid.: 3, 56.

48 Rose, *Black Noise*: 107–111. Boogie Down Production, "Who Protects Us from You?" *Ghetto Music: The Blueprint of Hip Hop* (Jive/Zomba Records, 1989). L. L. Cool J., "Illegal Search," *Mama Said Knock You Out* (Def Jam/Columbia Records, 1990).

49 Bakari Kitwana, *The Hip Hop Generation: Young Blacks and the Crisis in African American Culture*. New York: Basic Civitas, 2002: 121–130.

50 The characterizations are those of Michael Eric Dyson, *Holler If You Hear Me: Searching for Tupac Shakur*. New York: Basic Civitas, 2001: 13, 67, 109, 138. Shakur's mother was the activist Afeni Shakur; his surrogate mother was the exiled radical Assata Shakur; and his godfather was the unjustly imprisoned Black Panther Geronimo Pratt.

51 Kelley, "Kickin' Reality, Kickin' Ballistics": 137, and Rose, *Black Noise*: 28–34.

　　Rap producers like Russell Simmons and Sean Combs come from middle-class backgrounds. Notorious B.I.G.'s mother was a teacher. But as Eminem's movie *8 Mile* shows, the fact that a black rapper comes from the suburbs can be used against him.

52 Examples of rap musicians who lost their authenticity through mainstream success are LL Cool J (whose audience is heavily female and whose music is used in advertisements), Will Smith (who became a television and movie star), Queen Latifah (who became a movie star), and Sean "P Diddy"/ "Puffy" Combs (who bought a house in the Hamptons, launched a successful clothing line, and through other investments has grown very rich).

53 See Lola Ogunnaike, "And They Said He Couldn't Run a Major Label," *New York Times*, March 2, 2003: sect. 2: 1, 38 and Christina Cramer, "Lauryn Hill," *Rolling Stone.com*, n/d, www.rolling-stone.com/artists/bio.asp?oid=4895&cf=4895.

　　Simmons's Rush Communications conglomerate includes the Def Jam record label, the Rush Artist Management company, Phat Farm clothing company, the Def Pictures movie production house, *One World* magazine, Rush Media advertising agency, and several television shows including "Def Comedy Jam" and "Russell Simmons' Oneworld Music Beat." In the late 1990s Simmons was the third most powerful African American in entertainment, after Robert Johnson and Oprah Winfrey. See *Salon.com*, July 6, 1999, www.salon.com/people/bc/1999/07/06/simmons/index1.html.

54 Brent Staples, "What the United States Army Teaches Us about Affirmative Action," *New York Times*, January 6, 2003: A20.

55 Lee represents the 9th California congressional district. She said, "The resolution was a blank check to the president to attack anyone involved in the Sept. 11 events—anywhere, in any country, without regard to our nation's long-term foreign policy, economic and national security interests, and without time limit. In granting these overly broad powers, the Congress failed its responsibility to understand the dimensions of its declaration. I could not support such a grant of war-making authority to the president; I believe it would put more innocent lives at risk.

　　"The president has the constitutional authority to protect the nation from further attack and he has mobilized the armed forces to do just that. The Congress should have waited for the facts to be presented and then acted with fuller knowledge of the consequences of our action." See Barbara Lee, "Statement of Congresswoman Barbara Lee on Opposing the Use of Force Resolution," in "Black America: After 9/11," *The Black Scholar* 32, No. 2 (Summer 2002): 10–11.

56 A Joint Center for Political and Economic Studies poll taken in October 2002 found that only 19.2

percent of blacks supported the idea of a war against Iraq. The Joint Center poll also found that the most popular figure in the Bush administration was Secretary of State Colin Powell, with a 73.3 percent favorable rating. President Bush's approval rating among African Americans was 50.8 percent. Vice President Dick Cheney's favorable rating was 43.2 percent, and National Security Advisor Condoleezza Rice's favorable rating was 41.1 percent. See Joint Center for Political and Economic Studies, Washington, D.C., "Joint Center 2002 National Opinion Poll Shows War with Iraq a Low Priority for Black Voters," October 29, 2002, http://130.94.20.119/pressrel/103002.htm.

Epilogue: A Snapshot of African Americans in the Early Twenty-First Century

1 Table HINC-05. Percent Distribution of Households, by Selected Characteristics within Income Quintile and Top 5 Percent in 2003, in U.S. Census Bureau, Current Population Survey, 2004 Annual Social and Economic Supplement, http://ferret.bls.census.gov/macro/032004/hhinc/new05_000.htm.

 The white middle class was more than 20 percent of the total white population by 1910. Mary Pattillo-McCoy, "Middle Class, Yet Black: A Review Essay," *African American Research Perspectives* 5, 1 (1999): 2–3, and http://216.239.53.100/search?q=cache:8y6c7OgmB-MC:www.rcgd.isr.umich.edu/prba/perspectives/fall1999/mpattillo.pdf+middle+class,+yet+black&hl=en&ie=UTF-8. See also Mary Pattillo-McCoy, *Black Picket Fences: Privilege and Peril in a Black Middle Class Neighborhood*. Chicago: University of Chicago Press, 1999.

2 Kimberly Blanton, "Jobless Rate Again at Double-Digit Levels for Blacks," Boston *Globe*, May 23, 2003, says: "Unemployment among black Americans, which fell to record lows in 2000, has returned to double-digit levels, dampening hopes engendered by the nation's longest economic expansion, when unemployed blacks were encouraged to look for work and found it." U.S. Department of Labor, Bureau of Labor Statistics: http://data.bls.gov/cgi-bin/surveymost.

 In the summer of 2002 the Ford Foundation publicized a study showing that about one-third of women and minority job seekers encounter discrimination. Massachusetts and Pennsylvania were particularly tough on black applicants. In Massachusetts, a black applicant was likely to experience job discrimination 45 percent of the time. The national figure was 41 percent of the time. See Alfred W. Blumrosen and Ruth G. Blumrosen, *The Reality of Intentional Job Discrimination in Metropolitan America—1999*, Newark, N.J.: Rutgers School of Law, Center for Law and Justice, 2000: 1–2. See also Donna Goodison, "Job Discrimination Study Slams Mass.," *Boston Herald*, August 8, 2002: 35.

3 Pattillo-McCoy, "Middle Class, Yet Black": 3.

4 In comparison, median Native American family income in 1999 was $31,929. Hispanic family income in 2001 was $34,490 and white family income was $54,067. See U. S. Census Bureau, Historical Income Tables-Families: www.census.gov/hhes/income/histinc/f05.html and factfinder.census.gov/servlet/GCTTable?ds_name=D&geo_id=D&mt_name=DEC_2000_SF3_U_GCTP14_US14&_lang=en. See also Celeste M. Watkins, "A Tale of Two Classes: The Socio-Economic Divide among Black Americans under 35," in Lee Daniels, ed., *The State of Black America 2001: Black Americans under Thirty-Five*. New York: National Urban League, 2001.

5 U. S. Census figures: see www.census.gov/Press-Release/www/2002/cb02-95.html.

6 Similarly the percentage of African Americans who had graduated from high school has continued to rise. In 1980, 51 percent had high school diplomas; in 1990 the figure was 63 percent. In 2000, 72 percent of African Americans had graduated from high school.

 Although increased education yields increased income to African Americans, racial disparities persist relative to nonblack Americans. Non-Hispanic whites with a high school education earn an average of $1.3 million over their lifetimes, compared with about $1.1 million by African Americans and Latinos. While African Americans and Latinos with college degrees will earn about $1.7 million in their lifetimes, non-Hispanic whites with a college degree will earn about $2.2 million. See factfinder.census.gov/servlet/BasicFactsServlet, http://www.census.gov/Press-Release/www/2002/cb02-95.html, www.census.gov/apsd/wepeople/we-1.pdf, and Jennifer Cheeseman Day and Eric C. Newburger, *The Big Payoff: Educational Attainment and Synthetic Estimates of Work-Life Earnings: US Census Bureau Special Studies*. Washington, D.C.: Government Printing Office, 2002: 6–7.

7 Jesse McKinnon, *The Black Population in the United States: March 2002, Current Population Reports, Series P20-541*. Washington, D.C.: U.S. Census Bureau, 2003: 4.

8 According to Kimberly Edelin-Freeman, "African-American Men and Women in Higher Education: 'Filling the Glass' in the New Millennium," in Lee Daniels, ed., *The State of Black America 2000: Blacks in the New Millennium*. New York: National Urban League, 2000: 62: "In 1997, African Americans constituted 10.7 percent of all students in America's colleges and universities . . . 11.2 percent of all undergraduates, 7.5 percent of all graduate students, and 7.1 percent of all first-professional students. In 1997, there were more than 1.5 million African Americans enrolled in higher education, compared to just over 1 million in 1978. . . . As the number of African-American undergraduates has increased by 43 percent since the 1970s, the number of African-American women undergraduates has far surpassed the number of black undergraduate men."

9 In the younger eighteen to twenty-five age group, 21.5 percent of black men and 31.6 percent of black women were poor. See Russell L. Stockard, Jr., and M. Belinda Tucker, "Young African-American Men and Women: Separate Paths?" in Lee Daniels, ed., *The State of Black America 2001: Black Americans under Thirty-Five*. New York: National Urban League, 2001: 149–150.

10 Jesse McKinnon, *The Black Population in the United States*: March 2002: 6.

11 Billy J. Tidwell, "Parity Progress and Prospects: Racial Inequalities in Economic Well-Being," in Lee Daniels, ed., *The State of Black America 2000: Black in the New Millennium*. New York: National Urban League, 2000: 117–118. The figures on poor black children come from the U.S. Census Bureau.

According to the Children's Defense Fund, 16.2 percent of American children were poor in 2000. For white children, the rate was 13.0 percent; for black children, 30.9 percent; for Hispanic children, 28.0 percent. See Appendix II in Lee Daniels, ed., *The State of Black America 2002: Opportunity and Equality = One America*. New York: National Urban League, 2002: 208.

12 Tidwell, "Parity Progress and Prospects": 294–295. Source: U. S. Census Bureau, Current Population Survey, "Historical Income Tables," Table F-5. See also Linda Villarosa, "More Teenagers Say No to Sex, and Experts Aren't Sure Why," *New York Times*, December 23, 2003: F6. Stockard and Tucker, "Young African-American Men and Women": 144, 150.

13 The overall sex ratio in the United States in 2000 was 96.3, meaning that women outnumbered men in the general population. In 1980 the overall American sex ratio fell to its lowest point: 94.5. Frank Hobbs and Nicole Stoops, "Demographic Trends in the 20th Century," *Census 2000 Special Reports*. Washington, D.C.: U.S. Census Bureau, November 2002: 62.

14 Stockard and Tucker, "Young African-American Men and Women": 151.

15 Strictly speaking, the U.S. Census keeps figures according to "household" rather than family. I am using "family" and "household" interchangeably, although they are not exactly the same things. According to the U.S. Census, a household consists of all the people, related or unrelated, who occupy the same housing unit. The person whose name comes first in the report of the household is ordinarily the owner or prime tenant of any gender. A household includes family members, lodgers, foster children, or employees who live in the same housing unit.

Household wealth gives a better sense of financial well-being than income because wealth is more stable than income. Income changes drastically when a worker loses his or her job or gets a big promotion. Wealth changes less suddenly and provides a cushion during hard times.

"Median net worth" is a dollar value found by dividing the households in half. One half has more, and one half has less than the median value. Median values are less likely than averages to be distorted by extreme values. See Michael E. Davern and Patricia J. Fisher, *Household Net Worth and Asset Ownership. Current Population Reports: The Survey of Income and Program Participation*. Washington, D.C.: U.S. Government Printing Office, 2001: A-1, A-2. This report breaks the U.S. population down into just three racial groups: Hispanic/Latino, Black, and White. See also Dalton Conley, "The Black-White Wealth Gap," *The Nation* 272, No. 12 (March 26, 2001): 20–22.

16 Davern and Fisher, *Household Net Worth*: v, vii, xv.

17 U.S. Census Bureau, *American Housing Survey for the United States*: 2001. Washington, D.C.: U.S. Government Printing Office, 2002: 42.

See Margery Austin Turner et al., "All Other Things Being Equal: A Paired Testing Study of Mortgage Lending Institutions," Urban Institute, Washington, D.C., 2002: 111, 36. This study

found that the majority of black and Latino applicants were treated fairly. See also Reed, "Guess Who's Coming for a Mortgage?" and Bruce D. Haynes, *Red Lines, Black Spaces: The Politics of Race and Space in a Black Middle-Class Suburb*. New Haven: Yale University Press, 2001.

In early 2003 the famed African-American novelist Ishmael Reed (b. 1938) described his very recent experiences with redlining in the inner city of Oakland, California. Black people still face obstacles as they attempt to secure real estate financing. See Ishmael Reed, "Guess Who's Coming for a Mortgage?" *New York Times* op-ed., January 16, 2003: A29. See also Donna Goodison, "Job Discrimination Study Slams Mass.," Boston *Herald*, August 8, 2002: 35. Professor Blumrosen concluded that 37 percent of the 205,393 business establishments surveyed intentionally discriminated against minorities (African Americans, Latinos, and Asians), discrimination that affected 1,361,083 qualified minority workers. They found a "hard core" of 22,269 establishments that discriminated against minorities over the course of at least nine years. These establishments were responsible for about one-half the job discrimination against minority workers.

18 "In 1984, 33 percent of black families had zero or less family wealth, compared to 7.9 percent of white families. . . . almost half of black families (49 percent) had wealth of $3,200 or less, compared to 16 percent of white families. . . . [in 1999], more than 32 percent of black families held zero or less wealth, compared to 12.2 percent of white families." William D. Bradford, "Black Family Wealth in the United States," in Lee Daniels, ed., *The State of Black America 2000*. New York: National Urban League, 2000: 103–146.

19 TLC's leveraged buy out of Beatrice was not the first by a black entrepreneur. Bruce Llewellyn (b. 1927) made similar purchases eighteen years before Lewis's company bought Beatrice. *Fortune Magazine* ranked the company number 512 on its list of the 1,000 largest companies in 1996, TLC-Beatrice's peak year. Juliet E. K. Walker, *The History of Black Business in America: Capitalism, Race, Entrepreneurship*. New York: Macmillan, 1998: 333.

Vincent Smith's (1929-2003) "Portrait of Reginald F. Lewis" hangs in the Harvard Law School. The portrait plays upon the conventions of portraiture by depicting Lewis with his possessions, here African art and books. Through the window Smith shows children playing, indicating Lewis's devotion to family and children. A piece of African sculpture on the bookcase testifies to Lewis's interest in the art of his African heritage. See *International Review of African-American Art Comprehensive Guide to African-American Art* (1998): 3, for a reproduction of "Portrait of Reginald F. Lewis."

20 BET consists of five different cable channels and reaches nearly 62 million homes. In 1991 Johnson listed BET on the New York Stock Exchange, making it the first black-owned company to be traded publicly. Johnson summed up his personal philosophy of doing business in a racist society like this: "Treat racism like rain. Racism exists, but put up an [emotional] umbrella and go to work. Don't stand out there and get drenched in it [racism]. Certainly protect yourself legally, if need be, but don't define your life by filing a law suit every time someone says something racist. I liken it to playing in the NFL. You know you're going to get hit, so get up and keep on playing. Get on with your life and do what needs to be done." Quoted in Robert G. Miller, "Robert L. Johnson: A Business Titan—Redefining Black Entrepreneurial Success," *Black Collegian* 31, No. 1 (October 2000): 143.

Johnson is the first African American to own a major professional sports team since the desegregation of professional sports. During the Jim Crow era two pioneers of Negro basketball owned teams. Rube Foster, founder of the Negro National League in 1920, owned the American Giants of Chicago. In the 1920s Robert Douglas, the "Father of Black Basketball" formed the famous Harlem Rens. William C. Rhoden, "Sports of the Times: Finally, a Member of the Club," *New York Times*, December 19, 2002: D1, and Richard Sandomir, "Founder of TV Network Becomes First Black Owner in Major Sports," *New York Times*, December 19, 2002: A1, D3.

21 Fletcher is the founder and chairman of Fletcher Asset Management. Part of the donation will go to individuals like James P. Comer (b. 1935) and part to institutions like Howard University School of Law, the NAACP, and the NAACP Legal Defense and Educational Fund Inc. Sara Rimer, "$50 Million Gift Aims to Further Legacy of *Brown* Case," *New York Times*, May 18, 2004.

22 Michael Eric Dyson, "Penn or the Pen?" *Savoy* 2, No. 10 (December 2002–January 2003): 51.

23 James R. Lanier, "The Empowerment Movement and the Black Male," in Lee Daniels, ed.,

The State of Black America 2004: The Complexity of Black Progress. New York: National Urban League, 2004: 146.

While about 12 percent of black men in their twenties and thirties were incarcerated, comparable figures for white men were 1.6 percent and 4 percent for Latinos. While the vast majority of inmates were men, the numbers of incarcerated women has grown more quickly than the numbers of incarcerated men. See Marc Mauer, *Race to Incarcerate: The Sentencing Project*. New York: New Press, 1999: 1, and Paige M. Harrison and Jennifer C. Karlberg, "Prison and Jail Inmates at Midyear 2002," *Bureau of Justice Statistics Bulletin*, U.S. Department of Justice, April 2003: 2, 5, 11. See also Joy James, ed., *States of Confinement: Policing, Detention, and Prisons*. Washington, D.C.: American Sociological Association, 2003, and Angela Y. Davis and Gina Dent, "Conversations: Prison as a Border: A Conversation on Gender, Globalization, and Punishment," *Signs* 26, No. 4 (Summer 2001): 1235–1241. See also Angela Y. Davis, "Masked Racism: Reflections on the Prison Industrial Complex," *ColorLines Magazine* 1, No. 2 (Fall 1998), www.arc.org/C_Lines/CLArchive/story1_2_01.html.

24 Deborah Small, "The War on Drugs Is a War on Racial Justice," *Social Research* 68, No. 3 (Fall 2001): 896–903.

25 Forced labor in chain gangs became a replacement for slave labor in the late nineteenth- and early twentieth-century South. By the mid-twentieth century, chain gains were considered the kind of cruel and unusual punishment the U.S. Constitution prohibits. In 1962 Georgia became the last state to end the use of forced convict labor in chain gangs. However in the late-twentieth-century rush to get tough on crime, the state of Alabama reinstated the chain gang as cruel punishment, not to produce any particular economic product. In 1996 a guard shot and killed a chain gang inmate, provoking public outcry. According to the Boston *Globe*, the only women's chain gang is in Arizona: www.boston.com/globe/magazine/1998/5-31/featurestory/.

26 Quoted in Dyson, "Penn or the Pen?": 51.

27 According to the Sentencing Project, "Under this format, a dealer charged with trafficking 400 grams of powder, worth approximately $40,000, could receive a shorter sentence than a user he supplied with crack valued at $500. The maximum sentence for simple possession of any other drug, including powder cocaine, is 1 year in jail."

"Approximately 2/3 of crack users are white or Hispanic, yet the vast majority of persons convicted of possession in federal courts in 1994 were African American, according to the USSC. Defendants convicted of crack possession in 1994 were 84.5% black, 10.3% white, and 5.2% Hispanic. Trafficking offenders were 4.1% white, 88.3% black, and 7.1% Hispanic. Powder cocaine offenders were more racially mixed. Defendants convicted of simple possession of cocaine powder were 58% white, 26.7% black, and 15% Hispanic. The powder trafficking offenders were 32% white, 27.4% black, and 39.3% Hispanic. The result of the combined difference in sentencing laws and racial disparity is that black men and women are serving longer prison sentences than white men and women." The Sentencing Project, "Crack Cocaine Sentencing Policy: Unjustified and Unreasonable," www.sentencingproject.org/brief/pub1003.htm.

28 Nationally, 26 percent of people convicted for possession of powder cocaine were white (30 percent were black; 43 percent were Latino). Deborah Small, "The War on Drugs Is a War on Racial Justice": 896–903, and Mauer, *Race to Incarcerate*: 156.

29 The number of blacks imprisoned for drug offenses increased four times as much as the increase for whites even though five times as many whites were using drugs as blacks. In 2000 prisons and jails cost nearly $40 billion. Almost $24 billion paid for the incarceration of the 1.2 million non-violent offenders. Phillip Beatty, Barry Holman, and Vincent Schiraldi, *Poor Prescription: The Costs of Imprisoning Drug Offenders in the United States*. San Francisco: Center on Juvenile and Criminal Justice, 2000, www.cjcj.org/pubs/poor/pp.html. See also Small, "The War on Drugs": 896–903.

30 The convention opened on Tupac Shakur's birthday and closed on Juneteenth—June 19, the unofficial holiday commemorating emancipation in Texas in 1865. See Tammy La Gorce, "A Political Convention, with Beats," *New York Times*, June 27, 2004: Sect. 14: 9, 14.

31 Maulana Karenga, "The Million Man March/Day of Absence Mission Statement," *Black Scholar: Million Man March* 25, No. 4 (Fall 1995): 2–3.

32 George Winslow, "Capital Crimes: The Political Economy of Crime in America," *Monthly Review* 52, No. 6 (November 2000): 38–53.

33 John J. Dilulio, Jr., "Living Faith: The Black Church Outreach Tradition," *Report* 98-3, The Manhattan Institute Jeremiah Project (1999), www.manhattan-institute.org/html/jpr-98-3.htm, and Ron Ozio, "Black Congregations Have a Higher Rate of Providing Social Services in Philadelphia," *Penn Office of University Communication*, April 27, 2001: www.upenn.edu/pennews/article.php?id=374.

34 See Hollie I. West, "Down from the Clouds: Black Churches Battle Earthly Problems," *Emerge* 1, No. 2 (May 1990): 48.

35 Andrew Billingsley, *Mighty Like a River: The Black Church and Social Reform*. New York: Oxford University Press, 1999: 159–162.

36 National Urban League Institute for Opportunity and Equality and Global Insight, Inc., "The National Urban League Equality Index," in Lee Daniels, ed., *The State of Black America, 2004: The Complexity of Black Progress*. New York: National Urban League, 2004: 22; Centers for Disease Control, *HIV Prevention in the Third Decade: Specific Populations* (n.d.). www.cdc.gov/hiv/HIV_3rdDecade/section4.htm; DeNita S. B. Morris, "AIDS Pandemic: African American Women Can't Sleep on This," *Black Women's Health Imperative* news, May 7, 2004: www.blackwomenshealth.org/site/News2?news_iv_ctrl=-1&page=NewsArticle&id=5235; *Black Women's Health Imperative* news: www.blackwomenshealth.org/site/News2?page=NewsArticle&id=6506&news_iv_ctrl=1201; and Darryl Fears, "U.S. HIV Cases Soaring Among Black Women: Social Factors Make Group Vulnerable," Washington *Post*, February 7, 2005: A1.

37 The total U.S. population of all races in 2000 was 281,421,906. Of African Americans reporting black and another race, 49 percent said they were black and white; 18 percent said black and some other race; 12 percent said black and American Indian/Alaska Native; 7 percent said black and Asian. The Census does not count Hispanic or Latino as a race. Jesse McKinnon, *The Black Population in the United States: March 2002*: 2, 6, 9. See also Nicholas A. Jones and Amy Symens Smith, "The Two or More Races Population: 2000," *Census 2000 Brief*. Washington, D.C.: U.S. Census Bureau, 2001: 7–9.

 The U.S. Census Bureau's Current Population Report on black population for 2000 includes detailed tabulations of mixed race and alone race. Such details disappeared from the report of the black population in 2002.

38 Jesse McKinnon, *The Black Population in the United States: March 2002*: 8.

39 Lynette Clemetson, "Hispanics Now Largest Minority, Census Shows," *New York Times*, January 22, 2003: A1, A17.

40 The foreign-born portion of the black population was 3.1 percent in 1980, 1.1 percent in 1970, and 0.7 percent in 1960. See Dianne A. Schmidley, "Current Population Reports, Series P23-206," *Profile the Foreign-born Population in the United States: 2000*. Washington, D.C.: U.S. Census Bureau, 2001: 3, and U.S. Census Tech Paper 29, Table 8, "Race and Hispanic Origin of the Population by Nativity: 1850-1990," www.census.gov/population/www/documentation/twps0029/tab08.html. See also Xue Lan Rong and Frank Brown, "The Effects of Immigrant Generation and Ethnicity on Educational Attainment among Young African and Caribbean Blacks in the United States," *Harvard Educational Review* 71, No. 3: 536–565. See also X. L. Rong and J. Preissle, *Educating Immigrant Students: What We Need to Know to Meet the Challenge*. Thousand Oaks, Calif.: Sage-Corwin, 1998.

41 Families headed by an immigrant from Asia earned $51,363 in 1999; families headed by an immigrant from Latin America earned $29,388. Dianne A. Schmidley, "Current Population Reports, Series P23-206": 37, 45.

42 My Princeton students, for whom "African American" means simply any American of African descent, sometimes call African immigrants and their children "African-African Americans."

43 Department of Homeland Security Office of Immigration Statistics, in Elizabeth Grieco, "The African Foreign Born in the United States," Migration Policy Institute, September 1, 2004: www.migrationinformation.org/USfocus/display.cfm?id=250.

44 Sam Roberts, "More Africans Enter U.S. Than in Days of Slavery," *New York Times*, February 21, 2005: A1, B4.

45 This is the U.S. Census Bureau's accounting of the civilian, non-institutionalized population. See Jesse McKinnon, *The Black Population in the United States: March* 2002: 1–7. See also Roderick J. Harrison, "The Great Migration, South," *The New Crisis* 108, No. 4 (July/Aug 2001): 20–22.

In 1970 19.2 percent of African Americans lived in the Northeast. The Midwestern proportion of the black population has been decreasing since that time. In 2000 17.6 percent African Americans lived in the Northeast. While 20.2 percent of African Americans lived in the Midwest in 1970, the Midwestern proportion of the black population has been decreasing since that time. In 2000 18.8 percent of African Americans lived in the Midwest. See Frank Hobbs and Nicole Stoops, "Demographic Trends in the 20th Century," *Census 2000 Special Reports.* Washington, D.C.: U.S. Census Bureau, November 2002: 83.

46 Steve Chambers and Nikita Stewart, "City's Southerners Are Moving On: Foreign-born Blacks Are New Arrivals," Newark *Star-Ledger*, February 16, 2003: 23, 26.

47 Newark's Latino population was 61,254 in 1980 and 80,622 in 2000. See Nikita Stewart and Jeffery C. Mays, "Rift Between Blacks, Latinos Widens in Newark: Potent Voting Bloc Crumbles as Population Shifts," Newark *Star-Ledger*, April 6, 2003. The *Star-Ledger* figures come from the U.S. Census Bureau.

◈ Further Reading ◈

Preface

Romare Bearden and Harry Henderson, *A History of African-American Artists from 1792 to the Present.* New York: Pantheon, 1993.

Lisa Gail Collins, *The Art of History: African American Women Artists Engage the Past.* New Brunswick: Rutgers University Press, 2002.

Lisa E. Farrington, *Creating Their Own Image: The History of African-American Women Artists.* New York: Oxford University Press, 2004.

Henry Louis Gates, Jr., and Nellie Y. McKay, eds., *Norton Anthology of African-American Literature.* 2nd ed. New York: W. W. Norton, 2003. (Originally published 1996.)

International Review of African American Art

Carolyn Mazloomi, *Spirits of the Cloth: Contemporary African American Quilts.* New York: Clarkson Potter, 1998.

Sharon F. Patton, *African-American Art: Oxford History of Art.* New York: Oxford University Press, 1998.

Richard Powell, *Rhapsodies in Black: Art of the Harlem Renaissance.* Berkeley: University of California Press, 1977.

James Prigoff and Robin J. Dinitz, *Walls of Heritage, Walls of Pride: African American Murals.* San Francisco: Pomegranate, 2000.

Gary A. Reynolds and Beryl J. Wright, eds., *Against the Odds: African-American Artists and the Harmon Foundation.* Newark: The Newark Museum, 1989.

Thomas Riggs, ed., *St. James Guide to Black Artists.* Detroit: St. James Press, 1997.

1: Africa and Black Americans

John Henrik Clarke and Amy Jacques Garvey, eds., *Marcus Garvey and the Vision of Africa.* New York: Random House, 1974.

Jacqueline Goggin, *Carter G. Woodson: A Life in Black History.* Baton Rouge: Louisiana State University Press, 1993.

Leonard Harris, ed. *The Philosophy of Alain Locke: Harlem Renaissance and Beyond.* Philadelphia: Temple University Press, 1989.

Alain Locke, ed., *The New Negro,* reprint ed., with preface by Robert Hayden. New York: Atheneum, 1975. (Originally published 1925.)

Elinor Des Verney Sinnette, *Arthur Alfonso Schomburg, Black Bibliophile and Collector: A Biography.* Detroit: Wayne State University Press, 1989.

2: Captives Transported, 1619–ca. 1850

Robert Edgar Conrad, *In the Hands of Strangers: Readings on Foreign and Domestic Slave Trading and the Crisis of the Union.* University Park: Pennsylvania State University Press, 2001.

Philip D. Curtin, *Africa Remembered: Narratives by West Africans from the Era of the Slave Trade.* Madison: University of Wisconsin Press, 1967.

Maria Diedrich, Henry Louis Gates, Jr., and Carl Pedersen, eds., *Black Imagination and the Middle Passage.* New York: Oxford University Press, 1999.

Henry Louis Gates, Jr., and William L. Andrews, eds., *Pioneers of the Black Atlantic: Five Slave Narratives from the Enlightenment, 1772–1815.* Washington, D.C.: Civitas, 1998.

Joseph E. Inikori and Stanley Engerman, eds., *The Atlantic Slave Trade: Effects on Economics, Societies, and Peoples in Africa, the Americas, and Europe.* Durham: Duke University Press, 1992.

Philip D. Morgan, *Slave Counterpoint: Black Culture in the Eighteenth-Century Chesapeake and Lowcountry.* Chapel Hill: University of North Carolina Press, 1998.

Hugh Thomas, *The Slave Trade*. New York: Simon & Schuster, 1997.

3: *A Diasporic People, 1630–ca. 1850*

Ira Berlin, *Many Thousands Gone: The First Two Centuries of Slavery in North America*. Cambridge, Mass.: Harvard University Press, 1998.

Edward Countryman, ed., *How Did American Slavery Begin?* Boston: Bedford/St. Martin's, 1999.

Michael Gomez, *Exchanging Our Country Marks: The Transformation of African Identities in the Colonial and Antebellum South*. Chapel Hill: University of North Carolina Press, 1998.

Annette Gordon-Reed, *Thomas Jefferson and Sally Hemings: An American Controversy*. Charlottesville: University of Virginia Press, 1997.

Michael D. Harris, *Colored Pictures: Race and Visual Representation*. Chapel Hill, University of North Carolina Press, 2003.

Allan Kulikoff, *Tobacco and Slaves: The Development of Southern Cultures in the Chesapeake, 1680–1800*. Chapel Hill: University of North Carolina Press, 1986.

Lawrence W. Levine, *Black Culture and Black Consciousness: Afro-American Folk Thought from Slavery to Freedom*. New York: Oxford University Press, 1977.

Gary B. Nash, *Red, White, and Black: The Peoples of Early America*. 2nd ed. Englewood Cliffs, N.J.: Prentice Hall, 1982. (Originally published 1974.)

Mechal Sobel, *The World They Made Together: Black and White Values in Eighteenth-Century Virginia*. Princeton: Princeton University Press, 1987.

Sterling Stuckey, *Slave Culture: Nationalist Theory and the Foundations of Black America*. New York: Oxford University Press, 1987.

John Thornton, *Africa and Africans in the Making of the Atlantic World, 1400–1800*, 2nd ed. Cambridge, UK: Cambridge University Press, 1998.

John Wood Sweet, *Bodies Politic: Negotiating Race and the American North, 1730–1830*. Baltimore: Johns Hopkins University Press, 2003.

4: *Those Who Were Free, ca. 1770–1859*

Sylvia R. Frey, *Water from the Rock: Black Resistance in a Revolutionary Age*. Princeton: Princeton University Press, 1991.

Graham Russell Hodges, *Root and Branch: African Americans in New York and East Jersey, 1613–1863*. Chapel Hill: University of North Carolina Press, 1999.

James O. Horton and Lois E. Horton, *In Hope of Liberty: Culture, Community, and Protest among Northern Free Blacks, 1700–1860*. New York: Oxford University Press, 1997.

Alfred N. Hunt, *Haiti's Influence on Antebellum America: Slumbering Volcano in the Caribbean*. Baton Rouge: Louisiana State University Press, 1988.

Nell Irvin Painter, *Sojourner Truth, a Life, a Symbol*. New York: W. W. Norton, 1996.

Benjamin Quarles, *Black Abolitionists*. New York: Oxford University Press, 1969.

Patrick Rael, *Black Identity and Black Protest in the Antebellum North*. Chapel Hill: University of North Carolina Press, 2002.

Marilyn Richardson, ed., *Maria Stewart, America's First Black Woman Political Writer: Essays and Speeches*. Bloomington: Indiana University Press, 1987.

Shane White, *Somewhat More Independent: The End of Slavery in New York City, 1770–1810*. Athens: University of Georgia Press, 1991.

Jean Fagan Yellin, *Harriet Jacobs, A Life*. New York: Basic Books, 2004.

5: *Those Who Were Enslaved, ca. 1770–1859*

Herbert Aptheker, *American Negro Slave Revolts*. Foreword by John H. Bracey. New York: International Publishers, 1983. (Originally published 1944.)

Jean M. Humez, *Harriet Tubman: The Life and the Life Stories*. Madison: University of Wisconsin Press, 2003.

Walter Johnson, *Soul by Soul: Life Inside the Antebellum Slave Market*. Cambridge, Mass.: Harvard University Press, 1999.

Wilma King, *Stolen Childhood: Slave Youth in Nineteenth-Century America*. Bloomington: Indiana University Press, 1995.

Peter Kolchin, *American Slavery, 1619–1877*. New York: Hill and Wang, 1993.

Dylan C. Penningroth, *The Claims of Kinfolk: African American Property and Community in the Nineteenth-Century South*. Chapel Hill: University of North Carolina Press, 2003.

Albert Raboteau, *Slave Religion: The "Invisible Institution" in the Antebellum South*. New York: Oxford University Press, 1978.

Michael Tadman, *Speculators and Slaves: Masters, Traders, and Slaves in the Old South*. Madison: University of Wisconsin Press, 1996. (Originally published 1989.)

Deborah Gray White, *Ar'n't I a Woman? Female Slaves in the Plantation South*. 2nd ed. New York: W. W. Norton, 2000. (Originally published 1985.)

6: *Civil War and Emancipation, 1859–1865*

R. J. M. Blackett, ed., *Thomas Morris Chester, Black Civil War Correspondent: His Dispatches from the Virginia Front*. Baton Rouge: Louisiana State University Press, 1989.

Herbert Gutman, *The Black Family in Slavery and Freedom, 1750–1925*. New York: Pantheon Books, 1976.

Wilbert L. Jenkins, *Climbing Up to Glory: A Short History of African Americans During the Civil War and Reconstruction*. Wilmington, Del.: Scholarly Resources, 2002.

Keith Krawczynski and Steven D. Smith, "African Americans

in the Civil War," in *A Historic Context for the African-American Military Experience*, Steven D. Smith and James A. Ziegler, eds., 1998: www.denix.osd.mil/denix/Public/ES-Programs/Conservation/Legacy/AAME/aamel.html. (This text exists principally in electronic format.)

James M. McPherson, *The Negro's Civil War: How American Blacks Felt and Acted during the War for the Union*. New York: Ballantine, 1991. (Originally published 1965.)

Benjamin Quarles, *The Negro in the Civil War*. Boston: Little, Brown, 1969. (Originally published 1953.)

Robert L. Ransom and Richard Sutch, *One Kind of Freedom: The Economic Consequences of Emancipation*. New York: Cambridge University Press, 1977.

John David Smith, ed., *Black Soldiers in Blue: African American Troops in the Civil War Era*. Chapel Hill: University of North Carolina Press, 2002.

7: The Larger Reconstruction, 1864–1896

W. E. B. Du Bois, with an introduction by David Levering Lewis, *Black Reconstruction in America*. New York: Atheneum, 1992. (Originally published 1935.)

Eric Foner, *Reconstruction: America's Unfinished Revolution, 1863–1877*. New York: Harper & Row, 1988.

John Hope Franklin, *Reconstruction after the Civil War*. 2nd ed. Chicago: University of Chicago Press, 1994. (Originally published 1961.)

Evelyn Brooks Higginbotham, *Righteous Discontent: The Women's Movement in the Black Baptist Church, 1880–1920*. Cambridge, Mass.: Harvard University Press, 1993.

Thomas C. Holt, *Black over White: Negro Political Leadership in South Carolina during Reconstruction*. Urbana: University of Illinois Press, 1977.

Tera W. Hunter, *To 'Joy My Freedom: Southern Black Women's Lives and Labors after the Civil War*. Cambridge, Mass.: Harvard University Press, 1997.

Gerald D. Jaynes, *Branches without Roots: Genesis of the Black Working Class in the American South, 1862–1882*. New York: Oxford University Press, 1986.

J. Morgan Kousser, *The Shaping of Southern Politics: Suffrage Restriction and the Establishment of the One-Party South, 1880–1910*. New Haven: Yale University Press, 1974.

William H. Leckie, *The Buffalo Soldiers: A Narrative of the Negro Cavalry in the West*. Norman: University of Oklahoma Press, 1967.

Leon F. Litwack, *Been in the Storm So Long: The Aftermath of Slavery*. New York: Alfred A. Knopf, 1979.

Nell Irvin Painter, *Exodusters: Black Migration Following Reconstruction*. New York: W. W. Norton, 1992. (Originally published 1976.)

8: Hard-Working People in the Depths of Segregation, 1896–ca. 1919

A'Lelia Bundles, *On Her Own Ground: The Life and Times of Madam C. J. Walker*. New York: Scribner's, 2001.

Rayvon Fouché, *Black Inventors in the Age of Segregation: Granville T. Woods, Lewis H. Latimer & Shelby J. Davidson*. Baltimore: Johns Hopkins University Press, 2003.

James R. Grossman, *Land of Hope: Chicago, Black Southerners, and the Great Migration*. Chicago: University of Chicago Press, 1989.

Louis R. Harlan, *Booker T. Washington: The Wizard of Tuskegee, 1901–1915*. New York: Oxford University Press, 1983.

David Levering Lewis. *W. E. B. Du Bois: Biography of a Race, 1868–1919*. New York: Henry Holt, 1993.

Bernard C. Nalty, *Strength for the Fight: A History of Black Americans in the Military*. New York: Free Press, 1986.

Patricia A. Schechter, *Ida B. Wells-Barnett and American Reform, 1880–1930*. Chapel Hill: University of North Carolina Press, 2001.

Eileen Southern, *The Music of Black Americans: A History*. 3rd ed. New York: W. W. Norton, 1997.

Stewart E. Tolnay and E. M. Beck, *A Festival of Violence: An Analysis of Southern Lynchings, 1882–1930*. Urbana: University of Illinois Press, 1995.

Juliet E. K. Walker, *The History of Black Business in America: Capitalism, Race, Entrepreneurship*. New York: Macmillan, 1998.

9: The New Negro, 1915–1932

Barbara Foley, *Spectres of 1919: Class and Nation in the Making of the New Negro*. Urbana: University of Illinois Press, 2003.

Amy Jacques Garvey, introduction by John Henrik Clarke, *Garvey and Garveyism*. New York: Octagon Books, 1978. (Originally published 1968.)

Florette Henri, *Black Migration: Movement North, 1900–1920. The Road from Myth to Man*. New York: Anchor/Doubleday, 1975.

David Levering Lewis, *W. E. B. Du Bois: The Fight for Equality and the American Century, 1919–1963*. New York: Henry Holt, 2000.

———, *When Harlem Was in Vogue*. New York: Oxford University Press, 1982.

Joe William Trotter, Jr., ed., *The Great Migration in Historical Perspective: New Dimensions of Race, Class, and Gender*. Bloomington: Indiana University Press, 1991.

10: Radicals and Democrats, 1930–1940

Jervis A. Anderson, *A. Philip Randolph: A Biographical Portrait*. Berkeley: University of California Press, 1986.

Beth Tompkins Bates, *Pullman Porters and the Rise of Protest Politics in Black America, 1925–1945*. Chapel Hill: University of North Carolina Press, 2001.

Nell Irvin Painter, *The Narrative of Hosea Hudson: His Life as a Negro Communist in the South*. 2nd ed. New York: W. W. Norton, 1992. (Originally published 1979.)

Brenda Gayle Plummer, *Rising Wind: Black Americans and U.S. Foreign Affairs, 1935–1960*. Chapel Hill: University of North Carolina Press, 1996.

Harvard Sitkoff, *A New Deal for Blacks: The Emergence of Civil Rights as a National Issue*. New York: Oxford University Press, 1978.

Patricia Sullivan, *Days of Hope: Race and Democracy in the New Deal Era*. Chapel Hill: University of North Carolina Press, 1996.

David K. Wiggins and Patrick B. Miller, *The Unlevel Playing Field: A Documentary History of the African American Experience in Sport*. Urbana: University of Illinois Press, 2003.

11: The Second World War and the Promise of Internationalism, 1940–1948

John Dittmer, *Local People: The Struggle for Civil Rights in Mississippi*. Urbana: University of Illinois Press, 1994.

Martin Bauml Duberman, *Paul Robeson*. New York: Alfred A. Knopf, 1988.

John Egerton, *Speak Now against the Day: The Generation Before the Civil Rights Movement in the South*. New York: Alfred A. Knopf, 1994.

Darlene Clark Hine. *Black Victory: The Rise and Fall of the White Primary in Texas*. Millwood, N.Y.: KTO Press, 1979.

Kenneth Robert Janken, *White: The Biography of Walter White, Mr. NAACP*. New York: New Press, 2003.

Quintard Taylor, *In Search of the Racial Frontier: African Americans in the American West*. New York: W. W. Norton, 1998.

12: Cold War Civil Rights, 1948–1960

Thomas Borstelmann, *The Cold War and the Color Line: American Race Relations in the Global Arena*. Cambridge, Mass.: Harvard University Press, 2002.

Mary L. Dudziak, *Cold War Civil Rights: Race and the Image of American Democracy*. Princeton: Princeton University Press, 2000.

Richard Kluger, *Simple Justice: The History of* Brown v. Board of Education *and Black America's Struggle for Equality*. New York: Alfred A. Knopf, 1976.

Douglas S. Massey and Nancy A. Denton, *American Apartheid: Segregation and the Making of the Underclass*. Cambridge, Mass.: Harvard University Press, 1993.

Thomas J. Sugrue, *The Origins of the Urban Crisis: Race and Inequality in Postwar Detroit*. Princeton: Princeton University Press, 1996.

Timothy B. Tyson, *Radio Free Dixie: Robert F. Williams and the Roots of Black Power*. Chapel Hill: University of North Carolina Press, 1999.

Penny Von Eschen, *Race Against Empire: Black Americans and Anticolonialism, 1937–1957*. Ithaca: Cornell University Press, 1999.

13: Protest Makes a Civil Rights Revolution, 1960–1967

Taylor Branch, *Parting the Waters: America in the King Years, 1954–1963*. New York: Simon & Schuster, 1988.

——, *Pillar of Fire: America in the King Years, 1963–1965*. New York: Simon & Schuster, 1998.

Clayborne Carson, *In Struggle: SNCC and the Black Awakening of the 1960s*. Cambridge, Mass.: Harvard University Press, 1981.

Michael Eric Dyson, *I May Not Get There with You: The True Martin Luther King, Jr.* New York: Free Press, 2000.

David J. Garrow, *Bearing the Cross: Martin Luther King, Jr., and the Southern Christian Leadership Conference*. New York: William Morrow, 1986.

Gerald Horne, *The Fire This Time: The Watts Uprising and the 1960s*. Charlottesville: University Press of Virginia, 1995.

Chana Kai Lee, *For Freedom's Sake: The Life of Fannie Lou Hamer*. Urbana: University of Illinois Press, 1999.

Leonard N. Moore, *Carl B. Stokes and the Rise of Black Political Power*. Urbana: University of Illinois Press, 2002.

Howell Raines, ed., *My Soul is Rested: Movement Days in the Deep South Remembered*. New York: Putnam, 1977.

Barbara Ransby, *Ella Baker and the Black Freedom Movement: A Radical Democratic Vision*. Chapel Hill: University of North Carolina Press, 2003.

Harvard Sitkoff, *The Struggle for Black Equality, 1954–1980*. New York: Hill and Wang, 1981.

Mark V. Tushnet, *Making Civil Rights Law: Thurgood Marshall and the Supreme Court, 1936–1961*. New York: Oxford University Press, 1994.

James E. Westheider, *Fighting on Two Fronts: African Americans and the Vietnam War*. New York: New York University Press, 1997.

14: Black Power, 1966–1980

Scot Brown, *Fighting for Us: Maulana Karenga, the US Organization, and Black Cultural Nationalism*. New York: New York University Press, 2003.

Rod Bush, *We Are Not What We Seem: Black Nationalism and Class Struggle in the American Century*. New York: New York University Press, 1999.

Bettye Collier-Thomas and V. P. Franklin, eds., *Sisters in the Struggle: African-American Women in the Civil Rights-Black Power Movement*. New York: New York University Press, 2001.

Herman Graham III, *The Brothers' Vietnam War: Black Power, Manhood, and the Military Experience*. Gainesville: University Press of Florida, 2003.

Robert O. Self, *American Babylon: Race and the Struggle for Postwar Oakland*. Princeton: Princeton University Press, 2003.

Heather Ann Thompson, *Whose Detroit? Politics, Labor, and Race in a Modern American City*. Ithaca: Cornell University Press, 2001.

William L. Van Deburg, *New Day in Babylon: The Black*

Power Movement and American Culture, 1965–1975. Chicago: University of Chicago Press, 1992.

Deborah Gray White, *Too Heavy a Load: Black Women in Defense of Themselves, 1894–1994*. New York: W. W. Norton, 1999.

Yohuru Williams, *Black Politics/White Power: Civil Rights, Black Power, and the Black Panthers in New Haven*. St. James, N.Y.: Brandywine Press, 2000.

Komozi Woodard, *A Nation Within a Nation: Amiri Baraka (LeRoi Jones) and Black Power Politics*. Chapel Hill: University of North Carolina Press, 1999.

15: Authenticity and Diversity in the Era of Hip-Hop, 1980–2005

"Black Election: 2000," *The Black Scholar* 31, No. 2 (Summer 2001).

Michael Eric Dyson, *Holler If You Hear Me: Searching for Tupac Shakur*. New York: Basic Civitas, 2001.

Robin D. G. Kelley, *Freedom Dreams: The Black Radical Imagination*. Boston: Beacon Press, 2002.

Bakari Kitwana, *The Hip Hop Generation: Young Blacks and the Crisis in African American Culture*. New York: Basic Civitas, 2002.

William Eric Perkins, ed., *Droppin' Science: Critical Essays on Rap Music and Hip Hop Culture*. Philadelphia: Temple University Press, 1996.

Tricia Rose, *Black Noise: Rap Music and Black Culture in Contemporary America*. Hanover, N.H.: Wesleyan University Press/University Press of New England, 1994.

Philip F. Rubio, *A History of Affirmative Action, 1619–2000*. Jackson: University Press of Mississippi, 2001.

Randall Robinson, *The Debt: What America Owes to Blacks*. New York: Dutton, 2000.

Epilogue: A Snapshot of African Americans at the Turn of the Twenty-First Century

Lee Daniels, ed., *The State of Black America 2000: Blacks in the New Millennium*. New York: National Urban League, 2000.

——, *The State of Black America 2001: Black Americans Under Thirty-five*. New York: National Urban League, 2001.

——, *The State of Black America 2002: Opportunity and Equality = One America*. New York: National Urban League, 2002.

——, *The State of Black America 2004: The Complexity of Black Progress*. New York: National Urban League, 2004.

Joy James, ed., *States of Confinement: Policing, Detention, and Prisons*. Washington, D.C.: American Sociological Association, 2003.

Jesse McKinnon, *The Black Population in the United States: March 2002, Current Population Reports, Series P20-541*. Washington, D.C.: U.S. Census Bureau, 2003.

Mary Pattillo-McCoy, *Black Picket Fences: Privilege and Peril in a Black Middle Class Neighborhood*. Chicago: University of Chicago Press, 1999.

Recent Textbooks in African-American History

John Hope Franklin and Alfred A. Moss, Jr., *From Slavery to Freedom: A History of African Americans*. 8th ed. New York: Alfred A. Knopf, 2000.

Darlene Clark Hine, William C. Hine, and Stanley Harrold, *The African-American Odyssey*. 2 vols, 2nd ed. Upper Saddle River, N.J.: Prentice Hall, 2002.

James O. Horton and Lois E. Horton, *Hard Road to Freedom: The Story of African America*. New Brunswick, N.J.: Rutgers University Press, 2001.

Robin D. G. Kelley and Earl Lewis, eds., *To Make Our World Anew: A History of African Americans*. New York: Oxford University Press, 2000.

Colin A. Palmer, *Passageways: An Interpretive History of Black America*. 2 vols. Fort Worth, Tex.: Harcourt Brace, 1998.

A note to readers regarding my use of textbooks and my citations in my notes: I have cited the sources I have actually used—sound textbooks from careful scholars—rather than pretending I have done all their research myself. Historians call the unethical practice of citing of other scholars' sources without citing the scholars' work "mining footnotes." Today, when such excellent and up-to-date textbooks exist, I have not found it necessary to reinvent the wheel of African-American history myself. My notes represent my respect for my colleagues' research.

◇ Artists Whose Work Appears in *Creating Black Americans* ◇

Major Sources

Bearden and Henderson, *A History of African-American Artists*: Romare Bearden and Harry Henderson, *A History of African-American Artists from 1792 to the Present*. New York: Pantheon, 1993.

Chassman, *In the Spirit of Martin*: Gary Miles Chassman, *In the Spirit of Martin: The Living Legacy of Dr. Martin Luther King, Jr.* Atlanta: Tinwood, 2002.

Driskell, *Narratives of African American Art and Identity*: David C. Driskell, *Narratives of African American Art and Identity: The David C. Driskell Collection*. San Francisco: Pomegranate Communications, 1998.

IRAAA: International Review of African American Art

Mazloomi, *Spirits of the Cloth*: Carolyn Mazloomi, *Spirits of the Cloth: Contemporary African American Quilts*. New York: Clarkson Potter, 1998.

St. James Guide to Black Artists: Thomas Riggs, ed., *St. James Guide to Black Artists*. Detroit: Gale, 1997.

Willis, *Reflections in Black*: Deborah Willis, *Reflections in Black: A History of Black Photographers, 1840 to the Present*. New York: W. W. Norton, 2000.

Abernathy, Sylvia (See OBAC below)

Allen, Erika (b. 1969)
7.5. "Broken Promises" (1996).
Erika Allen is of African, Jewish, and Seminole descent. She graduated from the School of the Art Institute of Chicago and also holds a master's degree in art therapy. Allen visited a Lakota reservation in South Dakota, which moved her to introduce black-Indian themes into her artwork. She says of that visit: "I started a dialogue that has continued to this day that has given me personal insight and a connection to both my African and Native predecessors. In my work, I depict the historical legacies these groups have left us and how it affects me." Based in Chicago, she exhibited in the "Black Indians" exhibition at the Two Rivers Gallery of the American Indian Center in Minneapolis in 1999.
Source
IRAAA 17, No. 1 (2000): 26.

Allen, Tina (b. 1955)
11.2. "A. Philip Randolph (detail)" (1988).
Monumental sculptor Tina Allen received her B.F.A. from the School of Visual Arts in New York and has studied at the University of Southern Alabama, Pratt Institute in New York, and the University of Venice, Italy. She sees herself as a descendant of the Harlem Renaissance, working to reverse negative stereotypes of African Americans. Allen says: "My work is not about me, it's about us."

Allen's many important monuments include a life-sized statue of George Washington Carver for the Missouri Botanical Gardens in St. Louis, a twelve-foot bronze statue of Martin Luther King, Jr., in Las Vegas, Nevada, a twelve-foot bronze Sojourner Truth memorial statue in Battle Creek, Michigan, a thirteen-foot seated bronze monument of Alex Haley in Knoxville, Tennessee, and a life-size bust of the late Commerce Secretary Ron Brown in the Commerce Department building in Washington, D.C. A recipient of numerous honors, Tina Allen lives in North Hills, California.
Sources
Eric Hanks in *St. James Guide to Black Artists*: 6–8.
www.findarticles.com/cf_dls/m1264/11_32/83667281/p1/article.jhtml.
www.nat-king-cole.org/allebio.htm.

Alston, Charles (1907–1977)
12.1. "Walking" (1958).

Muralist, sculptor, and painter Charles Alston was born in Charlotte, North Carolina. He attended high school and college in New York City, earning his B.F.A. and M.F.A. at Columbia University. A Harlem Renaissance artist, Alston used African motifs and depicted the lives of ordinary African Americans. As a rare African-American supervisor on the WPA, he taught Jacob Lawrence. Alston broke many color barriers: He was the first black artist to be exhibited in the Museum of Modern Art and the first to teach at the Art Students League. A founder of Spiral, the 1960s New York collective of black artists that included Romare Bearden, Norman Lewis, and Hale Woodruff, Alston influenced a new generation of artists, including Emma Amos. In the 1960s Alston showed black figures with vague or non-existent facial features to protest American society's refusal to see African Americans as individual people. This style gained wide popularity among black artists. Alston painted in many different styles over the course of a long career. The Metropolitan Museum of Art and the Whitney Museum of American Art in New York are two of the museums holding his work.
Sources
Jacqueline Francis in *St. James Guide to Black Artists*: 8–10.
Smithsonian Institution, Archives of American Art.

Amos, Emma (b. 1936)

12.3. "Paul Robeson Frieze (Robeson photo by Nikolas Muray, ca. 1930s)" (1995).

Painter Emma Amos was born in Atlanta and always knew she would be an artist. She studied at Antioch College in Ohio, Central School of Art in London, New York University, and in Robert Blackburn's (1920–2003) Printmaking Workshop. She was the only woman member of Spiral, the New York black artists' group of the 1960s. Amos uses mixed media (including etching, photography, painting, fiber) to create thoughtful depictions of people of many backgrounds. She often borders her paintings with African fabric, giving them a flavor of the African Diaspora even when the subject matter is not obviously black.

Amos has remained involved in feminism and the politics of culture. Often using photographed self-portraits, she paints subjects that question the conventions of Western art and American culture. She teaches at the Mason Gross School of Art of Rutgers University in New Jersey.
Sources
Smithsonian Institution, Archives of American Art.
www2.kenyon.edu/ArtGallery/exhibitions/0001/amos/amos
 .htm.

Ball, James Pressley (1825–1925)

4.5. "Portrait of Frederick Douglass" (ca. 1860s).

Born in Virginia, the photographer James Pressley Ball was one of a handful of pioneering African-American photographers. Ball learned daguerreotypy from the Boston-based black photographer John B. Bailey. Like many other American photographers, Ball began his career as an itinerant in Ohio,

Pennsylvania, and Virginia. He opened his own studio in Cincinnati in 1851. Ball employed several helpers, including the landscapist Robert S. Duncanson, to hand tint photographs. As a prosperous businessman and abolitionist in 1855, Ball commissioned the painting by African-American artists of a huge panorama, "Ball's Splendid Mammoth Pictorial Tour of the United States Comprising Views of the African Slave Trade; of Northern and Southern Cities; of Cotton and Sugar Plantations; of the Mississippi, Ohio, and Susquehanna Rivers, Niagara Falls, &C," a work that, sadly, has disappeared.

In the mid-1850s Ball toured Europe and opened studios in London, Liverpool, and Paris. Queen Victoria praised the portrait he took of her in 1856. Ball's Cincinnati studio flourished through the 1860s. In 1872 he and his family moved west. He worked in Minneapolis, and then among silver and gold miners in Helena, Montana. In about 1900 Ball opened a studio in Seattle. He most likely died in Hawaii, where he had sought relief from arthritis.
Sources
Theresa Leininger-Miller in *St. James Guide to Black Artists*:
 28–29.
Willis, *Reflections in Black*: 4–9, 20–22.

Bannister, Edward Mitchell (1828–1901)

8.4. "Newspaper Boy" (1869).

Edward Mitchell Bannister, landscape and portrait painter, was born in St. Andrews, Canada. He moved to Boston as an adult, where he and his wife were active in antislavery and other social causes. Bannister was the first African-American artist to receive a national art award, the first prize bronze medal at the Philadelphia Centennial Exposition in 1876. This recognition inspired the young Henry Ossawa Tanner. One of the rare African-American artists to gain prominence during the nineteenth century, Bannister remained respected in New England throughout his life. He was a founder of the Rhode Island School of Design and the Providence Art Club.
Sources
Smithsonian Institution, Archives of American Art.
www.bcps.k12.md.us/students/Artist/Edward_Bannister.asp.
www.thewalters.org.

Barthé, Richmond (1901–1989)

12.2. "Paul Robeson as Othello" (1974).

One of the foremost artists and the leading sculptor of the Harlem Renaissance, Richmond Barthé was born in Bay St. Louis, Mississippi. At eighteen he moved to New Orleans then to Chicago, where he attended the Art Institute and came under the influence of Archibald Motley, Jr. Upon graduating from the Art Institute in 1929, Barthé moved to New York and quickly gained prominence for his portraits of African Diaspora subjects, famous and ordinary.

After a brilliant career between the two world wars, Barthé spent many years abroad, notably in Jamaica. During his last years he lived in Pasadena, California, where the actor James

Garner helped support him. After Barthé's death, Garner gave the work that had not already been acquired by museums to the Museum of African American Art in Los Angeles and the Schomburg Center for the Study of Black Culture in New York.

Sources

Thomas M. Shaw in *St. James Guide to Black Artists*: 37–38.

www.mcps.k12.md.us/schools/edison/studentsites/sites/
 Black%20History/James%20Salko/Richmond.htm.

Basquiat, Jean-Michel (1960–1988)

10.10. "St. Louis Surrounded by Snakes" (1982).

Painter Jean-Michel Basquiat was born in New York City. Basquiat came from a family of middle-class Caribbean immigrants, but when he became famous in the late 1970s, he was known as a graffiti artist from the streets. As rap artists would a few years later, Basquiat portrayed himself as a child of the streets even though he came from a middle-class home. Basquiat was self-trained and liked to see himself as a fine artist influenced by a range of artists including Leonardo Da Vinci and the abstract expressionists. He attracted attention as a graffiti artist in New York in the late 1970s. His tag was SAMO for "same old shit." Art patrons like Andy Warhol saw Basquiat as "The Radiant Child," a naïve young genius. Before he died at age twenty-seven of a drug overdose, he had shown his work widely in the United States and Europe. After his death the Whitney Museum in New York mounted a retrospective of his work. Basquiat was also the subject of a 1996 feature film entitled *Basquiat* by Julian Schnabel, starring Jeffrey Wright as Basquiat.

Sources

Laurie Fitzpatrick in *St. James Guide to Black Artists*: 38–39.

Marc Mayer, ed., *Basquiat*. London: Brooklyn Museum and
 Merrell, 2005.

www.artchive.com/artchive/B/basquiat.html.

www.johnseed.com/basquiat.html.

Battey, C. M. (Cornelius Marion) (1873–1927)

9.5. "Portrait of W. E. B. Du Bois" (1918).

A leading photographer of the New Negro, Cornelius Marion Battey was born in Augusta, Georgia. By 1900, he had established his standing as a photographer of African-American community leaders, statesmen, and musicians in Cleveland and New York. In 1916 he became director of Tuskegee Institute's Photographic Division. Battey's work won awards in the United States and Europe. Between 1915 and 1927, his photographs appeared on the covers of *The Crisis*, *The Messenger*, and *Opportunity* magazines. Battey photographed the most prominent African Americans of the turn of the twentieth century, including Frederick Douglass, John Mercer Langston, Booker T. Washington, W. E. B. Du Bois, and Paul Laurence Dunbar. He sold these images in postcard format as symbols of racial pride.

Source

Willis, *Reflections in Black*: 37–38.

Bearden, Romare (1914–1988)

2.4. "Roots Odyssey" (1976).

9.9. "Jammin' at the Savoy" (before 1982).

13.10. "Black Manhattan" (1969).

One of the most celebrated and influential of African-American artists, the painter and collage-artist Romare Bearden was born in Charlotte, North Carolina. He moved to Harlem as a child. He attended Boston University but graduated from New York University in 1935. Bearden lived in Harlem and painted jazz musicians repeatedly as part of his documentation of black American life.

In the mid-1930s Bearden continued his studies with the German Expressionist artist George Grosz at the Art Students League of Baltimore while working as a political cartoonist for the Baltimore *Afro-American* newspaper. Bearden served in the U.S. Army and used his veteran's benefits to study in Paris. In France he met the leading artists Henri Matisse and Juan Miró and deepened his knowledge of Western culture.

A member of the Harlem Artists Guild in the 1930s, Bearden continued to support black artists throughout his life. In the 1960s he was a founding member of Spiral and the Black Academy of Arts and Letters. He was also the director of the Harlem Cultural Council. During the 1960s the issues of the Civil Rights movement engaged Bearden deeply. He changed his style from painting to collage, gluing bits of paper, fabric, and photographs on paper and painting the whole. Bearden's collages became extremely influential; they were exhibited throughout the United States, Europe, and Japan. Bearden and his long-time friend Harry Henderson wrote *A History of African-American Artists, from 1792 to the Present* (1988). In 1987 President Ronald Reagan awarded Bearden a National Medal of Art.

Sources

Kinshasha Holman Conwill, ed., *Memory and Metaphor: The
 Art of Romare Bearden, 1940–1987*. New York: Studio
 Museum in Harlem and Oxford University Press, 1991.

Smithsonian Institution, Archives of American Art.

www.pbs.org/newshour/extra/teachers/lessonplans/art/
 bearden_10–23.html.

http://sheldon.unl.edu/HTML/ARTIST/Bearden_R/SSII.
 html.

Bedou, (Arthur) P. (1882–1966)

8.9. "Booker Taliaferro Washington, Portrait of the Educator on His
 Horse" (1915).

Arthur P. Bedou was born in New Orleans, where he worked as a photographer for more than fifty years. He was also one of the founders of the People's Life Insurance Company of Louisiana. A well-respected photographer, Bedou is known for his portraits of prominent African Americans, notably documentation of the public and private sides of Booker T. Washington, principal of Tuskegee Institute.

Source

Willis, *Reflections in Black*: 38.

Biggers, John T. (1924–2001)

1.5. "Before the Shrine (Queen Mother)" (1962).

2.3. "Middle Passage" (1947).

5.10. "Harriet Tubman and Her Underground Railroad" (1952).

Painter and muralist John Biggers was born in Gastonia, North Carolina. His studies with Viktor Lowenfeld at Hampton Institute influenced Biggers profoundly. Lowenfeld, a Jewish Austrian refugee from Nazism, encouraged his students at Hampton to engage with their African artistic heritage. He also introduced his students to American regionalists, the Ash Can School, and the leading Mexican muralists.

At Hampton Biggers also encountered the writing and artwork of the Harlem Renaissance. Charles White painted a mural on the Hampton campus while Biggers was a student. White included a portrait of Biggers in the mural and became Biggers's mentor. Biggers was drafted in 1943 and served in the United States Navy until 1945. He returned to Hampton, then followed Lowenfeld to Pennsylvania State University. Biggers received his B.S. and M.S. degrees from Penn State in 1948. In 1949 Biggers established the Art Department at Texas State University for Negroes (now Texas Southern University) in Houston, where he remained on the faculty until his retirement in 1983.

Biggers was one of the first African-American artists to visit Africa, spending time in newly independent Ghana and visiting neighboring Benin, Togo, and Nigeria in 1957. He published an illustrated travel diary, *Ananse, the Web of Life in Africa* (1962). His work continues to exhibit African motifs and has been widely exhibited.

Sources

John Thomas Biggers, *Ananse, the Web of Life in Africa*. Austin: University of Texas Press, 1962.

Smithsonian Institution, Archives of American Art.

Olive Jensen Theisen, *The Murals of John Thomas Biggers: American Muralist, African American Artist*. Hampton, Va.: Hampton University Museum, 1996.

Alvia J. Wardlaw, ed., *The Art of John Biggers: View from the Upper Room*. New York: Harry N. Abrams, in association with the Museum of Fine Arts, Houston, 1995.

Jeanne Zeidler in *St. James Guide to Black Artists*: 50–52.

Billops, Camille (b. 1933)

8.15. "The KKK Boutique" (1994).

Sculptor and filmmaker Camille Billops was born in Los Angeles. She received her M.F.A. from the City College of New York. Her work in several genres (including painting, costume and set design, and acting) always incorporates social criticism and discussion of the meaning of black identity. Billops and her husband James Hatch created the Hatch-Billops Archives of Black American Cultural History in New York City, a collection of visual materials, oral histories, and books on black artists in the visual and performing arts. Billops and Hatch also publish the annual journal *Artist and Influence*. Billops's sculpture and films are shown worldwide and belong to the permanent collections of museums in New York, London, and Berne, Switzerland.

Sources

Christine Miner Minderovic in *St. James Guide to Black Artists*: 52–54.

www.varoregistry.com/billops/.

Birch, Willie (b. 1942)

13.1. "Memories of the 60s" (1990).

Painter and paper mâché artist Willie Birch was born in New Orleans, where he continues to work. He was trained in abstract expressionism but works more figuratively on historical themes. His documentation of the Civil Rights movement stresses race pride and prejudice. Birch says, "Like King, I think of myself as someone just trying to do my part, to make whatever contribution I can with whatever talent and vision I possess." Birch's recent work addresses New Orleans's musical heritage and also the experience of African-American men.

Sources

Chassman, *In the Spirit of Martin*: 127, 213.

A. M. Weaver in *St. James Guide to Black Artists*: 54–56.

www.arthurrogergallery.com/Artists/Birch/birch.htm.

Blue, Carroll Parrott (b. 1943)

14.3. "Angela Davis in Los Angeles" (1972).

Documentary filmmaker Carroll Parrott Blue was born in Houston, Texas. She graduated from Boston University and received her M.F.A. in film studies from the University of California, Los Angeles, in 1980. She teaches film at the University of Central Florida. Her films include *Nigerian Art—Kindred Spirits*; *Conversations with Roy Decarava*, and *Varnette's World: A Study of a Young Artist*.

Sources

Carroll Parrott Blue, *The Dawn at My Back: Memoir of a Black Texas Upbringing*. Austin: University of Austin Press, 2003.

http://www-rohan.sdsu.edu/dept/schlcomm/BLUE.html.

Bolling, Leslie Garland (1898–1955)

8.7. "Cousin-on-Friday" (1935).

Self-taught sculptor Leslie Bolling was born in Dendron, Virginia. He began carving in 1926. Carl Van Vechten, a promoter of the Harlem Renaissance, showed Bolling's work for the first time in 1928. Bolling attracted broader attention in the National Exhibition of 1933 at the Smithsonian Institution. Although considering himself simply a porter who whittled in his spare time as a hobby, he flourished as a sculptor in the 1930s and 1940s. He exhibited regularly in the Harmon Foundation shows in New York and was the first black artist to have a one-man show at the Academy of Arts in Richmond. Bolling was the first African-American woodcarver to receive national recognition during his lifetime.

Sources

Reginia Perry in *St. James Guide to Black Artists*: 62–63.

www.artnoir.com/index.bolling.html.

Brown, Kay (b. 1932)

13.7. "The Black Soldier" (1969).

Mixed media and collage artist Kay Brown lives in Washington, D.C. Early in her career Brown belonged to the Weusi Artists, who sought to express their African ancestry and discuss the sociopolitical issues of the time. She later co-founded the "Where We At" Black Women Artists collective that incorporated the artistic philosophy she had experienced as the only woman member of Weusi.

Sources

www.asrc.cornell.edu/blacknessincolor/galleries/fig5.html.
www.retirement-living.com/profile.asp?pid=49.

Burley-Leake, Viola (n.d.)

2.7. "Middle Passage" quilt (1994).

Quilter Viola Burley-Leake has visited Africa and lives in Washington, D.C. She says "This quilt was inspired by slavery, the Black Holocaust, and draws a connection between the history of Africans and African Americans."

Source

Mazloomi, *Spirits of the Cloth*: 97.

Burnett, Calvin (b. 1921)

13.5. "Fannie Lou Hamer" (1977).

Abstract painter and printmaker Calvin Burnett was born in Cambridge, Massachusetts. He began taking WPA art classes as a high school student and continued at the Massachusetts School of Art, graduating in 1942. Poor eyesight kept him out of the armed forces, so he spent the war working in the Boston Navy Yard, observing fellow workers and painting on the side. He began exhibiting at the Institute of Modern Art in Boston in 1943, the Germanic Museum (now the Busch-Reisinger Museum) at Harvard in 1946, and at Atlanta University in 1947. In the 1950s he received a degree in art education from the Massachusetts College of Art and soon joined the faculty of the Elma Lewis School in Roxbury. In 1956 he returned to the Massachusetts College of Art as an instructor of perspective. Burnett published *Objective Drawing Techniques* in 1966. He received his M.F.A. from Boston University in 1960. His work has been exhibited throughout New England and the mid-Atlantic states.

Sources

Christine Miner Minderovic in *St. James Guide to Black Artists*: 83–85.
Smithsonian Institution, Archives of American Art.

Catlett, Elizabeth (b. 1919)

5.1. "Harriet" (1975).
8.2. "Sharecropper" (1968).
14.1. "Negro es Bello II" (1969).

A leading American painter, printer, and sculptor, Elizabeth Catlett was born in Washington, D.C., and was educated at Howard University (where she studied with Lois Mailou Jones), Iowa State University (M.F.A.), the Art Institute of Chicago, the Art Students League in New York, and the Escuela de Pintura y Escultura in Mexico. Catlett was the first student to receive an M.F.A. degree from the State University of Iowa in 1940. Her Iowa master's thesis project, "Mother and Child," won the first prize in the American Negro Exhibition in Chicago in 1940.

Her widely admired work addresses African-American themes with a social consciousness. Her black feminist vision appears in one of her favorite pieces, "Negro es Bello (Black is Beautiful)" (1968). Catlett was married to the artist Charles White while she served as chair of the Art Department of Dillard University in New Orleans. She and White taught at Hampton Institute in the 1940s, where they encountered the young John Biggers. Catlett also worked closely with Hale Woodruff in Atlanta.

Catlett went to Mexico to study in the late 1940s, and exposure to Mexican muralists deepened her dedication to socialist expressive art. Although traveling often to the United States, Catlett remains based in Cuernavaca, Mexico, where she settled permanently in the 1960s. She is considered one of the most influential African-American and Mexican artists. Her work consists of indoor and outdoor sculpture and paintings and has been exhibited around the world.

Sources

Bearden and Henderson, A *History of African-American Artists*: 418–426.
Samella Lewis, *The Art of Elizabeth Catlett*. Claremont, Calif.: Handcraft Studios, 1984.
Jontyle Theresa Robinson in *St. James Guide to Black Artists*: 100–103.
Smithsonian Institution, Archives of American Art.

Chandler, Dana (b. 1941)

13.9. "Noddin Our Liberation Away" (1974).

Painter and muralist Dana Chandler was born in Lynn, Massachusetts. He received his B.A. from Massachusetts College of Arts in Boston in 1967. He says he recognized his artistic task during a protest at the welfare office in the Grove Hall section of Boston, in which white police officers beat the black protesters. He says: "After that day on June 5, 1967, my mission became very clear. . . . Whether you were part of the protest or coming home from work, the police attacked everyone with black skin. It was a blatant reminder. This scene depicted visually that the police were an occupying force." Chandler visited West Africa in 1970. His work began to show African women's beauty and the ways in which men oppress women. Two fundamental themes in his work are the Atlantic slave trade and religion. Chandler has been a professor of art at Simmons college and artist-in-residence at Northeastern University since 1974.

Sources

Coria Holland in *St. James Guide to Black Artists*: 104–106.
www.eagle2.american.edu/~gb3107a/Chandler.html.

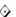

Chase-Riboud, Barbara (b. 1939)

4.4. "Sojourner Truth Monument" model (1999).

15.3. "Africa Rising" (1998).

Internationally respected sculptor Barbara Chase-Riboud was born in Philadelphia. She studied at Temple University, the American Academy in Rome, and Yale Art School (M.F.A., 1960). In the 1960s and 1970s she began to receive international recognition for her monumental abstract sculpture, which combines bronze with woven fiber forms, usually silk. Chase-Riboud draws upon the aesthetic traditions of European fine art to produce art on themes often related to the African Diaspora. Her work is in the collections of the Metropolitan Museum of Art and the Museum of Modern Art, New York, the Centre Georges Pompidou, Paris, and the Philadelphia Art Museum. Chase-Riboud lives in Paris and works in Milan. She is also the author of five novels and a book of poetry.

Sources

Jontyle Theresa Robinson in *St. James Guide to Black Artists*: 106–107.

Peter Selz and Anthony F. Janson, *Barbara Chase-Riboud, Sculptor*. New York: Harry N. Abrams, 1999.

Clark, Chris (b. 1958)

12.6. "Louis Armstrong" quilt (2005).

Quilter Chris Clark grew up in Birmingham, Alabama. He attended Livingston University and spent time in the U.S. Army. He began painting on wood while recuperating from diabetes during the 1980s. In 1989 his grandmother taught him quilting, and he began exhibiting his quilts, which he also painted upon, in 1991. A deeply spiritual person, Clark often quilts biblical scenes. He was featured in *Revelation, Alabama's Visionary Folk Artists*, and the Birmingham Museum of Art owns some of his work.

Source

Mazloomi, *Spirits of the Cloth*: 118.

Clark, Claude (1915–2001)

5.4. "Slave Lynching" (1946).

14.10. "Polarization" (1969).

Painter Claude Clark was born in Rockingham, Georgia, and studied at the Barnes Foundation, 1939–1944. He was employed on the WPA in Philadelphia, where he worked alongside African-American printer Dox Thrash. He received his M.A. from the University of California, Berkeley, in 1962. Clark was instrumental in establishing the Art Department at Alabama's Talladega College, teaching there from 1948 until 1955, when he was succeeded by the young David Driskell. Clark's influence spread as he moved to Oakland, California, where he taught art at a juvenile justice facility until 1967. In 1969 he joined the staff of Oakland's Merritt College, where he responded to the call by the Black Panther Party to develop a curriculum that was relevant to black culture by writing *A Black Art Perspective: A Black Teacher's Guide to a Black Vi-*sual *Arts Curriculum*. Clark was revising and updating this guide when he died of complications from diabetes.

Sources

Lizzetta LeFalle-Collins in *St. James Guide to Black Artists*: 110–112.

www.africanmetropolis.com/Claude_Clark/Additional_Information/driskell.htm.

Conwill, Houston (b. 1947), Joseph De Pace (b. 1954), and Estella Conwill Majozo (b. 1949)

3.1. "The New Ring Shout" (1994–1995).

Sculptor Houston Conwill, architect Joseph De Pace, and poet Estella Conwill Majozo began collaborating in New York City in the 1980s. Conwill and Majozo, brother and sister, were born in Lexington, Kentucky. Conwill received his B. F. A. from Howard University in 1973 and his M. F. A. from the University of Southern California in 1976. Majozo received her B. A. from the University of Louisville in 1975 and her Ph.D. from the University of Iowa in 1980. De Pace received his B. Arch. from the City University of New York in 1978 and his M. Arch. from Harvard University in 1982.

Conwill, De Pace, and Majozo have won several public art commissions, including "DuSable's Journey" (1991) in the Harold Washington Library Center in Chicago, "Stations" (1993) in the Niagara Frontier Community, United States and Canada, and "Rivers" (1991) in the Langston Hughes Auditorium rotunda of the Schomburg Center for Research in Black Culture, the New York Public Library, which won an Award for Excellence in Design from the Art Commission of the City of New York.

This interdisciplinary team of collaborating artists aims to use art to bring meaning to everyday life by preserving and communicating the wisdom of black history. Their works are spiritual as well as political, creating a synthesis of cross-cultural references that reverse stereotypes and break down barriers between peoples of diverse backgrounds. The work of Conwill, De Pace, and Majozo builds bridges of compassion and serves to establish a common ground of shared human values.

Sources

Reginia Perry in *St. James Guide to Black Artists*: 118–121.

www.ijele.com/vol1.1/frohne.html

Cook, Brett (Dizney) (b. 1968)

15.1. "Why Fight for a Crayon That's Not Our Color?" (1988).

Spray paint muralist Brett (Dizney) Cook was born in San Diego and was educated at the University of California, Berkeley. He has exhibited continuously since graduating in 1991. Cook began spray painting in 1984, before a spray painting subculture existed in San Diego. His work critiques the values of hip-hop, materialism, and sexuality. He strives to paint people who would not otherwise be represented and says: "Part of this work is about building communities, both for those people who were involved, and outside the community—and with

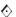

me." His murals are found throughout the United States, Brazil, and Barbados.

Sources

James Prigoff and Robin J. Dunitz, *Walls of Heritage, Walls of Pride: African American Murals*. San Francisco: Pomegranate, 2000: 173.

www.citylimits.org/content/articles/articleView.cfm
?articlenumber=185.

www.findarticles.com/cf_dls/m1248/10_89/79276171/p1/
article.jhtml.

www.gse.harvard.edu/news/features/bcd02062001.html.

Crite, Allan Rohan (b. 1910)

8.6. "Beneath the Cross of St. Augustine" (1936).

10.6. "Marble Players" (1938).

Painter and illustrator Allan Rohan Crite was born in Plainfield, New Jersey, and moved to Boston as a child with his family. He received his formal art training at Boston University, the Massachusetts School of Art, the Boston Museum of Fine Arts School, and Harvard University (B.A., 1968). Crite's "romantic-realist" oil and watercolor paintings express two main themes: everyday life of black Bostonians in the 1930s and 1940s and his "geography of the Bible." Crite says: "For a long time, I felt as far as the Church was concerned, that there was too much the impression of a mostly European institution, practically to the exclusion of anything else." To redress this imbalance, Crite produced paintings of Christian themes in black imagery.

Sources

Julie Levin Caro, *Allan Rohan Crite, Artist-Reporter of the African American Community*. Seattle: Frye Art Museum and University of Washington Press, 2001.

Coria Holland in *St. James Guide to Black Artists*: 123–125.

Smithsonian Institution, Archives of American Art.

www.absolutearts.com/artsnews/2001/03/10/28211.html.

www.inform.umd.edu/EdRes/Colleges/ARHU/Depts/ArtGal
/.WWW/exhibit/98–99/driskell/exhibition/sec3/crit_a
_01.htm.

Davis, Willis "Bing" (b. 1937)

13.8. "Ghetto Voice" (1967).

Ceramist, painter, photographer Willis "Bing" Davis was born in Greer, South Carolina, and was educated at DePauw University (B.A., 1959), Miami University of Ohio, Indiana State University, and Dayton Art Institute. He became chair of the Art Department of Central State University in Wilberforce, Ohio, in 1978, retiring in 1998.

Davis works in a variety of media, including drawings, ceramics, mixed media, photography, and installations. Much of his work is abstract, some of which draws on the motifs he encountered traveling in Africa. He says, "The conscious inclusion of social commentary in my works is the first step toward speaking to a universal condition. The rich artistic heritage of African art with its religious, social, and magical substance is what I select as an aesthetic and historical link."

Sources

Gabriel Tenabe in *St. James Guide to Black Artists*: 130–132.

www.absolutearts.com/artsnews/2001/03/15/28243.html.

Delaney, Beauford (1901–1979)

10.2. "Can Fire in the Park" (ca. 1946).

Painter Beauford Delaney and his younger brother Joseph were born in Knoxville, Tennessee. Beauford Delaney studied at the Massachusetts Normal Art School, the South Boston School of Art, and the Copley Society in Boston. He moved to New York in 1929, joining the Harlem Artists Guild and working in the studio of Charles Alston. He moved permanently to France in 1953. He lived in France from 1953 until his death in 1979. Throughout his life Delaney painted a series of powerful portraits of his friends, e.g., the writer James Baldwin. One of Delaney's closest friends for nearly thirty years and the subject of nearly a dozen Delaney portraits, Baldwin called the painter his "spiritual father" and "principal witness," "a cross between Brer Rabbit and St. Francis of Assisi." Delaney worked effectively in both abstract and realist styles and gained a good measure of fame during his lifetime. However, poverty and mental instability reduced the satisfaction he took in the exhibition and sale of his work.

Sources

Bearden and Henderson, *A History of African-American Artists*: 280–287.

David Leeming, *Amazing Grace: A Life of Beauford Delaney*. New York: Oxford University Press, 1998.

Gabriel Tenabe in *St. James Guide to Black Artists*: 136–137.

Delaney, Joseph (1904–1991)

11.6. "Times Square, V-J Day" (1961).

Expressionist painter and brother of Beauford, Joseph Delaney was born in Knoxville, Tennessee. He moved to New York City in 1930 and began art study with Thomas Hart Benton and others at the Art Students League. He worked on WPA projects in New York in the 1930s and taught at settlement houses in Brooklyn and Harlem and at the Art Students League. His career flourished in New York through the 1970s, when he began to exhibit at the University of Tennessee in Knoxville. He was an artist-in-residence at the University of Tennessee (a position the author Alex Haley, also from Knoxville, helped arrange) from 1986 until his death. Although Joseph Delaney exhibited widely, he never reached his brother's level of fame. Joseph explained: "Beauford and I were complete opposites; me, an introvert, and Beauford, an extrovert."

Sources

Bearden and Henderson, *A History of African-American Artists*: 287–293.

Aaronetta H. Pierce in *St. James Guide to Black Artists*:137–138.

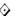

Smithsonian Institution, Archives of American Art.
http://sunsite.utk.edu/delaney/delaney.htm.
http://nmaa-ryder.si.edu/1001/2001/02/020901.html.
www.askart.com/biography.asp.

Donaldson, Jeff (1932–2004)

13.6. "Aunt Jemima & the Pillsbury Doughboy" (1963).

14.2. "Wives of Shango" (1968).

A leading painter, printmaker, and art historian, Jeff Donaldson was born in Pine Bluff, Arkansas. He studied at the University of Arkansas, Pine Bluff, the Illinois Institute of Technology, and Northwestern University (Ph.D., 1974). As a member of the Organization of Black American Culture (OBAC) in Chicago, he organized the artists who painted the "Wall of Respect" in 1967. A founder of AfriCobra in 1968, Donaldson was a prime mover of the Black Art movement of the 1960s and 1970s, which sought to forge a new African-American aesthetics that expressed pride in black identity. ("AfriCobra" was an acronym for African Commune of Bad Relevant Artists and Coalition of Black Revolutionary Artists.) He remained a leader in the TransAfrican Art movement, an expression of Black Power that links the many visual traditions of the African Diaspora in writing, artwork, and exhibitions. Widely exhibited, awarded, and published, Donaldson was dean of the College of Fine Arts at Howard University.

Sources

Salah Hassan in *St. James Guide to Black Artists*: 152–154.
www.howard.edu/CollegeFineArts/Art/Faculty/Jeff
_Donaldson.html.

Douglas, Aaron (1899–1979)

1.1. "Building More Stately Mansions" (1944).

6.5. "Study for Aspects of Negro Life: From Slavery Through Reconstruction" (1934).

7.1. "Study for Aspects of Negro Life: From Slavery Through Reconstruction" (1934).

The quintessential Harlem Renaissance painter and muralist Aaron Douglas was born in Topeka, Kansas, and studied at the University of Nebraska (B.F.A., 1922) and Teachers College of Columbia University (M.A. 1944). As a child he had been influenced by the work of Henry Ossawa Tanner. Moving to Harlem in 1925, he quickly attracted the attention of W. E. B. Du Bois and Charles S. Johnson, editors of *The Crisis* and *Opportunity*. Douglas illustrated Alain Locke's *The New Negro* (1925), which exhorted black artists to draw on African themes. Douglas's work embodied Locke's exhortation. Throughout his long, productive life, Douglas's modernist work evoked Africa and often used techniques of ancient Egyptian art. Du Bois, Johnson, and the publishers of books and magazines on black subjects commissioned Douglas's illustrations. On a trip to France in the late 1930s, Douglas met Tanner and Palmer Hayden. Returning to New York in 1928, Douglas became the first president of the Harlem Artists Guild. In 1937 he moved to Nashville and established the

Art Department at Fisk University, which he headed until his retirement in 1966.

Sources

Amy Helene Kirschke, *Aaron Douglas: Art, Race, and the Harlem Renaissance*. Jackson: University Press of Mississippi, 1995.

Amy Kirschke in *St. James Guide to Black Artists*: 154–156.

Driskell, David C. (b. 1931)

12.4. "Of Thee I Weep" (1968).

Painter, art historian, and collector, David C. Driskell was born in Edmonton, Georgia, and studied at the Skowhegan (Maine) School of Painting and Sculpture and Howard University (1955) with James A. Porter and Lois Mailou Jones. Porter exposed Driskell to the work of Aaron Douglas and Henry Ossawa Tanner. Driskell also came to know other artists and art historians such as Alain L. Locke, Romare Bearden, Jacob Lawrence, and Sam Gilliam (b. 1933), Charles White, and Elizabeth Catlett. And he worked with Mary Beattie Brady of the Harmon Foundation. Driskell earned his M.F.A. from Catholic University in 1962.

After teaching at Talladega College and Howard University, Driskell succeeded Aaron Douglas as chair of Fisk University's Art Department. In 1972 Driskell curated a major retrospective of the work of William H. Johnson. He continues to curate major exhibitions of African-American art and to advise collectors such as Bill and Camille Cosby, Oprah Winfrey, Spike Lee, and Bill and Hillary Clinton. Driskell taught in the Art Department of the University of Maryland at College Park from 1978 until his retirement in 1998. Driskell lectures and exhibits his work internationally. He has received numerous honors and honorary degrees. The David C. Driskell Collection represents nearly half a century of collecting American, African, Asian, and European art and rare books.

Sources

Driskell, *Narratives of African American Art and Identity*.

Leslie King-Hammond in *St. James Guide to Black Artists*: 158–160.

www.artgallery.umd.edu/driskell/david_driskell/.

Duncanson, Robert Scott (1817–1872)

1.3. "Man Fishing" (1848).

Hudson River School painter Robert Duncanson was born in Cincinnati (some sources say upstate New York in 1823) and studied art in Italy and Glasgow, Scotland. He started his career in his Michigan family's house-painting business and began gaining recognition as a portrait painter. Duncanson went abroad in the 1860s and gained recognition in Europe and Canada before suffering a mental breakdown and committing suicide in 1872. Duncanson began painting before black subjects were considered appropriate in fine art, and his work does not depict racial themes or African-American subjects. Nonetheless historians of African-American art consider him a pioneer.

Sources

Regina Holden Jennings in *St. James Guide to Black Artists*: 160–161.

www.liu.edu/cwis/cwp/library/aavaahp.htm#duncanson.

Edwards, Melvin (b. 1937)

1.6. "Gate of Ogun" (1983).

8.14. "Lynch Fragments: Resolved and Afro-Phoenix no. 2" (1963/1964).

One of the most productive and respected black sculptors, Melvin Edwards was born in Houston, Texas, and educated at Los Angeles City College, the Los Angeles County Art Institute, the University of Southern California (M.F.A.) and Robert Blackburn's Printmaking Workshop in New York City. Edwards's abstract sculpture is both monumental and intimate, incorporating found objects such as hammer heads, railroad spikes, chains, and locks into a welded whole that is abstract yet evocative of African-American history. Although he has exhibited his prints, Edwards is best known for his "Lynch Fragments," which protest against racist violence and also express a strong affinity with the art of Africa. Edwards says the lynching of Emmett Till in 1955 influenced his art over the course of four decades. Edwards frequently visits Africa, especially Nigeria, and African art continually influences his work. Edwards taught at Rutgers Mason Gross School of Art from 1972 until his retirement in 2001. His work is internationally exhibited and collected.

Sources

Thomas M. Shaw in *St. James Guide to Black Artists*:170–172.

Smithsonian Institution, Archives of American Art.

http://ur.rutgers.edu/focus/index.phtml?Article_ID=667.

www.procuniarworkshop.com/home/index/article/24.html.

Ellison, Walter (1899–1977)

10.3. "Leaving Macon Georgia" (1937).

Born in Macon, Georgia, the painter Walter Ellison studied in the Art Institute of Chicago. He worked in the WPA-sponsored South Side Community Art Center in the early 1940s.

Source

www.artic.edu/artaccess/AA_AfAm/pages/AfAm_4.shtml.

Feelings, Tom (1932–2003)

2.2. from *The Middle Passage* (1995).

Feelings was born in Brooklyn but was a truly diasporic illustrator. He attended the School of Visual Arts in New York, then joined the air force. In the early 1960s he drew portraits of black Southerners, work that appeared in *Look* magazine. He lived in Ghana for two years in the mid-1960s and in Guyana, South America, from 1971 to 1974. The drawing used here appears in his two-decades' long masterwork on the Middle Passage.

Source

Tom Feelings, *The Middle Passage*. New York: Dial, 1995.

www.juneteenth.com/Tom_Feelings.htm.

Freeman, Roland L. (b. 1947)

14.5. "Kwanzaa Quilt" (1989).

Photographer and quilter Roland L. Freeman was born in Baltimore.

His long-running goal is to document African-American folk culture though photographs and collaboration with folklorists, historians, sociologists, and community activists. A research associate for the Smithsonian Institution's Center for Folklife and Cultural Heritage since 1972, Freeman is the founder and president of the Group for Cultural Documentation.

Sources

Roland Freeman, *A Communion of the Spirits: African-American Quilters, Preservers, and Their Stories*. Nashville: Rutledge Hill Press, 1996.

www.tgcd.org/tgcd.cfm?a=rf.

Fuller, Meta Warrick (1877–1968)

1.2. "Ethiopia Awakening" (1914).

6.9. "Emancipation" (1913).

A major sculptor whose career lasted more than seventy years, Meta Warrick Fuller was born in Philadelphia and studied at the Pennsylvania Museum School for the Industrial Arts and the Académie Colarossi and the École des Beaux-Arts, Paris. She also studied privately with Henry Ossawa Tanner in France. She exhibited in the Paris Salons in 1898, 1899, and 1903 and continued to exhibit her work until her death in 1968. Fuller's Paris work burned in a fire in her Philadelphia studio in 1910.

Although Fuller is considered the leading woman artist of the Harlem Renaissance, she both pre-dated and out-lived it. She depicted black figures before other black artists embraced racial themes. Appreciation of her work came late, but before her death in 1968 several Southern black institutions honored her with commissions and honorary degrees. One of her last works, "Crucifixion," commemorated the murder of four girls in the Sixteenth Street Baptist Church in Birmingham, Alabama, in 1963.

Sources

Salah Hassan in *St. James Guide to Black Artists*: 203–204.

Judith N. Kerr, "Fuller, Meta Vaux Warrick (1877–1968)," in Darlene Clark Hine, ed., *Black Women in America: An Historical Encyclopedia*, Vol. I. Brooklyn: Carlson Publishing, 1993: 470–473.

Delores Nicholson, "Meta Warrick Fuller (1877–1968)," in Jessie Carney Smith, ed., *Notable Black American Women*. Detroit: Gale Research, 1992: 374–376.

Goodnight, Paul (b. 1946)

11.7. "Salt Peanuts Don't Belong to Jimmy Carter" (1980).

Painter and muralist Paul Goodnight was born in Chicago but moved to Connecticut and Boston as a child. He overcame the trauma of combat in Vietnam through the study of art at Roxbury Community College, the Vesper George School of Art, and the Massachusetts College of Art (B.A. 1975). Artists

Dana Chandler, Gary Rickson, Alan Rohan Crite, and John Biggers mentored Goodnight as a young painter. During the 1980s Goodnight's work was featured on several television programs, including "The Cosby Show." His increased exposure permitted him to travel and study art widely. Often depicting sports themes, Goodnight was commissioned to create a piece for the 1996 Olympic Games and designed the 1998 World Cup poster.

Sources

Edmund Barry Gaither in *St. James Guide to Black Artists*: 214–215.

www.paulgoodnight.com.

Haggins, Robert L. (1922–ca. 2000)
12.5. "Malcolm X" (1963).

Robert L. Haggins, Jr., Malcolm X's personal photographer, lived in the Bronx, New York. He is known for his photographs of Malcolm X made in the 1950s and 1960s, while Malcolm X belonged to the Nation of Islam and after he left it. Haggins's most striking images are open, yet intimate street scenes of Malcolm X speaking to crowds of listeners.

Source

Willis, *Reflections in Black*: 116.

Hamilton, Ed (b. 1947)
6.7. "Spirit of Freedom" monument (1977–1998).

Ed Hamilton was born in Cincinnati and grew up in Louisville, Kentucky, where he still lives and works. Hamilton received his art training in Louisville, where local supporters helped him establish his first studio in 1978. His first break came in 1983, when Hampton University commissioned him to create a statue of Booker T. Washington. Many other monumental commissions followed: Joe Louis for the City of Detroit, the Amistad Memorial in New Haven, the "Spirit of Freedom: African-American Civil War Memorial" in Washington, D.C., and the statue of York, the slave of William Clark who accompanied the Lewis and Clark expedition of 1803–1806, for the city of Louisville on the occasion of the Lewis and Clark Bicentennial.

The recipient of many honors, Hamilton was inducted into the Gallery of Great Black Kentuckians in 2001.

Source

www.edhamiltonworks.com/biography.htm

Hammons, David (b. 1943)
12.7. "Bird" (1973).
14.12. "Injustice Case" (1970).
15.2. "How You Like Me Now?" (1988).

A leading African-American painter and performance artist, David Hammons was born in Springfield, Illinois, and studied at Los Angeles Trade Technical City College, the Chouinard Art Institute, Los Angeles, and the Otis Art Institute of the Parsons School of Design. He became famous in the early 1970s through his "body prints" and ironic use of the American flag as an emblem of racist violence. His best-known works are a series incorporating black hair and a 1988 billboard in Washington, D.C., showing the Reverend Jesse Jackson with blue eyes and blond hair, entitled "How Ya Like Me Now?" Since 1988 he has divided his time between New York and Rome.

Sources

Alanna Heiss et al., *David Hammons: Rousing the Rubble*. New York: Institute for Contemporary Art and MIT Press, 1991.

Reginia Perry in *St. James Guide to Black Artists*: 225–227.

Hardison, Inge (b. 1914)
4.3. "Sojourner Truth" (1968).

Sculptor and photographer Inge Hardison was born in Portsmouth, Virginia, and studied at Tennessee A & I University, Vassar College, and the Art Students League in New York. She began creating her "Negro Giants in History" series of sculptures of Harriet Tubman, Frederick Douglass, Sojourner Truth, Paul Robeson, and others in 1963. Commissioned by the black alumni of Princeton University, Hardison's "Douglass" is housed in the reference room of Princeton's Firestone Library. Then New York governor Mario Cuomo gave Nelson Mandela of South Africa Hardison's two-foot tall statue of Sojourner Truth in 1990. Hardison says: "By memorializing such great, selfless people . . . I have been able to put within the experience of many school children, college students, and adults those much-needed models of inspiration, and many of those who read the biographies of these sculptured heroes are encouraged to try to make their own lives more meaningful."

Sources

Thomas M. Shaw in *St. James Guide to Black Artists*: 229–230.

www.aaregistry.com/african_american_history/1201/Inge _Hardison_has_a_creative_soul.

Harleston, Edwin A. (1882–1931)
8.3. "The Old Servant" (1928).

Painter and muralist Edwin Harleston was born in Charleston, South Carolina, and studied at the Boston Museum School of Fine Arts. A painter of an older generation of black Southerners, Harleston won the Amy Spingarn prize for portraiture in 1924 awarded by the Harmon Foundation.

Sources

James A. Porter, *Modern Negro Art*, with a new introduction by David C. Driskell. Washington, D.C.: Howard University Press, 1992: 96, 97–98. (Originally published 1943).

Leo Twigs in *St. James Guide to Black Artists*: 231–232.

Hathaway, Isaac Scott (1874–1967)
4.6. "Frederick Douglass" (1919).

Sculptor and ceramist Isaac Scott Hathaway was born in Lexington, Kentucky, and studied in many institutions, including Chandler College in Lexington, the Art Department of the New England Conservatory of Music in Boston, the Cincin-

nati Art Academy, and the State University of New York at Alfred. He sculpted busts of prominent African Americans, such as Booker T. Washington, Frederick Douglass, Richard Allen, Paul Laurence Dunbar, George Washington Carver, and C. C. Spaulding, and distributed them by mail through his Isaac Hathaway Art Company. Hathaway was a founding member of the Department of Ceramics at Tuskegee Institute, where he taught from 1937 to 1947. He designed the Booker T. Washington coin (1946) and the George Washington Carver coin (1951) for the U.S. Mint.

Sources

Richard J. Powell, *Black Art and Culture in the 20th Century*. New York: Thames & Hudson, 1977: 36.

www.liunet.edu/cwis/cwp/library/aavaahp.htm#hathaway.

Hayden, Palmer (1890–1973)

1.4. "Fétiche et Fleurs" (1926).

7.4. "Tenth Cavalry Trooper" (1939).

8.1. "John Henry" (1944–1954).

10.5. "The Janitor Who Paints" (1936).

Painter Palmer Hayden was born Peyton Hedgeman in Wide Water, Virginia, and served in the U.S. Army during the First World War. After the war he studied at Cooper Union in New York and Boothbay Art Colony in Maine. He won first prize in the Harmon foundation's first exhibition in 1926 for a Booth Bay scene and moved to Paris shortly afterward. He studied and painted independently in France from 1927 to 1932. Hayden, along with Aaron Douglas, was among the first African-American artists to use African subjects.

Although "Fétiche et Fleurs" embodies the Harlem Renaissance's approach to Africa, it does not characterize Hayden's oeuvre. Hayden's work often used black people as subjects, but often with an ironic twist, for example, his "The Janitor Who Paints a Picture," of a painting friend, also captures Hayden's own situation. Despite his training in the United States and at the École des Beaux-Arts in Paris, Hayden was often mistakenly considered self-trained. A WPA artist during the Great Depression, he became known for narrative depictions of urban and Southern African Americans. Hayden painted his well-known "John Henry" series over a ten-year period in the 1940s. One of these paintings appears in chapter 7 of this book.

Sources

Bearden and Henderson, *A History of African-American Artists*: 157–169.

Christine Miner Minderovic in *St. James Guide to Black Artists*: 238–240.

Smithsonian Institution, Archives of American Art.

Hicks, Kyra E. (b. 1965)

15.5. "Black Barbie" quilt (1996).

E.2. "Single Black Female" quilt (1994).

Quilter Kyra Hicks of Kansas City, Missouri, studied marketing at Howard University, the University of Michigan (M.B.A.), and the London School of Economics. In 2003 she published *Black Threads: An African-American Quilting Sourcebook*. She says: "My primary goal in compiling this book was to document the range of ways African-American quilting has been interpreted: in cloth, in art, and in written and spoken words, by women and men."

Sources

Kyra E. Hicks, *Black Threads: An African-American Quilting Sourcebook*. Jefferson, N.C.: McFarland and Company, 2003.

Mazloomi, *Spirits of the Cloth*: 182.

Houzell, Paul A. (b. 1943)

12.8. "Chuck Berry: Nadine Honey Is That You?" (1999).

Internationally exhibited Florida artist Paul Houzell was born in Bainbridge, Georgia, and teaches art at the View Park Preparatory Accelerated Charter Schools in Los Angeles. He has created art aimed at members of black sororities and fraternities.

Source

www.viewparkprep.org/about/.

Hudson, Julien (1811–1844)

3.11. "Portrait of Young Man, Said to Be a Self-portrait" (1839).

A professional portrait painter in New Orleans, Julien Hudson studied art privately in New Orleans in 1826 and 1827 and in Paris. In 1831 he opened a portrait studio on Bienville Street. He documented the contribution of free black soldiers to the War of 1812 in "Battle of New Orleans." His 1939 self-portrait is virtually unique for the antebellum period. Only four of Hudson's signed oil paintings have been identified, two of which are owned by the Louisiana State Museum.

Source

Patricia Brady in *St. James Guide to Black Artists*: 255–256.

http://lsm.crt.state.la.us/painting/hudson.htm.

Humphrey, Margo (b. 1942)

3.7. "The Last Bar-B-Que" (1989).

Printmaker, sculptor, and installation artist Margo Humphrey was born in Oakland, California, and received her B.F.A. in painting and printmaking from the California College of Arts and Crafts in Oakland and her M.F.A. in printmaking from Stanford University (1974). She was the first black woman printmaker to attain international recognition. She says: "My work may have been more difficult to categorize because I didn't want to be blatant about my subject. I felt that if the symbolism was too pronounced, the time would come when the work would be rejected because it would fit a certain period. The symbolism would not be profound or lasting enough." She teaches in the Art Department of the University of Maryland, College Park.

Sources

Robert Steele in *St. James Guide to Black Artists*: 258–259.

www.artgallery.umd.edu/exhibit/02–03/faculty2002/humphrey.html.

www.art.umd.edu/newsite/ARTWEBSITE/people/humphrey
.html.

Hunt, Richard (b. 1935)

2.5. "Model for Middle Passage Monument" (1987).

14.7. "I've Been to the Mountaintop" (1977).

One of the most respected sculptors in the United States, Richard Hunt was born on Chicago's South Side. He studied at the Art Institute of Chicago (B.A.E., 1957) where he now teaches. Although influenced by the historical currents of the 1960s and 1970s, Hunt has kept aesthetic values, rather than polemic, uppermost in his work. The creator of an abundance of monumental, abstract public sculpture, Hunt says: "One of the central themes in my work . . . is the reconciliation of the organic and the industrial. I see my work as forming a kind of bridge between what we experience in nature and what we experience in the urban, industrial technology-driven society we live in." Hunt became the first black American artist given a retrospective exhibition at the Museum of Modern Art in New York. He has received many awards and honorary degrees and was inducted into the American Academy of Arts and Letters in 1998.

Sources

Louise Davis Stone in *St. James Guide to Black Artists*: 259–261.

www.h-net.msu.edu/~rhunt/statement.html.

Hunter, Clementine (ca. 1886–1988)

3.6. "Baptism" (ca. 1964).

Self-taught painter Clementine Hunter was born in 1885, 1886, or 1887, in Natchitoches, Louisiana, on Melrose Plantation where she labored for most of her life without any formal education. Hunter did not begin painting until she was in her fifties, but produced more than four thousand paintings in her lifetime. Her work portrays the daily life of the plantation: church scenes, cotton picking, and other workaday activities.

Several of Hunter's works, including her African House murals, painted in 1956, are on display at Melrose Plantation.

Sources

Driskell, *Narratives of African American Art and Identity*: 144.

Christine Miner Minderovic in *St. James Guide to Black Artists*: 261–262.

Stacey Morgan, "Clementine Hunter and Melrose Plantation," *American Art* 19, No. 1 (Spring 2005): 25–28.

Johnson, Malvin Gray (1896–1934)

9. 4. "Negro Soldier" (1934).

Painter and commercial artist Malvin Gray Johnson was born in Greensboro, North Carolina. He studied at the National Academy of Design in New York City and depicted themes from Negro spirituals and everyday life in Harlem. Unable to travel to Paris, Johnson associated with Harlem Renaissance artists influenced by European modernism and the African aesthetics. He won the Otto H. Kahn Prize of the Harmon Foundation in 1929 for best painting in the Harmon Foundation exhibition. Despite his formal training and Cubist tendencies, reviewers praised his work only for its "real Negro spirit." Johnson died unexpectedly on his return from a painting trip to Virginia.

Source

Lizzeta LeFalle-Collins in *St. James Guide to Black Artists*: 275–276.

Johnson, William H. (1901–1970)

3.2. "Jesus and the Three Marys" (1935).

6.2. "Abraham Lincoln" (ca. 1945).

8.8. "Chain Gang" (ca. 1939).

10.8. "Haile Selassie" (ca. 1945).

11.3. "Lessons in a Soldier's Life" (ca. 1942).

William Henry Johnson, one of the most productive American artists of the twentieth century, was born in Florence, South Carolina. He studied at the National Academy of Design in New York and moved to Paris in the mid-1920s. In Paris he met the African-American master painter, Henry Ossawa Tanner. Johnson painted in Paris and in the South of France during the late 1920s. He moved back and forth between Denmark and New York in the 1930s. A member of the Harlem Artists Guild, Johnson had his first major show in New York in 1941.

Johnson painted in a sophisticated Expressionist style in the 1920s and 1930s, before shifting to the false naïve, stick-figure style for which he is famous. He said of his later work on black themes: "In all my years of painting, I have had one absorbing and inspiring idea, and have worked towards it with unyielding zeal: to give—in simple and stark form—the story of the Negro as he has existed." This simpler style and its black subject matter have proven far more popular with his American audience than his earlier work.

Johnson spent the last twenty-three years of his life institutionalized in a mental hospital and died in obscurity in 1970. The Harmon Foundation acquired all of Johnson's work in 1956 and presented it to the Smithsonian American Art Museum in 1967.

Sources

Lizzetta LeFalle-Collins in *St. James Guide to Black Artists*: 279–280.

Richard Powell, *Homecoming: The Art and Life of William H. Johnson*. Washington, D.C.: National Museum of American Art, Smithsonian Institution, 1991.

Smithsonian Institution, Archives of American Art.

Johnston, Joshua (ca. 1765–1830)

3.4. "Portrait of a Gentleman," thought to be the Reverend Daniel Coker (1805–1810).

One of the earliest African-American professional painters, Joshua Johnston was born in Baltimore. A freeman, Johnson produced more than eighty formal family portraits between 1795 and 1825.

Sources

Bearden and Henderson, *A History of African-American Artists*: 3–17.

J. Hall Pleasants, *An Early Baltimore Negro Portrait Painter, Joshua Johnston*. Windham, Conn.: Walpole Society, 1940.

Dorothy Valakos in *St. James Guide to Black Artists*: 280–281. www.mdhs.org/kids/joshua.html.

Jones, John W. (b. 1950)

6.4. "The New Order" (1998).

John Jones was born in Columbia, South Carolina. Although largely self-taught, he took illustration classes while a draftee in the U. S. Army in the early 1970s. Jones's illustrations appear in corporate publications of Time Life Books, IBM, Westinghouse, Rubbermaid, NASA, Goddard Space and Flight Center, and the U.S. Postal Service. He sees himself as a figurative artist whose mission is to depict the African-American experience from the slave trade through the present. He specializes in imagery of black Civil War soldiers, the Buffalo soldiers, and the people of the South Carolina Low Country.

Source

www.gallerychuma.com/johnwjonesbio.htm.

Lawrence, Jacob (1917–2000)

4.1. "Frederick Douglass Series No. 30 — The Free Man" (1938–1939).

4.2. "General Toussaint" (1986).

5.6. "Cinqué Aboard the *Amistad*" (1992).

5.9. "Harriet Tubman Series No. 10" (1938–1939).

9.1. "Migration of the Negro, Panel 1: During the World War there was a Great Migration North by Southern Negroes" (1940–1941).

One of the most honored African-American painter of the twentieth century, Jacob Lawrence was born in Atlantic City, New Jersey, and studied in the school of the great black sculptor Augusta Savage, who got him on the WPA's arts project. In Harlem Professor Charles Seifert (1871–1949), an independent black scholar who taught Negro history at the 135th Street branch of the New York Public Library (later the Schomburg Center for the Study of Black Culture), encouraged Lawrence's interest in African-American history. Lawrence also met regularly with the artists around James Lesene Wells and Charles Alston to discuss black artists' prospects and frustrations. In 1941 he married the painter Gwendolyn Knight (1913–2005).

Known for his sense of historical narrative and exciting use of color, Lawrence fused Cubist, Expressionist, and African forms in his work to connect the concerns of the Harlem Renaissance, the Civil Rights era, and social realism. Lawrence was recognized throughout his professional life: He was the first black artist exhibited in the Museum of Modern Art in New York (1974). He was the first artist to win the NAACP's Spingarn Medal (1970). In 1983 he became only the second African American (the novelist Ralph Ellison was the first) to be elected to the American Academy of Arts and Letters. For many years he headed the Art Department at the University of Washington in Seattle.

Sources

Bearden and Henderson, *A History of African-American Artists*: 293–314.

Reginia Perry in *St. James Guide to Black Artists*: 316–319.

Peter T. Nesbett and Michelle DuBois, eds., *Over the Line: The Art and Life of Jacob Lawrence*. Seattle: University of Washington Press, 2000.

Smithsonian Institution, Archives of American Art.

Lewis, Charlotte (n.d.–ca. 1997)

5.11. "The Harriet Tubman Quilt" (1996).

Quilter Charlotte Lewis lived in Portland, Oregon. Although her grandmother quilted, Lewis only began making quilts of her own in the mid-1990s, after graduating from the Portland Museum Art School and working as a multi-media artist for many years. Her quilts feature stamped and stenciled designs and include threading, beads, and sequins.

Source

Mazloomi, *Spirits of the Cloth*: 184.

Lewis, Edmonia (ca. 1845–1910)

6.8. "Forever Free" (1867).

Sculptor Edmonia Lewis was born in 1840, 1843, 1844, or 1845 in Rensselaer County, New York. Her father was African-American, her mother, Native American. Lewis was raised as a Mississauga Indian. In about 1858 she enrolled in the Preparatory Department of Oberlin College. She also studied privately in Boston and Rome. Lewis spent her career in Rome, where she created a large body of work recognizing both her African-American and Native American heritages. She showed "Cleopatra" at the United States Centennial Exposition in Philadelphia in 1876. She returned to the United States occasionally to show her work but never escaped from poverty.

Sources

Bearden and Henderson, *A History of African-American Artists*: 54–77.

Laurie Fitzpatrick in *St. James Guide to Black Artists*: 323–324.

Lewis, Samella (b. 1924)

8.5. "Waterboy" (1944).

Pioneering artist and art historian Samella Lewis was born in New Orleans. She studied under Elizabeth Catlett at Dillard University, who sent her to Hampton Institute to study with Viktor Lowenfeld. Lewis earned her Ph.D. from Ohio State University (1951), the first African-American woman to receive a doctorate in art history.

Lewis taught art history at Scripps College in Claremont, California, from 1969 to 1984. She has provided enormous support to other black artists through the founding of the Museum of African American Art in Los Angeles and the *International Review of African American Art*, from which many of the illustrations in this book are drawn.

Sources

Samella Lewis, Mary Jane Hewitt, and Floyd Coleman, *African American Art and Artists*, 3rd ed. Berkeley: University of California Press, 2003. (Originally published 1978).

Jeanne Zeidler in *St. James Guide to Black Artists*, 326–328.

Ligon, Glenn (b. 1960)

14.8. "Malcolm, Martin" (1991).

Painter and installation artist Glenn Ligon studied at the Rhode Island School of Design, Wesleyan University, and the Whitney Museum. He lives in Brooklyn. Ligon's work uses quoted language to address issues of racial and gender identity and the politics of representation to "make language into a physical thing, something that has real weight and force to it."

A. M. Weaver in *St. James Guide to Black Artists*: 330–332.

www.diacenter.org/ligon/intro.html.

www.walkerart.org/programs/vaexhibligon.html.

Mason, Phillip Lindsay (b. 1939)

14.9. "The Deathmakers" (1968).

Black Power artist Phillip Lindsay Mason depicted themes of politics and the black family in his work from the 1960s. Working in California, Mason specializes in figure and street scenes.

Sources

Lewis, *African American Art and Artists*: 168–170.

www.iniva.org/library/resource/3985.

Maynard, Valerie (b. 1937)

6.1. "General Fred" (1973).

Sculptor and printmaker Valerie Maynard was born in New York. She studied at The New School, the Museum of Modern Art, and Goddard College, Vermont (M.F.A., 1977). Maynard works in many media, producing work that is self-consciously feminist and narrative. Well respected and honored, Maynard has lectured widely on African-American art and art history.

Sources

A. M. Weaver in *St. James Guide to Black Artists*: 354–355.

www.irapintogallery.com/Maynard.htm.

McGruder, Aaron (b. 1975)

E.4. "The Boondocks" (1999).

One of a very few prominent black cartoonists, Aaron McGruder was born on the South Side of Chicago but grew up in Columbia, Maryland. He majored in African-American Studies at the University of Maryland, where he began publishing Boondocks cartoons in the campus newspaper. In 1999 the Universal Press Syndicate began publishing "The Boondocks" nationally. The strip, occasionally censored, now appears in more than three hundred newspapers daily.

"The Boondocks" features Huey Freeman, a ten-year-old black nationalist named for the Black Panther leader Huey Newton. Huey lives in the nearly all-white suburbs with his grandfather and younger brother Riley, a wannabe thug. Their neighbors include the interracial Du Bois family whose daughter, Jazmine, avoids an African-American identity.

A highly-visible critic of self-importance and conservatism in American society, McGruder is known for his uncompromising politics. The liberal *Nation* magazine featured Huey Freeman on its cover on November 17, 2003, as one of the purest emblems of progressivism. McGruder now lives in Los Angeles.

Sources

Karen Grigsby Bates, "Aaron McGruder's Greatest Hits," *Black Issues Book Review* 5, No. 5 (September/October 2003): 36.

Ben McGrath, "The Radical; Profiles," *The New Yorker*, April 19, 2004: 153.

Michael Moore, "Aaron McGruder's Right to Be Hostile," *The Nation*, November 17, 2003: 20.

Mills, Lev T. (b. 1940)

14.4. "LeRoi?" (1972).

Sculptor, printer, and installation artist Lev. T. Mills was born in Tallahassee, Florida, and studied at Florida A & M University, the University of Wisconsin-Madison (M.F.A., 1970), the Slade School of Fine Art, London, the Atelier 17 Workshop, Paris, and the School of Visual Arts, New York. He exhibits internationally and has lectured in East, West, and North Africa. Mills teaches art at Spelman College.

Sources

Michael D. Harris in *St. James Guide to Black Artists*: 358–360.

www.wcenter.spelman.edu/Art/htmlpages/mills.html.

Moorhead, Scipio (ca. 1750–n.d.)

3.8. "Phillis Wheatley" (1773).

Painter and poet Scipio Moorhead, enslaved in Boston, learned from his owner, Sarah Moorhead, who had studied art in Europe. Moorhead was commissioned to engrave the frontispiece of Phillis Wheatley's *Poems on Various Subjects, Religious and Moral*. Little else is known about him beyond her recognition of him in a penciled note in a copy of her 1773 edition of *Poems on Various Subjects*: "To S. M., a young African painter, on seeing his works. Still may the painter's and the poet's fire/ To aid thy pencil, and thy verse conspire!"

Sources

Laurie Fitzpatrick in *St. James Guide to Black Artists*: 366.

www.pbs.org/wgbh/aia/part2/2h7.html.

Motley, Archibald J., Jr., (1891–1981)

9.2. "Black Belt" (1934).

14.6. "The First One Hundred Years: He amongst you who is without Sin Shall Cast the First Stone: Forgive Them Father For They Know Not What They Do" (ca. 1963–1972).

One of the most important African-American painters of

the twentieth century, Archibald J. Motley, Jr., was born in New Orleans and studied at the Art Institute of Chicago (1914–1918). He painted murals as part of the WPA arts project (1935–1939) in Chicago. Motley was one of the earliest African-American painters to concentrate on everyday black life, especially urban nightlife in Chicago's Black Belt, conveying the sound and motion of jazz through technique, composition, and color, especially the violet-red of artificial night light. Motley was fascinated with African Americans' many different skin colors, which he portrayed in his work.

Sources

Christine Miner Minderovic in St. *James Guide to Black Artists*: 372–374.

Jontyle Theresa Robinson and Wendy Greenhouse, *The Art of Archibald Motley, Jr.* Chicago: Chicago Historical Society, 1991.

Smithsonian Institution, Archives of American Art.

Organization of Black American Culture (OBAC): Abernathy, Sylvia (n.d.), Jeff Donaldson (1932–2004), Elliot Hunter (n.d.), Wadsworth Jarrel (n.d.), Barbara Jones-Hogu (n.d.), Carolyn Lawrence (n.d.), Norman Parish (b. 1937), and William Walke (n.d.)

14.13. "Wall of Respect" (1967), 43rd and Langley, Southside Chicago. OBAC added to the "Wall of Respect" through 1969.

OBAC was an expression of the Black Arts movement, a black nationalist movement flourishing between the mid-1960s and mid-1970s and encompassing novelists, dramatists, and poets as well as visual artists. The Black Arts movement sought to liberate black artists from the stifling, racist conventions of American art and to find the beauty of ordinary black people. Other organizations sharing OBAC's ideals in Chicago were the Association for the Advancement of Creative Music and the African Commune of Bad Relevant Artists (AfriCobra).

Source

Sahah Hassan in St. *James Guide to Black Artists*: 152–154.

Pindell, Howardena (b. 1943)

2.6. "Autobiography: Water/Ancestors/MiddlePassage/Family Ghosts" (1988).

5.2. "Slavery Memorial" (1993).

13.2. "Homage to MLK" (1968).

Prominent painter, curator, and performance artist Howardena Pindell was born in Philadelphia and studied at Boston University (B.F.A., 1965), Yale University (M.F.A. 1967). Pindell worked figuratively until 1980, when she spent several months in Japan. Today she works both figuratively and abstractly on subject matter than is often African-American and autobiographical in a variety of media: collages, painting, found objects. She spent twelve years in the Curatorial Department of the Museum of Modern Art and has taught in the Art Department of the State University of New York, Stony Brook, since 1979. She has also been a visiting professor at Yale University and at the Skowhegan (Maine) School of Painting and Sculpture.

Sources

Smithsonian Institution, Archives of American Art

Roslyn Adele Walker in St. *James Guide to Black Artists*: 418–420.

www.africanpubs.com/Apps/bios/0982PindellHowardena.asp?pic=none.

www.wadsworthatheneum.org/afamart2.htm.

Pippin, Horace (1888–1946)

4.9. "John Brown Going to His Hanging" (1942).

Self-taught painter Horace Pippin was born in West Chester, Pennsylvania. After the death of his parents, he moved to Paterson, New Jersey, where he worked in industry. During the First World War he served in France with the 369th Infantry. A war wound precluded his painting in the 1920s, but he made colored wood panels with a hot iron poker and colored paint.

White collectors and curators discovered Pippin in the late 1930s and praised him as an authentic Negro artist unspoiled by formal training. Albert C. Barnes, the influential white art collector, praised Pippin's work in 1940 for the "simplicity, directness, sincerity, naïveté, and vivid drama of a story told by an unspoiled Negro in his own words. It is probably not an exaggeration to say that he is the first important Negro painter to appear on the American scene." Pippin was unaware of the Harlem Renaissance artists working in New York City until he attended a show in 1941 in which Jacob Lawrence's work was shown.

Sources

Smithsonian Institution, Archives of American Art

Bearden and Henderson, A *History of African-American Artists*: 356–369.

Porter, James A. (1905–1970)

9.6. "Soldado Senegales" (ca. 1935).

Painter and "Father of African-American Art History," James A. Porter was born in Baltimore. He graduated from Howard University (B.A., 1927) and continued his art education at the Art Students League in New York, the Institut d'Art et d'Archeologie, in Paris, and New York University (M.F.A., 1937). In 1933 he won the Schomburg portrait prize in the Harmon exhibition with "Woman Holding a Jug." As a painter, Porter traveled widely throughout the African Diaspora painting people of African descent in the Caribbean and Africa as well as the United States. He was one of the earliest African-American artists to travel to newly independent West Africa. In 1963 he painted scenes of daily life in Lagos, Nigeria. He said: "My paintings reflect the enthusiasm and the understanding admiration which I have felt for Africa and the Africans." A professor at Howard University from 1935, Porter wrote the first black American art history: *Modern Negro Art* (1943, republished in 1969 and 1994).

As an art historian Porter disagreed with his Afrocentric Howard University colleague, Alain Locke, on whether African-American artists should concentrate on their African heri-

tage. Having begun his pursuit of black art history with Robert S. Duncanson, Porter felt Duncanson and Henry Ossawa Tanner had every right to paint nonblack subjects in whatever style they pleased.

Sources

Reginia A. Perry, *Free Within Ourselves: African-American Artists in the Collection of the National Museum of American Art*. Washington, D.C.: Smithsonian Institution, 1992: 153.

James A. Porter, *Modern Negro Art*. Washington, D.C.: Howard University Press, 1992, with new introduction by David Driskell. (Originally published 1943.)

Gabriel Tenabe in *St. James Guide to Black Artists*: 432–433.

Powers, Harriet (1837–1911)

3.5. "Bible Quilt" (ca. 1898).

Famed quilter Harriet Powers lived outside Athens, Georgia, and did not read or write. Her best-known works are her two Bible quilts, 1886 and ca. 1898, which combine Christian faith, African-American community, and her own life's trajectory from slavery to freedom. She exhibited at the Athens, Georgia, Cotton Fair of 1886 and in the Negro Building at the Atlanta Cotton States and International Exposition of 1895 (where Booker T. Washington gave the speech that came to be known as the "Atlanta Compromise"). The wives of Atlanta University professors saw Powers's original Bible Quilt and commissioned her to make the second Bible Quilt, shown in this text. Powers is the most famous of a host of women who made quilts for their own families or those for whom they worked. Today quilting enjoys tremendous popularity among Americans of all races and ethnicities, who are primarily, but not entirely, women. African-American quilters, such as Peggie L. Hartwell, honor Harriet Powers as a leader in the practice of their art.

Sources

Patton, *African-American Art: Oxford History of Art*. New York: Oxford University Press, 1998: 68–71.

Reginia Perry in *St. James Guide to Black Artists*: 4.

Ringgold, Faith (b. 1930)

2.1. "We Came to America" (1997).

13.3. "Dream 2: King and the Sisterhood" (1988).

14.11. "Flag for the Moon: Die Nigger" (1969).

Painter, quilter, performance artist, and sculptor, Ringgold was born in New York City and studied at the City College of New York (M.A., 1959). Always political, her work has moved through three phases over the course of her long career. She initially painted critiques of American culture in pop art style. Then, in the 1970s, she began working with cloth as a feminist statement in an art world that discounted women artists. Her cloth sculpture celebrated famous and ordinary African Americans and incorporated the fabric art of her mother, the fashion designer Willi Posey (d. 1981). Ringgold led demonstrations against the exclusion of black artists from the New York art world of galleries and museums in the 1960s and

1970s. In 1980 Ringgold and Posey began making quilts, on which Ringgold painted portraits and texts depicting family and figures from African-American history. Ringgold's work continues to tell stories that revise sexist and racist history, sometimes in collaboration with her daughter, the literary critic Michele Wallace. One of the best-known black women artists, Ringgold has exhibited internationally.

Sources

Dan Cameron et al., eds., *Dancing at the Louvre: Faith Ringgold's French Collection and Other Story Quilts*. New York: New Museum of Contemporary Art and Berkeley: University of California Press, 1998.

Lisa E. Farrington, *Art on Fire: The Politics of Race and Sex in the Paintings of Faith Ringgold*. New York: Millenium Fine Arts, 1999.

Laurie Fitzpatrick in *St. James Guide to Black Artists*: 454–457.

Faith Ringgold, *We Flew over the Bridge: The Memoirs of Faith Ringgold*. Boston: Little, Brown, 1995.

Smithsonian Institution, Archives of American Art.

Saar, Alison (b. 1956)

3.3. "Afro-Di(e)ty" (2000).

Leading sculptor and installation artist Alison Saar was born in Los Angeles and studied with Samella Lewis at Scripps College (B.A., 1978) and at the Otis Art Institute, Los Angeles (M.F.A., 1981). Saar is the daughter of the artist Betye Saar. While Alison Saar's work protests against racial injustice and the distortion of black women's images in Western culture, she is unusual among black artists who often avoid nudes, a traditional subject in Western art. The racial identity of Saar's nudes is indeterminate, but they always protest American racism and sexism, whether overtly or indirectly.

Saar has exhibited her work constantly since 1982 in major individual and group shows. She created a cast bronze screen for the 125th Street Metro North commuter station in Manhattan.

Sources

Lisa Gail Collins, *The Art of History: African American Women Artists Engage the Past*. New Brunswick: Rutgers University Press, 2002: 38–63.

Mary Nooter Roberts, *Body Politics: The Female Image in Luba Art and the Sculpture of Alison Saar*. Seattle: University of Washington Press, 2002.

Jontyle Theresa Robinson in *St. James Guide to Black Artists*: 463–464.

www.mta.info/mta/aft/pa/pamnr_saarny.htm.

www.phylliskindgallery.com/artists/as/bio.html.

www.scrippscol.edu/~dept/gallery/alumnae/saar.htm.

Saar, Betye (b. 1926)

8.11. "The Liberation of Aunt Jemima" (1972).

Assemblage artist Betye Saar was born in Los Angeles. She studied at the University of California, Los Angeles (B.A., 1949), California State University, Long Beach, the Univer-

sity of Southern California, and California State University, Northridge. Saar uses photographs and found objects to construct shadow boxes that explore and critique African-American history and stereotypes of race and gender. She made installations at Newark Penn railroad station and a Metrorail station in Miami. She exhibits internationally. In recent years she has collaborated with her daughter, the sculptor Alison Saar.

Sources

Jontyle Theresa Robinson in *St. James Guide to Black Artists*: 464–465.

www.usc.edu/isd/archives/la/pubart/Downtown/Broadway/Biddy_Mason/saar_bio.html.

www.legacy-project.org/artists/display.html?ID=130.

Sam, Joe (b. 1939)

3.10. "Cohia" (1996).

Self-trained mixed media painter and sculptor Joe Sam was born in Harlem. He earned a doctorate in educational psychology from the University of Massachusetts at Amherst and worked in human services until 1984. Since that time he has devoted himself to art. His work uses bright colors to deliver social and political critique. In 1989–1990 he shifted the scale of his work and began receiving commissions for public sculpture, some of which is found in a regional police facility and a metro rail station, both in South Central Los Angeles.

Sources

www.joesam.com/.

www.usc.edu/isd/archives/la/pubart/Metroart/Bline/sam4.html.

Samuels, O. L. (b. 1931)

15.7. "Saddam Husein [sic]" (1992).

Self-taught wood sculptor, O. L. Samuels was born in Wilcox County, Georgia. Doing unskilled labor up and down the East Coast, he boxed for a while and installed car parts at a service station. Samuels began carving in his fifties to overcome clinical depression following two heart attacks and an occupational injury. He decorates his sculptures with paint, glitter, sawdust, and glue. He says, "I like to work on a piece, then sit it down and look at it. When it talk to you, you go to it and you work." He now lives in Tallahassee, Florida.

Sources

Kathy Moses, *Outsider Art of the South*. Atglen, Penn.: Schiffer Publishing, 1999: 128.

www.thebrogan.org/outsiderart/artist7.html.

Samuels, Melvyn Henry, Jr., (Noc) (b. 1961)

15.5. New York subway car, spray can (1981).

Graffiti artist Noc (Melvyn Henry Samuels, Jr.) was born in New York City and began painting ("tagging") subway cars when he was eleven. He painted with The Death Squad and OTB ("Out to Bomb") until 1980. During the early 1980s his work was exhibited in group shows. He lives in Brooklyn.

Source

James Prigoff and Robin J. Dunitz, *Walls of Heritage, Walls of Pride: African American Murals*. San Francisco: Pomegranate, 2000: 138, 256.

Savage, Augusta (1892–1962)

9.7. "Marcus Garvey" (ca. 1930).

Harlem Renaissance sculptor and art educator Augusta Fells Savage was born in Green Cove Springs, Florida, and studied at Tallahassee State National School and Cooper Union in New York. Savage encountered many obstacles to her art on account of her race, sex, and poverty. While she made a glowing reputation as a sculptor of famous and humble people, she supported herself as an educator. After studying in Europe on a Rosenwald Fellowship in the early 1930s, she founded the Savage Studio of Arts and Crafts in Harlem and mentored other artists such as the young Jacob Lawrence and Gwendolyn Knight. Savage belonged to the Harlem Artists Guild and served as one of the rare African-American supervisors on the WPA.

Savage's major commission was a monumental statue, "The Harp," inspired by James Weldon and Rosamond Johnson's "Lift Every Voice and Sing," also known as the Negro National Anthem, for the 1939 World's Fair in Queens, New York. Savage could not afford to cast the piece in bronze, so "The Harp" was destroyed after the fair closed. Such was the fate of most of her work. After the World's Fair, Savage moved to rural Saugerties, New York. Failing to sell much of her work, she destroyed it.

Sources

Bearden and Henderson, *A History of African-American Artists*: 168–180.

Leslie King-Hammond in *St. James Guide to Black Artists*: 470–472.

www.greencovesprings.com/savage.htm.

www.si.umich.edu/CHICO/Harlem/text/asavage.html.

Scott, Joyce J. (b. 1948)

5.5. "No Mommy Me (1)" (1991).

8.12. "Man Eating Watermelon" (1986).

Sculptor and performance artist Joyce Scott was born in Baltimore and studied at the Maryland Institute College of Art (B.F.A., 1970), the Instituto Allende, Guanajuato, Mexico (M.F.A., 1971), and Haystack Mountain (Maine) School of Crafts. Scott works in several media, including paint, cloth, beads, glasswork, printing, and assemblages, forging witty works that protest against racism, sexism, violence, and stereotypes. Scott's work draws on themes from the histories of Native Americans, African Americans, and the American West. Her work features sly humor along with biting social commentary. She exhibits and performs internationally.

Sources

Joyntle Theresa Robinson in *St. James Guide to Black Artists*: 475–476.

www.tfaoi.com/articles/anne/ae7.htm.

www.arts4allpeople.org/rm/JOYCE210.RM.

Singleton, Herbert, Jr., (b. 1945)

15.6. "Blood for Oil" (1990).

E.1. "Ain't Gonna Be first, Won't Be Last" (1997).

Self-taught sculptor Herbert Singleton was born in New Orleans and worked as a steelworker and certified bridge painter. He began sculpting in the 1970s in clay, then in wood. Having served three prison terms, he makes incarceration one of his main artistic themes. He now supports himself as an artist in New Orleans.

Source

Kathy Moses, *Outsider Art of the South*. Atglen, Penn.: Schiffer, 1999: 67–69.

Smith, Albert A. (1896–1940)

9.3. "The Reason" (1920).

Printmaker Albert A. Smith was born in New York City and studied at the Ethical Culture Art School. After serving in the U.S. Army in 1918–1919, he returned to study at the National Academy of Design in New York. Smith supported himself as a jazz musician, chauffeur, and radio musician while he won prizes as an artist. His work appeared often in *Opportunity* and *The Crisis*. Much of his work protested against racism and segregation, but he also made a series of prints showing black people having a good time together. He won a Harmon Foundation bronze medal for his work in 1929, and in 1938 he exhibited three paintings at the Salon of American professions in Paris and was reviewed in *La Revue Moderne*. His skilled depiction of minstrels helps explain the acceptance of his work into exhibitions in the Museum of Fine Arts in Boston in 1932 and the Baltimore Museum of Art's 1939 Exhibition of Negro Art in conjunction with the Harmon Foundation.

Source

Lizzetta LeFalle-Collins in *St. James Guide to Black Artists*: 492–495.

Smith, Morgan (1910–1993) and Marvin (1910–2003)

10.4. "The Reverend Adam Clayton Powell, Jr., leads a protest on 125th Street in Harlem—'Don't Buy Where You Can't Work' campaign" (1942).

Photographers and painters Morgan and Marvin Smith, identical twins, were born in Nicholasville, Kentucky. They moved to New York City in 1933, got jobs with the city Parks Department, and took art lessons with the sculptor Augusta Savage in her studio. Savage brought the Smiths into contact with the Harlem Artists Guild.

In 1937 the Smiths set up their photo studio near Harlem's Apollo Theater, and they photographed news events, everyday life, and prominent African Americans living and visiting in Harlem until 1968. Marvin Smith studied under Romare Bearden in Paris in 1950. While Marvin was in Paris, Morgan became interested in film, becoming a sound technician for ABC. After closing their photographic studio in 1968, the Smiths worked as television sound technicians until their retirement in 1975. Marvin became an expert in needlework and designed crocheting patterns for *McCall's* magazine.

Sources

Douglas Martin, "Marvin Smith, 93, Whose Photographs Defined Harlem Life," *New York Times*, November 12, 2003: C13.

Tracie Rozhon, "At Home With: Marvin Smith; the Heartbeat of a Photogenic Life," *New York Times*, December 25, 1997: F1.

Morgan Smith, Marvin Smith, and James A. Mille, *Harlem: The Vision of Morgan and Marvin Smith*. Lexington: University Press of Kentucky, 1997.

PBS documentary, "M & M Smith: For Posterity's Sake—The Lives and Work of Renowned Harlem Renaissance Photographers Morgan and Marvin Smith" (1995).

Willis, *Reflections in Black*: 86–87.

Stevens, Nelson (b. 1938)

14.14. "Work to Unify African People" (1973).

The muralist Nelson Stevens was born in Brooklyn, New York, and studied at the University of Ohio. He received his M.F.A. from Kent State University, Ohio, in 1969. One of the first members of AfriCobra in Chicago in the mid-1960s, Stevens sought to use art as a means of liberating black people. He participated in the Black Arts movement of the 1970s, celebrating blackness of body and style. Stevens has always wanted to make black art accessible to ordinary people. Toward that end he edited *Drum* magazine and *Art in the Service of the Lord*.

Sources

Michael D. Harris in *St. James Guide to Black Artists*: 510–511. http://www-unix.oit.umass.edu/~afriart/Stevens.html.

Tanksley, Ann (b. 1934)

5.8. "Running to Freedom" (1987).

Ann Tanksley, a painter and printmaker, was born in Philadelphia. She studied at the Carnegie Institute of Technology, the Art Students League, Parsons School of Design, and Bob Blackburn's Printmaking Workshop in New York. She lives in Great Neck, New York. Inspired by African and Caribbean art, Tanksley is known for her depiction of ordinary working people. She has also made a series of paintings to illustrate the writing of Zora Neale Hurston, a writer of the Harlem Renaissance. Tanksley's brilliant sense of color makes her work accessible and commercially attractive. Her original use of perspective and bodily proportion endows her work with an unexpected immediacy.

Sources

Terry Bain in *St. James Guide to Black Artists*: 519.

www.bofa.com/foundation/index.cfm?N1=gallery&N3=canal.

Tanner, Henry Ossawa (1859–1937)

8.10. "The Banjo Lesson" (1893).

The most famous African-American painter at the turn of the twentieth century, Henry Ossawa Tanner was born in Pittsburgh, Pennsylvania. His father was a bishop in the African Methodist Episcopal Church. Bishop Tanner became editor of the AME newspaper, the *Christian Recorder*, in Philadelphia in 1864. In the Philadelphia Centennial Exhibition of 1876, Henry Tanner not only encountered the work of leading American and European artists, but he also discovered Edmonia Lewis and Edward M. Bannister, both of whose works appear in *Creating Black Americans*.

After study with Thomas Eakins at the Pennsylvania Academy of Fine Arts, Tanner became the first professor of art at Clark University in Atlanta. Tanner painted his two best-known paintings with African-American subjects in the mid-1890s: "Banjo Lesson" (1893) and "Thankful Poor" (1894). Tanner sold these and other paintings to finance a return to Europe in 1896 (he had visited Rome and Paris in the early 1890s). "Thankful Poor" had been stored in a closet of the Philadelphia School for the Deaf for years when William and Camille O. Cosby purchased it for $250,000 in 1981. At the time this was the highest price ever paid for an African-American artist's work.

Tanner spent the balance of his life in France. His paintings on religious themes earned him a 1896 gold medal from the Salon du Societé des Artistes Français in Paris. He traveled to the Holy Land, Egypt, and Italy as well. At home in the village of Sceaux, outside Paris, and Trépied, on the English Channel, Tanner continued to paint along nineteenth-century lines. In the early twentieth century he exhibited widely in France and the United States. When he visited the United States after the First World War, he took great interest in the art education of young black people. Back in France, he welcomed black American visitors like Hale Woodruff, but he did not heed Alain Locke's call for black artists to paint black subjects. He also ignored prevailing fashions in European art such as Cubism and German Expressionism. During the 1920s, 1930s, 1940s, and 1950s, as African-American artists concentrated on art protesting racism and celebrating working-class black people, Tanner's work fell out of favor on account of its nonblack subject matter. Since the 1960s, however, the virtuosity of his technique has regained him the success his work enjoyed during the first two decades of the twentieth century.

Sources

Bearden and Henderson, *A History of African-American Artists*: 78–109.

Lizzetta LeFalle-Collins in *St. James Guide to Black Artists*: 519–521.

Smithsonian Institution, Archives of American Art.

Tesfagiorgis, Freida High W. (b. 1946)

8.13. "Homage to Ida B. Wells" (1990).

Painter and art historian Freida High Tesfagiorgis received her M.F.A. from the University of Wisconsin–Madison in 1971. She belongs to the faculty of the University of Wisconsin–Madison Department of Afro-American Studies. As an art historian, she specializes in black women artists. Her own work addresses themes of race and gender.

Sources

Michael D. Harris, *Colored Pictures: Race and Visual Representation*. Chapel Hill: University of North Carolina Press, 2003: 122–123.

Robert Henkes, *The Art of Black American Women: Works of Twenty-Four Artists of the Twentieth Century*. Jefferson, N.C.: McFarland and Company, 1993: 113–120.

http://polyglot.lss.wisc.edu/aas/high.html.

Thrash, Dox (ca. 1892–1965)

11.1. "Defense Worker" (ca. 1942).

Printmaker Dox Thrash was born and raised in Griffin, Georgia. Between 1914 and 1923 he studied at the Art Institute of Chicago and served in France during the First World War. He settled in Philadelphia in about 1926 and matured as a printmaker. Thrash worked in Philadelphia's WPA Graphic Arts Workshop from 1939 to 1940 along with fellow artist Claude Clark. While on the WPA he invented the carborundum process of printmaking by using the carborundum crystals (ordinarily used to clean lithograph stones) on copper plates. This new carborundum etching process produced deep, dark tones with bright highlights.

Sources

John Ittmann, ed., *Dox Thrash: An African American Master Printmaker Rediscovered*. Philadelphia and Seattle: Philadelphia Museum of Art and University of Washington Press, 2001.

Theresa Leininger-Miller in *St. James Guide to Black Artists*: 527–528.

www.philamuseum.org/exhibitions/exhibits/thrash/flash.html.

Van Der Zee, James (1886–1983)

9.8 "UNIA Parade" (1924).

Born in Lenox, Massachusetts, where he was the second person in town with a camera, photographer James Van Der Zee was the most famous studio photographer in Harlem during much of the twentieth century. After a brief career with a band in New York City, he became a darkroom technician in 1914. Opening his own studio on 135th Street in Harlem in 1915, he began recording the people of Harlem pictorially.

He photographed Marcus Garvey's Universal Negro Improvement Association and hundreds of black middle-class New Yorkers with dignity and respect. One of his best-known works (1932) captures a Harlem couple in raccoon fur coats posing with their Cadillac in the depths of the Great Depression (1932). Glamorous and prosperous, they look on top of the world. This image of New Negro success has delighted viewers over several generations.

Van Der Zee operated a studio in which he made portraits in a heroic, nineteenth-century manner. Whether of ordinary

or famous subjects, his photographs projected an urbane elegance. However, the photograph of the fur-clad couple with the Cadillac was the first high-water mark of Van Der Zee's career. Hard times forced him and his wife to move to a smaller studio and to undertake less remunerative work. The photography business declined until Van Der Zee was rediscovered in 1968, when he was eighty-two years old. The "Harlem on My Mind" exhibition at the Metropolitan Museum of Art featured his work prominently. Van Der Zee emerged from retirement into the limelight. He once again photographed celebrities.

Sources

Reginald McGhee, ed., *The World of James Van Der Zee: A Visual Record of Black Americans*. New York: Grove Press, 1969.

Willis, *Reflections in Black*: 42–43.

Walker, Bo (1951–1986)

4.7. "Frederick Douglass Ikenga" (1978).

Sculptor Bo Walker was born in Virginia, moved to Brooklyn in 1972, and studied at Pratt Institute (B.F.A.). He specialized in restoring African art and in art education.

Source

Black New York Artists of the Twentieth Century: Selections from the Schomburg Center Collections. New York: New York Public Library, 1998: 41.

Walker, Kara (b. 1969)

5.3. "Slavery! Slavery!" (1997).

One of the more controversial African-American artists working today, Kara Walker received her B.A. from the Atlanta College of Art in 1991, and her M.F.A. from the Rhode Island School of Design in 1994. She teaches at Columbia University.

Walker works in the nineteenth-century medium of the silhouette. She uses racist and offensive imagery to subvert and transcend racism, but other artists see her work as racist, sexist, and degrading. In Geneva in 2000 she exhibited a series "Why I Like White Boys: an Illustrated Novel, by Kara E. Walker." Since her New York debut in 1994 Walker's work has been shown internationally. She received a John D. and Catherine T. MacArthur Foundation fellowship in 1997 and was chosen to represent the United States at the 2002 São Paulo Bienal in Brazil. Her MacArthur Foundation "genius award" prompted an outpouring of protest from more established black artists such as Betye Saar.

Walker says of her work: "I knew that if I was going to make work that had to deal with race issues, they were going to be full of contradictions. Because I always felt that it's really a love affair that we've got going in this country, a love affair with the idea of it [race issues], with the notion of major conflict that needs to be overcome and maybe a fear of what happens when that thing is overcome—And, of course, these issues also translate into [the] very personal: Who am I beyond this skin I'm in?"

Sources

Ian Berry et al., eds., *Kara Walker: Narratives of a Negress*. Cambridge, Mass.: MIT Press, 2003.

http://owa.chef-ingredients.com/postUK/20/walker.htm.

www.gregkucera.com/walker.htm.

www.moma.org/onlineprojects/conversations/kw_f.html.

Wandless, Paul Andrew (b. 1967)

13.4. "American Dreamer" (2000).

Ceramist and painter Paul Andrew Wandless was born in Miami and grew up in Delaware. He studied at the University of Delaware and Minnesota State University, Mankato. He received his M.F.A. from Arizona State University in 1999. He currently teaches at the Herron School of Art at Indiana University–Purdue University in Indianapolis. His primary media are clay, mixed media, and oil. Some of his work is clearly political, other is quite personal. Wandless uses texture and color to project each piece's individual emotion.

Source

www.blackstarstudio.net/statement.html.

Washington, Augustus (1820–1875)

4.8. "John Brown," (ca. 1846–1847).

Augustus Washington grew up in Trenton, New Jersey, and studied at the New York Oneida Institute, one of the rare educational institutions in the antebellum United States to admit black students. After teaching black children in Brooklyn, he became one of the first black men to study at Dartmouth College. In 1844 Washington moved to Hartford, Connecticut, as a teacher, but he found fuller opportunities as a daguerreotypist two years later. He operated his Hartford studio until the Compromise of 1850 imperiled the lives of free African Americans.

In 1853 Washington and his family migrated to the colony of Liberia, where he continued taking photographs and became a farmer. Chosen speaker of the Liberian House of Representatives in 1865, he was elected to the Liberian Senate in 1871. He founded a newspaper, the *New Era*, in 1873. Washington died in Monrovia.

Sources

Ann M. Shumard, *A Durable Memento: Augustus Washington, African American Daguerreotypist*. Washington, D.C.: National Portrait Gallery, Smithsonian Institution, 2000.

www.npg.si.edu/exh/awash/awhart.htm.

Wells, James Lesesne (1902–1993)

10.1. Book jacket for *The Negro Wage Earner* (1930).

James Lesesne Wells, a prominent graphic artist and art teacher, was born in Atlanta and grew up in Florida. He began winning prizes in art at thirteen. Wells studied at Lincoln University in Pennsylvania and Columbia University. African sculpture in the Brooklyn Museum of Art inspired him, as did the woodcuts of Albrecht Dürer and German Expressionist

painters. With the support of Alain Locke, Wells joined the art faculty at Howard University in 1926. In 1931, he won the Harmon Gold Medal for "Flight into Egypt." Rare among African-American artists, Wells was represented by a fine art gallery that sold his work on a regular basis.

During the 1930s Wells directed a summer art workshop in Harlem, where his assistants included artists whose work appears in *Creating Black Americans*: Charles Alston, Jacob Lawrence, and Palmer Hayden. (Later on he taught David Driskell.) In the early 1930s Wells turned from painting to printmaking. He said: "Becoming aware of the social and economic conditions of the time and the awakening of the 'New Negro,' I felt that the graphic arts would lend itself readily to the projection of ideas about these issues."

Sources

Bearden and Henderson, A *History of African-American Art*: 389–396.

Smithsonian Institution, Archives of American Art.

Robert Steele in *St. James Guide to Black Artists*: 558–560.

"James Lesesne Wells, November 2, 1902–January 20, 1993," *The Black Renaissance*, in Washington, D.C. Library: http://dclibrary.ong/blknen/bios/wellsjl.html.

www.dclibrary.org/blkren/bios/wellsjl.html.

White, Charles (1918–1979)

5.7. "Wanted Poster Series" (1970).

6.6. "General Moses" (1965).

11.4. "Bayonets" (1943).

11.9. "Woman Worker" (1951).

Painter and printmaker Charles White, one of the best-known and most influential of mid-twentieth-century black artists, was born in Chicago. He studied at the Art Institute of Chicago, the Art Students League, New York, and the Taller de Gráfica Popular, Mexico. As a Chicago teenager, he read Alain Locke's *The New Negro* (1925), which he recalled as "a book that fascinated me and opened up new vistas. . . . I had never realized that Negro people . . . had contributed so much to the development of America. . . . It became a kind of secret life, a new world of facts and ideas."

In 1934 he met young men and women studying for the careers that would later make them famous: choreographer Katherine Dunham (b. 1910), poets Gwendolyn Brooks (1917–2000), and Margaret Walker (1915–1998), sociologist Horace Cayton (1903–1970), and novelist Richard Wright (1908–1960). These and other thinkers and artists whom White met through Dunham gave him his cultural orientation. Like many other black artists of his generation, White worked on the WPA, which saved his career as an artist. As a WPA painter, he made one of his first black history murals, featuring Sojourner Truth, Frederick Douglass, George Washington Carver, Booker T. Washington, and Marian Anderson. He married his first wife, the artist Elizabeth Catlett, in 1941. White taught at the Otis Art Institute, Los Angeles, from 1945 to 1979.

White painted another black history mural at Hampton Institute that depicted Crispus Attucks, Peter Salem, Nat Turner, Denmark Vesey, Booker T. Washington, George Washington Carver, Max Yergan, and Paul Robeson. During the 1940s White moved away from massive, symbolic historical figures and began painting realistic depictions of ordinary African Americans. During the Civil Rights era he captured the courage and dignity of the nonviolent movement. The book *Images of Dignity* (1967) features these works. In the late 1960s White produced the "WANTED" portrait series, based on historical documents of slavery: advertisements for slave auctions and wanted posters for runaway slaves. White had attracted a strong following among African Americans in the 1940s, and by the 1970s he received wide recognition and exhibited internationally.

Sources

Bearden and Henderson, A *History of African-American Artists*: 404–417.

Smithsonian Institution, Archives of American Art.

Williams, Pat Ward (b. 1948)

8.16. "Accused/blowtorch/Padlock" (1986).

Photographer Pat Ward Williams was born in Philadelphia. Her father was an avid amateur photographer. After studying at Cheney State University and the Moore College of Art (B.F.A., 1982), she received an M.F.A. degree from the Maryland Institute, College of Art, Baltimore, in 1987. In the late 1980s she worked as a staff photographer for the Baltimore *City Paper*. She taught in Philadelphia and Baltimore before moving to the CalArts Institute in Valencia, California, in 1989.

Williams cites Roy De Carava's *Sweet Flypaper of Life* (1955), a book of affectionate photographs of the people of Harlem accompanied by essays by Langston Hughes, and her experience at the Haystack Mountain School of Crafts in Deer Isle, Maine, in the summer of 1974 ("the African and African-American summer") as pivotal influences. She says *Sweet Flypaper of Life* "contained characterizations of black people and black families who were human, not statistical, and I was just in love with it. For a very long time, I drew pictures from those photographs." Williams learned more than just techniques: she came into close contact with black people her age who also wanted to become professional artists. One of them, Joyce Scott, is also represented in *Creating Black Americans*.

Sources

Kellie Jones, "Pat Ward Williams: Photography and Social/Personal History," www.thegalleriesatmoore.org/publications/pwwkj.shtml.

Moira Roth, "Pat Ward Williams: A Narrative Chronology," www.thegalleriesatmoore.org/publications/pwpww.shtml.

Paul von Blum in *St. James Guide to Black Artists*: 572–573.

http://thegalleriesatmoore.org/publications/pwpww.shtml.

Woodruff, Hale Aspacio (1900–1980)

7.3. "The History of the Negro in California, Settlement and Development (detail)" (1949).

10.7. "The Cigarette Smoker" (n.d.).

Born in Cairo, Illinois, Hale A. Woodruff studied at the John Herron Art Institute in Indianapolis, the Fogg Art Museum at Harvard University, the Académie Scandinave, and the Académie Moderne in Paris. In 1926 he won the Harmon Foundation Bronze Award. He met Henry Ossawa Tanner in Paris. He also worked with the leading Mexican muralist, Diego Rivera, in Mexico in 1936. Woodruff was one of the artists of the Harlem Renaissance and New Deal eras profoundly influenced by African art.

Over the course of a successful fifty-year career specializing in landscapes, murals, and woodcuts, he made the transition from segregated Negro exhibitions to distinguished solo retrospectives. Major exhibitions honoring Woodruff include "Hale Woodruff: 50 Years of His Art" (Studio Museum in Harlem, second retrospective exhibition in its Black Masters Series, 1979) and "Homage to Hale Woodruff" (Waddell Gallery, Atlanta University, 1981). Woodruff's best-known murals—in the Harlem Hospital, Talladega College, Atlanta University, and the Golden State Insurance Company in California—depict African-American history. In the mid-1950s Woodruff's work became abstract. Woodruff helped found Spiral, a group of black artists in New York who wanted to spread awareness of black art and discuss issues relating to race in the art world.

Sources

Bearden and Henderson, A *History of African-American Artists*: 200–215.

Smithsonian Institution, Archives of American Art.

Leo Twiggs in *St. James Guide to Black Artists*: 585–588.

Young, Purvis (b. 1943)

E.3. "The Chain Gang" (1996).

A self-taught artist born in Miami, Young began painting in Raiford State Prison in the late 1960s. Since the early 1970s he has supported himself through his art. Young reads widely and studies art history on his own. His influences range from the Chicago "Wall of Respect" to the work of the Renaissance painter Rembrandt. In 1972 he painted his first mural on three abandoned buildings at the corner of Northwest Third Avenue and 14th Street in the inner-city Miami neighborhood of Overtown. Much of the mural was ruined when the U.S. Department of Housing and Urban Development destroyed the buildings in 1975. Young exhibited in "Souls Grown Deep," an exhibition mounted as part of the Atlanta Summer Olympic Games in 1996.

Sources

Kathy Moses, *Outsider Art of the South*. Atglen, Penn.: Schiffer, 1999: 199–200, 203.

www.theoutsidersart.com/gallery/2091611064340/.

◇ Picture Credits ◇

1: *Africa and Black Americans*

1.1. Aaron Douglas, "Building More Stately Mansions," 1944. *Oil on canvas, 54 x 42. Reprinted with permissions of the Fisk University Galleries, Nashville, Tennessee*

1.2. Meta Warrick Fuller, "Ethiopia Awakening," 1914. *Courtesy of the Schomburg Center for the Study of Black Culture)*

1.3. Robert Scott Duncanson, "Man Fishing," 1848. *Oil on canvas, 25 x 30. Courtesy of the Walter O. Evans Collection of African American Art*

1.4. Palmer Hayden, "Fétiche et Fleurs," 1926. *The Museum of African American Art, Los Angeles, California, Palmer C. Hayden Collection, gift of Miriam A. Hayden*

1.5. John T. Biggers, "Before the Shrine (Queen Mother)" 1962. *Photo courtesy of Hazel Biggers*

1.6. Melvin Edwards, "Gate of Ogun," 1983. *Collection Neuberger Museum of Art, Purchase College, State University of New York, museum purchase with funds provided by Vera List and the Roy R. and Marie S. Neuberger Foundation, Photo Credit: Jim Frank*

2: *Captives Transported, 1619–ca. 1850*

2.1. Faith Ringgold, "We Came to America," 1997. *Faith Ringgold © 1997 We Came to America, acrylic on canvas, 74½ x 79½*

2.2. Tom Feelings, from *The Middle Passage.* New York: Dial, 1995, n.p. *Printed with permission from Kamili Feelings*

2.3. John T. Biggers, "Middle Passage," 1947. *Reprinted with permission from Hazel Biggers*

2.4. Romare Bearden, "Roots Odyssey," 1976. *Art © Romare Bearden Foundation/Licensed by VAGA, New York, N.Y.*

2.5. Richard Hunt, "Model for Middle Passage Monument," 1987. *Richard Hunt (b.1935), Bronze, 12 x 33 x 33. Courtesy of The Walter O. Evans Collection of African American Art*

2.6. Howardena Pindell, "Autobiography: Water/Ancestors/Middle Passage/Family Ghosts," 1988. *Courtesy of Howardena Pindell and Wadsworth Atheneum, Hartford*

2.7. Viola Burley-Leake, "Middle Passage" quilt, 1994. *Designed and produced by artist Viola Burley-Leake*

3: *A Diasporic People, 1630–ca. 1850*

3.1. Houston Conwill, "The New Ring Shout," 1995. *Rivers by Houston Conwill, sculptor, Joseph DePace, architect and graphic artist, and Estella Conwill, poet. Photograph by Manu Sassoonian, Bernstein Associates. Courtesy of the Schomburg Center for Research in Black Culture, The New York Public Library*

3.2. William H. Johnson, "Jesus and the Three Marys," 1939. *Courtesy of Smithsonian American Art Museum, Washington, D.C./Art Resource, N.Y.*

3.3. Alison Saar, "Afro-Di(e)ty," 2000. *H. Allen Evans, courtesy Jan Baum Gallery and the artist*

3.4. Joshua Johnston, "Portrait of a Gentleman," thought to be the Reverend Daniel Coker (1805–1810). *Courtesy of The American Museum in Britain*

3.5. Harriet Powers, "Bible Quilt," ca. 1898. *Bible Quilt © 1898 Museum of Fine Arts, Boston*

3.6. Clementine Hunter, "Baptism," ca. 1964. *Courtesy of the Ogden Museum of Southern Art*

3.7. Margo Humphrey, "The Last Bar-B-Que," 1989. *Courtesy of Margo Humphrey*

3.8. Scipio Moorhead, "Phillis Wheatley," 1773. *Courtesy of Library of Congress*

3.9. Buffalo soldier and Indian wife, n.d. *Buehman Collection, Courtesy of the Arizona Historical Society/Tucson, Bueh # B112998*

3.10. Joe Sam, "Cohia," 1996. *Courtesy of Joe Sam*

3.11. Julien Hudson, "Portrait of a Young Man," said to be a self-portrait, 1839. *Courtesy of the Louisiana State Museum*

4: Those Who Were Free, ca. 1770–1859

4.1. Jacob Lawrence, "Frederick Douglass Series No. 30—The Free Man," 1938–1939. *Collection of Hampton University Museum, Hampton, Virginia, © 2005 Artists Rights Society (ARS), New York/ ADAGP, Paris*

4.2. Jacob Lawrence, "General Toussaint," 1986. *Photograph Courtesy of Gwendolyn Knight Lawrence/Art Resource, N.Y. Printed with permission from the Artists Rights Society (ARS), New York*

4.3. Inge Hardison, "Sojourner Truth," 1968. *Courtesy of the Schomburg Center for the Study of Black Culture, The New York Public Library*

4.4. Barbara Chase-Riboud, "Sojourner Truth Monument" model, 1999. *Collection of U.S. General Services Administration, The Wiessman Federal Building, 290 Broadway, New York, N.Y.*

4.5. James Pressley Ball, "Portrait of Frederick Douglass," ca. 1860s. *Courtesy of the Schomburg Center for the Study of Black Culture, The New York Public Library, Cincinnati Museum Center-Cincinnati Historical Society Library*

4.6. Isaac Scott Hathaway, "Frederick Douglass," 1919. *Harvard University Archives, Cambridge, Massachusetts*

4.7. Bo Walker, "Frederick Douglass Ikenga," 1978. *Courtesy of the Schomburg Center for the Study of Black Culture, The New York Public Library*

4.8. Augustus Washington, "John Brown," ca. 1846–1847. *National Portrait Gallery, Smithsonian Institution, Washington, D.C., U.S.A.*

4.9. Horace Pippin, "John Brown Going to His Hanging," 1942. *Oil on canvas, 24.125 x 30.25 inches, Accession number 1943.11, Courtesy of the Pennsylvania Academy of the Fine Arts, Philadelphia, John Lambert Fund*

5: Those Who Were Enslaved, 1770–1859

5.1. Elizabeth Catlett, "Harriet," 1975. *Art © Elizabeth Catlett/ Licensed by VAGA, New York, N.Y.*

5.2. Howardena Pindell, "Slavery Memorial," 1993. *Courtesy of Howardena Pindell*

5.3. Kara Walker, "Slavery! Slavery!" 1997. *Courtesy Brent Sikkema N.Y.C.*

5.4. Claude Clark, "Slave Lynching," 1946. *Permission to reproduce Slave Lynching by Claude Clark is granted by the Claude Clark Estate*

5.5. Joyce Scott, "No Mommy Me (1)," 1991. *Collection Susan & Michael Hort /© Scott*

5.6. Jacob Lawrence, "Cinqué Aboard the *Amistad*," 1991. *Jacob Lawrence (1917–2000). Ink on Paper, 7½ x 5¼. Courtesy of The Walter O. Evans Collection of African American Art. Printed with permission from the Artists Rights Society (ARS), New York*

5.7. Charles White, "Wanted Poster Series," 1970. *© 1970 The Charles White Archive*

5.8. Ann Tanksley, "Running to Freedom," 1987. *Courtesy of Ann Tanksley*

5.9. Jacob Lawrence, "Harriet Tubman Series No. 10," 1938–1939. *Collection of Hampton University Museum, Hampton, Virginia. Printed with permission from the Artists Rights Society (ARS), New York*

5.10. John T. Biggers, "Harriet Tubman and Her Underground Railroad," 1952. *Collection of Hampton University Museum, Hampton, Virginia*

5.11. Charlotte Lewis, "The Harriet Tubman Quilt," 1996.

6: Civil War and Emancipation, 1859–1865

6.1. Valerie Maynard, "General Fred," 1973. *Collection of The Studio Museum in Harlem, Gift of the artist. 81.12.2*

6.2. William H. Johnson, "Lincoln at Gettysburg III," ca. 1939–1942. *Gouache and pen and ink on paper. 17⅜ x 16³⁄₁₆ inch, gift of the Harmon Foundation. Smithsonian American Art Museum, Washington D.C./Art Resource, N.Y.*

6.3. Frederick Douglass's two Sons, Lewis (left) and Charles, in army uniforms, ca. 1863. *Moorland-Spingarn Research Center, Howard University*

6.4. John Jones, "The New Order," 1998. *Courtesy John W. Jones*

6.5. Aaron Douglas, "Study for Aspects of Negro Life: From Slavery Through Reconstruction," 1934. *Courtesy of the Schomburg Center for the Study of Black Culture, The New York Public Library*

6.6. Charles White, "General Moses," 1965. *Golden State Mutual Life Insurance Company*

6.7. Ed Hamilton, "Spirit of Freedom" monument, Washington, D.C., 1997–1998. *African American Civil War Memorial Foundation*

6.8. Edmonia Lewis, "Forever Free," 1867. *Howard University Gallery of Art, Washington, D.C.*

6.9. Meta Warrick Fuller, "Emancipation," 1913.

7: The Larger Reconstruction, 1864–1896

7.1. Aaron Douglas, "Study for Aspects of Negro Life: From Slavery Through Reconstruction," 1934. *Courtesy of the Schomburg Center for the Study of Black Culture, The New York Public Library*

7.2. Currier and Ives Lithography Company, "The First Colored Senator and Representatives, in the 41st and 42nd Congress of the United States," 1872. *National Portrait Gallery, Smithsonian Institution /Art Resource, N.Y.*

7.3. Hale A. Woodruff, "The History of the Negro in Cali-

fornia, Settlement and Development (detail)," 1949. *Golden State Mutual Life Insurance Company*

7.4. Palmer Hayden, "Tenth Cavalry Trooper," 1939. *The Museum of African American Art, Los Angeles, California, Palmer C. Hayden Collection, gift of Miriam A. Hayden*

7.5. Erika Rae Allen, "Broken Promises," 1996. *Courtesy Erika Rae Allen*

8: *Hard Working People in the Depths of Segregation, 1896–ca. 1919*

8.1. Palmer Hayden, "John Henry on the Right, Steam Drill on the Left, from the John Henry Series," 1944–1954. *The Museum of African American Art, Los Angeles, California, Palmer C. Hayden Collection, gift of Miriam A. Hayden*

8.2. Elizabeth Catlett "Sharecropper," 1968. *Art © Elizabeth Catlett/Licensed by VAGA, New York, N.Y.*

8.3. Edwin A. Harleston, "The Old Servant," 1928. *National Archives and Records Administration*

8.4. Edward Mitchell Bannister, "Newspaper Boy," 1869. *Oil on canvas, 30⅛ x 25 inches, Smithsonian American Art Museum, Washington, D.C./ Art Resource, N.Y.*

8.5. Samella Lewis, "Waterboy," 1944. *Collection of Hampton University Museum*

8.6. Allan Rohan Crite, "Beneath the Cross of St. Augustine," 1936. *Courtesy Allan Rohan Crite and Howard University Gallery of Art, Washington D.C.*

8.7. Leslie Garland Bolling, "Cousin-on-Friday," 1935. *Virginia Museum of Fine Arts, Richmond. Gift of The Honorable and Mrs. Alexander W. Weddell. Photo: Katherine Wetzel © Virginia Museum of Fine Arts*

8.8. William H. Johnson, "Chain Gang," ca. 1939–1940. *Oil on plywood, 45¾ x 38½ inches, Smithsonian American Art Museum, Washington, D.C./Art Resource, N.Y.*

8.9. Arthur P. Bedou, "Booker Taliaferro Washington, Portrait of the Educator on His Horse," 1915. *Library of Congress*

8.10. Henry Ossawa Tanner, "The Banjo Lesson," 1893. *Collection of Hampton University Museum, Hampton, Virginia*

8.11. Betye Saar, "The Liberation of Aunt Jemima," 1972. *Berkeley Art Museum*

8.12. Joyce J. Scott, "Man Eating Watermelon," 1986. *Collection Edward & Ursula McCracken / © Scott*

8.13. Freida High W. Tesfaggiorgis, "Homage to Ida B. Wells," 1990. *Courtesy of Freida High, 8 x 2½ x 7½ feet, Media: mixed media installation, Detail of Mixed Media: Acrylic on canvas, trees, rope, Mississippi red dirt, Georgia red dirt, Mississippi magnolia leaves, chicken feathers, painted Wisconsin pine needles and pine cones, horse shoe, iron farm implements, paper, texts [lynch victims—names, Mississippi counties, dates of lynching], painted leaves—sculpted/molded wilt adhesive,*

Picture of work on display at Milwaukee Art Museum, Milwaukee, W.I.

8.14. Melvin Edwards, "Lynch Fragments: Resolved and Afro Phoenix no. 2," 1963/1964. Edwards' series uses found metal objects welded together into instruments of lynching's torture and death. *Permission to reprint resolved courtesy of The Newark Museum / Art Resource, NY The Newark Museum, Newark, New Jersey, U.S.A. Permission to reprint Afro Phoenix no.2 courtesy of CDS Gallery and the Collection of Jayne Cortez, New York*

8.15. Camille Billops, "The KKK Boutique," 1994. *Courtesy of the Schomburg Center for the Study of Black Culture, The New York Public Library.*

8.16. Pat Ward Williams, "Accused/Blowtorch/Padlock," 1986. *Wood, tar paper, gelatin silver prints, film positive, paper, pastel and metal, overall 59½ x 107 x 4½ inches, [151.13 x 271.78 x 11.43 cm], Whitney Museum of American Art, New York; Purchase, with funds from The Audrey & Sydney Irmas Charitable Foundation 93.64*

9: *The New Negro, 1915–1932*

9.1. Jacob Lawrence, "Migration of the Negro, Panel 1: During the World War there was a Great Migration North by Southern Negroes," 1940–1941. *The Phillips Collection, Washington, D.C. Printed with permission from the Artists Rights Society (ARS), New York*

9.2. Archibald J. Motley, Jr., "Black Belt," 1934. *Collection of Hampton University Museum, Hampton, Virginia*

9.3. Albert A. Smith, "The Reason," 1920. *Oxford University Press wishes to thank The Crisis Publishing Co., Inc., the publisher of the National Association for the Advancement of Colored People, for the use of this work first published in the March 1920 issue of The Crisis Magazine.*

9. 4. Malvin Gray Johnson, "Negro Soldier," 1934. *Courtesy of the Schomburg Center for the Study of Black Culture, The New York Public Library*

9.5. C. M. (Cornelius Marion) Battey, "Portrait of W. E. B. Du Bois," 1918. *Library of Congress*

9.6. James A. Porter, "Soldado Senegales," ca. 1935. *Oil on canvas, 38¼ x 30 inches, Smithsonian American Art Museum, Washington, D.C./Art Resource, N.Y.*

9.7. Augusta Savage, "Marcus Garvey," ca. 1930. *Collection Estate of Mrs. Amy Jacques Garvey*

9.8. James Van Der Zee, "UNIA Parade," 1924. *Courtesy of the Schomburg Center for the Study of Black Culture, The New York Public Library, Photographer: James Van Der Zee, © by Donna M. Van Der Zee).*

9.9. Romare Bearden, "Jammin' at the Savoy," n.d. [before 1982]. *Collection of the Studio Museum in Harlem, Gift of Mrs. Frank Saunders, 91.24, Art © Romare Bearden Foundation/Licensed by VAGA, New York, N.Y.*

10: Radicals and Democrats, 1930–1940

10.1. James Lesene Wells, book jacket for *The Negro Wage Earner*, 1930. *Addison Gallery of American Art*

10.2. Beauford Delaney, "Can Fire in the Park," ca. 1946. *Oil on canvas, 24 x 30 inches, Smithsonian American Art Museum, Washington, D.C./Art Resource, N.Y.*

10.3. Walter Ellison, "Leaving Macon Georgia," 1937. *Collection of Hampton University Museum, Hampton, Virginia*

10.4. Morgan and Marvin Smith, "The Reverend Adam Clayton Powell, Jr., leads a protest on 125th Street in Harlem—'Don't Buy Where You Can't Work' campaign," 1942. *Courtesy of the Photographs and Prints Division, Schomburg Center for Research in Black Culture, The New York Public Library, Astor, Lenox and Tilden Foundations, with permission of Mrs. Monica Smith, New York, New York*

10.5. Palmer Hayden, "The Janitor Who Paints," 1937. *Oil on canvas 39⅛ x 32⅞ inches, Smithsonian American Art Museum, Washington, D.C./Art Resource, N.Y.*

10.6. Allan Rohan Crite, "Marble Players," 1938. *Courtesy Allan Rohan Crite and Boston Athenaeum*

10.7. Hale Woodruff, "The Cigarette Smoker," n.d. *Collection of Hampton University Museum, Hampton, Virginia*

10.8. William H. Johnson, "Haile Selassie," ca. 1945. *Smithsonian American Art Museum, Washington, D.C./Art Resource, N.Y.*

10.9. Poster for Joe Louis movie, *The Fight Never Ends*, 1949. *Library of Congress*

10.10. Jean-Michel Basquiat, "St. Louis Surrounded by Snakes," 1982. *Tony Shafrazi Gallery,* © *2005 The Estate of Gwendolyn Knight Lawrence / Artists Rights Society (ARS), New York*

11: The Second World War and the Promise of Internationalism, 1940–1948

11.1. Dox Thrash, "Defense Worker," ca. 1942. *Federal Works Agency, Work Projects Administration, on deposit at the Philadelphia Museum of Art, 1943*

11.2. Tina Allen, "A. Philip Randolph (detail)," 1988. *Courtesy of Tina Allen*

11.3. William H. Johnson, "Lessons in a Soldier's Life," ca. 1942. *Smithsonian American Art Museum, Washington, D.C./Art Resource, N.Y.*

11.4. Charles White, "Bayonets," 1943. *Courtesy of the Schomburg Center for the Study of Black Culture, The New York Public Library*

11.5. Seven flyers from the state of New York on the cover of a nationally circulated magazine, the NAACP's *The Crisis*, February 1945. *Oxford University Press wishes to thank The Crisis Publishing Co., Inc., the publisher of the magazine of the National Association for the Advancement of Colored People, for the use of this image on the cover of the February 1945 issue of* The Crisis Magazine.

11.6. Joseph Delaney, "Times Square, V-J Day," 1961.

11.7. Paul Goodnight, "Salt Peanuts Don't Belong to Jimmy Carter," 1980. *Courtesy of Color Circle Art Publishing, Inc.*

11.8. Mary McLeod Bethune (1875–1955), 1945. *Bethune Museum and Archives*

11.9. Charles White, "Woman Worker," 1951. *Charles White (1918–1979). Oil on canvas, 30 x 24. Courtesy of the Walter O. Evans Collection of African American Art*

12: Cold War Civil Rights, 1948–1960

12.1. Charles Alston, "Walking," 1958. *Collection of Sydney Smith Gordon, oil on canvas*

12.2. Richmond Barthé, "Paul Robeson as Othello," 1974. *Courtesy of the Schomburg Center for the Study of Black Culture, The New York Public Library*

12.3. Emma Amos, "Paul Robeson Frieze (Robeson photograph by Nikolas Muray, ca. 1930s)," 1995. *Photo credit: Besket Logan* © *1995 Emma Amos*

12.4. David Driskell, "Of Thee I Weep," 1968. *Courtesy of David C. Driskell*

12.5. Robert L. Haggins, "Malcolm X," 1963.

12.6. Chris Clark, "Louis Armstrong" quilt, 2005. *Courtesy of Chris Clark*

12.7. David Hammons, "Bird," 1973. *Printed with permission from Carmen Hammons*

12.8. Paul A. Houzell, "Chuck Berry: Nadine Honey Is That You?" 1999.

13: Protest Makes a Civil Rights Revolution, 1960–1967

13.1. Willie Birch, "Memories of the 60s," 1990. *Courtesy of Arthur Roger Gallery, New Orleans*

13.2. Howardena Pindell, "Homage to MLK," 1968. *Courtesy of Howardena Pindell*

13.3. Faith Ringgold, "Dream 2: King and the Sisterhood," 1988. *Faith Ringgold* © *1988, Dream 2 King and the Sisterhood. Acrylic on canvas 94 x 60*

13.4. Paul Andrew Wandless, "American Dreamer," 2000. *Paul Andrew Wandless*

13.5. Calvin Burnett, "Fannie Lou Hamer," 1977. *Courtesy of Calvin Burnett*

13.6. Jeff Donaldson, "Aunt Jemima & the Pillsbury Doughboy," 1963.

13.7. Kay Brown, "The Black Soldier," 1969. *Courtesy of Kay B. Brown*

13.8. Willis "Bing" Davis, "Ghetto Voice," 1967. *Courtesy of Willis "Bing" Davis*

13.9. Dana Chandler, "Noddin Our Liberation Away," 1974. *Courtesy of Dana Chandler*

13.10. Romare Bearden, "Black Manhattan," 1969. *Courtesy of the Schomburg Center for the Study of Black Culture, The New York Public Library, Art* © *Romare Bearden Foundation/Licensed by VAGA, New York, N.Y.*

14: *Black Power, 1966–1980*

14.1. Elizabeth Catlett "Negro es Bello II," 1969. *Lithograph, ed. 100 © Elizabeth Catlett/Licensed by VAGA, New York, N.Y., image courtesy Stragow Gallery, New York, N.Y., Photo Credit: A. van Woerkom*

14.2. Jeff Donaldson, "Wives of Shango," 1968.

14.3. Carroll Parrott Blue, "Angela Davis in Los Angeles," 1972. *Courtesy of Carroll Parrott Blue*

14.4. Lev Mills, "LeRoi?" 1972. *Courtesy of Lev T. Mills*

14.5. Roland L. Freeman, "Kwanzaa Quilt," 1989. *Original design by Roland L. Freeman. Credit for Photo: © Roland L. Freeman*

14.6. Archibald Motley, Jr., "The First One Hundred Years: He Amongst You Who Is Without Sin Shall Cast the First Stone: Forgive Them Father For They Know Not What They Do," ca. 1963–1972. *Courtesy of the Chicago Historical Society, from the collection of Archibald Motley and Valerie Gerard Browne*

14.7. Richard Hunt, "I've Been to the Mountaintop," 1977. *Collection of Richard Hunt*

14.8. Glenn Ligon, "Malcolm, Martin," 1991. *Collection of the Hort Family, New York, New York*

14.9. Phillip Lindsay Mason, "Deathmakers," 1968.

14.10. Claude Clark, "Polarization," 1969. *The National Afro-American Museum and Cultural Center, Wilberforce, Ohio*

14.11. Faith Ringgold, "Flag for the Moon: Die Nigger," 1969. *Faith Ringgold © 1969, Flag for the Moon: Die Nigger, Oil on canvas, 36 x 50*

14.12. David Hammons, "Injustice Case," 1970. *Los Angeles County Museum of Art, Museum Acquisition Fund, Photograph © 2005 Museum Associates/LACMA, M.71.7. Printed with permission from Carmen Hammons*

14.13. Sylvia Abernathy, Jeff Donaldson, et al., "Wall of Respect," 1967 (original version), 43rd and Langley, Southside Chicago, Illinois. *Photograph © 1967 Robert A. Sengstacke*

14.14. Nelson Stevens, "Work to Unify African People" mural, 1973, United Community Construction Workers Labor Temple, Roxbury, Boston, Massachusetts.

15: *Authenticity and Diversity in the Era of Hip-Hop, 1980–2005*

15.1. Brett Cook (Dizney), "Why Fight for a Crayon That's Not Our Color?" 1988. *Printed with permission from Brett Cook Dizney*

15.2. David Hammons, "How You Like Me Now?" 1988. *Printed with permission from Carmen Hammons*

15.3. Barbara Chase-Riboud "Africa Rising," 1998. *Collection of U.S. General Services Administration, The Wiessman Federal Building, 290 Broadway, New York, N.Y., Design Award Best Sculpture in a Federal Building 1998, cast bronze*

15.4. Kyra E. Hicks, "Black Barbie" quilt, 1996. *Courtesy Kyra E. Hicks, Photography by David Smalls*

15.5. Melvyn Henry Samuels, Jr. "Noc," New York subway car, 1981. *Photograph courtesy of Henry Chalfant*

15.6. Herbert Singleton, Jr., "Blood for Oil," 1990. *Courtesy of Alvina and Paul Haverkamp*

15.7. O. L. Samuels, "Saddam Husein [sic]," 1992.

Epilogue: A Snapshot of African Americans in the Early Twenty-First Century

E.1. Herbert Singleton, Jr., "Ain't Gonna Be First, Won't Be Last," 1997. *Courtesy of Dale R. Fleishmann*

E.2. Kyra E. Hicks, "Single Black Female" quilt, 1994. *Courtesy of Kyra E. Hicks, Photograph by David Smalls*

E.3. Purvis Young, "The Chain Gang," 1996. *Courtesy of Gallery 721*

E.4. Aaron McGruder, "Boondocks," 1999. *THE BOONDOCKS © 1999 Aaron McGruder. Distributed by UNIVERSAL PRESS SYNDICATE. Reprinted with permission. All rights reserved.*

◇ Index ◇